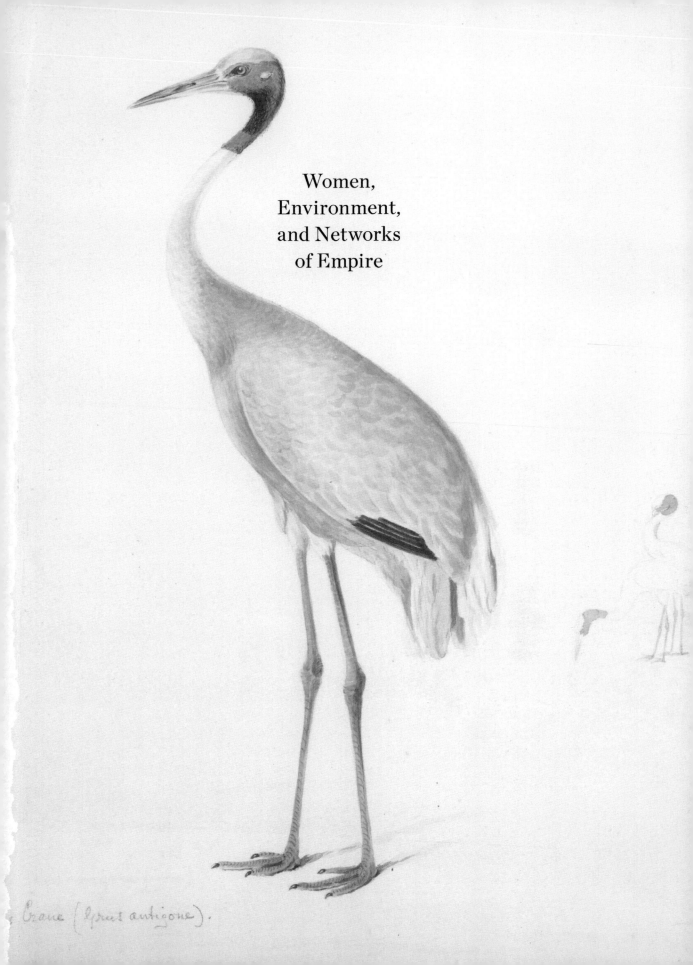

Women,
Environment,
and Networks
of Empire

Crane (Grus antigone).

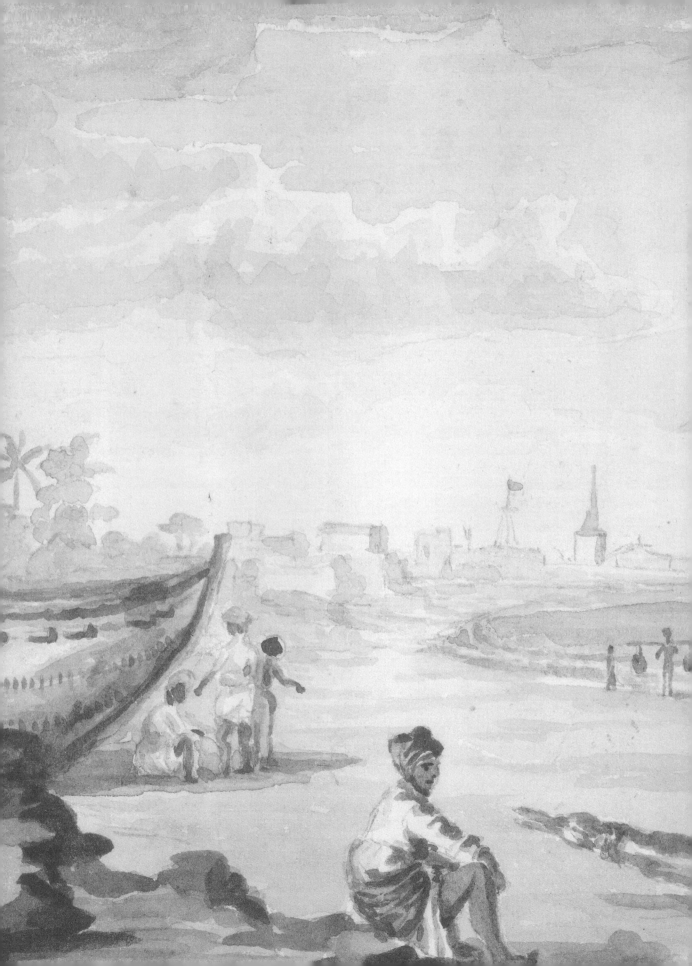

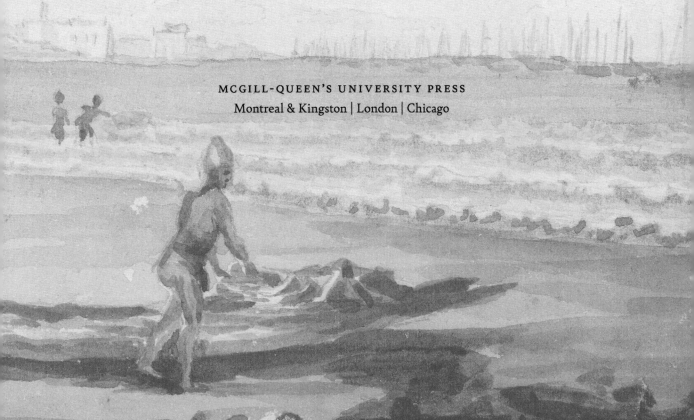

Women, Environment, and Networks of Empire

Elizabeth Gwillim and
Mary Symonds in Madras

Edited by
ANNA WINTERBOTTOM, VICTORIA DICKENSON,
BEN CARTWRIGHT, *and* LAUREN WILLIAMS

MCGILL-QUEEN'S UNIVERSITY PRESS
Montreal & Kingston | London | Chicago

ISBN 978-0-2280-1886-5 (cloth)
ISBN 978-0-2280-1987-9 (ePDF)

Legal deposit fourth quarter 2023
Bibliothèque nationale du Québec

Printed in Canada on acid-free paper

We acknowledge the support of the Canada Council for the Arts.
Nous remercions le Conseil des arts du Canada de son soutien.

McGill-Queen's University Press in Montreal is on land which long served as a site of meeting and exchange amongst Indigenous Peoples, including the Haudenosaunee and Anishinabeg nations. In Kingston it is situated on the territory of the Haudenosaunee and Anishinaabek. We acknowledge and thank the diverse Indigenous Peoples whose footsteps have marked these territories on which peoples of the world now gather.

LIBRARY AND ARCHIVES CANADA CATALOGUING IN PUBLICATION

Title: Women, environment, and networks of empire : Elizabeth Gwillim and
 Mary Symonds in Madras / edited by Anna Winterbottom, Victoria Dickenson,
 Ben Cartwright, and Lauren Williams.
Other titles: Elizabeth Gwillim and Mary Symonds in Madras
Names: Winterbottom, Anna, 1979– editor. | Dickenson, Victoria, editor.
 Cartwright, Ben, editor. | Williams, Lauren (Liaison librarian), editor.
Description: Includes bibliographical references and index.
Identifiers: Canadiana (print) 20230226426 | Canadiana (ebook) 20230226477
 ISBN 9780228018865 (cloth) | ISBN 9780228019879 (ePDF)
Subjects: LCSH: Gwillim, Elizabeth, 1763–1807. | LCSH: Symonds, Mary, 1772–1854.
 LCSH: Women painters—India—Chennai—Biography. | LCSH: Painters—India—
 Chennai—Biography. | LCSH: Women—India—Chennai—Biography. | LCSH:
 British—India—Chennai—Biography. | LCSH: Painting, British—India—Chennai—
 19th century. | LCSH: Watercolor painting—India—Chennai—19th century.
 LCSH: Wildlife painting—India—Chennai—History—19th century. | LCSH: Natural
 history—India—Chennai—History—19th century. | LCSH: Chennai (India)—In art.
 LCSH: Chennai (India)—Social life and customs—19th century.
Classification: LCC ND496 .W66 2023 | DDC 759.2—dc23

Design: Lara Minja, Lime Design

Main body set in 11 pt/14 pt Bely with titles in Chronicle Display. Subheads, caption identifiers, intro paragraph text (Contributors), and footers set in Mr Eaves San OT. Special character fonts include Adobe Tamil, Tamil Sangam MN, and Telugu MN.

This book is dedicated to two individuals whose research laid
the foundation for the Gwillim Project: Rosemary Ruddell,
a Canadian anthropologist whose great intellectual curiosity
led her to the world of the Gwillims, and S. Muthiah, an unrivalled
historian of Chennai, whose work has inspired us all.

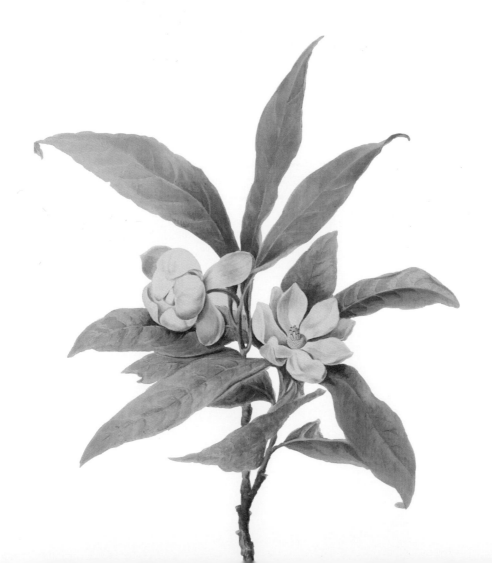

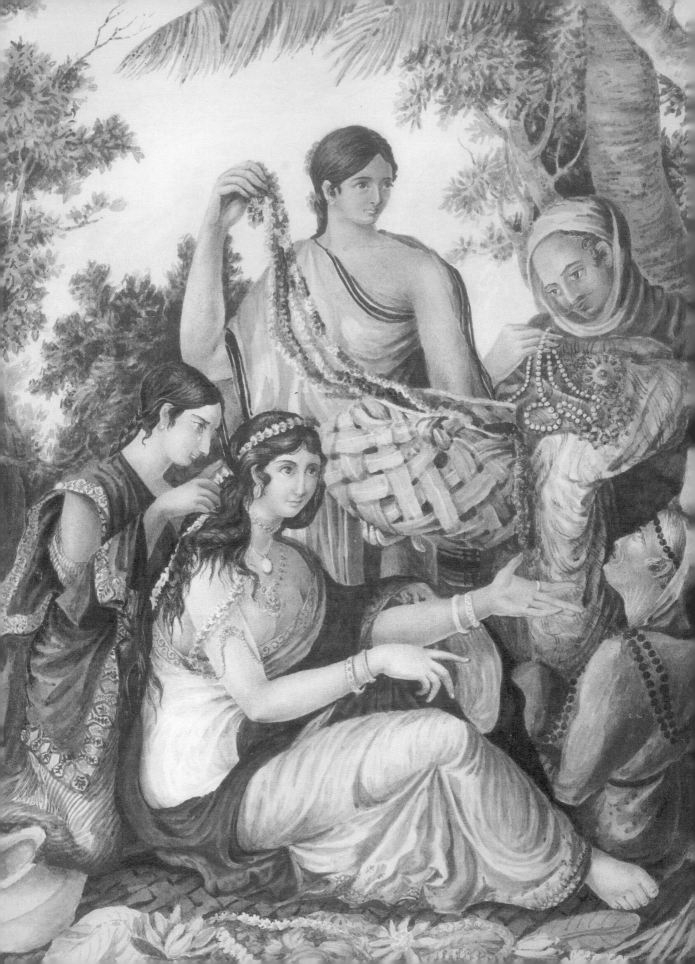

Contents

Acknowledgments

The Gwillim Project (2019–22) was hosted by Rare Books & Special Collections, Osler, Art, and Archives (ROAAr) at McGill University, and we are grateful to all the staff there. Special thanks are due to Nathalie Cooke and Jacquelyn Sundberg for their help in getting the project off the ground, and to Christopher Lyons and Jennifer Garland for their interest and encouragement throughout.

This book draws on research supported by the Social Sciences and Humanities Research Council of Canada (SSHRC), and we appreciate the assistance of the Office of Sponsored Research at McGill in securing this grant. The project also received funding from the Shastri Indo-Canadian Institute (SICI). Many thanks are due to Madhav Badami for his encouragement at an early stage of the project and to Reshma Rana Verma for her ongoing support as the pandemic made it necessary to repurpose much of the original Shastri funding.

We are grateful to Jenn Riley, Alexandra Kohn, and Ana Rogers-Butterworth and the Application Development team of McGill Digital Initiatives, and to Richard Laurin, who worked with us to develop a complementary website for the project, funded through Digital Museums of Canada.

Our project partners – the Indian Ocean World Centre at McGill, the Aga Khan Museum in Toronto, the Centre for World Environmental History at Sussex University, the South Asia Collection in Norwich, IIT Madras, and Dakshina Chitra Museum in Chennai – were invaluable in lending the expertise of their members. We are especially grateful to John Bosco Lourdusamy and Suzy Varughese, for hosting a symposium at IIT Madras. Deborah Thiagarajan, Lalitha Krishnan, Gita Hudson, Sharath Nambiar, and Rekha Vijayashankar hosted several exhibitions and events at Dakshina Chitra. We thank Philip and Jeanie Millward of the South Asia Collection and Ulrike al-Khamis of the Aga Khan Museum for their support for the project and for hosting exhibitions at their institutions.

We are grateful to staff at the British Library, including Xerxes Mazda, Margaret Makepeace, Antonia Moon, and Matthew Lambert, who helped us acquire digital copies of the original correspondence of Elizabeth Gwillim and Mary Symonds, navigate the complex copyright rules around using them, and draw attention to the project through the Untold Lives blog.

Members of the research network were essential in the cataloguing of the Gwillim watercolours at McGill Library. For identifying the birds depicted by Elizabeth Gwillim, we are grateful to Suryanarayana Subramanya, whose contributions to this project have gone far beyond his chapter in this volume. For identifying the fish, we are grateful to Shyamal Lakshminarayanan and to A. Gopalakrishnan, director, ICAR-CMFRI, and his colleagues Drs Sreenath K.R. and Ranjith L. of the Marine Biodiversity and Environment Management Division.

We appreciate all members of the network for presenting their work at the online symposium that led to this book, for moderating sessions, and for offering feedback. As well as the authors represented here, we acknowledge with thanks the contributions of Satwinder Bains, Gwyn Campbell, John Bosco Lourdusamy, Akash Muradlidharan, Kate Smith, V. Sriram, A. Srivathsan, Deborah Thiagarjan, and Patrick Wheeler. Special thanks are due to Jeffrey Spear and Patrick Wheeler for sharing their transcriptions of the sisters' correspondence and to Jane Ruddell for transferring to McGill her mother Rosemary Ruddell's transcriptions of the correspondence as well as her research notes relating to the Gwillim family.

Our student research assistants and associates have been invaluable members of the project team, bringing many new insights and perspective on the material. We thank Myles Browne and Anmol Gupta for their work developing the project website; Rebekah McCallum and Emilienne Greenfield for their careful transcriptions of the manuscript correspondence; Saraphina Masters, Hana Nikčevic, Ciel Haviland, and Carleigh Nicholls for researching and writing a range of informative case studies; and all those who worked on the project newsletter, including Saraphina, Hana, Ciel, and Maryam Rahimi Shahmirzadi. We thank Nora Shaalan and Carleigh Nicholls for their administrative support and Emily Zinger for organizing the online symposium series and collating the transcriptions. We are grateful to Qianru Wang, who made interactive maps for the project. Special thanks are due to Hana Nikčevic for her meticulous copyediting of this volume.

We would like to thank the editorial staff at McGill-Queen's University Press, especially Jonathan Crago and Kathleen Fraser, for their encouragement and support throughout the publication of this book. Thanks are also due to Barbara Tessman for her meticulous copyediting.

Finally, we want to acknowledge the kindness and generosity of all members of the Gwillim Research Network, without whom this project would have been impossible, and with whom we have developed fruitful and enduring collaborations.

Women,
Environment,
and Networks
of Empire

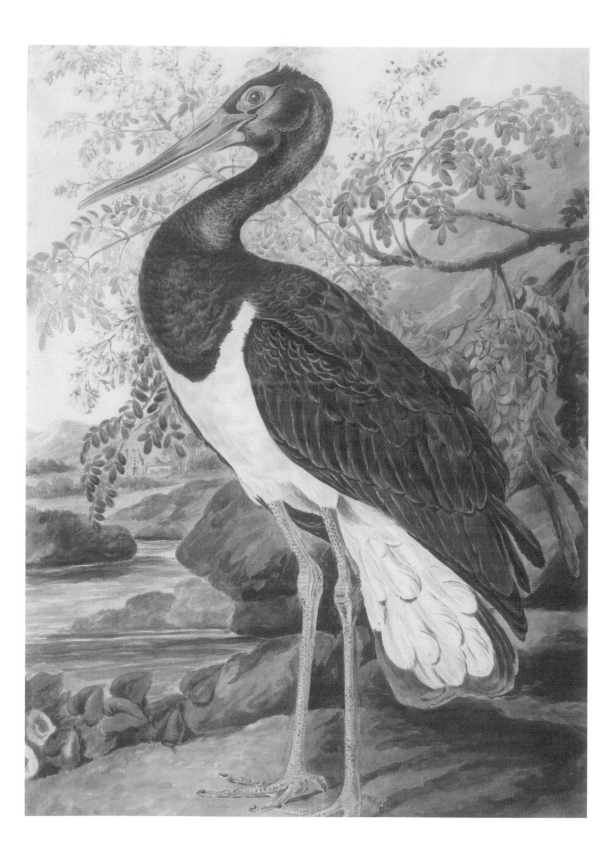

Introduction

ANNA WINTERBOTTOM

This book showcases and contextualizes the paintings and correspondence of Elizabeth, Lady Gwillim, née Symonds (21 April 1763–21 December 1807) and her sister Mary Symonds (18 September 1772–28 January 1854),[1] made during their stay in Madras (now Chennai). The sisters left their native England for India following the appointment of Elizabeth Gwillim's husband, Sir Henry Gwillim, as a judge in the Supreme Court in Madras. They sailed on the ship *Hindostan*, leaving Portsmouth on 31 March 1801 and arriving in Madras some four months later, on 26 July.[2] Elizabeth Gwillim died at the age of forty-four and was buried in St Mary's Church in Madras on 21 December 1807. Henry Gwillim and Mary Symonds returned to England, leaving Madras in October 1808.

Elizabeth Gwillim is best-known for her ornithological paintings, which are remarkable for their period. One hundred and twenty-one of her bird watercolours remain in the Blacker Wood Collection at McGill University Library, as well as thirty-one paintings of fish, most of which can be attributed to Mary Symonds, and twelve botanical paintings.[3] Seventy-eight artworks depicting landscapes and people around Madras (*The Madras and Environs Album*), most by Mary Symonds, with some by Elizabeth Gwillim, are held by the South Asia Collection in Norwich.[4] The family's correspondence with their relatives in England, seventy-eight long letters dating from 1801 to 1808, occupies four large volumes in the British Library.[5] Together, these documents reveal an unusually detailed picture of the sisters' time in Madras. They enable us to reflect on the role of British women in natural history, the natural and social environment of early nineteenth-century Madras, and the informal networks of exchange that underpinned the Company Raj.

The chapters and case studies in this book explore different facets of the sisters' work and lives during their time in India and place them in the context of wider developments in natural knowledge, artistic expression, and cross-cultural exchanges of goods and ideas. This introduction places the sisters' lives and work in the context of global events at the dawn of the nineteenth century and discusses their early lives and intellectual influences.

Eric Hobsbawm characterized the period 1789–1848 as the "age of revolution," while Christopher Bayly referred to the "first age of global imperialism," beginning from 1780.[6] The first years of the nineteenth century were crucial in determining the long-term effects of the political, economic, and social revolutions of the late eighteenth century. As the *Hindostan* sailed toward India, the newly independent country of Haiti adopted its first constitution, and the British and Napoleonic armies fought in Egypt. The revolutions of the period drove the expansion of the "second" British Empire, following the loss of the American colonies after 1779. European wars on a global stage were used to justify further acquisitions of colonial territory.[7] The British Empire can be seen as a massive counter-revolution, which transformed and turned to its own ends many of the ideas of the age of revolutions (most obviously liberty, equality, and fraternity) circulating not just in the Atlantic but also across the Pacific and Indian Oceans.[8]

The Napoleonic Wars disrupted both the land routes and sea routes through which correspondence and goods were sent between Britain and India. A brief peace established by the Treaty of Amiens of 27 March 1802 lasted only until 18 May 1803. The Napoleonic Wars were interconnected with conflicts in India, as Indian rulers who opposed the British turned to the French for military support. Île de France (Mauritius) and Bourbon (Réunion) in the Indian Ocean were used as bases for French naval attacks on British shipping.[9] The danger of attack required ships to travel in convoy, and news and correspondence were often delayed or even intercepted. Elizabeth Gwillim wrote in 1806 that a fleet that was expected to depart from England ten months earlier had still not reached Madras, adding, "I rail at Buonaparte & all the causes of the war which has so much interrupted our intercourse ever since we have been here."[10]

The English East India Company (EIC), in various incarnations, had represented the British government in Asia since Elizabeth I's 1600 charter. Between 1757 and 1765, it had acquired control of significant territories and the right to level taxes in Bengal, granted by the Mughal emperor Shah Alam II (r. 1760–1806). Despite its growing power in India in this period, the EIC became increasingly dependent on the British government for loans and attracted widespread criticism in Britain for its handling of Indian affairs.[11] The result was that the EIC became increasingly subject to regulation by the British government from the 1770s onwards. This tightening of control over the EIC territories included the direct appointment of judges by the British government. The Supreme Court in Madras was created by George III's charter of

26 December 1800 to dispense justice to all inhabitants of the settlement based on English laws.[12] Elizabeth Gwillim's husband, Henry Gwillim, was one of three justices appointed to the new court.

Like many British women of their era, Elizabeth Gwillim and Mary Symonds came to India to accompany a male relative.[13] And like many of their female contemporaries, they soon carved out independent roles as observers of Indian natural and social environments. The ways in which the sisters documented their experiences in India and the networks on which they drew to gather and share information were founded on their earlier experiences. Therefore, before returning to their lives after the *Hindostan* anchored off Madras (plate 1), let us reconstruct what we can of the sisters' early lives.

EARLY LIVES

Elizabeth Gwillim (née Symonds), Mary Symonds, and their sisters grew up in a professional, provincial household, where they were exposed to some of the intellectual and artistic trends of the late eighteenth century. Elizabeth was born in 1763 and Mary in 1772 in Hereford. They had an older sister, Ann James (b. 1759), referred to as Nancy in their letters, but their middle sister Hester James (b. 1768), known as Hetty, then living in London, was their main correspondent during their time in India.[14] Both Elizabeth and Mary also wrote to their mother, Esther Symonds (1743–1806), who, after the death of their father, Thomas Symonds (1730–1791), had continued his business as an architect, stonemason, and surveyor.[15]

Late eighteenth-century Hereford was surrounded by rich pasture and arable lands and orchards. The city's population was 5,232 in the mid-1760s and 6,007 by 1796.[16] Despite its fertile rural environment, the city lacked the manufacturing base that had become important as the Industrial Revolution gathered pace: an earlier trade in gloves was in decline, and an attempt to start woollen manufacture had come to nothing, partly due to a lack of ready access to coal. The resulting shortage of employment prompted the opening of the city's first workhouse, in the 1790s.[17] Although the Symonds and Gwillim families were members of the professional classes, the declining fortunes of the city perhaps explain why many of the younger generation left, moving to London or abroad. Elizabeth and Mary's older sister, Ann, and her husband, Edward ("Ned") James, who remained in Hereford, apparently suffered financial difficulties.[18]

By 1801, Esther Symonds lived in Capuchin Lane, close to Hereford Cathedral, where for many years Thomas Symonds had acted as surveyor to the dean and chapter (the governing body) of the cathedral. Symonds carved monuments for

several churches around Hereford, often featuring portrait medallions.[19] He retired from his post after the collapse of the tower at the west end of Hereford Cathedral in 1786, a disaster he had previously warned was likely.[20] By 1775, he had become clerk of works for Richard Payne Knight of Downton Castle.[21]

In addition to his evident skill in portraiture, Thomas Symonds was also a draughtsman. Esther Symonds probably acquired similar skills from working alongside her husband: Elizabeth referred to her mother as "a great architect."[22] The sisters were likely instructed in drawing and painting by their parents. Thomas Symonds's involvement with the antiquarian and author Richard Payne Knight might have brought his daughters into contact with Payne's own collections and his theories on picturesque beauty, and perhaps also with Thomas Hearne, who during the mid-1780s produced several landscape paintings of Downton Castle.[23] Elizabeth and Mary were also mentored by their family friend George Samuel (d. 1823), a landscape painter and member of Thomas Girtin's sketching club who produced several scenes of Hereford. While in India, both sisters wrote to Samuel for artistic advice,[24] and on occasion he supplied them with materials.[25]

Probably while growing up in Hereford, the sisters visited Wales. The letters mention Llandrindod Wells, a popular spa town, where Elizabeth believed she first caught the ague or fever that would later afflict her in Madras.[26] The sisters also compared the seaside towns of Borth and Barmouth to the seascapes around Madras.[27] Describing the seaside village of Kovalam, Elizabeth wrote, "the Rocks & rivers are romantick as Wales tho the Hills are not lofty."[28] The sisters' lives coincided with what is generally described as the "Romantic era" in Britain, ca. 1770–1830.[29] A literary and artistic movement, Romanticism celebrated the power of the emotions and the imagination, inspired by sights such as remote natural landscapes or ancient ruins. Elizabeth's reference to the landscapes of both Wales and Kovalam and the elements of the picturesque in Mary's paintings demonstrate the influence of Romanticism on their later reactions to Madras.[30]

As Rosemary Raza notes, women's educational backgrounds also influenced their responses to India.[31] Elizabeth and Mary probably received a good general education at a local school. Mary felt entitled to look down on the educational level of the mixed-race female children of EIC employees in Madras, who, she wrote, "are sent home to England, to be educated as it is called, that is to learn to dance to *squall* and to strum."[32] On the other hand, she was careful to distance herself from the radical educational ideas of Mary Wollstonecraft's husband, William Godwin, which she considered a little too "modern."[33] By the late eighteenth century, schooling for girls was widely available to the professional classes, and Hereford boasted several "ladies boarding schools."[34] The curricula would have included instruction in drawing, natural history, and

perhaps other sciences, as well as history, geography, mathematics, and modern languages.[35] Elizabeth evidently had a basic knowledge of Latin, probably gained by independent study.[36]

Like many women of their era, Elizabeth and Mary added to their formal education through independent reading and study.[37] Growing up, the sisters had access to some reading material at home: Thomas Symonds subscribed to Wellins Calcott's popular collection of moral and religious aphorisms.[38] Elizabeth referred to some classics of English literature, noting, for example, that the cuckoo was regarded as an ill omen by both Chaucer and Milton but was considered auspicious in Indian culture.[39] The sisters would have read some descriptions of "the Orient" and some popular translations like the *Arabian Nights Entertainment*, which Elizabeth mentions.[40]

In 1784, Elizabeth Symonds married Henry Gwillim (1759–1837) at St Bride's Church in Fleet Street, London. At the time, Henry was studying law at the Middle Temple, one of the four Inns of Court where barristers were trained. Three years later, in 1787, he was called to the bar, formally beginning his legal career.[41] Henry and Elizabeth Gwillim settled in Boswell Court, close to Fleet Street, and had a daughter, Elizabeth, who was born in 1785 but died early the following year.[42] Two children were born to an Elizabeth and Henry Gwillim in Sarnesfield, Hereford, close to where the Symonds family lived: Ann in 1787 and Henry in 1789. Henry died in infancy,[43] and, if Ann was indeed the daughter of our Elizabeth Gwillim, she must also have died, since by the time they reached India, the couple were childless.[44] Henry and Elizabeth had an affectionate marriage, and they shared interests in natural history and the arts. Henry's support would have been crucial to Elizabeth's ability to pursue her scholarly and artistic interests.[45] Henry Gwillim also encouraged Mary Symonds, urging her to put aside an interest in portrait miniatures to focus on more serious subject matter.[46]

Henry Gwillim was from another Hereford family. His father, John Gwillim (1728–1818), was a respected surgeon and apothecary who served as mayor and alderman of the city.[47] The two families were clearly friendly, and Mary Symonds corresponded with the younger John Gwillim, Henry's older brother, also a Hereford apothecary.[48] It was perhaps through the Gwillim family that the sisters acquired a connection with Reginald Whitley's nursery gardens at Brompton. A John Gwillim is listed as a subscriber to the Brompton Botanical Gardens in 1803, where his two-guinea subscription allowed him the privilege of walking in the gardens, studying the plants, and perusing the books in the library alone or in the company of friends.[49]

Hester James (née Symonds) moved to London after her marriage in 1796 to Richard James, who ran a warehouse business with his nephews and was involved in the textile trade.[50] His business was thriving by 1802, when Mary

Symonds jokingly advised her sister to "spend your husbands' money, he has not time to."[51] Richard James belonged to another local Hereford family, and he seems to have been related to the Edward James, who married the eldest Symonds daughter, Ann.[52] Mary Symonds spent considerable time staying in London with her married sisters, and the sisters passed weekends in Brompton, where they became close friends with Reginald Whitley and his stepdaughters Elizabeth ("Lizzie") and Mary Thoburn.[53]

LONDON LIVES, CA. 1784–1801

Spending time in London between 1784 and 1801 would have enabled Elizabeth Gwillim and Mary Symonds to expand their intellectual horizons by visiting museums and art galleries, gardens, and the theatre, enjoying conversations with educated friends, and perhaps attending public lectures. They would also have gained some impressions of India. In 1782, a German visitor to London compared the city to a giant cabinet of curiosities, the large, illuminated windows of shops displaying "paintings, mechanisms, curiosities of all kinds."[54] As this observation suggests, innovations in art and science and collections of natural and artificial objects were closely connected with London's status as an international commercial hub. The East India Company, which by 1800 employed 30,000 people in London alone,[55] was a major driver of London's commercial development. Its warehouses, which dominated the area around Leadenhall Street, provided many of the commodities sold by specialist apothecaries and grocers as well as textile and clothing merchants.[56] Hester James's husband, Richard James, would have been a regular presence at the Company's headquarters, East India House, where goods were sold by auction.

As Arthur MacGregor notes, the EIC played a major role in the acquisition not just of trade goods, but also of "curiosities": artifacts and natural specimens designated as collector's items. Like the artifacts taken from Tipu Sultan by Colonel Arthur Wellesley, worth at the time an estimated £1,600,000, many objects were looted with the complicity of the EIC, while others were purchased by or gifted to Company servants. In 1801, as the Gwillims left London, the Company's museum officially opened in East India House in Leadenhall Street.[57] Private collections and the British Museum, opened in 1756, were also filled with curiosities bought or looted from India. Company surgeons, naturalists, and amateur collectors sent plants and seeds from the Company settlements to Kew Gardens, founded the same year as the British Museum, and a host of smaller botanical gardens and nurseries like the Brompton gardens. Elizabeth Gwillim mentions the collection of Sir Ashton Lever (1729–1788), located near Blackfriars' Bridge from 1786 onwards.[58] By the 1780s, the Leverian

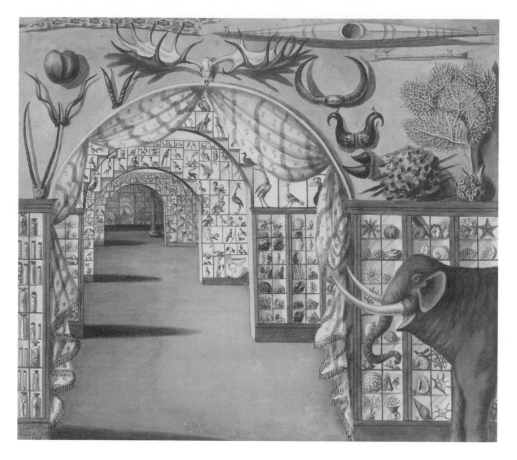

Museum contained around 26,000 items, most natural history specimens.[59]
The bird specimens included a pheasant sent from India by Mary, Lady
Impey, wife of the Calcutta judge Elijah Impey. Perhaps seeing this prompted
Elizabeth Gwillim to send an Argus Pheasant from Madras to her friend Mary
Yorke (née Maddox) (1740–1820).[60] Gwillim might conceivably have crossed
paths with Mary Impey in London during the 1780s and 1790s and might
even have seen Impey's collection of paintings of Indian birds, commissioned
from Indian artists in Calcutta.[61] Gwillim may also have been aware of George
Shaw's catalogue of the Leverian collection, which contains illustrations of
birds by the artist Sarah Stone and others.[62]

Despite its prominent position in the city and influence in government,
the EIC continued to generate controversy, not only from domestic manufac-
turers who opposed its imports of Indian textiles, but also from those who

considered the EIC's rule in India despotic and believed that the wealth of the returning "Nabobs" (EIC employees who had profited from private trade in Asia) threatened to corrupt British society.[63] This critique culminated in the impeachment of Warren Hastings between 1787 and 1795. Hastings's trial was a theatrical and highly public event, which Dalrymple describes as "the nearest the British ever got to putting the Company's Indian Empire on trial."[64] Elizabeth Gwillim would have certainly been aware of the trial, and perhaps, like her contemporary Fanny Burney, she even attended parts of it.

Interest in India was at a peak in late eighteenth-century Britain. At least thirteen plays with Indian themes were staged in London theatres between 1780 and 1800.[65] During the same period, the Royal Academy of Arts displayed at least 119 paintings depicting Indian subjects by artists including William Hodges, and Thomas and William Daniell.[66] These included landscapes, often depicting ruins or religious buildings. Portraits included depictions of famous men, including the Mughal emperor Shah Alam II,[67] Lord Robert Clive, who was the first British governor of the Bengal Presidency,[68] and the judge and scholar William Jones,[69] but there were also several of Hindu and Muslim women.[70] These images and translations of works from Indian languages, like those of William Jones, were widely read and served as inspiration for Romantic painters and writers in Britain. Although many British intellectuals and politicians of the era were critical of EIC rule, few supported ending the British presence in India.[71] In fact, those who sought to end abuses of power by the EIC often advocated for greater involvement by the British government. A prominent example is Edmund Burke, who, despite spearheading the prosecution of Warren Hastings, had no wish to relinquish any of the EIC's territorial possessions.[72]

Women were excluded from most of the learned societies that had been springing up in London since the Royal Society's first charter of 1662. However, there were two women among the founding members of the Royal Academy of Arts, Mary Moser and Angelica Kauffman. Moser, a flower painter, also exhibited at the Society for the Encouragement of Arts, Manufacturers and Commerce (now the Royal Society of Arts),[73] where Henry Gwillim was elected as a member in 1795/96.[74]

Female authors were also beginning to carve out a specialist niche in depicting India and British society in India, as well as "the Orient" more generally, through published correspondence, novels, and plays. As Rosemary Raza points out, letter writing was a common activity for women of the period and provided a bridge to publication. For example, Elizabeth Hamilton's *Letters from a Hindu Raja*, published in 1796, used fictional letters to critique Anglo-Indian society.[75] Elizabeth Gwillim certainly read novels with an Oriental setting, since, in a letter of 1806, she criticized a novel by William Linley as being merely

a reworking of an earlier book by Frances Sheridan. To prove her point, she invited Hester James to borrow both books from Mr Lane's circulating library in London.[76] Circulating libraries were important patrons for female authors and catered to a growing female readership.[77]

Elizabeth Gwillim might also have frequented London bookshops, such as the natural history bookshop run by Benjamin White at Horace's Head, at the corner of Fleet Street and the Strand. She referred to Benjamin White's brother Gilbert's acclaimed *Natural History and Antiquities of Selborne*.[78] In addition to Philip Miller's *Gardener's Dictionary*, Gwillim consulted Mark Catesby's *Natural History of Carolina, Florida, and the Bahama Islands*, completed in 1747, which was ground-breaking for its close observations of plants and animals.[79] Particularly influential on her was Thomas Bewick's illustrated work on British birds; she sent Hester James an urgent request for the second volume of this work in 1805.[80]

While in London, then, Elizabeth Gwillim and Mary Symonds would have been exposed to a range of paintings, literature, and natural history collections – including some by women – that likely inspired their own artistic work and writings. Although officially excluded from organizations like the Linnean Society (founded in 1788), they moved in social circles in which new ideas about the human and natural world were being discussed. By the time they arrived in Madras, they considered themselves part of a community of learned amateurs engaged in amassing knowledge about the natural world and foreign lands.[81] Gwillim clearly took her studies of the natural world seriously: she referred to her painting as her "career,"[82] and expressed frustration that her social duties left only two hours each day for writing, learning, and drawing.[83] Such occupations were more socially acceptable for older, married women. Younger, unmarried women were more vulnerable to accusations of displaying too much knowledge, which was considered vain and unfeminine.[84] Nonetheless, Symonds evidently considered her painting not merely a polite accomplishment, but rather a tool for documenting the world around her. In 1801, she wrote: "I hope now we are settled that I shall be able to send something for the *curious* by every opportunity."[85]

MADRAS IN 1800

Madras at the time of the Gwillim/Symonds family's visit reflected the East India Company's transition from being a largely coastal presence in India, reliant on a network of agreements with local rulers, to becoming the militaristic, bureaucratic, and despotic ruler of swaths of the subcontinent.[86] Susan Basu writes that, in 1800, Madras was "poised between its long-standing role as a

territorial enclave of a foreign commercial enterprise and its future status as the regional capital of an imperial power."[87]

The land on which the colonial city of Madras was built had been granted to the EIC in 1639 by Darmala Venkatappa, a Telugu *nāyaka* (overlord), whose father had been a powerful commander within the Vijayanagar Empire. The name that Venkatappa gave the city was Cheṇṇapaṭṭiṇam or Cheṇṇai, as it is now officially named.[88] By the time Elizabeth Gwillim and Mary Symonds arrived, Madras had assimilated the ancient port city of Mylapore, birthplace of the Tamil philosopher Valluvar, and the neighbouring Portuguese settlement of San Thomé.[89] Madras had been an important centre of EIC power during the late seventeenth century because of its trading links across the Bay of Bengal. It was also a centre for natural history scholarship during the seventeenth and early eighteenth centuries. During the mid-eighteenth century, its population had dwindled, and it was captured by the French in 1746, although returned to English control in 1748. By the early nineteenth century, English relations with three Indian dynasties had again placed Madras at the centre of EIC politics.

A key turning point for the EIC was the defeat of Tipu Sultan, ruler of Mysore, at the battle of Srirangapatam (Seringapatam) in May 1799. Tipu Sultan, son and heir of Haider Ali, was a formidable enemy, known for his statecraft, which combined elements of Hindu and Muslim kingship. He experimented with European technology, created a navy and trading company to manage commerce with the Persian Gulf, and dispatched embassies to his French allies.[90] Tipu Sultan is also famed for his collections of books and artefacts, many plundered from rulers he had conquered since coming to power in 1782.[91] Tipu Sultan appeared only in passing in Gwillim's and Symonds's correspondence.[92] However, his sons, held hostage by the British, figured in the most dramatic event that occurred during the sisters' time in Madras: the uprising at Vellore of 10 July 1806.

By 1801, the EIC was completing its annexation of the Carnatic, previously ruled from Arcot, sixty miles to the west of Madras. By the late eighteenth century, the nawabs of Arcot had become indebted to the EIC for military assistance against French-backed rivals, and the Arcot court had moved to Triplicane, a suburb of Madras. By 1800, the governor of Madras, Lord Edward Clive, was putting pressure on the nawab, Umdat ul Umara, to formally transfer the administration of the Carnatic to the EIC. The nawab died in July 1801, having nominated as successor his son, Ali Hussain, who refused to acquiesce to the annexation. The Company therefore recognized another relative, Azim ud Doula, on condition that he cede his territory to the EIC. Azim ud Doula was crowned on 31 July 1801. Within a few days, Ali Hussain died, raising suspicions that he had been poisoned by the EIC.[93]

These events would have been among the first that Elizabeth Gwillim and Mary Symonds witnessed on arriving in Madras. Symonds referred only in passing to Azim ud Doula's coronation, describing the garlands presented to dignitaries during the ceremony.[94] However, she painted the tomb of Ali Hussain (plate 2), surrounded by men, some in attitudes of prayer. As Gwillim wrote, "the Moor men consider him as a saint. – I fear he fell a Martyr."[95] As she also noted, the British press reported on these events, with some commentators condemning the "usurpation" of the Carnatic and the nawab's treatment.[96] The assassination of Ali Hussain would have provided a stark reminder of the violent machinations of the East India Company that underlay the apparent calm of Madras. The reactions that the sisters record highlight both the continued dissent from EIC rule within Madras and the scrutiny of Company policy in Britain.

The third conflict in which the EIC was involved during the early nineteenth century was with the Marathas, a Hindu dynasty that controlled much of western and central India and had become the power behind the Mughal throne. The EIC would not achieve a final victory over the Marathas until the third period of conflict, in 1817–19.[97] However, following the defeat of the Maratha forces in the 1803 Battle of Delhi, the EIC took possession of the Mughal capital and captured Emperor Shah Alam II. While this event, at a distance from Madras, was not discussed by Elizabeth Gwillim and Mary Symonds, it marked a seismic shift in Company power in India that would have been felt across the settlements.

In his recent history of the EIC, William Dalrymple selects 1803 as the year that the Company became the de facto ruler of India.[98] Nonetheless, British rule in India remained fragile and contested. The Vellore mutiny or uprising – in which Indian sepoys (soldiers) from the EIC and British armies killed several British officers and took over Vellore Fort, raising the flag of the Mysore Sultanate and proclaiming Muiz-ud-Din, Tipu Sultan's son, the new ruler – was a clear demonstration of discontent with British rule. Mary Symonds wrote, "thank God the evil has not extended beyond Vellore but attempts have been made at other places & a general massacre of the English was intended."[99] The sisters also passed along an account from Hyderabad of a similar uprising planned there.[100] While some accounts of the Vellore uprising cite objections to the new dress codes that had been imposed on Indian soldiers, others see it as expressing a wider discontent with British rule and prefiguring the much larger uprising of 1857.[101]

The early nineteenth century was also a turning point in the intellectual history of the East India Company. As the Company itself transitioned from a fluid, networked entity toward a bureaucratic imperial state, scholarship gradually shifted from an earlier reliance on informal networks toward being centrally

organized and funded.[102] The EIC provided financial and logistical support for projects including mapping and surveying territory, accumulating knowledge of natural history, and teaching Indian languages. All these initiatives were designed primarily to bolster EIC control over the settlements, although they were often shaped more by events on the ground than directives from London. While information-gathering efforts were designed to replace the EIC's dependence on Indian authority, these efforts nonetheless remained heavily reliant on Indian expertise.[103]

The chapters in this book examine the evidence that Elizabeth Gwillim and Mary Symonds's paintings and correspondence provide about Madras, its intellectual life, and the wider world in this period of political and cultural transition. They contextualise the sisters' artistic and natural history work with reference to contemporary intellectual trends in both Britain and India.

THEMES AND ORGANIZATION OF THIS BOOK

This book takes an interdisciplinary approach to investigating the Gwillim and Symonds archives. Several chapters and case studies have been co-authored by scholars from different fields. While the chapters offer broad overviews of the topics they address, the case studies focus in more detail on specific aspects of the sisters' lives or work. The ten chapters and five case studies are organized into two sections. The first section, "Painting, Collecting, and Observing," focuses on Elizabeth Gwillim and Mary Symonds as painters; on their ornithological, ichthyological, and botanical studies; and on their observations of the natural and built environment. Their observations are contextualized with reference to art and natural history scholarship in both India and Britain. The second section, "Social Lives, Social Networks, and Material Culture," focuses on the evidence that the sisters' letters and paintings provide about the political, social, and cultural life of Madras and the informal networks, local and international, forged by the exchange of ideas and material objects. The sisters' experiences are placed in the context of other contemporary life writings by British women in India.

Painting, Collecting, and Observing

The book opens with Ben Cartwright's discussion of the paintings of landscapes and people in *The Madras and Environs Album* held in the South Asia Collection in Norwich. This collection consists mainly of paintings by Mary Symonds, with some by Elizabeth Gwillim and a few unattributed paintings. Chapter 1 gives a close reading of several images, providing insight into their

making and into the sisters' lives. Cartwright also places the album in its contemporary context of paintings and prints depicting South India.

In case study 1, Hana Nikčević focuses on Mary Symonds's innovative pasteboard models of street scenes of Madras, exploring her potential sources of inspiration. Nikčević argues that Symonds was using a feminine craft in an innovative way to depict, and perhaps to render manageable, the scenes that surrounded her in Madras.

In chapter 2, Suryanarayana Subramanya focuses closely on Elizabeth Gwillim's ornithological paintings, held in McGill University's Blacker Wood Collection. He shows how the 121 paintings provide insights into the avifauna of Madras. Elizabeth Gwillim was unusual in painting live subjects and adding backgrounds that place the birds within their habitats. In addition, details in the background of the paintings sometimes pointed to the significance of the bird in Indian culture. Gwillim's letters give further details of birds' habitats and behaviour and how they were viewed by local people. Subramanya's chapter places Gwillim's painting and her ornithological observations within the context of eighteenth-century natural history scholarship. As Subramanya shows, Elizabeth Gwillim was the first artist to depict many of the birds she painted, and, if not for her untimely death, she would likely have had more influence over their naming and classification within the scientific record. Subramanya's appendices discuss several of the ornithological images in more detail and provide the current scientific names for the birds Elizabeth Gwillim described or depicted.

The sisters' fish paintings, while fewer in number and less detailed in execution than the ornithological paintings, are nonetheless of great interest. They are comparable to contemporary ichthyological studies by Company naturalists including Patrick Russell and Francis Buchanan-Hamilton and predate the publication of these works.[104] In case study 2, Shyamal Lakshminarayanan and Hana Nikčević identify several of the species depicted, some of which are now endangered. Based on the correspondence, at least some of the fish paintings that had been credited to Gwillim can be re-attributed to Symonds. The sisters were painting during a stay in the coastal village of Kovalam. Inscriptions on several of the fish appear to represent local Tamil names rendered in Urdu script, some of which are otherwise unknown. The fish paintings therefore provide interesting information about both the marine environment around Madras and local knowledge relating to fish.

As Vikram Bhatt and Vinita Damodaran show in chapter 3, the sisters' artworks and observations provide invaluable records of the natural and built environment of Madras in the early nineteenth century. This was a period of expansion, during which the city's population was growing rapidly. Many arriving British merchants and officials preferred to reside in semi-rural "garden

houses," like the Gwillims' residence near San Thomé. The sisters described a green and pleasant landscape around the city, noting the small rivers that broadened after rain, and the network of large tanks (reservoirs) and dams, that were part of a hydraulic system long used to preserve water for agriculture. Late eighteenth- and early nineteenth-century maps of Madras show a network of rivers and rivulets, joining great lakes, reservoirs, and village waters. Most of these bodies of water have since been filled in. The sisters' paintings thus illustrate a natural environment that has almost entirely disappeared. While the period 1801–08 was relatively calm, the sisters' correspondence notes the danger of famine after a drought. As Bhatt and Damodaran point out, by 1800 the threat to rural livelihoods posed by the climate was already being exacerbated by colonial taxation and resource extraction.

We turn next to Elizabeth Gwillim's and Mary Symonds's botanical interests. Botany in India was formalized from the late eighteenth century, with the founding of the Calcutta Botanical Gardens in 1787 and the appointment of official EIC naturalists, beginning with Johann Gerhard König, who had previously worked for the nawab of Arcot. König was followed by Patrick Russell, who published studies of Indian snakes and fish.[105] Russell's successor was William Roxburgh, who made extensive studies of the plants of the Coromandel Coast.[106] Roxburgh and his successor Benjamin Heyne also worked closely with missionary botanists Christoph Samuel John and Johann Peter Rottler. As Henry Noltie shows in chapter 4, Elizabeth Gwillim and Mary Symonds became friendly collaborators with the circles of European botanists around Madras. Beginning in 1804, Gwillim received lessons in botany from Rottler. Both sisters also collaborated with the Scottish surgeons James Anderson and Andrew Berry, and Gwillim corresponded with Heyne. Gwillim built on her connections with the nursery gardens in Brompton, sending plants, seeds, and information to Reginald Whitley and Elizabeth Thoburn. Through Rottler, her painting of a magnolia entered the herbarium of James E. Smith, founder of the Linnean Society.

Perhaps the most important networks that the sisters developed were with the Indians who acted as plant collectors and translators, and advised them on the identities and properties of the plants they encountered around Madras. In case study 3, Saraphina Masters highlights the role of Indian experts in enabling the detailed studies of the natural world that the sisters made. As she shows, the methods of restraining live birds used by local birdcatchers were crucial in enabling Elizabeth Gwillim's lifelike images.

The final chapter in this section, by Marika Sardar and Abdul Jamil Urfi, opens by placing Elizabeth Gwillim and Mary Symonds's work within the context of Indian traditions of recording, studying, and illustrating the natural world. They argue that, from the sixteenth century, both European and South

Asian approaches to nature underwent a shift, prompted by encounters with novel landscapes. In both cases, new creatures and plants inspired a focus on detailed depiction and classification. These two developments converged in the eighteenth century, when Europeans began commissioning Indian artists to make illustrations of animals and plants. The chapter then considers the development of ornithology in the period of British colonialism in India. Unlike during the Mughal period, those who documented the birds of India under the EIC and later the Raj were mainly amateur enthusiasts. Some institutions established under the Raj, like the Bombay Natural History Society, continue to be important institutions for Indian ornithology today.

Social Lives, Social Networks, and Material Culture

The second section of the book opens with Arthur MacGregor's account of the tumultuous career of Henry Gwillim during his time in Madras. Elizabeth Gwillim and Mary Symonds were drawn into the politics of Madras as Henry Gwillim's efforts to dispense justice in line with British law conflicted with the policies of the EIC governor and council in Madras.[107] These tensions culminated in a major confrontation in 1807. As Haruki Inagaki has shown, Henry Gwillim's struggles were part of a wider conflict between the British judiciary in India and the EIC, eventually resolved in the charter of 1834, which granted the EIC control over the judiciary, effectively rendering the law an "instrument of despotism."[108] Henry Gwillim was depicted as a "radical," "revolutionary," or "Jacobin," by those who demanded his removal in 1807. As MacGregor notes in chapter 6, Elizabeth Gwillim's and Mary Symonds's correspondence paints quite a different picture of Henry, as a humorous and sensitive, if short-tempered, man whose fierce sense of justice ultimately led to his removal. Henry Gwillim's own writings show that, in contrast to the caricature of him painted by his enemies, he expressed horror at the excesses of the French Revolution and affirmed the value of the "old liberties" contained within English law. As MacGregor shows, Henry Gwillim clearly linked his opposition to the merging of civil and military power in the company's police force to the wider problem of despotism. Henry Gwillim's resolve to uphold the impartiality of the law won him praise from many sectors of Madras society, both Indian and British.

The next several chapters and case studies use Elizabeth Gwillim's and Mary Symonds's correspondence and paintings as evidence for cross-cultural exchanges in food, ceramics, and textiles. Unlike the stereotype of the "bluestocking," a scholarly woman unconcerned by her physical appearance, the sisters were intensely interested in the latest fashions. They both requested regular shipments of clothing and accessories from England and sent Indian textiles to their friends and family at home. As Toolika Gupta, Alexandra Kim,

and Ann Wass show in chapter 7, their letters reveal much about the ways that garments were borrowed and adapted across cultures – for example, by refashioning shawls into waistcoats. Some of these innovations were prompted by the increasingly stringent limits on importing Indian manufactured textiles to Britain. The climate of Madras also induced the sisters to request certain types of clothing and accessories from home and adapt those they received. The sisters depicted the clothing of the local inhabitants of Madras in unusual detail in both their paintings and correspondence. Their letters were written at a time of transition, during which Britain moved from being primarily an importer of Indian textiles to exporting textiles to India, with detrimental effects on India's own textile industries.

In case study 4, Victoria Dickenson shows that, just as the British sought to imitate and ultimately capture the market for Indian textiles, so too they sought to replace the demand for Chinese porcelain with English manufactures. Like her contemporaries, Elizabeth Gwillim proudly displayed her Wedgwood to company. At the same, she collected and sent home examples of ceramics from China and of local Indian earthenware.

Just as they altered their dress to suit the Indian climate, Elizabeth Gwillim and Mary Symonds also gradually adapted their diets. Nathalie Cooke, in chapter 8, uses the sisters' correspondence to explore what she describes as a three-stage culinary adaption of the British in India. The first stage, characterized by a desire to import English cuisine to India, was marked by the sisters' requests for their favourite English foods, including preserves and vinegar, and for seeds to grow their own familiar vegetables and herbs. However, over time the sisters began to use Indian ingredients in ways that mimicked British dishes. The exchange of food, as with the exchange of clothing, was a two-way process, and Cooke charts the rising popularity of Indian food in Britain as well as the emergence of a distinctive Anglo-Indian cuisine in India by 1900.

The sisters' descriptions of Indian society can be viewed in the context of the "Orientalist" scholarship that influenced Company policy from around 1780 until the mid-1830s. A distinctive strain of "Madras Orientalism" was led by Francis Whyte Ellis and several Indian scholars, who founded the College of Fort St George in 1811 and formulated the theory of the Dravidian language family.[109] The Gwillim household reflected the Orientalist inclination of the day, with Henry Gwillim studying Persian, Elizabeth Gwillim studying Telugu, and Richard Clarke, who lodged with the family, learning Tamil. Mary Symonds and Elizabeth Gwillim actively engaged with current Orientalist literature: Symonds illustrated a scene from a translation of a Sanskrit drama by the Asiatic Society's founder William Jones, most likely his *Sacontala: Or, The Fatal Ring*, first published in 1789.[110] The influence of contemporary Orientalist scholarship is evident in their descriptions of Indian people and places.

Jeffrey Spear provides a close focus, in chapter 9, on the "proto-ethno-graphic" descriptions of Indian society that appear in Elizabeth Gwillim's and Mary Symonds's correspondence. British female writers often specialized in depicting the lives of Indian women and, in particular, the "mysteries of the zenana" or women's quarters in Hindu and Muslim houses.[111] Symonds wrote an account of her visit to female relatives of the rulers of Arcot in 1804, the same year that Thomas Daniell painted an imagined scene from a zenana for a British collector.[112] Her account mirrors many contemporary European ste-reotypes about the mixture of misery and splendour in the Orient. Gwillim similarly described Muslims as "a ferocious people enervated by luxury."[113] Her characterization of Hindus as childlike and feminine and her depiction of their culture as timeless and unchanging were similarly part of develop-ing stereotypes that were used to justify British colonialism.[114] Nonetheless, as Spear notes, Gwillim's accounts of Hindu culture could also be unusual-ly detailed and reflective. Spear focuses on Gwillim's account of a festival in Mylapore and the devadasi she witnessed there. Unlike other British female writers of the era, Gwillim did not describe these women in terms of their sex-uality (as prostitutes or debauched women) but instead focused on describing their ornaments and the steps of the dance. Spear situates Gwillim's account of a Hindu procession, with its themes of obscurity, awe, vastness, and wonder, within the contemporary concept of the "Sublime."

In case study 5, Minakshi Menon calls attention to the uneasy gaze with which the British and Indian inhabitants of Madras regarded one another. Menon's close reading of an extraordinary letter written by Mary Symonds in what Symonds referred to as "black English" shows that this item contains multiple layers of mimicry – the servants' mimicry of the colonial idiom as well as Symonds's mocking reproduction of their speech. The letter also sug-gests that the exchange of natural history expertise discussed elsewhere in this volume overlaid incommensurable relationships with the local environment.

Rosemary Raza, in chapter 10, situates Elizabeth Gwillim and Mary Symonds in the broader context of other contemporary British women in India during the eighteenth and nineteenth centuries. She shows that women were essential in recreating elements of British family life in India, includ-ing by incorporating young men into their households, as the sisters did with Richard Clarke and another young friend, William Biss. In their discussions of food, Gwillim and Symonds can be compared with contemporary women writers, including Emma Roberts, while their interest in fashion mirrors that of writer Eliza Fay, who worked as a dressmaker. Moreover, Raza shows that Gwillim's and Symonds's scholarly interests were far from unusual for women of their time. She notes that several of the sisters' contemporaries acquired fluency in one or more Indian languages, including their close contemporary

Henrietta Clive, who studied Persian. The sisters' interests in gardening and botany, too, found echoes among other women who had spent time on the subcontinent, including Ann Monson and Sarah Amherst. Even Elizabeth Gwillim's interest in birds was not unique, but was shared by Mrs Ellerker as well as Mary Impey, who both established aviaries while in Calcutta, and, later in the nineteenth century, by Margaret Cockburn, who also painted Indian birds. Raza concludes that, while Elizabeth Gwillim and Mary Symonds were not unusual, they were exceptional in the quality of their work. This applies particularly to Gwillim's naturalistic paintings of birds, which are comparable to the much better-known work of the American artist, John James Audubon.

The concluding chapter, by two of the editors, sums up what the Gwillim and Symonds archives can tell us about women, environment, and networks of empire at the dawn of the nineteenth century. It also discusses the research project from which this volume emerged. We reflect on how approaching the Gwillim and Symonds archives through a multidisciplinary, transnational collaboration shaped the questions we posed to the materials.

Notes

1 Regarding names, we have used full names at the beginning of a section or paragraph and surnames thereafter. Titles have been used only when relevant to the context. First names are used where confusion is likely between individuals with the same family name. For some people mentioned in the records, particularly servants, only one name is recorded, and we have therefore also used that name.

2 According to the log of the *Hindostan*, British Library, India Office Records (BL IOR) /L/MAR/B/267D.

3 The paintings held at McGill can be accessed via the Archival Collections Catalogue, at https:// archivalcollections.library.mcgill.ca/index.php/ gwillim-collection.

4 See "The Gwillim Project," The South Asia Collection, Norwich, https://thesouthasia collection.co.uk/research/the-gwillim-project/.

5 BL IOR Mss.Eur.C.240/1–4.

6 Hobsbawm, *The Age of Revolution*; Bayly, *The Birth of the Modern World*.

7 Bayly, *The Birth of the Modern World*

8 Sivasundaram, *Waves across the South*.

9 Margerison, "French Visions of Empire."

10 Elizabeth Gwillim to Hester James, 12 February 1806, BL IOR Mss.Eur.C.240/4, ff. 314r–318v, on f. 314r.

11 Webster, *The Twilight of the East India Company*.

12 The charter is reproduced in Shaw, *The Charters of the High Court of Judicature*. Previously, justice had been administered by a Recorder Court, established in 1798 (52–84), and before that, by the mayor and aldermen elected within the city.

13 Raza, *In Their Own Words*.

14 Two other siblings, Frances (b. 1758) and Thomas (b. 1766), died before reaching adulthood. The baptism records for the family are in the records of the parish of St John the Baptist, held at Hereford Cathedral Archives. I am grateful to Elizabeth Semper O'Keefe, cathedral archivist for supplying these details.

15 Roscoe, *A Biographical Dictionary of Sculptors*, 1215–16 notes that Esther Symonds ran the business between 1791 and 1803.

16 Price, *An Historical Account of the City of Hereford*, 55, 58–9.

17 Ibid., 65–71.

18 Elizabeth Gwillim to Hester James, 6 March 1805, BL IOR Mss.Eur.C.240/4, ff. 258r–266r.

19 Roscoe, *A Biographical Dictionary of Sculptors*, 1216.

20 Ibid., 1216.

21 See Clarke, *The Arrogant Connoisseur*.

22 Elizabeth Gwillim to Esther Symonds, 23 January 1802, BL IOR Mss.Eur.C.240/1, ff. 21r–32r. For two examples of Esther Symonds's work, see Roscoe, *A Biographical Dictionary of Sculptors*, 1215–16.

23 See, for example, Thomas Hearne, "The River Teme at Downton, Herefordshire," 1785–86, Victoria and Albert Museum, accession no. 2933-1876.

24 Mary Symonds to Hester James, 18 March 1802, BL IOR Mss.Eur.C.240/1, ff. 55r–57v; Mary Symonds to Hester James, 7 February 1803, BL IOR Mss.Eur.C.240/2, ff. 104r–106v.

25 Mary Symonds to Hester James, n.d. [1803], BL IOR Mss.Eur.C.240/2, ff. 122r–127v.

26 Elizabeth Gwillim to Hester James, 16 October 1804, BL IOR Mss.Eur.C.240/3, ff. 236r–241v, on f. 236v.

27 Mary Symonds to Hester James, n.d. [1802], BL IOR Mss.Eur.C.240/1, ff. 58r–61v (Barmouth); Elizabeth Gwillim to Esther Symonds, 17 October 1801, BL IOR Mss.Eur.C.240/1, ff. 14r–18v (Borth).

28 Elizabeth Gwillim to Esther Symonds, n.d. [received 28 February 1806], BL IOR Mss.Eur.C.240/4, ff. 271r–278v, on f. 275r.

29 For a longer view of Romanticism and its history as an intellectual movement in Asia, see Watson and Williams, *British Romanticism in Asia*.

30 In her description of Pammal, Mary refers to it as a "pretty picturesque country": Mary Symonds to Esther Symonds, 2 February 1805, BL IOR Mss.Eur.C.240/4, ff. 248r–252v, on f. 249v.

31 Raza, *In Their Own Words*, xx–xxi.

32 Mary Symonds to Hester James, Madras, 11 February 1802, BL IOR Mss.Eur.C.240/1, ff. 39r–46v, on ff. 39r and 41v. Throughout, underscored words in the letters have been converted to italics.

33 Ibid., f. 40v.

34 Rees, *The Hereford Guide*, 65.

35 On women's education in the sciences, see Shteir, *Cultivating Women*. On women's education in general, see Cohen, "'A Little Learning'?"

36 Elizabeth Gwillim to Hester James, Mount near Madras, 6 March 1805, BL IOR Mss.Eur.C.240/4, ff. 258r–266r.

37 For a general discussion of women's participation in intellectual culture in the late eighteenth and early nineteenth centuries, see Raza, *In Their Own Words*, xx–xxi; Shteir, *Cultivating Women*.

38 Calcott, *A Collection of Thoughts*, xlii.

39 Elizabeth Gwillim to Hester James, n.d. [1803], BL IOR Mss.Eur.C.240/2, ff. 167r–177v.

40 *Arabian Nights Entertainments: Consisting of One Thousand and One Stories* was the first version of the *One Thousand and One Nights*, a collection of stories originally written down in Arabic. The French translation was produced by Antoine Galland between 1704 and 1717 and was translated into English by Beaumont, appearing in various editions from 1706 onwards.

41 Sturgess, *Register of Admissions to the Honourable Society of the Middle Temple*, 389. Information courtesy of Arthur MacGregor.

42 Elizabeth was born on 31 March 1785 and baptized on 20 June following at St Bride's Church. The burial register records her as "Elizabeth Gwillim from the Middle Temple," 13 January 1786. City of London, London Metropolitan Archive, MS 6541/1. Information courtesy of Arthur MacGregor.

43 Marshall, *The Registers of Sarnesfield*, 20–1 (baptism of Ann and Henry); Ancestry.com, England: Selected Deaths and Burials, 1538–1991 (online database) accessed 2021 (burial of Henry).

44 Elizabeth Gwillim to Hester James, n.d. [September/October 1806], BL IOR Mss.Eur.C.240/4, ff. 329r–343v, on f. 330r.

45 On the importance of a supportive husband for female scholars in this period as well as of women's work in enabling their husbands' scientific work, see Fara, *Pandora's Breeches*.

46 Mary Symonds to Hester James, n.d. [1803], BL IOR Mss.Eur.C.240/2, ff. 122r–127v, on f. 122r.

47 *The Gentleman's Magazine*, 124 (January–June 1818), 645.

48 Mary Symonds to Hester James, Madras, 12 February 1806, BL IOR Mss.Eur.C.240/4, ff. 314r–318v.

49 Brompton, *A Catalogue of the Brompton Botanic Garden*.

50 A notice dated 27 February 1830 in the *London Gazette* 1 (1830), 442 announces the dissolution of this business, "Richard James and Nephews," upon Richard James's retirement.

51 Mary Symonds to Hester James, 11 February 1802, BL IOR Mss.Eur.C.240/1, ff. 39r–46v, on f. 46v.

52 Elizabeth Gwillim to Hester James, 6 March 1805, BL IOR Mss.Eur.C.240/4, ff. 258r–266r, on n.f. [265a] refers to Hetty and her husband as having a "double bond" with Ned and Nancy James.

53 In an undated, unsigned letter, Mary describes an imagined scene in which she and her sisters are staying with the Whitley/Thoburn family: [Mary Symonds] to Hester James, n.d. [1802], BL IOR Mss. Eur.C.240/1, ff. 58r–61v, on f. 60r. In a letter to Hester James, Elizabeth refers to her friend Biss's weekend visits being "like a Brompton expedition": 24 August 1805, BL IOR Mss.Eur.C.240/4, ff. 279r–296v, on ff. 281v–282r.

54 Karl Philipp Moritz, cited in Delbourgo, *Collecting the World*.

55 Bowen, *The Business of Empire*, 272.

56 Wallis, "Consumption, Retailing, and Medicine."

57 MacGregor, *Company Curiosities*, 168; Ratcliff, "The East India Company."

58 Elizabeth Gwillim to Hester James, n.d. [spring 1803], BL IOR Mss.Eur.C.240/2, ff. 167r–177v, on f. 176r.

59 King, "New Evidence for the Contents of the Leverian Museum."

60 Reference in Mary Yorke's correspondence with the Rt Hon. Lady Lucas, 7 December 1806, from the Bedford Archives, courtesy of Anthea Jones.

61 Dalrymple, *Forgotten Masters*.

62 King, "New Evidence for the Contents of the Leverian Museum."

63 Lawson and Phillips, "'Our Execrable Banditti.'"

64 Dalrymple, *The Anarchy*, 259–60.

65 Based on a search of Adam Matthews' database Eighteenth Century Drama, 2021, www.eighteenthcenturydrama.amdigital.co.uk (accessed 14 June 2021).

66 Based on a search of the Royal Academy's database of exhibition catalogues, https://www.royalacademy.org.uk/art-artists/search/exhibition-catalogues (accessed 17 June 2021). Thanks to Hana Nikčević for this information.

67 Tilly Kettle, *Shaw Allum, the present Mogul of Hindostan, reviewing the 2d Brigade of the East-India Company's troops, from the state-tent, on the plains of Allahabad*, exhibited at the Royal Academy's 13th exhibition, 1781.

68 Benjamin West, *Lord Clive receiving from the Mogul the grant of the Duanney*, exhibited at the Royal Academy's 27th exhibition, 1795.

69 J. Flaxman, *Sir William Jones writing from the Hindoo doctors or Pundits, reading their sacred law*, exhibited at the Royal Academy's 29th exhibition, 1797.

70 Thomas Banks, *A Hindoo female going to the Ganges* and *A Hindoo female returning from the Ganges*, exhibited at the Royal Academy's 24th exhibition, 1792;

Francesco Renaldi, *Portrait of a Mughal Lady*, exhibited at the Royal Academy's 29th exhibition, 1797.

71 For some exceptions, see Cohen-Vrignaud, *Radical Orientalism*.

72 Rudd, *Sympathy and India*, 54.

73 Vikery, "Hidden from History."

74 Henry Gwillim's name appears as a member in the *Transactions of the Society for the Encouragement of Arts, Manufacturers and Commerce* 14 (1796): 370 and for three years thereafter. Thanks to Arthur MacGregor for this information.

75 Raza, *In Their Own Words*.

76 Elizabeth Gwillim to Hester James, 12 February 1806, BL IOR Mss.Eur.C.240/4, ff. 314r–318v. The works referred to are Sheridan's *History of Nourjahad* and *Forbidden Apartments*.

77 Blakey, *The Minerva Press*.

78 White, *The Natural History and Antiquities of Selborne*; Elizabeth Gwillim to Hester James, n.d. [spring 1803], BL IOR Mss.Eur.C.240/2, ff. 167r–177v, on f. 176v.

79 Elizabeth probably had access to the third edition, published in 1777, which was much less expensive than the earlier editions (thanks to Victoria Dickenson for this information). Catesby, *The Natural History of Carolina*.

80 Bewick, *History of British Birds*; Elizabeth Gwillim to Hester Symonds, March 6, 1805, BL IOR Mss. Eur.C.240/4, ff. 258r–266r.

81 The word "amateur" had more positive connotations in the eighteenth century, closer to the Latin term *amator*, signifying love for a particular subject. There was little distinction made between professional and amateur studies of the natural world before the nineteenth century. See Easterby-Smith, *Cultivating Commerce*, 77–119.

82 Elizabeth Gwillim to Hester James, 6 March 1805, BL IOR Mss.Eur.C.240/4, ff. 258r–266r, on f. 263v.

83 Elizabeth Gwillim to Hester James, 3/4/10 September 1803, BL IOR Mss.Eur.C.240/2, ff. 142r–149v, on f. 148v.

84 Shteir, *Cultivating Women*.

85 Mary Symonds to Hester James, 14 October 1801, BL IOR Mss.Eur.C.240/1, ff.12r–13v, on f. 13r.

86 Inagaki, *The Rule of Law and Emergency*, 6.

87 Susan Basu, "Madras in 1800," 221.

88 Ibid.

89 Winius, "A Tale of Two Coromandel Towns."

90 Moienuddin, *Sunset at Srirangapatam*.

91 Ehrlich, "Plunder and Prestige."

92 Elizabeth Gwillim to Hester James, 15 February 1803, BL IOR Mss.Eur.C.240/2, ff. 111r–114v.

93 Rajayyan, "British Annexation of the Carnatic."

94 Mary Symonds to Esther Symonds, 14 October 1801, BL IOR Mss.Eur.C.240/1, ff. 4r–11v, on f. 7v.

95 Elizabeth Gwillim to Esther Symonds, 16 August 1803, BL IOR Mss.Eur.C.240/2, ff. 140r–141v, on f. 141r.

96 For example, the letter to the editor from Asiaticus: "Nabobs of Arcot," *London Morning Chronicle*, 3 February 1802.

97 For a detailed recent account of this conflict, see Cooper, *The Anglo-Maratha Campaigns*.

98 Dalrymple, *The Anarchy*, 2.

99 Mary Symonds to Hester James, 30 September 1806, BL IOR Mss.Eur.C.240/4, ff. 326r–n.f [329v a].

100 Copy of a letter from Captain Livingston (a possible error for Captain Thomas Sydenham, the resident at Hyderabad), BL IOR Mss.Eur.C.240/4, f. 356r.

101 Plliay, "The Causes of the Vellore Mutiny"; Hoover, *Men without Hats*.

102 Winterbottom, "An Experimental Community."

103 Dodson, *Orientalism, Empire, and National Culture*, 1.

104 Russell, *Descriptions and Figures of Two Hundred Fishes*; Hamilton, *An Account of the Fishes Found in the River Ganges*.

105 Russell, *An Account of Indian Serpents*; Russell, *Descriptions and Figures of Two Hundred Fishes*.

106 Roxburgh, *Flora Indica*.

107 Cocks, "Social Rules and Legal Rights."

108 Inagaki, *The Rule of Law and Emergency*, 6.

109 Trautmann, *Languages and Nations*.

110 Mary Symonds to Hester James, 7 February 1803, BL IOR Mss.Eur.C.240/2, ff. 104r–106v, discusses this image, probably South Asia Collection no. 106.39.

111 Raza, *In Their Own Words,* 6; Dutta, "The Memsahibs' Gaze."

112 This painting was sold at Christies in 2003. See the description of it at Christie's Arts of India auction site, https://www.christies.com/lot/lot-thomas-daniell-ra-1769-1837-a-zenana-4147577/?.

113 Elizabeth Gwillim to Esther Symonds, 17 October 1801, BL IOR Mss.Eur.C.240/1, ff. 14r–18v, on f. 16r.

114 Teltscher, *India Inscribed*.

Part One

Painting, Collecting, and Observing

1

"Busy in Making Drawings of the Country"

The Madras and Environs Album

BEN CARTWRIGHT

The taste of salt and the thunder of breaking waves on the long sandy beach on Madras's foreshore (plate 1). The chatter of fishermen pulling their catamaran past a pile of freshly caught sankara fish (plate 36). The gentle conversation of three Brahmins in the shadow of a temple.[1] The breeze rustling through the leaves of a breadfruit tree (plate 44). The muddy stench of buffalo being driven through market crowds (plate 10). A flamingo draped across the arms of a bird hunter (plate 48). The calls of triumph at the celebration of a wedding anniversary in a Muslim home.[2] The cries of despair at "The Tomb of Ali Hoossain," who was said to have been murdered by the East India Company (plate 2). These are just some of the sights captured in watercolour by two sisters roughly fifty years before the first photographs were taken in India.

Today, these images survive at the South Asia Collection Museum in Norwich, a high barrel-vaulted building, constructed as a roller-skating rink in the Victorian era. Stepping through the double doors, visitors are met by a large yellow lion, *vahana* (vehicle) of the goddess Durga, that was dragged in processions when the goddess needed to travel through Tamil Nadu. What visitors might not know is that the museum cares for one of the most important set of watercolours to be made in southern India at the start of the nineteenth century. This set of paintings takes the viewer up close to life in Madras (now Chennai) in a way few other artists managed.

The Madras and Environs Album (the *Madras Album*) is a collection of seventy-seven watercolours, and one image in coloured chalks, that were arranged in the forty-three leaves of a hardbound album with marbled end papers. These paintings

were made between 1801 and 1808 by Mary Symonds and, probably, her sister Elizabeth Gwillim.[3] The album also contains two pen-and-ink drawings by at least one other hand, although the identity of this painter is, sadly, unknown.[4]

These watercolours open a window on Madras at the beginning of the nineteenth century, and the lives of the two sisters there. The images can be crudely divided into types: scenes of life at home, portraits, life on the streets, picturesque views, and ocean journeys. The lives of the sisters are woven throughout these images. Some of the paintings carry a written inscription in pencil on the reverse. Others had an inscription on the album leaf, like an exhibition label. These pencilled inscriptions trace out the arc of the sisters' lives in Madras. They give us the people, places, wildlife, plants, and hobbies that engaged them, and the street scenes they passed through and the country retreats where they stayed, including the tragic "Mr Webb's cotton farm house at Pummel – where lady G died" (plate 15).

Occasionally, these pencil marks give us a date. The earliest is 1803, and the latest 1808. Some of the watercolours have also been marked with the initials "M.R.," standing for Mary Ramsden, the name Mary Symonds took after she married the captain of the *Phoenix*, John Ramsden, after their hurricane-swept voyage back to England from Madras in 1808–9. So perilous was the *Phoenix*'s situation that all the men, including Henry Gwillim, were ordered to man the pumps.[5] In this chapter, I am going to explore some of the paintings to try to uncover the stories hidden in them, and something of their making.[6]

"ST THOME'S HOUSE" (PLATE 3)

To the newly arrived, Madras could seem disjointed, a collection of suburbs and villages rather than a defined city. San Thomé (today's Santhome) lay to the south of Fort St George, along the coast. According to tradition, this was the place where the martyred St Thomas was laid to rest in the first century CE.

From Madras, Mary Symonds and Elizabeth Gwillim took day trips to the town of San Thomé, carried in palanquins through the lapping waves.[7] There, they bought fresh fish from fishermen freshly landed in their catamarans and attended the festival of the marriage of Shiva. Bunting and painted paper lanterns were hung between the cocoa palms across the wide streets. At one end of the square, Hindu "pagodas" (temples) rose up beside the tank (reservoir) of water.[8]

San Thomé took up a place in their imagination. The watercolour "St Thome's House" shows the house that Mary Symonds, her sister Elizabeth Gwillim, and Henry Gwillim moved into in 1802. The viewer is looking out

from a behind a row of chunam-coated columns. Outside, the sun bakes the ground, despite the cumulus clouds in the sky. The clouds blown in, perhaps, on a sea breeze from the nearby beach. Palm fronds rustle. The columns cast cool shadows. The exterior of the house glows in the sun. Once a year, the house staff would grind shells from the beach and mix them with sand and water, making chunam to re-plaster the walls, which were polished to shine like marble.[9] Most of the house is open. Columns serve the purpose of walls, holding up the flat roof (with the help of wooden beams) and allowing as much of a breeze as possible into the living spaces. Glass was a rare building material in European houses in the Madras Presidency at this time. The rooms were sealed off with wooden shutters and venetian blinds made of cane by local craftspeople. Mary Symonds wrote that these garden houses remind her of Italian villas,[10] a comment that takes note of the Palladian fashions that swept through Britain and Madras in the late eighteenth century.[11] But this painting by Mary Symonds, dated to 1806, is not just a scene of the Italianate picturesque or of a gentle curiosity with life in a new climate.

The house was not a private space. The sisters' days were interrupted by the coming and goings of the house staff and their requests. Mary Symonds wrote to her mother that it was impossible to get any privacy, "unless one shuts oneself up in ones bed chamber."[12] This was especially true for her, since she had the role of housekeeper. Look closely at the balustrades in this watercolour to see servants busy cleaning, or heading off on an errand, or stopping to chat or to scold each other. The household was a finely balanced thing, and it was Mary Symonds who had to keep that balance and control the pay book.

What can be said about this painting as a work of art? The garden houses of Madras appear in watercolours of the time, but they are usually the work of soldier-artists – officers in the East India Company or King's Army who had been taught the basics of landscape drawing at military colleges in Britain. These skills were promoted for their use in preparing maps and visual studies. The painter Paul Sandby was the drawing master for the Royal cadets at Woolwich until 1796. His contemporary Theodore Henry Fielding, author of *On the Theory of Painting*, taught East India cadets at the Military Academy in Addiscombe. Silver boxes containing cakes of watercolour were presented to the best students.[13] The pictures these military men created of garden houses in Madras are usually rather flat: a few servants and perhaps a palanquin or some holy men on a large lawn, the square white house behind them, and then the sky.[14] They are not artworks that adhere to fashionable ideas about painting: rather, they are depictions, a form of recording, similar to the way battlefields were sketched and coloured.

Mary Symonds's watercolour of the veranda of the house in San Thomé, by contrast, is quite astounding in its inside-out view, its use of perspective, and the tonal variation of bright sunshine and thick shadow. It was part of her project to depict all the places the family lived.[15] As early as 1801, she was promising her mother, "you shall have some sketches to give you an idea of the houses very soon."[16] And in 1806, she promised her sister Hester James "views of all the houses we have inhabitted in India."[17] Mary Symonds often sent her watercolours back to Britain, and the inscriptions would have helped the viewer to know what they were looking at. One painting, with a white chunam-covered home in the background, is full of activity. A man in a dhoti carries water pots suspended from a pole. A group of servants make a fuss around a young child. A boy follows a dog. The inscription tells the viewer:

> The tall figure is the bowlman. The white dog is our dog Lady, a great pet of young, and of mine from her gentle nature. The boy leading her is the maratta. The building in the background is part of our habitations, then next are the offices. The scene in the distance is a large tree the natives call Col. St Ledger from his having planted it.[18]

Another, "Domestic Offices Madras,"[19] dated and signed "1806, M.R.," provides a zoomed-in portrait of the servants' quarters. It shows a low white building with chimneys with servants coming and going, or sitting on the ground, as carriages wait for horses and two cows gently nose each other. The offices were an important part of Mary Symonds's role at home, as it was here that the meals were prepared, under her instructions. She wrote a pen portrait of the same scene:

> The Kitchens and other offices are built at a little distance from the house. These people are very excellent cooks but they have a very odd way of cooking all their utensils are very simple but elegant in their forms. The kitchen is a long narrow room ... they light a fire of sticks for roasting and the spits are turned by boys who are apprentices to the cook. The boiling is generally done over Charcoal fires which are lighted in earthen pots and stand out in the garden on any convenient place. They boil and stew every thing in earthen vessels which they have of all sizes and various pretty shapes.[20]

Mary Symonds's letters home were full of requests for ingredients and instructions on how they are to be shipped. Particularly popular were a gammon that had the chief justice, Thomas Strange, coming back again and again

for lunch, fruit preserves that she rationed out into the puddings that were a particular favourite of Henry Gwillim, and pickles, which the servants kept stealing, much to her annoyance.

It is this knowing housekeeper's gaze, a gaze that calculated lists of ingredients, tasks, and the payroll, that stares out through the chunam-coated columns in "Veranda. St Thomé – Sir H Gwillim's House." It is a startling point of view and one that is absent from other house paintings of this time. It allows the viewer closer to the artist than is normal. But there is more. Look closely. Follow the balustrade, past the open hall, past the bedroom and the maid climbing the stairs, and arrive at the furthest veranda. Two European women are pointing out across the balustrade as they look intently at something. Could this be a form of self-portrait, showing the sisters, Mary Symonds and Elizabeth Gwillim, perhaps drawing side by side?

"A LADY'S MAID, A PARIAH WOMAN" (PLATE 4)

A lady's maid stands before us. She has a woven bamboo basket on her hip. She is pausing, mid-task on the veranda of a European house. Behind her, in faint pencil, is a chunam-coated column, and a balustrade – like the one in "Veranda. St Thomé – Sir H Gwillim's House." She has tattoos on her arms and hands. The pencil inscription on this image includes the date 1803 and the initials "M.R." Both sisters had a lady's maid. The relationship was intimate. The maid helped with dressing and washing and slept nearby.

In her letters home to her mother, Elizabeth Gwillim describes her maid, known only as Poppa, in great detail and with affection, as well as with occasional frustration. Although Poppa's voice has been lost to the shifting sands of history, the letters and this painting give us a sense of character. And it is possible that this watercolour portrait is of Poppa. Lady's maids were often from lower-caste communities, the condescendingly named pariahs (Paraiyars).

Poppa's life had been a struggle. As a Paraiyar, she was discriminated against. She had learned the basics of English from her mother, who had been a water-woman. The struggle to access the English language, as a means to better employment, was a feature of life for her community. Work in European households provided stable employment. But it also came with its risks, especially for women in the employ of single men.[21] Poppa said she had been married twice. Her first husband was a Dutch captain, who bought her when she was ten. Later, she married another man who worked as a steward and had a son with him, who was in charity school. Her second husband now had another family, and he gave her nothing and took no notice of the child. Poppa

said that she often received offers, via domestic workers, to go and "live with their masters" but that she did not want a man – all she wanted was to be allowed to visit her child.[22]

We get a sense of the strangeness of Elizabeth Gwillim and Poppa's relationship, which was a working one. Poppa slept on the hard floor in the room next to Elizabeth Gwillim's bedroom, with bricks for a pillow, even though she had been offered carpets for her comfort. She slept in her muslin clothes and gold necklaces. Henry Gwillim, who was presumably working late on his legal papers, called out several times a night for toast and "she always jumps up in good humour & appears in full dress, as that requires nothing but shaking herself ... at five in the morning she smokes her Saroot of strong tobaco & when her work is done reheats it & basks under a tree asleep on the ground in the best cloaths I can give her."[23]

Looking closely at the maid, the viewer may be amazed by the amount of jewellery she is wearing. There are rings on her toes, often the sign of a married woman. Her neck is collared by a gold necklace with a ruby-studded star, pearl earrings hang like chandeliers, and star-shaped ruby studs pierce her ears and nose. Elizabeth Gwillim noted that her maid wore "rings & pins & has a large star in the one side of her nose made of Rubies set in gold which disfigures her not a little."[24] The skin tones are made by little feathery brushstrokes, the painter using a very fine brush. The same narrow tip was used to mark the tattoos on the maid's forearms, and the inky diamonds on the back of her hands above her many golden rings.

This fine brushwork in "A Lady's Maid, a Pariah Woman" contrasts with the thicker washes of sky and shadow in "Veranda. St Thomé – Sir H Gwillim's House." It may reflect Mary Symonds's growing skill as a portrait painter. As early as 1802, she was busy with this new occupation: "amongst my female friends; I am become a *miniature painter* (don't laugh) I have finished one Lady's portrait, have two more in hand, and twenty petitioners praying to be drawn; but I don't undertake gentlemen for if I did I should not have breathing time."[25]

Portrait painters were highly sought after in Madras at the turn of the nineteenth century. Portraitist John Smart was resident for a decade until 1795. Samuel Andrews moved into Smart's old house in 1795 before eventually moving to Calcutta. The portrait artist George Chinnery stepped ashore in 1802. Written accounts state that he became the most popular portraitist in Madras. Most of his portraits, like Mary Symonds's, were watercolour miniatures.[26]

These artists were capitalizing on local demand, like their contemporaries Ozais Humphrey and Diana Hill in Calcutta. In a period when families were separated by oceans, miniature portraits were used to create a sense of connection. Husbands and wives often commissioned joint sets before a parting.

Portraits were also commissioned to send home, to show parents and relatives how the sitter had changed.

These fine watercolours were often painted onto ivory and then framed in glass. We can see that Mary Symonds was fitting into this mould, judging from her material requests: "I shall be much obliged to you if you will send me a dozn of glasses for miniatures of different sizes and let them come by the first opportunity, our friend G. Samuel will tell you where to get them; I can buy plenty of Ivory here, and have got some charming brushes and white paint from China."[27] For Mary Symonds, the early rush of European society portraits did not last. In 1803, Henry Gwillim scolded her, "it was nonsense to [waste] my time drawing a parcel of foolish concieted girls instead of drawing ... natives & other things of this [country] which my friends at home [would] want to see."[28]

At first reading, this advice might be about showing friends at home a picture of India as the three of them were experiencing it. But there was something else under the surface of these remarks. By 1803, Henry Gwillim's relationship with the governor of Madras had become strained, due to Henry Gwillim's insistence that the police force should be under the control of the judiciary rather than the government. A police force under direct government control, used for collecting taxes, was a further step toward despotism. The sisters found themselves on one side of a social schism developing in Madras society.[29]

> Here has been a fine hue & crie this last 3 months some of the foolish people about the Government ~~Now~~ chose to oppose the authority of the Judges by military force but they have brought them upon their marrow-bones & I believe no such attempt will ever be made here again, it has however cost poor Sir Henry & Sir Thos. Strange a great deal of anxiety & fatigue, but nothing can be more complete than thier victory.[30]

This rupture might have made it trickier for Mary Symonds to act the society portraitist. Some invitations may have been withdrawn. The very act of inviting Henry Gwillim's sister-in-law into one's home had perhaps become a political act.

From this time, Mary Symonds's view of European society changed from one of enjoyment to one of disdain. As her stay in India continued, she seemed to turn her artistic attention more and more to the Indian world around her. Perhaps the portrait "A Lady's Maid, a Pariah Woman" was part of this shifting of the gaze. This painting certainly shows all the skill and deftness of touch of a painter used to making miniature portraits. The fine brush lines used to create shading. The drawing of hands and feet. The drapery. The jewellery.

And, perhaps most importantly, the ability to not only depict what a person looks like, but to capture a sense of inner character, of who they are.

By 1803, Mary Symonds was busy asking people to pose for her. Not high-society ladies, but the men and women she met day to day. "I have got an old woman to stand, to me, & a Moor man to sit, both of whom are so handsome that I should be very sorry to lose the opportunity of drawing them."[31] The portrait of a lady's maid is one of a number of portraits of Indians in the *Madras Album*. These include a dubash (interpreter and go-between who often acted as head steward),[32] a local farmer,[33] a man holding a palm leaf book, who is perhaps a munshi (a term used by Europeans to refer to an Indian teacher of local languages) (plate 61), a holy man and his young assistant (plate 56), and a chobdar (silver mace bearer).[34] This is before we even begin to consider her street scenes as group portraits.[35]

"BIRD CATCHERS" (PLATE 48)

In this small painting, an older man holds a captive flamingo, while his young assistant produces another bird from under layers of cloth. Over the years, the sisters employed a variety of means to capture birds for Elizabeth Gwillim to paint. In 1803, Mary Symonds wrote that bird catchers bought them birds, but that "when the birds are brought in alive they stare, or kick, or peck" and "poor Betsy" (Elizabeth Gwillim) was often "frightened out of her wits" or took pity on the birds, thinking they look ill, and let "them fly before they are finished." Soon they employed "a venerable looking old Moor man," who caught the birds and secured them in a piece of cloth, then later held them in the right posture for Elizabeth Gwillim to draw. Mary Symonds wrote that the grounds of their home were full of tethered birds, including cranes and stalks, that needed to be fed hundreds of frogs and fish.[36] In 1805, while in Pammal, Elizabeth Gwillim wrote home about "a couple of shooting men who go upon the hills & collect me curious birds when they bring them in I am obliged to sit down & draw them for here if dead they will only keep one day & if alive they cannot long be kept so – & are suffering much."[37]

"Bird Catchers," for me, is evidence of the way the two sisters dovetailed their artistic practices, the two of them living and working in close proximity, as shown in "Veranda. St Thomé – Sir H Gwillim's House." In a letter from 1803, Mary Symonds wrote, "Betsy, sits opposite me drawing."[38] When one wrote a detailed description in letters home, the other often supplied a painting. They shared materials. Their interests bled into each other. This small portrait, probably by Mary Symonds, is a record by one sister of the other's artistic practice. Mary Symonds was painting the men who brought the birds

that her sister painted in a naturalistic style. It is a behind-the-scenes glimpse of the process that lay behind the large collection of ornithological paintings now held in the Blacker Wood Collection.

UNTITLED ("GROUP OF PANDURAMS WITH ... BROWN BEADS, TWO PAGODA BRAHMINS") (PLATE 9) AND "CARRYING AN ENGLISHMAN" (PLATE 5)

The *Madras Album* contains a number of street scenes, probably by Mary Symonds. These are an rich record of life in and around Madras. We can really feel the hustle and bustle. Accounts of Madras at this time, including those of the sisters, note that, considering the lack of housing, there seemed to be an amazing number of people on the streets. The centre of Madras was home to wealthy Brahmins and merchants; much of the working population came in from surrounding villages. Elizabeth Gwillim wrote home to her sister Hester James and referenced the painting showing a "group of pandurams with ... brown beads" by Mary: "You will see ... a group of young Pandurams ... These Pandanums are very well drawn & so are two Bramins sitting down in the same piece." Elizabeth thought that these street scenes "are by much the best things I ever saw to give an idea of the people in the streets or roads here in crowds & so various in her dresses."[39]

Mary Symonds invented a form of painting on pasteboard, with the idea that she could prop the images up to create a scene as if the viewer were passing down a Madras street (plates 9–12).[40] These paintings are fast and fluid, giving the dizzying sense of glancing down the side of a busy road. The torso of a woman gathering fodder is rendered in three or four flicks of a brush (plate 9). Unlike the feathery brush marks of "A Lady's Maid," depth is created by a single darker tone washed on in quick dabs. Faces are constructed with fine black marks for eyes, noses, and mouths.

The watercolour "Carrying an Englishman" feels almost satirical. In 1801, shortly after arriving, Elizabeth Gwillim wrote home to her mother and described the arrival of Henry Gwillim's new palanquin. As was customary, a ceremony was performed when it was handed over to Henry Gwillim, and a sheep was killed and cooked. There were thirteen palanquin bearers. And Elizabeth Gwillim notes that "you never meet an English person but in a carriage or in a Palankeen."[41] The following year, she wrote that, at dinners, the guests would arrive in "Palakeens & each palankeen has from 9 to 13 men & two Lanthorn men. These set the Palankeens under the trees before the doors & lie down to sleep or talk 'till they are called if it be all night the Carriages wait in the same way, & they altogether form very pretty groups under the trees."[42]

The image of the European being carried by his bearers was common among European artists in India. George Chinnery, once he arrived in Madras, underwent a revolution in how he composed the outdoor scenes he liked to work on alongside portraiture, moving from formal compositions to a much more fluid use of line. In 1805, part way along this transformation, he sketched *Englishman in a Palanquin Carried by Four Indians*.[43] Mary Symonds's image is unique in how much detail it gives us. Painted across a fold in the paper, the work treats the viewer not just to a glimpse of the Englishman lying horizontally and the palanquin bearers, but the whole world through which they are moving.

A terrier yaps and runs along beneath the Englishman. A woman carries a large clay pitcher on her head. A man makes his way slowly along under a parasol. A wealthy woman in a shiny blue sari stops to stroke the head of a child. Through the opening in the palanquin, we can see that the Englishman is reading a book. Is this a comment on Europeans trying their best to ignore the country around them? And is the artist making the point that, perhaps, the things of most interest might not be in the printed word but on the street? Or is this a portrait of Henry Gwillim himself, desperately trying to keep up with the work he has imposed on himself to try to best represent those people on the street in the courts of law?

"SCENE FROM A SANSKRIT DRAMA" (PLATE 6)

While the street scenes are often fast and fluid, the album also contains highly composed and stylised images. In 1803 Mary Symonds wrote home to her sister Hester James, "I have been very busy drawing some more such *fine figures*." Thomas Strange, the chief justice, had seen some of her paintings and, she wrote, had "requested me make him some little sketches from a book which was translated by Sir William Jones ... I had made some which he saw & admired so much that he begged them, some time or other I will send you something of the same kind."[44]

"Scene from a Sanskrit Drama" is a large watercolour that shows a young woman in a forest grove being dressed in garlands and jewels. She gestures at an old sage wrapped in japamala beads. The ring on her finger glints in the tree-dappled light. The maid tying flowers into the young woman's hair is crying. A holy man draped in saffron offers her a pearl necklace. This watercolour probably shows a scene from *Abhijñānaśākuntalam*, the fifth-century play by the famous playwright Kālidāsa.[45] William Jones's version of the play, *Sacontalá or The Fatal Ring*, was translated in 1789 and went on to be a success in Europe. It had a huge influence on the Romantic movement. In 1791, Goethe noted, "when I mention Sakontala everything is said."[46]

In this image, Shakuntala is about to leave her home at the ashram run by her adopted father in the middle of the forest. She is being dressed in her bridal robes to go to meet King Dusyanta, who she fell in love with when he came hunting in the wood. It is the king's ring on her finger, the ring that she thinks will help him remember her. But, when crossing a wide river, she lets her hand dip into the water and the ring slips off.

The *Madras Album* contains other set-piece images. One, "From a Hindoo Poem," shows a young hunter with his arms crossed, speaking to a holy sage.[47] Another, "Hindoo travellers" (plate 59), shows a Brahmin family approaching a temple choultry (rest house), as a woman rides a bull to the same shelter, and a bearded holy man wearing saffron and draped in beads beckons to the viewer.[48] In the background are recognizably Madrassi hills and palmyra palms, the whole scene framed by the draping boughs of a banyan tree.

Mary Symonds was engaging with Indian literary traditions. In India, she was surrounded by people learning Tamil and Telugu and Persian, although she never seriously attempted a second language herself. In a letter home, she joked, "as I have never yet been able to acquire any knowledge in my own tongue it would be great affectation in me to attempt to gabber in the Eastern ones."[49] Nonetheless, her paintings seem to reveal a less flippant and more diligent appreciation of the intellectual traditions around her.

There are few obvious comparisons to this work. In their tree-bound nature, some of the smaller pictures bear comparison to the paintings of James Forbes that appeared as prints in his *Oriental Memoirs*. But it is unlikely that Mary Symonds could have used these as a model. When in India, Forbes was based in Bombay, and most of his imagery was not published until several years after Mary Symonds's return to England.

At the turn of the nineteenth century, European artists in India were busy recording views, buildings, and peoples, like an exercise in artistic mapping. But these images were probably not a direct source of inspiration for the watercolour of Shakuntala. Some of William Jones's works were published with illustrations. *On the Gods of Greece, Italy, and India* featured Indian musicians, and gods and goddesses sat or stood in profile, like the many paintings of the trades and occupations of India at this time.[50] European books did sometime carry classical-like scenes as an opening illustration, a trend inspired by antiquarian texts. Jones's own *Caissa*, published in 1810, has an opening image of a group of classically sculptural-bodied women sitting around a chess table. It is possible that Mary Symonds was inspired by an illustration in one of the books in the sisters' or Henry Gwillim's possession, or perhaps in the collection of Thomas Strange, or another acquaintance. These classical figures may have suggested the broad-limbed, statuesque bodies of the figures in "Scene from a Sanskrit Drama."

Throughout her time in India, Mary was learning and practising. One of the ways she honed her skills was to copy and rework images from prints. In 1806, she wrote to Hester James, saying "I send you a specimen, of my performance, in a copy I have made of a holy family from a print."[51] That same year, Mary Symonds produced "Brahmans,"[52] an image of three Brahmin men, recognizable through their locks of hair and clothing, standing in conversation, with a temple sticking up above the trees, as a woman squats and tends to a small child. These illustrative watercolours would seem to be another startling piece of innovation, mixing a number of different traditions.

"A CHATTRAM OR CHOUDRY" (PLATE 7)

Cattle nose past a row of local houses, with their distinctive wooden pillars and tiled rooves. A mother raises her hand in greeting to the choultry. A woman guides a bull with two large baskets on its flanks. In the travellers' shelter, two white-robed attendants move what might be a large clay cooking pot. And behind everything, perched on its rocky outcrop, are the distinctive buildings of Thiruneermalai temple.

The earliest dated landscape painting in the album is from 1804. In a letter from 1805, Mary Symonds wrote that she had been painting "Pagodas & Coultries ... & Mosques & Mousoleums".[53] These images were part of a long-term effort to paint the landscapes around Madras. As soon as she arrived in Madras, she wrote, "I think this is a most beautiful country."[54] Her early letters contain a series of pen portraits. "The palm trees shewing only their graceful tops ... are constantly waveing their long branches in the most stately manner ... The tombs of great persons are very handsome buildings and I am told that the inside of some of them is kept constantly hung round with flowers."[55] And, when Elizabeth Gwillim picks up the mantle of curious observer, Mary Symonds supplies illustrations to match her sister's "description of the Country."[56]

"A Chattram or Choudry, a Native Bazar" was probably made when the sisters were staying at Pammal. In one painted view of Mr Webb's cotton farmhouse at Pammal, where the sisters were living, the pagodas can be seen perched on a distant shadowy hill. This temple appears in close-up in five paintings in the album, two of which are signed "M.R." These watercolours have a close stylistic resemblance to each other: the scene they depict was clearly a preferred haunt for a determined watercolourist.

The *Madras Album* is flooded with pictures of mausoleums, temples, villages, and choultries, as well of river crossings and banyan trees with their curtains of dangling roots. To understand these pictures, we have to look beyond the sisters and find what was influencing them. To explore trends in European

art in India, I am going to use the example of topographical prints. Views of India were hugely popular in late eighteenth-century Britain. William Hodges was the first professional artist to be given an East India Company salary, in 1780, and was invited to depict the country by his friend and patron Governor-General Warren Hastings.[57] William Hodges's images are full of the idea of the picturesque. The viewer forever seems to be stumbling out from among trees and shrubs onto an architectural ruin or temple or fortress.

William Hodges's *Select Views in India* inspired Thomas and William Daniell to begin the venture they became famous for: images documenting three epic journeys in India. The two men, uncle and nephew, arrived at Calcutta in early 1786. Between 1788 and 1793, they travelled to northern India (where they vowed to improve on Hodges's work), to the south, and then to the west. The result was a popular series of prints titled *Oriental Scenery*, originally published between 1795 and 1807 and reprinted several times thereafter. William Hodges's and Thomas and William Daniell's paintings of Indian scenes were regularly displayed at the Royal Academy between 1785 and 1826.

In Britain, the drawing room had recently become a fashionable room in the houses of the middle classes. It was a place where prints, from the booming print market in London, could be displayed alongside drawings and paintings. In 1802, Mary Symonds wrote to her sister Hester James "your new drawing room will be an additional inducement to me to endeavour at improving myself in drawing."[58] These rooms created a huge market for printed views in aquatint, a form of printing that looked like watercolour but was much more affordable. *Oriental Scenery* grew to be so popular that wallpaper, curtains, and dinner plates were produced with scenes from the prints on them. Country houses were designed with these images in mind. Indeed, Thomas Daniell went on to advise on buildings and gardens that were being constructed in the Indian style, like those at Sezincote, in the Cotswolds. An idea of how India looked had permeated the English middle and upper classes. Families like the Symonds of Herefordshire, whose daughters were taught the art of drawing, could not have avoided it.

The Daniells were in Madras, on their tour of the south, in 1792, culminating in a lottery of their work that winter. Between November 1792 and February 1793, sixty-eight oil paintings were offered up for sale, along with other works.[59] In the south, Thomas and William painted views of the landscapes around the city, the beach, the Armenian bridge, the rock at Trichinopoly, Srirangam temple, and Fort St George. Their views had also permeated the consciousness of Europeans in southern India. I think of images like those of the Daniells as a guidebook. These pictures created an idea of India, of what was worth seeing and painting in India. This influence is evident in the sisters' paintings of the banyan tree. When she painted "Pagodas

& Coultries ... & Mosques & Mousoleums" Mary Symonds was picking out buildings, framing them, forming her foreground, middle ground, and distance, with this weight of topographic print culture at the back of her mind.[60]

We can see another echo in this picture and many others in the *Madras Album*: so many of the pictures have hills in the background. The ridgelines, with their distinctive shapes, become like recognizable faces craning in at the edge of many landscape scenes. The choice of rocky pinnacles as a backdrop was not a decision made with only beauty or the picturesque in mind. Toward the end of the eighteenth century, the wars with Mysore bought thousands of troops to Madras. The conflict with Tipu Sultan created an insatiable appetite for news. Military memoirs became best sellers, and accounts of prisoners in the hillforts across Mysore were commonly read.

The Mysore wars also created a genre of art, the work of solder-artists such as Alexander Allan, Robert Home, Robert Colebrook, and James Hunter. Alexander Allan was a surveyor, and his views of hill forts show his skill at delineation, which he was taught at the military academy in Britain before his posting. His images of hill forts were meant to be "read." Much of the art from this period appeared with text. The viewers would have known the accounts of the battles, the prisoners, the tigers, and deprivations. All of this information was in the popular press. Alexander Allan's images take the viewer on a battlefield tour, the groups of sepoys in the foreground serving as a reminder of the military stories attached to the landscape. James Hunter created a different sort of work in his *Picturesque Scenery in the Kingdom of Mysore*. Although James Hunter was also a military artist, there is a quietness to his images, something Rosie Dias calls an elegiac silence, and an air of remembrance seems to hang over the pictures.[61]

Colonel Francis Swain Ward had his oil paintings of Indian vistas turned into a series of prints in 1803, along with works by William Daniell, in *24 Views in Hindostan, Drawn by William Orme from the original pictures painted by Mr. Daniell & Colonel Ward*. Today, these images seem rather tame. The hill forts appear as far off specks on top of ridges. The hills themselves are the stars of the pieces. They are certainly not the spectacle pieces of later Victorian artists or the macabre theatre of Robert Ker Porter's *The Storming of Seringapatam*, a giant panorama of Tipu Sultan's last stand, made by an artist who never set foot in India.

The rocky outcrops and dramatic ridgelines that appear in the background of so many of the views in the *Madras Album*, then, were following an already established aesthetic. Painting hills in and around Madras evoked the storied landscapes of soldier-artists. It connected the painter to the gory expansion of East India Company control in southern India, even if Mary Symonds could write that "it is the policy of these governments to keep all thier measures extremely seecret and I fear many of them would not bear the eye of open day."[62]

"ASCENSION ISLE" (PLATE 8)

A colour drawing. The long shape of Ascension Island in the middle of the South Atlantic Ocean rendered in a dark silhouette. The lines of the chalk shading clearly visible. A ship with cross bars and its sails rigged sailing slowly out toward the artist, on a grey-blue ocean. "Ascension Island" is part of a set of images, including "The Cape of Good Hope"[63] and "St Helena – James' Town,"[64] that document Mary Symonds's journey between Madras and England.

This type of image is reminiscent of naval sketches. In the early nineteenth century, as British shipping networks expanded, naval officers drew the coastlines of the lands they visited. Reproductions of these views were then used as a tool by others. After months at sea, these images of headlands and the topography of the shore were used to help position ships at landfall and guide them to harbour.[65]

This image of Ascension Island is dated 1808 and carries the pencil initials "M.R." It was made by Mary Symonds on her voyage back to England, accompanying the widowed Henry Gwillim. Emotionally, Mary Symonds must have been in an odd situation. She was returning without her sister Elizabeth Gwillim, who had died in Pammal at the end of the previous year. Mary Symonds herself had travelled to India in search of a husband and had failed to find a man who met her expectations. She was returning to England unmarried. But, in the midst of a journey that saw the ship *Phoenix* battle through a horrific hurricane, she found herself getting acquainted with the ship's captain, John Ramsden.[66] Soon they would be engaged. Is it possible that her growing relationship with the ship's captain could have given Mary Symonds access to learning about naval drawing? This drawing style might have inspired this image.

MAKING DRAWINGS OF THE COUNTRY

Betsy has been very busily employed in drawing birds & the village people have been very good in bringing many curious ones to her, I assure you I have lost no time but have also been very busy in making drawings of the country & well done or ill done I take care to make them as much like nature as I can by colouring them on the spot, so that I trust in God we shall one day have the pleasue of giving you & all our friends some idea of this country & its inhabitants.[67]

To conclude, I want to think a little bit about the making of these watercolours. The paper was a source of frustration for both sisters. The watercolours are made on a mixture of wove and laid paper. Locally made "India paper" was

"much cheaper than Europe paper,"[68] but Mary Symonds described its quality as "shameful."[69] Elizabeth Gwillim's bird paintings took precedence, using the good-quality wove paper. Mary Symonds often had to make do with odds and ends, even making her paintings on letter paper.[70] For a watercolourist, paper quality is crucial. As a medium, watercolour relies on different textures made from dabs, dry brushing, and thicker washes. On laid paper, with its coarse barred structure, watercolour tends to run and pool and lie where the painter doesn't intend it to. This is evident in the *Madras Album*, where, for example, skies have bled out, little branches of blue snaking out into the grey-white clouds.

The sisters also had to contend with the climate, which ranged from hot dry winds through to the muggy heat of the monsoon. Mary Symonds wrote about the paper and how the climate has affected it, complaining that she had "no paper for landscape; what we brought out with us has entirely lost the size & sinks worse than blot paper."[71] The sisters probably pinned or clamped sheets of paper to a drawing board. In the heat, the paint would have dried quickly. In the monsoon, it would have stayed damp, and the sisters would have had to wait for the paper to dry before applying new layers of watercolour.

Both sisters were still in contact with the artist George Samuel, who had been their mentor, sending him gifts and paintings. For example, Elizabeth Gwillim sent a cut section of a shawl home and asked her sister Hester James to have a waistcoat made up and sent with some vellum stones "to G. Samuel with my compliments." In the same letter, she mentioned that she was "working away after his manner in back grounds to my birds."[72] George Samuel had suggested the sisters try using Chinese brushes and colours, but Mary Symonds wrote that they were "useless."[73] The constant need for good paper, and cakes of watercolours from brands like Reeves, were a common topic in their letters. Mary Symonds missed George Samuel's instruction, complaining to her sister Hester James about how hard it was to get good advice: "I am quite mad at myself for not being able to do sky's and backgrounds, & it is very hard work to find things out without instructions." She bemoaned the fact that "the Girls who are educated for this country think of nothing but husbands," and that suitors, pearls, and diamonds were the topics of conversation, not paint.[74] In 1805, Mary Symonds wrote, "we have been this cool season at a place called Pommel about 12 miles from Madras the country about it is extremely pretty & I have made myself very busy sketching, so you may now tell George Samuel in answer to his enquiries, that I have got Pagodas & Coultries ... & Mosques & Mousoleums, but alas: no paper for landscape."[75] And, in 1806, she told her sister Hester James, "I have sent George Samuel two or three little scraps with a request that he will give me a little instruction."[76]

What sort of influence might George Samuel have been? He was part of the late eighteenth- to early nineteenth-century group of artists dedicated to

painting from nature in the open air. His watercolours contain rocky outcrops and wind-brushed foliage.[77] The sisters seem to have been influenced by his artistic shorthand – for example, in the way trees are often quickly sketched in using watercolour. George Samuel has a quirky fondness for centring trees in his foreground and for a slightly off-centre perspective, all features that appear in the *Madras Album*. Significantly, George Samuel was the keeper of the minutes at Thomas Girtin's sketching society. Members of the society believed in making paintings *in situ*, outdoors, in all weathers. The artists, including Thomas Girtin, Robert Ker Porter, and John Sell Cotman, met on Saturday evenings. Choosing a poetic subject, they would all then set about illustrating it.[78] This practice puts me in mind of Mary Symonds's attempts to illustrate Sanskrit texts. Had she been influenced by George Samuel's tastes?

It is likely that both sisters had been exposed to ideas about the picturesque. The landscape watercolours in the *Madras Album* correspond with contemporary ideas about beauty and what a good image was, ideas that followed the influence of William Gilpin and Richard Payne Knight. Payne Knight was Thomas Symonds's employer when the sisters were growing up. In his influential poem "The Landscape," he wrote that it was "nature's common works" that "move ... melt," and "elevate the mind." Rather than focusing on terror in wild landscapes of "hills on hills to scale the skies," he argued that pictures should create "sympathy" in the viewer.[79]

Added to these possible influences, we know about some of the art objects the sisters were exposed to while in India. In 1805, Elizabeth Gwillim wrote to her sister Hester James, "Mr: Keene has given me such an exquisite elegant book – It is a manuscript ... & contains above 700 pages ... & borders of scarlet blue & gold intermixed round every page, besides various paintings of Hindoo stories."[80]

In 1806, in a letter to Hester James, Mary Symonds discusses using a print as a model, and trying a new technique, the application of body colour:

> I have sent some little drawings for Mr. Keene, but have directed them [to] you because I like that you & George Samuel should see them pray remember me most kindly to him & tell him I hope to recive some hints from him. I have been trying to work in body colours a little lately & I send you a specimen, of my performance, in a copy I have made of a holy family from a print.[81]

It is not surprising to find paintings of ayahs and holy men in the album. As early as October in their first year in Madras, Mary Symonds wrote home saying, "I am endeavoring to make a set of drawings of the different Casts and descriptions of the natives of this country to give you all an exact idea of

their dresses."[82] Even if her method of depiction is often startling. A number of European artists in India were producing views of occupations and castes. Pierre Sonnerat's illustrations for *Voyages aux Indes* were made in southern India, and there is something in his stout, thick-armed figures that finds an echo here.[83] Today, one of the most famous sets of images in this category is Balthazar Solvyn's *Les Hindoûs*, which was published from 1796 in Calcutta, London, and Paris. The portraits in the *Madras Album* contain a number of occupations – ayahs, dubashes, and chobdars – that were also depicted by Solvyn. Both Solvyn's works and the paintings in the *Madras Album* are contextual images that include a background setting.

The *Madras Album* also contains a number of watercolours – like many of the street scenes and a portrait of a Pandaram and his young assistant – that have a flat white background. The use of flat backgrounds resembles the approach in what have come to be called Company School or Company style pictures, which were works created by Indian artists for a European market.[84]

Charles Gold, in his *Oriental Drawings*, published in 1806, included a print of a lame beggar and his family, which was painted by a Tanjore artist. Gold wrote:

> The Moochys, or Artists of India, usually paint in the stile represented in the present drawing ... On the suggestion of Europeans, some of the country artists have been induced to draw series of the most ordinary casts or tribes, each picture representing a man and his wife, with the signs or marks of distinction on their foreheads, and not in their common, but holiday clothes.[85]

At this time, a visitor to Seringam (Srirangam) Temple could buy a painting of the temple from local artists outside to remind them of their visit. And it was common for Europeans to collect albums of paintings by local artists, depicting trades and occupations. Local artists also worked on more specialist projects. In Tanjore, Serfoji II, the rajah, embarked on an extensive survey of flora and fauna, using local painters to create a record. Similarly, in 1811, the governor of Madras, Mountstuart Elphinstone Grant Duff, commissioned Rangia Raju to take on a two-year project painting local plant species.[86]

But there was a difference in perception between the paintings made by many European artists, or for European visitors as souvenirs, and those of the sisters. From their correspondence, we know a little of what Mary Symonds and Elizabeth Gwillim thought of their sitters. For example, for Charles Gold, dubashes were a respectable caste of men who had fallen on hard times. He called them "cheaters," who would extort the Europeans they attached themselves to.[87] But the sisters had a different opinion:

I must mention that nobody who has not been in a country like this can imagine what immense time is spent for want of language – Translations by a translator imperfect in the language are fatiguing always [words crossed out] & how can any man be perfect in them? Instead of one Dubash each we ought to have half a dozen – These men as I have said generally write 3 but they speak four languages … yet our lads that come out knock these fellows about if they make the least mistake & call them stupid, ignorant, degenerate savages – and all this to lads of their own age who sit down & correspond in three languages & translate in four whilst they cannot correctly write their own![88]

While the sisters were influenced by contemporary art styles and tastes, as well as social opinions, the collection of watercolours, and one drawing in coloured chalk, in the *Madras Album* hint at an artistic project that was unique. By the time Mary Symonds boarded the *Phoenix* in 1808, her art had started to investigate the world around her in new and startling ways, from portraits of a lady's maid and the other Indian men and women she chose to paint, through to a new form of street scene. Perhaps the greatest contribution of these images is to place in history characters who would otherwise have been written out of it. This was at a time, around fifty years before the introduction of photography, that British society in India was hardening in its attitudes toward local communities, and the Madras government was slipping toward despotism. So while Mary Symonds and Elizabeth Gwillim were part of the colonial project, at times they also viewed Madras through a more sympathetic lens, providing a view of the different people shaping and experiencing the Madras Presidency at the beginning of the nineteenth century.

Notes

1 Mary Symonds, "Brahmins," the South Asia Collection Museum, NWHSA: PIC106.50.

2 Mary Symonds, "A Mussalman and Family on the Anniversary of Their Marriage," the South Asia Collection Museum, NWHSA: PIC106.59.

3 I have chosen to refer to individuals by their first and family name, where possible. While it is common for historians to refer to their subjects by surname, this can create gender biases and power imbalances where some individuals are referred to in historical sources or historical accounts only by their forename.

4 For more details see, Cartwright, *A Different Idea of India*.

5 Taylor, *Storm and Conquest*.

6 I would like to acknowledge the work of my predecessor at the South Asian Decorative Arts and Crafts Collection Trust (SADACC), Diana Gratton, and the research she did for the exhibition *Madras and Environs Album, 1804–1808: Early British Observations*. I am also grateful for the assistance of Christine Blackburn, assistant curator, the South Asia Collection Museum, Norwich.

7 Elizabeth Gwillim to Hester James, 7 February 1802, British Library, India Office Records (BL IOR) Mss.Eur.C.240/1, ff. 33r–38v.

8 Elizabeth Gwillim to Esther Symonds, 16 July 1802, BL IOR Mss.Eur.C.240/1, ff. 62r–71v.

9 For a guide to chunam in Madras, see, Balfour, *Cyclopedia of India*, 1: 230.

10 Mary Symonds (probably) to Hester James, 18 October 1802, BL IOR Mss.Eur.C.240/1, ff. 4r–11v.

11 Herbert, *Flora's Empire*.

12 Mary Symonds to Esther Symonds, 14 October 1801, BL IOR Mss.Eur.C.240/1, ff. 4r–11v, on f. 5v.

13 Kattenhorn, "Sketching from Nature."

14 See, for example, *Holy Men outside Sir Thomas Strange House*, a watercolour from 1811 by John Young Porter, held at the British Library. John Young Porter was a captain in the 9th Regiment of Native Infantry.

15 The attribution to Mary Symonds is based on a number of details and techniques in this watercolour that are similar to those appearing in watercolours with her initials on them.

16 Mary Symonds to Esther Symonds, 14 October 1801, BL IOR Mss.Eur.C.240/1, ff. 4r–11v, on f. 11r.

17 Mary Symonds to Hester Symonds James, 12 February 1806, BL IOR Mss.Eur.C.240/4, ff. 319r–321v, on f. 319v.

18 Colonel John Hayes St Leger, close associate of the Prince of Wales, and member of Parliament, died in Madras in 1800.

19 Mary Symonds, "Domestic Offices Madras," the South Asia Collection Museum, NWHSA: PIC106.20.

20 Mary Symonds to Esther Symonds, 14 October 1801, BL IOR Mss.Eur.C.240/1, ff. 4r–11v, on f. 6.

21 Sinha, Varma, and Jha, *Servants Pasts*; Sinha, "Who Is (Not) a Servant."

22 Elizabeth Gwillim to Esther Symonds, 12 October 1804, BL IOR Mss.Eur.C.240/3, ff. 217r–228v.

23 Ibid., f. 221r.

24 Elizabeth Gwillim to Hester James, 12 February 1802, BL IOR Mss.Eur.C.240/1, ff. 47r–48v, on f. 47v.

25 Mary Symonds to Hester James, 18 March 1802, BL IOR Mss.Eur.C.240/1, ff. 55r–57v, on f. 55v.

26 Aronson and Wiesman, *Perfect Likeness*; Conner, "The Poet's Eye."

27 Mary Symonds to Hester James, 18 March 1802, BL IOR Mss. Eur.C.240/1, ff. 55r–57v, on f. 55v.

28 Mary Symonds to Hester James, n.d. [1803], BL IOR Mss.Eur C.240/2, ff. 122r–127v, on f. 126r. Some words in this letter were cut off or were unclear. Unclear words are indicated by square brackets, while an ellipsis denotes a missing word.

29 See Cocks, "Social Rules and Legal Rights" and Arthur MacGregor's chapter in this volume.

30 Mary Symonds to Hester James, 7 February 1803, BL IOR Mss.Eur.C.240/2, ff. 100r–103v, on f. 100v.

31 Mary Symonds to Hester James, 10 September 1803, BL IOR Mss.Eur.C.240/2, ff. 150r–153v, on f. 150r.

32 Mary Symonds, "A Dabach," the South Asia Collection Museum, NWHSA: PIC106.62.

33 Mary Symonds, Untitled, the South Asia Collection Museum, NWHSA: PIC106.45.

34 Mary Symonds, "A Chobdar," the South Asia Collection Museum, NWHSA: PIC106.65.

35 For an overview of dubashes in Madras, see Susan Basu, "The Dubashes of Madras."

36 Mary Symonds to Hester James, 7 February 1803, BL IOR Mss.Eur.C.240/2, ff. 100r–103v, on ff. 101r–102r.

37 Elizabeth Gwillim to Esther Symonds, n.d. [late 1805], BL IOR Mss.Eur.C.240/4, ff. 300v–302v, on ff. 301v–302r.

38 Mary Symonds to Hester Symonds James, 7 February 1803, BL IOR Mss.Eur.C.240/2, ff. 104r–106v, on f. 104v.

39 Elizabeth to Hester Symonds James, n.d. [spring 1803]. BL IOR Mss.Eur.C.240/2, ff. 167r–177v, on f. 167v.

40 See Hana Nikčević's case study in this volume.

41 Elizabeth Gwillim to Esther Symonds, 17 October 1801, BL IOR Mss.Eur.C.240/1, ff. 14r–18v, on f. 17r.

42 Elizabeth Gwillim to Esther Symonds, 23 January 1802, BL IOR Mss.Eur.C.240/1, ff. 21r–32r, on f. 29r.

43 This pen-and-watercolour drawing is dated 5 September 1805. The Courtauld Gallery.

44 Mary Symonds to Hester James, 7 February 1803, BL IOR Mss.Eur.C.240/2, ff. 104r–106v, on f. 105r.

45 See also Nikčević, "A Scene from a Sanskrit Drama."

46 Damrosch, *World Literature in Theory*, 15.

47 Mary Symonds, "From a Hindoo Poem," The South Asia Collection, NWHSA: PIC106.3.

48 The full written inscription on this painting reads "The Banyan tree – It does not ascend but only sends down pillars to support their large elongated branches."

49 Mary Symonds to Hester James, n.d. [1802], BL IOR Mss. Eur C.240/1, ff. 58r–61v, on f. 60v.

50 Jones, *On the Gods of Greece, Italy, and India*.

51 Mary Symonds to Hester James, November 1806[?], BL IOR Mss.Eur.C.240/4, ff. 346r–352v, f. 352r.

52 Mary Symonds, "Brahmans," the South AsiaCollection, NWHSA:PIC106.72.

53 Mary Symonds to Hester James, 4 March 1805, BL IOR Mss.Eur.C.240/4, ff. 253r–257v.

54 Mary Symonds to Esther Symonds, 14 October 1801, BL, IOR Mss.Eur.C.240/1, ff. 4r–11v, on f. 13r.

55 Ibid., f. 8r.

56 Mary Symonds to Esther Symonds, 3 October 1802, in pencil, BL IOR Mss.Eur.C.240/1, ff. 86r–87v, on f. 87r.

57 Quilley, *William Hodges*.

58 Mary Symonds to Hester Symonds James, 11 February 1802, BL IOR Mss.Eur.C.240/1, ff. 39r–46v, on f. 39r.

59 Mertinelle and Michell, *Oriental Scenery*.

60 Mary Symonds to Hester Symonds James, 4 March 1805, BL IOR Mss.Eur.C.240/4, ff. 253r–257v, on f. 255r.

61 Dias, "Memory and the Aesthetics."

62 Mary Symonds to Hester Symonds James, 20 October 1803, BL IOR Mss.Eur.C.240/2, ff. 163r–166v, on f. 165v.

63 Mary Symonds, "The Cape of Good Hope," the South Asia Collection Museum, NWHSA: PIC106.63.

64 Mary Symonds, "St Helena – James' Town," the South Asia Collection Museum, NWHSA: PIC106.24.

65 Driver and Martins, "John Septimus Roe ."

66 Taylor, *Storm and Conquest*.

67 Mary Symonds to Esther Symonds, 2 February 1805, BL IOR Mss.Eur.C.240/4, ff. 248r–252v, on ff. 249v–250r.

68 Mary Symonds to Esther Symonds, 14 October 1801, BL IOR Mss.Eur.C.240/1, ff. 4r–11v, on f. 10.

69 From Mary Gwillim to Hester James, n.d. [1802], BL IOR Mss.Eur.C.240/1, ff. 58r–61v, on f. 61v.

70 Mary Symonds to Hester James, 4 March 1805, BL IOR Mss.Eur.C.240/4, ff. 253r–257v.

71 Mary Symonds to Hester James, 4 March 1805, BL IOR Mss.Eur.C.240/4, ff. 253r–257v, on f. 255r.

72 Elizabeth Gwillim to Hester James, 18 March 1802, BL IOR Mss.Eur.C.240/1, ff. 49r–54v, f. 50v.

73 Mary Symonds to Hester James, 7 February 1803, BL IOR Mss.Eur.C.240/2, ff. 104r–106v, on f. 104r.

74 Ibid., 105v.

75 Mary Symonds to Hester Symonds James, 4 March 1805, BL IOR Mss.Eur.C.240/4, ff. 253r–257v, on f. 255r.

76 Mary Symonds to Hester Symonds James, 12 February 1806, BL IOR Mss.Eur.C.240/4, ff. 319r–321v, 321r.

77 See George Samuel, *A View in Avon Dale Near Bath*, Rhode Island School of Design, www.watercolourworld.org/painting/view-avon-dale-near-bath-tww018050.

78 Bermingham, "Girtin's Sketching Club."

79 Earlier, in 1786, Payne Knight had written specifically on a subject from India, the Shiva lingam (a sacred object representing the deity), in *Discourse on the Worship of Priapus and Connections with the Mystic Theology of the Ancients*. This work opens the possibility that the art of India might have been discussed in circles around the two sisters as they grew up in Herefordshire.

80 Elizabeth Gwillim to Hester James, 24 August 1805, BL IOR Mss.Eur.C.240/4, ff. 279r–296v, on f. 296v.

81 Mary Symonds to Hester James, November 1806[?], BL IOR Mss.Eur.C.240/4, ff. 346r–352v, on f. 352r.

82 Mary Symonds to Esther Symonds, 14 October 1801, BL IOR Mss.Eur.C.240/1, ff. 4r–11v, on f. 10.

83 *Voyages aux Indies Orientales et á la Chine* was published in 1782.

84 Archer, *Company Paintings*; Losty, *India Life and People*.

85 Letterpress accompanying "A lame beggar and his family," Pl. 40. In Gold, *Oriental Drawings*.

86 Nair, "Native Collecting and Natural Knowledge."

87 Gold, *Oriental Drawings*. See also Almeida and Gilpin, *Indian Renaissance*.

88 Elizabeth Gwillim to Esther Symonds, 12 October 1804, BL IOR Mss.Eur.C.240/3, ff. 217r–228v, on f. 223v.

— Case Study 1 —

"I Have Had My Share of Amusement in Making Them"

Mary Symonds's Pasteboard Models

HANA NIKČEVIĆ

This case study considers Mary Symonds's four street scenes from *The Madras and Environs Album* (the *Madras Album*), each of which depicts the quotidian activities of Madras's diverse inhabitants (plates 9–12).[1] Inscriptions identify Brahmins and pandaram holy men, and, among the crowd, we see a palanquin with four bearers and a reclining passenger, a white ox pulling an ornate cart, and a group of water buffalo being herded.[2] Seemingly referring to these images, Elizabeth Gwillim wrote to her sister Hester James in 1803 that Symonds had sent some drawings to England, and, "slight as they are, they are by much the best things I ever saw to give an idea of the people in the streets or roads here, in crowds & so various in their dresses."[3] Symonds also mentioned the scenes: when she noted, for example, that "the carriages of the natives are extremely elegant, particularly the Hackery, which is drawn by milk white Bullocks," she added that "there is one in one of these rows."[4] This case study contextualizes Symonds's street scenes within the aesthetic practices and discourses of her time, seeking out her potential sources of inspiration and considering how her artistic handiwork may have functioned as a means of mediating her experience of Madras.

Mary Symonds's representations of India, as preserved in the *Madras Album*, manifest above all the contextual British (and, broadly, European) interest in, and history of, illustrating foreign locales, as noted by Vikram Bhatt and Vinita Damodaran in their contribution to this volume (see chapter 3). Maritime expeditions in the so-called Age of Discovery and subsequent Enlightenment era considered the depiction of newly explored territories to be

integral components of the journey; as these voyages' objectives were increasingly presented as scientific and rational, professional artists began to number among the ships' passengers, sketching, painting, and dutifully cataloguing each new species, shoreline, and society. These journeys of "exploration" were, fundamentally, imperial in nature, intended to reap for their commissioning governments and organizations an entwined bounty of knowledge, resources, and power. And the ongoing economic project of the East India Company in India required that British military men, surveyors, and artists alike produce reams of maps and images reporting, preserving, and attesting to their consummate understanding and control of the region.[5] Imperial exploration had, moreover, instigated the Romantic interest in foreign people and places, and this interest was directed by contemporaneous scientific ideas and antiquarian interests in the ethnographic and historical.[6] The British metropole was, thus, fascinated by depictions of regions overseas, surveying from home India's lands, architecture, flora and fauna, and people.[7]

Mary Symonds's watercolours of Madras and its environs reflect this context, featuring such local architectural features as Hindu temples and water tanks as well as (as in the street scenes discussed here) Indian individuals of various identities and occupations. Indeed, when Symonds's mentor George Samuel suggested that she illustrate "pagodas and choultries ... and mosques and mausoleums," and when her brother-in-law Henry Gwillim advised that she forgo painting miniatures of "foolish conceited girls" and depict instead "natives and other things of this country," they may have been thinking specifically of artists William Hodges's and Thomas and William Daniell's well-known images of the same subjects. George Samuel proposed to Symonds that she represent India in the manner already understood to be most interesting and edifying, emphasizing buildings and other local features that represented cultural presents and histories and that manifested (or could be portrayed according to) the aesthetic tenets of the British picturesque.[8]

Mary Symonds's "rows" are of interest, however, not simply because they offer us a glimpse of early nineteenth-century Madras or because they demonstrate their artist's culturally and historically specific interest in depicting India's customs and demographics. The rows are additionally significant because they may also evidence her engagement with domestic craft and optical spectacle. It appears that, in 1803, Symonds was intrigued by the possibility of not just depicting but recreating her surroundings as three-dimensional miniature scenes. In a number of images in the *Madras Album*, such as the scene captioned "the burial of Ali Hossein, a Musulmann prince" (plate 2),[9] and another depicting five palanquin bearers resting (plate 13),[10] the figures and objects have been carefully cut out from their paper backgrounds. In October 1803, Symonds informed her sister Hester James of a creative

undertaking: she had made some "memorandums" of a party and intended to turn them into a pasteboard "model."[11]

That such an endeavour – the production of a pasteboard model – was intended for the four street scenes is suggested, first, by the fact that one of the rows has already been cut out, separating the painted individuals from their background (plate 12). In addition, a letter from Symonds, written in or before 1803, reveals that she intended to cut out multiple watercolour rows and assemble them together to form a three-dimensional representation of a Madras street. She wrote to her sister of the rows: "I intended to make a great many more, and to fix them in a box, to represent a street ... this method I invented to give you some idea of the population of this country, [as] they would then be about as thick as the people are here in the streets."[12] The single snipped-out row may have been cut out by Symonds herself; alternately, it is possible that Hester James started to put together the paper scene according to her sister's descriptions.

This case study positions Symonds's three-dimensional pasteboard street scenes within the context of late eighteenth- and early nineteenth-century visual culture in both England and India. Demonstrating that Symonds likely synthesized a number of aesthetic ideals and strategies to create her street scenes, I suggest that she produced not only a unique contribution to the vast body of British work dedicated to representing India, but also a novel use of domestic, feminine craft to, symbolically and phenomenologically, attempt to assert control over an "exotic," unfamiliar place. While her letters attest to her enjoyment of various aspects of life in Madras, they also record her ongoing dissatisfaction with the climate and society; this consistent discomfort, I suggest, may have informed her desire to represent her new environment in a manner that rendered it manageable and safe. By reproducing her surroundings in miniature and as a domestic object, and by claiming to have invented that method of reproduction, Symonds both "tames" her new environment and lays claim to the means of so doing.

A speculative model allows us to envision what Symonds may have had in mind for her rows (see figure 2). As a three-dimensional, peopled scene, it first seems that the obvious point of reference for her planned structure was the toy or paper theatre, or "juvenile drama," popular throughout England in the nineteenth century, in which child-sized paper stages were outfitted with cut-paper set pieces and paper-doll thespians.[13] Likewise, similar in their material, scale, and three-dimensional nature are paper "peepshows," or perspective views, also popular in England.[14] Yet toy theatres are referenced in England only from around 1811, and paper peepshows surfaced still later, around 1820.[15]

Although the earliest iterations of miniature viewing boxes are likely sixteenth-century "combination clocks and peepshows" by an Augsburg clock-maker named Marggraf and "perspective boxes"[16] created by the seventeenth-

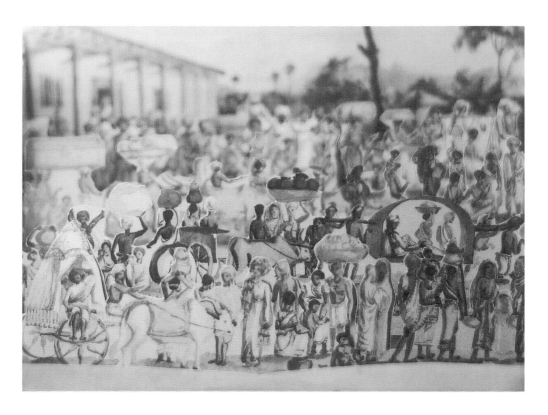

FIGURE 2
Model of Madras street scene, paintings ca 1803 by Mary Symonds (Figures 9–12),
paper and printed images, assembly by Hana Nikčević.

century Dutch painter and art theorist Samuel van Hoogstraten, the more
direct predecessors to England's nineteenth-century toy theatres and peep-
shows are probably Augsburg publisher Martin Engelbrecht's "perspective
views," produced in the thousands between the 1720s and 1770s.[17] These are
small paper "theatres" given the effects of depth and three-dimensionali-
ty by paper layers; the primary difference between Engelbrecht's views and
nineteenth-century peepshows is that Engelbrecht's views consisted of mul-
tiple individual sheets designed to be slotted into a viewing box, while nine-
teenth-century peepshows required no external support, as the individual
layers were connected at the sides like an accordion.[18] By dint of a royal decree,
Engelbrecht maintained a monopoly on the production of perspective views;
charming and meticulously crafted though the scenes were, other publishers
did not appropriate the genre.[19] Engelbrecht's enterprise thus extended abroad,
and art historian Frances Terpak notes that some of the views must have trav-
elled to England, as they were printed with text in English (others featured
German, French, Italian, or Latin).[20] Likewise, the Universal Studios Archives
and Collections hold a wooden viewing box from eighteenth-century England

appropriate for observing Engelbrecht's perspective views; this was likely used by a travelling showman, whose itinerant spectacles were the principal sites at which one could see a perspective view in eighteenth-century England.[21] With their diminutive size and paper layers, Engelbrecht's perspective views – if Symonds ever came across one – may have inspired her Madras scenes, just as they likely inspired the array of three-dimensional miniature paper scenes that flourished in nineteenth-century England.

Both Engelbrecht's perspective views and English toy theatres manifest an impulse to miniaturize the spectacle of the theatre (the German baroque and Georgian theatres, respectively).[22] We could extend the same creative agency to Mary Symonds: even if she did not chance upon an Engelbrecht perspective view, the scenery of an English play may have directly inspired her production of a three-dimensional, layered, painted scene. We know Symonds to have painted in miniature in Madras, so producing diminutive representations of a life-size world was no unfamiliar pursuit,[23] and a play's scenery would have caught her attention: the stage settings of the Georgian theatre were dynamic and integral to the performance, and they were changed, scene to scene, in full view of the audience.[24] While painted backdrops stood at the back of the stage in layers, one behind the other, the primary visual effects of layering on the stage occurred at the wings, which consisted of various similar panels arranged one in front of the other, as well as through the inclusion of additional set pieces, sometimes crafted of pasteboard.[25] Examples of Georgian layered scenery survive in the stage models of artist and Drury Lane set designer Philip James de Loutherbourg, held at the Victoria and Albert Museum. These models demonstrate that the creation of a three-dimensional environment on stage was effected through layering paintings. It is possible, thus, that Symonds took inspiration from the stage to imagine her miniature Madras streets.

Given the multivariate effects of the British interest in viewing and depicting India, Mary Symonds may have been expressly primed to view her surroundings through the lens of the theatrical. Not only did London's theatres frequently present plays featuring Indian subject matter, but those plays were sometimes staged with scenery modelled after William Hodges's and Thomas Daniell's depictions of India, a fact proudly announced in those plays' promotional materials.[26] Perhaps also significantly, in early 1803, Symonds wrote of being asked by Sir Thomas Strange to sketch illustrations for a book translated by Sir William Jones. This book was likely the Śakuntalā, an Indian drama (Jones's 1789 translation was very influential in the West, and the author, Kālidāsa, was dubbed "the Shakespeare of India" in 1876).[27] Indeed, the *Madras Album* contains an image labelled "Scene from a Sanskrit Drama" (plate 6), the arrangement of characters in which can be correlated with Act IV of the Śakuntalā.[28] The trees in the background of this image recall those painted by

Symonds in her landscape sketches – palms interspersed with smaller-leafed trees – so Strange's project may have led Symonds to draw on her immediate surroundings for the representation of a theatrical tableau. Symonds likely had experience both viewing and producing representations of India that were theatrical in nature, and she may have been thus inspired to conceive of her surroundings as representable through the conventions of a play. As a dynamic world operating fully apart from her own, its participants attired in unfamiliar styles of clothing, the streets of Madras could easily have appeared to Symonds, a spectator, as akin to the stuff of the stage.

De Loutherbourg engineered yet another kind of small-scale theatre: the Eidophusikon. Meaning "image of nature," the Eidophusikon opened at London's Leicester Square in 1781 and was billed as a show of "Natural Phenomena, represented by Moving Pictures."[29] According to contemporary William H. Pyne, the Eidophusikon deployed dynamic lighting, transparent paintings, and pasteboard cut-outs to produce its animated scenes; Pyne also emphasized the Eidophusikon's convincing rendering of depth, effected through the placement of some pasteboard elements (buildings, ships) behind others.[30] It is possible that Symonds viewed or at least heard of de Loutherbourg's contraption: we know her to have visited London and "Exeter Change" (officially Exeter Exchange), at which the Eidophusikon was exhibited in 1785 and 1786.[31]

The Eidophusikon's mechanics might draw our attention to another central element of eighteenth- and nineteenth-century visual culture: transparencies – that is, backlit paintings done on translucent materials.[32] These featured on advertisements for de Loutherbourg's show, serving as both components of the theatre and entertainment between scenes. While we cannot be certain that Symonds viewed the Eidophusikon, we know from her correspondence that she met with transparencies in other contexts, including at social gatherings in India. Writing to Hester James in 1802, Symonds noted that a "Free Masons' grand Ball" was decorated with "festoons of blue silk, and painted transparencies"; in 1803, she wrote, a farewell ball for Lord Clive (Edward Clive, 1st Earl of Powis, 1754–1839) also featured transparencies.[33] Her mention of these visuals in a letter home suggests that she was impressed by them: transparencies were often one of the only elements of an event that she reported. Notably, it was not just English transparencies that were circulating in India at the time: in 1802, Elizabeth Gwillim described the backlit transparent paintings she viewed at a Hindu festival.[34] Viewing transparencies may have suggested to Symonds the artistic potential in layering images, in conceiving of images as not opaque, two-dimensional, and individual sheets, but rather malleable components to be combined with other elements, all visible simultaneously.

Symonds offers no explanation of what a transparency is in her letters, making it clear that the works are a familiar sight to both her and her sister back home. This point of aesthetic reference suggests that her interest in the pasteboard model format was based not only on its association with theatre and entertainment, but also, very likely, on her familiarity with optical devices and, perhaps, their redolence of the domestic environment. Transparencies were popular in late eighteenth-century England not just as public entertainment but also as women's genteel pursuits. Jane Austen mentions them in her 1814 novel *Mansfield Park*, for example, as one of many handicrafts engaged in by the Bertram sisters (in fact, she suggests that the sisters briefly experienced a "rage for transparencies"),[35] and John Plunkett, scholar of the Victorian period, has argued that the popularity of transparencies owed much to "their becoming part of the repertoire of refined feminine accomplishments."[36] It is thus likely that Symonds crafted transparencies herself at home in England. Significantly in relation to the Madras rows, these homemade backlit transparencies were often produced through the layering of sheets of paper and cutting out of figures. Multiple papers would be fastened together, and then those areas of the image that were intended to let more light through – such as, for instance, the moon in a night-time landscape – would have more layers of paper cut away.[37] Clearly, the cutting and layering of paper required for the production of a transparency was closely akin to the construction Symonds had in mind for her Madras street scene. She may well have deployed a familiar methodology in the service of a new craft.

It is Symonds's deployment of this particular familiar methodology, a hallmark of feminine craft in her time, that may make of her cut-outs a unique material articulation of a British perspective on India. While the life-size theatre and the smaller-scale Eidophusikon presented scenes of distant-from-London locales, these spectacles were, naturally, dramatic – public, loud, dynamic. For example, de Loutherbourg's staging of John O'Keeffe's *Omai, or A Trip Round the World* (1785), inspired by the voyages of Captain Cook, featured an extravagant nineteen scenes (some comprising over forty pieces) and such special effects as fire, a storm, moving ships, and hovering balloons.[38] A reviewer in the *Daily Universal Register* (later the *Times*) deemed *Omai*'s visuals "infinitely beyond any designs or paintings the stage has ever displayed," making it "a spectacle the most magnificent that modern times has produced."[39] *Omai*'s global content, crucially, ranked highest in entertainment value: "to the rational mind," the reviewer asked, "what can be more entertaining than to contemplate prospects of countries in their natural colourings and tints? To bring into living action, the customs and manners of distant nations?" The Eidophusikon likewise circumnavigated the globe, travelling from the "Port of Tangier" to "the Alps" and from the "coast of Japan" to the "Cataract of Niagara in North America."[40]

Hodges's and the Daniells' paintings – like those of other artists engaged in depicting foreign regions – were similarly public, sent to the Royal Academy to garner London's approval; their prints, bound as books, were intended for contemplative perusal.

Symonds's pasteboard model, meanwhile, was meant for a different audience and experience. Its production, she wrote, afforded her "amusement," and she sent the cut-outs (along with instructions on their assembly) to her sister Hester James to provide her with "entertainment."[41] Although she explained her motivation behind the three-dimensional scene as an interest in accurate representation, noting that "there are an immense number of employments which I can describe better in that way than any other," she also suggested that the white bullock featured in the rows would have to suffice until she could send to James an "accurate drawing."[42] Beyond just qualifying as domestic entertainment, though, the street scene may have been a toy: in a note appended to her letter, she wrote, "the figures mentioned in this letter are those I had given to Sir Henry for the Miss Carews." The "Miss Carews," identifiable through the sisters' other letters as the grandchildren of John Yorke and, thus, the children of his only daughter, Jemima Yorke, with Reginald Pole-Carew, were likely no older than thirteen when Symonds sent them the pasteboard illustrations (the eldest, Harriet Pole-Carew, was born in 1790).[43] The pasteboard model may have offered a uniquely accurate means of representing a busy street, and it may have engaged with the theatre's emphasis on entertainment and visual spectacle, but, as her letters suggest, it also functioned as a plaything: an object for children, to be used in the home.

While Symonds's watercolours reflect and contribute to the British interest in the visual consumption of distant locales, her pasteboard models introduce the subject matter into the space of domestic amusement. Although few such homemade objects appear to survive, the Victoria & Albert Museum holds a handmade perspective view depicting a far-from-England region, *View of L'Angostura de Paine in Chile* (1802–ca. 1835). It is attributed to Maria Graham, later Lady Callcott, who travelled widely and published on her voyages. Graham also produced two-dimensional works, but, like Symonds, she may have been one of a small number of travellers to depict her surroundings in a miniature three-dimensional format. Such a representational choice was likely informed by Graham's and Symonds's identities as not just travellers but also women – a well-off English woman was expected to have cultivated a range of domestic and artistic skills. For instance, much as Mary Symonds and Elizabeth Gwillim's accounts of India survive in letters, so, too, did other women travellers publish accounts of their voyages based on their correspondence. As David Arnold has written, endeavouring to write a book might have appeared implausible for a woman, necessitating knowledge and experience

available only to men, but writing letters accomplished, first and foremost, the necessary objective of tending to relationships with friends and family at home.[44] Likewise, because drawing and painting in watercolour were expected components of a refined British woman's set of talents and accomplishments, Symonds and Gwillim were readily able to portray their environments in those media. Thus did Symonds take up painting portrait miniatures of her British social circle in Madras, and so, too, was she likely able to draw on her experience crafting transparencies – that genteel pastime – to represent Madras. Her pasteboard models, ultimately, capture her view of India in a visual vernacular that draws not only on the British interest in visual spectacle but also, specifically, on her experience as a woman: her training in watercolour painting, her years spent engaging with domestic craft, and her desire to communicate her residence abroad in a manner appealing to her friends and relatives.

Symonds's translation of Madras into diminutive form can thus be seen as the synthesis of various artistic and social reference points prominent in her world. We could, now, consider the implications of this artistic strategy. Talia Schaffer, scholar of the Victorian period, has proposed that the regular deployment of natural objects (e.g., shells, leaves, flowers, and sand) in Victorian women's domestic handicrafts reflected not only a Romantic appreciation for the decorative qualities of the organic world but also a desire to tame the nonhuman world.[45] Schaffer suggests that crafts allowed "the space of interior culture" to "exert a disciplining and ordering effect on these wild imports."[46] She draws on Mary W. Helms's broadly anthropological argument that, in craft-making societies, "the safe, civilized, ordered, moral, domesticated life of the home society where people live in the here-and-now is contrasted either with a dangerous, chaotic, immoral or amoral, pre-civilized natural world outside or with the outside as a mystically powerful place of sacred superiority" and that crafts, in such contexts, assume a mediating function, transforming "outside" objects – thrilling but dangerous – into acceptable components of the "inside" world.[47] Crafting, as Helms summarizes, is "the creation of form, shape, order, and refinement from that which is formless, shapeless, chaotic, and unrefined."[48]

Symonds described Madras's streets as sites of chaos, their dangers mitigated only by the horse keepers' "horrid noises" aimed at directing traffic.[49] Her assessment of Madras at large, moreover, was complex: amid her appreciation of the opportunities for painting, gardening, and socializing, she complained that her housekeepers were shiftless and untrustworthy; derided women of mixed Indian and European parentage ("not one" was "tolerable") and claimed that the climate deteriorated their characters further; critiqued the weather and expressed relief that she had avoided the "vile tingling disorder" of "prickly heat"; flippantly chastised her brother-in-law for suggesting she might marry a "black man"; and remarked on the "misery" of the "disorderly and

offensive ... zenana."[50] In short, while the Gwillims found Madras and India to be enjoyable and fascinating new environments, they also perceived them as unfamiliar and in many ways inhospitable. In an unattributed letter, one of the sisters concisely observed the irony of British discomfort in India: "We rule these people absolutely," she wrote, and yet "not a boat of ours can touch their shores, without being dashed to atoms by the high surf."[51]

Translating the perceived strangeness of Madras into the familiar, domestic format of the handicraft – the pasteboard model – could thus be seen as Symonds's attempt to employ craft for its "taming" function, as Helms and Schaffer describe. The loud noises and fast-paced, closely packed action of Madras's people, vehicles, and animals are made harmless and docile through their transformation into an English paper craft – quiet, neat, quotidian, refined, and of the home. Inextricable from this deployment of craft's domesticating capacity, also, is the street scene's nature as a miniature: while a trinket box encrusted with shells might domesticate the ocean by making decorations of its fauna, the paper theatre not only makes a domestic object of its depicted environment, but it also significantly and overtly alters that environment's scale. Underlining the "taming" effect of the crafted theatre, Symonds presents a tiny Madras, a Madras to be peered at and manipulated – not one by which to be overwhelmed or inconvenienced – one fit, even, for the scrutiny and amusement of children. If a comprehensive understanding of the near-universal charm of the miniature seems stubbornly elusive, theorists have, at least, consistently settled on one line of interpretation: Susan Stewart and Gaston Bachelard, among others, have proposed that the miniature's fundamental appeal lies in its creation, however illusory, of control.[52] Bachelard summarized the perspective: "The cleverer I am at miniaturizing the world, the better I possess it." Laying claim to the original invention of her craft-inspired pasteboard cutouts ("this method I invented"), Symonds may have sought, in part, to lay claim precisely to the clever, home-spun domestication of her new and unfamiliar world.

Even if she conceived of her pasteboard models expressly as domestic, English artifacts, they may still manifest the aesthetics of Indian visual culture. In addition to the transparencies described by Elizabeth Gwillim, in Madras, Symonds could have encountered Indian cut-paper gouache figures or paintings on mica, the latter of which make use of figure painting, layering, and transparency. Although it may never be possible to chart in full and with total accuracy the constellation of visual, material, social, and cultural references synthesized by Symonds's pasteboard models, they offer a compelling view into women's artistic innovation and engagement abroad. Far from being passive companions on their male relatives' voyages, Mary Symonds and other women actively met their ever-changing environments by creating novel means of mediating the world.

Notes

1 The album is held in the South Asia Collection, Norwich.

2 Elizabeth Gwillim also noted to her sister Hester James – likely referring to these images – that one can "see in one row a group of young Pandarums in their salmon-colour'd muslins & their Moutren [?] beads – or brown beads as you call them – they are a very handsome cast of people." Elizabeth Gwillim to Hester James, n.d. [1803], British Library, India Office Records (BL IOR) Mss. Eur.C.240/2, ff. 167r–177v, on f. 170v.

3 Ibid.

4 Mary Symonds to Hester James, n.d. [1803], BL IOR Mss.Eur.C.240/4, ff. 376r–377v, on f. 376v. Symonds also referred to the women in these scenes: the Brahmin women "never touch any earthen pot. They only use the Brass ones; They are also distinguished by wearing the cloth like trousers, as the men do," while "the other women wear theirs straight round like petticoats."

5 Dias, "Recording and Representing India."

6 Byrne, *Geographies of the Romantic North*, 5.

7 For more on the Daniells, see Archer, *Early Views of India*.

8 Mary Symonds to Hester Symonds James, 4 March 1805, BL IOR Mss.Eur.C.240/4, ff. 253r–257v, on f. 255r; Mary Symonds to Hester Symonds James, 1803, BL IOR Mss.Eur.C.240/2, ff. 122r–127v, on f. 126r. See also Archer, *Early Views of India*, for more on the picturesque.

9 Elizabeth Gwillim to Esther Symonds, 16 August 1803, BL IOR Mss.Eur.C.240/2, ff. 140r–141v, on f. 141r. She wrote: "the tomb (or rather grave for the tomb was not then built) which Polly [Mary] drew was that of Alli Hassein the young Nabob." The image is *Madras and Environs Album*, NWHSA: PIC106.30.

10 Mary Symonds, *Madras and Environs Album*, NWHSA: PIC106.36.

11 Mary Symonds to Hester Symonds James, 20–21 October 1803, BL IOR Mss.Eur.C.240/2, ff. 163r–166v, on f. 164r.

12 Mary Symonds to Hester Symonds James, n.d. [1803], BL IOR Mss.Eur.C.240/4, ff. 376r–377v, on f. 376r.

13 Speaight, *Juvenile Drama*.

14 Hyde, *Paper Peepshows*, cat. 238.

15 Speaight, *Juvenile Drama*, 21; Hyde, *Paper Peepshows*, 10. In Britain, peepshows were first termed "area-oramas," "expanding views," "perspective views,"

"telescopic views," and "pocket panoramas"; the term "peepshow" surfaced around 1910.

16 Altick, *The Shows of London*, 56.

17 Stafford and Terpak, *Devices of Wonder*, 336.

18 Ibid., 341.

19 Ibid., 336.

20 Ibid.

21 Ibid., 338.

22 Speaight, *Juvenile Drama*, 22; Stafford and Terpak, *Devices of Wonder*, 336.

23 Mary Symonds to Hester Symonds James, 18 March 1802, BL IOR Mss.Eur.C.240/1, ff. 55r–57v, on f. 55v. Symonds wrote, "I am become a miniature painter (don't laugh)."

24 Southern, *The Georgian Playhouse*, 21.

25 Mulhallen, *The Theatre of Shelley*, chap. 1.

26 In November 1798, for instance, *Ramah Droog (or, Wine Does Wonders)* was performed at the Covent Garden Theatre with "Scenery painted by Richards, Phillips, Lupino, Hollogan, Blackmore, &c. based on drawings of Indian scenery by Thomas Daniell." Already in February 1788, *All the World's a Stage* at the Theatre Royal Drury Lane had presented a "variety of new Scenery," noting that "a view of Calcutta, from a painting done on the spot by Hodges, opens the piece." See *The London Stage* Database, 1660–1800, https://www.eighteenthcenturydrama.amdigital.co.uk/LondonStage/Database.

27 Mary Symonds to Hester Symonds James, 7 February 1803, BL IOR Mss.Eur.C.240/2, ff. 104r–106v, on f. 105r; Cannon and Pandey, "Sir William Jones Revisited." For the Shakespeare analogy, see Kālidāsa, Śakuntalā, 3 (preface).

28 *Madras and Environs Album*, PIC106.39.

29 Bermingham, "Technologies of Illusion."

30 Pyne, *Wine and Walnuts*, 287–8. Pyne also noted that Sir Joshua Reynolds advised "the ladies in his extensive circle to take their daughters, who cultivated drawing" to see the Eidophusikon (281–2). Pyne, though writing about two decades after Symonds crafted her pasteboard cutouts, even suggested that "some little circle of ladies, who have attained a proficiency in landscape painting … endeavour to form a stage upon De Loutherbourg's plan" (282).

31 Mary Symonds to Hester Symonds James, 18 March 1802, BL IOR Mss.Eur.C.240/1, ff. 55r–57v, on f. 57r (she mentioned "Exeter-change"); Bermingham, "Technologies of Illusion," 384.

32 The supports for transparencies included paper, silk, linen, muslin, and calico; the genre was popular partly for its versatility, adorning such sundry objects as lampshades, screens, and window blinds. See Plunkett, "Light Work," 44. Pyne mentioned linen for the Eidophusikon; *Wine and Walnuts*, 286.

33 Mary Symonds to Hester Symonds James, 11 February 1802, BL IOR Mss.Eur.C.240/1, ff. 39r–46v, on f. 43v (Freemasons' ball); Mary Symonds to Hester Symonds James, 10 September 1803, BL IOR Mss.Eur.C.240/2, ff. 150r–153v, on f. 151r (Lord Clive's farewell).

34 Elizabeth Gwillim to Esther Symonds, 16 July 1802, BL IOR Mss.Eur.C.240/1, ff. 62r–71v. For the cut-paper gouache figures, see, for example, *A Dancing Woman with Four Male Musicians of South India*, Wellcome Library no. 728669i, https://wellcomecollection.org/works/hzybnkzt. For an example, though late, of such a mica painting, see *A Box covered and lined with brocade containing a card painted with a face, and with a verandah covered with a striped rug; also twelve mica overlays depicting dancers and musicians* (ca 1860), Victoria & Albert Museum IM.80:3-1938, https://collections.vam.ac.uk/item/O404110/a-box-covered-and-lined-painting-unknown/.

35 Austen, *Mansfield Park*, 318.

36 Plunkett, "Light Work," 44.

37 Ibid., 52–3.

38 Altick, *Shows of London*, 120.

39 Ibid.

40 Ibid., 121.

41 Mary Symonds to Hester Symonds James, n.d. [1803], BL IOR Mss.Eur.C.240/4, ff. 376r–377v, on f. 376r.

42 Ibid., ff. 376v–377r.

43 Elizabeth Gwillim to Hester Symonds James, 18 October 1802, BL IOR Mss.Eur.C.240/1,

ff. 88r–91v, on f. 89v. For Harriet's birth date, see the grave information for Harriet Pole-Carew Eliot, Find a Grave, https://www.findagrave.com/memorial/87028793/harriet-eliot.

44 Arnold, "The Travelling Eye."

45 Schaffer, "Women's Work," 25.

46 Ibid.

47 Ibid., referencing Helms, *Craft and the Kingly Ideal*, 46, 25.

48 Helms, *Craft and the Kingly Ideal*, 25.

49 Mary Symonds to Hester Symonds James, n.d. [1803], BL IOR Mss.Eur.C.240/4, ff. 376r–377v, on f. 376r.

50 Mary Symonds to Hester Symonds James, 11 February 1802, BL IOR Mss.Eur.C.240/1, ff. 39r–46v, on ff. 45r and 41r; Mary Symonds to Hester Symonds James, 7 February 1803, BL IOR Mss.Eur.C.240/2, ff. 104r–106v, on f. 106v; Mary Symonds to Hester Symonds James, 1803, BL IOR Mss.Eur.C.240/2, ff. 122r–127v, on f. 124r; Mary Symonds to Richard Clarke's father, Thomas Clarke, 14 October 1803, BL IOR Mss.Eur.C.240/3, ff. 242r–247v, on ff. 243v–245r.

51 Anon. (Mary Symonds or Elizabeth Gwillim) to unnamed recipient, 10 February 1804, BL IOR Mss.Eur.C.240/3, ff. 212r–216v, on f. 214v.

52 Stewart, *On Longing*, 68; Bachelard, *The Poetics of Space*, 150. Writing on early modern Dutch dollhouses (late 1600s–early 1700s), Hanneke Grootenboer notes that miniature spaces have long been assessed as, primarily, objects that afford their beholder/user/owner the experience of control: "Both early modern and scholarly accounts of dollhouses explain their reduced size as a means whereby a devoted housewife could exercise control of an environment." Grootenboer, "Thinking with Shells," 106.

2

The Ornithology of Elizabeth, Lady Gwillim

SURYANARAYANA SUBRAMANYA

In 1924, Casey Wood, one of the founders of the Blacker Wood Collection at McGill University in Montreal, Canada, was in London acquiring books, manuscripts, paintings, drawings, and artifacts for the library. His search led to a select London dealer, where he chanced upon a small collection of paintings of flowers and fish as well as over 100 watercolours of Indian birds found in "an immense, dust-laden, but extremely well made portfolio about five feet broad and four feet high, which was brass-bound, provided with a safety lock and supported by a wide wooden back." The paintings "faithfully depicted as to the plumage and posture, with the backgrounds painted in a fashion worthy of [John Gerrard] Keulemans and [Henrik] Grønvold."[1] Wood bought the entire portfolio, which had been purchased by the dealer at "a sale in the country" many years before. Following this purchase, Wood's intense efforts to piece together details about the artist revealed that the paintings were done by Elizabeth Gwillim (21 April 1763–21 December 1807).

Between 1801 and 1807, as indicated by the numbers she inscribed on her works, Gwillim appears to have created about 201 paintings of birds.[2] Her illustrations of the flora and fauna of Madras, now archived in the Blacker Wood Collection at McGill University Library, include 121 paintings of birds and 12 of flowers, as well as 31 images of fish and other aquatic creatures (see case study 2, by Shyamal Lakshminarayanan and Hana Nikčević, for a discussion of the fish paintings).[3] The whereabouts of the remaining 80 bird paintings are unknown.

During her seven years in India, Elizabeth Gwillim provided the first accurate illustrations of birds of the erstwhile Madras Presidency (present-day Chennai). Through her paintings and her extensive correspondence, she gives a detailed account of the birds found in and around this early nineteenth-

century city on the Coromandel Coast. Her artworks were painted two decades before John James Audubon, the celebrated American artist, published *Birds of America*.[4] Like Audubon, Gwillim was among the first artist-ornithologists to create life-size paintings of large birds (at least 90 centimetres in length). Yet she never published her work, perhaps in keeping with the practice of many women in the period, for whom art and natural history studies were considered a vocation rather than profession.[5] Indeed, until Wood's chance discovery of her portfolio, she remained largely unknown, which allowed her near contemporary Audubon to achieve pride of place among artist-ornithologists.

Even if she had no intention of publishing her paintings, Gwillim frequently exhibited them to visitors to her home in Madras and was showered with praise. As she ruefully commented, "I hope to get a good collection but my time is sadly taken up with exhibiting them to company who pay me with praises for the loss of my time."[6] She always desired to send her works home to her mother and sister for safekeeping and curation. She was on the lookout for a dependable friend with whom the paintings could sent to England, but was apprehensive about their safe passage, noting that "so many things were lost in the Prince of Wales," an East India Company ship that was wrecked en route to England from Madras in 1804.[7] The entire collection of her paintings appears to have arrived in England only after her untimely death, brought home by her widowed husband and sister.

Since the discovery of her work, there have been several efforts to identify the birds in Elizabeth Gwillim's paintings. Ornithologists who examined her work included E.C. Stuart Baker (1864–1944), a British ornithologist and police officer in both India and England; Harry Kirke Swann (1871–1926), a British ornithologist and authority on birds of prey; and W.L. Sclater (1863–1944), a British zoologist, museum director, and deputy superintendent of the Indian Museum in Calcutta.[8] The bird names written in pencil below the illustrations were added by Wood's librarian Henry Mousley, who likely annotated them shortly after the collection arrived at McGill in 1925. My comparisons of the paintings with Thomas Jerdon's lists and with the fuller catalogue of William Oates have revealed that many genera of Indian birds were not represented in Gwillim's oeuvre.[9] Nevertheless, by any standard, Gwillim painted a diverse range of birds, and, coupled with her epistolary observations on their habits, these paintings ultimately established her eminence as one of the earliest naturalists in nineteenth-century Madras. Her masterly paintings, in which every one of the birds can be accurately identified, will remain as a permanent ornithological record of the avifauna of the region.

A detailed compilation of information from Elizabeth Gwillim's work and correspondence reveals that she described a total of 136 species of birds: 104 birds were depicted in her 121 paintings, while the others were described in her

letters (see appendix B at the end of this chapter).[10] She accomplished this at a time when no comprehensive list of birds of the Madras area existed. The only earlier effort to depict the local avifauna was a set of illustrations of the birds of Fort St George originally made by an Indian artist and sent by the East India Company surgeon Edward Bulkley to John Ray. Two plates based on these illustrations appeared in Ray's *Synopsis Methodica Avium & Piscium*, published posthumously in 1713.[11] These plates were the first illustrations of birds from India to be published,[12] but the quality of the illustrations does not permit accurate identification of all twenty-seven species that they depict. Gwillim's extraordinary skill at painting birds with a high degree of scientific accuracy has enabled the identification of each species. Her paintings, compared with late eighteenth- or early nineteenth-century published etchings or engravings of birds, were well ahead of their time. Her focus on painting living birds was especially innovative, and the works remain an accurate documentation of the birds of the region.

This chapter takes a fresh look at Elizabeth Gwillim's paintings and correspondence and reflects on her work in the context of the region and of contemporary ornithology. I include a quantitative assessment of her paintings as part of this reflection and in addition, I discuss a few anomalies in the identification of birds in her paintings and highlight the depiction of backgrounds in some of her works. This chapter will help to further establish Elizabeth Gwillim in her rightful place in Indian ornithology, as one of the finest bird artists of her times and as the founder of Madras ornithology.

ORNITHOLOGY IN THE EIGHTEENTH CENTURY

The eighteenth century was a period of discovery and accumulation of ornithological knowledge. As mentioned above, the scientific documentation of the ornithology of the Indian subcontinent started with the publication of Ray's *Synopsis Methodica Avium & Piscium* in 1713. Other published works of ornithology available during the period included Eleazar Albin's *A Natural History of Birds*, published in three volumes between 1731 and 1738.[13] This work, comprising 205 hand-coloured illustrations, included several birds from India, such as the Nicobar Pigeon, Magpie Robin, and the Hill Myna. By the mid-eighteenth century, George Edwards, known as the father of British ornithology, published his *Natural History of Uncommon Birds* in four parts beginning in 1743, and *Gleanings of Natural History*, accompanied by illustrations of mostly foreign birds, published between 1758 and 1764.[14] The Swedish botanist, zoologist, and physician Carl Linnaeus used these works, among others, to assign binomial names to birds. His monumental *Systema Naturae* laid

out a workable system of classification that became widely used by the late eighteenth century.[15] Also in the eighteenth century, Thomas Pennant published *Indian Zoology*, in which several species were described and illustrated based on the fine collection of watercolour paintings commissioned by Joan Gideon Loten, the Dutch governor of Zeylan (now Sri Lanka), between 1752 and 1757 and painted between 1754 and 1757 by Pieter Cornelius de Bevere.[16] John Latham, an English physician, naturalist, and author, followed the Linnaean system of classification in his *General Synopsis of Birds* (1801), in which every avian genus was illustrated using copper plate engravings, including many of Indian birds.[17]

BIRDS OF MADRAS

It is not clear from Elizabeth Gwillim's letters if she had any mentors in ornithology, but she appears to have been interested in birds even before arriving in Madras.[18] Her correspondence does not indicate whether she had accessed any of the ornithological works mentioned above or read them either before her arrival or while she painted birds in India. What is evident from her letters is that she had read the *History of British Birds* by naturalist and author Thomas Bewick.[19] In a letter to her sister Hester James in London, she revealed that she had seen a large white owl in Madras like the one depicted in Bewick's work.[20] She also compared the Brahminy Kite (*Haliastur indus*) with the White-headed Eagle (= Bald Eagle, *Aquila capitae albo = Haliaeetus leucocephalus*) in Mark Catesby's *Natural History of Carolina, Florida, and the Bahama Islands*,[21] and made a passing reference to Gilbert White's *Natural History and Antiquities of Selborne*, when connecting the language spoken by Indians living in the forests near Madras with that spoken by the "gypsies" (Romani) in England.[22]

While staying in and around Madras, Elizabeth Gwillim appears to have keenly observed the birds around her garden and learned much about them from the local people. In a long letter of spring 1803 to her sister Hester James, she wrote detailed accounts of several of these birds.[23] She compared some of the birds that she saw around her garden house at San Thomé (now Santhome) in Madras (plate 3) with those she was familiar in England. Most these birds had been listed in Bewick's *History of British Birds*, which was clearly an important influence on Gwillim, in terms of her knowledge of birds. In fact, in 1805, she asked James to send her the second volume of Bewick's book, focusing on waterbirds.[24] Gwillim's 1803 letter included a list of "the Birds in Madras – which I have yet seen that are the same as in England."[25] She compared the Bar-headed Goose (*Anser indicus*) with "geese, wild geese"; the Spot-billed Duck (*Anas poecilorhyncha*) and Cotton Pygmy Goose (*Nettapus coromandelianus*) with

"ducks of all sorts" (and remarked that these were good table birds); and the Spotted Dove (*Spilopelia chinensis*), Blue (Rock) Pigeons (*Columba livia*), and Green Pigeons (*Treron* sp.) with "Pidgeons" of all sorts. In addition, she noted that partridges are the same in appearance to those in England, but "dry & bad to eat."[26] She also compared the Barn Owl (*Tyto alba*) with the Large White Owl (*Strix flammea*); the Spotted Owlet (*Athene brama*) with the Small Owl (possibly Eurasian Pygmy Owl: *Glaucidium passerinum = Strix passerina*); a kite or puttock (quite possibly *Milvus milvus = Falco milvus*) with the Black Kite (*Milvus migrans*); the Indian Roller (*Coracias benghalensis*) with the roller (European Roller, *Coracias garrulus*); and shrikes, possibly the Bay-backed Shrike (*Lanius vittatus*), with a small shrike or Butcherbird (= the Red-backed Shrike, *Lanius collurio*). She calls the Brown Shrike (*Lanius cristatus*) the Brown-backed Shrike or Butcherbird; she compares the House Sparrow (*Passer domesticus*) with a sparrow, a lark (quite possibly the Bushlark, *Mirafra affinis*) with the Wood Lark (*Lullula arborea*), and the Common Kingfisher (*Alcedo atthis*) with the English Kingfisher (the same species).

The same 1803 letter from Gwillim to James also gives the reader a peek into the habits of some of the birds around Madras, many of which she found calling and singing continuously.[27] These are the first-ever natural history observations on the birds of Madras. She described several of these birds in detail: the Black Drongo (*Edolius macrocercus*), with its remarkably long forked tail, she compared to the Eurasian Blackbird (*Turdus merula*), which she knew from England: she remarked that, locally, it was called the "King Crow" to reflect its bold and pugnacious habit, but also a "Cowbird," reflecting its habit of sitting on grazing cattle and sheep to make sorties to catch insects disturbed from the grass by their moving hooves.[28] She wrote about the black-and-white Oriental Magpie-Robin (*Copsychus saularis*), known locally as the Dyal. In addition, she noted varieties of bulbuls: Red-vented and White-browed Bulbuls (*Pycnonotus cafer; P. luteolus*), which she equated with the Nightingale (*Luscinia megarhynchos*) when describing their call, and Red-whiskered Bulbuls (*Pycnonotus jocosus*), with tufts on their heads. She also described some birds that she had observed constantly running under the rose trees in the evenings "with their tails up & wings down": these were perhaps Indian Robins (*Copsychus fulicatus*).

Gwillim compared one of the crows found in Madras (the House Crow, *Corvus splendens*) to the Hooded Crow or the "Royston Crow" (*Corvus cornix*) of England, owing to their similar appearance, and wrote about their habit of boldly entering houses and stealing food and pilfering grain spread out on mats for drying. She remarked that the natives tolerated their scavenging and stealing habits, yet they "hold these in the utmost detestation they are called Pariar Crows,"[29] quite possibly owing to their scavenging habits and

feeding on offal and carrion.[30] She draws attention to another species of crow, the Indian Jungle Crow (*Corvus culminates*), which she equated with the British Raven (*Corvus corax*), while noting that the Jungle Crow is much smaller in size. She mused on how crows disperse from their roost in the morning: "With the first ray of light exactly at the firing of the guns which give notice of day break, the crows awake as if they were really called by the gun & having as I suppose by the noise & confusion settled with difficulty their plan for the day they disperse."[31]

Gwillim apparently assumed that the names of the Brahminy Kite (*Haliastur indus*) and Brahminy Duck (= Ruddy Shelduck, *Tadorna ferruginea*) derived from the word "Brahmin": she seems to be unaware that these birds owe their names to the rusty-red of their plumage, similar to the colour of a brahmin's robes. She also mentioned seeing two species of owls, the Barn Owl and the Spotted Owlet, and wrote that the natives were superstitious about them – perhaps not surprisingly, as, historically, many cultures have vilified owls as bad omens or harbingers of death.[32]

In contrast to the owls, cuckoos were held in high esteem by the natives in Madras, according to Gwillim. She wrote that the sweetness of the notes of the "Kokila" (Asian Koel, *Eudynamys scolopaceus*) could lull people to sleep and added that it is "the favourite idea in poetry."[33] She specifically mentioned painting three species of cuckoos differing in their plumage – the Asian Koel (plate 25), the Grey-bellied Cuckoo (*Cocomantis passerines*), and the Common Hawk Cuckoo (*Hierococcyx varius*).[34] However, the McGill collection also includes two more cuckoo species: the Jacobin Cuckoo (*Clamator jacobinus*) and the Common Cuckoo (*Cuculus canorus*).[35] Gwillim remarked that, while the people in Madras speak of the cuckoo with delight, as a bird visiting in the "pleasant season" (spring), she notes that Chaucer and Milton portray the cuckoo as a bird of ill omen with evil intentions.[36]

She reported that green parakeets (quite possibly the Rose-ringed Parakeet, *Psittacula krameri*, and the Plum-headed Parakeet, *Psittacula cyanocephala*) were very common in Madras. She described the very colourful Indian Roller (*Coracias benghalensis*) with its harsh call, and two species of bee-eaters (quite possibly the Asian Green Bee-eater *Merops orientalis* and the Blue-tailed Bee-eater *M. philippinus*), with their down-curved beaks and elongated mid-tail feathers, which are found around Chennai even in the present day.[37] Also common were House Sparrows, which nested inside houses, and she observed that every house in Madras during her time had a nesting pair.

Gwillim observed various sunbirds, which in the long 1803 letter to Hester James she referred to as "creepers."[38] These would have included at least the Purple-rumped Sunbird (*Leptocoma zeylonica*), the Purple Sunbird (*Cinnyris asiaticus*), and the Long-billed Sunbird (Loten's Sunbird, *Cinnyris lotenia*), all of

which figure in her paintings.[39] She described these birds visiting the *Ipomea* and *Convolvulus* that flowered profusely in local gardens. In addition, she mentioned three species of kingfishers: the White-throated Kingfisher (*Halcyon smyrnensis*), the Black and White Pied Kingfisher (*Ceryle rudis*), and the Common Kingfisher (*Alcedo atthis*).[40] She also observed that different species of vultures and plenty of kites and hawks were found in open areas. Gwillim also noted that partridges and quails were trained to fight, and she observed them running behind their owners like little dogs.[41]

In the same long letter of 1803, Elizabeth Gwillim noted that, although in her early days in Madras, she had remarked on the absence of swallows, she later became acquainted with the birds. She reported to Hester James that they did not build their nests inside buildings.[42] In this passage, she was referring to the migratory Barn Swallow (*Hirundo rustica*), which breeds in the Himalayas, where they do build nests inside buildings, and winter in the plains of India.[43] Other resident swallow species (quite possibly the Wire-tailed Swallow (*Hirundo smithii*), the Red-rumped Swallow (*Cecropis daurica*), and the Streak-throated Swallow (*Petrochelidon fluvicola*)[44] are found elsewhere in South India, and as she accurately indicated, none build their nests inside buildings in the plains of India.[45]

Gwillim spent some time describing the habits and appearance of the Baya (*Ploceus philippinus*), noting that it has slightly different plumage than the House Sparrow and that it could be held in a cage and trained to perform many tricks. Of its nest, she observed that "there is a chamber within for the family a perch across the bottom for the young birds to sit in before they can fly."[46] She reported that the Baya came only to particular trees in the garden next to hers and observed many nests hanging from the leaves of a tall date palm (*Phoenix sylvestris*). She noted that a colony of over a hundred Baya nests that were built on one immensely high coconut palm in the garden of Sir Thomas Strange, the chief justice of Madras.[47] At one point, she sent her sister a Baya's nest, in the care of William Templar, a lieutenant on HMS *Leopard*.[48]

Gwillim also wrote about birds of prey. She vividly described, for example, how the Brahminy Kite was entwined with local tradition and was revered by the natives. She reported as well that Indians were fond of falconry. Many carried trained hawks on their wrists, and it was common, she informed her sister, to see seven or eight people standing together and talking, each with a hawk on their hands.[49] This observation appears to be the first account of the sport of falconry being practised in southern India, although it is widely believed that it existed in India from as early as 500 BCE, and the sport flourished during the Mughal era (1526–1856).[50]

ORNITHOLOGICAL EXPERTISE

Elizabeth Gwillim's references to Bewick's, Catesby's, and White's works have been mentioned above. There are a few other references in her letters to works on natural history and classification that she consulted either while in Madras or before arriving. In one of her letters to Hester James, Gwillim mentions that Thomas Martyn's edition of Philip Miller's *Gardener's Dictionary* aided her in reading Latin.[51] She also gives a clear indication that she consulted the thirteenth edition of Carl Linnaeus's *Systema Naturae*, edited by Johann Friedrich Gmelin, when she writes, "I think there are some non-descripts – for I have two species which I think are Jacanas not described in Gmelin."[52] Also, many of the inscriptions behind her paintings contain binomials or the generic names of birds, as when she refers to the Lesser Florican as "*Otis Indica:* White-chinned Bustard of Gmelin Florikin," per Gmelin.[53] This inscription establishes her familiarity with the Linnaean system of binomial nomenclature and systematic classification of birds, and she appears to have been well aware of the higher taxonomic groupings of birds. Her handwritten inscriptions on the back of her painting of the Kentish Plover (*Charadrius alexandrinus*) and Lesser Sand Plover (*Charadrius mongolus*) show that she correctly identified both birds to their genus, but questioned their more specific classification: "71. *Charadrius* – Coot – footed & three toed – the larger bird on the paper; 72. *Charadrius* – Coot – footed & three toed – the smaller bird on the paper; are these varieties or distinct species?"[54]

It is quite likely that Gwillim was introduced to the Linnaean system by J.P. Rottler, who mentored her in botany. Her query "are these varieties?" inscribed on the back of her plovers painting suggests Rottler's botanical stamp, as the term "varieties" is used in classification only to refer to plants (as opposed to "sub-species" for animals). It is also significant that, in her notes on the back of her painting of the Asian Koel (plate 25), she correctly names the plant she had painted as *Melia azadirachta*, as per Linnaeus's *Species Plantarum* – again, quite possibly prompted by Rottler (the plant was later renamed *Azadirachta indica* by Adrien Jussieu).[55] The binomial identifications she wrote on the reverse of her paintings of a Pied Harrier ("*Falco melanoleucos*"), a Whimbrel ("*Scolopax phaeopus*"), a Brown-headed Gull ("*Larus ridibundus*"), and a White-browed Wagtail ("*Motacilla maderaspatensis*") show beyond doubt that Gwillim was well versed in the thirteenth edition of *Systema Naturae*.[56]

PRESERVATION OF BIRD SKINS

Many of the birds that Elizabeth Gwillim painted were skinned afterwards, as she wrote to Hester James:

> You might see how busy I am by the bird skins which I get skinned & he [Richard Clarke, a friend and employee of Sir Henry Gwillim and a register clerk with the Madras civil service] sends to his uncle – the skins are not well cured for I have only the Cook to do them – & as they are frequently done too late, for I am obliged to draw them first that is delineate them, – & the skins become tender.[57]

Elizabeth Gwillim's sister Mary Symonds, who lived with her in Madras, reported to Hester James that there were "dryed Skins of birds in all corners of the house, but I suppose you will see all their pictures in time if we have the good fortune we hope for."[58] It is not known what became of these skins, or if they deteriorated due to the poor techniques used. The remarks of both sisters imply that Gwillim had many of her subjects skinned, particularly those brought to her dead from the hunt. She preferred to release her living subjects after they had sat for their portraits.[59]

Little is known about the beginnings of taxidermy for scientific purposes.[60] Successful preservation methods for bird skins were developed in 1748 by René Antoine Réaumur in France,[61] and Sir Ashton Lever published a pamphlet on preparing skins for museums in the 1770s.[62] It is unclear as to when skins of birds were first prepared in India. One of the earliest surviving labelled bird skins from the subcontinent is of a Black-bellied Tern (*Sterna melanogaster*) collected from Chogra River in north India on 25 October 1778 by E.W. Cleveland.[63] The earliest known bird skins collected from Madras were of two species: *Tephrodornis pondicerianus pondicerianus* and *Sturnus malabaricus malabaricus*, collected on 1 January 1820 by Alfred Duvaucel, a French naturalist and explorer based in Madras.[64] In 1834, a Jerdon's Bushlark (*Mirafra affinis*) was collected from Madras by a Mr Stuchburg.[65] It would seem that Gwillim was ahead of her time in attempting to preserve birds as skins in India, a practice that was on the upswing only by the mid-nineteenth century, with T.C. Jerdon, among others, taking it up. It is not known if Gwillim's bird skins were being preserved as labelled study skins or for the purpose of mounting, nor are there any details on the method of preservation used. If Gwillim's bird skins had survived, they could have yielded a wealth of information on the status, distribution, and taxonomic affiliations of birds of the region, using the molecular tools available today.[66]

ELIZABETH GWILLIM'S PROCESS
OF PAINTING BIRDS

The plan to draw landscapes and natural history subjects must have already taken shape in Mary Symonds's and Elizabeth Gwillim's minds even before they embarked on their journey to India, as it appears that they were well prepared with initial supplies, as evident in one of Gwillim's letters to her mother, in which she remarked, "when I was on board ship I did a good deal of drawing of such things as we caught."[67] The Physalia, or Portuguese man-of-war was perhaps one of these drawings.[68]

The precise locations in which the birds were painted are not given by Gwillim, although, as described below, some of the backgrounds provide clues. From their correspondence it can be seen that, besides the Garden House at San Thomé (plate 14), the sisters spent considerable stretches of time at the cotton farm of Mr William Webb in Pammal (plate 15) and in a house near St Thomas Mount.[69]

From Elizabeth Gwillim's correspondence, it becomes quite evident that most of her paintings were done at Webb's cotton farm, where she was well supplied with birds.[70] Mary Symonds indicated that the birds painted by her sister were sourced from local villagers. She wrote: "Betsy has been very busily employed in drawing birds & the village people have been very good in bringing many curious ones to her."[71] In one of her letters, Gwillim herself wrote, in reference to Pammal:

> I came here a week ago & obtained by a favour the loan of a couple of shooting men who go upon the hills & collect me curious birds when they bring them in I am obliged to sit down & draw them for here if dead they will only keep one day & if alive they cannot long be kept so – & are suffering much.[72]

One of the paintings by Symonds shows two the bird catchers who supplied birds to her sister (plate 48), as discussed by Saraphina Masters in case study 3.

The following passage by Mary Symonds described in detail the birds that her sister painted, and the process she used:[73]

> Poor Betsy is never out of trouble for if you get dead subjects to draw from they become offensive before she can finish the work to her mind, & when the birds are brought in alive they stare, or kick, or peck, or do some vile trick or other that frightens her out of her wits, sometimes she thinks the birds look sick, that is whenever they stand quiet & then in a great fit of tenderness she lets them fly before they are finished, lest thier

sufferings should be revenged upon her or their ghosts should come flying round her & flapping thier great wings, scare her to death. These are serious troubles I assure you. But we do all we can to remedy such evils & have now got a venerable looking old Moor man who catches a bird at a time he holds them in proper attitudes or feeds these miserable captives in a proper manner, for her poor concience sake, now you will think all must be right & the drawing going on bravely but it is no such thing, for when she is prepared & the drawing implements are all arranged, this wicked servant & his bird are missing they are perhaps retired to some distant hovel to smoake a pipe or drink a little arack together for my part I think this world is quite full of trouble!! We have now a large Old Kite who was caught last night & is kept in swadling cloths the Old man has a curious method of securing their wings & their claws he takes a round piece of cloth and makes a hole in the middle of it big enough to thrust the birds head through he then gathers the edges of this garment together round the bottom of the birds body & ties them close with a string, beside this we have six or eight large Cranes & Storks fastened by thier legs in different parts of the garden these great long legged things are 3 or 4 feet high, they eat fish and frogs by hundreds. The bird catchers always bring them blindfolded; then there is a cock & hen Pheasant of a curious kind, who occasion much sorrow & trouble by thier disorderly behaviour for this Rascally cock pecks his wife & uses her so ill that Betsy has at last been obliged to have articles of separation drawn & each has now a house & establishment to himself, but this is nothing we have blue Pidgeons & green Pidgeons; partridges of different sorts & Quails a great Cassowary, ... but I suppose you will see all thier pictures in time ... as I assure you that is her principal motive for taking all this pain to collect them, & I sincerely hope she will have health to go on with this kind of amusement as such an employment will make the time we are absent from you seem much shorter.[74]

In the same letter, Symonds remarked, "I believe Betsy will leave her part to me as she has now 3 curious birds waiting to be drawn & her conscience is concerned in doing them as soon as possible for the poor things will not eat in confinement so they are let to fly away when they have done sitting for thier portraits."[75]

These descriptions indicate that several of her subjects, quite possibly passerines, or perching birds, were held in cages, while the large water birds were maintained in an open menagerie. It also appears that some of the paintings were executed from dead birds: for example, notes on the back of her painting of a female Lesser Florican indicate that it was painted "from a dead specimen the feathering right the attitude very bad."[76]

SUBJECTS OF ELIZABETH GWILLIM'S
ORNITHOLOGICAL WATERCOLOURS

Elizabeth Gwillim's 121 ornithological watercolours are not only aesthetically pleasing but also scientifically accurate, allowing each species to be identified. In addition to what she had learned from her former mentor, the artist George Samuel, and a "Mr. Dance,"[77] Gwillim appears to have developed a technique and style of her own with watercolours, building up her work layer by layer, with a wet brush, starting from the palest shade to the darkest, in such a way that, one would think, she had a mental plan of working away with the layers and the patterns of the plumage. One of the best examples of her technique is a brilliantly executed painting of the juvenile Crested Serpent-Eagle (plate 23), where one sees every feather in place, with due attention given to posture, perspective, and proportions.[78] Her distinct style differs a great deal from the tradition of working with gouache on paper, as seen in some of the work of Shaikh Zain ud-Din and Ram Das in Lady Impey's collection,[79] where more detailing of feathers can be seen (compare, for example, Zain ud-Din's and Gwillim's rendering of the Sarus Crane in plates 16 and 17, respectively).[80] Gwillim's habit of working with a wet brush appears to have prevented this precise level of detail. Gwillim's working technique also appears to have been distinctly different from that of Audubon, who layered multiple washes of watercolour.[81]

Elizabeth Gwillim possessed a canary, cockatoo, cassowary, crowned pigeons, a Crested Partridge, and an Argus Pheasant,[82] a fact that points to a thriving pet or cage-bird trade in Madras in the early nineteenth century. Thus, it is quite conceivable that the Sarus Crane (plate 17) and the Greater Adjutant that she painted, which are not found in southern India,[83] were sourced from central and northeast India, respectively. They may have been obtained from bird traders, similarly to how other birds must have been procured, including the cassowary, a bird native to the tropical wet forests of New Guinea (Papua New Guinea and Indonesia), Aru Islands, and north-eastern Australia,[84] and the Crested Partridge, a resident of lowland rainforests in south Myanmar, south Thailand, Malaysia, Sumatra, and Borneo.[85] The movement of pet birds must also have been facilitated by trade connections from Bengal and specifically from Calcutta, the capital of the British East India Company at that time.

As noted above, Elizabeth Gwillim painted 104 species of birds in her 121 paintings. These represent 18 avian orders and 40 families. Of these, 47 percent are waterbirds, while 22 percent represent birds of prey. Subsistence hunting driven by local traditional demand for wild meat was prevalent in early nineteenth-century Madras[86] and it continues even in recent times, with intense

FIGURE 3
Size distribution of Elizabeth Gwillim's paintings.

hunting pressure on waterbirds.[87] Thus, a greater representation of waterbirds in her paintings was possibly due to the fact that waterbirds were the most commonly hunted species. It is difficult to say more with certainty, since the village-based hunters or tribal people who would have caught the birds appear only fleetingly in the records.[88]

An analysis of the sizes of Gwillim's works in the Blacker Wood Collection shows that her paintings come in all sizes and that many birds have been painted life-size. By far the largest painting is that of a Woolly-necked Stork (plate 19), which measures 93.0 x 69.2 cm, and the smallest, a Plain Prinia, measuring 20.2 x 25.6 cm.[89] The widest painting is that of a Brahminy Kite (plate 18), measuring 69.5 x 78.9 cm. (See figure 3 for a comparison of the sizes of these three paintings.)

Upon further analysis of the size of the paintings in relation to the body sizes of the birds painted (see figure 4),[90] it becomes evident that Elizabeth Gwillim was severely handicapped by a dearth of drawing paper. While most of the paintings were executed life-size, and are on drawing paper of the right size to accommodate the bird, at least ten are painted on under-sized drawing paper. These include the Oriental Darter, Grey Heron, Intermediate Egret,

FIGURE 4
Use of art paper by Elizabeth Gwillim for painting birds.

Sarus Crane, Greater Adjutant, Lesser Adjutant, Asian Openbill, Red-headed Vulture, and the Spot-billed Pelican.[91] For example, the Sarus Crane, the tallest Indian bird, at about 152 cm tall, has been painted on a drawing sheet only 41.9 cm high. In the inscription on the back of the Lesser Adjutant painting, Gwillim notes, "the bird being too large for a [illegible] drawing."[92] With two other paintings, that of two newly fledged Purple-rumped Sunbirds and Red Avadavats, the paper used has clearly been cut from larger sheets. Hana Nikčević has explored in detail the dearth of paper, paints, and brushes faced by both sisters in India.[93]

The Paintings' Backgrounds

In each of Elizabeth Gwillim's paintings, the birds have been painted in full, with their feet showing. The backgrounds were added later, as can be seen from the painting of the Marsh Harrier (plate 28), which is devoid of a painted background but has a distinctly sketched background in pencil, which Gwillim apparently intended to paint later.[94] However, thirty-seven paintings have no background.

The works with complete backgrounds have been painted with an artful combination of twenty or more components, which have been worked into the composition. These include items from the natural world, such as other animals; various trees, including coconut and palmyra palms, and other plants; boulders; and hills. In about forty paintings, the backgrounds include boulders overgrown with trees; plants, including climbers; and broken tree trunks in rivers or streams. Eight paintings show birds perched on tree trunks in front of boulders while another eighteen depict them perched on broken, hollowed-out tree trunks surrounded by foliage; another four positioned birds on tree branches. Seven paintings place birds at the water's edge with vegetation, while another seventeen feature plain ground with vegetation and boulders.

Many of the plants depicted in the backgrounds or as perches for birds in Gwillim's paintings can be readily identified. These include the banyan, *Ficus benghalensis* (plate 18); the rattan, *Calamus rotang* (plate 19); the ivy gourd, *Coccinia grandis* (plate 23); a popular vegetable widely cultivated and grown on hedges as well as in kitchen gardens by the locals, the chaste tree (*Vitex negundo*); the drumstick (*Moringa oleifera*); the neem tree (*Azadirachta indica*); and mango (*Mangifera indica*) blossoms.[95] Similarly, the fish in the beak of the juvenile Purple Heron in plate 20 incorporates considerable detail, enabling its tentative identification as a *Mystus* sp., which is primarily a brackish water fish that enters and lives in fresh water. The dragonfly that the male Asian Koel in plate 25 is trying to catch appears to be a female Blue Ground Skimmer/Chalky Percher dragonfly (*Diplacodes trivialis*), which Gwillim has accurately illustrated, with amber patches at the bases of the wings and the *nodus* and *pterostigma* depicted correctly along the costal wing margins.

Besides these natural elements, the backgrounds in some paintings illustrate aspects of local architecture, customs, and traditions, as in the paintings of the Brahminy Kite (plate 18), where the twin gopurams of the Ranganatha Temple, which still exist today, are visible in the background behind the foliage. Plate 40 shows a fuller view of the temple in a landscape painting attributed to Mary Symonds. Gopurams can also be seen in Gwillim's paintings of the Shaheen Falcon (plate 29), and White-browed Wagtail (plate 30).[96]

The natural elements present in the background of these paintings, along with a smattering of the distant silhouettes of hills and buildings such as gopurams, churches, and mosques, should be seen as the hallmarks of Gwillim's style, perhaps influenced by contemporary ideas of the picturesque. Most of her paintings are outstanding portraits of Indian birds, and they avoid the over-theatrical aspects that can seen in some of the works of Audubon.[97] Her style is also very different from "Company style" – that is, a hybrid Indo (Mughal)-European style of paintings made in India by Indian artists who

worked for European patrons during the eighteenth and nineteenth centuries. This contrast can be demonstrated by comparing Gwillim's depiction of the Sarus Crane (plate 17) with that by Shaik Zain ud-Din (plate 16).[98]

HABITAT AFFILIATIONS OF
ELIZABETH GWILLIM'S BIRDS

Elizabeth Gwillim's letters give no indication of her having spent time studying her subjects in their natural habitats. Further analysis of her paintings with reference to the habitats of these birds detailed in *Handbook of the Birds of Indian and Pakistan* shows that she depicted many species of birds in atypical habitats.[99] Indeed, a close examination of her backgrounds indicates a lack of understanding of the niche relationship or the habitat affiliation of most of the bird species she painted. For example, some extremely shy and skulking birds, such as bitterns and Baillon's Crake, have been placed in wide-open conditions.[100] Similarly, birds often found around water, such as the Lesser Florican and the Pond Heron, appear in parched, barren settings.[101] Other examples of atypical habitats include the paintings of the Woolly-necked Stork (plate 19), Purple Heron (plate 20), Crested Serpent-Eagle (plate 23), Marsh Harrier (male) (plate 28), Shaheen Falcon (plate 29), Brown-headed Gull, Intermediate Egret, Bronze-winged and Pheasant-tailed Jacanas, Pied Harrier, Montagus's Harrier (male and female), Large Cuckooshrike, Black-headed Cuckooshrike, Oriental Magpie Robin, Ashy Woodswallow, Blue-faced Malkoha, Eurasian Collared Dove, Plain Prinia, Forest Wagtail, Common Ringed Plover, and Red Avadavat.[102] Gwillim thus seems to have conceived backgrounds depicting natural settings in order to enhance the aesthetic value of the paintings. It is clear that she did not invest time in studying her subjects in their natural settings, but painted them opportunistically.

The anomalies in these backgrounds might result from Gwillim basing her backgrounds on the description provided by her trappers of the landscapes in which her subjects were found, rather than on objective knowledge of their natural haunts. The paintings that are devoid of a background were probably of birds given to her by others or procured from a third party by her trappers/suppliers, or the result of a shortage of painting supplies, or even a lack of time, as Gwillim was prone to frequent illness. An inscription on the back of her depiction of a pair of Painted Spurfowls clearly indicates that she did not know what to paint in the background, as the birds were "presented by Reverend Mr. Vaughan (Aug 24th 1806) caught in the woods near Madras."[103] She may not have had a chance to visit the woods (drier rockier foothills with impenetrable thorn scrub).[104]

Despite the many anomalies, it should be noted that the habitat details are fairly accurate in a few of her paintings, including those of the Asian Koel (plate 25), Black-winged Stilt (plate 27), White-browed Wagtail (plate 30), Common Iora (plate 31), Common Babbler, Purple and Long-billed Sunbirds (males), Indian Paradise Flycatcher, and fledglings of the Purple-rumped Sunbird.[105]

DISTRIBUTION OF BIRDS IN NINETEENTH-CENTURY INDIA

At the time Elizabeth Gwillim was painting, bird distributions within India had not been properly worked out. An analysis of the distribution of the 104 species of birds represented in her 121 paintings, based on the details provided in Ali and Ripley's *Handbook,* Rasmussen and Anderton's field guide, and the present-day eBird distribution maps of birds,[106] reveals that about 70 species are residents and 27 species are winter visitors to Chennai (i.e., the Madras area). The Crested Partridge is extralimital to India, while Madras is beyond the distributional range of the Sarus Crane (plate 17) and Greater Adjutant.[107] The Slaty-breasted Crake, Great-eared Nightjar, and Nilgiri Thrush are mainly denizens of faraway Western Ghats, and the Malay Cock (plate 26) is a domesticated fighting cock.[108] It will be interesting to know the status of the birds painted by Elizabeth Gwillim in the missing eighty paintings, if ever they are found.

The status of birds painted by Elizabeth Gwillim has changed considerably over the past two centuries. What may have been common or uncommon in her time could have a different status and distribution today. For example, some of the birds she painted – for example, the Red-headed Vulture and Indian Vulture – have become critically endangered and have largely disappeared from the region.[109] In addition, the Greater Adjutant, Egyptian Vulture and Lesser Florican are endangered; the Sarus Crane (plate 17) and the Lesser Adjutant are vulnerable; and the Oriental Darter, Curlew Sandpiper, Woolly-necked Stork (plate 19), Spot-billed Pelican, Crested Partridge, and Black-headed Ibis (plate 21) are near-threatened,[110] as per the International Union for Conservation of Nature Red List of Threatened Species.[111] One of the rarest bird species that Gwillim painted was the Corn Crake, which is known to be a casual vagrant, based on records from Sri Lanka in 1950, 1970, and 1972.[112] Similarly, species like the Common Ringed Plover, Common Starling, and the Desert Wheatear, which were earlier deemed uncommon, have been recorded from South India in recent years, indicating that they may have had a regular visitation status.[113] They were probably sourced locally for Gwillim. Thus,

FIGURE 5
Timeline of descriptions of bird species painted by Elizabeth Gwillim.

the early nineteenth century may have been a period of abundant birdlife. It is also difficult for us to infer how local hunting may have impacted native populations of birds, and how bird populations would have been affected by changes in environmental and climatic conditions between the nineteenth century and the present day.[114]

TIMELINES OF BIRD DESCRIPTIONS

When one maps the timeline of the original descriptions of each species of bird painted by Elizabeth Gwillim, commencing with the publication of the tenth edition of Linnaeus's *Systema Naturae*, it can be seen that seventy-five species of birds painted by her were given a binomial name even before she set foot on the shores of Madras (see figure 5). One species was named when she was busy painting in Madras, and twenty-eight species that she painted were unknown to science in her time. It is unfortunate that Gwillim did not assign binomial names to all the birds she painted, did not date her paintings, and never published or presented her findings to a scientific body in England. Had she done so, her names would be in use, and the type localities of these twenty-eight species would have been Madras (as dictated by the Principle of Priority as per the International Code of Zoological Nomenclature),[115] changing the course of the ornithological history of the region.

CONCLUSION

The information in the paintings of Elizabeth Gwillim as well as that in letters to her family remain the first detailed documentation of the birds of Madras, during a period when scientific ornithology was still in its infancy in South India. The 136 species of birds painted or described by her represent the most comprehensive documentation, numerically, of the birdlife of Madras up to her time. Thus, the bird paintings that she executed at the beginning of the nineteenth century redefined the ornithology of Madras, in a period when very little was known about the birds of this coastal city and its surroundings. They enable a brief, but glorious, view of the avifauna of this region in the early nineteenth century. As Casey Wood rightly admitted, "there are, of course, many gaps – many genera are not represented at all; but, considering the circumstances, one can easily believe that if the artist had lived a few years longer she would have made a gallery of Indian bird-pictures of the greatest scientific value, worthy to rank with the major collections of the world. Her sudden and early death, however, prevented the completion of the task, and probably consigned many of her best efforts to oblivion."[116] If ever the missing paintings are discovered, they may well serve to fill some of these gaps in Elizabeth Gwillim's ornithology of Madras.

APPENDIX A:
ELIZABETH GWILLIM'S
ORNITHOLOGICAL WATERCOLOURS

This appendix focuses closely on fourteen of Gwillim's bird painting (plates 18–31), with descriptions of the birds' appearance and habitat as well as the backgrounds.

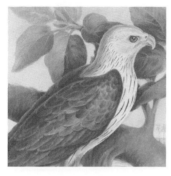

Brahminy Kite, *Haliastur indus*
(Plate 18; CA RBD Gwillim-1-002)

This is one of the most beautiful paintings by Elizabeth Gwillim. It depicts the Brahminy Kite in its distinctive bright chestnut-coloured plumage with a whitish head and chest. This species is spread across India, frequently seen at well-watered inland localities, and along the sea coast as well as in cultivated and urban areas.[117]

It is a year-round resident, with some individuals nesting in tall trees in gardens. They are attracted to coasts around fishermen's wharfs and are abundant along the Madras coast during the prawn season, which starts in September. Initially named *Falco indus* by Pieter Boddaert in 1783, based on a specimen collected in 1760 from Pondicherry, India, by the French zoologist Mathurin Jacques Brisson, it was later assigned to the genus *Haliastur* by John Selby Prideaux in 1840.[118]

Elizabeth Gwillim's Brahminy Kite is perched on a banyan (*Ficus benghalensis*) tree. In the notes on the back of the painting, she writes that the bird is "on a bough of the banyan tree with the shoots that descend down to earth & take root," aptly describing and illustrating the prop roots produced by the tree.[119]

In the background are three Indians standing next to coconut palms and offering salutations to the bird with folded hands. In a letter to her sister, Gwillim wrote, "the natives feed them with great care & consider them as Gods – they must see them every Sunday morning before they eat, & whenever they see them make to them what they call Dandamulus [దండములు, in Telugu]. A salaam is a salute to a Master, [while] a Dandamulu [దండములు] is to a God or Brahmin, it is holding the hands up closed as we do in prayer."[120] Indian mythology likens the Brahminy Kite to Garuda, the *vahana* or vehicle of the Hindu deity Lord Vishnu, the bird thus being an object of veneration.[121] In her garden near St Thomas Mount, Elizabeth found a nest of this species on top of a mango tree, which the natives visited in order to offer prayers on Sunday mornings. The deep background of the painting also features the twin gopurams of the Sri Ranganatha Temple, Thiruneermalai, atop a hill near Pammal, Madras.

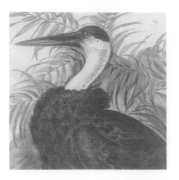

Woolly-necked Stork, *Ciconia episcopus*
(Plate 19; CA RBD Gwillim-1-003)

This species of stork was described by the French polymath Georges-Louis Leclerc, Comte de Buffon, in 1780 in his *Histoire naturelle des oiseaux* from a specimen collected from the Coromandel Coast of India.[122] The bird was also illustrated in a hand-coloured plate engraved by François-Nicolas Martinet in the *Planches enluminées d'histoire naturelle* which was produced under the supervision of Edme-Louis Daubenton to accompany Buffon's text.[123] In 1783, Boddaert coined its binomial name.[124] The stork is a sparsely distributed resident, found in well-watered tracts, dryland cultivations, and forest pools across India.[125] Usually the black, deeply forked tail of the species is obscured by long stiff under-tail coverts, but, in this painting, Gwillim has slightly angled the tail to illustrate both these body parts. She has also brilliantly captured the fluffed swathe of long feathers around the base of the neck, which are usually erected when the bird is alarmed.

The scandent palm growing in the background wrapping over the boulders, is a common rattan, most likely *Calamus rotang*, which is native to India and known to grow commonly around Chennai and elsewhere in Tamil Nadu[126] and not *Calamus dioicus* (a native of Vietnam),[127] as in Gwillim's notes at the back of the painting. The rattan palm is used in wickerwork for making baskets, furniture, walking-sticks and umbrellas.

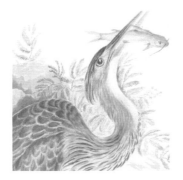

Purple Heron, *Ardea purpurea*
(Plate 20; CA RBD Gwillim-1-004)

This species of heron frequents reedy swamps, lakes, and rivers. It is shy and secretive, keeping to dense vegetation cover in the shallows, where it may easily be overlooked, given its the bittern-like camouflage.[128] It is a common resident across India. Gwillim has painted a juvenile feeding on a catfish, quite possibly *Mystus* sp. (Bagridae),[129] at the edge of a stream that is flowing amid boulders with what appears to be a sprig of the Indian gum arabic tree (*Vachellia nilotica*) in bloom.

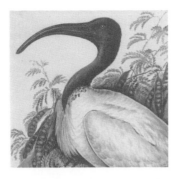

Black-Headed Ibis, *Threskiornis melanocephalus*
(Plate 21; CA RBD Gwillim-1-009)

Described by John Latham in 1790, this resident species of ibis is found across India. It is an open country bird that frequents marshes, swamps, margins of lakes and rivers, flooded areas, and inundated paddy fields, as well as wet grasslands, tidal marshes, and brackish lagoons. Gwillim has illustrated this handsome bird in its breeding plumage, with dark grey elongated and "disintegrated" inner secondary feathers that hang over its lower back. Long ornamental plumes overhang at the base of the neck.[130]

The plant that is growing among the boulders in the stream is *Senegalia rugata* (Fabaceae),[131] a woody climber popularly known as *Shikakai*, which is used traditionally by people in South India as a natural shampoo. The pod, harvested from this woody climber, is dried in the shade and powdered before use. Gwillim appears to have gained familiarity with this plant through her interaction with local people.

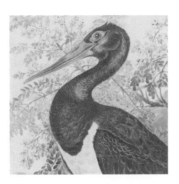

Black Stork, *Ciconia nigra*
(Plate 22; CA RBD Gwillim-1-010)

Named by Carl Linnaeus in 1758, this migratory stork species is encountered in India only during the winter.[132] It frequents marshy ground and is found along the edges of rivers and inland waterbodies.

This is one of Gwillim's most stylishly executed works. The glossy plumage of this stately bird has been brilliantly captured, with the neck and breast almost entirely glossed in green, and the upperparts in varying shades of glazed green, purple, and bronze. The white underparts and the fluffed white under-tail coverts are well illustrated. The deep red bare skin of the face highlights the eye. What should have been a straight dagger-shaped coral-red beak has been delicately stylized. The boulder-strewn riverine habitat with an overhanging branch of a drumstick (*Moringa oleifera*: Moringaceae) tree forms an evocative backdrop. The inclusion of the drumstick indicates her familiarity with this tree, as is also evident from a letter to her sister Hester James: "I wish you had some good Moringas to eat well stewed or cou'd see the tree, a lovely object, waving, light as air – sweet flowers – & the long pods we stew & they are as nice as asparagus not that they are alike but as much to be longed for."[133] The stew being referred to is drumstick sambar, a popular dish among the people of Madras, even today.

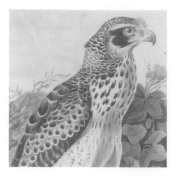

Crested Serpent-Eagle, *Spilornis cheela*
(Plate 23; CA RBD Gwillim-1-013)

This Crested Serpent-Eagle is one of the finest of Gwillim's paintings of Indian birds. This elegant, first-year juvenile has every feather delineated in detail, and its posture is true to life. Its patterned plumage is strikingly different from the dark brown plumage of the adult (not illustrated), which sports a full, round, black-and-white nuchal crest.[134] The Serpent-Eagle is a large bird, described by John Latham in 1790. It is a resident in India, found in well-wooded and well-watered areas across the country. The juvenile in this portrait appears to have been captured from the forests up in the hills by bird trappers.

The ivy gourd climber (*Coccinia grandis*: Cucurbitaceae), depicted in the background laden with ripe, red fruit, is a very popular vegetable in present-day Tamil Nadu. It is commonly cultivated and grown as a hedge plant. Among others, a very tasty *Porriyal* ("curry" in Tamil), a fried or sautéed vegetable dish, is prepared from this gourd by the people of this region. In a letter to her mother, Gwillim says, "they [have] several things of the Cucumber & Gourd kind which are excellent stewed – & some other seed vessels. – As the hedges & trees yield them so many things."[135]

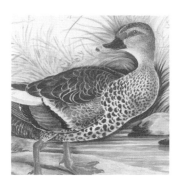

Indian Spot-Billed Duck, *Anas poecilorhyncha*
(Plate 24; CA RBD Gwillim-1-018)

This is a resident nomadic, and occasionally migratory, duck, commonly found all over the Indian subcontinent. It inhabits reedy and vegetation-covered wetlands and lakes.[136] The species was first described by J.R. Forster in 1781, based on a specimen collected from Ceylon (now Sri Lanka).[137]

In Gwillim's painting, the duck has been set against a boulder-strewn wetland habitat overgrown with tall sedges (possibly *Cyperus* sp.). She has brilliantly executed this painting to illustrate the scaly patterned dark-brown plumage, with the black-and-white verged metallic green speculum, bordered above by a broad pure-white wing bar. The yellow-tipped dark bill is accurately depicted. However, what should have been bright coral-red legs and two swollen orange-red spots at the base of the upper mandible on either side of the forehead have been coloured brown. This anomaly is possibly attributable to a dearth of red paints, though the artist Terence Michael Shortt was of the opinion that "every detail of the living

colours of these unfeathered parts is invariably accurate. Only the reds are weak, the result, probably, of Gwillim's use of those notoriously fade-prone pigments, the rose madders, rather than any inadequacy of artistic skill."[138]

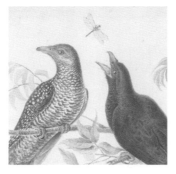

Asian Koel, *Eudynamys scolopaceus*
(Plate 25; CA RBD Gwillim-1-022)

The Asian Koel is a largely frugivorous dimorphic cuckoo, the size of a crow, but slender in build. Its loud calls were interpreted as *ko-el* or *kokila* (*Cokilla*) by the Indian inhabitants of Madras. Originally described as *Cuculus scolopaceus* by Carl Linnaeus in 1758, it was later moved to the genus *Eudynamys*. It is a brood-parasite, laying eggs in nests of passerines, particularly crows (*Corvidae*). Found throughout the Indian subcontinent, koels are common in gardens, groves, and open country, abounding in large leafy trees.[139]

Painted at Gwillim's garden house in San Thomé (now Santhome), and set against the backdrop of the Bay of Bengal, with the coconut and palmyra palms (*Borassus flabellifer*) depicted along the banks, this pair of koels are perched on a branch of neem (*Azadirachta indica*). The male is trying to catch a female blue ground skimmer/chalky percher dragonfly (*Diplacodes trivialis*: Libellulidae), one of the commonest Odonata species, which can be readily identified from the artist's reasonably accurate depiction. This is one of the very few paintings where Gwillim has dramatized her subjects. In the inscription on the back of the painting, she notes, "two species of Cuculus – not rarely found in the gardens around Madras – Some assert that they are male and female, but I believe them to be distinct species – drawn at Madras home," and she correctly identifies the tree as "*Melia azadirachta*," as per the original 1753 Linnaean *Species Plantarum* binomial name.[140]

Domestic Fowl: Malay Cock, *Gallus* sp.
(Plate 26; CA RBD Gwillim-1-030)

This painting illustrates the fighting cock, known as the Malay Cock, believed to have been introduced to India from Sumatra or Java, and one of the most ancient landraces of poultry to have originated in Southeast Asia. This domestic game breed is known to have stood as tall as a metre and weighed up to four kilograms. This illustration clearly shows the low and thick strawberry-shaped comb, small

wattles and earlobes, the short, broad, hooked beak, and yellow legs with remarkably large scales, which are typical features of a Malay Cock.[141] These fowls are found in parts of northern India, Malaysia, and Indonesia and are said to have ancestors in the Kulm fowl.[142] The breed is known to have been taken to England in the 1830s, where there was serious debate on the origin and ancestry of birds of its kind.[143]

This painting appears to have been done at Gwillim's garden house at San Thomé in Madras, as the two minarets of the local mosque can be seen faintly in the distance. The scene in the background is complete with stables, horses, carriage, and attendants.

Black-winged Stilt, *Himantopus himantopus*
(Plate 27; CA RBD Gwillim-1-049)

These extra-long-legged birds are basically shallow-water feeding waders, found in a variety of habitats including freshwater and tidal lagoons and inundated fields.[144] Gwillim illustrates the stilts near one of their typical habitats – a shallow winding stream. Three birds are seen resting on firm ground, with one of them preening. All the birds are females.

This is one of the few paintings where Gwillim gives an indication that she has observed her subjects in their natural settings. This painting is a decisive departure from her customary depiction of riverine backgrounds with boulders and a lush growth of trees, bushes, and climbers. The stream-edge clump of grass depicts the barnyard grass *Echinochloa crus-galli*.[145]

Western Marsh Harrier, *Circus aeruginosus*
(Plate 28; CA RBD Gwillim-1-061)

An exquisite painting depicting a handsome male Marsh Harrier. This is a fine example showing the process of illustration that Gwillim adopted. This incomplete painting clearly shows that, after having painted the bird in full, she had plans to include boulders and a broken tree trunk in the background, as can be seen by the light pencil sketch, a setting that would have been identical to the paintings of the other two species of harriers that she had completed. This species frequents waterbodies, marshes, and flooded paddy fields during winter.[146]

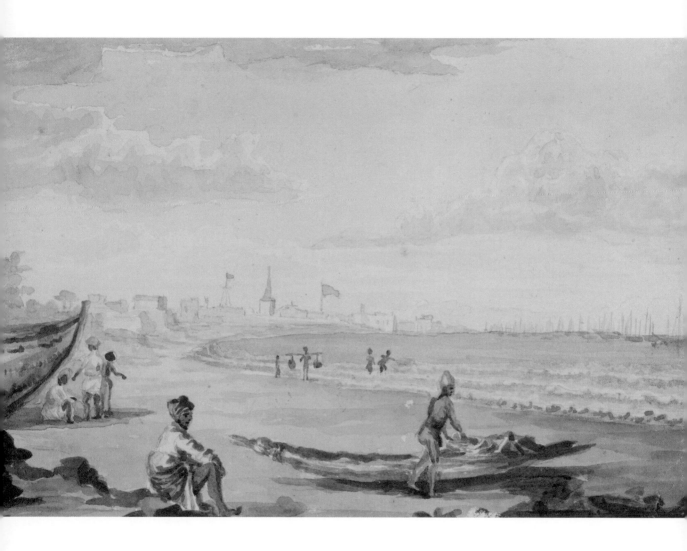

PLATE I
Attributed to Mary Symonds, "Coast Near Madras"
(title from inscription on verso), 10.5 x 16.7 cm, watercolour.
The South Asia Collection Museum NWHSA PIC106.78.

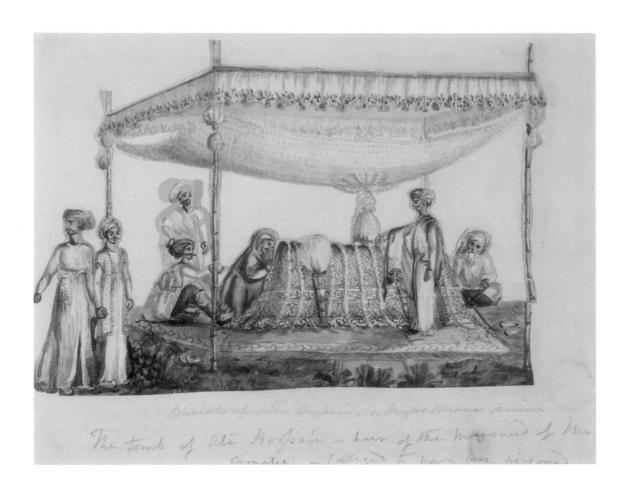

PLATE 2
Attributed to Mary Symonds, "Burial of Ali Houssain, a mussulman
prince" (title from inscription on recto), 1803, 18.0 x 23.0 cm,
watercolour. The South Asia Collection Museum NWHSA PIC106.30.
Additional inscription on recto: "The tomb of Ali Hoossain –
heir of the musnud of the Carnatic –
(alleged to have been poisoned)."

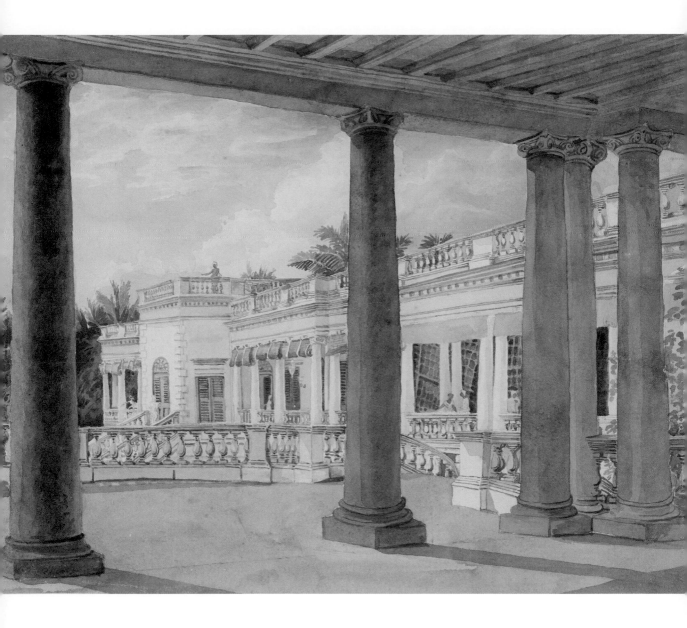

PLATE 3
Mary Symonds, "St Thome's House. The part in front, built for
Sir HG" (title from inscription on verso), 27.5 x 36.0 cm, watercolour.
The South Asia Collection Museum NWHSA PIC106.77.
Additional inscription on verso: "Sir HG's bedroom.
The Miss Symonds' drawing room."

PLATE 4 *(left)*
Mary Symonds, "A Lady's Maid ... a Pariah
Woman" (title from inscriptions on album),
1803, 36.5 x 21.0 cm, watercolour.
The South Asia Collection Museum
NWHSA PIC106.75.

PLATE 5 *(bottom)*
Attributed to Mary Symonds, "Carrying
an Englishman" (title from inscription
on album), 9.0 x 38.5 cm, watercolour.
The South Asia Collection Museum
NWHSA PIC106.60.

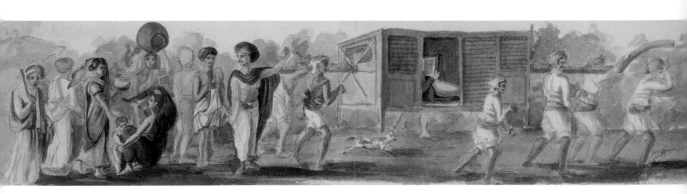

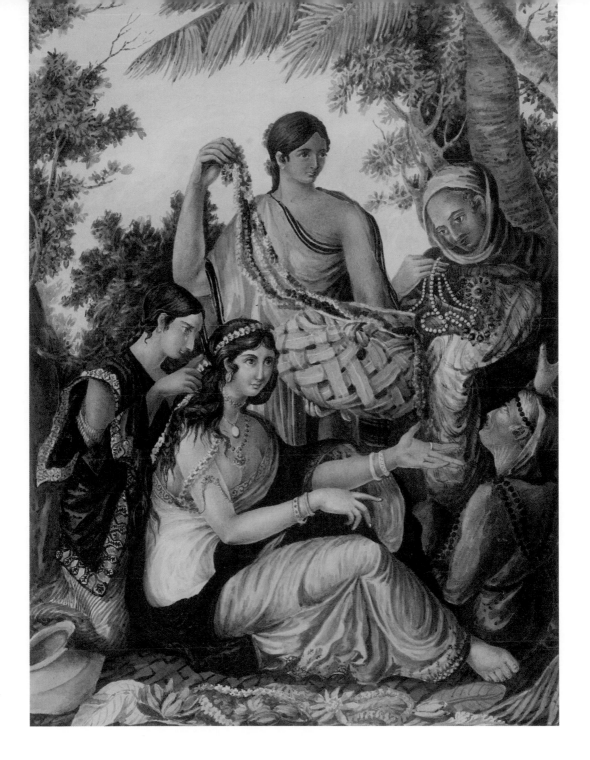

PLATE 6
Attributed to Mary Symonds, "Scene from a Sanskrit Drama"
(title from inscription on album), 35.0 x 25.0 cm, watercolour.
The South Asia Collection Museum NWHSA PIC106.39.

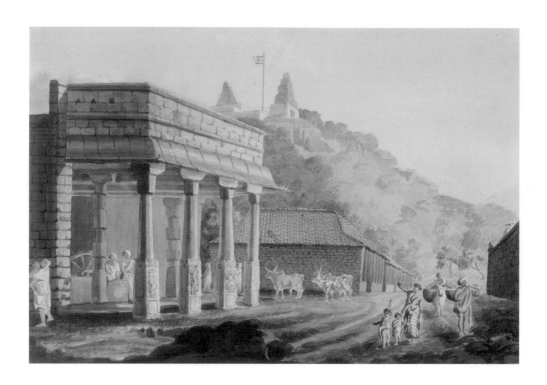

PLATE 7 (top)
Attributed to Mary Symonds, "A Chattram or Choudry
[Choultry]" (title from inscription on verso),
21.0 x 31.5 cm watercolour. The South Asia Collection
Museum NWHSA PIC106.5. Additional inscription
on verso: "a Native Bazar."

PLATE 8 (bottom)
Mary Symonds, "Ascension Isle" 1808
(title from inscription on verso), 16.5 x 32.5 cm,
coloured chalk. The South Asia Collection Museum
NWHSA PIC106.32.

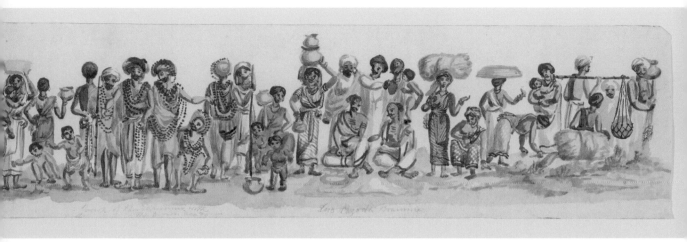

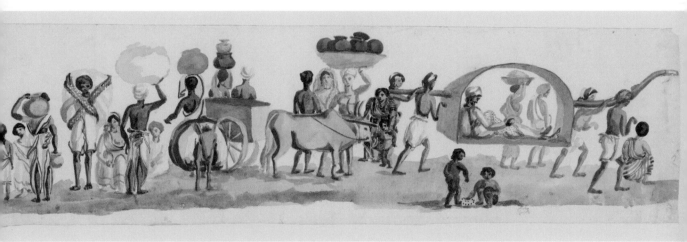

PLATE 9 *(top)*
Attributed to Mary Symonds, *Untitled*, ca. 1803,
11.0 x 39.0 cm, watercolour. The South Asia Collection
Museum NWHSA PIC106.51. Inscriptions on recto:
"Group of Pandarums with brown beads ...
Two Pagoda Brahmins."

PLATE 10 *(bottom)*
Attributed to Mary Symonds, *Untitled*, ca. 1803,
11.5 x 40.0 cm, watercolour. The South Asia Collection
Museum NWHSA PIC106.52.

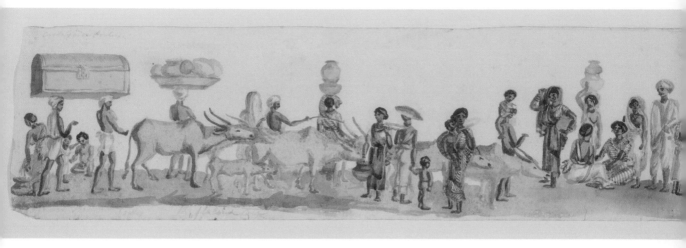

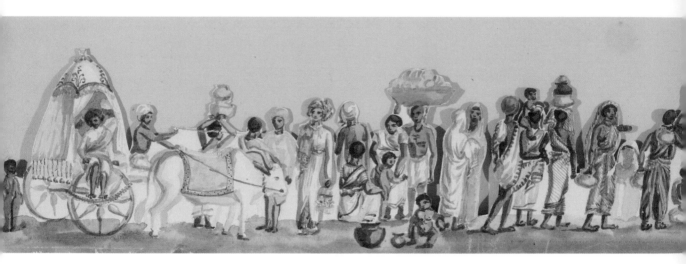

PLATE 11 (*top*)
Attributed to Mary Symonds, *Untitled*, ca. 1803,
12.1 x 42.0 cm, watercolour. The South Asia Collection
Museum NWHSA PIC106.53. Inscriptions on recto:
"Cooleys or Porters ... Buffalo."

PLATE 12 (*bottom*)
Attributed to Mary Symonds, *Untitled*, ca. 1803,
10.0 x 36.5 cm, ca. 1803 watercolour. The South Asia
Collection Museum, NWHSA PIC106.54.

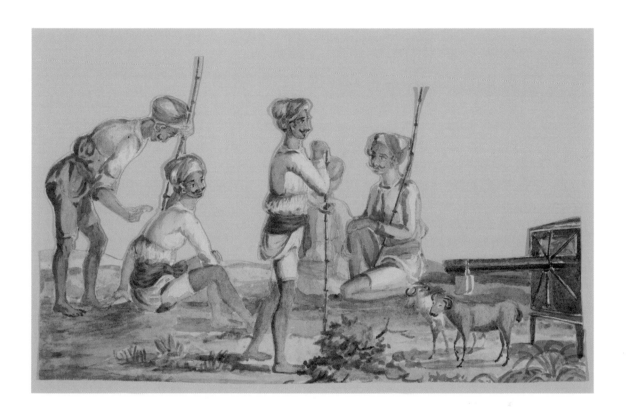

PLATE 13
Attributed to Mary Symonds, "Palaquin [palanquin] Boys Resting"
(title from inscription on album), 15.5 x 24.5 cm, watercolour.
The South Asia Collection Museum NWHSA PIC106.36.

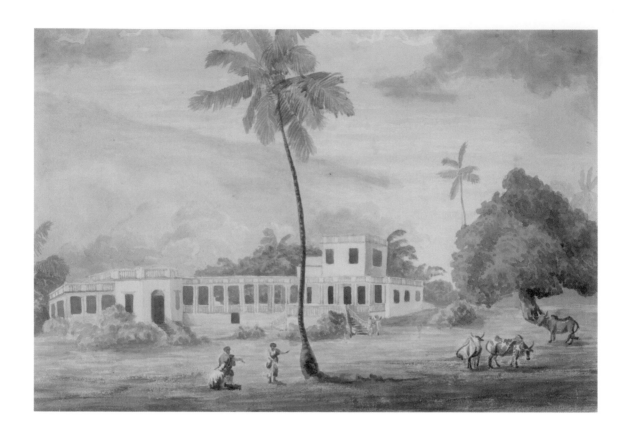

PLATE 14
Attributed to Mary Symonds, "Front view of St Thomé House
near Madras" (title from inscription on album).
The South Asia Collection Museum NWHSA PIC106.4.

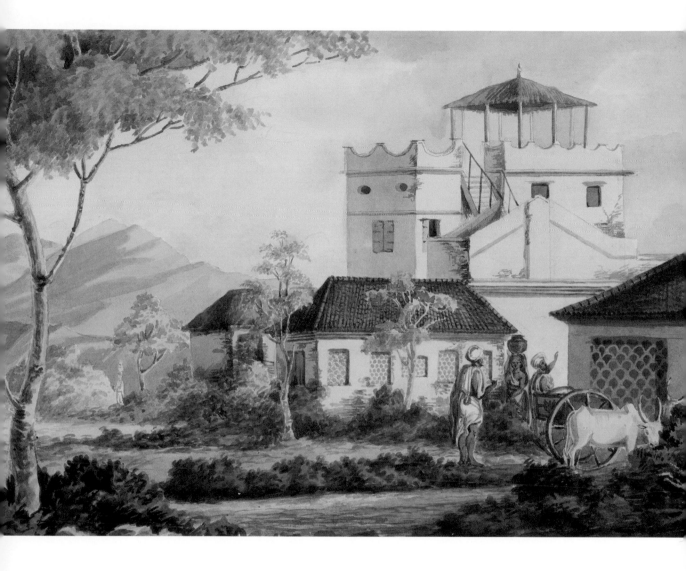

PLATE 15
Mary Symonds, "Farm-house belonging to Cotton plantation, 1806
M.R. at Pumell [Pammal]" (title from inscription on verso),
1806, 21.0 x 31.5 cm, watercolour. The South Asia Collection
Museum NWHSA PIC106.76. Additional inscription on album reads:
"Mr Webb's cotton farmhouse at Pummel [Pammal] –
where lady G died."

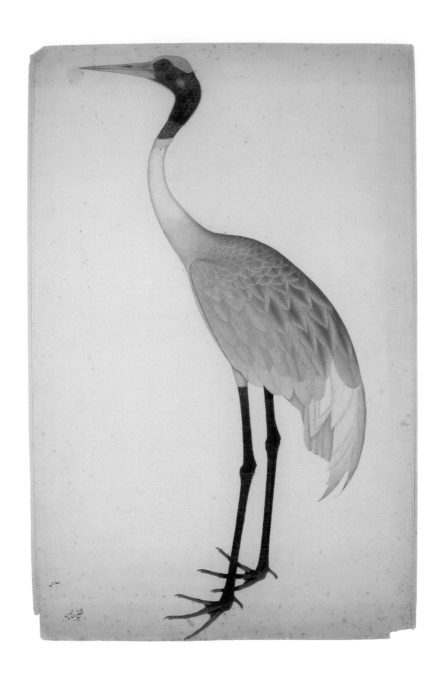

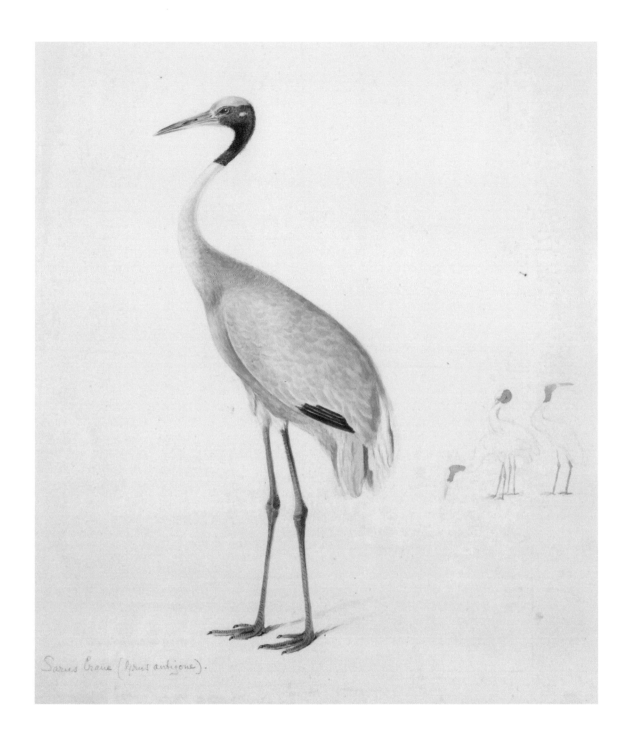

Sarus Crane (*Grus antigone*).

PLATE 17
Elizabeth Gwillim, *Sarus Crane, Antigone antigone*
(title from 2021 identification of species), Blacker Wood Collection,
CA RBD Gwillim-1-038, 41.9 x 26.7 cm watercolour on paper, pencil.
McGill University Library. Inscription on verso, "Ardea Antigone."

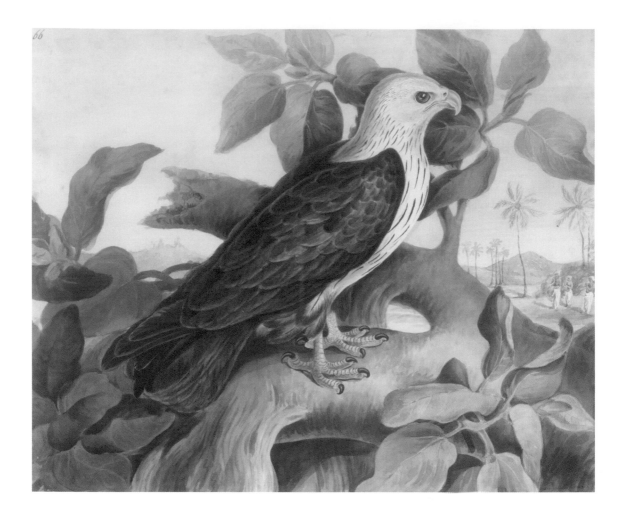

PLATE 18
Elizabeth Gwillim, *Brahminy Kite, Haliastur indus*
(title from 2021 identification of species), 69.5 x 78.9 cm,
watercolour on pencil sketch. Blacker Wood Collection,
CA RBD Gwillim-1-002, McGill University Library.

PLATE 19 (*opposite*)
Elizabeth Gwillim, *Woolly-necked Stork, Ciconia episcopus*
(title from 2021 identification of species), 93.0 x 69.2 cm,
watercolour on pencil sketch. Blacker Wood Collection,
CA RBD Gwillim-1-003, McGill University Library.
Inscription on verso "No.122 – Ardea leucocephala?
The plant is the Calamus dioicus. At least I believe it
to be so. It is common about Madras. EG."

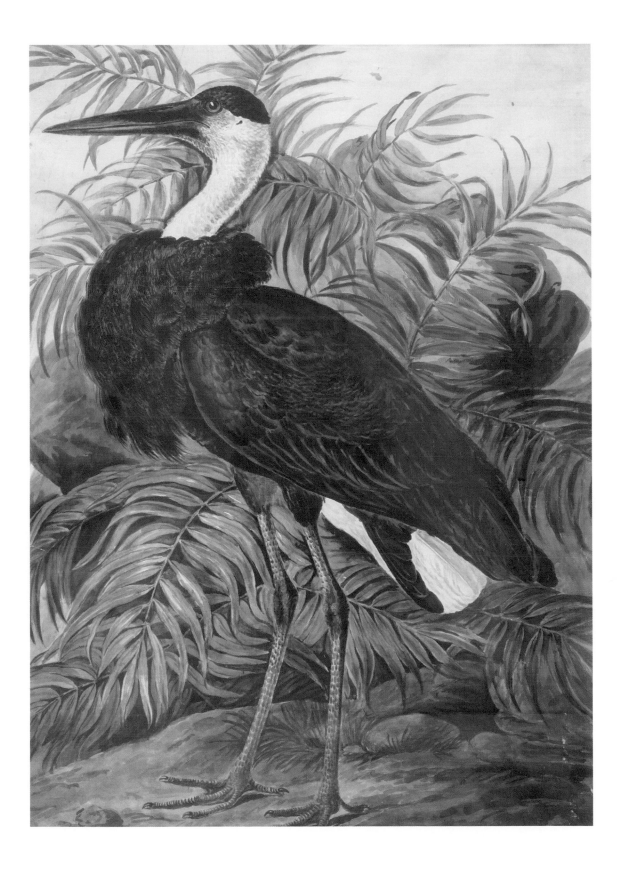

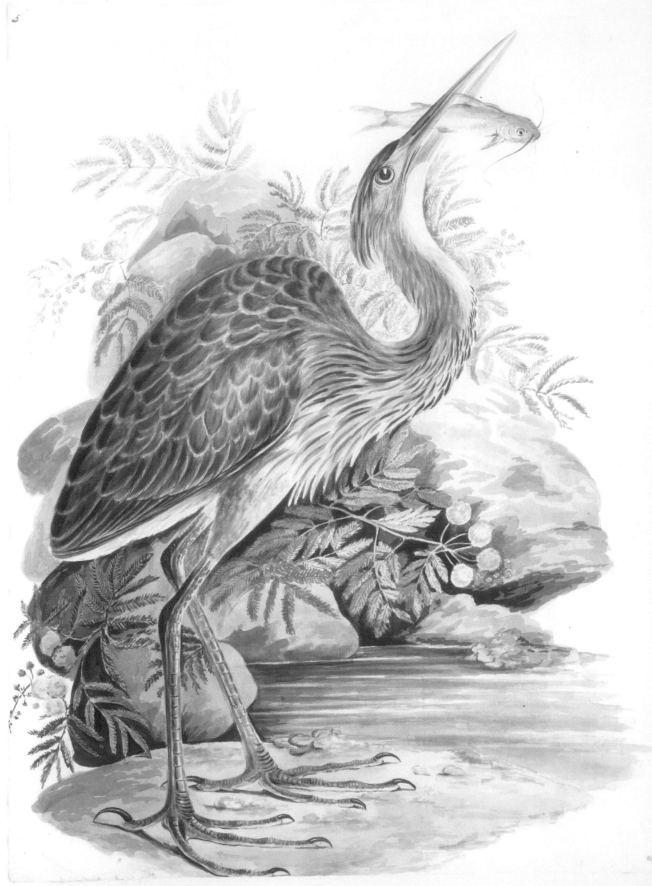

5

Castor Purple Heron, juv. (Ardea purpurea) *Ardea*

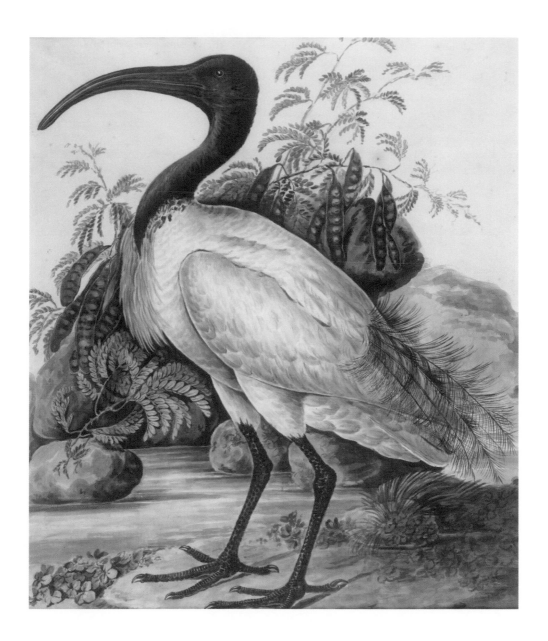

PLATE 20 (opposite)
Elizabeth Gwillim, *Purple Heron, Ardea purpurea*
(title from 2021 identification of species), 92.6 x 63.7 cm,
watercolour on pencil sketch. Blacker Wood Collection,
CA RBD Gwillim-1-004, McGill University Library.
Inscriptions below the painting read: "?
Eastern Purple Heron juv. (Ardea manillensis),"
and in the lower right corner: "Ardea."

PLATE 21
Elizabeth Gwillim, *Black-headed Ibis,*
Threskiornis melanocephalus (title from 2021 identification
of species), 70.2 x 61.0 cm, watercolour on pencil sketch.
Blacker-Wood Collection, CA RBD Gwillim-1-009,
McGill University Library. Inscription on verso,
"No 116 – of Bruce."

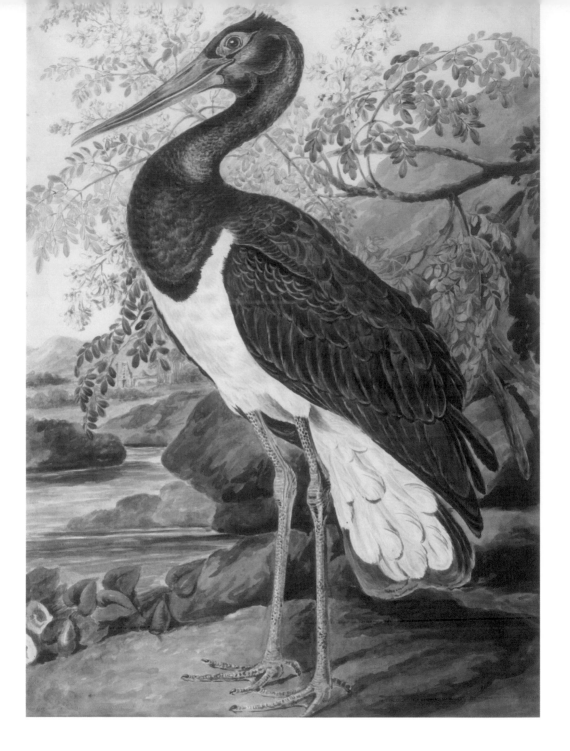

PLATE 22
Elizabeth Gwillim, *Black Stork, Ciconia nigra*
(title from 2021 identification of species), 92.1 x 67.3 cm,
watercolour on pencil sketch. Blacker Wood Collection,
CA RBD Gwillim-1-010, McGill University Library.

PLATE 23 *(opposite)*
Elizabeth Gwillim, *Crested Serpent Eagle, Spilornis cheela*
(title from 2021 identification of species), 89.0 x 73.7 cm,
watercolour on pencil sketch. Blacker Wood Collection,
CA RBD Gwillim-1-013, McGill University Library.

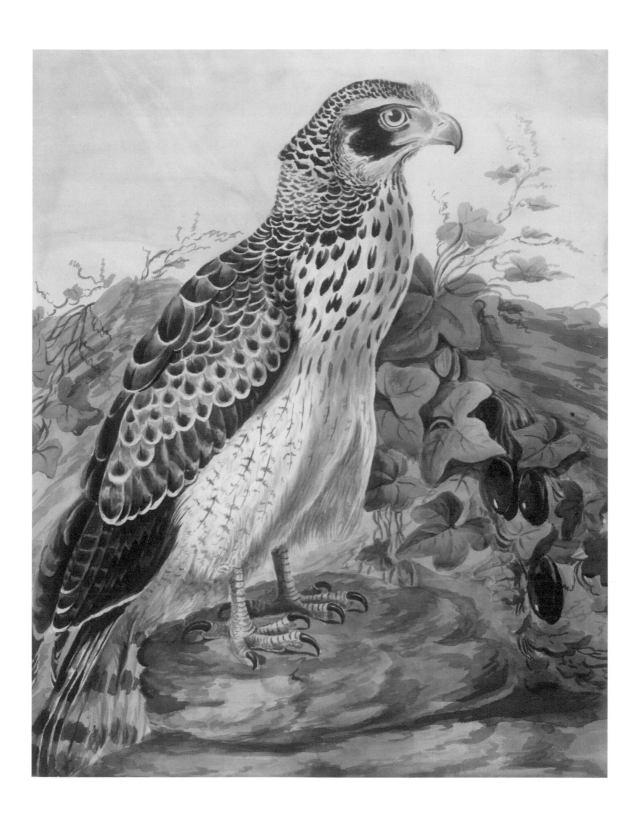

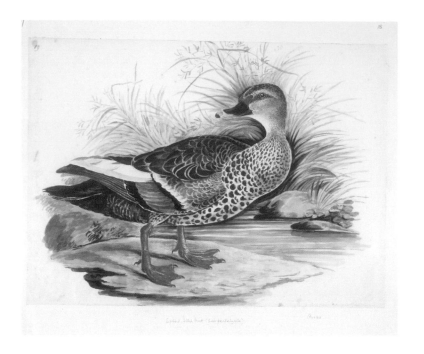

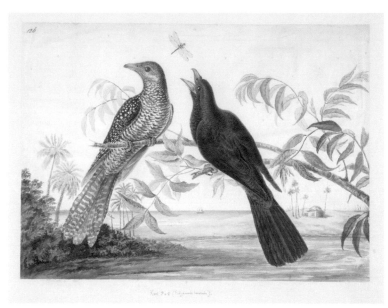

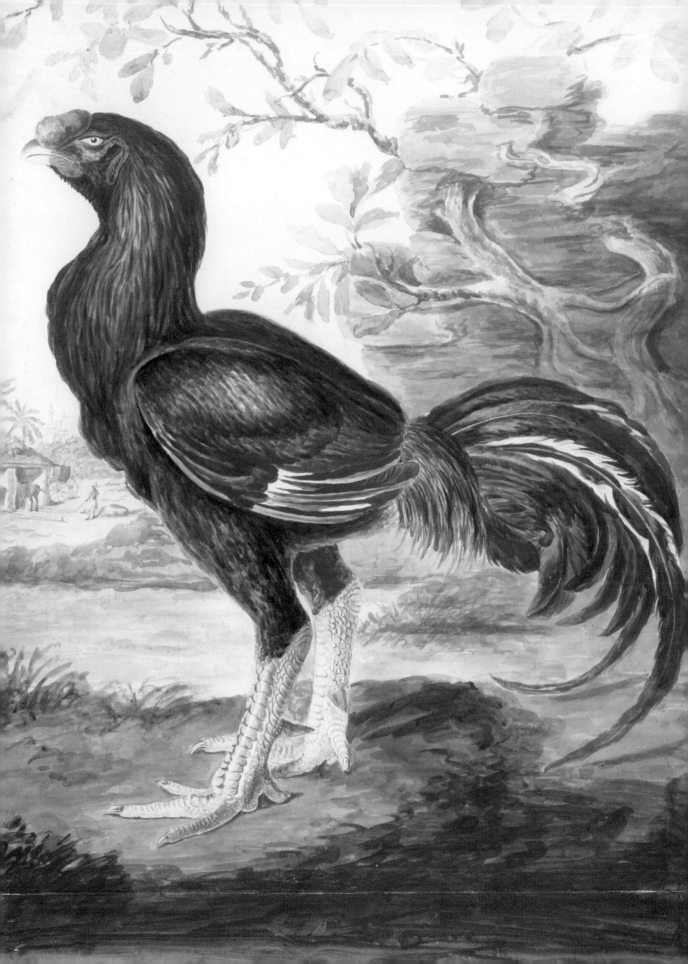

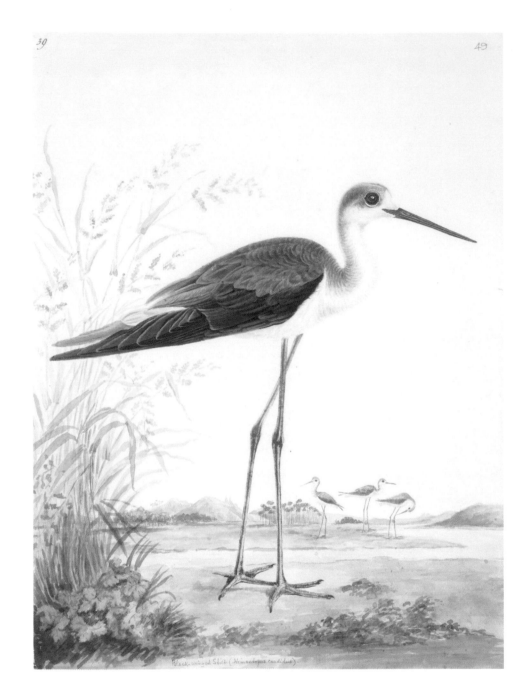

Black-winged Stilt (*Himantopus candidus*).

PLATE 27
Elizabeth Gwillim, *Black-winged Stilt, Himantopus himantopus*
(title from 2021 identification of species), 50.0 x 36.4 cm,
watercolour on pencil sketch. Blacker Wood Collection,
CA RBD Gwillim-1-049, McGill University Library. Inscription
on verso: "No 16 Chardrius himantopus Madras."

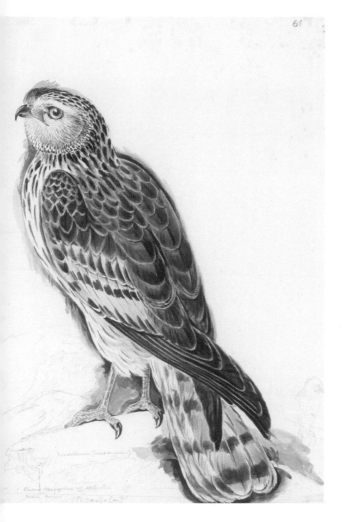

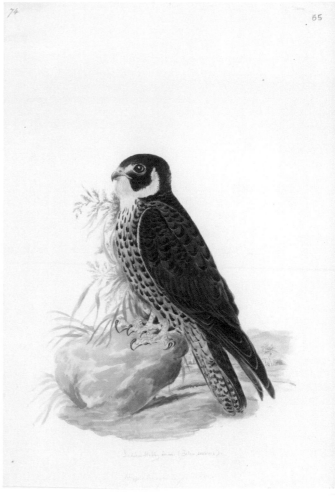

PLATE 28 *(left)*
Elizabeth Gwillim, *Western Marsh Harrier, Circus aeruginosus* (title from 2021 identification of species), 48.7 x 36.0 cm, watercolour on pencil sketch. Blacker Wood Collection, CA RBD Gwillim-1-061, McGill University Library.

PLATE 29 *(right)*
Elizabeth Gwillim, *Peregrine (Shaheen) Falcon, Falco peregrinus peregrinator* (title from 2021 identification of species), 52.2 x 35.7 cm, watercolour on pencil sketch. Blacker Wood Collection CA RBD Gwillim-1-065, McGill University Library. Inscription on recto: "Falco severus indicus (immature) Central Indian Hobby (? ♀)."

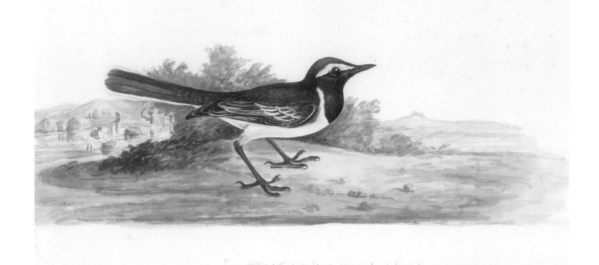

Large Pied Wagtail (Motacilla maderaspatensis).

Common Iora ♀ (Aegithina tiphia).

PLATE 30 (*top*)
Elizabeth Gwillim, *White-browed Wagtail, Motacilla maderaspatensis* (title from 2021 identification of species), 25.2 x 34.8 cm, watercolour on pencil sketch. Blacker Wood Collection, CA RBD Gwillim 1-104, McGill University Library. Inscription at bottom centre reads, "Large pied wagtail (Motacilla maderaspatensis)."

PLATE 31 (*bottom*)
Elizabeth Gwillim, *Common Iora, Aegithina tiphia* (title from 2021 identification of species), 35.4 x 27.1 cm, watercolour on pencil sketch. Blacker Wood Collection, CA RBD Gwillim 1-108, McGill University Library. Inscription on verso "No. 159 Pers ... [text obscured]."

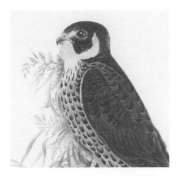

Shaheen Falcon, *Falco peregrinus peregrinator*
(Plate 29; CA RBD Gwillim-1-065)

This is a medium-sized resident falcon that keeps to steep, rugged peninsular hills with large rocky outcrops and that forages over the vast tracts of surrounding countryside.[147] Gwillim brilliantly captures the powerful build and forceful nature of this falcon, which is seen here perched on a rock on the ground.

In miniature in the distant background (to the right of the falcon's tail), Gwillim illustrates toddy tapping, a local occupation, possibly by the Nadars, a community mostly engaged in the cultivation of palms and toddy tapping.[148] Mary Symonds described toddy as follows: "Toddy is a liquor which is drawn from the Cocoanut trees, it is thought very wholesome if drunk early in the morning before the sun rises, & as soon as it is drawn from the tree, but if it is kept till the sun is up it becomes fermented, & has an intoxicating quality for which, the natives drink it. I have drawn a toddy man, who is distinguished according to the custom by a cocoa palm leaf."[149] In Gwillim's painting, one man is drawn up on the palm extracting the liquor; two others are shown waiting on the ground, quite possibly to savour the freshly tapped toddy.

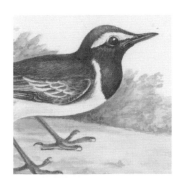

White-browed Wagtail, *Motacilla maderaspatensis*
(Plate 30; CA RBD Gwillim-1-104)

The White-browed Wagtail is a common resident found across the Indian peninsula to as far north as the Himalayan foothills.[150] It is encountered frequently along water courses, particularly slow-running streams, in big and small wetlands and inundated rice paddies, and quite often in dry cultivations and on lawns. A male is shown here in one of its typical riverside haunts.

In the background, Elizabeth Gwillim brilliantly captures a washermen's cove and illustrates the process of washing cloth: a saddled load of clothes being taken off a donkey, one man scrubbing the cloth with soap, another beating it on a rock, and yet another giving it a final rinse. In her letter to her sister Hester James, Gwillim recounts the damage this process did to her clothes:

> linen cloth is worn out sooner than you cou'd think – They [washer men] beat it on the pieces of rock in the rivers where they wash & the

linen cut directly as to hems whether of callico or linen about 4 or five washings beat them entirely out, & they must be done again. They say here that the Washer men beat the linen & whatever they know to be European articles & that they sing all the time they beat – *"Europá Europá Europá."*[151]

The painting superbly reflects the local Indian name *Dhobin*, which compares wagtails to the wives of washer men, owing to their fondness for water and the habit of wagging their tails.[152]

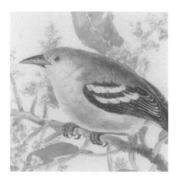

Common Iora, *Aegithina tiphia*
(Plate 31; CA RBD Gwillim-1-108)

This painting illustrates a male Common Iora in non-breeding plumage, perched on a mango (*Mangifera indica*: Anacardiaceae) inflorescence. The bird appears to have been painted during January to March, when the mango trees are in bloom in Madras. The species is a resident, found across India, frequenting gardens in towns or groves of trees on the outskirts of villages and open forests.[153] This painting appears to have been done in Elizabeth Gwillim's garden house at San Thomé and is of a captive bird.

Gwillim notes in one of her letters that

the favourite fruit of the country is the Mango & the Mango trees are now in full bloom smelling very fresh & nice. The orchards look like Walnuts or Pear trees but the flower is a large spike of small blossoms like Meadow-sweet – There are as many sorts of Mangos as of apples & as much difference in them. I like them unripe in tarts they are like a fine green apple – but I fear I shall not like them ripe again as I was ill after eating them.[154]

APPENDIX B:
BIRDS PAINTED BY ELIZABETH GWILLIM,
OR DESCRIBED IN HER LETTERS

Species No.	Order	Family	Common name	Scientific name	Authority and year of description**
1	Anseriformes	Anatidae	Bar-headed Goose	*Anser indicus*	(Latham, 1790)
2			Cotton Pygmy Goose	*Nettapus coromandelianus*	(J.F. Gmelin, 1789)
3			Ruddy Shelduck*	*Tadorna ferruginea*	(Pallas, 1764)
4			Garganey*	*Spatula querquedula*	(Linnaeus, 1758)
5			Indian Spot-billed Duck	*Anas poecilorhyncha*	J.R. Forster, 1781
6			Eurasian Teal*	*Anas crecca*	Linnaeus, 1758
7			Tufted Duck	*Aythya fuligula*	(Linnaeus, 1758)
8	Galliformes	Phasianidae	Indian Peafowl*	*Pavo cristatus*	Linnaeus, 1758
9			Red Spurfowl	*Galloperdix spadicea*	(J.F. Gmelin, 1789)
10			Painted Spurfowl	*Galloperdix lunulata*	(Valenciennes, 1825)
11			Jungle Bush Quail*	*Perdicula asiatica*	(Latham, 1790)
12			Rain Quail	*Coturnix coromandelica*	(J.F. Gmelin, 1789)
13			Grey Francolin*	*Ortygornis pondicerianus*	(J.F. Gmelin, 1789)
14			Crested Partridge†	*Rollulus rouloul*	(Scopoli, 1786)
15			Grey Junglefowl*	*Gallus sonneratii*	Temminck, 1813
16			Malay Cock†	*Gallus* sp.	
17	Phoenicopteriformes	Phoenicopteridae	Greater Flamingo*	*Phoenicopterus roseus*	Pallas, 1811
18	Columbiformes	Columbidae	Rock [Feral] Pigeon*	*Columba livia*	J.F. Gmelin, 1789
19			Eurasian Collared Dove	*Streptopelia decaocto*	(Frivaldszky, 1838)
20			Red Collared Dove	*Streptopelia tranquebarica*	(Hermann, 1804)
21			Spotted Dove	*Streptopelia chinensis*	(Scopoli, 1786)
22			Grey-fronted Green Pigeon*	*Treron affinis*	(Jerdon, 1840)
23	Otidiformes	Otididae	Lesser Florican	*Sypheotides indicus*	(J.F. Miller, 1782)
24	Cuculiformes	Cuculidae	Blue-faced Malkoha	*Phaenicophaeus viridirostris*	(Jerdon, 1840)
25			Jacobin Cuckoo	*Clamator jacobinus*	(Boddaert, 1783)
26			Asian Koel	*Eudynamys scolopaceus*	(Linnaeus, 1758)
27			Grey-bellied Cuckoo	*Cacomantis passerinus*	(Vahl, 1797)
28			Common Hawk-Cuckoo	*Hierococcyx varius*	(Vahl, 1797)
29			Common Cuckoo	*Cuculus canorus*	Linnaeus, 1758

Species No.	Order	Family	Common name	Scientific name	Authority and year of description**
30	Caprimulgiformes	Caprimulgidae	Great Eared-Nightjar†	*Lyncornis macrotis*	(Vigors, 1831)
31	Gruiformes	Rallidae	Corn Crake	*Crex crex*	(Linnaeus, 1758)
32			Eurasian Coot*	*Fulica atra*	Linnaeus, 1758
33			Slaty-breasted Rail	*Lewinia striata*	(Linnaeus, 1766)
34			White-breasted Waterhen	*Amaurornis phoenicurus*	(Pennant, 1769)
35			Slaty-legged Crake†	*Rallina eurizonoides*	(Lafresnaye, 1845)
36			Baillon's Crake	*Zapornia pusilla*	(Pallas, 1776)
37		Gruidae	Sarus Crane†	*Antigone antigone*	(Linnaeus, 1758)
38	Charadriiformes	Recurvirostridae	Black-winged Stilt	*Himantopus himantopus*	(Linnaeus, 1758)
39		Charadriidae	Yellow-wattled Lapwing	*Vanellus malabaricus*	(Boddaert, 1783)
40			Red-wattled Lapwing	*Vanellus indicus*	(Boddaert, 1783)
41			Lesser Sand Plover	*Charadrius mongolus*	Pallas, 1776
42			Kentish Plover	*Charadrius alexandrinus*	Linnaeus, 1758
43			Common Ringed Plover	*Charadrius hiaticula*	Linnaeus, 1758
44		Rostratulidae	Greater Painted-snipe	*Rostratula benghalensis*	(Linnaeus, 1758)
45		Jacanidae	Pheasant-tailed Jacana	*Hydrophasianus chirurgus*	(Scopoli, 1786)
46			Bronze-winged Jacana	*Metopidius indicus*	(Latham, 1790)
47		Scolopacidae	Eurasian Whimbrel	*Numenius phaeopus*	(Linnaeus, 1758)
48			Curlew Sandpiper	*Calidris ferruginea*	(Pontoppidan, 1763)
49			Sanderling	*Calidris alba*	(Pallas, 1764)
50			Common Snipe*	*Gallinago gallinago*	(Linnaeus, 1758)
51			Pin-tailed Snipe*	*Gallinago stenura*	(Bonaparte, 1831)
52		Glareolidae	Collared Pratincole	*Glareola pratincola*	(Linnaeus, 1766)
53		Laridae	Brown-headed Gull	*Chroicocephalus brunnicephalus*	(Jerdon, 1840)
54			Lesser Black-backed Gull	*Larus fuscus*	Linnaeus, 1758
55			Caspian Tern	*Hydroprogne caspia*	(Pallas, 1770)
56			Whiskered Tern	*Chlidonias hybrida*	(Pallas, 1811)
57	Ciconiiformes	Ciconiidae	Asian Openbill	*Anastomus oscitans*	(Boddaert, 1783)
58			Black Stork	*Ciconia nigra*	(Linnaeus, 1758)
59			Woolly-necked Stork	*Ciconia episcopus*	(Boddaert, 1783)
60			Lesser Adjutant	*Leptoptilos javanicus*	(Horsfield, 1821)
61			Greater Adjutant†	*Leptoptilos dubius*	(J.F. Gmelin, 1789)
62	Suliformes	Anhingidae	Oriental Darter	*Anhinga melanogaster*	Pennant, 1769
63		Phalacrocoracidae	Great Cormorant	*Phalacrocorax carbo*	(Linnaeus, 1758)

Species No.	Order	Family	Common name	Scientific name	Authority and year of description**
64	Pelecaniformes	Pelecanidae	Spot-billed Pelican	*Pelecanus philippensis*	J.F. Gmelin, 1789
65		Ardeidae	Eurasian Bittern	*Botaurus stellaris*	(Linnaeus, 1758)
66			Cinnamon Bittern	*Ixobrychus cinnamomeus*	(J.F. Gmelin, 1789)
67			Grey Heron	*Ardea cinerea*	Linnaeus, 1758
68			Purple Heron	*Ardea purpurea*	Linnaeus, 1766
69			Intermediate Egret	*Ardea intermedia*	Wagler, 1829
70			Eastern Cattle Egret	*Bubulcus coromandus*	(Boddaert, 1783)
71			Indian Pond Heron	*Ardeola grayii*	(Sykes, 1832)
72			Striated Heron	*Butorides striata*	(Linnaeus, 1758)
73		Threskiornithidae	Black-headed Ibis	*Threskiornis melanocephalus*	(Latham, 1790)
74	Accipitriformes	Accipitridae	Egyptian Vulture	*Neophron percnopterus*	(Linnaeus, 1758)
75			Crested Honey Buzzard	*Pernis ptilorhynchus*	(Temminck, 1821)
76			White-rumped Vulture*	*Gyps bengalensis*	(J.F. Gmelin, 1788)
77			Red-headed Vulture	*Sarcogyps calvus*	(Scopoli, 1786)
78			Indian Vulture	*Gyps indicus*	(Scopoli, 1786)
79			Crested Serpent-Eagle	*Spilornis cheela*	(Latham, 1790)
80			Short-toed Snake-Eagle	*Circaetus gallicus*	(J.F. Gmelin, 1788)
81			Booted Eagle	*Hieraaetus pennatus*	(J.F. Gmelin, 1788)
82			Bonelli's Eagle	*Aquila fasciata*	Vieillot, 1822
83			Western Marsh Harrier	*Circus aeruginosus*	(Linnaeus, 1758)
84			Pied Harrier	*Circus melanoleucos*	(Pennant, 1769)
85			Montagu's Harrier	*Circus pygargus*	(Linnaeus, 1758)
86			Black Kite*	*Milvus migrans*	(Boddaert, 1783)
87			Brahminy Kite	*Haliastur indus*	(Boddaert, 1783)
88			Long-legged Buzzard	*Buteo rufinus*	(Cretzschmar, 1829)
89	Strigiformes	Tytonidae	Western Barn Owl*	*Tyto alba*	(Scopoli, 1769)
90		Strigidae	Indian Eagle-Owl	*Bubo bengalensis*	(Franklin, 1831)
91			Spotted Owlet*	*Athene brama*	(Temminck, 1821)
92	Coraciiformes	Alcedinidae	Common Kingfisher*	*Alcedo atthis*	(Linnaeus, 1758)
93			White-throated Kingfisher*	*Halcyon smyrnensis*	(Linnaeus, 1758)
94		Alcedinidae	Pied Kingfisher*	*Ceryle rudis*	(Linnaeus, 1758)
95		Meropidae	Asian Green Bee-eater*	*Merops orientalis*	Latham, 1801
96			Blue-tailed Bee-eater*	*Merops philippinus*	Linnaeus, 1767
97		Coraciidae	Indian Roller*	*Coracias benghalensis*	(Linnaeus, 1758)
98	Piciformes	Picidae	Black-rumped Flameback	*Dinopium benghalense*	(Linnaeus, 1758)

Species No.	Order	Family	Common name	Scientific name	Authority and year of description**
99	Falconiformes	Falconidae	Common Kestrel	*Falco tinnunculus*	Linnaeus, 1758
100			Peregrine (Shaheen) Falcon	*Falco peregrinus peregrinator*	Sundevall, 1837
101	Psittaciformes	Psittaculidae	Rose-ringed Parakeet*	*Psittacula krameri*	(Scopoli, 1769)
102			Plum-headed Parakeet*	*Psittacula cyanocephala*	(Linnaeus, 1766)
103	Passeriformes	Campephagidae	Large Cuckooshrike	*Coracina macei*	(R.P. Lesson, 1831)
104			Black-headed Cuckooshrike	*Lalage melanoptera*	(Rüppell, 1839)
105		Oriolidae	Indian Golden Oriole	*Oriolus kundoo*	Sykes, 1832
106		Artamidae	Ashy Woodswallow	*Artamus fuscus*	Vieillot, 1817
107		Aegithinidae	Common Iora	*Aegithina tiphia*	(Linnaeus, 1758)
108		Dicruridae	Black Drongo*	*Dicrurus macrocercus*	Vieillot, 1817
109			White-bellied Drongo	*Dicrurus caerulescens*	(Linnaeus, 1758)
110		Monarchidae	Indian Paradise-Flycatcher	*Terpsiphone paradisi*	(Linnaeus, 1758)
111		Laniidae	Brown Shrike	*Lanius cristatus*	Linnaeus, 1758
112			Bay-backed Shrike	*Lanius vittatus*	Valenciennes, 1826
113		Corvidae	House Crow*	*Corvus splendens*	Vieillot, 1817
114			Indian Jungle Crow*	*Corvus culminates*	Sykes, 1832
115		Alaudidae	Jerdon's Bush Lark*	*Mirafra affinis*	Blyth, 1845
116		Cisticolidae	Plain Prinia	*Prinia inornata*	(Sykes, 1832)
117		Pycnonotidae	Red-vented Bulbul*	*Pycnonotus cafer*	(Linnaeus, 1766)
118			Red-whiskered Bulbul	*Pycnonotus jocosus*	(Linnaeus, 1758)
119			White-browed Bulbul	*Pycnonotus luteolus*	(R.P. Lesson, 1841)
120		Leiothrichidae	Common Babbler	*Argya caudata*	(Dumont, 1823)
121		Sturnidae	Common Starling	*Sturnus vulgaris*	Linnaeus, 1758
122			Brahminy Starling	*Sturnia pagodarum*	(J.F. Gmelin, 1789)
123		Turdidae	Nilgiri Thrush†	*Zoothera neilgherriensis*	(Blyth, 1847)
124		Muscicapidae	Indian Robin	*Copsychus fulicatus*	(Linnaeus, 1766)
125			Oriental Magpie-Robin	*Copsychus saularis*	(Linnaeus, 1758)
126			Black Redstart	*Phoenicurus ochruros*	(S.G. Gmelin, 1774)
127			Pied Bush Chat	*Saxicola caprata*	(Linnaeus, 1766)
128			Desert Wheatear	*Oenanthe deserti*	(Temminck, 1825)
129		Nectariniidae	Purple-rumped Sunbird	*Leptocoma zeylonica*	(Linnaeus, 1766)
130			Purple Sunbird	*Cinnyris asiaticus*	(Latham, 1790)
131			Loten's Sunbird	*Cinnyris lotenius*	(Linnaeus, 1766)
132		Estrildidae	Red Avadavat	*Amandava amandava*	(Linnaeus, 1758)
133		Passeridae	House Sparrow*	*Passer domesticus*	(Linnaeus, 1758)
134		Ploceidae	Baya Weaver*	*Ploceus philippinus*	(Linnaeus, 1766)
135		Motacillidae	Forest Wagtail	*Dendronanthus indicus*	(J.F. Gmelin, 1789)
136			White-browed Wagtail	*Motacilla maderaspatensis*	J.F. Gmelin, 1789

Note: Taxonomy, nomenclature, and description details are per Gill F. Bennington, D. Donsker, and P. Cecile Rasmussen, eds., IOC World Bird List (v13.1), https://www.worldbirdnames.org/bow/ and https://www.worldbirdnames.org/new/ioc-lists/master-list-2/ (accessed 16 February 2023) (IOC World Bird List).

* Bird species observed by Elizabeth Gwillim in Madras, as identified in her correspondence. The rest of the species listed were painted by her, documented in the McGill Archival Collection Catalogue, 2021, https://archivalcollections.library.mcgill.ca/index.php/birds.

** Parentheses around the authority's name and year of description "indicate that the species was originally described under a different name, so synonyms exist. If there are no parentheses, the species has only had one scientific name and the author correctly placed it in the right genus when first described" (IOC World Bird List).

† Species is not native to Madras and appears to have been sourced from outside Madras area.

Table Note

I am grateful to Victoria Dickenson for inviting me to be part of the Gwillim Network and leading me through the Gwillim Project. Lauren Williams readily helped me with many queries on the Gwillim Archival Collection. Anna Winterbottom has been a great support and an invaluable link in the project. I cannot thank her enough for responding readily to my innumerable queries and requests, and her many editorial inputs greatly improved the quality of this chapter. I am thankful to Shyamal Lakshminarayanan, Prashanth Mohanraj, and Aasheesh Pittie for reading through earlier drafts of this chapter and offering valuable comments and suggestions. Shyamal, the "Wikipedia extraordinaire," provided me with many supporting insights. M. Sanjappa and A.N. Sringeswara helped with identifications of many plants depicted in Elizabeth Gwillim paintings. K.A. Subramanian identified the dragonfly in one of Elizabeth Gwillim's paintings. The access provided to archival material by the Gwillim Network, at McGill in Montreal, and the South Asian Decorative Arts and Crafts Collection Trust, Norwich, is gratefully acknowledged. I thank the network members for sharing their insights and work. Finally, I would like to thank Nora Shaalan, Emily Zinger, Myles Browne, Saraphina Masters, and Hana Nikčević for their support at various stages of the project.

Notes

1 Wood, "Lady [Elizabeth] Gwillim," 595. See also Keulemans and Coldewey, *Feathers to Brush*; Lodge, "Obituary: Henrik Grønvold."

2 Wood, "Lady [Elizabeth] Gwillim."

3 McGill Archival Collections Catalogue, Gwillim Collection, https://archivalcollections.library.mcgill.ca/index.php/gwillim-collection.

4 Audubon, *The Birds of America*.

5 Lank, "Forgotten Women of Wildlife Art." Shteir, *Cultivating Women*.

6 Elizabeth Gwillim to Esther Symonds, n.d. [1805], British Library, India Office Records (BL IOR) Mss. Eur.C.240/4, ff. 301r–302v, on ff. 301v–302r.

7 Elizabeth Gwillim to Esther Symonds, n.d. [1805], BL Mss.Eur.C.240/4, ff. 271r–278v, on ff.274v–275r.

8 Wood, "Lady [Elizabeth] Gwillim"; Warr, *Manuscripts and Drawings*; "Obituary: Mr. H. Kirke Swann"; Clerk and Bannerman, "Obituary: William Lutley Sclater.

9 Jerdon, "Catalogue of the Birds of the Peninsula of India"; Oates, *The Fauna of British India*.

10 Partly owing to changes in taxonomy in recent years, as well as corrections to earlier misidentifications, the nomenclature of the birds Gwillim painted has now been updated in the McGill catalogue based on my identifications. See Gill, Bennington, Donsker, and Rasmussen, eds., *IOC World Bird List* v11.1 (2021), https://www.worldbirdnames.org/new/ioc-lists/master-list-2/, and the McGill Archival Collections Catalogue, https://archivalcollections.library.mcgill.ca/index.php/gwillim-collection. See also the list in appendix B at the end of this chapter.

11 Ray, *Synopsis methodica avium & piscium*; Love, *Vestiges of Old Madras*; Pittie, *Birds in Books*; Winterbottom, *Hybrid Knowledge*.

12 Pittie, *Birds in Books*.

13 Albin, *A Natural History of Birds*.

14 Edwards, *A Natural History of Uncommon Birds*; Edwards, *Gleanings of Natural History*.

15 Linnaeus, *Systema naturæ ... Editio decima*; Linnaeus, *Systema naturæ ... Editio duodecima, reformata*. See also Pittie, *Birds in Books*.

16 Pennant, *Indian Zoology*; Donald Ferguson, "Joan Gideon Loten."

17 Latham, *A General Synopsis of Birds*.

18 Elizabeth kept pigeons when she lived in Hereford, and seems very fond of birds. She also visited the popular Leverian Museum and may have seen watercolours of birds by Sarah Stone or Charles Reuben Ryley (see Anna Winterbottom's introduction to this volume).

19 Bewick, *A History of British Birds*.

20 Elizabeth Gwillim to Hester James, n.d. [spring 1803], BL IOR Mss.Eur.C.240/2, ff. 167r–177v.

21 Catesby, *The Natural History of Carolina*; Elizabeth Gwillim to Hester James, n.d. [spring 1803], BL IOR Mss.Eur.C.240/2, ff. 167r–177v, on f. 176r.

22 White, *The Natural History and Antiquities of Selborne*; Elizabeth Gwillim to Hester James, n.d. [spring 1803], BL IOR Mss.Eur.C.240/2, ff. 167r–177v, on f. 176r.

23 For example Elizabeth Gwillim to Hester James, n.d. [spring 1803], BL IOR Mss.Eur.C.240/2, ff. 167r–177v, on f. 177r; Winterbottom, "Elizabeth Gwillim's Botanical Networks."

24 Elizabeth Gwillim to Hester James, n.d. [spring 1803], BL IOR Mss.Eur.C.240/2, ff. 167r–177v, on f. 177r. The request for the copy of Bewick was made in 1805. Elizabeth Gwillim to Hester James, 6 March 1805, BL IOR, Mss.Eur.C.240/4, f. 264r.

25 Elizabeth Gwillim to Hester James, n.d. [spring 1803], BL IOR Mss.Eur.C.240/2, ff. 167r–177v, on f. 177r.

26 The possibilities for the occurrence of local birds are taken from the eBird checklist of present-day Chennai and compared with the birds painted by Lady Gwillim. The nomenclature follows that used for birds of the Chennai region on eBird, an application and online database of bird distribution and abundance, Cornell Lab of Ornithology, 2023, http://www.ebird.org (hereafter eBird); *Gill, Donsker, and Rasmussen eds., IOC World Bird List 2021* (version 13.1), https://www.worldbirdnames.org/new/ioc-lists/master-list-2/. Elizabeth Gwillim to Hester James, n.d. [spring 1803], BL IOR Mss.Eur.C.240/2, ff. 167r–177v, on f. 177r.

27 Elizabeth Gwillim to Hester James, n.d. [spring 1803], BL IOR Mss.Eur.C.240/2, ff. 167r–177v, on f. 177r.

28 S. Ali and Ripley, *Handbook of the Birds of India*, vol. 5.

29 Elizabeth Gwillim to Hester James, no date [spring 1803], BL IOR Mss.Eur.C.240/2, ff. 167r-177v, on f. 174v. "Pariah," which is now widely considered an offensive term, comes from *paraiyar* in Tamil, meaning "scavenger." Raj Sekhar Basu, *Nandanar's Children*; Agoramoorthy, "Disallow Caste Discrimination."

30 S. Ali and Ripley, *Handbook of the Birds of India,* vol. 5.

31 Elizabeth Gwillim to Hester James, n.d. [spring 1803] Mss.Eur.C.240/2, ff. 167r–177v, on f. 173v.

32 Ibid., f. 174v.

33 Ibid., f. 175r.

34 These and all other paintings by Elizabeth Gwillim mentioned below are in the Blacker Wood Collection of the McGill University Library: the Asian Koel, 1-022; the Grey-bellied Cuckoo, 1-078; and the Common Hawk Cuckoo, 1-079. The identification numbers used here correspond to the reference codes (CA RBD Gwillim-1-002 to Gwillim-1-121), given to the paintings in Series 1 of the Gwillim Collection in the McGill Archival Collection Catalogue, https://archivalcollections.library.mcgill.ca/index.php/gwillim-collection. Hereafter the codes are abbreviated to 1-001, 1-002 etc.

35 The Jacobin Cuckoo, 1-081; the Common Cuckoo, 1-114.

36 Elizabeth Gwillim to Hester James, n.d. [spring 1803] Mss.Eur.C.240/2, ff. 167r–177v, on f. 175r.

37 Ibid. See eBird, 2022.

38 Elizabeth Gwillim to Hester James, n.d. [spring 1803] Mss.Eur.C.240/2, ff. 167r–177v, on f. 175r.

39 Purple-rumped Sunbird, 1-090 and 1-120; Purple Sunbird and Long-billed Sunbird, 1-089.

40 Elizabeth Gwillim to Hester James, n.d. [spring 1803] Mss.Eur.C.240/2, ff. 167r–177v, on f. 175r.

41 Ibid.

42 Ibid.

43 See S. Ali and Ripley, *Handbook,* vol. 5.

44 See eBird. 2022.

45 S. Ali and Ripley, *Handbook,* vol. 5.

46 Elizabeth Gwillim to Hester James, n.d. [spring 1803] Mss.Eur.C.240/2, ff. 167r–177v, on 175v.

47 Elizabeth Gwillim to Hester James, 18 March 1802, BL IOR Mss.Eur.C.240/1, ff. 55r–57v, on f. 58v.

48 "I sent you a nest by Mr. Templar which I hope you received": Elizabeth Gwillim to Hester James, n.d. [spring 1803], BL IOR Mss.Eur.C.240/2, ff. 167r–177v, on f. 175v.

49 Ibid.

50 Naoroji, *Birds of Prey.*

51 Martyn, *The Gardener's and Botanist's Dictionary*; Elizabeth Gwillim to Hester James, 6 March 1805, BL IOR Mss.Eur.C.240/4, ff. 258r–266r, on f. 263v.

52 Linnaeus, *Systema naturæ … Editio decima tertia*; Elizabeth Gwillim to Hester James, 24 August 1805, BL IOR Mss.Eur.C.240/4, ff.279r–296v, on f. 288v.

53 Lesser Florican, 1-023. Linnaeus, *Systema naturæ … Editio decima tertia,* Tome 1, Part 2, p. 725.

54 Lesser Sand Plover, 1-051.

55 Linnaeus, *Species Plantarum,* 1: 550; Jussieu, "Mémoire sur le groupe des Méliacées."

56 Pied Harrier, 1-062; Whimbrel, 1-044; Brown-headed Gull, 1-021; White-browed Wagtail, 1-104.

57 Elizabeth Gwillim to Hester James, 11 February, 1806, BL IOR, Mss.Eur.C.240/4, ff. 310r–313v, on f. 311v.

58 Mary Symonds to Hester James, 7 February 1803, BL IOR Mss.Eur.C.240/2, ff. 100r–103v, on f. 102r.

59 Mary Symonds to Esther Symonds, 2 February 1805, BL IOR ff. 248r–252v, on ff. 249v–250r.

60 Pequignot, "The History of Taxidermy."

61 Farber, "The Development of Taxidermy"; Browne, *Practical Taxidermy.*

62 Ritter, "'Wonderful Objects'"; W.J. Smith and King, "'Sir Ashton Lever," 80; King, "New Evidence for the Contents of the Leverian Museum," 177.

63 American Museum of Natural History (AMNH) Bird Collection, Record ID: SKIN-746613, https://emu-prod.amnh.org/db/emuwebamnh/index.php.

64 Naturalis Biodiversity Center, Leiden, Netherlands, specimens collection dataset, https://doi.org/10.15468/dl.9qqeek, accessed via GBIF.org.

65 AMNH Bird Collection, Record ID: SKIN-556524.

66 Pequignot, "The History of Taxidermy."

67 Elizabeth Gwillim to Esther Symonds, 23 January 1802, BL IOR Mss.Eur.C.240/1, ff. 21r–32r, on f. 31r.

68 Based on the quality of the drawing (CA RBD Gwillim-2-07) and this passage, Elizabeth Gwillim possibly drew this catch on the outward voyage of the *Hindostan*. The paper used for this image is different from that used for the other fish drawings, most of which can be attributed to Mary Symonds (see case study 2, by Shyamal Lakshminarayanan and Hana Nikčević, in this volume).

69 Elizabeth Gwillim to Hester James, 11 February 1806, BL IOR Mss.Eur.C.240/4, ff. 310r–313v, on ff. 313r–313v; Elizabeth Gwillim to Esther Symonds, 7 March 1804, BL IOR Mss.Eur.C.240/3, ff. 184r–192v, on ff. 187v–188r.

70 Elizabeth Gwillim to Hester James, 11 February 1806, BL IOR Mss.Eur.C.240/4, ff. 310r–313v, on ff. 310v–311r.

71 Mary Symonds to Esther Symonds, 2 February 1805, BL IOR Mss.Eur.C.240/4, ff. 248r–252v, on f. 250r.

72 Elizabeth Gwillim to Esther Symonds, n.d. [1805], BL IOR Mss.Eur.C.240/4, ff. 300v–302v, on ff. 301v–302r; Elizabeth Gwillim to Esther Symonds, n.d. [1805], BL IOR Mss.Eur.C.240/4, ff. 271r–278v, on ff. 271r–272v.

73 Gwillim is also known to have painted an Asian palm civet or the Toddy cat (*Paradoxurus hermaphroditus*, family: Viverridae) from Dr Anderson's garden (Mary Symonds to Hester James, 7 February 1803, BL IOR, Mss.Eur.C.240/2, ff. 100r–103v), and a leopard cat (*Prionailurus bengalensis*, family: Felidae, referred to as a "Tiger cat, which a Captain Cleveland was taking home" (Elizabeth Gwillim to Hester James, 11 February 1806, BL IOR Mss.Eur.C.240/4, ff. 310r–313v, on ff. 313r–313v).

74 Mary Symonds to Esther Symonds, 2 February 1805, BL IOR Mss.Eur.C.240/4, ff. 248r–252v, on ff. 249v–250r.

75 Ibid., f. 252v.

76 Painting 1-023.

77 Possibly Nathaniel Dance Holland. See "Nathanial Dance," British Museum, https://www.britishmuseum.org/collection/term/BIOG68097.

78 Crested Serpent-Eagle, 1-013.

79 Topsfield, "Natural History Paintings."

80 Sarus Crane, 1-038.

81 Snyder, "Complexity in Creation."

82 For the reference to the canary, see Elizabeth Gwillim to Hester James, 13 August 1803, BL IOR Mss.Eur.C.240/2, ff. 128r–133v, on f. 131v; Cockatoo: Elizabeth Gwillim to Hester James, n.d. [1803], BL IOR Mss.Eur.C.240/2, ff. 167r–177v, on f. 172v; Cassowary: Mary Symonds to Hester James, 7 February 1803, BL IOR Mss.Eur.C.240/2, ff. 104r–106v, on f. 106r; Crowned Pigeon: Elizabeth Gwillim to Hester James, 18 October, 1802, BL IOR Mss.Eur.C.240/1, ff. 88r–91v, on f. 90r; Crested Partridge and Argus Pheasant: Mary Symonds to Hester James, 28 February 1804, BL IOR Mss.Eur.C.240/3, ff. 179r–183v, on f. 183r. The Crested Partridge is in the McGill Gwillim Collection, painting 1-094.

83 Greater Adjutant, 1-039. S. Ali and Ripley, *Handbook of the Birds of India*, vol. 1. Collar, *Threatened Birds of Asia*.

84 Clements, *The Clements Checklist.*

85 Crested Partridge, 1-094. Philip J.K. McGowan, Guy M. Kirwan, and Peter F.D. Boesman, "Crested Partridge (*Rollulus rouloul*)," version 1.0,

Birds of the World, Cornell Lab of Ornithology, 2020, https://birdsoftheworld.org/bow/species/crepar1/1.0/introduction.

86 Buchanan, *A Journey from Madras.*

87 Ramachandran et al., "Hunting or Habitat?"

88 Rangarajan, "The Raj and the Natural World."

89 Plain Prinia, 1-100.

90 *Rasmussen* and *Anderton, Birds of South Asia*. Figure 4 shows the results of a correlation analysis between the body sizes of the birds painted and the sizes of the art paper used by Elizabeth Gwillim in her 121 paintings. This analysis reveals that Elizabeth always used paper suited to the body size of the birds (enclosed within the oval to the left of the image), with the exception of ten paintings (found within the oval to the right). These ten paintings are therefore likely to have been made on smaller paper as a result of the lack of drawing paper of suitable sizes, as they had to be sourced from England (which is also mentioned in the letters).

91 Oriental Darter, 1-026; Grey Heron, two paintings: 1-033 and 1-034; Intermediate Egret, 1-035; and Lesser Adjutant, 1-040; Asian Openbill, 1-041; Red-headed Vulture, 1-059; Spot-billed Pelican, 1-117.

92 Inscription on the reverse of painting 1-040.

93 Purple-rumped Sunbird, 1-120; Red Avadavats, 1-121. Nikčević, "'I Shall Want Colours and Paper.'"

94 Marsh Harrier, 1-061.

95 Chaste tree, 1-017; drumstick, 1-010 and 1-118; neem tree, 1-022; mango blossoms, 1-108.

96 Shaheen Falcon, 1-065; White-browed Wagtail, 1-104.

97 Audubon, *The Birds of America.*

98 Dalrymple, "Paintings for the East India Company."

99 S. Ali and Ripley, *Handbook of the Birds of India.*

100 See the paintings of the Eurasian Bittern, 1-029; the Cinnamon Bittern, 1-043; and Baillon's Crake, 1-058.

101 Pond Heron, 1-031.

102 Brown-headed Gull, 1-021; Intermediate Egret, 1-035; Bronze-winged and Pheasant-tailed Jacanas, 1-054, 1-055; Pied Harrier, 1-062, and Montagus's Harrier, 1-063, 1-064; Large Cuckooshrike, 1-074; Black-headed Cuckooshrike, 1-075; Oriental Magpie Robin, 1-085; Ashy Woodswallow, 1-086; Blue-faced Malkoha, 1-087; Eurasian Collared Dove, 1-095; Forest Wagtail, 1-103; Common ringed Plover, 1-109.

103 Inscription on the reverse of 1-091. Edward Vaughan (1776–1849), an Anglican priest, was the second archdeacon of Madras in the early nineteenth century.

104 S. Ali and Ripley, *Handbook of the Birds of India*, vol. 2.

105 Common Babbler, 1-076; Purple and Long-billed Sunbird (males), 1-089; Indian Paradise Flycatcher, 1-118; fledglings of the Purple-rumped Sunbird, 1-120.

106 S. Ali and Ripley, *Handbook of the Birds of India*; *Rasmussen* and *Anderton, Birds of South Asia*; eBird, 2022.

107 Collar, *Threatened Birds of Asia*.

108 Slaty-breasted Crake, 1-056; Great-eared Nightjar, 1-111; Nilgiri Thrush, 1-113; and Malay Cock, 1-030.

109 Indian Vulture, 1-006.

110 Egyptian Vulture, 1-007; Oriental Darter, 1-026; Curlew Sandpiper, 1-045.

111 See Praveen Jayadevan, Rajah Jayapal, and Aasheesh Pittie, Checklist of the Birds of India version 5.1, 31 October 2021, http://www.indian-birds.in/india/.

112 Corn Crake, 1-115. S. Ali and Ripley, *Handbook of the Birds of India*.

113 Common Ringed Plover, 1-109; Common Starling, 1-112; and Desert Wheatear, 1-116. eBird, 2022; Santharam, "The Desert Wheatear."

114 Bloomberg News, "How One of the World's Wettest Major Cities Ran Out of Water," 3 February 2021, https://www.bloomberg.com/news/features/2021-02-03/how-a-water-crisis-hit-india-s-chennai-one-of-the-world-s-wettest-cities; see also Vikram Bhatt and Vinita Damodaran's chapter in this book.

115 "International Code of Zoological Nomenclature," Article 23, Principle of Priority International Commission on Zoological Nomenclature, https://www.iczn.org/the-code/the-code-online/.

116 Wood, "Lady [Elizabeth] Gwillim," 597.

117 S. Ali and Ripley, *Handbook of the Birds of India*, vol. 1.

118 Boddaert, *Table des planches enluminéez*, 25n416; Prideaux, *Catalogue*, 3.

119 Inscription on back of painting CA RBD Gwillim-1-002.

120 Elizabeth Gwillim to Hester James, n.d. [1803], BL IOR Mss.Eur.C.240/2, ff. 167r–177v, on f. 176r.

121 Daniélou, *The Myths and Gods of India*, 161.

122 Buffon, "Le héron violet."

123 Buffon, Martinet, Daubenton, and Daubenton, "Heron, de la côte de Coromandel."

124 Boddaert, *Table des planches enluminéez*, 54n906.

125 S. Ali and Ripley, *Handbook of the Birds of India*, vol. 1.

126 "*Calamus rotang L.*," India Biodiversity Portal 2021, https://indiabiodiversity.org/species/show/258788.

127 "*Calamus dioicus*," Royal Botanic Gardens, Kew, Plants of the World online, https://powo.science.kew.org/taxon/urn:lsid:ipni.org:names:665052-1.

128 S. Ali and Ripley, *Handbook of the Birds of India*, vol. 1.

129 "*Mystus gulio* (Hamilton, 1822), Long whiskers catfish," http://www.fishbase.org/summary/5139.

130 S. Ali and Ripley, *Handbook of the Birds of India*, vol. 1.

131 "*Senegalia rugata* (Lam.) Britton & Rose," Royal Botanic Gardens, Kew, *Plants of the World Online*, https://powo.science.kew.org/taxon/urn:lsid:ipni.org:names:518300-1.

132 S. Ali and Ripley, *Handbook of the Birds of India*, vol. 1.

133 Elizabeth Gwillim to Hester James, n.d. [1803], BL IOR Mss.Eur.C.240/2, ff. 167r–177v, on f. 171v.

134 S. Ali and Ripley, *Handbook of the Birds of India*, vol. 1.

135 Elizabeth Gwillim to Esther Symonds, 23 January 1802, BL IOR Mss.Eur.C.240/1, ff. 21r–32r, on f. 26v.

136 S. Ali and Ripley, *Handbook of the Birds of India*, vol. 1.

137 Pennant, *Indian Zoology*, 52, plate 14.

138 Shortt, "Gwillim as Artist and Ornithologist."

139 S. Ali and Ripley, *Handbook of the Birds of India*, vol. 3.

140 Linnaeus, *Species Plantarum* (1753), 384.

141 "Malay Chicken," The Livestock Conservancy, https://www.livestockconservancy.org/index.php/heritage/internal/malay.

142 Ibid.; Ekarius, *Storey's Illustrated Guide*; Tegetmeire, *The Poultry Book*.

143 Temminck, *Histoire naturelle*; Sykes, "Catalogue of Birds", 151; Tegetmeire, *The Poultry Book*; Grouw and Dekkers, "Temminck's *Gallus Giganteus*."

144 S. Ali and Ripley, *Handbook of the Birds of India*, vol. 3.

145 Identified by Dr. Henry J. Noltie, personal communication (email, 2021).

146 S. Ali and Ripley, *Handbook of the Birds of India*, vol. 1.

147 Ibid.

148 Hardgrave, *The Nadars of Tamilnad*.

149 Mary Symonds to Hester James, n.d. [1807], BL IOR Mss.Eur.C.240/4, ff. 376r–377v, on f. 376v.

150 S. Ali and Ripley, *Handbook of the Birds of India*, vol. 9.

151 Elizabeth Gwillim to Hester James, 7 February 1802, BL IOR Mss.Eur.C.240/1, ff. 33r–38v, on ff. 35r–35v.

152 Finn, *Garden and Aviary Birds of India*, 106–7.

153 S. Ali and Ripley, *Handbook of the Birds of India*, vol. 6.

154 Elizabeth Gwillim to Hester Symonds James, 18 March 1802, BL IOR Mss.Eur.C.240/1, ff. 49r–54v, on f. 52r.

— Case Study 2 —

"Curious for Fish"

Ichthyological Watercolours

SHYAMAL LAKSHMINARAYANAN AND HANA NIKČEVIĆ

In an article published in *The Ibis* in 1925, Casey A. Wood recounted his for-tuitous visit to a London dealer of *objets d'art*. Wood had been seeking "any old drawings or paintings of birds or other animals," and, to his amazement and delight, he left with a brass-bound portfolio containing Elizabeth Gwillim's bird paintings (works "by the hand of no mean draughtsman," he noted). Gwillim's birds had materialized because a salesman had happened to recall the paintings and chose to root around in the cellar for them. While this clerk searched, Wood was occupied with a selection of other zoological waterco-lours, the first set that the dealer had proffered him.[1]

This set was, per Wood, "a parcel containing about thirty small (10 x 14 in.) mounted and coloured drawings of Indian Fishes." "Each mat bore an auc-tioneer's (or dealer's) printed number; a few were signed 'E.G.,' and upon still more were written legends (that Sir Henry Drake-Brockman later translated for me as Urdu) of the native names of the subjects portrayed." Although he did not grant the fish quite the same praise he bestowed upon Gwillim's birds, Wood nevertheless purchased the lot, and they remain in McGill University's Blacker Wood Collection to this day.

Of the thirty-one watercolour paintings in this album, twenty-nine are illustrations of fish, one is a painting of a Marsh Crocodile (*Crocodylus palustris*), and one is of a Portuguese Man o' War (*Physalia physalis*). Many bear pencilled numbers, likely written by Elizabeth Gwillim or her sister Mary Symonds; on the Moon Wrasse (*Thalassoma lunare*) painting, the number 14 is written upside-down, suggesting that the numbering system and the illustrations were not completed simultaneously. Although only thirty-one images survive, the

numbering system indicates that there were originally at least fifty-two paint-
ings. Perhaps, like Gwillim's bird paintings, some of the collection had already
been sold. Despite Casey Wood's claim, the initials "E.G." do not now appear
on any of the paintings, although three do bear notes.[2] The scientific names
included on each of the paintings may have been contributed by a fish expert,
possibly at the British Museum, where Wood had connections; not all of these
scientific names are accepted today. The inscriptions rendered in ink on ten
of the images and described as "Urdu" by Sir Henry Drake-Brockman may
have been added at the time of painting; the pencil transliterations were likely
supplied by Henry Mousley, Wood's librarian. The watercolour of the Marsh
Crocodile (plate 32) bears additional pencil inscriptions, most likely from the
artist: "10 feet" and "a large alligator taken from the ditch at Vellore." There
is no indication that Elizabeth Gwillim or Mary Symonds visited Vellore, but
they clearly had contacts there, apparently including Amelia Farrer, Lady
Fancourt, whose account of the mutiny or uprising of July 1806 Symonds later
received.[3] Perhaps Fancourt or another correspondent sent either a specimen
or an image of the creature.

Wood's greater esteem for the bird paintings reflects the slightly sketchier
rendering of the fish. While twelve of the watercolours depict their specimens
floating in negative space, the nineteen that include a suggestion of water do so
in a schematic fashion, featuring a blue-grey wash underneath the central fish.
The watercolours laid down are fairly translucent, and pencil underdrawings
are visible; highlights are often indicated with the negative space of an
unpainted area, with the occasional addition of white paint for animals' eyes.
The technique is often more impressionistic or rudimentary than that employed
for the bird paintings; fish scales, for instance, are occasionally suggested with
pencil cross-hatching underneath the watercolour or simply repeated half-
circle brushstrokes. The paintings are, however, neither poorly done nor grossly
inaccurate. For example, if the illustration of the Pinecone soldierfish (*Myripristis
murdjan*) (plate 33) is compared to Albert C.L.G. Günther's 1875 work (plate 34),[4]
we see accurate counts of the dorsal spines. In contrast, there are inaccuracies in
the number of spines for the Brown-marbled Grouper (*Epinephelus fuscoguttatus*)
when compared to the illustration in Francis Day's *Fishes of Malabar* (1865).
Similarly, the Flying Fish, *Exocoetus* sp. (plate 60), shows several more scale rows
than are present in the two species known from the Eastern Indian Ocean.[5] It is
likely that the artist exercised some artistic licence.

The painting of the Narrow Sawfish (*Anoxypristis cuspidata*) (plate 35),[6] on the
other hand, suggests careful observation and faithful depiction; a distinctive
characteristic of this species is that the basal part of its snout is toothless, and
this element is clearly represented in the watercolour. The representational
style – a fish depicted in a lateral view with minimal or no background –

Shyamal Lakshminarayanan and Hana Nikčević

was likely inspired by the visual methods used for contemporaneous natural history illustrations of fish; British naturalist Thomas Pennant's *Indian Zoology* of 1790, for instance, which the sisters may well have perused in preparation for their trip, features a floating side view of a "Zeylon Wrasse," and natural history artist Sarah Stone's watercolours in John White's 1790 *Journal of a Voyage to New South Wales* also depict fish in this manner. The deployment of an aesthetic that was the province of zoological documentation suggests that the artist was not only familiar with natural history publications but also was interested in presenting her own specimens in accordance with their visual conventions and, thus, within the discourse of scientific knowledge.

Given his identification of Elizabeth Gwillim's handwriting on some of the paintings, Wood postulated that the fish, like the birds, were her work. Passages from the sisters' letters, however, allow us to consider these images anew, shedding light on multiple aspects of the watercolours' creation, including the attribution of at least some of the paintings to Mary Symonds, and the sisters' connections with the local people and environment at the time of their production.

In their letters, both sisters noted the variety of freshwater and marine fish available around Madras. In 1802, Gwillim mentioned travelling in her palanquin to San Thomé to meet the catamarans coming into shore and buying fish directly from the fisherman. She wrote: "I have seen a great variety of fish that I shou'd never other wise have seen for they never bring from the markets any but a few particular kinds – all the rest go by the name of Palankeen boys fish, which is indeed all the name I can get for any of them."[7] Among the catch, she mentioned both edible fish and other types, like the "ink fish," that are curiosities.

In early 1806, Gwillim told her mother about the sisters' recent sojourn in the village of Kovalam/Covelong:

I must ... finish my account of our stay in the old Chapel, which I told you in my last letters we had visited. We spent nearly two months there, and I saw more of India than I ever have done before. We had the building shaded on all sides with sloping roofs of palm leaves, and the thick walls and roof defended us so well from the land winds that I attribute Sir Henry's good health in a great measure to them. *Covelong, or properly Comalam*, was a settlement made by the Emperor of Germany, but the port and all were destroyed as the place was an object of jealousy both to the French and English who have their Presidencies on the Coast. The rocks and rivers are romantic as Wales, though the hills are not lofty, and the place is abundant in rarities. *It is particularly curious for fish.* There are fish to be found in no other part of the world, and had I not seen them I could not have believed that such or such varieties existed.

There is every colour: red fish of every tint, green, purple, and yellow, and striped like the most showy flowers, many as if wholly composed of rows of jewels, rubies and topazes set in chains. *Mary drew above thirty sorts,* but that is a mere trifle – it would take an age to do them all. She intends to have sent home these drawings, but, as so many things were lost in the Prince of Wales, Dr. Anderson has entreated that she will let a native copy them before they go home, that they may not be entirely lost if an accident should happen. When that is done you will see them.[8]

Elizabeth's letter gives us insight into the location of the watercolours' production – "Covelong, or properly Comalam" – and indicates that her sister Mary was the artist of at least some of the paintings. Gwillim attributes over thirty images to her sister; the remaining images among the original collection of over fifty could be by either sister.

Covelong, or Kovalam, is a village on the southeast coast of India, forty kilometres south of Chennai and eleven kilometres north of Mahabalipuram. It was originally a port town developed by the nawab of Carnatic, Saadat Ali, but it was taken over by the French in 1746, and then taken again by Lord Robert Clive for the British in 1752. At that point, Clive destroyed the fort to prevent the French from retaking it (thus Elizabeth Gwillim's description of the site as an "object of jealousy").[9] The Catholic church she mentioned still stands on the beach. This church may have been a well-known retreat for British travellers; notably, Henrietta Clive's writings document that she and her daughters made a similar sojourn to the village. In 1800, Lady Clive wrote that she, her two daughters, and the girls' governess, Anna Tonelli (an artist), stayed in an "old ruined Roman Catholic church," dining at one end of the church and sleeping at the other.[10] (Henrietta Clive was the wife of Lord Clive, governor of Madras from 1798 to 1803; in 1802, Gwillim wrote that "it was a disappointment that Lady Clive and her two daughters had left this place, as they also were very free and agreeable."[11])

Elizabeth Gwillim was evidently impressed by the variety and quantity of the fish at Kovalam, comparing them to jewels in myriad hues and noting that painting them all would require "an age." Given that the sisters' time in Kovalam seems to have inspired Mary Symonds to paint this series of fish, it appears that she, too, was fascinated by the village's abundance and diversity of fish. Indeed, Kovalam remains a fishing town to this day, hosting a vast fish market. One can even find current media in which the same fish that so compelled the sisters in 1806 continue to draw people's attention today: videos of the sizeable "*Serranus horridus*" from the McGill watercolours, a fish now known in scientific terminology as *Epinephelus fuscoguttatus* and in common language

as the Brown-marbled Grouper, freshly caught at the Kovalam fish market, capture up close the gaping jaw, glistening scales, and mottled colouring.[12]

The sisters' fish paintings, then, likely offer a historical record of not only Kovalam's aquatic inhabitants but also the fishing traditions of the village's human inhabitants. First, the range of fish depicted in the watercolours provides possible insight into environmental changes, as a few of the species portrayed are today endangered. The Widenosed Guitarfish (*Glaucostegus obtusus*) is now considered critically endangered by the International Union for Conservation of Nature (IUCN).[13] *Anoxypristis cuspidata*, another endangered species, and *Epinephelus lanceolatus* are no longer found in that region.[14]

Furthermore, much as Gwillim acquired not just information about her bird and floral specimens but also, crucially, the specimens themselves from skilled Indian individuals, so, too, did Symonds most likely paint fish that had been retrieved from the ocean by local fishers. Certain species that she depicted represent curiosities or by-catch, such as the Puffer Fish, Portuguese Man o' War, and Flying Fish. Whether they were brought to Symonds expressly for her artistic use is not certain. *The Madras and Environs Album* (see the discussion in Ben Cartwright's chapter in this volume) features a painting of fishermen (plate 36): four men hoist a catamaran (from the Tamil word *kattumaram* for "tied logs") filled with nets, while caught fish sit in the right foreground and soft waves lap at a shoreline in the background. Boats and ships dot the harbour. Could this be Kovalam?

In addition to disclosing that Mary was the sister responsible for painting Kovalam's fish, Elizabeth Gwillim's letter states that Scottish physician and botanist James Anderson (1738–1809) had advised Mary Symonds to have her fish copied by an Indian artist. Whether the fish paintings currently held in the Blacker Wood Collection are Symonds's originals or the copies that may have been done after her illustrations is difficult to ascertain. No further information about the artist who may have been recruited to copy the fish paintings is available, but, since William Roxburgh and Benjamin Heyne (both friends of James Anderson) employed Indian artists in Madras to work on botanical subjects,[15] we know that there were painters in the city capable of making detailed natural history drawings. Given Anderson's close connections with Tanjore, whose ruler, Serfoji II, was a personal friend,[16] it is also possible that the fish artist was drawn from the Tanjore school of painters, who worked for both Indian and European patrons.[17] The *Tanjore Album*, commissioned by Serfoji II and now held at the British Library, also includes paintings of fish.[18] Interestingly, these include a species of snapper, with the local name given as "mooshery" (plate 37), which seems to correspond to the local name given for the John's Snapper (*Lutjanus johnii*) in the Gwillim archive (plate 38).

The inscriptions on some of the McGill fish paintings – identified by Wood's friend Sir Henry Drake-Brockman as "Urdu" – could indicate the hand of an Indian artist. The inscriptions appear to have been written with a calligraphic pen (a bamboo or wooden dip pen with a flat tip). The identification of the script as Urdu was confirmed by Torsten Tschacher, although a number of the inscriptions seem to be transliterations from Tamil. In several cases, including the Moon Wrasse (*Thalassoma lunare*) (plate 39), the inscriptions include the Tamil word for fish, *mīn* ("meen"). The transcription for the Bartail Flathead (*Platycephalus indicus*) is unique in using a Tamil-Arabic (also known as Arwi) character ﻝ to represent the Tamil name *urpātti* or *urpāṟṟi* (with a retroflex -ṟ-). Some of the local names recorded on the margins of the paintings are undocumented and missing from the otherwise comprehensive FishBase database.[19] Fish identification by fishing communities is usually consistent, and local names have, in the past, been incorporated into the Latin binomials, such as those of freshwater fish recorded from the Deccan region by W.H. Sykes.

The combination of Urdu script and Tamil fish names suggests that the inscriptions were added in or around Madras, and, so, at the time of the watercolours' production rather than by a later collector, as Wood suggested. Since the reign of Muhammad Ali Walajah (1749–1795), the court of the nawabs of Arcot had attracted Urdu-speaking scholars and poets from northern India.[20] Despite the loss of political power and territory after Walajah's death, the nawab's court remained a centre for scholarly patronage under Azim ud-Daula.[21] Since the inscriptions were likely written by a speaker of Urdu rather than Tamil, it is possible that they were produced in the ambit of the nawab's court, which, by the early nineteenth century, was based in Triplicane.[22]

So, are those select fish paintings that bear Urdu-Tamil inscriptions "copies" by an Indian artist, while those without are "originals" by Mary Symonds? Perhaps. It is also possible, however, that an Indian individual with knowledge of the local fish species contributed the Urdu-Tamil inscriptions to the original watercolours. We know from the sisters' correspondence that the Gwillim household, with the exception of Symonds, were engaged in learning local languages.[23] As Henry Noltie and Saraphina Masters note in this volume (see chapter 4 and case study 3), Elizabeth Gwillim's interests in botany and local languages were intertwined; she had an interest in learning species names in the local languages and frequently asked local Indian experts about their knowledge on the matter.[24] As she recorded in 1802, Gwillim was in the habit of discussing fish and their names with local fishermen. It is thus possible that she or her sister desired that the original fish paintings be annotated with the local names. Another possibility is that an individual employed by the Gwillim-Symonds family acted as an intermediary between the sisters and the deliverer and identifier of the fish.

The fish paintings can also be considered in the context of scientific studies of fish from southern India.[25] Fisherfolk have long been considered reliable identifiers of fish, at least of those of utility, and pre-Linnaean works on fish include those of the Strasbourg fisherman and naturalist Leonhard Baldner (1612–1694). The codification of western knowledge of fish diversity accounted, though unreliably, for species from India;[26] in the tenth edition of the *Systema Naturae* (1758), Linnaeus described and provided binomial names for several species from the Indian region, basing his text on specimens, descriptions, or illustrations available to him. Several of these species were associated with only vague locations by virtue of the tenuous networks through which information travelled. His "apostle" Peter Forsskål (1732–1763) travelled east to the Red Sea and collected specimens and recorded localities more carefully than others; he died, however, on the expedition. Forsskål made use of Arabic names used in the Red Sea region, such as *murdjan* and *djarbua*, in his binomial nomenclature.[27] Marcus Elieser Bloch (1723–1799) produced a meticulously illustrated catalogue of the fishes of Germany as well as those specimens he received from abroad. Several of the specimens sent to Bloch from the Indian region were obtained by the Halle missionary Christoph Samuel John (1747–1813) in the Danish colony of Tranquebar (Tharangambadi). Upon obtaining, with difficulty, glass containers, corks, and supplies of alcohol infused with local arrack, John sent jars of preserved fish to Berlin, along with locally recorded names and illustrations made by Indian artists. Bloch named the genus *Johnius* and the species *Lutjanus johnii* in gratitude.[28]

John also sent illustrations and specimens to Patrick Russell (1727–1805), who described and illustrated 200 fishes from the Bay of Bengal, largely during his stay in Vishakapatnam. Russell's book made use of uncoloured illustrations by a local artist, which were engraved and printed in England.[29] Russell noted that, although he had originally intended that the paintings should be coloured, as his images of snakes had been, he was obliged to relinquish this plan, because:

> in a hot climate, the colours of fish are more rapidly fugitive after death than in serpents. They escape while the painter is adjusting his palette; and in the fine gradations from the most brilliant to the softer evanescent tints, nature, through boundless variety, ever maintains a certain harmony and characteristic simplicity in her transitions, that required a delicate pencil under more masterly guidance than my artist had pretensions to.[30]

Russell's comment here suggests that Mary Symonds painted her fish relatively fresh from the water, before the colours had time to fade. Russell also recorded local names while commenting on variability in usage across communities on the coast.

By the time of Symonds's paintings, nearly half of the identifiable species depicted had already been formally described and given binomial names. Species that she illustrated that were yet to be described and formally assigned binomial names include *Cephalopholis formosa* (described by George Shaw in 1812, originally in the genus *Sciaena*); *Lutjanus rivulatus* (originally placed in *Diacope*) and *Chaetodon decussatus*, which were described by the Cuvier brothers in France between 1828 and 1829; *Rhinobatos obtusus*, described by the Germans Johannes Müller (1801–1858) and Jacob Henle (1809–1885) in 1841; *Holocanthus xanthurus*, described in 1833 by Edward Turner Bennett (1797–1836); and *Hemiramphus dussumieri* (now in *Hyporhamphus*), described by Achille Valenciennes in 1847 based on specimens collected by Jean-Jacques Dussumier (1792–1883). The Dutch East India Company also began to document fish in the region through the work of army physician Pieter Bleeker (1819–1878).

Francis Buchanan (1762–1829) travelled from Madras through the peninsula westwards in the 1800s, and, although he noted the local names of fish of economic value, he did not describe many species (for example, he described only three carp species).[31] In his later work of 1822, he described nearly a hundred new species of freshwater fish.[32] When Colonel W.H. Sykes described fish from the rivers of Maharashtra in 1838, he commented that "it will scarcely excite surprise, that out of 46 species described, no less than 42 are new to science."[33] Sykes had a draftsman draw fish while also recording local names, several of which were incorporated into the Latin binomials (despite Linnaeus's decree against "barbarous" names). Major General Thomas Hardwicke (1755–1835) had Indian artists draw various fauna, and these included several fish, although largely from the Gangetic region. Some of these were illustrations copied from Francis Buchanan, and several were published by Gray and Hardwicke in 1833–34.[34] In his spare time, army surgeon T.C. Jerdon (1811–1872) made studies of fish from southern India (his time included two years at Madras),[35] drawing some of his own illustrations. His friend Sir Walter Elliot (1803–1887) employed Indian artists and recorded Telugu fish names used in Waltair and Madras.[36] Careful taxonomic studies began under another army surgeon, Francis Day (1829–1889), who became an inspector of fisheries. Day first published *Fishes of Malabar* in 1865, which led to the *Fishes of India* (1875–78) and, finally, the two volumes in the magisterial *Fauna of British India* series in 1889.[37] Day was himself a fine illustrator. The fish paintings in the Gwillim archive at McGill offer some interesting insights into the marine life in the waters around Madras, including several species that are now endangered, while the inscriptions add to our knowledge of local names. Although they are less detailed than Elizabeth Gwillim's bird paintings, they demonstrate a similar concern with anatomical accuracy combined with attention to colour, and they are of comparable quality to illustrations

made for natural history works of the period. Like the ornithological paint-
ings, they were pioneering in depicting several species that had yet to receive
binomials. They were made before any of the ichthyological studies by the
East India Company naturalists described above had been published, and
thus qualify as some of the earliest depictions of the marine life of Madras
and its environs.

Paying attention to both how Symonds may have gained access to the fish
she illustrated as well as the potential source of the Tamil inscriptions on the
paintings, we might begin to reconstruct not just the artistic practices of the
two sisters but also some of the ecological conditions of early nineteenth-
century Tamil Nadu and the local Indian people who enabled the sisters'
artistic and naturalist efforts. Symonds's fish along with Gwillim's birds
manifest the sisters' desire to create an accurate visual record of their new
surroundings; the gem-like hues of the fish made them captivating subjects,
and albums of images provided a means of recording the appearance of the
creatures, which were appealing but quite perishable. Collection – real or
representational – was a common element of the colonial British engagement
with India.[38] Gwillim noted of Lady Clive that "she delighted in this Country &
made large collections of curiosities."[39] Several such collections of illustrations
in the India Office collections at the British Library have been documented
by Mildred Archer.[40] The well-known Impey Album, commissioned by Elijah
and Mary Impey from Indian artists, similarly collates local species in an
illustrated compendium. Literary scholar Thomas Richards, in *The Imperial
Archive*, places this desire to order and assemble in the colonial context: as the
empire expanded, "the British collected information," sometimes taking the
shape of accounts of flora and fauna, "about the countries they were adding to
their map."[41] As historians of science have increasingly emphasized, however,
forms of scientific knowledge that have been assumed to be Western in
origin – including natural history collections – were, and are, in fact based
on collaborative works resulting from intercultural encounters in colonial
settlements and other contact zones.[42] As a result, they often bear traces of
other world views and objectives other than those of the Europeans who put
their names to them.[43] Furthermore, scientific categories that were previously
assumed to have originated in Europe were often more widely distributed.
Over two millennia of Indian history attest to the classification of plants and
animals, fish included, by such properties as morphology and habitat and into
such familiar categories as oviparous/viviparous.[44] Although an artifact with
an epistemological basis in England's imperial outlook, the illustrations in the
Gwillim archive also speaks to how the sisters' illustrative and scientific efforts
were not only enabled but also shaped by the work of Indian individuals.

APPENDIX:
FISH DEPICTED BY MARY SYMONDS AND ELIZABETH GWILLIM

Blacker Wood number	Name on plate	Plate serial	Current identification	Inscription in Urdu script and transliteration (written in pencil on drawings)	Notes
CA RBD Gwillim-2-1	*Serranus lanceolatus*	2	*Epinephelus lanceolatus* (Bloch, 1790)		• Illustration depicts a juvenile individual
CA RBD Gwillim-2-2	*Tetrodon oblongus*	6	*Takifugu oblongus* (Bloch, 1786)		• A species that is traditionally considered poisonous and not eaten • Jerdon notes the name *Palasi*
CA RBD Gwillim-2-3	*Exocoetus*	7	*Exocoetus* sp.		• *Exocoetus* sp.: two species known from the eastern Indian Ocean – *E. volitans* and *E. monocirrhus.* The former has 6 rows of scales above the lateral line, the latter has 7; this illustration shows 10–11
CA RBD Gwillim-2-4	*Serranus formosus*	n/a	*Cephalopholis formosa* (Shaw, 1812)	کلوان (?) Kīlwān	• கலவா மீன் (*Kalava Meen*); Urdu script can also be transliterated as *kalawān*, matching the currently used generic local name for groupers
CA RBD Gwillim-2-5	*Julis lunaris*	14	*Thalassoma lunare* (Linnaeus, 1758)	یلمی مین یحی	• No English transcription in original; has been doubtfully transcribed as *Yallemi meen yahyee* • A shallow reef fish • Jerdon notes the name of *Moonjilli*
CA RBD Gwillim-2-6	*Therapon servus*	10	*Terapon jarbua* (Fabricius [ex Forsskål] in Niebuhr, 1775)	کیچان Kīchān	• கீசன். Transcribed name matches a known Tamil name, recorded also by Jerdon as *kichan* • A small fish – about 15 cm long; it also enters estuaries

CA RBD Gwillim-2-7	*Physalia*	16	*Physalia physalis* (Linnaeus, 1758)		
CA RBD Gwillim-2-8	*Apogon cupreus*				• Belongs to family Apogonidae, possibly an *Apogon* but is not identifiable to species. *A. cupreus* is a *nomen dubium*
CA RBD Gwillim-2-9	*Triacanthus brevirostris*	17	*Triacanthus biaculeatus* (Bloch, 1786)	مُز ليبر ? Misrălīr?	• Jerdon records the name *Moolean*
CA RBD Gwillim-2-10	*Mesoprion johnii*	18	*Lutjanus johnii* (Bloch, 1792)	مُصری Musri	• One of the species named after its collector, C.S. John of Tranquebar • Jerdon notes the name as *Mooseri*
CA RBD Gwillim-2-11	*Platycephalus insidiator*	19	*Platycephalus indicus* (Linnaeus, 1758)	اُرباڪ Urpāḳi	• The Urdu inscription transcribes *tourpātti* or *urpāṛṛi* in Tamil. Here, the Arabic-Tamil or Arwi letter ڪ is used to write ṛ • Jerdon transcribes as *Ooda-pati* and notes that it is very common in the estuaries
CA RBD Gwillim-2-12	*Teuthis javus*	20	*Siganus javus* (Linnaeus, 1766)		
CA RBD Gwillim-2-13	*Balistes viridescens*	21	*Balistoides* sp.		• Painting lacks typical colourations of *B. viridescens* or any identifiable species: the specimen may have lost its colour before it reached the artist
CA RBD Gwillim-2-14	*Myripristis murdjan*	22	*Myripristis murdjan* (Forsskål, 1775)	كاكاجى Kākāji:	• Jerdon notes the name *kakasi* for species of *Ambassis* as well as *Kurtus indicus*
CA RBD Gwillim-2-15	*Serranus horridus*	23	*Epinephelus fuscoguttatus* (Forsskål, 1775)	جپ كلوان Chăpkĭlwān	• Urdu script correctly transliterated as *cappukalavā* – would mean "flat-" *kalawā* / grouper

CA RBD Gwillim-2-16	*Hemiramphus dussumierii*	24	*Hyporhamphus dussumieri* (Valenciennes, 1847)		
CA RBD Gwillim-2-17	*Mesoprion fulviflamma*	25	*Lutjanus fulviflamma* (Forsskål, 1775)		
CA RBD Gwillim-2-18	*Holocanthus imperator*	26	*Pomacanthus imperator* (Bloch, 1787)		• A reef fish
CA RBD Gwillim-2-19	*Sphyraena obtusata*	27	*Sphyraena jello* (Cuvier, 1829)		• Jerdon noted *S. jello* as commoner in Madras than *S. obtusata*
CA RBD Gwillim-2-20	*Mesoprion bohar*	28	*Lutjanus rivulatus* (Cuvier, 1828)		• An immature specimen
CA RBD Gwillim-2-21	*Chrysophrys hasta*	31	*Dentex* sp.	كاركَتّى Kārkăṭi	• Jerdon notes the name *Mattiwai* for *Chrysophrys* and *Kandal min* for *Dentex*
CA RBD Gwillim-2-22	*Holocanthus xanthurus*	36	*Apolemichthys xanthurus* (Bennett, 1833)	كنَاِرى Kinārbī	• The transcriber has written "u" and "a" under the "" (to indicate that the identity of the short vowel is unclear).
CA RBD Gwillim-2-23	*Rhinobatos granulatus*	37	*Glaucostegus obtusus* (Müller & Henle, 1841)		• A juvenile specimen • Now considered critically endangered
CA RBD Gwillim-2-24	*Chaetodon vagabundus*	43	*Chaetodon decussatus* (G. Cuvier, 1829)		• Jerdon notes the name *Kunnadi*
CA RBD Gwillim-2-25	*Pristis cuspidatus*	45	*Anoxypristis cuspidata* (Latham, 1794)		
CA RBD Gwillim-2-26	*Callichrous chechra*	47	*Ompok bimaculatus* (Bloch, 1794)		• A riverine catfish • The name Ompok is from Limpok, a Malay name
CA RBD Gwillim-2-27	*Pseudeutropius sp.*	48			• Not identifiable; possibly a *Wallago*
CA RBD Gwillim-2-28	*Cirrhina*	49			• Not identifiable as a *Cirrhinus*; may be a *Labeo*, given the branched dorsal-fin ray count of approximately 15

CA RBD Gwillim-2-29	*Notopterus kapirat*	50	*Notopterus notopterus* (Pallas, 1769)	• A fresh/brackish water fish
CA RBD Gwillim-2-30	*Crocodilus palustris*	51	*Crocodylus palustris* (Lesson, 1831)	
CA RBD Gwillim-2-31	*Coryphaena equiselis*	52	*Coryphaena equiselis* (Linnaeus, 1758)	

Notes

Several people were consulted to identify the fish in the Gwillim archive, to provide information on status, and to verify possible Tamil names that match the Urdu-script inscriptions. We thank Dr A. Gopalakrishnan, director, ICAR-CMFRI, and his colleagues Drs Sreenath K.R. and Ranjith L. of the Marine Biodiversity and Environment Management Division. Dr R.J. Ranjit Daniels of Care Earth Trust helped with identification, and his daughter Rosella helped with transcriptions of some Tamil names. Dr Rahul G. Kumar also contributed to discussions on taxonomy. Dr Torsten Tschacher, Freie Universität Berlin, contributed greatly to our understanding and context of the Urdu inscriptions.

1 Wood, "Lady [Elizabeth] Gwillim, 594.

2 Mary Symonds, *Mesoprion johnii*, Blacker Wood Collection, CA RBD Gwillim-2-10, has a faint note, probably in Elizabeth Gwillim's handwriting. Mary Symonds, *Balistes viridescens* (CA RBD Gwillim-2-13) includes a note in pencil at the bottom of the image, which reads "Devil train oil," apparently in reference to the large amount of oil that these fish have in their livers. The note on Elizabeth Gwillim, *Marsh Crocodile, Crocodilus palustris* (CA RBD Gwillim-2-30, plate 32) is discussed below.

3 Elizabeth Gwillim to Hester Symonds James, September/October 1806, British Library, India Office Records (BL IOR) Mss.Eur.C.240/4, ff. 329r–343v.

4 There are several variations in marking and coloration across populations.

5 Information courtesy of the central Marine Fisheries Research Institute (CMFRI).

6 In facing right, this illustration and that of the Marsh Crocodile are somewhat unusual within the set. The species is now considered endangered.

7 Elizabeth Gwillim to Hester Symonds James, 7 February 1802, BL IOR Mss.Eur.C.240/1, ff. 33r–38v, on ff. 37r–38r.

8 Elizabeth Gwillim to Esther Symonds, received in England on 28 February 1806, BL IOR Mss. Eur.C.240/4, ff. 271r–278v, on ff. 274av–275r. Emphasis added. The *Prince of Wales* was an East India Company ship that foundered in June 1804 on its homeward voyage from Madras with the loss of everyone aboard.

9 Butterworth, *The Madras Road-Book*, 175.

10 Clive, *Birds of Passage*, 346.

11 Elizabeth Gwillim to Esther Symonds, 2 October 1802, BL IOR Mss.Eur.C.240/1, ff. 82r–83v, f. 82v.

12 One can find such videos keyed to locations on Google Maps; the video in question of the Brown-marbled Grouper is said to be at Kovalam's "fish fry shop."

13 L.J.V. Compagno and A.D. Marshall, "Whitenose Guitarfish – *Glaucostegus obtusus*," *The IUCN Red List of Threatened Species* (2019): e. T60170A124447244, https://dx.doi.org/10.2305/IUCN.UK.2019-2.RLTS.T60170A124447244.en.

14 Personal communication with K.R. Sreenath, CMFRI (email, 24 January 2022).

15 Archer, *Natural History Drawings*, 21, 28. See Henry Noltie's chapter in the present volume for more details on Anderson and his circle.

16 Nair, *Raja Serfoji II*, 5, 9, 17, 28, 33–5, 58, 74–5.

17 Although these artists would likely have been speakers of Telugu rather than Urdu, there are examples of Tanjore-school paintings that are

polyglottal in their labelling. Archer, *Company Paintings*, 59–65, describes an album of paintings from Tanjore made in ca. 1830 and labelled in Tamil, Telugu, and Modi (Tanjore Marathi) as well as English.

18 The Tanjore Album is in the prints and drawings department of Asia, Pacific, and Africa Collections, British Library, NHD 7/1060. On this and other natural-historical works from Tanjore, see Nair, "Illustrating Plants at the Tanjore Court."

19 R. Froese and D. Pauly, eds, *FishBase*, 2022, www.fishbase.org, version (08/2022). Original native language transcriptions are also wanting. Some of the entries are reverse transliterated by software and are defective.

20 Schwartz, "The Curious Case of Carnatic."

21 Susan Bayly, *Saints, Goddesses and Kings*.

22 Personal communication with Torsten Tschacher (email 5 November 2021).

23 Mary Symonds to Hester Symonds James, 1802, BL IOR Mss.Eur.C.240/1, ff. 58r–61v, f. 60v.

24 Mary Symonds to Esther Symonds, n.d., BL IOR Mss.Eur.C.240/2, ff. 160r–162v, f. 160v.

25 A good overview on the historical development of ichthyology can be found in Nellen and Dulčić, "Evolutionary Steps in Ichthyology."

26 We use "fish" in the lay sense, referring to the assemblage that includes extant bony and cartilaginous fishes.

27 Fricke, "Authorship, Availability and Validity of Fish Names."

28 MacGregor, "European Enlightenment in India."

29 Russell, *Descriptions and Figures of Two Hundred Fishes*.

30 Ibid., iii–iv.

31 Buchanan-Hamilton, *A Journey from Madras*.

32 Buchanan-Hamilton, *An Account of the Fishes Found in the River Ganges*.

33 Sykes, *On the Fishes of the Dukhun*.

34 Hora, "An Aid to the Study of Hamilton Buchanan's 'Gangetic Fishes'"; Gray and Hardwicke, *Illustrations of Indian Zoology*.

35 Jerdon, "Ichthyological Gleanings in Madras."

36 Thanks to Ann Sylph at the Zoological Society of London for information on the Elliot and Day fish paintings.

37 Day, *Fishes*.

38 MacGregor, *Company Curiosities*.

39 Elizabeth Gwillim to Esther Symonds, 2 October 1802, BL IOR Mss.Eur.C.240/1, ff. 82r–83v, on f. 82v.

40 Archer, *Natural History Drawings*.

41 Richards, *The Imperial Archive*, 3.

42 Raj, *Relocating Modern Science*; Winterbottom, *Hybrid Knowledge*.

43 Sobrevilla, "Indigenous Naturalists."

44 Bagchi and Jha, "Fish and Fisheries in Indian Heritage," 95.

3

Mosques and Gopurams, Varied Waters, and Stormy Seas

*Built and Natural Environments
of Early Nineteenth-Century Madras*

VIKRAM BHATT AND VINITA DAMODARAN

Madras
Clive kissed me on the mouth and eyes and brow,
Wonderful kisses, so that I became
Crowned above Queens – a withered beldame now,
Brooding on ancient fame

RUDYARD KIPLING, "THE SONG OF THE CITIES"

Almost a hundred years after Elizabeth Gwillim and her husband, Henry, and her younger sister Mary Symonds arrived in Madras (now Chennai), Rudyard Kipling wrote "The Song of the Cities," a poem about his grand tour of the empire, which included, in one of the fifteen quatrains, his description of the changing fortunes of Madras.[1] In the first decade of the nineteenth century, when Elizabeth Gwillim and Mary Symonds were in Madras, the city was emerging as a place of consequence. This chapter records the sisters' remarkable documentation of the landscape and architecture of Madras and its surroundings.

In 1522, the Portuguese were the first European power to gain a foothold on the Coromandel Coast, through a colony at San Thomé, some four to five kilometres south of the present Chennai city centre.[2] By the time the Gwillims and Mary Symonds arrived, San Thomé had been absorbed into the settlement of Madras, and it was there that they settled after 1802, in a house next to the current Ambedkar Bridge.

Madras, or Madraspatnam, developed around Fort St George, a trading post founded in 1639, in the wake of negotiations between Francis Day and Andrew Cogan of the English East India Company (EIC) and the local Hindu ruler from the Vijayanagar Empire. The dangers posed by the natural environment quickly became clear to the settlers. Three weeks into the settlement, an unseasonal cyclonic storm sank ships in the harbour of the nascent fort.[3] When the British took possession, the population of Madras amounted to 7,000. The famine that followed seven years later in 1646 is said to have killed 4,000 of the population, which at that point had amounted to 19,000.[4]

After the establishment of the EIC's factory, merchant communities, including weavers, were attracted from many other south Indian centres, settling along the coast north of Fort St George, in what became known as "Black Town," as opposed to "White Town" (also called "Christian Town"), which was surrounded by a new wall built in the 1650s. White Town was designated as an administrative centre controlled by a governor (a presidency) by 1652. Over the period 1688–1749, it gradually began administering the region in a radius of eight kilometres around it. The name "White Town" initially came about because the ruling nayak had decreed that the town inhabited by the English be painted only white, but the name and the area were increasingly associated with its mainly European inhabitants. By the early eighteenth century, Black Town was also walled, funded by its Indian inhabitants under pressure from the EIC.[5] Captain William Dampier recorded the beauty of the fort in 1690:

> I was much pleased with the Beautiful prospect this place makes off at Sea. For it stands in a plain Sandy spot of Ground close to the shore, the Sea sometimes washing its Walls which are of Stone and high, with Half Moons and Flankers, and a great many Guns mounted on the Battlements; so that what with the Walls and fine Buildings within the Fort, the large Town of Maderas without it, the Pyramids of the English Tombs, Houses and Gardens adjacent, and the variety of fine Trees scatter'd up and down, it makes as agreeable a Landskip as I have any where seen.[6]

As this passage highlights, although Fort St George was the earliest forti-fied settlement of the East India Company in South India, it was completely exposed to the sea – and remained so for more than three hundred years until the construction of a protected harbour in the late nineteenth century. Even relatively smaller tall ships had to anchor offshore and land their passengers and cargoes via small boats. This transfer using simple flat-bottomed country crafts through heavy Indian Ocean surf was precarious, and passengers were often taken ashore on the shoulders of native boatmen. During monsoon, the surf was so high that the harbour remained closed. In a letter to her mother, Elizabeth Gwillim wrote:

> The months of November December & January are what is called here the Monsoon, that is the rainy season. The surf of the sea is very great on this Coast & therefore during this Period it is thought unsafe for any Vessels to lye near the Coast. For this reason at the commencement of the Monsoon the flag is struck, & not set up again till it is over, to indicate that no ships are to remain in the Harbour or Roads nor to come into it.[7]

During the seventeenth century, the EIC was embroiled in wars between the Mughal Empire and its enemies, which included the Marathas and the near-by kingdom of Golconda, and was in a fragile position.[8] It also saw struggles between the Dutch and the French for a foothold in the Coromandel Coast. Nonetheless, the trade of the EIC was extremely profitable. One of the most fa-mous governors of Fort St George was Elihu Yale, who began his governorship in 1687. He returned to England with considerable wealth that he had amassed in India. He then assisted a struggling collegiate school in the American colo-nies with a gift of books and pictures that realized £560, a gift that ultimately led to the school adopting his name, when it became Yale University in 1718.[9]

Gradually, the EIC settlement became the centre of the Company's opera-tions on the Coromandel Coast, and the subsequent migration of Indian trad-ers resulted in a population of 80,000 by the start of the eighteenth century. However, in 1732, Governor G.M. Pitt noted the decline of the Madras trade, which had previously boasted of exporting thousands of bales of calicoes, due to the increase in ground rents.[10] The impact of increasing taxes on manufac-tures was becoming apparent. White Town had higher property values but lower taxes, a system that was designed to favour the English.[11] The French occupation of Madras between 1746 and 1748 involved the destruction of the original Black Town, moving its inhabitants only a few hundred metres from the gates of White Town. The English retained this reorganization, expanding the fortifications further and enlarging the area of White Town.[12]

When the French took over Madras in 1746, the city was plundered, and its population plummeted to 55,000. By the end of the century, though it had risen again, to 125,000. By that time, the English were in a more assured position, having taken over Bengal in 1785 and having defeated and killed Tipu Sultan in Mysore in 1799 following the fourth Anglo-Mysore War. In this period, the East India Company's territorial acquisitions drained vast sums from its coffers, but individuals were still making immense profits. For example, the Battle of Plassey in 1757 had yielded a payout of £1,238,575, of which Robert Clive, commander of the British land forces, received £31,500.[13]

By the later eighteenth century, the British had begun to colonize large areas of the subcontinent of India. Conflict, agrarian interventions, and heavy taxation had rendered the peasants impoverished and subject to natural disasters, including floods and droughts, with limited resilience. Exacerbated by the climate, by these policies contributed to a series of scarcities and famines in 1782–83, 1785, and 1791–92. These affected South India, including Madras and the surrounding areas (under Company rule) and the extended Kingdom of Mysore (then under the rule of Haider Ali and his successor, Tipu Sultan). In 1801, when the Gwillims arrived, the countryside around Madras was still recovering from the war with Tipu Sultan, which had resulted in the dismantlement of Mysore to the benefit of the East India Company.

VISUAL REPRESENTATIONS

For the EIC, the tracts of land that they gained control of following the defeat of Tipu Sultan were new and largely unknown territories, which needed documenting. Rosie Dias writes that "the visual recording and representation of colonial settlements and exotic landscapes was crucial to the expansion and legitimisation of Britain's empire in the 18th and 19th centuries. Nowhere was this more apparent than in the East India Company's active engagement of visual production as a means of acquiring and cementing colonial knowledge and control."[14] According to Dias, the Company's new territories represented

> an unfamiliar and often inhospitable landscape encompassing hundreds of thousands of square miles and stretching from the northern to southern, and from the western to eastern, extremities of modern-day India, and beyond. It incorporated a series of highly disparate environments and political configurations which were inflected not only by nature, but by the practices and legacies of native peoples and previous invaders ... Establishing, comprehending and controlling this landscape necessitated

the production of visual records and representations in unprecedented volume and in a variety of forms.[15]

Conspicuously, the visual recordings of the Mysore war spilled over beyond the shores of India. J.M.W. Turner, the beloved British Romantic painter, was one of the eminent artists who employed his skills and imagination illustrating this war. For, in nineteenth-century England, exotic Indian scenery was a portable commodity. A wide variety of artists, including Turner, who had never visited India, produced numerous sketches, watercolours, and designs, and engravers provided illustrations for consumption by a growing number of middle-class clients. It is therefore imperative to consider the visual evidence judiciously.

In 1779, William Hodges became the first major British artist to travel to India; prior to that, as an artist, he had accompanied the great explorer and cartographer Captain James Cook on his expeditions to the South Pacific. The seascapes and landscapes of that voyage are well discussed by Bernard Smith, but Hodges's Indian works are less known.[16] Under the patronage of Governor General Warren Hastings (1731–1818), Hodges recorded North Indian scenery. The works were published in London in 1786–88.[17] Elizabeth Gwillim and Mary Symonds may have owned or seen his portfolios. In any case, the works hugely influenced other artists, including the famous uncle-and-nephew team of Thomas and William Daniell. During three trips, the Daniells had recorded their visual impressions of India between 1786 and 1794. Although their visit to Madras was brief, they were able to provide a precise image of that colonial establishment and its surroundings, as they used a camera obscura – a device they had employed extensively in their work to set up compositions accurately and quickly.[18] Today, we recognize how their views are shaped by art historical conventions and the expectations of their English market. Yet Thomas Daniell himself drew parallels in the preface to his 1810 publication between his work and that of a "naturalist," "philosopher," or scientist exploring "the shores of Asia" for the "diffusion of truth."[19]

Another form of visual documentation of the landscape was surveying. The East India Company used charts and maps extensively to help it keep records, establish and expand its infrastructure, and run its growing empire. In India, the Company started the Madras Surveying School in 1794 to meet the growing need for trained surveyors necessitated by colonial expansion.[20] According to Jennifer Howes, the school also provided employment for Indian-born sons of the European military.[21] Howes has explored the legacy of the first surveyor general of India, who left behind a massive collection of manuscripts and drawings gathered between 1784 and 1821, which were collected mainly in southern India. On a relatively small scale, maps hold important

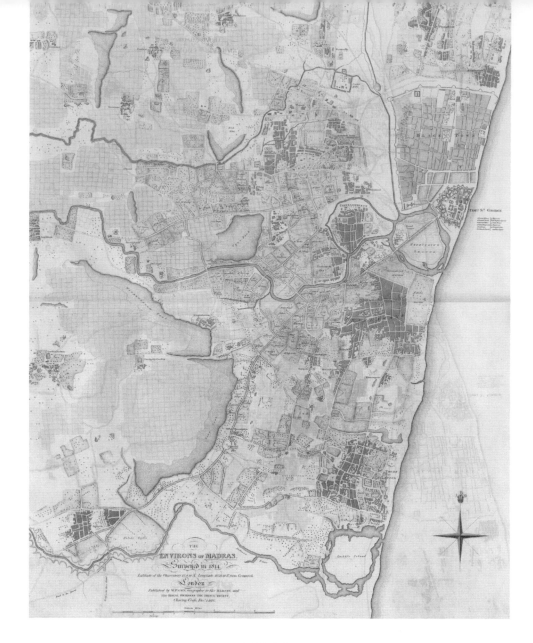

FIGURE 6
W. Faden, "The Environs of Madras, Surveyed in 1814"
(1816. © The British Library Board [maps_k_top_115_75_1]).

cadastral information, such as property lines and the location of buildings. A close look at city maps can reveal a lot: they tell us about the place and its setting, provide historical information, and inform us of the urban hierarchy and the spatial order. Several detailed maps of Madras are almost contemporary with the period of Mary Symonds and Elizabeth Gwillim's visit and can be read in conjunction with the sisters' correspondence and paintings, including a 1798 map that served to designate the area under the control of the Supreme

Court, on which Henry Gwillim sat.[22] A map based on an 1814 survey and another published in 1822 are also useful in situating the Gwillim and Symonds family's experience within its geographical context.[23]

Much of the perspective in the correspondence of Elizabeth Gwillim and Mary Symonds could be described as gendered. Sarah Mills has argued that we need to distinguish between male travel writing and female travel writing and that, while women's writings should also be seen as colonial texts, they differ from male-authored texts in privileging personal relations and resisting narrative authority. It is important that the heterogeneity of the texts be examined to understand whether the writing was constrained by the genre's conventions or societal expectations of femininity, which restricted women to self-deprecating and confessional modes.[24] In a recent study of three female travellers, Carl Thompson has argued that self-deprecation, such as professing an ignorance of botany, was often a form of self-defence for learned women, who otherwise risked being mocked for displaying excessive learning or pride, both of which were considered inappropriate for women.[25] Indeed, the sisters occasionally made self-deprecating statements about both their natural knowledge and their artwork. For example, Mary Symonds, in her letter to her sister Hester, wrote:

> I am at present incapable of giving you any satisfactory representations of this country or of the people and consequently cannot send you any thing that will be worthy of a place on the wall. But my anxiety to give you an accurate idea of these people makes me send you some little daubs from time to time by way of illustration to our letters.[26]

This self-effacing letter aside, the sisters' portfolios are comparable to the works of leading artists of the period working in the subcontinent and beyond. The correspondence similarly reveals that they were clearly interested in the land and the people, were often sympathetic and engaged with the landscape aesthetically, were drawn to the different flora and fauna, became amateur naturalists, and imbibed ways of seeing and being that showed a generosity of spirit. Theirs was not explicitly a conquest narrative but rather one about the pleasures of being in a foreign land. Nevertheless, it is worth noting that pursuits like collecting, describing, and other forms of natural history also enabled and justified empire.[27] Still, the detail in the letters and their attentiveness to natural history are useful for the environmental historian. For example, their depictions of rivers, tanks, and aquifers allow us to compare these to the landscape changes brought about in Madras in the nineteenth century and can be read as a source for the environmental history of a region.

If we examine contemporary maps of Madras, Black Town to the north of the fort is evident, with its ordered streets and much denser urban layout. Elizabeth Gwillim described it methodically like an urban geographer or a planner would. She began with the general overall description and gradually filled in the final details. She noted that the townscape was dotted with landmarks – various religious edifices like churches, "pagodas" (temples), mosques, and tombs, which were integrated throughout the settlement, rising up above the lower residential structures. The town followed an orthogonal circulation layout, streets were wide but not paved, street corners had signs written in two languages, Tamil (Gwillim referred to it as "Malabar") and English, and houses were numbered. The residential buildings addressed the street, with their two- to three-foot raised intervening stoops, platforms, and porches. Roof overhangs protected these platforms, which, during the day, might be used as places for conducting business, or just for sitting, and, at night, for sleeping, at least in good weather. Like most traditional cities, houses combined residential and commercial or trade activities. From the outside, houses were not ostentatious, and they had no windows overlooking the street. However, the entrances were decorated with wooden carvings: a practice that continues in the present. Describing this proud tradition and the interior layout of the courtyard dwellings, Gwillim wrote, "the door is small & low with a carving in wood over it & the wall of the house has no window to the street, but is painted according to the fancy of the owner – either with Tygers a Tyger hunt or dancing girls – flowers in borders or plain stripes. These paintings are in water colours painted on the white."[28]

Elizabeth Gwillim sketched the plan of one of these houses in a letter to her mother in 1802 (see figure 7). She illustrated and described the passage leading from the door lined with a bench and plastered in the same manner as the wall and the small room for cooking, shaded by a gourd vine and a closed, dark room used for sleeping during rainy times. Otherwise, she wrote, the people use the verandas for sleeping as well as working or keeping accounts.[29] Furthermore, she noted the interdependent relationships of these houses with the surrounding countryside:

> In such a house … the square wou'd be paved & no tree over it but the cooking & slop water thrown over it which is drained off but serves to keep it cool. – beyond this square there is another, which is a kind of yard where the Cows &c are kept & sometimes a Garden beyond, but their gardens are more frequently a mile or two from the towns in places appropriated to that use.[30]

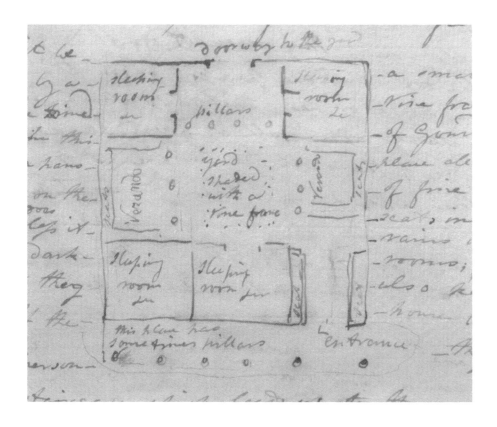

FIGURE 7
A sketch of a house from one of Elizabeth Gwillim's letters (Elizabeth Gwillim to
Esther Symonds, 23 January 1802, BL IOR Mss.Eur.C.240/1, ff. 21r–32r, f. 30r).

Moving to the south and west, the spread-out, almost country-like, landscape of Madras is evident. Originally, the governors of Madras lived within the protected confines of Fort St George in its compact surroundings. But the construction of fortifications was expensive, and so, despite the fear of repeated attacks by native and other European powers, the city started to grow outside the fortification, where EIC agents had laid out a garden for employees. Later, a Company garden house to welcome and entertain dignitaries was approved by the board. Soon after its construction, governors started to use this as a country place, but it was destroyed during the conflict with the French.[31] When Madras reverted to the British, the estate of a wealthy merchant's widow was acquired as a governor's house. In 1798, Edward Clive became governor of Madras. Finding the house inadequate, he commissioned his friend John Goldingham to renovate and enlarge it, adding a banquet hall. Goldingham was the head of the Madras Survey School and an astronomer and worked as an architect and engineer.[32] The Grecian hall he designed to commemorate the victory over Tipu Sultan included decorations of victory scenes of the

Battle of Plassey in 1757 and the Great Mysore War. Describing the beauty of this hall in one of her letters to her mother, Elizabeth wrote:

> Before the Monsoon it Lightened every night as soon as it was dark the sun set. The clouds have the most fantastick forms & the lightening shoots from different parts of the Sky in the most beautiful manner ... One Evening at a Ball at Lord Clive's where there are very large Glass Lusters, the Lightening shooting through the windows upon the cut glass, lighted up as they were, with the Dancers under them produced one of the finest effects I ever saw.[33]

Once the governor and the higher ups had stepped out of the fort, there was no stopping others from doing so. According to Norma Evenson,

> The founders of Madras and other colonial cities were temporary sojourners – adventurers in search of wealth. City planning involves an investment in the future, and the future, for those lucky enough to survive and make their fortunes, lay in Britain. Although the initial settlement pattern of Madras embodied compactness and regularity, the overall development of the city reflected a semi-rural type of building. While the London merchant, confined in a narrow terrace house, dreamed of the day when he might retire to a country estate, his counterpart in India enjoyed the life of a country gentleman while still engaged in urban commerce.[34]

Thus, many wealthy merchants and Company agents acquired large properties outside the fort. As noted by Evenson, despite the opposition of EIC officials to "the folly and vanity of merchants in having the parade of country houses and gardens and attempts by the Madras Council to restrict land grants to the upper rank of employees, a general movement outward proved irresistible."[35]

To the south and west of the fort, tree-lined avenues connected the luxurious estates of gracious bungalows and their large spaces, as we know from the sisters' letters. These estates were surrounded by small native settlements and varied village appendages. Looking closely at historical maps, we notice clumps of varied trees around numerous water bodies of varying sizes and as well as well-constructed water-tanks, each married to its own cluster of houses and other structures. All village settlements are surrounded by their adjoining farms and paddy fields. The colonial urban order of streets and buildings of varying sizes is dispersed within this semi-rural carpet. Describing the verdure-covered British follies and their giddy atmosphere, Elizabeth wrote:

I think nothing of the kind can exceed the beauty of an evening ride to see all the houses lighted up & people dining or dancing in the Verandoes with the attendants lying about the garden, particularly at a Ball when if there are 150 people or 200. which is generally the number, there will be 400. 500 or more of these people in their muslin dresses scattered under the trees before the house. The Fort is very handsome from the Fortifications it has several handsome squares in it & the buildings are all in the same stile as the Garden houses, but higher but with flat roofs – The Church & some publick buildings rise above them. In a view it looks like prints one has seen of views of Grecian Cities, all Temples & no middling houses.[36]

The tracts of land between the sea to the Saint Thomas Mount and between the Adyar and Cooums rivers were covered with gracious homes of successful British merchants, Company agents, and military officers, which include palatial structures like the Brody Castle, the Palladian mansion of the Chief Justice Sir Thomas Strange, and the Gwillims' own residence at San Thomé, of which Mary Symonds and her sister made several watercolours. These dramatic mini-palaces were interspersed with farms, paddies, waters, and interconnecting tree-lined avenues.

Mary Symonds's account of the landscape around Madras in 1801 gives us a clear description of the variety of native trees, many of them planted by local communities:

I think this is a most beautiful country here are a variety of fine trees and a delightfull verdure we drive out every morning from five to seven o'clock at which time it is quite fresh and cool here is the greatest variety of roads that can be made in a flat country and which ever one takes one is sure of a fine avenue or a beautiful lane shaded by the fall Bamboo intermixed with the gum Arabic tree which abounds here and is the most elegant tree that I ever saw, the largest trees that resemble English foliage are the tulip tree, the Banyan and the mango these I mean are common in the publick roads but we have a great number very fine in the Gardens.[37]

ARCHITECTURE

Symonds's paintings of their own residences in Madras and at San Thomé and other rambling dwellings, like Mr Falconer's villa at Adyar (which later became the Madras Club), beautifully capture their picturesque setting in the lush tropical vegetation.[38] Her watercolours of the interiors are more revealing of the organization of the homes, the spatial subdivision, the use of

bamboo screens, and their pavilion-like character with decorative balustrades. Elizabeth Gwillim's meticulous descriptions provide further architectural information. In a letter to her mother, she wrote:

> As you are a great architect I think you will like to hear something of the buildings here which are much talked of but I hardly know how to begin a subject so various – The Houses of all Europeans are nearly equal as to goodness & size in what situation soever the dwellers are, for building is cheap & young people generally build & these are let out afterward or sold – They are all like Pictures of Italian Palaces with flat roofs or balustrades, I hardly know what to compare them to that you know for they look like Marble & are all built with columns but it is a lighter kind of building than our fine churches in London & much more beautiful architecture than the inferiour ... many are only Pavillions with nothing above the ground floor which is the case of the house we live in, they are the prettiest houses, but the upstairs houses as they call them have more air.[39]

Her letter continued, describing in detail the locally made lime or chunam with which the houses were covered, lending them the bright white appearance that originally gave White Town its name:

> This Chunam is a finer lime than the Plaster of Paris it is made of the small white shells which this rough surf occasions the Sea to throw up in great quantities – To prevent them being carried back with the tide there are fishers who with a peculiar kind of net drag them out of the surf they are then carefully cleaned & burned. The Stucco made of this lime & called Chunam bears a pollish almost equal to white marble, but as is generally said, but I think it is more like the pollish of or glaze of very smooth white China.[40]

Gwillim went on describe the use of chunam on the columns and balustrades of the house and on the floors. In the Gwillim household, the chunam on the floor was interspersed with black squares and closely resembled marble. She also describes the green-painted Venetian window blinds and folding screens used in the rooms, and the verandas, on which dinner was served.[41]

Remarkably, Gwillim was aware of the inadequacies of the European-inspired architecture, especially when compared to the traditional dwellings, which better responded to the tropical climate. She judiciously compared the merits of Indian and European housing in the same letter to her mother:

These kind of houses are much cooler than our large houses they have a very thick wall & the light coming down in the middle does not heat it as ours are heated which are exposed all round – They never sit in a draught of air They indeed lye down in the open air before Choultries &c but being in a house or near buildings which bring current of air they always get a wall at their backs, generally on three sides of them; but the Europeans think the more air the better & build their houses like lanthorns so that one can never get out of a draught of air & the rooms are too hot & too cold at the same time They are certainly beautiful buildings, but many regret that they have not the coolness of the native houses.[42]

Interestingly, later in the nineteenth century, the British in India abandoned their Palladian-style villas in favour of bungalows, which were inspired by local housing.[43]

Another strategy to avoid the heat was to move out of town to higher ground at certain times of the year, a tendency that would later prompt the growth of hill stations. From 1803, the Gwillim/Symonds family began spending periods outside the city, first at St Thomas Mount and later at a cotton farm owned by a Mr Webb in Pammal, just over nineteen kilometres from the centre of Madras. At Pammal, Mary Symonds turned her attention to local architecture, writing to her sister Hester in 1805 to report sketching "Pagodas (temples) & choultries & montathums [mountains], mosques, and mausoleums."[44] Close to Pammal was the Ranganatha Temple, which, with its distinctive twin gopurams and *dwajasthambam* (flagstaff), is visible in the background of several paintings (see plates 7 and 40).

Symonds's paintings also include a domed building, probably a mosque (plate 41), a burial ground containing several tombs,[45] and a building with minarets and tombs.[46] Tomb shrines or dargahs were important places of worship for Sufis, whose devotions often focused on saints. The titling of some of the paintings betrays confusion over whether the building in question was a Hindu or Muslim religious building.[47] As well as being a result of retroactive labelling (Symonds seems to have labelled her paintings later, as shown by her use of her married initials M.R.), this confusion can be explained by the fluidity of religious traditions in the subcontinent, in which Muslim saints' shrines often became linked with Hindu cult divinities.[48]

Probably also while in Pammal, Symonds painted a village scene with a pillared veranda shown in the foreground and a series of smaller thatched buildings in the background.[49] Similar thatched buildings appear in the image titled *The Rustic Horn* (plate 42). Elizabeth Gwillim described these buildings in a letter: "The Villages are still more concealed they are for the most part in

the groves of Cocoa palms, in the neighbourhood of some Chouldry or Pagoda both which are very numerous. They consist of a set of houses made little other than larger bee hives of the palm leaves platted & thatched with the same or with Palmyra leaves another kind of Palm."[50]

In a later letter, Gwillim gave a similar description of the houses built under coconut palms, which provided shade. Here, she also conveyed a more detailed description of the fabrication of the house, which involved using brick, covered with mortar or chunam. She again describes the roofs as made from either coconut palm or palmyra and the walls from the same materials, plaited into a sort of mat.[51] These "beehive"-shaped houses with palm-leaf roofs still survive in parts of the region.[52] Their shape as well as their construction within groves of trees protected them against extreme weather, as Mary noted in another letter: "Wherever the natives of this country build they also plant every man makes a screen for his own house to shelter him from the bad winds & to shade him from the noonday sun."[53] This extract signals the close attention the sisters paid to the natural environment, which is discussed in more detail in the next section.

NATURAL ENVIRONMENT

Descriptions of weather, climate, and environment abound in European travel writings of the eighteenth and nineteenth century and are only beginning to be mined by environmental historians for the important insights they can provide into the environmental and climate history of India.[54] Local and regional environmental histories are also beginning to be written, based on a variety of colonial, local, and indigenous sources.

South India at the time when Mary Symonds and Elizabeth Gwillim arrived was rich in flora and fauna, and its environmental history has yet to be properly mapped. Well before the advent of the Mughals, the Deccan had a flourishing garden culture that influenced the north.[55] Irrigation systems flourished, and it was a Chola king who built the great anicut (dam) in the first century CE.[56] Most empires in South Asia in the first millennium remained close to riverbanks in the valleys and grasslands in the plateaus. In between were large swathes of forest that were home to a large variety of flora and fauna and to indigenous communities and forest polities.[57] By 1800, patterns of engagement between different agroecological zones were characterized by connections and mobility. The resource extractions of the Maratha and Mughal empires was beginning to weigh heavily, but, unlike in China, elephants were not on the retreat: they survived, in part, because of their use as war elephants.[58] Borders between cultivated and the uncultivated

(savannah, scrub, forest) lands were fluid. The Tamil word *kadu*, which signified dry land or thickets, was transformed through settlement and water tanks into *nadu,* or settled areas for cultivation, by the thirteenth or fourteenth centuries.[59] Rangarajan and Sivaramakrishnan argue that even as late as 1600 CE, only one-fourth of the land was under the plough. Wild animals such as cheetahs, elephants, and tigers were abundant, including in Vetavalam forests close to Gingee Fort in Tamil Nadu. This was the landscape that the EIC came to encounter during the expansion of its rule in the latter half of the eighteenth century.[60] By the later part of the nineteenth century, the destruction of the grasslands was apparent, with forest remaining only in the mountainous areas.

One of the most noticeable features of images and maps of this period is the abundance of water. As discussed in chapter 2, many of Gwillim's bird paintings set their subjects near water, but the sisters' works also included landscapes with water (see, for example, plate 43). They also described the abundance of water in their letters. For example, Gwillim described the seasonal and meandering character of the rivers:

> We have four Rivers in this place none of them navigable within some miles of this place & then only for boats – They are very shallow streams, but broad when there has been rain & the banks rich with wood in many parts, they wind about this plain in a most irregular manner & there are a great many Bridges over them, besides innumerable fords which being causeways well made in the dry seasons are quite safe & we seldom go out to dinner without passing one two or three of these. These Rivers run into the Sea at this place some of them come down the country 40 or 50 miles, & they enliven the country exceedingly. The great beauty of this place is that if you quit the sea side you have always a river on one hand or the other, or else a tank, by which you are to understand a Lake, partly natural, but aided by art the dams being carefully kept up; Some of these tanks are many miles long & are very fine pieces of water – many of the houses are built on the banks of them with flights of steps to the water.[61]

In addition, she reflected on the importance of the network of tanks, or reservoirs, to sustaining agriculture in the region. As she wrote in a letter of 1802, "the rice is Green in the fields & the flowers keep blowing on us. They do not depend immediately on the rains for the preservation of things of that kind – The tanks & rivers do not fail & they cut channels in every direction which they easily fill & water every part."[62] Two years later, she again referred to the importance of the tanks in providing water for agriculture during a year when famine had been threatened before the rains arrived.[63]

The accurate descriptions of agriculture are insightful; they reveal a wide variety of local irrigation methods. Gwillim wrote her mother in England: "It is carried on here in a manner just the reverse of your's and so is Gardening, for as you raise beds for the vegetables & leave a sunk path to walk round them, here they sink the bed about a hand-breadth, & the path round is raised. This is to retain the water which is of course much exhausted in the day."[64] The sisters' ruminations on agricultural practice also referred to enclosed fields with multiple cropping of items such as rice, coconut palm, and various trees and shrubs:

The inclosures of the rice corn fields are very irregular some small & others like common fields in England with groves & plantations of tall trees & flowering shrubs, of every form more various than you can guess from the great leaf of the cocoa Palm each one of which is a load for a strong man & which he binds up & carries on his head or shoulder like a deal plank – to the fine cut Mimosas of many of which are as light & thin as a piece of lace (The Gum Arabica is the finest of all.) – These groves & corners & the full Hedges give a remarkable richness to the look of the corn fields – Never were seen such beautiful hedge-rows as are on each side the roads & dividing every field & garden.[65]

Dams, which aided irrigation, supported local agriculture and nourished a thriving agricultural economy at the start of British rule. The abundant water and rich flora and fauna are well recorded in the sisters' paintings. In addition, their letters commented on the bounty of fruit and vegetables of all kinds:

Seasons are only considered in Vegetables – & in very few of those, most of the fruit trees bear blossoms & fruits at the same time. The plantains of all kinds are always growing, Mellons are not quite in yet – The favourite fruit of the country is the Mango & the Mango trees are now in full blow smelling very fresh & nice The orchards look like Walnuts or Pear trees but the flower is a large spike of small blossoms like Meadow-sweet – There are as many sorts of Mangos as of apples & as much difference in them.[66]

Descriptions of the monsoon and the weather abound in the correspondence, with an increasing degree of unease about the unwelcome heat as the weather progressed. Gwillim wrote that "the warm weather seems to agree with me very well it is now getting as warm as is agreeable – we had a few fine showers a day or two ago but we are not to expect *rain* till June & it will be hotter till that time. The last three months have been the most delightful weather that can be imagined – I begin to get quite a Housekeeper & to feel at home."[67]

CLIMATE AND WEATHER

These writings should be taken in the climatic context. The weather of the Madras region is governed mostly by the large-scale seasonal wind and pressure changes associated with the Southeast Asian (or Indian) Monsoon system, but it is significantly modified by the east coast position of Madras, which is adjacent to the Bay of Bengal. The main features of the climate at Madras can be divided into four seasons: 1) a cool, dry season with northeast winds from mid-December to mid-February; 2) a hot, dry season with southeast and later southwest winds from mid-February to May; 3) a southwest monsoon rainy season from June to September; and 4) a northeast monsoon rainy season from October to mid-December. Upper easterlies, which prevail during both the southwest and northeast monsoon rainy seasons, are replaced by upper westerlies in the dry season.[68] The southern peninsula of India is separated from the north by the Vindhya mountains and is more dependent on the monsoon, which runs east to west across central India. The monsoon marks the life of the seasons in South India, dominating agriculture and filling rivers, lakes, and irrigation channels.[69]

Madras was one of the earliest sites in India for which meteorological observations were regularly recorded. The Madras meteorological observatory was established in 1786. Even earlier, from the mid-1700s, various missionary groups operating around Madras recorded measurements of meteorological variables. Scholars have already studied various diaries containing their observations from 1732–37 and 1789–91, but more of this material needs to be assessed.[70] By the latter half of the 1700s, British colonial officers, such as the assistant surgeon Dr William Roxburgh and the comptroller-general of the army and fortification accounts on the Coromandel Coast Colonel James Capper, were making daily meteorological measurements, including those of barometric pressure, at Fort St George in Madras. Those of Roxburgh cover the period from October 1776 to May 1778, while those of Capper overlap for the period from March 1777 to May 1778, with some differences from Roxburgh's (Capper's records were written up in England after he had finished his tour of duty in India). These measurements testify to the local effects of larger climatic events.

The Gwillim/Symonds family was encountering the calm after the storm. India had been in the grips of a devastating El Niño from 1783 to 1793, which had killed an estimated 600,000 people in the Madras Presidency. The unsettled weather brought typhoons and storms in the first instance, and later droughts and famine.[71] The most valuable section of colonial records preceding the sisters' arrival is the one containing details of the famine and general upheaval caused by a series of storms in 1787. Several sources reported on this

event: an article in the *Nautical Magazine* recorded that "Captain Huddart describes one [storm] which destroyed ten thousand persons in the neighbourhood of Coringa, in May, 1787, and penetrated thirty-two kilometres over the country."[72] William Roxburgh noted a major loss of his papers, including those on various plant species in his collection, because of this event.[73] The Madras typhoon of May 1787 was one of a series of very severe storms that year, which also affected Bengal. Yet another storm was reported in November the same year, followed by an unprecedented "violent inundation" or flood.[74]

An important point here about the meteorological record is that the second storm (along with others described below), which occurred in November 1787, exacerbated the already difficult situation caused by the typhoon in May. This second disaster made the problems associated with the first much more challenging to recover from. The governor general, Lord Cornwallis, was suspicious of false claims, warning that "it will be the duty of the board of revenue to make the most scrupulous investigations, and to reject every ill-founded claim for deductions."[75] An embargo on exports was put in place for six months. The scale of the mortality was evidenced in Cornwallis's writings.

Already devastated by a famine in 1780, the circars of the Madras Presidency were severely affected by drought in 1789–92, and many villages of the Godavery delta were depopulated.[76] After 1782, according to Francis Buchanan-Hamilton, surgeon with the East India Company, rainfall levels had fallen in southeast India. This trend was also noticed by Roxburgh. The drought ended in 1792, to be followed by another period of drought in 1802–04. Significantly, the sisters note the lack of rainfall in the period 1801–03. In March 1804, Gwillim wrote that, between their arrival in July 1801 and April 1803, there had been only around ten days of monsoon rain.[77] Her sister noted how close the region had come to famine on this occasion, particularly after the imposition of an embargo on grain exports from Bengal:

> This is the first monsoon day we have had, it now blows hard from the Northward and rains torrents, we are all praying for a heavy monsoon as the late dry season has occasioned a scarcity of rice in some parts; which is a dreadful thing in this country as the natives depend entirely upon it for thier subsistence, in Bengal they seem to entertain some apprehension as Lord Wellesley has issued an order that no grain of any description shall be exported from there. I suppose that will come a little hard upon us for we recieve the greatest part of our wheat from thence.[78]

In contrast, between 1804 and 1806, the rains were almost continuous.[79] Agriculture in the district of Chingleput, forty kilometres from Madras, which depended on the northeast and southwest monsoons, provides insights into

how dependent the locals were on the monsoon in the nineteenth century. It can be deduced from the available evidence that the rainfall in the district was neither copious nor very regular. Rainfall averaged about forty-five inches over the course of a year, though this varied across localities. The variation was because the greater part of annual rainfall came from the northeast monsoon, which had parted with some of its moisture by the time it reached the eastern side of the district. Rainfall sufficient for cultivation usually was not available in April and May. During the southwest monsoon (June to September), the early "dry" crops were grown. However, much of the cultivation was carried out with the northeast rains, which were supposed to fill the tanks and enable the "wet" or irrigated crop to be raised.[80] Elizabeth Gwillim noted this pattern of cultivation in a letter of March 1804:

> The Natives are much pleased with the season for it is a season of plenty. Rain is their wealth & their Glory – If we had not had such rains there wou'd probably have been a famine a dreadful calamity everywhere but to these poor people who make no provision for the morrow horrid beyond description – All the parts about this place however dry in appearance & which have been barren ever since I came here were sowed with Rice & different grains the whole place has looked like a corn country in England in June – they sowed in Dec: & now is the Harvest I suppose the greater part will be cleared in about a week & the tanks that is reservoirs – or Lakes you may call them are still well stored & they will no doubt get a second crop.[81]

Elizabeth's claim about the lack of provision made by local people for times of hardship was one that would become a common feature of colonial discourse. Yet, in reality, local coping strategies were progressively eroded by colonial policies. Later in the nineteenth century, the rise of mill-made cloth would result in the loss of livelihoods for weaving communities – but that was yet to come at the time the sisters were writing. There is, however, no doubt that, even at this early date, the impact of a failure of the monsoon on the livelihoods of communities was exacerbated by British taxation and other colonial interventions.

Many of the sisters' comments on the weather relate to their own health and well-being. Both complained about the land winds, which blew between April and August. Elizabeth Gwillim wrote that, although the winds were considered healthy by locals, "they give sometimes people a dryness of the skin as if sand had been blown on it, & I found it impossible to keep my hair from curling to a perfect frizz."[82] She also wrote that, during the hot summer months of June and July, both she and her husband, Sir Henry, suffered from boils and prickly heat.[83] She described the damaging June heat in great detail:

This wind has in it nothing unwholsome but by blowing over a long space of Land heated by the Sun & by bringing with it a quantity of fine sharp Sand it gives a burning to the skin just like the effects of a sharp frost in England. The extremes of heat & cold seem to produce nearly the same effects. The wind sweeps with great violence & is dangerous for this reason that the heat & sharpness of it produces boils & prickly heat which if exposed to the wind are checked by it – for this reason we wear shawls & guard ourselves from it by shutting the windows as we do from Cold – These winds are not very troublesome when they are low or during the night & in good seasons the sea breeze sets in as it has lately done at nine in the morning.[84]

By April 1802, the Gwillim/Symonds family had moved closer to the sea, to San Thomé, to avoid the worst of the heat, with some success.[85]

David Arnold has written extensively about death that stalked white men and women in the tropics and how, in the latter half of the eighteenth century, graveyards were littered with the bones of young British men, women, and children who had died from various diseases, including malaria and other fevers caused by waterlogging and inclement weather.[86] Although the sisters' letters contain many complaints about the weather, they also believed that they would become "seasoned" to the climate over time.[87] As Mark Harrison and Suman Seth have shown, such an assumption about adaptability would give way, over the course of the nineteenth century, to a more rigid sense of racial difference, in which European constitutions were considered unsuited to the Indian climate.[88]

CONCLUSION

The sisters' stay in India was short. In the seventh year of their sojourn, Elizabeth Gwillim died, after which her sister and widowed husband departed for England. Nevertheless, the sisters left a remarkable trail of letters that offer a window into the social, cultural, and environmental history of India. Yet, it is essential to note not just what is said in the letters but what is unsaid. The unsettled conditions, the precariousness of British rule in the period, agricultural decline, increasing poverty, and famines that are implicit in the letters need to be brought to the fore. Their correspondence ends on a somber note, with news and descriptions of the Vellore mutiny or uprising on 10 July 1806, which was the first instance of a large-scale, violent mutiny by Indian sepoys against the East India Company, predating by half a century the Indian Rebellion of 1857. The revolt, which took place in the South Indian city of Vellore, lasted

one full day, during which Indian soldiers seized the Vellore Fort and killed or wounded 200 British troops, before the uprising was brutally suppressed.[89]

Despite the damage wrought by colonial rule, the landscapes and wildlife of India would continue to inspire British artists and writers over the centuries after the sisters' sojourn. Edward Lear (1812–1888) was the last major British painter to travel to India before the widespread use of photography. He began his artistic career as an ornithological painter. During his India trip in 1873–75, he made more than 2,000 watercolors and drawings, and his travels included time in the Coromandel, Mysore, and Travancore. In his Indian journals he wrote, "such redundant beauty one could hardly dream of! India, Indiaissimo! Every foot was a picture … Altogether, a new world my masters!"[90] In their paintings and correspondence of Elizabeth Gwillim and Mary Symonds similarly register their wonder at the beauty of the landscape and architecture of southern India.

Notes

1 The poem was first published in *English Illustrated Magazine* in May 1893, originally as one of the six poems that form "A Song of the English"; subsequently, it was included in Kipling's collection of poems *The Seven Seas*.

2 Allan et al., "A Reconstruction of Madras (Chennai) Mean Sea Level Pressure."

3 Love, *Vestiges of Old Madras*.

4 Ibid., 1: 89.

5 Nightingale, "Before Race Mattered."

6 Love, *Vestiges of Old Madras*, 1: 285

7 Elizabeth Gwillim to Esther Symonds, 23 January 1802, British Library, India Office Records (BL IOR) Mss.Eur.C.240/1, ff. 21r–32r, on f. 22r.

8 Winterbottom, *Hybrid Knowledge*.

9 Love, *Vestiges of Old Madras*, 2: 490.

10 Ibid.

11 Nightingale, "Before Race Mattered," 55.

12 Love, *Vestiges of Old Madras* 2: 347–8, 448–52, 520–38, and map facing 554; Nightingale, "Before Race Mattered," 56.

13 Chatterjee, *Representations of India*.

14 Dias, "Recording and Representing India."

15 Dias, "Recording and Representing India."

16 Bernard Smith, *Imagining the Pacific*.

17 Hodges, *Selected Views in India*.

18 Their trips were funded with sponsorship from the East India Company, which also helped with the production of their book *Oriental Scenery*. Hundreds of sketches, studies, and notes were made throughout their expeditions, many of which are in the British Library.

19 Daniell and Daniell, *A Picturesque Voyage to India*, i–ii.

20 The Madras Survey School later grew into the Guindy Engineering College. Because of its roots, it is considered the oldest technical education institution outside of Europe.

21 Howes, *Illustrating India*.

22 Limits of Madras (Circa the Recorder's Court 1798), Madras Record Office, The Tamil Digital Library, https://www.tamildigitallibrary.in/admin/assets/periodicals/TVA_PRL_0003301_The%20Journal%20of%20the%20Madras%20geographical%20association,%20October%20-%201928.pdf, reproduced and discussed in Srinivasachari, "Notes on the Maps of Old Madras."

23 Faden, "The Environs of Madras. Surveyed in 1814" (1816), https://www.raremaps.com/gallery/detail/44194/chennai-the-environs-of-madras-surveyed-in-1814-latitu-faden; W. Ravenshaw, "Plan of the town of Madras and its limits, as surveyed in 1822 for the use of the Justices in Session" (1822). A zoomable version of Ravenshaw's map can be seen at BnF Gallica, https://gallica.bnf.fr/ark:/12148/btv1b530986164/f1.item.zoom#.

24 Mills, *Discourses of Difference.*

25 Thompson, "Women Travellers."

26 Mary Symonds to Hester Symonds James, 11 February 1802, BL IOR Mss.Eur.C.240/1, ff. 39r–46v, on f. 39r.

27 See, for example, Schiebinger and Swan, *Colonial Botany.*

28 Elizabeth Gwillim to Esther Symonds, 23 January 1802, BL IOR Mss.Eur.C.240/1, ff. 21r–32r, ff. 29v–30r.

29 Ibid.

30 Ibid., on f. 30v.

31 The original location of the garden was to the north of the Black Town. What we see here in the 1814 map is its new location.

32 Goldingham is known for his work as an astronomer, which includes an experiment to measure the velocity of sound and to establish the geographical coordinates and the time of Madras. He was relieved of his banquet hall commission for charging very high fees, but that is another story.

33 Elizabeth Gwillim to Esther Symonds, 23 January 1802, BL IOR Mss.Eur.C.240/1, ff. 21r–32r, on ff. 24r–24v.

34 Evenson, *The Indian Metropolis*, 5.

35 Ibid.

36 Elizabeth Gwillim to Esther Symonds, 23 January 1802, BL IOR Mss.Eur.C.240/1, ff. 21r–32r, on ff. 29r–29v.

37 Mary Symonds to Esther Symonds, 14 October 1801, BL IOR Mss.Eur.C.240/1, ff.12r–13v. Planting trees as wayside shade has a history that goes back to Ashoka's edicts. The tradition was continued under the Mughal and later the British regimes.

38 See Mary Symonds's paintings in *The Madras and Environs Album*, South Asia Collection: Madras, NWHSA PIC106.55; San Thomé, NWHSA PIC106.77; the Falconers' villa, PIC106.47.

39 Elizabeth Gwillim to Esther Symonds, January 23, 1802, BL IOR Mss.Eur.C.240/1, ff. 21r–32r, on ff. 28r–29v.

40 Ibid.

41 Ibid.

42 Ibid., on ff. 30v.

43 Herbert, *Flora's Empire*, 22–42.

44 Mary Symonds to Hester Symonds James, 4 March 1805, BL IOR Mss.Eur.C.240/4, ff. 253r–257v.

45 "Palms Near Sacred Buildings," South Asia Collection, PIC106.2.

46 "A Mohamedan Tomb and Minarets," South Asia Collection, PIC106.13. PIC106.29 also shows a building with minarets, perhaps the same building from a different angle, and a domed building.

47 "Entrance into a Hindoo Temple," South Asia Collection, PIC106. 9, seems to show a mosque, while PIC106.6, showing a temple in the foreground, is variously labelled "A Mahomedan Mausoleum," "Buildings Attached to a Pagoda," and "Entrance to a Hindoo Temple."

48 Bayly, *Saints, Goddesses and Kings*, 13.

49 "A Hindoo Village," South Asia Collection, PIC106.7.

50 Elizabeth Gwillim to Esther Symonds, 17 October 1801, BL IOR Mss.Eur.C.240/1, ff. 14r–18v, on 15v.

51 Unsigned letter [Elizabeth Gwillim, probably to her friend Miss Thoburn], n.d., Mss.Eur.C.240/4, ff. 369r–371r, on f. 369v–370r.

52 "Coastal Andhra House," Dakshina Chitra Museum, https://www.dakshinachitra.net/coastal_andhra_house.

53 Mary Symonds to Esther Symonds, 2 February 1805, Mss.Eur.C.240/4, ff. 248r–252v, on f. 250r.

54 McNeill, "Observations on the Nature and Culture of Environmental History," 7. See also Grove, *Green Imperialism.*

55 Hill, *South Asia.*

56 Ibid.

57 Rangarajan and Sivaramakrishnan, *Shifting Ground*, 8–9.

58 Trautmann, *Elephants and Kings.* For a comparison with China see Elvin, *The Retreat of the Elephants.*

59 Rangarajan and Sivaramakrishnan, *Shifting Ground*, 12–13.

60 Habib, *Atlas of the Mughal Empire*, quoted in Rangarajan and Sivaramakrishnan, *Shifting Ground.*

61 Elizabeth Gwillim to Esther Symonds, 23 January 1802, BL IOR Mss.Eur.C.240/1, ff. 21r–32r, on ff. 27v–28r. Today, Chennai has only three main rivers: in the north, the Kosasthalaiyar; to the south, the Adyar; and in the middle, the Cooum, which flows through the city. The three rivers are connected by the Buckingham navigational canal, which was built in the nineteenth century after the Gwillims left Madras. There were several smaller rivers in the area. Many were covered over, so it is not evident which fourth river Elizabeth is referring to.

62 Elizabeth Gwillim to Hester Symonds James, 23 August 1802, BL IOR Mss.Eur.C.240/1, ff. 72r–76v, ff. 73r–73v.

63 Elizabeth Gwillim to Esther Symonds, 7 March 1804, Mss.Eur.C.240/3, ff. 184r–192v.

64 Elizabeth Gwillim to Esther Symonds, 23 January 1802, BL IOR Mss.Eur.C.240/1, ff. 21r–32r, on f. 28r.

65 Ibid., f. 27r.

66 Elizabeth Gwillim to Hester Symonds James, 18 March 1802, BL IOR Mss.Eur.C.240/1, ff. 49r–54v, on f. 52r.

67 Ibid.

68 Allan et al., "A Reconstruction of Madras (Chennai) Mean Sea Level Pressure."

69 Hill, *South Asia*.

70 Allan et al., "A Reconstruction of Madras (Chennai) Mean Sea Level Pressure."

71 Grove, *Ecology, Climate and Empire*; Damodaran, "The 1780s."

72 "Coringa Storm," *Nautical Magazine* 1 (1832): 293. Coringa is in Andhra Pradesh.

73 Campbell and Hunter, *Extracts from the Records in the India Office*.

74 William Roxburgh's diary, quoted in Campbell and Hunter, *Extracts from the Records in the India Office*, 142.

75 Campbell and Hunter, *Extracts from the Records in the India Office*, 141.

76 Ibid., 141.

77 Elizabeth Gwillim to Esther Symonds, 7 March 1804, BL IOR Mss.Eur.C.240/3, ff. 184r–192v, on f. 187r.

78 Mary Symonds to Hester James, 20 October 1803, BL IOR Mss.Eur.C.240/2, ff. 154r–159v, on f. 154v.

79 Elizabeth Gwillim to Hester James, 11 February 1806, BL IOR Mss.Eur.C.240/4, ff. 310r–313v, on ff. 310v–311r.

80 Chandra Babu, "A Study of the Factors," 4.

81 Elizabeth Gwillim to Esther Symonds, 7 March 1804, BL IOR Mss.Eur.C.240/3, ff. 184r–192v, on ff. 187r–187v.

82 Elizabeth Gwillim to Esther Symonds, 23 January 1802, BL IOR Mss.Eur.C.240/1, ff. 21r–32r, on f. 22v.

83 Elizabeth Gwillim to Esther Symonds, 16 July 1802, BL IOR Mss.Eur.C.240/1, ff. 62r–71v, on ff. 71r–71v.

84 Elizabeth Gwillim to Hester James, 23 August 1802, BL IOR Mss.Eur.C.240/1, ff. 72r–76v, on ff. 72v–73r.

85 Ibid., f. 72v.

86 Arnold, *The Tropics and the Travelling Gaze*.

87 Mary Symonds to Hester James, 7 February 1803, BL IOR Mss.Eur.C.240/2, ff. 100r–103v, on f. 102r.

88 Harrison, *Climates and Constitutions*; Seth, *Difference and Disease*.

89 Mary Symonds to Hester James, 30 September 1806, BL IOR Mss.Eur.C.240/4, ff. 324r–325v; Elizabeth Gwillim to Hester James, n.d. [ca. September 1806], BL IOR Mss.Eur.C.240/4, ff. 329r–343v.

90 Lear, *Indian Journal*, 200.

4

Lady Gwillim's Botany

HENRY NOLTIE

In an 1803 letter, dating from nearly two years after their arrival in Madras, Mary Symonds, writing to her mother, Esther, in Hereford, conjured up a remarkable scene of the botanical activities of her sister Elizabeth (Betsy), Lady Gwillim, who was

> in her glory; that is, with about twenty black men round her, a table full of books, the floor strewn with baskets of seeded branches of trees, and herself standing in the midst with her hat snatched to one side and talking away till she is quite fatigued. The seeds and plants are collected from the hills, & woods, by some poor country people, & she gets some of the native Doctors to give her the common name, the Brahmins tell her the Sanscrit & the Books are consulted to find out the Linnean names so that with collecting plants &c, raising them in our own garden, studying the Language & names of this country, & now and then drawing, we continue thank God to amuse ourselves, & fill up our time, without being indebted to the [European] society of this place, which is stupid enough in all conscience.[1]

These sentences are quite incredibly revealing about the sisters: their passionate natures and inquiring minds, which, as they were aware, set them apart from most of the expatriate community of Madras. Of particular note is the multiculturalism – not so much the relatively unremarkable interest in European (Linnaean) botany, but the determination to use local sources of information, and at three different levels: lower-caste plant collectors, Indian doctors (in Madras probably of the Siddha tradition), and learned Brahmins with access to Sanskrit literature. The letters of both sisters are remarkable documents, revealing their respect for, and fascination with, Indian life in its rich diversity, including cultural differences within and between castes and religions (not only

Hindus and Muslims, but Armenians and Roman Catholics). It is noteworthy that Elizabeth Gwillim preferred Hindus to Muslims, and Vaishnavite Telugu speakers ("Gentoos") to Tamil-speaking "Malabars" – her expressed reason for choosing to learn both to read and to write in the former language.

Also revealed in this letter are interests that the sisters had developed, and to an unusual degree, before reaching Madras. Both were highly skilled in draftsmanship and in watercolour technique, which they had been taught by George Samuel. Mary Symonds ("Polly") largely drew people and places (but also fish and, on occasion, plants); her sister specialized in birds and botany. Both had interests in gardening and in the exchange of ornamental and useful plants through their connections with the intermarried Whitley and Thoburn families and the Whitley nursery garden in Old Brompton, London. The extract from Symonds's letter also reveals their awareness of European scientific literature, though, in the letters, only a single (Linnaean) botanical textbook is specifically mentioned – the first volume of Thomas Martyn's edition of Philip Miller's *Gardener's Dictionary*.[2]

An equally revealing remark appears in one of Elizabeth Gwillim's letters to her sister Hester ("Hetty") James – the reason for her wanting to study botany in India:

> without some little knowledge of Botany it is impossible to read the Hindoo language: their allusions to particular plants which are essential to their different ceremonies, are so pointed that unless you know the plants, which Botany alone can teach you, the merit of the whole passage is lost; & after learning a little Botany it seems almost impossible to stop.[3]

This statement would have gladdened the heart of Sir William Jones, who shared this motivation for the Indian botanical studies he undertook jointly with his wife, Anna Maria Jones (née Shipley),[4] but it is hard to overemphasize what an extremely unusual source of inspiration this was for a European woman of the upper middle class. The usual route to the pursuit of botanical studies in India lay, ultimately, with medicine. While it was not a motivation for her own botanical interests, Elizabeth Gwillim was aware of indigenous interest in medicinal plants:

> Tho' they vainly expect from other herbs & roots supernatural effects, they find real ones & have many excellent medicines amongst their vegetables, which they apply frequently with great success, & indeed there is a knowledge of plants even amongst the lowest of people, that shows a great attention to the productions of nature. Altho' they have formed no notion how the qualities of vegetable act on the human body. They

divide all diseases into hot & cold, & certain plants are supposed to be suited to cool, & others to warm; but from what I can learn, an English Physician would neither agree with them as to the nature of the disease, or the power of the herb: however as their experience is better than their reasoning their patients are relieved.[5]

At this same time, Whitelaw Ainslie, a Scottish East India Company (EIC) surgeon, was codifying such indigenous knowledge in his *Materia Medica of Hindoostan*,[6] in which he was helped botanically by the Reverend Dr Johann Peter Rottler (1749–1836), the dedicatee of his volume. A generation earlier, another company surgeon, William Roxburgh, had extended botanical inquiry into an encyclopedic documentation of all plants – medicinal and otherwise – in his manuscript "Flora Indica" and his collections of drawings known as the "Icones," commissioned from Indian artists.[7] In the Gwillim era, Roxburgh's friend and fellow EIC surgeon Francis Buchanan (later Buchanan-Hamilton) – like Roxburgh, a product of the Edinburgh medical school – developed into a fine art the methods of "statistical survey," that is, documenting the natural resources of a country (including the botanical) that were of potential economic benefit, not least to the coffers of the EIC and its shareholders.[8] At the time of the Gwillim letters, in the wake of the 1799 defeat of Tipu Sultan, ruler of Mysore, and the newly acquired territories that resulted, one such survey was still in progress in southern India – that commissioned by Lord Edward Clive, a Gwillim acquaintance and governor of Madras from 1798 to 1803. In charge of the survey, which ran from 1799 until 1810, was Colonel Colin Mackenzie, and the botanist in its early years was Benjamin Heyne. Buchanan's own rapid survey of the same area (1800–01), commissioned by the governor general, Lord Richard Wellesley, had only recently been completed, and the Gwillim/Symonds family, tantalizingly, missed meeting Buchanan in Madras by a matter of only a few weeks.

INDIAN USES OF PLANTS

From the very first letter written by each of the sisters, their delight in Indian flora is apparent, both in its natural state and, more particularly, as modified by human hands – for that is largely what was visible in the intensively cultivated coastal plain around Madras. "The trees are large & tall & the whole place is like Parks & gardens with every beauty that can be in a flat country."[9] With respect to agriculture, it was not only European crops, fruits, and culinary herbs that they described, but the indigenous ones then unfamiliar to them: a variety of wild legumes, squashes and gourds, yams, sweet potatoes, greens,

and sorrels. Elizabeth noted the groves of coconut palms (whose fronds, like those of the palmyra, were used to thatch village houses) and fields of rice and millet (including the *natcheny* or finger millet *Eleusine coracana*). There were also unfamiliar fruits: mangoes, with "as many varieties as apples"; bananas; and ones used in tarts, such as calacca (*Carissa spinarum*) and bilimbi (*Averrhoa bilimbi*). Elizabeth also described the plants used for hedging: wild sugar cane (*Saccharum* spp.), prickly pear (*Opuntia dillenii*), bamboo (*Bambusa bambos*), "American aloes" (*Agave americana*), and "a kind of breadfruit" (discussed below). Ramping through the hedges were several wild bindweeds (*Ipomoea* spp.). They considered the "gum arabic" (*Acacia arabica*, now *Vachellia nilotica* subsp. *tomentosa*) to be the most beautiful of the trees. Also of interest were the ornamental flowers still popular in southern India today: in gardens were fragrant tuberoses (*Agave polianthes*) and, as they witnessed in use in a religious ceremony, the pink oleander (*Nerium oleander*).

Gwillim noted the interest taken by Indians in plants and the differences between their views and those of Europeans:

> The study of Plants would have been esteemed highly by the natives. Tho' their mode of studing Botany differs from our's at least our modern mode such respect have they for the vegetable tribes that many of the more useful plants are venerated like divinities. But their books & description are exactly in the stile of Culpepper. & a plant is seldom selected as a remedy for any natural quality, but for the influence which some Planet is supposed to have over it.[10]

One of the species venerated as a divinity must have been the *tulsi*, sacred basil (*Ocimum tenuiflorum*). Consulting a description by Nicholas Culpeper of a plant that Gwillim probably saw in India, one can see exactly what she meant by her last remark: of the fenugreek (*Trigonella foenum-graecum*), he wrote: "*Government and Virtues. – It is under the influence of Mercury, hot in the second degree, and dry in the first.*"[11]

In January, at the end of the winter monsoon, came "the great gardening time."[12] The Gwillims gardened at their main residence, Madras Gardens, in the settlement of San Thomé, where they had a head gardener and three to five undergardeners – all Tamilian and therefore deemed by Gwillim "not so neat as the Gentoos."[13] The gardeners swept the paths and watered the trees. They regarded garden produce as their own to sell, and yielded up only small amounts to the family – including various citrus (oranges, limes, "pumplemoose"), guavas, and jak fruit ("big as a peck measure"). The family also spent periods at St Thomas Mount in a house rented from an Armenian, where Gwillim also gardened and sowed seeds according to "orders" provided by

Dr Anderson.[14] It was probably here that she encountered an exotic flowering shrub from Batavia to be discussed later.

The sisters, especially Mary Symonds, gave vivid descriptions of the social uses to which Indians applied botany – including as decorations, both architectural and personal. In her remarkable *Scene from a Sanskrit Drama* (plate 6), probably an illustration to Sir William Jones's translation of Kalidasa's play *Sacontala*, Mary depicted one such use, as flower garlands.[15] Mary also wrote an account of the floral decorations she witnessed one Christmas, with banana stems resembling "a white Ivory looking column" attached to the pillars of a veranda, their arching leaves and inflorescences tied together by wreaths of flowers.[16] Flowers such as double jasmines, and an unidentified purple one, were used not in a naturalistic way but were threaded together to form wreaths and garlands often several yards in length, which were used as adornments not only for humans (including palanquin boys) but also for horses. Of particular interest in this context is a kind of "wild breadfruit," which had first appeared in one of Gwillim's letters as a hedging plant. This is *Pandanus odorifer* (commonly known as *P. odoratissimus*), a screw pine with slender, dichotomously branching trunks, large and just-about edible fruits, and prickly margined leaves. Symonds painted a portrait of an exceptionally large specimen of the tree (plate 44). Its cream-coloured male inflorescences are scented "like a musk flower," which her sister described as being plaited into hair and falling down women's backs.[17]

Several other identifiable plants or plant products are mentioned in the letters. "Faquier beads," which Gwillim pointed out were misnamed: fakirs were "Mohammedans," whereas the strings of beads were worn by low-caste Hindu mendicants known as pandarams, as shown in one of Symonds's paintings (plate 9).[18] Also known as rudraksha beads, these are the warty seeds of *Elaeocarpus angustifolius* (formerly *E. sphaericus* and *E. ganitrus*). With respect to plants of edible, rather than decorative or religious, significance, Gwillim says that Indian stews were called "Curry," from the "name of a leaf they put in them" – *Bergera koenigii*, one of the most distinctive culinary flavours of South India.[19] She also described what is clearly *Moringa oleifera*, "a lovely object waving light as air – sweet flowers and long pods we stew, they are as nice as Asparagus" and roots that yielded a kind of horseradish.[20] She also mentions a fodder plant that she called *Agrostis linearis* (now *Cynodon dactylon*),[21] though she seems to have been unaware of its religious significance as "durva," as described by Sir William Jones.[22]

As the wife of a judge, Lady Gwillim had social duties to perform – as did her sister. One such interaction – that with the governor – overlapped with their horticultural interests.[23] The Gwillims entertained Lord Edward Clive for dinner and attended the balls he gave at Government House. One of these, on 7 October 1802, was to celebrate the opening of the adjacent banqueting house, a grand neoclassical edifice built to commemorate the defeat of Tipu Sultan at Seringapatam. Their interactions would almost certainly have been deeper had not the governor's wife, Henrietta, Lady Clive, left Madras with their two precocious daughters three months prior to the arrival of the Gwillim party. Lady Clive, a sparkling Welsh aristocrat, was only too well aware, as were the inhabitants of Madras and Lord Wellesley, the governor general of India, that her husband was a man of limited abilities, made from a different mould to that of his talented, if arguably delinquent, father, Robert Clive. In 1799, for the duration of the final Mysore War, Richard Wellesley had felt it necessary to travel to Madras to direct the military campaign, and Clive seems meekly to have taken refuge in his garden and the rearing of livestock. As Mary Symonds put it,

> The present Lord Clive is a very good natured man but in the affairs of the Govt. he is a mere child and knows no more what is doing than I do, he is extremely fond of Gardening, and the natives who have a good deal of humour call him Gardener Maistrie, just as the people at home call the King Farmer George.[24]

Clive's gardening (largely of vegetables) was probably pursued in the grounds both of the palatial Government House to the south of Fort St George and at the governor's garden house at Guindy, much closer to the Gwillims at San Thomé. Rottler collected specimens in one of these gardens in 1804, and the previous year, from her rented garden at the Mount, Gwillim had sent seeds to Lord Clive.[25]

The Symonds sisters seem never to have strayed far from the environs of Madras, whereas Henrietta Clive (1758–1830), with a vast entourage including numerous elephants, her daughters, and the Italian artist Anna Tonelli (1763–1846), had between March and October 1800 made an intrepid, 1,860 kilometre tour of southern India (the visual records from their expedition are discussed below). During the course of their tour, the ladies met several of the botanists who would shortly interact with the Gwillims. In a published version of Henrietta Clive's letters and journals from this journey, Rottler is consistently referred to as "Rothem," and Heyne as "Hyzer."[26] Elizabeth Gwillim must have been told of Henrietta Clive's interests and regretted not meeting

her: "It was a disappointment that Lady Clive & her two daughters left this place, as they also were fine & agreeable. She delighted in this country & made large collections of curiosities which indeed any person might easily get; but there is great difficulty in preserving them from the ants."[27] The reference to collections, and the difficulty of their preservation, may explain why the sisters concentrated on making visual records of naturalia and why there is no evidence that they made a herbarium.

PLANT EXCHANGES WITH ENGLAND

Although Elizabeth Gwillim did, on at least one occasion, send dried specimens to J.E. Smith,[28] by far the most frequent botanical references in the letters, and therefore perhaps reflecting the deeper interests of both sisters, concern their exchange of seeds and plants with English correspondents.[29] This came about through their close friendship with Reginald Whitley and the Thoburn sisters Elizabeth ("Lizzie") (1783–1855) and Mary (born ca. 1785), who in 1791 became Whitley's stepdaughters. How, where, and when these friendships were established remains unclear.

Peter Thoburn (ca. 1754–1790), whose Christian name is frequently and apparently erroneously given as Frank,[30] established a nursery garden at Old Brompton, London, in 1784, which finally covered forty acres.[31] The year after Thoburn's death in 1790, Whitley married his widow and thereafter ran the nursery with a succession of partners. From 1801 to 1810, the whole of the Gwillims' time in Madras, his partnership was with Peter Brames. One of the plants Elizabeth Gwillim was most anxious to establish (though, in fact, it was already in cultivation under a different name) was her "Gwillimia indica," and, in a March 1805 letter, she mentioned "small boxes with [presumably living] sandal wood trees" (*Santalum album*).[32]

It is impossible to know what came of the innumerable bags of seeds sent to Whitley, and, as Madras has a tropical climate, the plants sent can have been cultivable in Britain only in the greenhouses of the wealthy. The only evidence of success is in the case of two species that made it into the pages of *Curtis's Botanical Magazine*. There is no evidence that Gwillim at this stage had corresponded with the magazine's editor, Dr John Sims, but she must soon have learned of his publishing her introduction of the snake gourd *Trichosanthes cucumerina*, via Whitley and Brames, illustrated under the name *T. anguina*, in February 1804 (plate 45).[33] In August of that year she wrote, "Dr Simms has paid me a great compliment, I blush; what can I send him, if anything I can do will be acceptable."[34] In the text accompanying the magazine illustration, Sims had stated that with her "pencil [Lady Gwillim] delineates subjects of Natural

History with delicacy and accuracy."[35] The second successful introduction, published in December 1805, was of the Seringapatam hollyhock, under the name *Althaea flexuosa,* coined for the plant by Sims but no longer considered distinct from *Alcea rosea* (plate 46).[36]

THE BOTANICO-HISTORICAL BACKGROUND

Madras, on the Coromandel Coast, where the sisters arrived in October 1801, had for a century been a fertile and well-ploughed ground for the study of Indian botany. Its military headquarters, Fort St George, was the cradle for investigations by British surgeon-botanists as far back as the closing decade of the seventeenth century. From this base, the surgeons Samuel Browne and Edward Bulkley collected and pressed plants, which they sent back to London, notably to the apothecary and botanist James Petiver and to Charles DuBois, treasurer of the EIC. The results of this initial period of collecting and documentation were recorded in the publications of Petiver, Leonard Plukenet, and John Ray.[37] A link between this early period and that of Elizabeth Gwillim can still be experienced today. On entering St Mary's Church in Fort St George by the porch at the northwestern end of its nave, just a few feet inside the church, inset into the pavement is the black gravestone of Elizabeth "pia conjux Henrici Gwillim, Eq[uitis] Aur[ati]," while in the graveyard behind and to one's left rests the brown ledger stone of Samuel Browne (d. 1698) and his family.

After this early period, the focus for botanical investigation moved southwards to the Danish colony of Tranquebar. Here were several missionary establishments, the most active in matters botanical being the one run from Halle, to which John Gerhard König, a pupil of Linnaeus, went as surgeon in 1768, to be followed by a number of naturalists (some missionaries, others medics) including the Reverend Christopher Samuel John, Johann Gerhard Klein, and J.P. Rottler. In Tranquebar, at the same time, there was also a Moravian missionary establishment (with its own garden), and one of its doctors, Benjamin Heyne, also plays a role in the Gwillim story. Despite sectarian rivalries, the botanists collaborated, and specimens collected by all of them were in the large herbarium assembled by Rottler. In the meantime, the British, especially the Scots, had entered the picture of botanical exploration. In 1778, a post of naturalist, or botanist, was created in the EIC's Madras establishment, of which König was the first holder. König died in post after seven years and was replaced first by Patrick Russell and then by William Roxburgh. From Roxburgh's departure to Calcutta in 1793 there was a hiatus until 1802, when Heyne was appointed to the naturalist's post after his spell on Mackenzie's Mysore Survey.

THE GWILLIMS' BOTANICAL CIRCLES IN MADRAS

The Germans: A Missionary and a Naturalist-Doctor

As J.P. Rottler was the closest of Elizabeth Gwillim's botanist contacts, it is appropriate to provide here a few details of his life and work.[38] Rottler, unlike the medics König and Klein, was a missionary. He trained in Germany (and briefly in Copenhagen) and went to Tranquebar in 1776 where, in order to be able to preach effectively, he rapidly learned Tamil. Rottler botanized with colleagues, including John and Klein, and supervised the missionary garden. Occasionally he travelled further afield, including two visits to Ceylon (now Sri Lanka). Rottler sent many specimens to European botanists, including Johann C.D. Schreber in Erlangen (these are now in the Munich herbarium) and, more significantly, Karl Ludwig Willdenow in Berlin. Willdenow published many new species based on Tranquebar material in his edition of Linnaeus's *Species Plantarum*. In a Berlin journal he published an account of an excursion from Tranquebar to Madras undertaken by Rottler between September 1799 and January 1800,[39] during which he met James Anderson and Andrew Berry and collected specimens in their gardens.

In 1803, Rottler was invited as missionary to the Vepery Mission of the British Society for the Promotion of Christian Knowledge (SPCK) in a western suburb of Madras. Discussion and disputes in and between Danish and British missionary societies meant that this posting lasted for less than a year, but Rottler remained in Madras. From 1804 to 1815 (a period that included the whole of the Gwillims' time there) his appointment was as chaplain of the Female Orphan Asylum. Later he would return as SPCK missionary to Vepery, where he supervised the building of St Mathias Church (opened in 1825), and it was there that he died, aged eighty-six, in 1836. During his Madras period, Rottler's linguistic studies were directed toward the compilation of a Tamil dictionary, of which only the first part came out during his lifetime, in 1834.[40] The dictionary has been said to contain a list of Tamil plant names,[41] but in fact these are scattered throughout the text and given only to generic level, though species-level identifications are provided for several plant concoctions used for medicinal or religious purposes. The authorities cited for the plant names he used include Klein, Linnaeus, and Willdenow.

As noted earlier, Elizabeth Gwillim was keen to learn botany primarily for cultural and literary reasons. Her enthusiasm led to something equally unusual for a woman of her status and position in India: the seeking out of formal tuition. In Rottler, a scholar of Tamil who had German botanical links, she found someone in a rare, if not unique, position to help her with both Indian and European botany. She first reported her once- or twice-weekly lessons in

October 1804,[42] and they were still taking place the following March, when she repeated her reasons for wanting to study botany and revealed the seriousness of her pursuit: "Dr. Rottler praises me too much, & makes me lazy, & turn my mind to other things. The truth is I should not have put myself upon so new & difficult a study ... & after learning a little Botany it seems almost impossible to stop."[43] Their interactions led to Rottler's desire to commemorate the name of his patron/pupil in what he believed to be a new genus: a flowering shrub that originated in Java, but that Gwillim encountered in the garden of an "Armenian," doubtless the one rented by the Gwillims at St Thomas Mount.

THE STORY OF "GWILLIMIA INDICA"

On 24 August 1805, Elizabeth Gwillim discussed "her" plant, the drawing she had made of it (plate 47), and her repeated attempts to introduce it to England in a living state:

> I have drawn the plant Dr. Rottler has done me the honour to call after me, "Gwillimia Indica." I have given one to Dr. Rottler. I hope it may be new, if so you will like to have it hung up. I have taken great pains to send it home. The plant General Trent was so kind as to carry was, I hear, alive when he left the ship & I hope it got safe, but it was a cold time for a plant that requires sun. This was the 4th time I have sent trees of it to England. It is a very sweet flower at least here, it has a delicate odour but not strong. It came from Batavia & is there called Sampa salaca – which means milk flower. It is very much like a Magnolia plant, but seldom opens wide until it is fading. I rather think that Dr. Rottler wants this drawing which I have made sent to Dr. Smith with the dried specimen – but perhaps he will return it to Mr. Whitly, & if he does, the drawing is for you – If not I will draw you another. The flowers are always larger in the early part of the year, but it flowers all the year.[44]

In December 1806, in *Curtis's Botanical Magazine*, Sims illustrated a specimen of *Magnolia pumila* from the famous Hammersmith nursery of Lee and Kennedy that had originated in China. He clearly suspected this to be the same as Gwillim's plant, of which he had probably seen the drawing and specimen in Smith's collection (they were both Edinburgh medical graduates, though ten years apart). While leaving some room for taxonomic doubt, Sims paid due credit to Rottler's protégée:

> We have been informed that some Botanists in Madrass, considering this plant as a new genus, named it GWILLIMIA in honor of the patroness

of the science in that Presidency; but as it cannot be separated from Magnolia, unless the fruit should be found to be different, we do not feel ourselves at liberty to adopt the alteration, though desirous of paying every respect to this amiable lady.[45]

Gwillim clearly got to hear about this, her second favourable mention by Sims, which suggests that she or, perhaps more likely, Reginald Whitley or one of the Thoburn sisters may have subscribed to the *Botanical Magazine*.

Magnolia pumila had first been described and illustrated (also from Chinese material) by Henry Andrews in 1802 in his magnificently illustrated *Botanist's Repository*.[46] In fact the plant had an earlier name, *Magnolia coco*, published in 1790 by the Portuguese missionary João de Loureiro, based on plants from Cochinchina, Macau, and Canton: it is this, therefore, that is the correct name for "Gwillimia indica." Native to southern China, Taiwan, and Vietnam, it is cultivated further afield for its scented flowers. The commemorative name does, however, survive in formal nomenclature, as a subdivision of the large genus to which it belongs: *Magnolia* Section *Gwillimia*, created by the Geneva botanist A.P. de Candolle in 1817.[47]

Gwillim's watercolour (plate 47) is still in Smith's herbarium at the Linnean Society of London, with a herbarium specimen and Rottler's covering letter containing a formal Latin description.[48] This is her only finished botanical drawing known to have survived, a fine example of eighteenth-century botanical art in the florilegium tradition of G.D. Ehret. On the verso is a tiny pencil annotation in Telugu script. When I sent this annotation to a colleague in Chennai for transliteration and translation, the response was "sum pa sa la ka – these are the letters – no meaning."[49] They do, however, have meaning, this being the name for the plant recorded by Gwillim. As she could herself read and write Telugu, it might be in her own hand, but the name must surely have been supplied by one of her Indian gardeners.

Benjamin Heyne

Rottler was not the only German naturalist with whom Elizabeth Gwillim was in touch in Madras. Benjamin Heyne (1770–1819) was appointed doctor to the Moravian mission at Tranquebar where he arrived in India in 1792. The following year, like König before him, Heyne transferred to the EIC, and, on Roxburgh's departure to the Calcutta Botanic Garden, Heyne replaced him at the experimental garden at Samulcottah, though he would not be formally appointed to the Madras naturalist's post until 1802. In the meantime, as noted earlier, from 1799 to 1801/2, Heyne was botanist on Mackenzie's Mysore Survey. Although Heyne collected botanical specimens

assiduously and commissioned an Indian artist to paint both plants (nearly 400 drawings survive in four volumes at Kew)[50] and birds (one volume in the British Library),[51] his main interest was in geology and mineralogy. This can be seen in his *Tracts, Historical and Statistical, on India*,[52] in which the botanical names used are given on the authority of Roxburgh (whose manuscripts he used) and of "my most respected friend the Rev. Dr. Rottler" (James Anderson's help is also acknowledged). Heyne's major botanical collection, deposited in Germany on a visit in 1814, was written up by A.W. Roth,[53] though some of the new species were first published by J.J. Roemer and J.A. Schultes in 1817.[54]

During the Gwillims' stay in Madras, Heyne (from 1802 to 1808) held the official post of Madras naturalist and was based at the garden in Bangalore, to which the plants from Samulcottah and the Nopalry had been moved. While there is nothing to prove it, Heyne is one possible candidate for the "gentleman lately come down the country" who, in 1804, lent Gwillim a large botanical library.[55] Bangalore would certainly be regarded as "up country," and, as Heyne's interests were primarily geological, it is conceivable that he might have felt happy to lend his botanical books. The pair were certainly in correspondence the following year, as, in August 1805, Gwillim wrote of Heyne, "He is very good natured & sends me baskets of little apples from Bangalore & lately a large basket of potatoes which they are trying to cultivate in the Mysore."[56] It is almost certain that the batch of "Mysore seeds" sent to Hester James, ostensibly from Rottler, in November 1806 originated with Heyne,[57] as Rottler's herbarium contains numerous specimens collected by Heyne from around Mysore.

The Scottish Surgeons: Anderson and Berry

After Rottler, the most significant naturalist with whom Elizabeth Gwillim was in touch in Madras was Dr James Anderson (1738–1809). Anderson was a Scottish EIC surgeon who had been in the city from 1762, and from 1786 had held the most senior medical position, as physician general. Among his greatest interests was the development of plant resources and agriculture, particularly the establishment of a silk industry and the introduction of the cochineal insect (to be used for red dye). He wrote repeatedly to the Madras government, the EIC, and Sir Joseph Banks in London about these subjects, among many others. In 1778, he acquired an eighty-seven-acre plot of land on the south side of the Kuvam River, to the west of Madras, which he developed as a private botanical garden. In August 1805, Gwillim noted a visit there by a party of friends.[58] Anderson provided Gwillim with medical advice, and, in March 1804, when her nerves proved problematic, he had "ordered me to go instantly to the Mount, which being high ground is like the Hampstead of Madras."[59]

In many ways, the most interesting of all the sisters' letters is the one from Mary Symonds to Reginald Whitley written in "Black English." Had it not been for the respect that the sisters expressed for their servants, this might have been deemed in dubious taste. Its tone, however, is not only affectionate but it shows that Mary possessed an exceptionally acute ear. In it, among much else, she explained that Anderson had lent "Mrs" (i.e., Elizabeth Gwillim) a volume of "Buffon," with which to identify a wild cat (probably an escaped caracal) that had been terrorizing her livestock: "One time is coming one, one esort large cat, kill away fowl some sheep, Mrs can very well understand that Cat because Mrs got book Dr. Anderson giving Buffon book that sake Mrs telling Palanqueen Boys kill away that Cat, then after Mrs draw picture Mrs espeak name Lynx."[60] The reference is to the *Histoire naturelle* of Georges-Louis Leclerc, Comte de Buffon, one of the most influential zoological works of the eighteenth century of which Buffon wrote, or supervised, thirty-six volumes between 1749 and 1788. It is probable that the sisters would have been able to read the French edition but, given his Scottish background, it is perhaps more likely that what Anderson lent Gwillim was a volume from one of the three editions of the English translation by the Edinburgh naturalist William Smellie published between 1780 and 1792.

In 1789, Anderson had persuaded the Madras government to allow him the use of some land at Marmalong to set up what was called a Nopalry (from the Mexican-Spanish word *nopal* for the prickly pear or *Opuntia* cactus, the host of the cochineal insect), with the hope of breaking the Spanish monopoly over the red dye obtained from that insect. The garden was put under the charge of Anderson's nephew Dr Andrew Berry (1764–1833), also an EIC surgeon. Despite much research and huge effort, Anderson's experiment was unsuccessful, though the cacti proved useful as an antiscorbutic. In February 1802, Gwillim reported drawing "the cochineal insect and plants."[61] Four different species of *Opuntia* were introduced to Madras from a variety of sources, from Kew to the Philippines, and the one that she drew was probably *Opuntia dillenii*.

When Anderson died in Madras, two years after Gwillim, two handsome memorials were raised to his memory. In St George's Cathedral is a superb life-size sculpture by Francis Chantrey, which shows Anderson seated in a chair with a herbarium specimen of an *Opuntia* on his lap. In the Island Cemetery stands his handsome mausoleum, with his name inscribed on four segmental pediments in Telugu, Tamil, Persian, and English. Today the structure is, sadly, on the point of collapse (death by peepal), and the marker stone smashed.[62]

The sisters also had dealings with Andrew Berry, and one of the batches of seed sent by Elizabeth Gwillim to Whitley in 1806 was on his behalf.[63] More interesting was his interaction with Mary Symonds over a climbing member of the family Menispermaceae now called *Jateorhiza palmata*, native

to East Africa.[64] Its yam-like tuber was the source of a medicinal tonic called Radix Columba or "columba root." With the help of a Monsieur Fortin, a trader, Berry had in 1805 been able to get a section of tuber from Mozambique. This sprouted and in 1807 produced male flowers, which he asked Symonds to paint. Berry had also asked an Indian artist to paint the root, and Symonds was anxious that a copy of her drawing be circulated in London, including to John Sims, in case the Indian drawing, of which she took a dim view, should reach there and give a mistaken impression. In fact, Sims can't have used the drawing, and the species did not figure in *Curtis's Botanical Magazine* until 1830, but it raises the question of the possible existence of other, unlocated, botanical drawings by Symonds.

BOTANICAL PAINTING IN MADRAS

As with botanical exploration, the Madras in which the Gwillim/Symonds family found themselves also had a history in terms of the depiction of natural history subjects. As far back as 1700, Edward Bulkley had commissioned copies of reasonably accurate paintings of birds by an Indian artist; later in the century, Patrick Russell employed Indian artists to illustrate snakes and fish. On the Coromandel Coast, the earliest botanical drawings commissioned by a European patron were probably those made for William Roxburgh in the 1780s. These drawings, which eventually numbered around 2,500, were modelled on European scientific botanical illustrations, intended as accompaniments to his written descriptions. It has been speculated that Roxburgh's artists were chintz painters,[65] and, in this context, it is interesting to note that, twenty years later, Elizabeth Gwillim described the work of such artisans painting palampores in San Thomé: "One person draws all the outline, & others put in the colours ... They will come to your house & paint you any pattern you like on a sheet of what cloth you chuse to give them."[66] Gwillim also recorded another indigenous art form – that of painting in what she called "watercolour" on the whitewashed interior walls of houses with subjects including tigers, tiger hunts, dancing girls, and "flowers in borders."[67]

As noted earlier, Benjamin Heyne employed Indian artists to illustrate plants, and these illustrations are somewhat similar in style to, and possibly inspired by, those of Roxburgh. Nothing is known about Heyne's artist, but, given Heyne's Tranquebar background, it is possible that the artist was of the Tanjore school.[68] These painters were Telugu-speaking and associated with the court of Tanjore and its ruler Sarabhoji (Serfoji); they also worked in Trichinopoly and were known to British patrons as "moochies." For Serfoji himself and for later patrons, these artists would learn to paint plants (and

birds) in a more westernized style, but in a volume from around 1790 we can see illustrations of cereals and pulses in a more traditional style, painted in thick gouache, with miniature landscape foregrounds; their mounting (with painted borders) and binding is also traditional in style.[69] This volume was given to Sir Joseph Banks by Robert Molesworth, who had received it from an unknown source in Madras. Molesworth had connections with Tranquebar and corresponded with Dr James Anderson over the nopal, so either of these could potentially be the origin of the volume. The sisters must have been aware of this Indian painting tradition, as there is a reference to a "native" artist in the context of copying Mary Symonds's fish drawings. As Elizabeth Gwillim wrote, "Dr Anderson has entreated that she will let a native copy them before they go home that they may not be entirely lost if an accident should happen; when that is done you will see them."[70]

There also existed in Madras what might be termed the European amateur tradition, to which the sisters themselves belonged. Between 1783 and 1791, the Austrian baron Thomas Joseph Reichel worked as a draftsman for the Corps of Engineers in the city.[71] Reichel made exceptionally fine watercolours of plants, rather similar in style to Elizabeth Gwillim's *Magnolia*, some of which are in the Natural History Museum, London. He also made a drawing for James Anderson of an insect found on a maritime grass – a creature that Anderson hoped might produce cochineal. Closer to Gwillim's work, in terms of their creator's gender and social background, are the botanical drawings associated with Henrietta Clive. The Clives' governess was the Italian artist Anna Tonelli. On her tour of southern India with Lady Clive and and the Clives' daughters, Henrietta Antonia (Harriet) and Charlotte, Tonelli made visual records of the people, places, and plants they encountered – a project similar to that of Mary Symonds. Some of Tonelli's original watercolours have been preserved in two early twentieth-century scrapbooks in the possession of descendants of Harriet (later Lady Williams-Wynn), which are expanded transcriptions of the Clive diaries. As well as some professional botanical drawings by their governess are some charming drawings by the two girls, made when they were about fourteen or fifteen. These depict native Indian species, some of which are mentioned in the Gwillim letters, including tamarind, sandalwood, mango, and oleander.

It is unfortunate that, as yet, only one of Elizabeth Gwillim's finished botanical paintings – of the *Magnolia coco* (plate 47) – has come to light. In the Gwillim Collection at McGill University Library is a ten-page album bearing a dozen botanical sketches that, in the absence of the finished watercolour, would have given an unfair impression of her skills in this genre.[72] These sketches must have been made in England before her departure for India and, with the exception of a yellow horned-poppy (perhaps made on a visit to a

seaside resort such as Brighton), are likely to have been made in an English garden or nursery. The subjects include popular outdoor plants such as Chinese aster, hepatica, and, more unusually, the male inflorescence of a maize plant, but there are also two, *Amaryllis belladonna* and *Erythrina herbacea*, that were probably grown in a conservatory.

In paintings from her Indian period, plants are also represented in the background of some of Elizabeth's bird portraits (see chapter 2 for a discussion of the flora in several of these works), but these are painted in an impressionistic style quite different from her botanical drawings. Rather than indicative of specific plant-bird interactions, these seem to be done more by way of props for the perching of passerines – in the tradition of illustrations such as those of George Edwards. She did, however, name three of the plants so depicted: a species of *Vitex* (either *negundo* or *agnus-castus*) with the Long-legged Buzzard, a "Mimosa" in her depiction of the Crested Honey Buzzard, and the rattan "*Calamus dioicus*" (perhaps *C. rotang*) in the portrait of the Woolly-necked Stork (plate 19). Several other background plants are identifiable: the male and female Asian Koel (plate 25) perch on a branch of neem (*Azadirachta indica*), with coconut palms in the background; beside the Black-winged Stilt (plate 27) is a clump of grass that is probably *Echinochloa crus-galli*; and in the background of the Black Stork (plate 22) are the flowers and leaves (but curiously not the distinctive drumstick fruits) of the horseradish tree, *Moringa oleifera*, over which she enthused in one of her letters.

ENVOI

In attempting to review the character and significance of Lady Gwillim's botanical work and interests, a major difficulty lies in the limitation of the sources. There must once have been more botanical drawings made in India, and perhaps notes of her lessons from Rottler, but, in the absence of these, one has only a single drawing and the letters to go on. Yet these sources are far richer and more extensive than for any other woman in India during this period with an interest in botany. Her desire to introduce exotic plants to British gardens and nurseries and to paint plants are relatively unsurprising. Among women, such pursuits were restricted largely to those of high status, the only ones with access to the networks necessary for the reception and dissemination of botanical material in Britain. Such occupations would become more common over the course of the nineteenth century. That one of Elizabeth's plants was described as a new species recognizes her minor contribution to the progress of knowledge. Providing such material would also later become more common, though the descriptions, needless to say, were undertaken in the metropolis and by men.

Although focused on England, Ann Shteir's book on women and botany in the period 1760 to 1860 has a brief section entitled "Colonial Travelers." It is significant that the earliest of those discussed from India dates from two decades after the Gwillim era – the governor general's wife, Sarah, Lady Amherst, who, like Elizabeth Gwillim, both painted and undertook horticultural exchanges.[73] Yet her predecessor as "first lady," Flora Mure-Campbell, Countess of Loudoun and Marchioness of Hastings, had in the 1810s also been active botanically: although she is not known to have drawn herself but, rather, commissioned others do so on her behalf, she sent large numbers of seeds to the Royal Botanic Garden Edinburgh. In chapter 10 of the present volume, Rosemary Raza discusses the botanical, artistic, and horticultural interests of European women in India more widely.

Elizabeth Gwillim stated that her primary interest in Indian plants was to understand those cited in Indian-language literature. This suggests a similarity with the work of Anna Maria Jones, undertaken in Calcutta between 1783 and 1793, but with which Gwillim was probably unaware, as, like the Gwillim letters, this was a private matter. While Anna Maria Jones was also married to a lawyer, notable differences exist between the botanical activities of the Madras- and Calcutta-based families. Whereas Henry Gwillim appears to have taken no part in his wife's botanical interests, Anna Maria Jones's work appears to have been undertaken entirely in conjunction with William Jones, whose interest shared the same motivation as Elizabeth Gwillim's, though for Sanskrit literature. More research is required on Anna Maria Jones's botanical work, but her drawings at the Royal Asiatic Society show that many relate to species described in William Jones's botanical papers in *Asiatic Researches*.[74] Her drawing skills were far inferior to those of Elizabeth Gwillim, but where finer drawings were required she could call on Shaikh Zain ud-Din, a superb botanical artist.

Unlike Henrietta Clive, whose intrepid journey involved the collection of natural history specimens (and drawings made by her children and their governess), Elizabeth Gwillim seems to have remained in or near Madras and (like many of her male contemporaries) relied on Indian collectors to bring material from further afield. She appears not to have made a herbarium, and her single surviving drawing has no analytical dissections indicative of visual and horticultural inspiration originating in her British background. The most noteworthy and unusual aspect of her botany is how it was transformed on reaching India. If modest in terms of "achievement," and known about only through her letters, it seems fair to say that Lady Gwillim's botanical interests and activities in India were highly unusual for the period and might well have been greater had her life not been cut short at the age of forty-four.

Notes

I would like to thank Victoria Dickenson for instigating this project, for speedy replies to innumerable enquiries, and for drawing my attention to several botanical references in the letters; and Rafela Fitzhugh, for showing me the Clive "scrapbooks," which contain paintings by Anna Tonelli and the Clive children. I am also grateful to the staff of the following institutions: Ben Cartwright, and Philip and Jeannie Millward at the South Asia Collection, Norwich; Andrea Hart at the Natural History Museum, London, for supplying an image of one of the Reichel water-colours; Geraldine Reid and Donna Young from the World Museum, Liverpool, for information on and access to the Roylc/Rottler herbarium (LIV); Leonie Berwick and Isabelle Charmentier, of the Linnean Society of London for access to the Smith Herbarium (LINN-HS); librarians at the Royal Botanic Gardens Kew –for access to material, including the Heyne drawings, and at the Royal Botanic Garden Edinburgh for continuing access to facilities and collections. Finally, thanks to Gita Hudson (Chennai) and S. Subramanya (Bangalore), who kindly provided information on the Telugu name "sampa salaka."

1 Mary Symonds to Esther Symonds, n.d. [October 1803], British Library, India Office Records (BL IOR) Mss.Eur.C.240/2, ff. 160r–162v, on f. 160r.
2 Martyn, *The Gardener's and Botanist's Dictionary*.
3 Elizabeth Gwillim to Hester James, 6 March 1805, BL IOR Mss.Eur.C.240/4, ff. 258r–266r, on f. 264r.
4 Jones, "Botanical Observations."
5 Elizabeth Gwillim to Esther Symonds, 20 October 1803, BL IOR Mss.Eur.C.240/2, ff. 154r–159v, on f. 157r.
6 Ainslie, *The Materia Medica*.
7 Robinson, *William Roxburgh*.
8 Mark F. Watson and Noltie, "Career, Collections, Reports and Publications."
9 Elizabeth Gwillim to Esther Symonds, 17 October 1801, BL IOR Mss.Eur.C240/1, ff. 14r–18v, on f. 14r. See also Mary Symonds to Esther Symonds, 14 October 1801, BL IOR Mss.Eur.C240/1, ff. 4r–11v, on f. 5r.
10 Elizabeth Gwillim to Esther Symonds, 20 October 1803, BL IOR Mss.Eur.C240/2, ff. 154r–159v, on f. 151r.
11 Culpeper, *Culpeper's Complete Herbal*, 137.
12 Elizabeth Gwillim to Esther Symonds, 23 January 1802, BL IOR Mss.Eur.C240/1, ff. 21r–32r, on f. 25r.
13 Elizabeth Gwillim to Esther Symonds, 12 October 1804, BL IOR Mss.Eur.C240/3, ff. 217r–228v, on f. 224v.
14 Elizabeth Gwillim to Hester James, 7 February 803, BL IOR Mss.Eur.C240/2, ff. 107r–110v, on f. 110v.
15 Ibid., f. 105r, on Sir T. Strange commissioning illustrations of a translation by Sir William Jones.
16 Mary Symonds to unknown recipient, n.d. [1802?], BL IOR Mss.Eur.C240/1, ff.92r–94v, on f. 93r.
17 Elizabeth Gwillim to Esther Symonds, 16 July 1802, BL IOR Mss.Eur.C240/1, ff. ff. 62r–71v, on f. 67v.
18 Elizabeth Gwillim to Hester James, 18 March 1802, BL IOR Mss.Eur.C240/1, ff. 49r–54v, on f. 49r, and 24 August 1805, BL IOR Mss.Eur.C240/4, ff. 279r–296v, on f. 294r.
19 Elizabeth Gwillim to Esther Symonds, 17 October 1801, BL IOR Mss.Eur.C240/1, ff. 14r–18v, on f. 15r.
20 Elizabeth Gwillim to Hester James, n.d. [spring 1803], BL IOR Mss.Eur.C240/2, ff. ff. 167r–177v, on f. 171v.
21 Elizabeth Gwillim to Esther Symonds, 12 October 1804, BL IOR Mss.Eur.C240/3, ff. 217r–228v, f. 225r.
22 Jones, "Botanical Observations."
23 Elizabeth Gwillim to Esther Symonds, 2 October 1802, BL IOR Mss.Eur.C240/1, ff. 82r–83v, on f. 82v.
24 Mary Symonds to Hester James, 7 February 1803, BL IOR Mss.Eur.C240/2, ff. 107r–110v, on f. 101r.
25 Ibid, on f. 110v.
26 Shields, *Birds of Passage*.
27 Elizabeth Gwillim to Elizabeth Symonds, 2 October 1802, BL IOR Mss.Eur.C240/1, ff. 82r-–83v, f. 83r.
28 Elizabeth Gwillim to Hester James, 6 March 1805, BL IOR Mss.Eur.C240/4, ff. 258r–266r, on f. 258v.
29 For the first of many references, see Elizabeth Gwillim to Esther Symonds, 17 October 1801, BL IOR Mss.Eur.C240/1, ff. ff. 19r–19v, on f. 14r.
30 Henrey, *British Botanical and Horticultural Literature*.
31 Harvey, "The Nurseries on Milne's Land-Use Map."
32 Elizabeth Gwillim to Hester James, 6 March 1805, BL IOR Mss.Eur.C240/4, ff. 258r–266r, on f. 258v.

33 Sims, "*Trichosanthes Anguina*."

34 Elizabeth Gwillim to Hester James, 13 August 1804, BL IOR Mss.Eur.C.240/3, ff. 208r–211v.

35 Sims, "*Trichosanthes Anguina*."

36 Sims, "*Althaea Flexuosa*."

37 Jarvis, "A Seventeenth-Century Collection of Indian Medicinal Plants"; Raman, "Plant Lists from 'Olde' Madras"; Winterbottom, "Medicine and Botany in the Making of Madras."

38 Foulkes, "Biographical Memoir of Dr. Rottler."

39 Matthew, "Notes on an Important Botanical Trip."

40 Rottler, *A Dictionary*.

41 Foulkes, "Biographical memoir of Dr Rottler," 2.

42 Elizabeth Gwillim to Hester James, 16 October 1804, BL IOR Mss.Eur.C.240/3, ff. 236r–241v, on f. 236r.

43 Elizabeth Gwillim to Hester James, 6 March 1805, BL IOR Mss.Eur.C.240/4, ff. Mss.Eur.C.240/4, ff. 258r–266r, on f. 264r.

44 Elizabeth Gwillim to Hester James, 24 August 1805, BL IOR Mss.Eur.C.240/4, ff. 279r–296v, on f. 288v.

45 Sims, "*Magnolia Pumila*."

46 Andrews, "*Magnolia Pumila*."

47 Candolle, *Regni Vegetabilis*, 1: 455.

48 Linnean Society, the Smith Herbarium, Specimen: LINN-HS 981.11; drawing and letter: LINN-HS 981.10.

49 Gita Hudson to HN, pers. comm., 6 August 2019.

50 Royal Botanic Gardens, Kew, "Plants of the Coromandel Coast: A Collection of 394 Botanical Watercolour Drawings of Plants and Flora," Illus-Gen HEY, barcode 58053-1001.

51 British Library, Asia, Pacific and Africa Collections, NHD 1 nos 32–75.

52 Heyne, *Tracts Historical and Statistical*.

53 Roth, *Novae Plantarum*.

54 Roemer and Schultes, "Caroli a Linné," 1.

55 Elizabeth Gwillim to Hester James, 16 October 1804, BL IOR Mss.Eur.C.240/3, ff. 236r–241v, on f. 236r.

56 Elizabeth Gwillim to Hester James, 24 August 1805, BL IOR Mss.Eur.C.240/4, ff. 279r–296v, on f. 290v.

57 Elizabeth Gwillim to Hester James, n.d. [November 1806], BL IOR Mss.Eur.C.240/4, ff. 344r–345v, on f. 344v.

58 Elizabeth Gwillim to Hester James, 24 August 1805, BL IOR Mss.Eur.C.240/4, ff. 279r–296v, on f. 287v.

59 Elizabeth Gwillim to Esther Symonds, 7 March 1804, BL IOR Mss.Eur.C.240/3, ff. 184r–192v, on f. 187v.

60 Mary Symonds to Reginald Whitley, 6 February 1803, BL IOR Mss.Eur.C.240/2, ff. 97r–99v, on f. 99r.

61 Elizabeth Gwillim to Hester James, 7 February 1802, BL IOR Mss.Eur.C.240/1, ff. 33r–38v, on f. 38v.

62 The peepal is the sacred fig (*Ficus religiosa*).

63 Elizabeth Gwillim to Hester James, n.d. [November 1806], BL IOR Mss.Eur.C.240/4, ff. 344r–345v, on f. 344v.

64 Mary Symonds to Hester James, 4 March 1807, BL IOR Mss.Eur.C240/4, ff. 365r–368v, f. 365v.

65 Noltie, "Moochies, Gudigars and Other Chitrakars."

66 Elizabeth Gwillim to Esther Symonds, 7 February 1802, BL IOR Mss.Eur.C.240/1, ff. 33r–38v, f. 34v.

67 Elizabeth Gwillim to Esther Symonds, 23 January 1802, BL IOR Mss.Eur.C.240/1, ff. 21r–32r, f. 29.

68 Noltie, *Robert Wight*.

69 Nair, "Illustrating Plants."

70 Elizabeth Gwillim to Esther Symonds, n.d. [August/September 1805], BL IOR Mss.Eur.C240/4, ff. 271r–278v, on f. 271v.

71 Phillimore, *Historical Records*.

72 Album of botanical paintings in Blacker Wood Collection, McGill University, Montreal, CA RBD Gwillim, series 3.

73 Shteir, *Cultivating Women*.

74 For example, Jones, "Botanical Observations."

Indian Expertise on the Natural World in the Gwillim and Symonds Archives

SARAPHINA MASTERS

Although Elizabeth Gwillim's watercolour paintings of birds may seem like isolated, serene works of art, they are part of many broader traditions that complicate our viewing and understanding of them. Letters written by Elizabeth Gwillim and her sister Mary Symonds focus as much on the people they encounter in Madras (now Chennai) as on the flora and fauna, and they locate the work of these women at the intersection of colonialism and natural history. In order to fully understand these art objects and their context, the influence and knowledge of native Indian people on Gwillim's work must be acknowledged and explored. Gwillim's artworks are not only evidence of her singular position in the field of natural history, but they also show how knowledge is transmitted, valued, and interpreted across cultural boundaries.

The majority of evidence for the influence and importance of Indian individuals to Gwillim's work in Madras comes from her and her sister's letters. Describing how her sister (whom she calls Betsy) worked, Symonds wrote:

> Poor Betsy is never out of trouble for if she gets dead subjects to draw from they become offensive before she can finish the work to her mind, & when the birds are brought in alive they stare, or kick, or peck, or do some vile trick or other that frightens her out of her wits, sometimes she thinks the birds look sick, that is whenever they stand quiet & then in a great fit of tenderness she lets them fly before they are finished, least thier sufferings should be revenged upon her or their ghosts should come flying round her & flapping thier great wings, scare her to death. These are serious troubles I assure you. But we do all we can to remedy such evils & have now got a venerable looking old Moor man who catches a

bird at a time he holds them in proper attitudes or feeds these miserable captives in a proper manner, for her poor concience sake.[1]

Symonds went on to describe the expert and novel (to her) manner in which this man secured a kite – a raptor with a three-foot wingspan – with a piece of cloth, proof of a familiarity with this bird and its behaviours, and a high level of technical knowledge concerning both trapping of wild birds of prey and management of captive birds. She depicted this "swaddling" technique in her watercolour entitled *Bird Catchers*, which shows one man holding a flamingo and another a wrapped bird (plate 48).[2] According to Symonds's letter, other bird catchers employed by Gwillim possessed similar skills, such as blindfolding the birds (presumably to keep them calm).[3]

Bird catchers were sometimes depicted in "Company style" paintings, executed by Indian artists for European patrons, which often included portraits of people of different castes and occupations. Images of bird catchers also appear among the mica paintings that were sold to European visitors to India during the nineteenth century. One image from Tanjore made around 1830 shows a male figure holding several dead birds and his wife with a live cock, peacock, and peahen (figure 8). Like the bird catchers Symonds painted, the male figure in this image seems be using the loose cloth wrapped around his body to contain birds.

Elizabeth Gwillim's bird paintings have been celebrated by ornithologists for their life-like appearance and for the rich detail of the birds' feathers that they include. The expertise of the bird catchers and handlers would have been important in enabling Gwillim to paint many of the birds from life, imbuing them with a liveliness and characteristic postures, in contrast to the depictions of many contemporary natural history illustrators who worked either from skins or from mounted birds. Many of Gwillim's surviving ornithological paintings depict large birds, which her sister notes were tied up in the garden and then released. Gwillim employed a bird handler to care for and feed these storks and cranes as well as her cage birds. She mentions keeping a baya (weaverbird) as well as cuckoos and a canary in cages.[4] The bird handlers held the living birds for Gwillim, so that they could be painted at life size, as paper stocks permitted. Life-size renderings were important to naturalists, as they permitted accurate measurement of the birds on paper, necessary for classification. For very large birds, such as vultures, Gwillim would sometimes draw a head or a foot life size – these were the parts that lost colour quickly once a bird was dead – and then sketch the whole bird and add measurements to the drawing.[5]

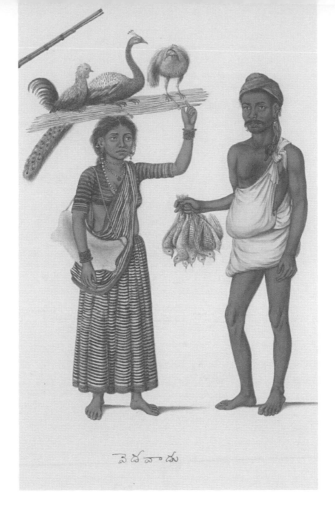

FIGURE 8

Detail from Anonymous, *Three Couples*, Tanjore, ca. 1830.
Victoria and Albert Museum, London, IS.39:19-1987.

While Elizabeth may have wanted to draw all the birds she saw, her subjects were limited to those she could observe in her immediate environment and those the bird catchers supplied. She observed many birds locally, though no paintings of the species mentioned in this passage are extant in the McGill collections:

We have two kinds of Bee eaters very common bright green with fine bent beaks & long feathers in the tail – & some Creepers of different colours very little larger than the humming & birds they come to the Ipomeas a sort of scarlet convolvolus that blows profusely in our gardens. – & we constantly see Kingfishers they are very numerous. here

are three kinds one large green & chesnut coloured – one black & white mottled & a small one the same as the English but smaller. – as for the sparrows tho very common I never see them but in pairs & they build their nests within the houses they come through the Venetians & build on the mouldings or on any books &c – They are slender in their form in which alone they differ – I have seen no house without them but never saw above one or two pair in a house.[6]

She was fortunate to have a Brahminy Kite (*Haliastur indus*) nesting in a mango tree in her garden at St Thomas Mount, which she did paint (plate 18). Otherwise, the avian subjects supplied by the bird catchers were likely dictated by the demands of the Indian bird trade. As many Company paintings suggest, bird catchers formed a distinct profession in nineteenth-century India. Birds were caught for various reasons, including for the table and for sport. The large number of water birds Elizabeth painted was evidence of the presence of wetlands in the Madras area and of the local markets for table birds like ducks and other waterfowl. Elizabeth mentions that hawking was a common sport in Madras in this period, as elsewhere in Mughal India, and she also describes partridges and quails, which were used for fighting.[7] As Suryanarayana Subramanya mentions in chapter 2 in the present volume, there was also a thriving trade in pet birds in Madras in this period.

Moreover, the sisters' letters reveal their reliance on Indian experts for botanical information as well. This seems to have begun through informal conversations with servants during their first days in Madras. In 1802, Elizabeth Gwillim reported, "there is certainly one very pleasant thing in the servants they all enter into your pursuits they are constantly bringing me flowers & insects & pointing out things to me as we go along."[8] By 1803, a letter from her sister shows that this informal reliance on the servants to provide natural historical specimens had become an organized enterprise involving collectors and several different experts. As Henry Noltie notes in chapter 4, Symonds vividly described her sister surrounded by around "twenty black men" comparing plant specimens collected locally with those depicted in books. As she describes it, Elizabeth Gwillim's botanical studies involved consulting with local doctors for the common names of the plants, Brahmins for the Sanskrit name, and then her books for the Linnaean classification.[9] Like most of their male contemporaries, the sisters did not identify by name the local people they relied on for their expertise. As Noltie also mentions, Gwillim's botanical studies were intertwined with her studies of Telugu.[10] While she refers to her botanical mentor, Dr Johann Peter Rottler, several times in her correspondence, she never reveals the identity of her Telugu teacher, who would have been equally important to her studies. He was perhaps her dubash, whom she referred to as

Sami (also written Samy or Saamy), who was a Telugu-speaker,[11] but it is also possible that she employed a dedicated language teacher (or munshi).

The "venerable looking old Moor man" and the "twenty black men" contributed expertise that Gwillim clearly needed. The former made it possible for her to adequately study her avian subjects so that she might paint them with the accuracy that characterizes her work, while the latter may have been equally important to her botanical work, of which less survives. These un-named Indian individuals enabled her studies, augmenting her work with their own expertise and knowledge. Despite her broad interests and open mind, Elizabeth Gwillim was part of an elite class within a colonial society, and her exchanges with her servants functioned within a power differential that precluded a truly collaborative relationship. Like other colonial naturalists of her era and class, Gwillim neglects to directly attribute information to the Indian experts she worked with, and in doing so, as John Bosco Lourdusamy has argued, she "collapsed their agency," a feature common in orientalist and colonial discourse.[12]

By considering all aspects of Gwillim's world, we gain a better understanding of her work. We may admire her skill and tenacity as a dedicated illustrator of natural history while, at the same time, recognizing the role she played in the broader context of imperialism. It is clear that Indian individuals had a major impact on her work but that these contributions, while mentioned in the letters, were not considered at the time to be equal to her own, or to those of her European mentors. In acknowledging this reality, the field of natural history in colonized spaces can expand slightly, to include and value equally all sources of knowledge.

Notes

1 Mary Symonds to Hester Symonds James, 7 February 1803, British Library, India Office Records (BL IOR) Mss.Eur.C.240/2, ff. 100r–103v.

2 South Asia Collection, Norwich, image 106.66. There is no painting of a flamingo among Elizabeth Gwillim's watercolours held in the Blacker Wood Collection at McGill. Casey Wood, who acquired the paintings in 1925, speculated that there originally had been about 200 paintings in the collection (see also chapter 2 by Suryanarayana Subramanya in this volume).

3 Mary Symonds to Hester Symonds James, 7 February 1803, British Library, India Office Records (BL IOR) Mss.Eur.C.240/2, ff. 100r–103v, on f. 102r.

4 Elizabeth Gwillim to Hester Symonds James, 11 February 1806, BL IOR Mss.Eur.C.240/4, ff. 310r–313v, on f. 312r.

5 For more details, see Dickenson, "Lady Gwillim and the Birds of Madras."

6 Elizabeth Gwillim to Hester Symonds James, April[?] 1802, BL IOR Mss.Eur.C.240/2, ff. 158v–159r.

7 Elizabeth Gwillim to Hester Symonds James, n.d. [spring 1803], BL IOR Mss.Eur.C.240/2, ff. 167r–177v, on f. 175v.

8 Elizabeth Gwillim to Hester Symonds James,
7 February 1802, BL IOR Mss.Eur.C.240/1,
ff. 62r–71v.

9 Mary Symonds to Esther Symonds, n.d.
[October 1803], BL IOR Mss.Eur.C.240/2, f. 160r.

10 Elizabeth Gwillim to Hester Symonds James,
6 March 1805, BL IOR Mss.Eur.C.240/4, f. 264r.

11 Elizabeth Gwillim to Hester Symonds James,
23 August 1802, BL IOR Mss.Eur.C.240/1,
ff. 72r–76v.

12 See John Bosco Lourdusamy's thorough response
to Henry Noltie's paper "Lady Gwillim's Botany"
during a webinar now posted on the Gwillim
Project's YouTube page, "Lady Gwillim's Botany,"
15 September 2020, https://youtu.be/ASrfoZAml2Y.

5

Artistic and Literary Contexts

Ornithology and Natural History Studies in India – The Mughal and Early British Periods

MARIKA SARDAR AND ABDUL JAMIL URFI

While the natural history drawings and paintings made by Elizabeth Gwillim and Mary Symonds can be understood within the frameworks of European illustrations for scientific study and European systems for classifying animals and plants, there is also an Indian context for their work. Indian painters had for centuries been producing nature studies, and there were longstanding conventions for describing and cataloguing the natural world in Persian-, Arabic-, and Sanskrit-language sources. A study of this aspect of Indian painting and investigation opens possibilities for identifying an Indian contribution to the emerging fields of botany and zoology in Madras and the related production of scientific paintings of flora and fauna there by European and Indian artists in the eighteenth to early nineteenth century.

Ample evidence exists from India about people's curiosity about the natural world in both prehistoric times and the Vedic periods (ca. 1500–1100 BCE). Valuable information about birds and wild animals, amalgamated into mythology and folklore, is reflected in myths, fables, artifacts, and tales from these periods.[1] Later, the study of natural history attained new heights during the Mughal period,[2] followed by great strides during the period of British rule (ca. 1612–1947), with particular reference to the field study of birds in India.[3] While this is merely a skeletal account of this trajectory, in this chapter we highlight the features of natural history documentation at the junction of two empires – the declining authority of the Mughals and the rising ascendency of the British in late eighteenth and early nineteenth centuries. We examine the developments, first, during the Mughal period, followed by a glimpse of the developments during the early phase of British rule in India. The second

period, when the British East India Company (EIC) had a presence in several parts of India (mostly on the coasts), coincides with the period when Elizabeth Gwillim (née Symonds) and her sister Mary Symonds lived in Madras and left an unusually detailed picture of their times, particularly in their paintings of local flora and fauna as well as observations in their correspondence and notes. An attempt to place the works of the sisters in context of their times is made here, with a note on developments in the study of birds in the times to follow.

AN EARLY SCIENTIFIC AGE

The Arabic, Persian, and Sanskrit Heritage

In the South Asian sphere, different cultures of inquiry were prevalent across the heterodox geography the region encompassed. For those trained in the intertwined Persian- and Arabic-language traditions, plants and animals had been classified, described, and illustrated according to systems ultimately deriving from the work of Aristotle (384–322 BCE), Dioscorides (ca. 40–90 CE), and other ancient philosophers. Aristotle's *Historia Animalium*, for instance, was referenced and expanded upon in numerous Arabic sources, including an eleventh-century text by Ibn Bakhtishu (d. 1058 CE), physician at the court of the Abbasid caliphs in Baghdad.[4] Following the Aristotelian model, Ibn Bakhtishu's text, *Kitab fi Manafi' al-Hayawan* (*On the Usefulness of Animals*), organizes the animals it discusses into classes such as domestic and wild quadrupeds, birds, fishes, and insects. For each animal a short text is provided, the first part always giving its principal characteristics and its habits (based on Aristotle's work), and the second discussing how the animal may be put to use in ways that benefit humans (understood to be Ibn Bakhtishu's contribution).[5]

A well-known manuscript including a Persian translation of Ibn Bakhtishu's text, made in Iran ca. 1300, is typical of this kind of treatise and its illustrations. On the folio (see figure 9), under the heading "Concerning the uses of the green magpie," the text describes the habits and properties of the bird: "it always tries to eat flies; its droppings, boiled up with gall-oak and fat, will blacken moustaches; low-quality gold will increase its carat value if placed under the bird and allowed to warm up."[6] Like the illustrations found in all of the copies of this text, the one on this page provides a view of the animal engaged in its typical behaviour, with a hint of its natural habitat. These illustrations were typically reproduced, along with the text, from one manuscript to the next. The principle of verifying the facts or making accurate drawings from direct observation was not considered as important as it would be in later

FIGURE 9

Shiqraq (green magpie) from a *Manafi' al-hayawan* (On the usefulness of animals) ca. 1300,
Iran or Iraq, opaque watercolour, ink, and gold on paper, 25.7 x 20.5 cm.
© The Aga Khan Museum, AKM83.

periods; at this time, the emphasis was evidently on preserving and handing down already enshrined knowledge.

Studies of plants were organized in a similar fashion and offered a similar pictorial approach. Yahya al-Nahwi's *Kitab al-Diryaq* (*The Book of the Theriac* [*Antidotes*]) provides the remedies devised by nine ancient physicians, including the Roman physician Galen (129–ca. 210 CE); copies of it were typically illustrated with summary depictions of the plants.[7] Arabic- and Persian-language versions of Dioscorides's writings on the medicinal value of different plants also circulated widely. Like the texts on animals discussed above, these studies of plants focus on the uses to which they might be put – to wit, their value as medicaments for humans. The earliest surviving examples of Dioscorides's text were made in Iraq at the turn of the thirteenth century,[8] but his work continued to be adapted and updated in India through at least the seventeenth century, forming, for example, the basis of new compilations such as the *Zakira-yi Nizam Shahi*, written at the Ahmadnagar court in the Deccan in the 1590s.[9] But most often copied in India was a Persian translation of *De Materia Medica* titled *Kitab al-Hasha'ish* (Book of herbs).[10] One example, from a manuscript dated to 1595, includes illustrations typical of the genre (plate 49). In it, each plant is depicted from roots to tip, with attention to the shape of any leaves, fruits, or flowers. While the intention was to depict the unique features of each one (presumably to aid in the identification of the plant in the wild), the representations tend to be generic and stylized. The various plants represented on the folios shown in plate 49 therefore appear to have nearly the same root system (if depicted in different shades of green), although the texture and shape of the leaves are differentiated.

Works of cosmology represent another strand of writing in the Persian and Arabic tradition that sought to classify plants and animals. The most prominent of this kind of text, reproduced hundreds of times across the Islamic world, is *'Aja'ib al-Makhluqat wa Ghara'ib al-Mawjudat* (The wonders of creation and the oddities of existing things), written in the mid-thirteenth century by Zakariya ibn Muhammad al-Qazwini (ca. 1208–1283). It presents various subjects as way to foster an appreciation for God's creations, given the variety and usefulness of living things he has made. The text has two parts, one dealing with heavenly bodies (the planets, constellations, and angels), and a second dealing with matters on earth (the four elements, the seven climes, and the three kingdoms of nature). These kingdoms – the animal, vegetable, and mineral – are each divided into further subgroupings. The animal kingdom is divided into seven categories: man, spirits, animals utilized for mounting and riding, grazing animals, beasts, birds and insects, and the fantastical.[11] The illustrations found in copies of al-Qazwini's work are similar in form to those found in the herbals and bestiaries, showing the subjects against blank

or minimal backgrounds, with the ostensible purpose of focusing on their distinguishing characteristics; yet they too tend to be generic representations. Copies of this text were being made up through the early eighteenth century in India, demonstrating its relevance into the early modern period.[12]

Within South Asia, treatises written in Sanskrit and other Indic languages dealt with plants and animals in ways comparable to the Persian and Arabic sources already discussed. Not unlike Aristotelian-derived texts, one type of Sanskrit literature organized birds and animals into broad groups (equivalent to the genus), and then distinguished different varieties (or species). An example would be the thirteenth-century treatise on mammals and birds known as *Mriga Pakshi Shastra*. In it, author Hamsadeva identifies thirty-six groups of animals (e.g., tigers, lions, elephants, pigeons, sparrows) in the realms of his patron, King Saudadeva, and discusses the common features of each group before providing details on the varieties within it, including a general physical description as well as information on sexual and other behaviours, gestational period, and lifespan.[13]

Another type of text that dealt with this subject matter was the medical treatise, which, again, find its counterparts in the Arabic and Persian (and ultimately Greek) traditions. Typical of this genre would be the widely influential *Bhavaprakasa* of Bhava Misra, written circa 1550–90 but with reprintings and new translations that have continued to appear into the twenty-first century. Within the first division of this treatise is a discussion of plants that have medicinal uses; this text organizes the plants by type (flowers, aromatics), whereas other ayurvedic studies discuss the plants by the effects they achieve (such as long life or strength). These texts tended not to be illustrated.[14] Finally, information on plants was also recorded in such texts as the *Amarakosa*, a dictionary that lists the plants and their literary associations, organized to facilitate the writing of poetry.[15]

The Sixteenth to Early Nineteenth Centuries

In the sixteenth century, both European and South Asian approaches underwent a shift, if due to different circumstances and toward different ends. In Europe, hundreds of specimens of novel (to the Europeans) forms of plant and animal life were arriving on ships exploring new territories, or travelling to familiar ports but in time frames faster than previously possible. As exploratory voyages were launched, a critical aspect of their operations was the collection of samples of the plants and animals that defined each land. Scientists soon grasped that previous systems of classification would not accommodate the types of natural life they were learning of, and they sought broader, and more easily expandable, forms of taxonomy. This was the basis of the system of

binomial nomenclature developed by Carl Linnaeus, which came to be the standard in the scientific community worldwide.[16]

In South Asia, the impetus for the changes that were taking place at the same time might also be said to come from the exposure to new vistas, as observed in the diaries and chronicles of the Mughal emperors (1526–1858).[17] The type of plants and animals of a particular area were, for instance, remarked upon by Babur (1483–1530), founder of the Mughal dynasty, as he travelled from his homeland in Uzbekistan into northern India. Moving through many novel landscapes, he recorded the natural features of each in his diary. He made basic observations about each tree or plant, the shapes of its leaves, the fruit it produced, or the area in which it was found. For animals, he might mention their coloration, size, or the difference between the male and female of the species. A description of blue-haired antelope is a representative example:

> The nilgai is as tall as but more slender than a horse. The male is blue, which is probably why it is called nilgai. It has two smallish horns. On its throat it has hair longer than a span that resembles a yak tail. Its hooves are like those of a cow. The female's color is like that of a doe, and it has no horns or hair on its throat. The female is also plumper than the male.[18]

The diary was not illustrated at the time that it was written, but, when it was translated from Chagatai Turkish into Persian for Babur's grandson, the emperor Akbar (1542–1605) in the late 1500s, it was copied and illustrated several times. Extant are pages from four surviving manuscript copies of the Persian version of the text, with paintings from a later period than that of Babur. Thus, they do not stand as examples of direct observation and recording during Babur's time, but rather illustrate the quality of Babur's descriptions. Their thoroughness allowed later artists to fill in the correct illustrations. In the page shown in plate 50, two male nilgiri are shown, and the painting records in great detail the physical characteristics of the body (which have been clearly differentiated from those of the hog deer also illustrated on this page).[19] The coloration of the fur, the shape of the horns, ears, and tail, and even the distinctive swirl of hair that marks the point where the neck meets the body, have all been ably captured by the artist, the acclaimed painter Mansur (fl. 1590–1624), whose animal paintings would achieve even greater heights later in his career.

In comparison to the illustrations made for earlier encyclopedic or medicinal texts, these paintings signify a major advancement: they were intended to be precise, and to capture visually as many details as presented verbally in the text – they were not the generic, decorative representations of the *'aja'ib* or *materia medica* texts. They are evidence for the training of artists in the

recording of natural phenomena from examination, as opposed to the creation of portraits or the illustration of literary texts, which, prior to this time, had been the typical subject matter expected of them.

Further evidence for the development of this novel type of painting during Akbar's period is that artists would include paintings that isolate the animals from a narrative framing, showing them by themselves, sometimes within a landscape setting and sometimes against a plain ground. These paintings have been cut down from their original folios and pasted into albums with new borders, and, as a result, we do not know why they were made in the first place, whether as illustrations to a text, as nature studies, or as decorative elements. But they were made around the same time as the illustrations to Babur's memoirs, and similarly appear to be making an attempt at documentation rather than simply depicting the animals as part of the background in outdoor scenes. Notably, all of the species in these individual folios, like those in the *Baburnama* manuscripts, can be identified, which indicates their attention to detail and the likelihood that they were made from direct observation. A painting of two hoopoes (plate 51), for example, captures the birds' distinctive striped plumage and long beaks, and, although the image cannot convey the sound of their call, the beak of the lower bird is depicted such that one can almost hear its song emanating from the page.

During the reign of Akbar's son Jahangir (1569–1627), this form of recording and painting developed further. Jahangir's interest in flora and fauna was so well known that examples of interesting animals were constantly being brought to his attention,[20] and there are many indications that he maintained a menagerie where animals were bred and otherwise experimented upon.[21] Jahangir himself recorded his observations about the animals presented to him, noting, for example, whether they were male or female (by remarking on the characteristics that allowed him to deduce that); alternatively, he might compare animals, loosely grouping them by similar features.[22] His observations on a pair of turkeys presented to him in 1612 are representative of his commentary, and bring to the fore his encouragement for the pairing of visual and verbal description:

> Since these animals looked so extremely strange to me, I both wrote of them and ordered the artists to draw their likenesses in the *Jahangirnama* so that the astonishment one has at hearing of them would increase by seeing them. One of the animals was larger in body than a peahen and significantly smaller than a peacock. Sometimes when it displays itself during mating it spreads its tail and its other feathers like a peacock and dances. Its beak and legs are like a rooster's. Its head, neck and wattle constantly change color. When it is mating they are as red as can be

– you'd think it had been all been set with coral. After a while these same places become white and look like cotton. Sometimes they look turquoise. It keeps changing color like a chameleon. The piece of flesh it has on its head resembles a cock's comb. The strange part about it is that when it is mating, the piece of flesh hangs down a span from its head like an elephant's trunk, but then when it pulls it up it stands erect a distance of two fingers like a rhinoceros' horn. The area around its eyes is always turquoise-colored and never changes. Its feathers appear to be of different colors, unlike a peacock's feathers.[23]

Jahangir rather famously charged artists with creating images of the plants and animals he observed, starting during a particular trip to Kabul in 1606.[24] In the case of the spotted forktail (plate 52), for instance, there is a note on the painting itself that states that it was drawn at life-size, from a bird that "the servants hunted in Jangespur and whose likeness they [i.e., His Majesty Jahangir] ordered [to be drawn] by the servant of the palace Nadir az-zaman [i.e., the painter Abu'l-Hasan]."[25] Again, that documentary urge must be re-marked on – the variation in the shape and orientation of the feathers on different parts of the body, the profile of the beak, and the disposition of the claws are all beautifully rendered. In addition, it is particularly interesting that the inscription states that the bird was drawn to scale, and in fact it has been shown close to the average length of twenty-five centimetres documented for this species.

As skilful as Abul's Hasan's painting is, the artist Mansur is perhaps most closely linked with this period of development. Not only do his works demonstrate a wonderful sensitivity to his animal subjects, but he was charged with painting some of the most unusual specimens presented to Jahangir, including a zebra (brought from sub-Saharan Africa), a turkey (brought from North America), and a dodo (brought from the Indian Ocean island of Mauritius). His painting of the dodo is considered among the most accurate depictions of the bird, and a rare one made from life rather than a stuffed specimen.[26] That Mansur developed this mode of painting specifically for the animal studies can be seen by comparing them to his other known works, which are more typical of the type of manuscript illustration prevalent across the Islamic world, in which the paint is applied in several opaque layers and the figures are indicated with minimal modelling or shading.[27]

What this period marked, then, was a shift in approach. Whereas bestiaries and herbals were structured in the same way and transmitted much of the same information as ancient classical sources, the emperors Babur, Akbar, and Jahangir moved toward new observation and the study of different aspects of plant and animal life. Even if the Mughal paintings and written records were

organized in anecdotal fashion – depending on what caught the eye of, or was brought to, the observer, rather than representing the systematic survey of a particular geographic area or a family of animals – the shift is as evident as in the European studies of the same time frame. Rather than providing generic descriptions and focusing on medicinal applications of plant and animal products, seeing the animals live brought out notes on their behaviour, their defining physical characteristics, and what made certain groups of animals similar in form. The emperors started to look into the features that distinguished the male and female of the species, mating habits, and lengths of gestation periods, penning descriptions that are close in content and tone to the descriptions typical of the eighteenth- and nineteenth-century ornithologists discussed below.

Moreover, this approach was coupled with a pictorial recording of the animals and plants being observed, paintings that were qualitatively different from those being made for other types of manuscripts. These paintings may even have been intended to be arranged in special albums dedicated to animal and plant studies. The original mounting and presentation of the paintings has been lost, however: most paintings survive today in later albums, such as ones created for Emperor Shah Jahan (1592–1666), using paintings and calligraphies from earlier periods.[28]

Ebba Koch would identify European scientific illustration, and particularly the type of work encouraged by Emperor Rudolf II (r. 1576–1612), as the inspiration for these developments, just as the new availability of printed European herbals is said to have spurred the development of plant studies at the Mughal court. Koch also suggests that Jahangir might have been motivated by his notion of an ideal ruler, and in particular the model of Solomon, who ruled over peaceable human and animal kingdoms.[29] Yet the roots of these developments can also be traced to the time of Jahangir's predecessor Akbar, and so might have been motivated by other factors as well. Akbar, for instance, commissioned the *Institutes of Akbar* ('*Ain-i Akbari*), an account that, inter alia, documented the animals used in the hunt and in the army, noting their habits, care, and feeding.[30] Situated within a text dedicated to recording the imperial infrastructure, the observation of animals became, as it would during the period of British rule, a way of documenting the resources of the state and encoding their management.

In other parts of the Indian subcontinent, paintings of birds are known from a similar period, but the context for their creation is not known. From the Deccan, for instance, come several paintings attributed to the courts of Bijapur and Golconda in the first quarter of the seventeenth century. Unlike for the Mughal works, there is no record of why they were made, and whether their purpose was decorative, allegorical, or scientific.[31]

Following this period, the interest in studying natural history shifted to other courts. Tipu Sultan (1750–1799), ruler of the kingdom of Mysore in southern India, is known, for instance, to have built upon the Lalbagh Gardens founded by his father, collecting specimens of plants from around India and abroad. Some evidence of this activity can be ascertained from a request made by an embassy from his court to that of Louis XVI to send certain plants from France, along with gardeners who could tend them.[32] Further proof of his interest in scientific studies are the at least forty-five volumes on different scientific topics in his extensive library, including a book of notes on botany lectures given in Edinburgh.[33] Upon the takeover of Mysore state, and the Lalbagh Gardens, by the British in 1799, a set of botanical illustrations was made of the wide variety of plants already established there;[34] the southern Indian artists who created it may well have already been in the employ of Tipu Sultan prior to this time.

Further south and in a slightly later period, Raja Sarabhoji or Serfoji II of Tanjore (1777–1832) established botanic gardens and a menagerie, along with a pharmaceutical workshop, libraries, and schools. His methods for studying plants and animals were in step with the latest work coming out of Europe, as he had studied with various British tutors and had access to the newest publications on natural history sent from London by his former resident adviser Benjamin Torin. Among other activities, Raja Serfoji established a garden for pharmaceutical plants and maintained a menagerie at his palace. There he had artists paint the various plant and animal specimens he collected; a large set of these, accompanied by Serfoji's written descriptions, are preserved in the British Library (see, e.g., plate 53).[35]

Through the eighteenth century and up to the period when Elizabeth Gwillim and Mary Symonds were resident in India, Europeans settling in the subcontinent would become an increasingly significant source of patronage for native artists. Calcutta in particular was a major centre of production, under the guidance of figures such as Mary, Lady Impey, wife of Sir Elijah Impey, chief justice of Bengal between 1777 and 1783. For several years, the artists Bhawani Das, Shaykh Zayn al-Din, and Ram Das were resident at the Impey estate, where they recorded in vivid watercolour animals collected from around the country, resulting in a set of 326 paintings.[36] Just after the Impeys' departure from Calcutta, a botanic garden was founded at nearby Shibpur; under the direction of William Roxburgh, Indian artists working there painted thousands of plant specimens from the 1790s to the 1810s.[37] Another large-scale project was undertaken by Dr Francis Buchanan-Hamilton between 1795 and 1818. While acting as surgeon for the East India Company in Bengal, he employed a group of artists, including one Haludar, to make paintings of

animals and fish Buchanan observed in the region. Haludar also found employment with Richard Colley Wellesley, First Marquis Wellesley (governor general of India from 1798 until 1805) at Wellesley's estate at Barrackpore, where there was a menagerie and aviary managed, for a time, by Buchanan. There, 2,660 paintings would eventually be made.[38]

Meanwhile in Madras, where Roxburgh had gotten his start, other European settlers were also sponsoring the work of Indian artists. Among them were John Peter Boileau (member of the Madras Civil Service from 1765 until 1785) and Henrietta, Lady Clive (wife of Lord Edward Clive, governor of Madras between 1798 and 1803).[39] Lady Clive was interested in animals, plants, and minerals, of which she collected specimens while on a long tour of southern India with her daughters and their governess. On their return to Madras, the animals formed the basis for a menagerie, and local artists were commissioned to paint them.[40] The Gwillim/Symonds sisters' own interactions with artists such as these seems to have been more limited, but can be gleaned from mentions in their letters. Elizabeth, for instance, writes that it had been suggested to Mary Symonds that she have her paintings copied by an Indian expert, and as Lakshminarayanan and Nikčević note in case study 2 in this volume, the surviving paintings of fish attributed to Symonds may indeed plausibly be those copies, as they include Tamil-language inscriptions rendered in Urdu script.[41]

The paintings created at this time were different from those being produced previously in that they were made on larger sheets of paper, were unbound, and were no longer embedded within manuscripts or albums with related scientific or descriptive texts. The backgrounds are minimal, a feature usually attributed to the Europeans' requests to bring the paintings in line with European scientific studies. However, as argued above, this practice had previously been a feature of the Indian tradition. Therefore, in style, the eighteenth- and nineteenth-century works can be considered to continue from earlier periods the skilful observation from life and attention to the distinguishing physical features of the various species. More significant in this era was a change in the way that studies of natural history were carried out. Much was done by the British colonial administration and its professional societies, but amateur practitioners such as the sisters were increasingly common, a subgroup able to contribute to official efforts.[42] This kind of contribution, less evident in previous eras, would be the hallmark of the nineteenth-century study of birds and animals in India.

ORNITHOLOGY DURING THE BRITISH PERIOD

As we have seen in the previous section, there was a shift in approaches to studying and documenting the natural world in both Europe and South Asia, from the sixteenth century onwards. While the eighteenth century saw a convergence of the two approaches, the period of British domination over India saw the growth in natural history studies in new directions.

One aspect in which these British works differ from prevailing natural history works in India is in the social backgrounds of their creators. For instance, the material available from Mughal times is largely the chronicles of monarchs recorded by court historians. In some cases, these chroniclers and court artists were known individually: this was particularly the case with painters – including Mansur, an artist during the reign of Jahangir – due to the styles they had developed. By contrast, in the case of the writers of the British period, first during the EIC rule and later under the Raj, we have an array of writings by contributors who were essentially commoners– servants of the empire, so to speak, who, though being the rulers over the natives, were not necessarily aristocrats, or even members of the elite. The impact of the writings of not only explorers (in some cases sponsored by the colonial government) and scientists but also ordinary people – officers, soldiers, lawyers, surgeons, and their wives – lingers till this day. They created a plethora of works, mostly in English and notable for the details recorded and the manner in which they are written. Thus, a shift is evident, from studies of wild animals and plants undertaken in a courtly context to one in which they were pursued by amateurs from a range of social backgrounds.[43] Elizabeth Gwillim's and Mary Symonds's work can be seen in the context of this explosion of amateur involvement in natural history.

The British naturalists in India were strongly dependent on native Indians for the supply of material (live or dead specimens) and local information, as, indeed, they were in their colonies elsewhere, particularly Africa.[44] As discussed in several other chapters in this volume, Elizabeth Gwillim's correspondence provides plenty of evidence of such collaboration. She derived information about the medicinal properties of plants and their locations from interactions with locals, who could have been people in the employ of the household or of the Supreme Court in Madras, where her husband, Sir Henry, was a judge. Lady Gwillim was particularly reliant on bird catchers, who formed a distinct profession in nineteenth-century India and whose services were also regularly utilized by other British naturalists in the subcontinent. As Saraphina Master notes in case study 3 in this volume, these people were not often named individually and not always credited. In the major treatise on Indian birds by T.C. Jerdon, which appeared more than half a century after the Gwillims' stay in India, there are several references to the help provided by locals (natives)

with respect to information about the birds.[45] For instance, Jerdon relied on the Yanadi tribe to collect birds and eggs and perhaps also to share bird lore with him. And, of course, the painting style of the natural history artists in Calcutta had roots in the earlier natural historical traditions described above, which then had an influence on the development of scientific illustration more broadly.

The amateur European naturalists who lived in India during the late eighteenth and early nineteenth century took their cue from scientific developments taking place in Europe at that time. For instance, it was becoming increasingly common in this period to record natural history information in a more systematic fashion, by preparing lists of birds, animals, insects, and plants from specific regions, with the aim of getting an overall impression of the diversity of flora and fauna in that area. These site-specific studies with lists of birds could be said to be the precursor of modern-day species checklists, which birdwatchers today routinely prepare as they attempt to relate the bird diversity to local conditions of terrain, vegetation, and climate.

Although Elizabeth Gwillim did not, as far we know, prepare such lists, she did document the behaviour of several birds in considerable detail, paying attention to their behaviour and interactions with humans. For example, in describing the Baya bird's unusual nest, which looks like an elongated sac woven out of dry grass, she wrote: "There is a chamber within for the family & a perch across the bottom for the young birds to sit in before they can fly."[46] She also remarked on local names for birds, and ways of classifying them, including by using the suffixes "Braminy" (in later ornithological literature Brahminy) or "Pariar" (Pariah). As she noted, "whatever is superior of its kind is called Braminy & whatever is inferior is called Pariar – thus we have Braminy Kite – Braminy Duck – Braminy Lizzard &c – & the contrary." This observation shows her familiarity with the caste structures and hierarchies inherent within Indian society.

In a global context, many British residents in India, and in colonies in Africa and elsewhere, were participants in global networks of information sharing and knowledge. The talented Gwillim and Symonds sisters certainly had a sense that they were contributing to the grand enterprise of classification. As Elizabeth Gwillim's correspondence reveals, she was aware of important publications in England (and in Europe generally) in the field of natural history.[47] Several of her observations also focused on identifying the birds she saw in Madras with specimens she had seen in London or depictions that she found in works of natural history. For example, after describing the "Braminy Kite," she wrote, "I dare say you cou'd see one at Parkinsons either under this name or under the name of Pondicherry Eagle – there is a print the first bird in Catesby's Carolina – if you shou'd meet with that book it is called the white headed Eagle."[48] (She was mistaken, however, in this identification of the North

American bird with the Indian species.) As Suryanarayana Subramanya also points out in chapter 2 in this volume, Gwillim, in her notes on her paintings, also made more formal efforts to classify the birds and plants she depicted according to contemporary binomials. For example, on the reverse of a painting of a stork (plate 19), she wrote, "Ardea leucocephala? The plant is the Calamus dioicus. At least I believe it to be so. It is common about Madras."[49]

Since Calcutta was the nucleus of the EIC, sponsorship of natural history painting and documentation, by a variety of painters (mostly anonymous), developed largely in that region. Nonetheless, the output of the Symonds sisters, added to the better-known work by William Roxburgh and the network of surgeon-naturalists who linked Tranquebar and Madras, demonstrates that Madras was also a centre for pioneering studies on Indian natural history. The period in which the Gwillim and Symonds sisters lived in India and made their observations and paintings on natural history was a precursor to developments that formed a separate trajectory, especially after the mid-nineteenth century.[50] Some of the greatest ornithological works by the British were published in the period following the transition from the EIC to the Crown. T.C. Jerdon's *Birds of India* is an early example. Although this well-known two-volume treatise on Indian ornithology was published after 1857, he began to publish the work leading to it in 1839. Jerdon was in India between until 1870 and pursued his interests in ornithology from his early days in the Madras Presidency onwards.[51]

After the 1857 mutiny or uprising, more British expatriates began to spend longer periods in India, and, as they became more settled, they set about creating nature clubs and societies. They also took an active interest in game hunting (which indirectly contributed to the growth of field ornithology and the production of books on ornithology) and took up bird observation as a hobby in their home gardens; indeed, many bird books are about observing in the home garden, and many British writers from the period, such as Rudyard Kipling, included the familiar imagery of birds in garden settings in their works.

Among the natural historical societies that sprang up in the later nineteenth century, the Bombay Natural History Society (BNHS), which was created in 1883, was a prominent example. Two of the founding members of the BNHS were Atmaram Pandurang and Sakharam Arjun. Both were physicians and social reformers or activists, and Arjun was an expert on Indian medicinal plants. The BNHS continued to serve as a platform for natural history research and biodiversity conservation in post-independence India. One of the most important workers to emerge in India after 1947 was Dr Salim Ali, who is regarded as the "bird man of India" and, with his books, became the benchmark for ornithological work in India.[52]

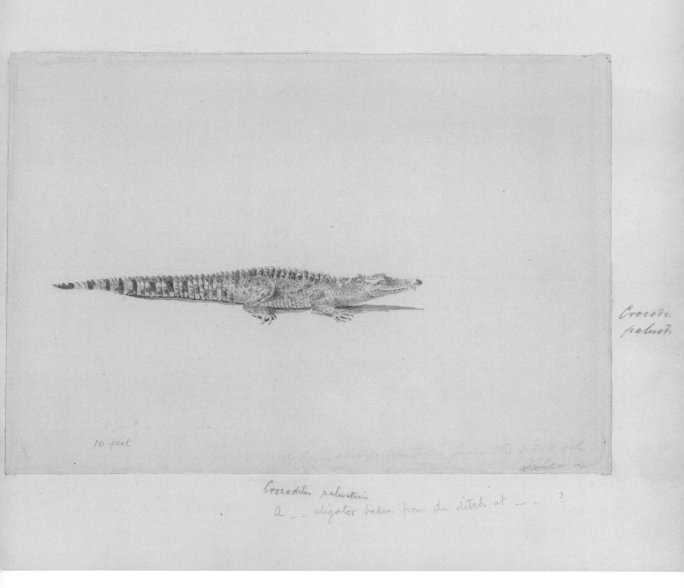

Crocodi
palust

10 feet

Crocodilus palustris
A _ _ aligator taken from the ditch at _ _ ?

PLATE 32
Attributed to Elizabeth Gwillim, *Marsh Crocodile, Crocodilus palustris*
(title from 2021 identification of species), 31 x 25 cm, watercolour
on wove paper. Blacker Wood Collection, CA RBD Gwillim-2-30,
McGill University Library. Inscriptions on recto: "51," "10 feet
[unclear]," and "A large alligator taken from the ditch at Vellore."

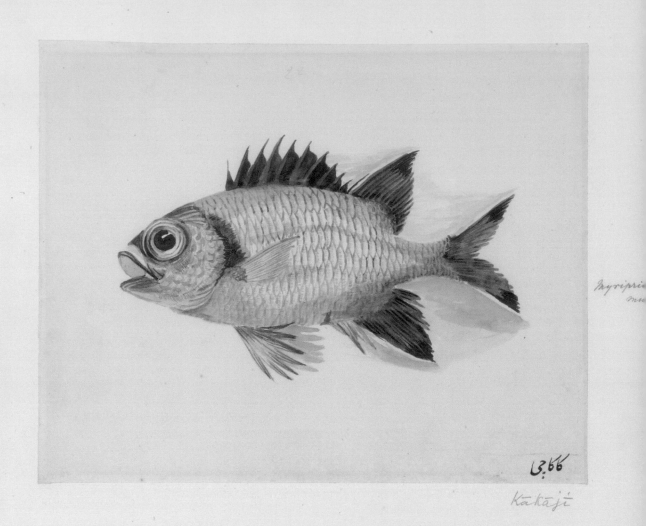

كاكاجى

Kākājī

Myripris
mu

PLATE 33
Attributed to Mary Symonds, *Pinecone soldierfish, Myripristis murdjan*
(title from 2021 identification of species), 31 x 25 cm, watercolour
on wove paper. Blacker Wood Collection, CA RBD Gwillim-2-14,
McGill University Library. Inscription on recto in Urdu script,
transliterated as *Kākāji*.

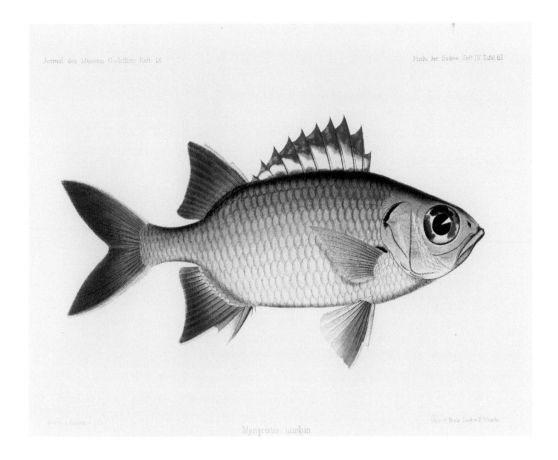

Myripristis murdjan

PLATE 34
Albert C.L.G. Günther, *Myripristis murdjan* from
Fische der Südsee (1875), Bild I, Heft IV, Plate 61.

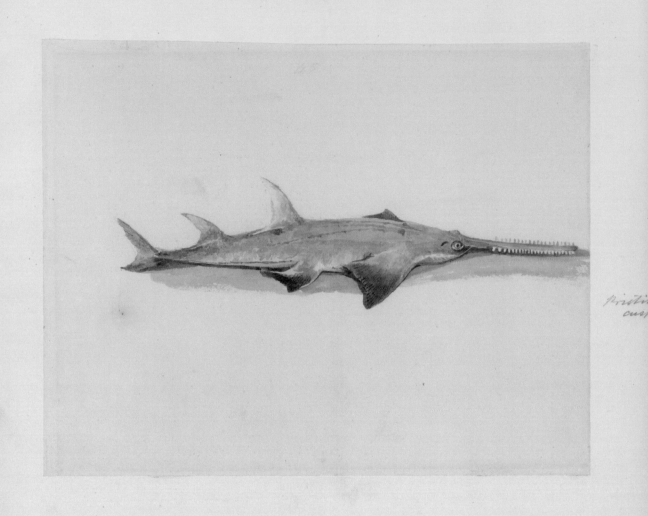

PLATE 35
Attributed to Mary Symonds, *Knifetooth sawfish, Anoxypristis cuspidata* (title from 2021 identification of species), 31 x 25 cm, watercolour on wove paper. Blacker Wood Collection, CA RBD Gwillim-2-25, McGill University Library.
Inscription on recto: "*Pristis cuspidatus.*"

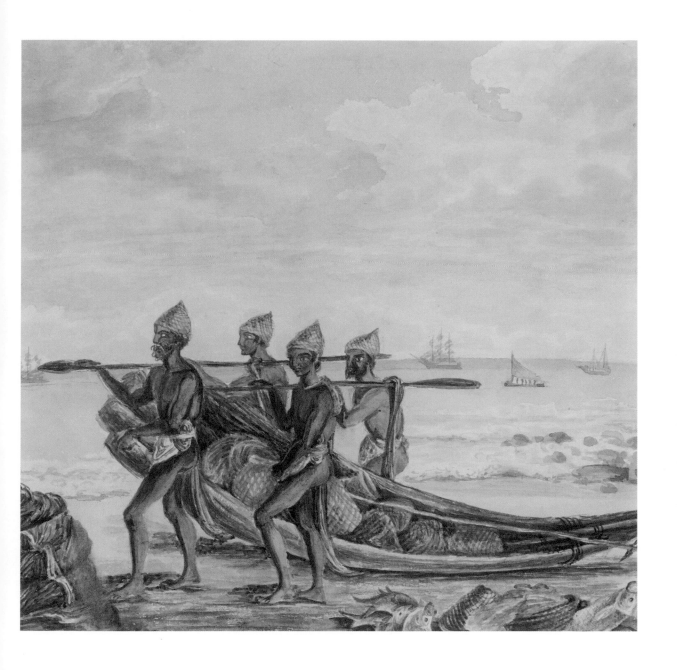

PLATE 36
Attributed to Mary Symonds, "Fishermen"
(title from inscription on verso), 20.0 x 21.2 cm, watercolour.
The South Asia Collection Museum NWHSA PIC106.64.

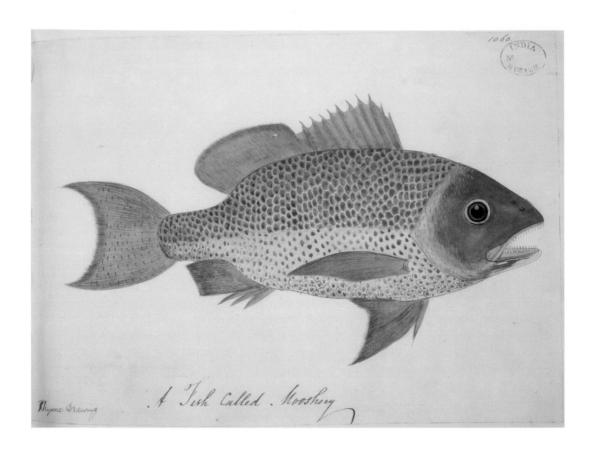

PLATE 37 *(above)*
A Fish Called Mooshery, Tanjore (Thanjuvar), ca. 1805–07.
British Library, © the British Library Board (NHD 7/1060).

PLATE 38 *(opposite, top)*
Attributed to Mary Symonds, *John's snapper, Lutjanus johnii* (title from 2021 identification of species), 31 x 25 cm watercolour on wove paper, Blacker Wood Library, CA RBD Gwillim-2-10, McGill University Library. Inscriptions on recto in Urdu script, transliterated as "Musri"; inscription on recto, "*Mesoprion johnii.*"

PLATE 39 *(opposite, bottom)*
Attributed to Mary Symonds, *Moon wrasse, Thalassoma lunare* (title from 2021 identification of species), 31 x 25 cm, watercolour on wove paper. Blacker Wood Collection, CA RBD Gwillim-2-5, McGill University Library. Inscription on recto: "*Julis lunaris.*"

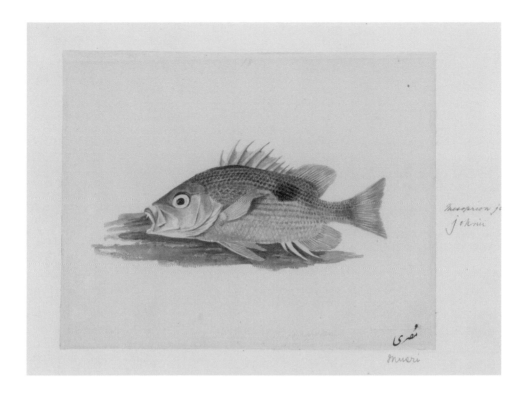

Mesoprion j̄
Johnii

مُصری

Musri

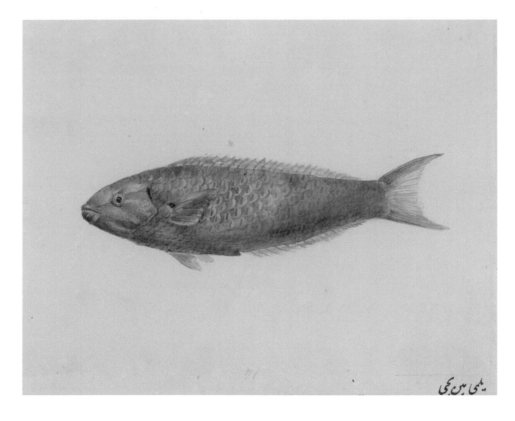

يلمى بىن بحى

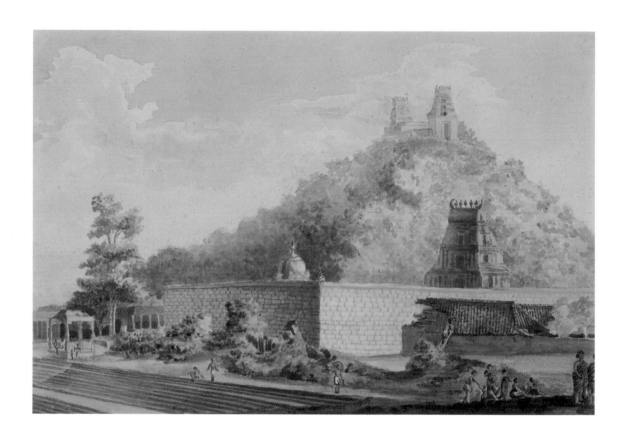

PLATE 40
Mary Symonds, "Pagodas" (title from inscription on verso),
1804, 21.0 x 31.0 cm, watercolour on laid paper.
The South Asia Collection Museum NWHSA PIC106.31.

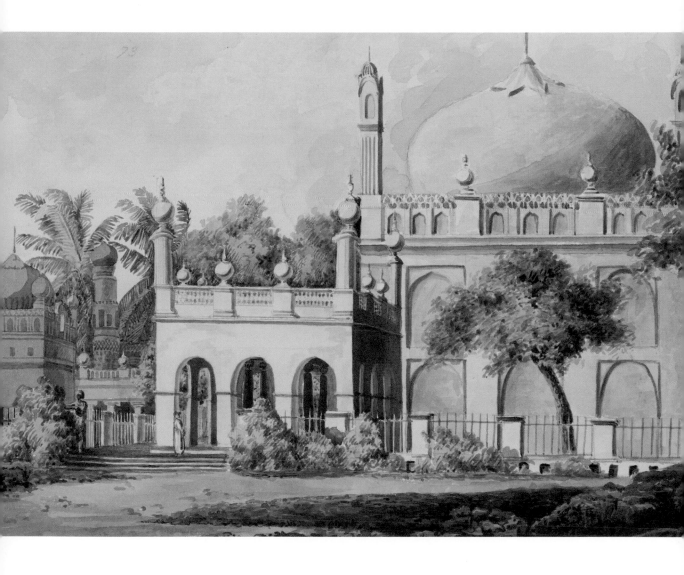

PLATE 41
Attributed to Mary Symonds, "Tombs of a mussulman family"
(title from inscription on verso), 21.0 x 31.0 cm, watercolour.
The South Asia Collection Museum NWHSA PIC106.9.

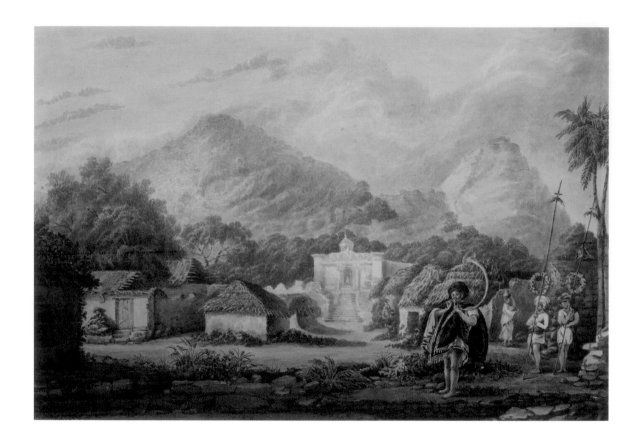

PLATE 42 (*above*)
Unattributed, "The Rustic Horn sounded on hills"
(title from inscription on verso), 21.5 x 31.5 cm, watercolour.
The South Asia Collection Museum NWHSA PIC106.1.

PLATE 43 (*opposite, top*)
Attributed to Mary Symonds, *Untitled*,
21.0 x 31.0 watercolour. The South Asia Collection
Museum NWHSA PIC106.44.

PLATE 44 (*opposite, bottom*)
Mary Symonds, "Pandanus Tree – Sort of Breadfruit"
[*Pandanus odorifer*] (title from inscription on album),
25.5 x 35.5 cm, watercolour. The South Asia Collection
Museum NWHSA PIC106.8.

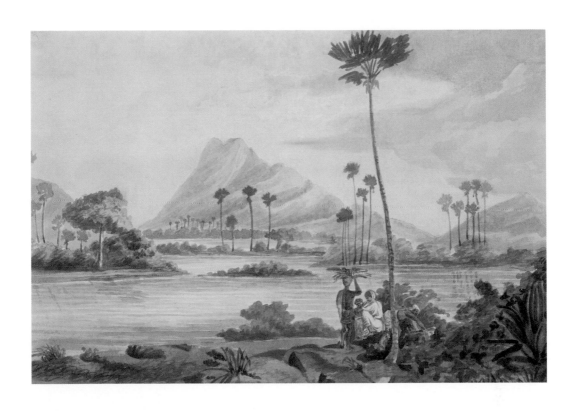

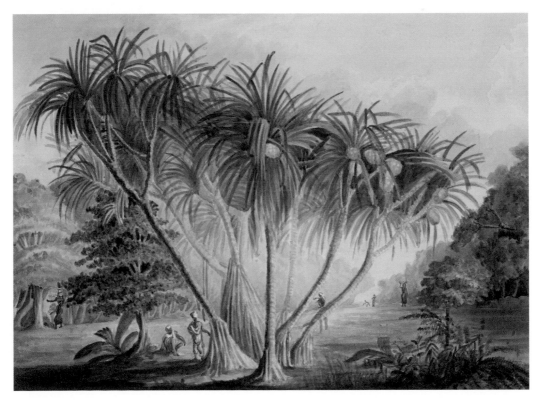

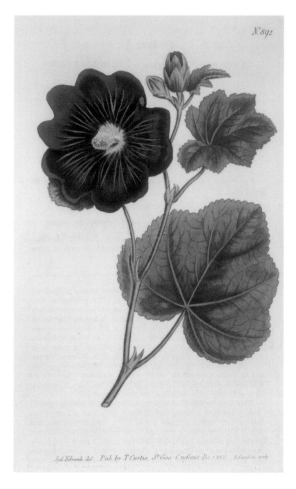

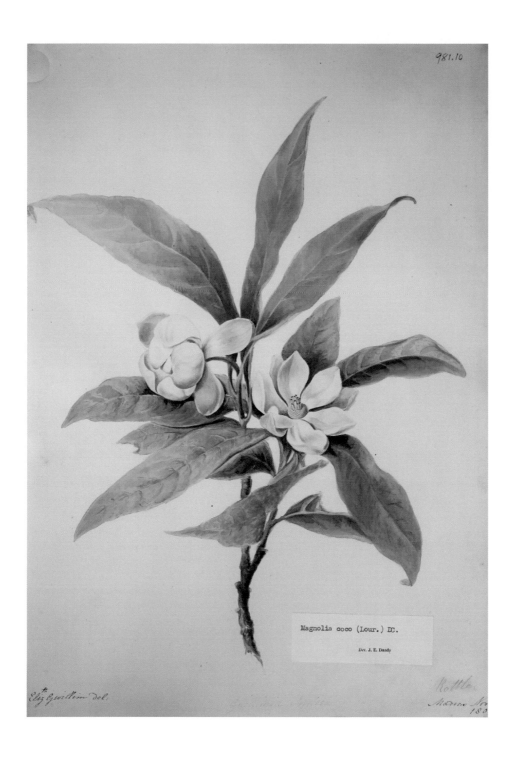

PLATE 47
Elizabeth Gwillim, *Gwillimia Indica*. LINN-HS 981.10.
Reproduced by permission of the Linnean Society of London.

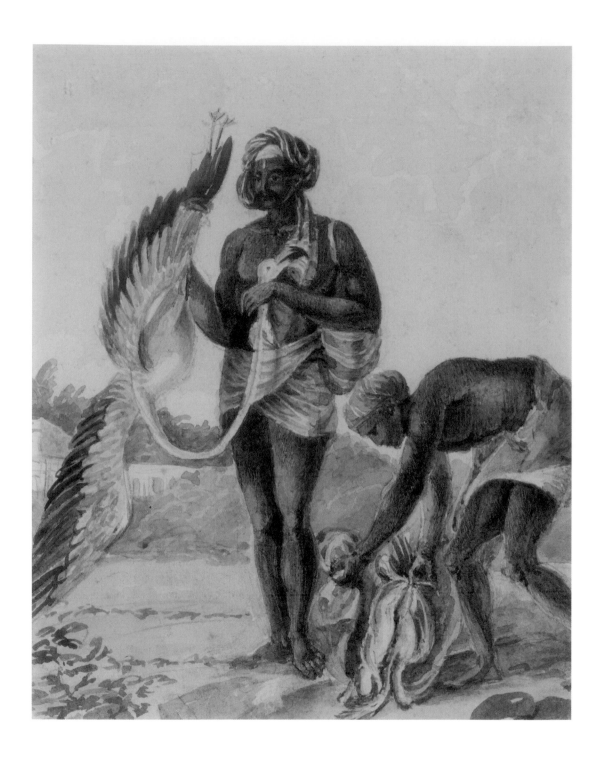

PLATE 48
Attributed to Mary Symonds, "Bird Catchers"
(title from inscription on verso), 12.5 x 10.0 cm, watercolour.
The South Asia Collection Museum NWHSA PIC106.66.

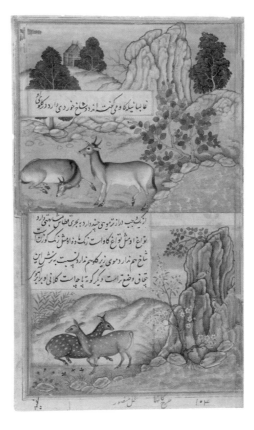

PLATE 49 (*top*)
Double folio from a
Kitab al-hasha'ish
(The book of herbs), dated
September 1595 India,
Deccan, probably Bijapur.
Opaque watercolour and ink
on paper, 40 x 51 cm. Freer
Gallery of Art, Smithsonian
Institution, Washington,
DC: Purchase – Charles
Lang Freer Endowment,
F1998.82.

PLATE 50 (*bottom*)
Two blue bulls and two
hog deer from a *Baburnama*
(Chronicles of Babur).
Ascribed to Mansur, ca.
1589, India, Mughal court.
Opaque watercolour, ink,
and gold on paper,
25.3 x 15.1 cm. Freer Gallery
of Art, F1954.29.

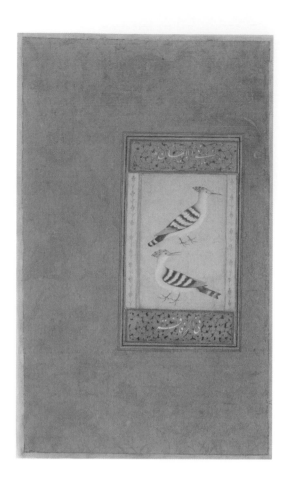

PLATE 51 (top)
Hoopoes. Painting mounted on a detached album folio. Mughal India, ca. 1600. Ink, opaque watercolour, and gold on paper, 13.65 x 7.3 cm. San Diego Museum of Art, Edwin Binney 3rd Collection, 1990.349.

PLATE 52 (bottom)
Spotted forktail from the Shah Jahan Album, ascribed to Abu'l Hasan, ca 1610–15, ink, opaque watercolour, and gold on silk, 38.6 x 26.3 cm. Metropolitan Museum of Art, 55.121.10.15.

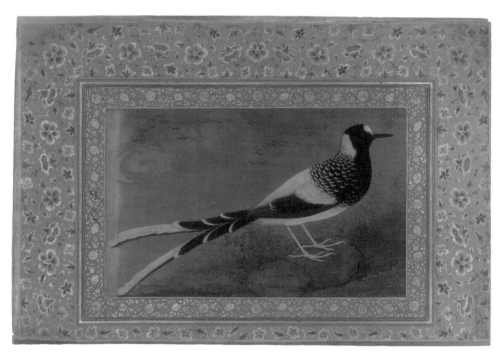

PLATE 53
Peregrine falcon (*Falco peregrinus*) ca 1805–07, India, Tanjore,
opaque watercolour and ink on paper. British Library, NHD 7/1010.

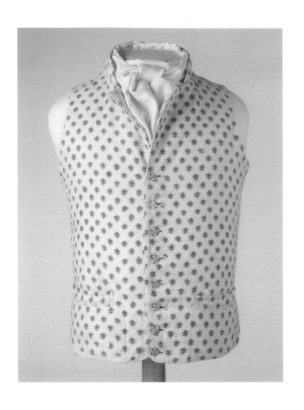

PLATE 54 (*top*)
Waistcoat made from a shawl.
Chertsey Museum © The Olive Matthews
Collection, Chertsey Museum.
Photo by John Chase Photography.

PLATE 55 (*bottom*)
Attributed to Mary Symonds, "An English
Nursery in India" (title from inscription
on album), 12.5 x 18.0 cm, watercolour.
The South Asia Collection Museum
NWHSA PIC106.35.

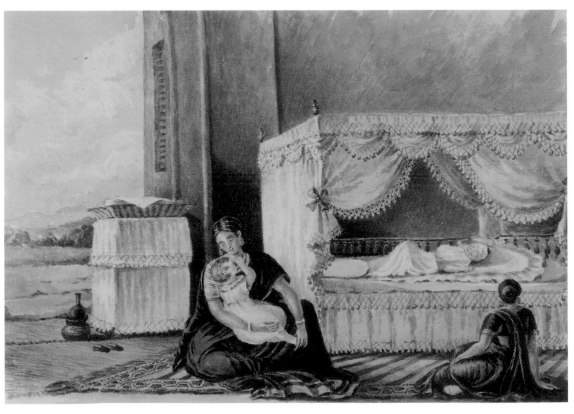

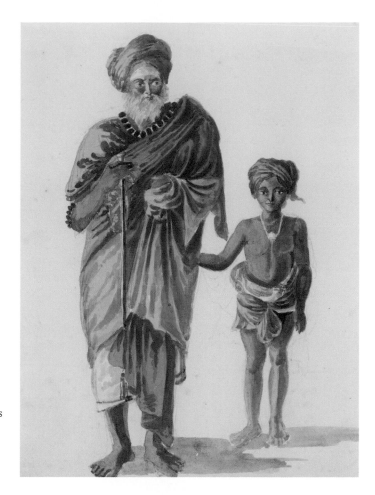

PLATE 56
Mary Symonds, "Pandaram – A Religious
Mendicant" (title from inscription on
frame), 24.0 x 18.0 cm, watercolour.
The South Asia Collection Museum
NWHSA PIC106.42.

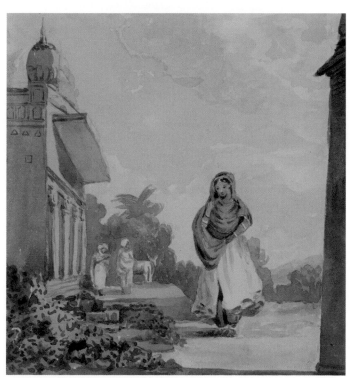

PLATE 57
Attributed to Mary Symonds, *Untitled*,
9.0 x 8.0 cm, watercolour. The South Asia
Collection Museum NWHSA PIC106.67.
The image shows a Muslim woman.

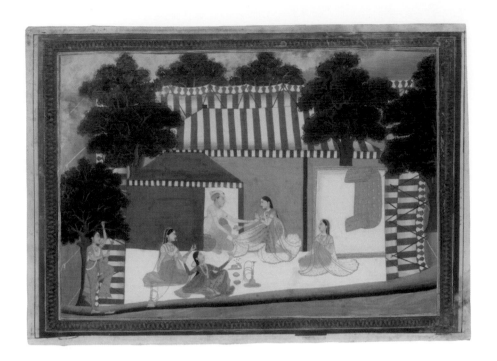

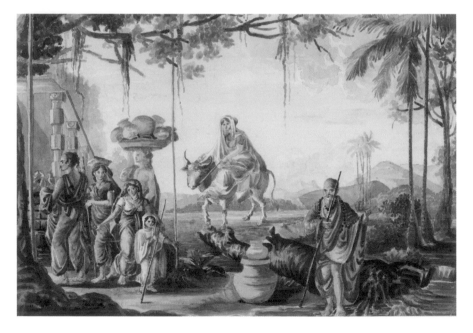

PLATE 58
Prince with Ladies in Camp, Lucknow, ca. 1760.
The painting shows Muslim women wearing
the peshwaz, as described by Mary Symonds
and Elizabeth Gwillim in their letters.
© Victoria and Albert Museum, London.

PLATE 59
Attributed to Mary Symonds, "Hindoo travellers"
(title from inscription on album), 21.0 x 31.5 cm,
watercolour. The South Asia Collection
NWHSA PIC106.18. Additional inscription on album:
"The banyan Tree it does not ascend by only sends
down pillars to support their large elongated branches."

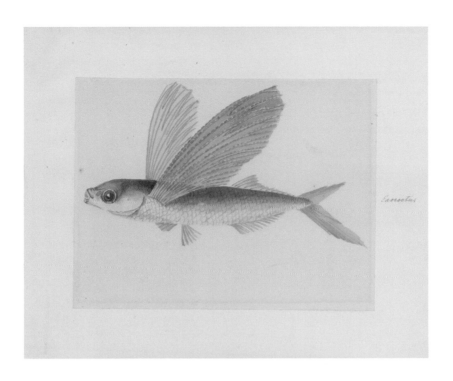

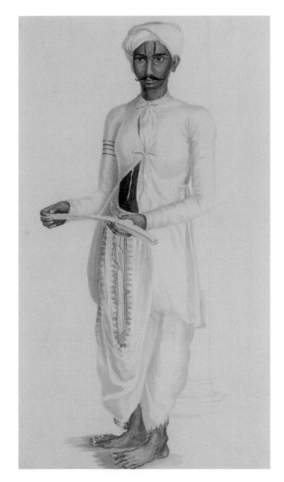

PLATE 60 (*top*)
Attributed to Mary
Symonds, *Flying fish,
Exocoetus sp.* (title from
2021 identification of
species), 31 x 25 cm,
watercolour on wove paper.
Blacker Wood Collection,
CA RBD Gwillim-2-3,
McGill University Library.

PLATE 61 (*bottom*)
Attributed to Mary
Symonds, "A native with
his book on palm leaves"
(title from inscription on
album) 36.5 x 21.5 cm,
watercolour. The South
Asia Collection
NWHSA PIC106.73.

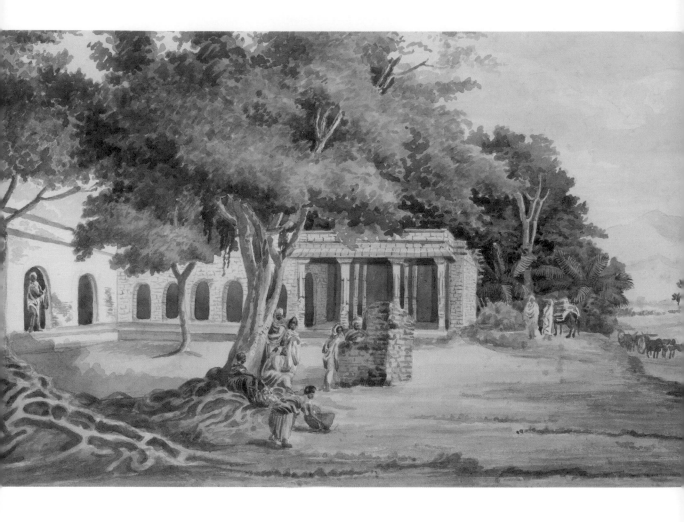

PLATE 62
Attributed to Mary Symonds, "Choultry Near Pummel [Pammal] ...
A Place Where Travellers Rest" (title from inscriptions on verso).
The South Asia Collection NWHSA PIC106.22.

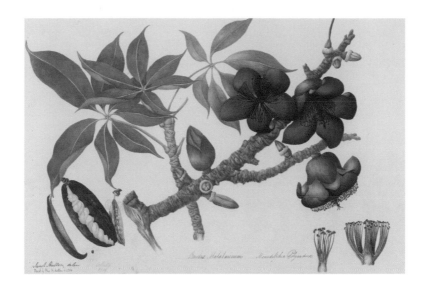

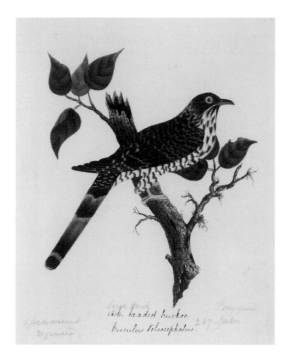

PLATE 63
Janet Hutton (née Robertson), *Bombax malabaricum*
(current accepted name *Bombax ceiba*), watercolour.
© Board of Trustees, Royal Botanic Gardens, Kew.

PLATE 64
Margaret Cockburn, *Large Hawk-Cuckoo, Hierococcyx
sparverioides* (title from 2023 identification of species),
watercolour. Courtesy of Library and Archives,
Natural History Museum, London. Inscription on recto:
"Ash headed cuckoo."

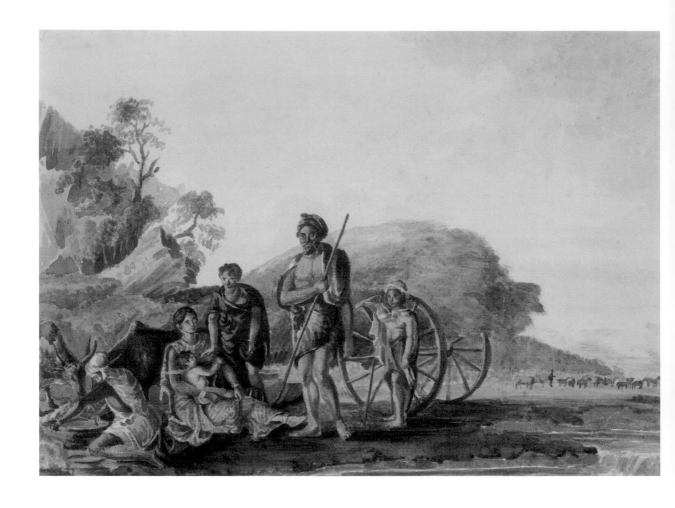

PLATE 65
Mary Symonds, *Untitled*, 1804, 19.0 x 27.0, watercolour
on laid paper. The South Asia Collection NWHSA PIC106.45.

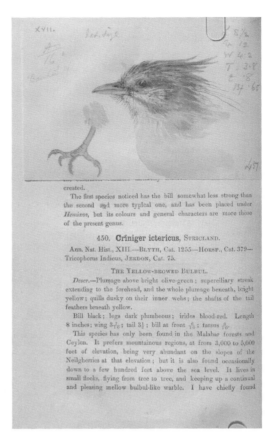

FIGURES 10

Title page of volume 2, part 1 of T.C. Jerdon, *Birds of India* (Calcutta, 1863).

FIGURE 11

Sketch from T.C. Jerdon, *Birds of India*, collections for rev. ed., vol. 2, part 1 (Calcutta, 1862). Blacker Wood Manuscripts Collection, QL691 I4 J47 1862a, McGill University Library, 82.

CONCLUSION

The period in which Elizabeth Gwillim and Mary Symonds lived and worked in Madras lay at the transition of empires, the Mughal Empire giving way to the East India Company, and is therefore of great historical significance. This chapter has described the transformation of Indian animal and plant studies from works that recount the wonders of the world and *materia medica* to a growing focus on observing physical features, size, and characteristics (such as breeding habits, gestational period, lifespan, and so on). "Scientific" classification, although defined in Europe, was a global enterprise that drew from

many existing ways of thinking about plants and animals. While the Mughal period witnessed great advancements in natural history studies in India, studies on birds developed further during the period of British rule. Perhaps the greatest contrast between the two empires with respect to natural history outputs was that, in the Mughal period, royalty took the lead in natural history documentation and scientific study, while, in the British period, commoners (including European expatriates) began to take an active interest. The Gwillim and Symonds sisters are a case in point. Servants of the EIC headquartered at Calcutta sponsored local artists to document Indian plants and animals and, through their sponsorship, contributed to the creation of what came to be called "Company painting."[53] Elizabeth Gwillim and Mary Symonds, in their efforts to document local flora and fauna, were largely acting independently and on their own initiative.

After the EIC phase, to which the sisters belonged, a period of immense output in natural history works, particularly books and paintings on Indian birds, developed. By looking at these centuries as a whole, rather than separating a study of the sixteenth and seventeenth centuries from that of the eighteenth and nineteenth, we can see in a clearer light the longer Indian engagement with ideas and notions usually attributed to a European scientific age. While many histories point to the triumph of the Linnaean system and European naturalists of the eighteenth century, in fact, many developments were occurring in the field in different parts of the world, any number of which might have eventually become universal, had the European colonial enterprise not also taken off at this moment, cementing the place of European sciences at the top of the hierarchy.[54] Also clear is the role of the Indian artists, who bridged the passage of these centuries and the accompanying changes in patronage, working continuously across the entire period and lending their depictions of plants and animals in support of the system of classification and the identification of new species.

Notes

We wish to thank Dr Anna Winterbottom for her helpful comments, which helped considerably in improving this chapter, and Professor Victoria Dickenson for encouragement. Abdul Jamil Urfi thanks the University of Delhi (India) for support.

1 Bhaduri, Tiwari, and Biswas, "Zoology"; Dave, *Birds in Sanskrit Literature*.

2 Salim Ali, *Ornithology in India* and "The Mughal Emperors."

3 Urfi, "What Colonial Writing about Indian Birds Reveals."

4 Contadini, "A Bestiary Tale," 19–20, and "The Kitab Manafi' al-Hayawān," 49n.21.

5 As Anna Contadini notes, Ibn Bakhtishu's text does not survive in its original form but in later digests that purport to be his exact text.

Contadini, "A Bestiary Tale," 19. The groupings, as listed in Contadini, "The Kitab Manafi' al-Hayawān," 41, are "man," domestic and wild quadrupeds, birds, fishes, and insects. A Persian translation of the text was made in the late thirteenth century (by 'Abd al-Hadi b. Muhammad b. Mahmud b. Ibrahim of Maragha, on the orders of Ghazan Khan [r. 1295–1304]), which includes ninety-four paintings of "mammals, birds, reptiles, insects, and humans." See Foltz, *Animals in Islamic Tradition*, 83–4, where this Persian translation is briefly mentioned.

6 Translation from an unknown source in the museum curatorial records. This folio was once part of a dispersed manuscript attributed to the Ilkhanid court at Maragha, Iran, ca 1300. For other pages, see Art Institute of Chicago 1935.166 and 1924.1346; Metropolitan Museum, 18.26.2 and 57.51.31; and "Qualities of Ringdoves (recto) from a Manafi' al-Hayawan (On the Usefulness of Animals) of Ibn Bakhtishu' (d. 1058)," unknown collection, https://www.gettyimages.ca/detail/news-photo/qualities-of-ringdoves-from-a-manafi-al-hayawan-of-ibn-news-photo/1172442647.

7 Kerner, "Art in the Name of Science," 25–6.

8 Rogers, "Dioscorides," 43–4.

9 Hussain, "Zakhira-e-Nizam Shahi."

10 In addition to the folios illustrated here, see a manuscript dated ca 1595 in the University of Pennsylvania Libraries (Kislak Special Collections Center, LJS278), and an early seventeenth-century example offered for sale at Christie's, Kitib al-Hasha'ish, https://www.christies.com/lotfinder/Lot/kitab-al-hashaish-india-probably-deccan-first-half-6024732-details.aspx.

11 Zadeh, "The Wiles of Creation"; and Salhi, "Prodigies of Cosmology." In addition, Karin Ruehrdanz has summarized her extensive research on this text and its adaptations on the Aga Khan Museum website, https://agakhanmuseum.org/collection/artifact/manuscript-of-the-wonders-of-creation-and-the-oddities-of-what-exists-akm367.

12 Examples include a dispersed manuscript attributed to the Deccan (for one folio, see Metropolitan Museum of Art, 1975.192.8), an eighteenth-century manuscript attributed to western India (US National Library of Medicine, MS P 3, https://www.nlm.nih.gov/hmd/arabic/natural_hist5.html), and a manuscript, *Aja'ib al-makhluqat wa ghara'ib al-maujunad*, offered for sale at Sotheby's, https://www.sothebys.com/en/auctions/ecatalogue/2018/arts-of-the-islamic-world-l18223/lot.87.html.

13 Translated into English as Sundaracharya, *Mriga Pakshi Sastra*. A typical entry would be the description of the group "Bears," pp. 11–12, which precedes an enumeration of the different species and the features unique to each. It mentions their mating habits, gestation, and care of their young, and also tries to describe the bears' temperament. Interestingly, a prefatory note to the translation mentions that, on its rediscovery, manuscript copies of the original work were supplied to the Maharaja of Travancore and to Dr Casey Wood of McGill University.

14 Wujastyk, "A Body of Knowledge"; Pole, *Ayurvedic Medicine*, 12-13.

15 Menon, "Making Useful Knowledge," 95.

16 Nyberg, "Linnaeus's Apostles," 75–7.

17 Salim Ali was the first to document the references to natural subjects in the Mughal documents, in "The Mughal Emperors of India as Naturalists and Sportsmen," a three-part essay published in 1927–8.

18 Babur, *Baburnama*, 335–6. See also Das, *Wonders of Nature*, 26–7.

19 This folio comes from the earliest copy of the *Baburnama*, dating to 1589 and containing 191 illustrations. The manuscript was dispersed in 1913; the largest part is in the Victoria and Albert Museum, London.

20 These descriptions have been extracted, translated, and matched with Jahangir's paintings, where possible, in Alvi and Rahman, *Jahangir the Naturalist*. Jahangir's achievements as a naturalist have previously been discussed in a number of key publications such as Salim Ali, *Ornithology in India*; Verma, "Portraits of Birds and Animals under Jahangir"; Alvi, "Jahangir's Passion for Exotic Animals"; and Koch, "Jahangir as Francis Bacon's Ideal."

21 As noted by the seventeenth-century traveller to Jahangir's court in William Foster, *Early Travels in India*, 103–4, as well as in Das, *Wonders of Nature*, 16, and Koch, "Jahangir as Francis Bacon's Ideal," 327–8, which gives the relevant primary sources.

22 Alvi and Rahman, *Jahangir the Naturalist*, 5–6, and descriptions of animals, such as those on 50–70.

23 Jahangir, *Jahangirnama*, 133.

24 The impact of this trip was first highlighted by Skelton, "A Decorative Motif in Mughal Art."

25 The painting is discussed, and the inscriptions translated, in Wheeler Thackston's translation

of the *Jahangirnama* and in Welch et al., *The Emperors' Album*, 162–5.

26 Das, *Wonders of Nature*, 130–1. See Koch, "Jahangir as Francis Bacon's Ideal," 321–2, for the scholarly debate on whether or not the dodo was drawn from life. For the dodo image, see "Dodo and Other Birds from the St Petersburg Album Attributed to Mansur," ca. 1627, Opaque watercolor on paper, 26 x 15.3 cm, Institute of Oriental Manuscripts, Russian Academy of Sciences, St Petersburg, MS E-14, fol. 80r, https://www.wikiart.org/en/ustad-mansur/untitled-dodo-1625.

27 His career has been documented, and all known paintings reproduced, in Das, *Wonders of Nature*. It is instructive to compare Mansur's paintings for other kinds of manuscripts illustrated in chapters 1 and 2 of the book to the animal paintings illustrated in chapter 5.

28 One of Shah Jahan's albums, in which several Mansur bird paintings are preserved (as well as his paintings of plants and other animals), is published in Welch et al., *The Emperors' Album*.

29 Koch, "Jahangir as Francis Bacon's Ideal," 299, 305–17, and 335.

30 'Allami, *Ain-i Akbari*, 1: 117–53.

31 See Zebrowski, *Deccani Painting*, 84–6 and 175, for a sampling of these paintings.

32 Easterby-Smith, "On Diplomacy and Botanical Gifts."

33 Watson and Noltie, "Career, Collections, Reports and Publications of Dr Francis Buchanan."

34 Jayaram, "Lalbagh Botanical Drawings," 70–2.

35 Nair, "Native Collecting and Natural Knowledge," 285–9 and 294–6. My thanks to Anna Winterbottom for identifying several eighteenth-century patrons of natural history and pointing me to the relevant sources.

36 Archer, *Company Paintings*, 97.

37 Sealy, "The Roxburgh *Flora Indica* Drawings."

38 Roy, "The Bengali Artist Haludar." The Barrackpore grounds themselves were painted by Charles D'Oyly; see British Library X666(16a) and X666(16b).

39 The Boileau album, made ca 1785, is held in the Victoria and Albert Museum, with pages numbered IS.75:1-1954 to IS.75:42-1954.

40 Lady Clive's travels are described in Jasanoff, *Edge of Empire*, 186–90; for the paintings, see a brief mention in Archer, *Company Paintings*, 44.

41 Elizabeth Gwillim to Esther Symonds, British Library, India Office Records (BL IOR) Mss. Eur.C.240/4, ff. 271r–278v; for the fish paintings, now in the Blacker Wood Collection at McGill University, see https://archivalcollections.library.mcgill.ca/index.php/fish-2.

42 Noltie, "Lady Gwillim's 'Madras' Magnolia."

43 Urfi, "What Colonial Writing about Indian Birds Reveals."

44 The role of European naturalists and ornithologists in the context of Africa, issues of colonial apartheid, and dependence upon local people for natural history information and the acknowledgement thereof have been examined in detail by focusing on two colonial ornithologists, Moreau and Bates, in Jacobs "The Intimate Politics of Ornithology."

45 See Pittie, "A Bibliographic Assessment."

46 Elizabeth Gwillim to Hester James, n.d. [spring 1803], BL IOR Mss.Eur.C.240/2, ff. 167r–177v, on f. 175v.

47 Ibid.

48 Ibid., on f. 176r.

49 Elizabeth Gwillim, notes on the verso of White-necked, or Woolly-necked Stork (*Ciconia episcopus*), Blacker Wood Collection, McGill University Library, CA RBD Gwillim-1-003.

50 Urfi, "What Colonial Writing about Indian Birds Reveals."

51 Jerdon, *The Birds of India*.

52 S. Ali and Silva, *The Book of Indian Birds*; S. Ali and Ripley, *Handbook of the Birds of India*. In his autobiography (*The Illustrated Salim Ali*), Ali mentions in detail the foundational work of the British naturalists and creators of the BNHS, which made later work in ornithology possible.

53 Previously unknown works from this school continue to come to light. See, for example, Tillotson, *Birds of India*.

54 As many have noted, the Linnaean system has its own methodological quirks and is not universally considered the most effective way to classify plants. See Raj, "Beyond Postcolonialism," and Menon, "Making Useful Knowledge," 87–8.

Part Two

*Social Lives, Social Networks,
and Material Culture*

6

Sir Henry Gwillim

Tender Husband, "Fiery Briton," and Stalwart Judge

ARTHUR MACGREGOR

While the present volume celebrates particularly the independent virtues of Elizabeth Gwillim, and her sister Mary Symonds, a brief account of Lady Gwillim's husband may help illustrate the circumstances that brought them all to India and that shaped their experiences of Anglo-Indian society during their sojourn in Madras. It seems certain that Sir Henry Gwillim's unbending pursuit of the (English) rule of law within the presidency, leading to his increasing isolation within the British establishment there, to years of stress and acrimony, and ultimately to his recall to London, could scarcely have been maintained without the refuge provided by the affectionate family unit formed by his wife and her sister: he depended on them as much as they relied on him. Their testimony, together with information gathered from independent sources, exposes the prejudicial nature of the account that has come down to us of Henry Gwillim's character and conduct – an account compiled largely by the virulently hostile establishment of the East India Company (EIC) in Madras, resentful at the imposition of independent Crown-appointed judges in what they had come to regard essentially as their private fiefdom. That struggle – being played out in the other presidencies at the same time – provides a background to the somewhat marginalized position within privileged British society in which Elizabeth Gwillim and Mary Symonds found themselves in India, an isolation that provided opportunity for them to develop their literary and artistic skills, but that took a heavy toll on Henry.

We know little of Henry Gwillim's youth between his birth in Hereford in 1759 and his matriculation at Christ Church, Oxford, at the age of sixteen; he graduated in 1779.[1] On 8 June of the following year, he was admitted to Middle Temple, and he was called to the bar on 9 February 1787,[2] by which time he and Elizabeth had already been married for three years.[3] The Gwillims set up home in Boswell Court, a distinctly Dickensian enclave off Carey Street, just to the north of Fleet Street. A single glimpse of their circumstances there is provided by a record of an insurance policy taken out in 1793, in which the contents of the household are valued at £100 and the books at £200 – an early indication of Henry Gwillim's dedication to the study as well as the practice of the law.[4] There are few records of his other activities at this time, beyond the occasional mention of a dinner of the Herefordshire Society held at the Crown and Anchor in the Strand, with Gwillim as one of the stewards.[5] Some indication of his broader interests is signalled by his election in the year 1795–96 to the Society for the Encouragement of Arts, Manufactures and Commerce.[6]

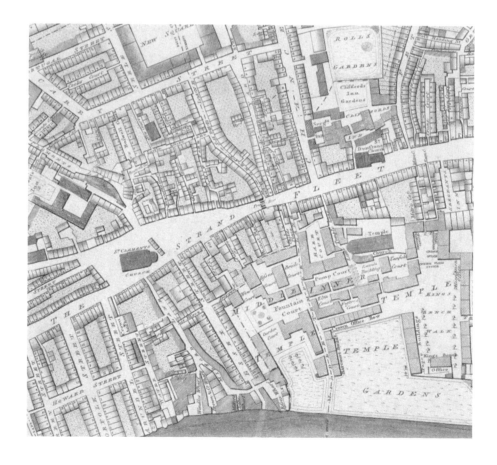

FIGURE 12 (*opposite*)
Horwood's map of London,
ca. 1794–99, 1st ed., D2. London
Picture Archive, record no. 34238.

FIGURE 13 (*right*)
Old Boswell Court, Shire Lane,
Strand, 1867 (later "Cleared away
for the Law Courts"). London
Picture Archive, record no. 312119.

Old Boswell Court Shire Lane Strand 1857
Cleared away for the Law Courts

Henry Gwillim's exceptional abilities within his profession were soon recognized, for, within seven years of his admission to the bar, he was appointed chief justice of the Isle of Ely.[7] Press notices in the years thereafter show him attending to his duties in a regular manner, presiding over the quarterly assizes at Ely and Wisbech. More concrete evidence that his energies extended beyond administering the law to its codification and rationalization emerges first with his preparation of a fresh (fifth) edition of Matthew Bacon's *New Abridgement of the Law* in 1798, "with additions including the latest authorities,"[8] and three years later with his own *Collection of Acts and Records of Parliament ... respecting Tithes* – acknowledged as "a work highly esteemed, and frequently quoted."[9]

One lesser twenty-page tract also deserves notice, not least for its resonances with an incident that would loom large in Henry Gwillim's later career. This is his *Charge delivered to the Grand Jury, at the Assizes Holden at Ely, on Wednesday the 27th Day of March 1799*.[10] Compiled during a period when the English establishment watched in horror the unfolding of events in

revolutionary France, Gwillim's text called on the jurors to be extra vigilant in their deliberations "at the present awful moment": what was at stake, he suggested, was nothing less than "our old usages, our old laws, our old government, our old liberties."[11] He looked back to the "miserable vicissitudes" of England's flirtation with popular democracy under Cromwell, and concluded that "our present scheme of government ... is not only most happily adapted to the genius of this country ... but is in itself perhaps the most stupendous system of polity that ever was devised by human wit."[12] When we come to consider Gwillim's later characterization as a "radical," a "revolutionary," or even a "Jacobin,"[13] it will be cautionary to remember this, the most considered and extended exposition of his political beliefs.

THE MADRAS YEARS

The year 1801 would prove particularly auspicious – not to say frenetic – for the Gwillims.[14] Having been selected for appointment as one of the judges of the Supreme Court at Madras, Henry was hurriedly presented by the lord chancellor to George III between bouts of the monarch's indisposition,[15] and, by the middle of February he was to be found, together with Elizabeth and her sister Mary Symonds, awaiting departure on board the *Hindostan*, bound for India.[16] The formalization of the knighthood with which he should have sailed evidently was delayed by the king's illness and by what Elizabeth Gwillim called "the confusions in the change of Ministry,"[17] so that it was not until 30 June that the *London Gazette* carried the announcement that "His Majesty has been pleased to grant the dignity of knighthood unto ... Henry Gwillim, Esq, one of the Judges of the Supreme Court at Madras."[18] As an aside, it is interesting that neither Sir Henry nor the newly elevated Lady Gwillim seems to have set much store by the honour: "It add[s] nothing to the respect of his situation," Elizabeth Gwillim wrote to her mother, "but he was desired to accept."[19]

No one could fault Henry Gwillim for the industry he displayed in his new post at Madras. Three judges had been assigned to the Court at its establishment by Act of Parliament in 1800:[20] Gwillim and Sir Benjamin Sullivan (or Sulivan) as puisne judges, and Sir Thomas Strange, designated the chief justice – a distinction that would become the subject of disagreement among them at a later date. Sullivan was already a veteran: over twenty years' service in India had taken a toll on his health, and he suffered repeated and prolonged bouts of illness and absence from duty. With the chief justice also absent for extended periods, it is with good reason that Elizabeth Gwillim described her husband as "the support of the court."[21]

Henry Gwillim too suffered in this new environment. At an early stage, Elizabeth Gwillim reported to her sister Hester James:

Mr. Gwillim & I have been great Martyrs during what is called here, the Griffinage, that is the first year ... We have both had boils & terrible prickly heat, which to a person so irritable as Mr. Gwillim, is perfectly a misery ... He was so little able to bear a disorder that requires so much patience, that he made himself quite ill.[22]

Fevers and agues evidently returned to plague him at other times, and it might be suggested that these afflictions go some way to explaining Henry Gwillim's extreme behaviour on occasion. Expounding on the effects of prickly heat, for example, the governor general of the day, Lord Minto, wrote: "To give you some idea of its intensity, the placid Lord William has been found sprawling on a table on his back; and Sir Henry Gwillim, one of the Madras judges ... was discovered by a visitor rolling on his own floor roaring like a baited bull."[23] The incident has been seized upon as evidence of Gwillim's ungovernable behaviour, but it offers a glimpse, rather, of the extremity to which the European population, as yet without effective medicaments, could be driven by the effects of the Indian climate.

This is not to deny that Henry Gwillim was indeed given to incandescent displays of temper: even his mild-mannered wife acknowledged that, once roused, he was "not apt to conceal his opinions when he has formed them."[24] Lord Minto's characterization of him as "a Welshman and a fiery Briton in all senses"[25] is no doubt objectively accurate. It finds confirmation from the rather waggish author – anonymous, but evidently a member of the bar – of a series of reminiscences of India that appeared in the *New Monthly Magazine* for 1828:

As for Sir Henry Gwillim, he was a little irascible Welshman, whose choler, in a constant state of liquefaction, was boiling over from morning to night. His irritabilities, indeed, were the overflowings of virtuous feelings; but they degenerated into infirmities quite alien from the judicial character, and fretted his sickly tenement of a constitution into premature decay.[26]

It would be wrong, however, to suggest that these displays were arbitrary in nature, even if of regular occurrence. Two important publications have shed light on the way the establishment of a Crown Court service in the respective seats of each of the presidencies immediately created tensions with the East India Company administrations and resentment at the erosion of their

hitherto unopposed authority.[27] With the introduction of an alternative jurisdiction, the EIC found its hitherto absolute authority repeatedly subverted for political ends as well as in the administration of civil justice. From the governors downwards, repeated attempts were made not only to frustrate and undermine the authority of the Crown Courts but to have them removed entirely. While Henry Gwillim's adherence to the rule of law, applied without favour to the Indian and European populations alike, set him immediately at odds with the Company administration, his stance needs to be understood in this wider context. The resulting isolation in which he and his family found themselves within Company-dominated Madras society was, to some extent, determined by these external considerations, their story shedding an interesting personal light on the uneasy tensions that emerged during this period of growing intervention from Whitehall in areas that the Company had previously considered its own. Henry Gwillim's displays of temper and frustration may perhaps be seen as responses to the intolerable stresses brought to bear on those who had to function professionally in this deeply divided society.

On one widely reported occasion, two Irish officers who had coerced a mild-mannered young captain into a fighting duel in which he was killed were brought before Henry Gwillim. The fact that the jury refused to convict them was attributed in the British press to its having been composed mostly of Madras businessmen, who were unwilling to risk alienating the army clientele on whom their trade so heavily relied. While bound to accept the verdict of the jury, Gwillim made no secret of his outrage at their decision and his personal conviction about the culpability of the officers.[28] Europeans who abused or ill treated the native Indian population further received no favour from him: James Stevens, an artilleryman whose servant Lutehoomy died after he had beaten and kicked her, escaped a murder charge on the basis that the medical evidence could not prove conclusively that she had died specifically of the injuries inflicted upon her; Stevens nonetheless received a lacerating address at his discharge from Gwillim, who clearly felt no need to disguise his opinion that justice had again failed to be done.[29]

But Henry Gwillim's pronouncements from the bench were by no means uniformly searing, and he could also be found advocating clemency when this seemed appropriate – particularly in relation to native Indians who found themselves in court.[30] There were even moments of levity, notably an episode concerning the propriety of the judges' wearing wigs (which were generally dispensed with by the profession in Madras, on account of the climate):

Upon the first formation of the court ... Sir Thomas Strange had strongly urged that the dignity and decorum of the bench required the judges to wear them. A batch of them were accordingly sent for from England ... I

shall never forget [the judges] making their first appearance in that absurd, and, considering the climate, intolerable costume. The cock-roaches had amused themselves during the passage with the wig of the Chief Justice, and made such havoc with it, that he came into court with one of his ears projecting out of a large hole ... Sir Henry Gwillim, though constitutional-ly irascible and nervous, bore the encumbrance with great composure; but it was too much for Sir Benjamin, who, finding that the wig harboured in its labyrinths an immense host of mosquitoes ... snatched it off in a sudden fit of indignation, and threw it with an oath, somewhat extra-judicial, into the middle of the court. His example was instinctively followed by the two others; and the three wigs flying from the bench, and lighting like so many birds on the same spot, constituted a most irresistible species of farce. A roar of laughter ensued; and it was some time before the court could recover its gravity sufficiently to go on with the business.[31]

Certainly, the letters written from Madras by Elizabeth Gwillim and her sister Mary Symonds show a much more humane character than that given to Henry Gwillim by the outside world – inconsolably crying all day at news of the death of a friend (and almost in tears at the loss of Elizabeth Gwillim's pet canary), delighting in the arrival of a favourite pepper-and-salt coat, "ravished with his shoes & boots," and delighted with silk stockings, his linens always "particularly neat." The house seems often to have been full of laughter, not least on the part of Henry Gwillim, who "loves a laugh."[32] After some time, he abandoned the palanquin that carried him daily from the family home at San Thomé to the courthouse, preferring to ride for the good of his health. The experience seems also to have put him in closer touch with nature, for before long we learn from Elizabeth Gwillim that he has "taken it into his head to be a great admirer of the animals of this country"[33] and is attempting to draw them – evidently without too much success, for his wife stepped in to produce some drawings of sheep and goats for him.

While continuing, in his official capacity, to be unsparing of those who flouted the law, Henry Gwillim was equally robust in his defence of judicial independence against those who sought to compromise it. In an extraordinary stand-off reported in 1804 (the year after the event), for example, he defied even armed troops sent to seize the person of Colonel Charles Mandeville, who had been dismissed by the Company after a court martial but whom Gwillim had given the shelter of the Court and of his own house, pending an appeal.[34] His refusal to yield an inch on the matter of the supremacy of his jurisdiction certainly contributed to the damaging falling-out that brought about his recall to England and that has come to be regarded as the definitive episode of his career.

THE DÉNOUEMENT

A number of complaints by East India Company personnel – some of them evidently of long standing – coalesced in the maelstrom that broke over Henry Gwillim's head in 1807. The principal protagonists were the chief justice Sir Thomas Strange; Alexander Anstruther, the Company's advocate-general in the presidency (and, Gwillim was quick to point out, Strange's brother-in-law); and Lord William Bentinck, governor of Madras – each of whom was involved to a greater or lesser degree in the grievances brought by the others. The catalyst was provided by a decision of the governor in council that the Company should institute a local police force charged with maintaining order over the native population, who were previously subject to the same system of English law enjoyed by the European residents. The force was led first by one Walter Grant and later placed under the command of a military officer, Captain James Grant.[35] He was given wide powers of arrest but was under no obligation to bring those detained before the Court (which remained answerable to the Crown rather than the Company). Gwillim and Sullivan (during a sixteen-month absence of Strange in England) were naturally incensed by what they saw as an affront to the established machinery of justice and responded by promptly cutting themselves off from all communication with the executive authority, so that, by the time of the final dénouement, the two camps were effectively isolated from each other and in a state of mutual antagonism.

The ultimate crisis erupted when, in response to a reported riot in the Black Town area of Madras, Captain Grant and his men had arrested a number of putative offenders on grounds so weak that charges were subsequently dropped against all but one of them – described by Gwillim (before whom the case was brought in this instance) as not a dangerous revolutionary but "a poor singing Brahmin." The terms in which the jury was directed and the language in which the police force was characterized were incendiary enough, but Gwillim compounded the force of his attack on the actions of the government by publishing the text of his directions.[36] Here Gwillim nailed his colours firmly to the mast: he expressed his pain at opposing the wishes of the government, but concluded that he must nonetheless do his duty, whatever the personal consequences. He argued that the Company's new police force had "raised itself above the civil power," being headed and directed by a military man and retaining a military force in its service; he characterized the head of this force, James Grant, as a "military despot" who "summons whom he pleases, detains where and as long as he pleases, and hears and determines what he pleases." Gwillim linked this specific case to the wider problems of despotism, warning that "arbitrary power cannot in the nature of things last long ... Though men cannot break their bonds, yet they will find the means of ridding themselves

of tyrants." He concluded by attributing the success of the British settlements in India to the fair government and impartial justice they hitherto had offered:

> Why have the natives of India clung to the English in preference to other Europeans? Because they have felt themselves more at liberty with them. Why has the population of this place increased so much as it has done within these past few years? Because people live in it under the protection of equal laws.

The effect on the governor in council was immediate and electrifying. Even before Gwillim's charge to the jury had been printed, the burden of the message and its character had been transmitted to Government House by Anstruther, the advocate-general, who had taken extensive notes in court and who commented further on the "great vehemence of manner" with which Gwillim had conducted himself there. A note was sent the next day to Sir Thomas Strange (recently returned from England), by the governor in council:

> We have received information that an address to the Grand jury was yesterday pronounced by Sir Henry Gwillim, in which the Acts of Government were severely arraigned, the Governor personally mentioned in terms most contemptuous and degrading, and the whole executive authority, from the Government to the lowest native officer, held forth as proper objects of public odium, suspicion, & disrespect, and the late arrangements of Police, which Government felt it to be its duty to establish, pointedly reprobated, with the evident intention to counteract and check its aspirations.[37]

Describing Gwillim's pronouncements as "highly dangerous to the public safety," the governor in council asked the chief justice to take his seat on the Court for the remainder of the session, with the clear intention of curbing Gwillim's behaviour and "as a measure essential to the maintenance of the authority of Government, and of the public tranquility."[38] Governor Bentinck made no bones of his personal adherence to a system of law (i.e., that administered by the Company) that he saw as essential to the well-being of the country but that was quite at odds with the principles of equality upheld on behalf of the Crown by Gwillim:

> We require a well-regulated despotism – the Government must be all-powerful – the principal object of our legislation is to give to the natives of these climes security for their persons and property and no further – this is civil liberty. Political liberty would turn us out of India

... It becomes us therefore in our ardent endeavours to secure to our subjects the full enjoyment of Civil Liberty, to take care that we go not an inch further from thence.[39]

He went further, declaring, "It was a great mistake in my humble opinion to have ever given English Laws to any part of this society."[40]

At the governor's request, Strange now joined Gwillim on the bench at his next sitting, only to promote the latter's further outrage and to set in train a whole new stream of mutual accusations in which grievances stretching back over several years were brought to a head. Strange's attempts to pick his way through this difficult process with a series of notes forewarning both Gwillim and Sullivan of his intentions "as a matter of duty" brought only a response from Gwillim accusing him of "criminal servility," of being the "willing tool" of government, and of trying to "overawe and control a brother judge."[41] The very question of the chief justice's authority over the two puisne judges, long disputed by Gwillim and Sullivan, who insisted on their independent authority, was brought into play again: Strange complained that they had both "professed an ignorance of any official rights belonging to him [as chief justice], as contra-distinguished from the Puisne judges, and have with the consistency to be expected, acted upon a denial of their existence."[42] They had acknowledged in him merely "a certain superiority in title, rank, and salary," while Strange claimed that his superior position was enshrined in the Court's founding charter. Access to the official seal of the Court was similarly disputed, the chief justice claiming that it should be applied solely by his hand, and the others dissenting.[43] Further, he commented that, in addition to the judges' suspending all communication with the governor in council, Gwillim had declined to communicate with Strange himself, ever since the latter's return from England in June 1806. Additionally, the two judges had independently proposed the appointment to the Court of native experts familiar with Hindu and Muslim law, evidently for the benefit of Indian parties in proceedings. Strange had opposed the idea, insisting that, if the proposal were to be made formally to the government, his dissent was to be made clear – and, again Gwillim and Sullivan had simply ignored his requests.[44]

This litany of grievances against Gwillim was set out at length and laboriously documented, with the intention that two formal complaints should be sent to London, one submitted by Strange directly to the Crown, claiming that the business of the Court had effectively been brought to a standstill and submitting the resolution of the situation to "the royal wisdom"; the other from the governor in council to the Court of Directors of the EIC with a request that they be laid before the king. It was the latter that prompted notable action in London, leading the Court of Directors to write to the prime minister on

10 September 1807.[45] While declaring themselves unwilling to "enter fully into such observations as suggest themselves from the facts," the members of the Court felt that "they cannot forbear to notice that in the state of the Public Mind under the Government of Fort St George, as described by late Accounts, they are very apprehensive that the conduct exhibited by Sir Henry Gwillim, invested as he is with a public Character, must have a direct tendency to foment dissention & encourage contempt of & resistance to Government." His immediate removal from office was urgently requested.

Gwillim, meanwhile, had been preparing his defence in characteristically trenchant terms, although he had some difficulty in transmitting it to England. The convoy carrying the dispatches of the governor and the chief justice had sailed almost immediately, leaving Gwillim to compile with all haste an initial response, which he hoped might arrive at the homeward-bound ships while they paused in Ceylon. His papers arrived there too late, however, and were returned to him and later sent on to Calcutta in the hope of finding an early passage to England.[46] The stress of these affairs would have been rendered almost unbearable by the death, on 21 December 1807, of Elizabeth Gwillim – whether suddenly or following a period of illness is unknown – rendering 1807 surely the blackest year of Henry Gwillim's lifetime.

However laudable his resistance to those whom he saw as trespassing on the rights and jurisdiction of the Court, and indeed on the rights of the Indian population, it must be admitted that Henry Gwillim handled the situation in such an obstinate – even contemptuous – manner that it was bound to end badly for him. In the event, an Order-in-Council was issued signifying His Majesty's pleasure that Gwillim, "with all convenient speed," should "repair to England" in order that the memorial and petition of the Court of Directors of the East India Company complaining of his conduct might be investigated.[47]

So it was that in the autumn of 1808 Henry Gwillim and his sister-in-law Mary Symonds prepared to leave India for England.[48] Among their well-wishers (and perhaps in the mind of Gwillim himself), it was by no means a foregone conclusion that he would not be back. There were many expressions of goodwill in his favour at this time, although the government doggedly tried to deny him the oxygen of favourable publicity. For example, seven of the "Officers and Practitioners of the Supreme Court" were bold enough to compile an address in Gwillim's favour, but the secretary to the government took it upon himself to ban its publication in the Madras newspapers.[49] In due course, the *London Pilot* was pleased to give it an airing, commenting with elaborate irony that "the public will thus be able to appreciate the *impartiality* with which Sir Henry has been treated, and the freedom of the Asiatic Press!"[50]

Other commentaries favourable to Gwillim came from a variety of lay sources, but they too were suppressed in Madras and had to wait for publication

in the British press, which naturally lay beyond the repressive control of the governor in council. The *Asiatic Annual Register* (published in London), for example, carried a series of testimonials dating from October 1808 that reveal – even allowing for the elaborate courtesies and hyperbole commonplace in such eulogies – a genuine sense of loss among the population at the departure of a much-respected member of their community.[51] Those emanating from the native Indian population in particular reveal a genuine warmth of feeling and contain many acknowledgements of the sympathetic treatment they had received at Gwillim's hands. For his part, he returned expressions of admiration for their "gentle manners and modest deportment," together with assurances that he would always keep them affectionately in his memory.

With so many endorsements ringing in his ears, Gwillim now made his formal exit from Madras, at which point (somewhat belatedly) European officialdom too paid him the respects that were his due:

> On Monday afternoon, the honorable Sir Henry Gwillim … embarked on board the honourable company's ship Phœnix, captain Ramsden, for Europe.
>
> Sir Henry was met at the beach by his excellency lieutenant-general Hay Macdowall,[52] commander-in-chief, the honorable Sir Benjamin Sulivan, Knight, and a most numerous assemblage of European and Native inhabitants of this settlement – the principal Khans of the Mussulman and the heads of Hindoo casts, personally paid their respects to Sir Henry Gwillim, prior to his reaching the boat, and a few of them proceeded with him on board.
>
> A salute of seventeen guns from the garrison of Fort St George announcing his leaving the beach, and a like salute from the honorable company's ship on his arrival on board the Phœnix.[53]

Despite the plethora of good wishes, the voyage home was not a comfortable one. The extremities to which the *Phœnix*, its passengers, and its crew were carried on that hurricane-tossed crossing, after weighing anchor in "light airs and pleasant weather" on 26 October 1808,[54] are well summoned up by Stephen Taylor.[55] Sir Henry too left a testimonial, when he wrote to his sister-in-law Hester James from Capetown on 15 January 1809: the voyage had already taken eleven weeks and two days (some three weeks longer than normal), "in the course of which we encountered a most tremendous gale, which lasted three days & three nights, & for nearly four & twenty hours we had little expectation that we would be able to weather it." They had long since lost contact with their escort vessel: "We suffered much, in ship & cargo … but happily for us our injuries were not such as irreparable at sea as to prevent us

from proceeding on our voyage."[56] It would be 13 May 1809 before the *Phœnix* reached Falmouth, where Gwillim and Symonds disembarked.[57]

Ahead lay the prospect of an equally tempestuous encounter with those who would decide on the action to be taken on the allegations that had led to Gwillim's recall to London. The Court of Directors of the East India Company had busied itself in trying to digest the "voluminous mass of papers" and copying them to be laid before Crown. The members were eager to add the weight of Government involvement to the proceedings in advance of Gwillim's arrival:[58] an approach by the chairman and deputy chairman to Whitehall as to "whether His Majesty's Ministers consider the case proper to be referred to the King's Law Officers for Prosecution on the part of the Crown" drew the response that "His Majesty's Government do not feel themselves called upon to direct any prosecution to be instituted against Sir Henry Gwyllim, but that the E. India Company will be at liberty on his arrival in England to adopt such furtherances ... as they may deem expedient."[59]

The evidence assembled by the Company has been summarized above. Gwillim's twenty-three-page response, dated 11 November 1809, is characteristically blunt: he has examined the allegations submitted by the Court of Directors – "charges so loosely framed and so destitute of proof, were perhaps never exhibited in an ordinary court of justice" – let alone against one of his Majesty's judges; he refers to "the concern Your Majesty would feel were calumny to fasten upon them [the judges] without their having an opportunity of repelling and exposing it." The evidence as presented is rebutted by Gwillim one point after another: the "riot" with which the whole affair had started, never took place; he denies that His Majesty's judges in India are precluded from making observations on the local government, especially when "persons acting under the authority, or the supposed authority of the local government are found to act offensively to their fellow subjects and in breach of the laws of the country"; the appointment of salaried justices by the governor in council had been "a piece of patronage extrinsick and quite foreign to the act" that had established the Supreme Court in Madras; he knew of no local disaffection of the population that might have justified the establishment of the system of police, which "argued imminent danger to the country, and a general distrust of our native fellow subjects," but whose introduction the chief justice himself had been only too willing to support; he readily admits to having had some of those police officers brought before the Court for their misdemeanours, but cannot see that it is an offence "to oppose assumed, unauthorized, summary jurisdiction" or to protect His Majesty's subjects from "arbitrary punishments"; the supposed verbatim accounts of his charge to the grand jury are nothing of the kind; by taking his seat alongside Sir Henry, the chief justice had committed an outrage on the Court, having "proclaimed to the country

that a Judge, appointed by Your Majesty and then in the execution of his duty, was unfit to be trusted"; and so on.[60]

It would be 11 April 1810 before a committee of the Privy Council made their final pronouncement on the case, recommending that he "should not return to his Seat in the Court at Madras" but that, "if Your Majesty should graciously so please, to direct some Allowance to be made to Sir Henry Gwillim."[61]

AFTER INDIA

Although Henry Gwillim had lost his position in Madras, he remained in sufficiently good standing to retain his pension from India of £100 a year. He purchased a house at Staplefield Place in Sussex – not a grand nabob's mansion, but a comfortable and pleasant-sounding residence for his retirement.[62] He married again in 1812, to Elizabeth Chilman, thirty years his junior;[63] they would have twenty-five years of married life together and produced a daughter, yet another Elizabeth.[64] An inheritance of £5,000 at the death of his father in 1818 would have confirmed his financial security for life.[65]

Henry's judicial career also continued – albeit at a more parochial level – with his appointment as a justice of the peace on the South Eastern Circuit. A document of 1825 records his name among the visiting justices at Horsham Gaol,[66] and in the same year we find him at the Horsham Quarter Sessions, "setting various carriage fees at the cattle market for the purchase and collection of hay and feed."[67] Two years later, he is involved in the settlement of a case involving "a piece of the highway stopped up as unnecessary."[68] Occasional newspaper references show him presiding over the assizes, sometimes adjourning them to Staplefield Place itself. The indications are that he continued to administer justice in his usual robust manner, even if now in a rural setting rather than in the international theatre of the East India Company: a tithe case brought before him in 1830, for example, involving the disputed pasturing of a cow and two calves, was settled with an award of costs against the owner of the cattle – a former attorney general.[69]

A final gesture in recognition of his services to the legal profession came too late for him to be able to take advantage of it. In a letter of 2 December 1827, Sir Henry thanks the masters of Middle Temple for their invitation to join them as a bencher of the inn:[70]

> I duly received your letter of the 28th inst. but was too unwell to return an immediate answer, agreeably to your wishes. I beg you will make my respectful compliments to the Masters, & tell them that my infirmities will not allow me [to] accept a seat at the Bench table. I am suffering

under a most severe nervous complaint, from which I have no hope of ever being delivered.

I am, Sir, your obedient servant

H. Gwillim

It would be a further ten years before Gwillim died. Popular assessment of him at the time was sympathetic and not at all tainted by his earlier falling-out with the East India Company. It would be entirely understandable if, among the legal profession in particular, his defence of the rights of the Court in Madras had attracted more support in England than it enjoyed from the Honourable Company. One obituary reads:

On the 12th [September 1837], at Staplefield, Sussex, in the 79th year of his age, [died] Sir Henry Gwillim, formerly first [sic] Puisne Judge of his Majesty's Supreme Court of Judicature at Madras. He acquired professional distinction before his appointment to India by his edition of *Bacon's Abridgement*, and he subsequently published a copious and highly valuable collection of tithe cases. His learning was deep and accurate – as an author his industry in research was unwearied – as a judge his integrity and independence were uncompromising.[71]

Notes

It is a pleasure to acknowledge the help of the following in tracking down documents relating to Sir Henry Gwillim: Barnaby Bryan, Middle Temple Archives; Sue Sampson, Cambridgeshire Archive Service; John Harnden and Lorna Standen, Herefordshire Archive and Records Centre; Alice Millard, West Sussex Record Office; and the staff of the British Library, the National Archives, the London Metropolitan Archives, and the National Archives. My thanks also go to Dr Patrick Wheeler and to Dr Anna Winterbottom, both of whom guided me to other useful sources.

1 Foster, *Alumni Oxonienses*, 1: 579: "matriculated 22 March 1776, aged 16; B.A. 1779, M.A. 1783." It may be noted that the Oxford MA is awarded on application after a number of years as a member of the university and is not dependent on the recipient having completed postgraduate study.

2 Sturgess, *Register of Admissions*, 389.

3 The marriage took place on 27 May 1784 at St Bride's Church, "the parish church of the Middle Temple," as their marriage certificate has it: City of London, London Metropolitan Archive, MS 6542/002.

4 City of London, London Metropolitan Archive, Mss.11936/388, 437.

5 *The True Briton*, no. 967 (1 February 1796). These meetings evidently were informal events, when "the Company of the Members of the Society, and any other Gentlemen of the County though not a member, [would] be esteemed a favour."

6 His name appears as a member in the *Transactions of the Society for the Encouragement of Arts, Manufactures and Commerce* 14 (1796): 370 and for three years thereafter.

7 See, for example, *General Evening Post*, 7 January 1794. The chief justice of the Isle of Ely was by ancient custom appointed under the hand and seal of the bishop of Ely (Stevenson and Bentham, *A Supplement*, 36).

8 Gwillim, *A New Abridgement of the Law*. Henry Gwillim's declared intention as editor "to retrench what was redundant in the work, and to expunge what appeared to him impertinent" (v) brought new authority to Bacon's rather arbitrary digest. That Bacon's *Abridgement*, first published in the 1730s, remained the most widely used digest of English law (on both sides of the Atlantic) well into the nineteenth century is due in no small measure to Gwillim's punctilious scholarship in overhauling the aging text. Further editions would follow in 1807 and 1832, demonstrating the continuing importance of this key work within its field.

9 Gwillim, *A Collection of Acts* (1801). A second edition appeared in 1825, again indicating the lasting value of this key work in its field.

10 Gwillim, *Charge Delivered to the Grand Jury*.

11 Ibid, 4.

12 Ibid, 9.

13 So characterized by Taylor, *Storm and Conquest*, 55, but while he was certainly a champion of equal rights under the law, Gwillim was no radical: see further Morgan, "A Sermon Preached at the Assizes Held at Wisbech," which was indeed published in the *Anti Jacobin Review and Magazine*, in which praise was heaped on Gwillim for his "meritorious labours in the cause of religion and social order."

14 The preface to Gwillim's *Collection of Acts and Records* apologizes for the imperfect state of the text and for the omission of a tract intended to prefix the whole volume, part of which had already been printed before having to be left out at the eleventh hour. The author is already styled on the title page "One of His Majesty's Judges of the Supreme Court at Madras," but the preface is signed at Portsea (a parish of Portsmouth), on 2 March 1801 – evidently as the Gwillims waited to board their ship. They set sail finally on 31 March.

15 For example, *Bury and Norwich Post*, 11 February 1801: "On Wednesday Mr. Henry Gwillim (late Chief Justice of the Isle of Ely) was presented to his Majesty by the Lord Chancellor, on being appointed one of the Judges at Madras."

16 Evidently the East Indiaman of that name was wrecked on its succeeding (fourth) voyage in a storm off Margate on 11 June 1803; on that occasion, fifteen lives were lost and 129 passengers were saved. See "Loss of the Hindsostan," *Liverpool Mercury*, 1913, http://www.old-merseytimes.co.uk/hindostan.html.

17 The Act of Union with Ireland had been implemented on 1 January, and the new Parliament of the United Kingdom sat for the first time on 2 February; Pitt the Younger resigned shortly afterwards. In the consequent turmoil at Whitehall, it seems unsurprising that the usual formalities were placed under strain.

18 *London Gazette*, 30 June 1801. By the same announcement, a knighthood was awarded to Benjamin Sullivan – already an old India hand – whom Gwillim would be joining on the bench at Madras.

19 Elizabeth Gwillim to Esther Symonds, Portsmouth, 21 [February] 1801, British Library, India Office Records (BL IOR) Mss.Eur.C.240/1 ff. 1r-3v, on f. 2r. Elizabeth Gwillim and Mary Symonds continued commonly to refer to him as "Mr Gwillim" in their correspondence from India.

20 Jain, *Outlines of Indian Legal History*, 125; Morley, *The Administration of Justice in British India*, 14–15. Letters patent granting the Charter of Justice to the Supreme Court in Madras were issued by George III on 26 December 1800: See "Letters Patent establishing a Supreme Court of Judicature at Fort St George," in Shaw, *Charters of the High Court*, 85–116.

21 Elizabeth Gwillim to Hester James, 3 September 1803, BL IOR Mss.Eur.C.240, Mss.Eur.C.240/2, ff. 142r–149v, on f. 144v. On that occasion Sir Thomas Strange had been "laid up with boils for 2 months"; his absence while in England at a later date, mentioned below, extended to almost a year and a half.

22 Elizabeth Gwillim to Hester James, 23 August 1802, BL IOR Mss.Eur.C.240, Mss.Eur.C.240/1, ff. 72r–76v, on f. 73r.

23 Minto, *Lord Minto in India*, 23. Lord William was William Henry Cavendish-Bentinck, governor of Madras in August 1803–September 1807 – that is, for much of the time the Gwillims were there.

24 Elizabeth Gwillim to Hester James, 14 August 1803, BL IOR Mss.Eur.C.240/2, ff. 134r–139v, on f. 139r.

25 Minto, *Lord Minto in India*, 23.

26 "Indian Society", 330.

27 Cocks, "Social Rules and Legal Rights"; Inagaki, *The Rule of Law*.

28 This can be accessed through the "Compilation of Documents Relating to Sir Henry in Madras" link on the "Henry Gwillim" page, the Gwillim Project, https://thegwillimproject.com/personal-lives/henry-gwillim/ ("Compilation of

Documents"). Although it seems not to have attracted attention in England at the time, the case was widely reported in the British press over twenty years later, following publication of an account in the *New Monthly Magazine and Literary Journal* 22 (1828): 229–31. The incident no doubt compounded the exasperation in which he was held by the Company administration.

29 "Madras Law Reports."

30 See, for example, the pleas for clemency lodged on behalf of convicted men recorded in BL, IOR /H/430, on ff. 449 and 453, 4 and 14 March 1807. Lest one should paint a falsely rosy picture of this relationship, however, the fate of six Indians who came before Gwillim in 1807 for various petty larcenies should be borne in mind: "The above six natives were ordered to be transported to Prince of Wales's island, five for seven, and one for fourteen, years" ("Madras Law Reports," 8; reproduced in full in "Compilation of Documents").

31 "Indian Society," 329

32 Elizabeth Gwillim to Hester James, 13 August 1804, Mss.Eur.C.240/3, ff. 208r–211v, on f. 209r.

33 Elizabeth Gwillim to Hester James, 16 October 1804, BL IOR Mss.Eur.C.240 Mss.Eur.C.240/3, ff. 236r–241v, on 236v: "meanwhile Sir Henry who has taken it into his head to be a great admirer of the animals of the Country tries to put upon drawing again & I have done him four drawings of sheep & goats – which if they ever get home you will like."

34 "Madras Occurrences for June 1803," 11–12.

35 The decision had been taken in the aftermath of the massacre at Vellore, on 10 July 1806. Much of the blame for that disaster was laid at the door of Lord William Bentinck, who found himself under attack from Gwillim for exceeding his powers in Madras. Bentinck strongly defended his actions there: "I venture to entertain the sanguine expectation that my conduct so far from deserving Publick shame will be found to have had constantly in view the happiness of the Natives of India, the true Interests of the East India Company, the Justice and honor of the British Character" (BL IOR Mss.H/Misc/431, ff. 127–137: Lord Bentinck to the President of the India Board, 9 March 1807). Cocks observes that Gwillim's opposition to the principle of a quasi-military police force should be seen against the background of widespread unease at the proliferation of new types of enforcement agencies in Britain, which, their opponents feared, "could

all too easily turn into instruments of tyranny" ("Social Rules and Legal Rights," 83–4).

36 *Sir Henry Gwillim's Charge to the Grand Jury, at Madras, 10th July, 1807* (Madras, "published at the request of the Grand Jury," 1807). The *Charge* was published without being passed before the government censor, further compounding the offence and leading first to its suppression and then to a hunt by the government to uncover the identity of the printer (BL IOR Mss.H/Misc/539, ff. 169, 177, 179, 181, 183); see the excerpt available at "Compilation of Documents."

37 Governor in Council to Sir Thomas Strange, Fort St George, 22 January 1807, BL IOR Mss 37/280, f. 202.

38 Ibid. A letter of 9 March 1807 from the governor to the president of the India Board stresses the need for the "earliest possible transmission of His Majesty's commands" on Gwillim's case, which he considers "to be fraught with danger to the State, as well as counteracting those measures which are deemed essential to the public security, as in holding out to public odium the Government of the Country, and thereby degrading its authority in the minds of our native subjects." BL IOR Mss.H/Misc/431, ff. 127–137: Lord Bentinck to the President of the India Board, 9 March 1807.

39 University of Nottingham, Portland Papers, quoted by Cocks, "Social Rules and Legal Rights," 86–7. In the same vein, Gwillim's *Charge to the Grand Jury* was suppressed, on the grounds that "the Native Inhabitants are incapable of forming a correct opinion of such publications, and are liable to be misled by the dangerous doctrines." BL IOR Mss.H/Misc/539, ff. 177–8.

40 University of Nottingham, Portland Papers, quoted by Cocks, "Social Rules and Legal Rights," 86–7.

41 BL IOR Mss.37/280, ff. 203–230, copies of correspondence all relating to the same dispute, between Gwillim, Strange, Anstruther and Bentinck. Cocks (ibid.) perceives that Strange may indeed have been complicit in the governor's plans for the destruction of his own court, having been assured of the lucrative post of president of the Company's courts in the event of these successfully replacing the Crown establishments.

42 BL IOR Mss.37/280, ff. 223–4, Sir Thomas Strange to [?] Governor in Council, undated.

43 The wording of the charter would seem to favour Savage on both these (Shaw, *Charters of the High*

Court, 89–90); Gwillim's detailed counter-arguments are not recorded.

44 Lord Bentinck to the President of the India Board, 9 March 1807, BL IOR Mss.H/Misc/431 ff. 127–37. The value of such specialists – maulavies and pundits, respectively – had been recognized by Parliament twenty years before the founding of the Supreme Court, when it was deemed appropriate for judges acting under Company jurisdiction "to refer any Question arising on the Mussulman or Hindoo Law to any Maulavy or Maulavies, Pundit or Pundits, Respect being had to the Law in which each is conversant" (*Reports from Committees of the House of Commons*, 5: 434). Strange, however, considered the proposed appointments to be potentially prejudicial rather than beneficial to the working of the Court. Sullivan largely escaped censure in the affair: his characterization by Bentinck as "the innocent tool of his Colleague and deserving rather of compassion than of censure" and other references to his general infirmity perhaps served to separate him from the true source of the government's ire.

45 Edward Parry and Charles Grant to Viscount Castlereagh, 10 September 1807, Kew, National Archives, PC 1/3822 (unpaginated bundle).

46 BL IOR Mss.H/430, ff. 445, 471, 5 March and 29 April 1807.

47 All the Privy Council papers relating to Gwillim's recall, the complaint against him, and his defence are gathered at the National Archives, PC1/. A letter from the Council Office at Whitehall to Edward Cooke of the East India Company, dated 20 September 1808, mentions that the Order-in-Council had been made on 7 October 1807, followed by a report of 10 November ordering Gwillim's recall.

48 Prinsep, *Record of Services*, xxxiv gives his resignation date as 28 October 1808, but to what this relates seems unclear.

49 BL IOR Mss.H/Misc/539, f. 199. This document, an extract from a letter dated 2 January 1809, describes both the testimonial and Gwillim's reply to it (but particularly the latter) as "of an exceptionable nature." We could believe that Gwillim's response (now lost) would have been framed in incisive terms, but the only offence in the lawyers' letter seems to be in its expression of admiration for the anathematized judge. A letter of 20 December 1808 to the government from Charles Marsh, a barrister practising in Madras, mentions that, prior to his departure for England,

Gwillim had requested that "in the event of your taking upon yourself to suppress the publication of the address of the Profession to him, and of his answer to that address, to let him know"; Marsh also asks for "the objectionable passages which rendered them unfit for circulation" to be pointed out to him. By way of reply, he was told that his letter had been laid before the governor in council, who considered "compliance with the application therein submitted to be unnecessary and improper"; furthermore, his application was considered as "in the highest degree disrespectful to the authority of the Government." BL IOR Mss.H/Misc/539 f. 201.

50 *London Pilot*, 31 May 1809; reproduced in full in "Compilation of Documents."

51 "Madras Occurrences for October," reproduced at length in "Compilation of Documents." Admiration for Sir Henry was by no means universal, of course: in a letter to Colonel Thomas Munro (recently returned to London from India), Frederick Gahagan writes from Madras: "Sir Henry Gwillim embarks on the *Phoenix*, and the Devil go with him" (9 October 1808, BL IOR Mss. Eur F151/20, f. 31).

52 MacDowall, appointed commander-in-chief of the Madras Army in 1807, would shortly resign his commission in consequence of a further dispute with the government in Madras; the East Indiaman in which he sailed for home was lost off the Cape of Good Hope before Gwillim reached England.

53 "Madras Occurrences for October," 157. Compare this account with that conjured up by Taylor in his *Storm and Conquest*: "On 23 October, amid hard rain, thunder & lightning, the disgraced judge and the spinster joined a bedraggled band of gentlefolk on the beach to be rowed out by *masoolah* to the waiting Indiaman. Gwillim was by now fixed in the public eye as a revolutionary Jacobin and Madras watched his going without regret" (55).

54 Log of the Honourable Company's Ship Phœnix, BL IOR Mss.175/G/I..

55 Taylor, *Storm and Conquest*, chap. 4.

56 Henry Gwillim to Hester James, Cape Town, 15 January 1809, Mss.Eur.C.240/4, ff. 381r–382v, on 381r.

57 Log of the Honourable Company's Ship Phœnix, BL IOR Mss.175/G/I. Mary Symonds's experience of the voyage had the happy outcome that she later married the ship's master, Captain Ramsden.

58 East India Company's complaint against Sir Henry Gwillim, Kew, National Archives, PC 1/3822.

59 Edward Parry and Charles Grant to Robert Dundas [undated copy]; Edward Parry and Charles Grant to Viscount Castlereagh, 10 September 1808; Robert Dundas to Viscount Castlereigh, 12 August 1808; Viscount Castlereagh to the Lord President, 23 August 1808, all National Archives, PC 1/3822.

60 "Answer of Sir Henry Gwillim to the Memorial and Petition of the Court of Directors of the East India Company, presented in October 1807," National Archives, Kew, PC 1/3822 (unpaginated).

61 Committee Report on the Memorial of the Court of Directors respecting Sir Henry Gwillim, 11 April 1810, National Archives, PC 1/3822; reproduced in "Compilation of Documents."

62 The house was described at the time of Gwillim's death as follows: "The Residence, although not large, contains ample accommodation for a Family; it is warm and sheltered, full of comfort, and has long been considered an excellent winter Abode." Apart from the six-bedroom house, the property included a brew house, coach house, and stabling for four horses; there were also gardens and "pleasure grounds," and thirty-six acres of land, sold as a separate lot. *Particulars and Conditions of Sale of a truly inviting Property ... at Staplefield Place, 23 April 1837*, BL Mss.RB.31.c.699.

63 His new wife was Elizabeth Chilman of Clerkenwell St James: see Surrey Marriage Bonds and Allegations, City of London, London Metropolitan Archive, Mss.1009/E/125. On the family tombstone at Holy Trinity Church burial ground, West Sussex (where she is recorded erroneously as "Dame Elizabeth Gwillim"), her date of birth is given as 1788. She died on 17 January 1837, eight months before her husband; her burial took place one week later, on 23 January: West Sussex Record Office, SAS-WA/334.

64 As recorded on the family monument, Elizabeth was born in 1817, though the baptism records of Cuckfield record her baptism on 11 December 1816. She married John Henry Hughes (1816–1844), and died at Eastbourne in 1845.

65 Will of John Gwillim, 24 October 1818, Herefordshire Archive Service.

66 Appointment of Visiting Justices at Horsham Gaol, 14 July 1825, West Sussex Record Office, QR/W736/3.

67 Horsham Quarter Sessions Rolls, 1825, West Sussex Record Office, QR/W736/4.

68 Horsham Quarter Sessions Rolls, 1827, West Sussex Record Office, Add. MS 39972.

69 *Morning Chronicle* no. 18846, 30 January 1830.

70 Middle Temple Archives.

71 *Examiner*, 24 September 1837. Sir Henry's will (Kew, National Archives, PROB11/1885) was proven on 9 October following. His second wife having predeceased him, the bulk of his estate would have passed to their daughter, who had evidently married by that time, her husband being described on the family tomb as Sir Henry's son-in-law. A sale of Gwillim's extensive library of legal books took place at Hodson's, 192 Fleet Street, on 9 February 1838.

7

"My Things by the Ships Have All Come Safe"

Clothing and Textiles in the Gwillim Letters and Drawings

TOOLIKA GUPTA, ALEXANDRA KIM, AND ANN WASS

Despite the separation of time and distance, Elizabeth Gwillim and Mary Symonds wrote with a sense of intimacy to their mother and sister. Among other topics, they often wrote about clothing and textiles, both English and Indian. Their interest in and desire for the latest English fashions were the subject of much discussion. As Lady Gwillim's husband, Sir Henry, occupied an important position in Madras society, his wife and sister-in-law were expected to attend social functions with the elite of the British community and dress accordingly. The sisters found it was difficult to have things made to their liking in India, but, at the same time, Elizabeth Gwillim herself preferred to devote her scarce free time to painting rather than sewing: "I do it awkwardly & in the same time I am making a cap I could draw a flower or a bird."[1]

Elizabeth Gwillim and Mary Symonds took advantage of the availability of Indian textiles to send them as gifts to family and friends. Indian shawls, in particular, were enjoying a surge in popularity in Europe and must have been very welcome. They sent not only whole shawls but also pieces of shawls, to be adapted for both men's and women's fashionable dress, uses that are rarely shown in contemporaneous sources, such as engraved fashion illustrations and portraits. The sisters also sent palampores, elaborately patterned panels of cotton fabric that were a specialty of the Coromandel Coast.

Finally, the sisters were acute observers of the local inhabitants, and their letters included eyewitness accounts of the dress of both Muslims and Hindus.

These included the retinue of Hindu servants who worked in their household. The distinctive salmon-coloured dress of local mendicants (pandarams) also captured their attention.

Illustrations referenced in this chapter include extant garments and textiles from museums that are representative of items the sisters described. Images from contemporaneous publications allow the reader to visualize the clothing described by the sisters. Mary Symonds's paintings vividly portray some of the local people that the sisters wrote about. While the three authors collaborated on this chapter, each author assumed primary responsibility for one section. Ann Wass compiled the section on clothing sent to Elizabeth Gwillim and Mary Symonds from home. Alexandra Kim considered selected gifts the sisters sent in return. With her first-hand knowledge of Indian dress, Toolika Gupta amplified the sisters' written and visual descriptions of the dress of the natives they observed around them.

RECEIVING (AND SHIPPING) GOODS

Sending goods (and letters) back and forth between India and England was an arduous process. The voyage of an East Indiaman from England to Madras took about four months. Ships sailed in convoys, so those sending letters and packages had to wait until a fleet was ready to sail. An added complication was the weather. Madras had no natural harbour, and ships had to anchor in the Madras Roads, a stretch of water about one kilometre off shore where there was a firm sand bottom for the ships to drop anchor. The Madras Roads were unsafe during the northeast monsoon, and no ships would arrive for nearly three months.[2] When ships did reach the roads, both cargo and passengers were offloaded onto masula boats. Indian crews manoeuvred these boats through the rough surf. Sometime in the 1810s, Mrs Major Clemons wrote, "Perhaps the most dangerous part of the voyage to Madras is the landing, for the surf is always high, and the tremendous breakers are never still; they roll along with thundering sounds, and no ship's boat can live for a minute in them."[3]

Another complication for those hoping to send or receive goods was the changing policies of the East India Company (EIC). In 1802, Elizabeth Gwillim and Mary Symonds were alerted that their family in England had prepared a large shipment of provisions. They must have intended this to be shipped on the *Skelton Castle*, which sailed for Madras in July and arrived right at the end of the monsoon season, in late January 1803. When the hoped-for shipment did not arrive, Gwillim wrote:

I hope you will not grieve yourself about our disappointment in not hav-ing our things by the Skelton Castle. I conclude that they will be safe & that they will come soon. – We sent to Captain Harrow for them & he answered that they had been put on board his ship but but [sic] that the Directors had ordered these & other packets sent without a regular order, to be unshipped – This is a new regulation, amongst many others lately made, which it wou'd seem is hardly worth their while to make ... It is now ~~better than~~ two years since we made our marketings.[4]

The long-awaited six cases finally arrived on the *Union* in August 1803.

CLOTHING FROM HOME

As Elizabeth Gwillim and Mary Symonds settled in Madras, they began to include requests for provisions from England in their letters. While it is the clothing, including accessories and jewellery, that concerns us here, they also requested household textiles, foodstuffs, china, and, of great importance for both their correspondence and artistic pursuits, writing and painting supplies.[5]

After shipments were received, the sisters' letters of thanks described the clothing and accessories. Gwillim and Symonds also pointed out items that did not travel well because of the way they were packed and included instructions to remedy the problem. For example, Gwillim wrote, "Pray tell Mr: Langstone he must put each glove in a seperate paper for in the ships the leather heats & all our gloves were sticking together, we were obliged to tear them asunder."[6] They also added requests for items to be included in future shipments.

The social functions they were required to attend were numerous, and the sisters expressed a desire for both variety and fashion. They also found that they needed replacements for garments and household textiles damaged by local washermen. Gwillim wrote in 1802:

Cloth is worn out sooner than you cou'd think – They beat it on the pieces of rock in the rivers where they wash & the linen cut directly as to hems whether of callico or linen about 4 or five washings beat them entirely out, & they must be done again. They say here that the Washer men beat the linen & whatever they know to be European articles & that they sing all the time they beat – "*Europá Europá Europá.*"[7]

Not surprisingly, the sisters found that their clothing required adjust-ments for the climate. The northeast monsoon or rainy season, from October through January, and the hot, dry land winds, from April through July, both

posed challenges. Mary wrote about the monsoon, "I hope you have thought of my wig & Betsys I shall want it sadly in October, ones own hair does very well at this dry season but during the rains and when the damp sea wind blows it is impossible to be comfortable without false hair."[8] Elizabeth described the land winds: "This wind is a strong breeze & in the degree we had then very pleasant to me at first but we soon found the effects they are said to produce, sometimes the one & sometimes the other ... I found it impossible to keep my hair from curling to a [word crossed out] perfect frizz."[9] It was the norm for women of the sisters' age and status to wear head coverings most of the time, and, in the absence of a wig, a pretty cap could cover the "frizz" that Elizabeth found annoying. (The sisters would finally receive their wigs in 1806. Mary Symonds wrote to her sister Hester James in February, "what is now come to our hands is a letter ... for Betsy & me from your dear self with a packet containing two wigs."[10])

The sisters and Sir Henry found that their European clothing was not comfortable in the intense heat of May and June. For example, Elizabeth wrote about a new coat for her husband in 1806: "Sir Henry's coat is very handsome ... but he wants another – without lining of some neat brown or fashionable colour; but it must be a kind of frock [coat] wholly unlined, except the sleeves – which shou'd be lined with sarsnet or silk serge."[11] The sarsnet or serge lining would be lightweight but functional.

It was Elizabeth Gwillim and Mary Symonds's sister Hester James (whom they called Hetty) who took on the primary responsibility of filling the commissions they sent. She lived in London, where the best and most numerous shops in the United Kingdom were found. Through her husband Richard James's business, she likely had access to a variety of textiles, and both likely had connections to other dealers and artisans, such as dressmakers, tailors, and milliners. Symonds once remarked that Hester James's selections "were carefully and nicely collected and packed."[12] What follows are some representative highlights in shipments that arrived for the Gwillim/Symonds family in Madras between 1803 and 1807.

In April 1803, the first shipment arrived. It was sent by Mrs Toussaint, who had made Elizabeth Gwillim's dress for presentation at court before she left London. (Gwillim wrote that the dress was then packed up for her to bring to Madras – it was likely also altered to be more suitable for wear as an evening dress.) Toussaint must have been a milliner as well as a dressmaker. In the early nineteenth century, milliners supplied more than just various hats, caps, and bonnets: they also sold fashionable accessories, such as stockings and gloves, and trimmings such as artificial flowers and ribbons. Symonds wrote that Toussaint had sent "two cloaks, two turbans, two undress caps, 2 bonnets & fancy hat & some flowers & a set of green combs, which I think truely

such *valuable* ornaments as those are very acceptable to me."[13] Gwillim was also pleased: "The ribbons were new to us but the bonnets we have seen before on others with envious eyes – but we were extremely glad of them the flowers & caps are very delightful.."[14]

The next month, the sisters received by a "delicate stratagem" some yardage of muslin fabric.[15] The lightweight, fine cotton fabric called muslin had long been made in India; however, it was very expensive, and muslin made in factories in the United Kingdom was becoming a fashionable alternative. The "stratagem" Gwillim referred to was likely making it into a small package like letters, thereby bypassing the need to have it shipped as freight. Despite their reluctance to have clothing made in India, the sisters had, Gwillim wrote, bought "a set of common gowns, & these muslins you have now sent, instead of being made up now will be laid by – & by your next sending you must send made up gowns alone & not any muslins, unless it should be something very striking."[16]

As noted above, August 1803 brought the arrival of a delayed shipment of six cases from Hester James. Their contents included "very pretty & well chosen" gowns; however, Elizabeth Gwillim requested some alteration be made in the future, to accommodate the Indian climate: "Some of the sleeves are lined which in future you will please tell Nancy [Green, probably a family friend] not to do, as it is very fatiguing to us. If the fashion will not do without a lining she can put in a bit of thin muslin."[17]

The cases also included a "ladies shirt"; Mary Symonds had tried to make one herself, but noted that the one in the shipment provided "a good pattern."[18] A shirt or habit shirt was useful for filling in the low neckline of a gown to make it more suitable for day wear. (The central woman in figure 15 wears a habit shirt under her gown.) The cases also contained caps, hats, gloves, and shoes. This time, the gloves were well packed and arrived unblemished. Symonds informed her sister that a local shoemaker made white shoes for them, and so "I do not think it worth your while to send us any white shoes, for tho these do not keep the shape very well, they are so cheap that one can well afford to change them often. " That said, "colourd and particularly figured shoes [shoes with stamped patterns] we shall be very thankfull for."[19]

The new governor of Madras, Lord William Cavendish Bentinck, and his wife, Lady Mary, arrived in August 1803, and the sisters agreed that the timing of their large shipment was opportune. Elizabeth Gwillim wrote, "I think upon the whole it is great luck that we have got all our new things to receive the new Governor in – there is a great importation of finery on the occasion."[20] Likewise, Mary Symonds observed, "Our things have arrived at an excellent time, just on the arrival of the new Governor and his Lady, which circumstance has made us all alive here. "[21]

XVI.

London, Published & Sold by Edw.d Orme March 1.st 1805.

*An European Lady attended by a Servant, using
a Hand-Punkah, or Fan.*

FIGURE 14
"An European Lady attended by a servant using a hand punkah or fan,"
from *The Costume and Customs of Modern India*, 1813, plate 16, hand-coloured aquatint.
Wellcome Collection.

In August 1804, Elizabeth Gwillim wrote, no doubt with relief, "Our things are all arrived safe that is the millinery & wearing apparel & I think it very well chosen, the ribbons & sattin shoes of different colours are all come out of one, as they always turn a little, & the very blue whites come best."[22] Mary Symonds admired a comb with Wedgwood ornaments, along with a blue necklace and earrings. Regarding millinery, she wrote, "I wish you always to send a little un-made material like the things you send as I can then copy them for myself & give

PROMENADE DRESSES.
Printed for R.Phillips.N°71 S.Pauls Church Yard.

FIGURE 15
Fashion plate from *Phillips
Fashions of London and Paris*,
June 1802. Private
collection.

up the originals to Betsy who you know does not like that sort of business." She added that she had copied a "very handsome" turban included in the shipment.[23]

In March 1805, the *Baring* arrived with two cases, one of which, Symonds noted, contained "a box of millinery." The shipment also contained "two black Cloaks," perhaps something like the one worn by the women on the left in figure 15. Symonds complimented her sister on her selection, writing that the garments "are very beautiful." There were more caps, which Symonds would "willingly resign" to Gwillim, as she would again make own.[24]

While she was happy with the shipment, Elizabeth Gwillim did make requests for several other things that she, her sister, and her husband needed: "A few short yellow gloves we shou'd be glad of. and Polly says also a few yellow long gloves she has none left – she says they are called Limmericks they are best for this country – If you cou'd get a pair of stays made of simple

India dimity & single shoulder straps I shou'd be glad of these but remember I am rather fatter than I was. "[25] In August, she renewed her requests: "white silk stockings very smart ones – as the open clocks [decorative panels on the ankles] stretch better & it is such a fatigue to drag on one's stockings in this country after pulling on a tight pair one is in a perfect bath. The weather is very close & hot now." She also asked for "two or three peticoats with little bodies or shoulder straps to wear under my gowns – they will serve as paterns for the taylor to make more."[26] (The "taylor" likely referred to an elderly household servant about whom Elizabeth had written before.)[27]

More millinery, including caps and bonnets, arrived in August 1805, along with some jewellery: a pearl crescent and beads. Hester had also sent shoes for the sisters, and shoes and boots for Sir Henry, along with a coat.[28]

On 27 June 1806, Elizabeth Gwillim and Mary Symonds received word that their mother, Esther Symonds, had died in January. This necessitated their wearing black for mourning. Gwillim described it as "the most sorrowful I ever wore," adding, "I conclude that you have sent us out more mourning –We must keep it by us for Court mourning & compliments. I hope I shall have nothing more anxious to use it for."[29] Symonds explained the "great difficulty in procuring any decent mourning … We have had muslin dyed in this country for every purpose, which looks well enough, but they have not thought of fixing the colour, so that our poor skins are every night as black as our gowns. The smell of the dye they use is very odious."[30]

Another hoped-for shipment did not arrive in 1806, as the fleet was delayed leaving Portsmouth until May, too late in the season to arrive before the monsoon. That shipment must have arrived in February 1807, shortly after the Madras Roads reopened. Symonds alluded to a letter acknowledging packages received, but it is missing from the collection. In a follow-up letter in March, she observed that "all the gowns were neat and elegant," but she did not specify whether there was any mourning attire. She liked "the little worked [embroidered] caps and shirts, both made and unmade" that could be "easily done up." She also mentioned a variety of headwear: a tiara, headbands, and hairnets, and told her sister that she put one of the nets on "as soon as they were unpacked."[31] This March 1807 letter is the last missive from either sister in the collection. We do not know if any more shipments of clothing were received after that.

The sisters' letters emphasize the importance of keeping up with fashion as well as dressing appropriately for the numerous social occasions they were expected to attend. With the assistance of friends and family at home, they were able to do so despite challenges posed by the difficulties of procurement. Their letters also provide insight into the strategies of modifying their clothing to cope with the climate of India, so different from what they knew at home.

SENDING CLOTHING AND TEXTILES HOME

As well as receiving eagerly anticipated letters, parcels, and packages from England, Elizabeth Gwillim and Mary Symonds regularly sent items back home as gifts. This process was as complicated for them as it was for those sending items to India. Ships did not carry many people beyond the crew, and the potential bearers of gifts home had strict baggage allowances. This space was often taken up with the traveller's own presents, leaving little room to accommodate others' requests. In 1802, Gwillim commented that "everybody that goes home likes to take all he can for himself duty free."[32]

The sisters would often entrust goods to members of the crew, including ships' surgeons; indeed, in 1802, they sent items back with three different surgeons.[33] Surgeons made excellent carriers of goods, for the contents of their locked medicine chests might escape inspection.[34] Gwillim's comments demonstrate that a number of different tactics were employed for avoiding customs duties, including splitting items up, sending them unpackaged, and making up fabrics so that they looked like pre-made dresses.

Dress historian Hilary Davidson highlights the pervasiveness of smuggling during the Napoleonic Wars: as a means to evade steep customs duties or the outright ban on some goods, "smuggling was a normal, expected and relied upon trading method throughout the wars."[35] In a number of letters, Gwillim explained how she had given the carrier an additional amount to factor in the cost to be paid to smugglers to land the goods, without their having to be taken to the India House (the EIC's headquarters in London). In 1804, she paid a ship's surgeon, Mr Lane, to carry a shawl for Nancy Green: "I was to give him 25 per cent which is what they give the smugglers to land things for them, for this premium they undertake to land the goods whatever they be, & if they fail pay the loss."[36] On another occasion, however, she warned that, rather than risk the goods being seized, another surgeon, Mr Livingstone, might take them to India House so that the duty could be paid. Gwillim noted that she was curious to know the cost of the duty, to see if it was worthwhile sending shawls back, or if the duty made the final cost too high.[37]

The ultimate danger, of course, was that items might never make it to England – or from England to India – if the ship was lost, whether sunk in stormy seas or captured or destroyed by enemy fleets. Gwillim warned in 1803, "if Mr Prosser's ship should be taken [the *United Kingdom*] you must all be content to lose your presents."[38]

Muslin Dresses

It is significant that the archetypal female Regency appearance was fashioned from two Indian textiles, creating the well-recognized image of a woman in her fine white muslin dress, accessorized with a highly prized Kashmir shawl. Elizabeth Gwillim and Mary Symonds were writing at a critical time in terms of the changing balance in the textile relationship between Britain and India, and the textile gifts that they sent home serve to illuminate this.

For centuries, muslin had been one of the pre-eminent textile products of India, described by John Forbes Watson in the 1860s as the "woven air" of Dacca (Dhaka in modern Bangladesh, then considered part of Bengal).[39] Bengal was the traditional centre of its production, a fact highlighted by Elizabeth's regular use of the phrase "Bengal muslin" to describe the fabric she was sending home.[40] Dacca lay at the centre of international trade routes, and, by the early eighteenth century, Bengal cotton and silks were major export products for the East India Company. As early as the eighteenth century, commentators such as William Bolts described how the Company's desire to monopolize trade led to the oppression of and hardship for Bengali weavers.[41] The assault on Indian muslin production was compounded by European efforts to imitate these desirable fabrics, using the new steam-powered machinery of industrialization. During the early nineteenth century, the duty on imported cotton for the British market was raised nine times, with the aim of promoting domestically manufactured fabrics. In 1817–18, Bengal's export of piece goods to Britain was overtaken for the first time by exports to India from the industrial towns of Manchester and Glasgow.[42]

Despite living in India, Elizabeth Gwillim and Mary Symonds requested muslin from Britain, echoing this changing trade. An 1802 letter from Gwillim provides one possible reason for this: she wrote to Hester James to explain that "the Bengal muslins are as dear here as in England, indeed dearer, unless you get some friend to choose them for you in Bengal where you must take more than you want."[43] The surprising and imbalanced logistics of the cotton trade between India and Britain drew remarks from other writers: as Maria Graham commented in 1812, "yet still it seems strange, that cotton carried to England, manufactured, and returned to this country, should undersell the fabrics of India, where labour is so cheap. But I believe this is owing partly to the uncertainty and difficulty of carriage here, although the use of machinery must be the main cause."[44] Nevertheless the sisters did send presents of muslin from India to their family, and, on at least one occasion, Gwillim refers to this cloth as "worked muslin," meaning that it was embroidered, most likely in white thread.[45]

Shawls

One of the fascinating elements of the letters is the way they provide evidence of dress and fashion nearly invisible in the pictorial and material object record. The idea of an Indian shawl in Western dress at the beginning of the nineteenth century conjures up an image of long, narrow fine woollen shawls in brilliant colours complementing white muslin dresses. The most desirable of these shawls were those made in Kashmir, using the soft, fine under-hair of indigenous mountain goats. In the last decade of the eighteenth century, these garments were highly prized trophies of war, brought back by Napoleon's army after the Egyptian campaign of 1798. The long rectangular shape of many of these shawls, which could be draped around the body or artfully composed in elegant folds, was well suited to the neo-classical silhouette of long, flowing lines. Yet this ubiquitous image of early nineteenth-century dress masks the many ways in which the shawls were used to fashion European styles of dress. Gwillim's detailed descriptions of the shawls she sends home provide a useful corrective. The sisters' letters offer little sense of the way in which the shawls would have been worn in an Indian context: Gwillim and Symonds seemed to view them as beautiful items that could be worn, refashioned, and even cut up to suit a European dress style and aesthetic. Many of Gwillim's directions about the shawls she sent home were that they should be cut up to make men's waistcoats – indeed, she makes ten mentions of sending shawls to England to be used in this way.[46] And yet, few waistcoats made from shawl fabric seem to have survived. Two rare examples are a waistcoat, circa 1800, made from an ivory shawl with a blue leaf pattern, which was sold at Christie's in 1996, and a waistcoat made from a similarly patterned fabric in the collection of Chertsey Museum, Surrey (plate 54).[47] Both these surviving waistcoats demonstrate that much use was made of the patterned ground; in the Christie's example, the narrow border has been employed as an edging.

The popularity of waistcoats made from shawls is suggested by not just the frequency but also the quantity of shawls that Elizabeth Gwillim sent for this purpose. In 1803, for example, she sent a shawl to make six waistcoats.[48] (The waistcoat backs would have been cut from a plain fabric. The one pictured in plate 54 has a cream linen back and lining.) Elizabeth also explained that she had cut up the shawl into six pieces, for convenience of carriage, and carefully detailed those family and friends to whom the pieces were to be given. On other occasions, Gwillim sent back only a piece of shawl to make the waistcoat. In 1802, she mentioned "a bit of a shawl for a waistcoat" and "a piece of spotted shawl for a waistcoat."[49] The warmth of the woollen fabric is perhaps one reason these waistcoats were so popular among Elizabeth's friends, and their appeal to clothes moths and other insects suggests a reason for their low rates of survival.

The close connection between female and male dress is made clear in the sisters' letters. Gwillim several times suggested that one shawl could be cut up and used both as a woman's shawl and a man's waistcoat; she wrote to Hester James in 1801 that "one will make you a square and James [Hester's husband] a waistcoat."[50] Further cutting is evidenced in the present of shawls for female family members and acquaintances. Once again, the visual record seems to diverge from written evidence both in Gwillim's letters and advertisements from shawl warehouses. While square shawls were produced in India and clearly advertised in the British press, they are rarely to be found in the portraits, prints, and fashion plates depicting early nineteenth-century dress.[51] Gwillim made clear, too, that they were not always so easy to find: "Square shawls are not to be had here but by chance & [are] very old; that for Mrs Gwillim is not a good one, but I know it is what she will like – we pay the same price for a bad square shawl as for a good long one, indeed a finer, & twice as large."[52]

Elizabeth Gwillim regularly cut shawls into two squares before sending them; in 1803, she wrote that she sent one half of a shawl to her mother while keeping the other half, perhaps an attempt, knowingly or subconsciously, to create a textile bond between her mother and herself.[53] But she also often directed her recipients to cut the shawls themselves: "Nancy can wear it long if she pleases or cut it into two squares."[54] All this cutting of shawls raises many questions. Without pictorial evidence, the question remains: how did early nineteenth-century women wear square shawls? What did they do with the cut edge, which would be left without a border?

We know that Gwillim sent shawls in a rainbow of colours, including orange, yellow, and green, but one of the most popular and desired colours seems to have been white. She explained that often the white shawls she sent were not new, because freshly made white shawls were so rare.[55] These mentions of white shawls pose another difficulty when trying to match the letters' descriptions with the surviving material. Shawls in museum collections, like the beautiful example from the Victoria and Album Museum shown in figure 16, suggest that the natural cream backgrounds of Kashmiri shawls were favoured. This shawl features a woven design in red, blue, yellow, and green. However, Bengal also produced fine muslin shawls, known as jamdani, for the export market.[56] So, when Elizabeth wrote of the "fineness and thinness" for which white shawls were esteemed, she could have been referring to qualities admired either in the Bengali muslin jamdani or the Kashmir woollen shawls.[57]

The other gifts that Gwillim often mentioned sending home were palampores, the brightly coloured cotton wall or bed hangings, which were one of the most famed products of the Coromandel Coast. She clearly demonstrated the immense appeal of these textiles: "I need not tell you how permanent the colours are They indeed get brighter the more they are washed."[58] She also

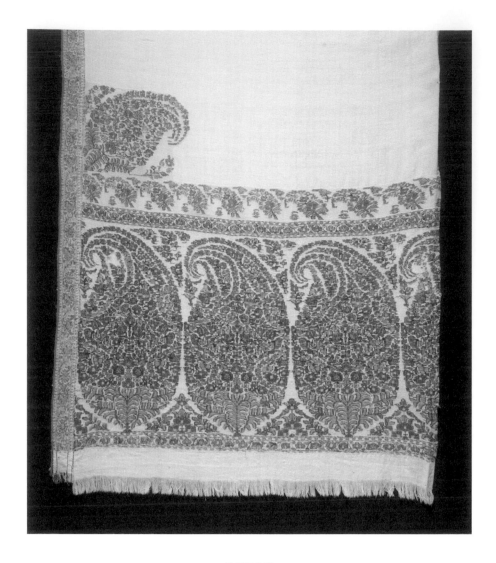

FIGURE 16
Cashmere shawl, early nineteenth century. © Victoria and Albert Museum, London,
IS.2081A-1883.

observed that they were made near her house and described the technique by
which the outline was drawn by hand. Although her description suggests that
all the colours were painted, the process was, in fact, complex and required
great skill and different mordants and dyes as well as wax resist to produce the
final product. A particularly popular design was an exuberantly flowering tree
of life, but Gwillim made almost no mention of the specific patterns that she
sent home, although on one occasion she noted that "I sent ... Palampos (no
apes or peacocks, but a Cockatoo) by the 'United Kingdom' sailed from here
the 10th. May 1803."[59] The gifts the sisters sent to friends and family reflect the

widespread popularity of Indian textiles, particularly muslin, Kashmir wool, and palampores, in England in the early nineteenth century. They also shed light on practices that, if common at the time, seem to have left little trace. The cutting up of shawls to provide pieces to make men's waistcoat fronts is one example; cutting a long shawl in half to make two square ones is another. Might there be examples hidden in museums waiting to be discovered?

INDIAN DRESS

In their letters home, Elizabeth Gwillim and Mary Symonds often mentioned the peculiarities of Indian dress, among other subjects that they fancied would amuse their readers. The dress that they saw Indian men and women wearing appeared almost like costumes or fancy dress, as the clothing was all new to them. They took pains to describe each article, and while they might not always have known the names of the articles of clothing, their descriptions were very vivid. They described the clothing in comparison to something that could easily be comprehended by their English readers. In addition to their correspondence, their paintings exemplify this desire to showcase the exotic. Their letters and paintings were rich sources of information for their audience, who had never seen India or its people. The sisters tried to classify forms of dress as belonging to types of people, defined either by their religion or their place of origin, and they tried to include as much information as possible. Their interest lay in everyday Indian things. They did not paint the dress of their fellow Europeans, perhaps because it would not have been of interest to their audience back home. Because of the detail they included, the sisters' observations help us immensely to understand the articles of Indian clothing then in use.

In 1801, Mary Symonds wrote to her mother that she wanted to draw and send home images of the variety of people that she saw around her: "I am endeavouring to make a set of drawings of the different (castes) and descriptions of the natives of this country to give you all an exact idea of their dresses but I fear that I shall not have more than one or two to send."[60] The dress of servants, mendicants, Muslim ("moor") women in the zenana, and the Hindu ("gentoo") Brahmins all caught their attention. The collections of paintings show the dress of Brahmin women, a chobdar (*chob* is a mace, and the man who carries it is called a chobdar), a Brahmin priest, palanquin boys, families travelling, nannies in a nursery (plate 55), a scene from a play, and much more. These paintings are a rich source for studying the material culture, dress, and architecture of the period.

Elizabeth Gwillim and Mary Symonds were surrounded by servants – sometimes, they felt, too many of them. As Symonds wrote to her mother in October

1801, "provisions are in general very cheap and so are the servants wages but the quantity of food you are obliged to put on your table and the number of servants you are obliged to keep make houskeeping quite dear enough."[61] The proximity of so many servants gave the sisters a chance to observe them very carefully, as is evident from the letters. Symonds also wrote to her sister Hester James, noting the fine jewellery worn by servants as well as the sari (or saree): "Their whole dress consists of a long peice of cloth or muslin which they wrap about them in an Elegant manner," adding that "the necklace bracelets and earring of the lowest servants are of the finest gold some of the better order of women are quite loaded with gold and jewels, but in these ornaments consist their whole wealth."[62] Symonds's observations are borne out by her nursery painting (plate 55), which depicts two servants, one for each child. They wear gold jewellery and coloured saris. (In contrast, the children's clothing is white muslin, as are the bed hangings.) The sisters must have spoken with the servants to realize that they wore these many gold ornaments as a way of keeping their assets on their person. Gold was portable wealth and could be sold if money was needed. The practice of investing in gold continues in India today.

Servants accompanied the guests who attended the grand parties given by the English community. Gwillim found the atmosphere of the first such event she attended very romantic, different from anything she had ever seen. The servants' clothes, in particular, caught her attention, and she described them in a letter to her mother:

> The first dinner I saw I thought it wonderfully striking particularly from the immense number of servants waiting with such extreme stillness & so delicately dressed all in white muslins & white or figured turbans & large gold earrings. Besides one's own servants everybody who dines brings one or two with him so that if we sit down twenty or three or four & twenty to dinner there are at least thirty servants waiting at table ...
>
> I think nothing of the kind can exceed the beauty of an evening ride to see all the houses lighted up & people dining or dancing in the Verandas with the attendants lying about the garden, particularly at a Ball when if there are 150 people or 200. which is generally the number, there will be 400. 500 or more of these people in their muslin dresses scattered under the trees before the house.[63]

Symonds was fascinated as well by the white muslins of the palanquin boys. She painted them twice, once while they were resting (plate 13) and again when they were carrying an Englishman (plate 5). As was the case among the fashionable European women in Madras, white muslin was the prevalent fabric worn by palanquin bearers, servants, and other attendants.

Elizabeth Gwillim and Mary Symonds were also fascinated by the strange style of dress they saw on the pandarams on the streets (plate 56). The vivid salmon colour of their draped muslin dress, in contrast to the common white muslin, was unique to these individuals, and it must have been eye-catching. The sisters did not know who these strangers were, observing that they owned nothing and that other people gave them alms and listened to them. The sisters thought that they were beggars of some superior kind and described them to their family as such. In fact, the pandarams are mendicants, not beggars. In India, there are many sadhus, or learned men, who own nothing; they wander about, and some families provide them with whatever they want, in return for their blessings and knowledge. Gwillim wrote a fascinating portrait of the pandarams:

> Their dress is the most beautiful, considered as picturesque of any of the people. Many of the Tanks (Pools) & Wells all over India are stained with a kind of red earth; and muslin being dipped in them with the addition of some leaves becomes of a beautiful clear salmon colour ... Now these beggars wear a vast quantity of Muslin an under cloth of about 6 yards an upper one of as much thrown over the shoulder in a fanciful manner & a large Turban in loose folds all this Muslin is dipped in these staining waters, whether for men women or children & sometimes it is almost a rose colour. Over these muslins they wear these beads in great profusion; long strings of the largest sort are thrown over their necks & fall as low as the knee & others of a smaller size are in shorter chains they have frequently a dozen chains round their necks one lower than another.[64]

Symonds's paintings of pandarams capture the salmon-coloured muslin. The colour the sisters called salmon has also been referred to as ochre and is known as *geru* in India. Geru is a mineral dye that is used to colour terracotta flowerpots and to paint on the walls in villages. The coloured clothes of the pandarams are called in Hindi *Gerua* or *gerva vastra*, meaning "ochre-coloured clothing." It is believed that those who wear this colour are religious mendicants who are not attached to worldly things.

Elizabeth Gwillim and Mary Symonds often mentioned the brown beads they saw the pandarams wearing. These beads are the seeds of a tree, identified by Henry Nolte as *Elaeocarpus angustifolius* (see chapter 4), considered sacred in the Hindu religion. Most Indian religious gurus and mendicants wear them as another indication of their lack of attachment to worldly things. The sisters noticed how these beads were strung in order to be worn around the neck or on turbans. Symonds illustrated how they were worn in profusion (plate 9). The sisters also sent some of the beads back to England.

Both Muslims and Hindus lived in and around Madras. The sisters described the Muslim women of the zenana, the private quarters where women were sequestered. Plate 57 shows Mary's image of a Muslim woman. Gwillim wrote to her sister Hester James that:

> the Moorish people delight in having all the richest colours that they can put together their [word crossed out] [word crossed out] Trowsers which are as full as peticoats & the same only divided are made of Sattins of the most elegant stripes & patterns whether for men or women ... the women wear over their drawers colourd muslin or gauze robes with, broad gold borders & a piece of the same gauze also bordered with gold wove in – of the size of a long shawl which they hang at the back of their heads, & spread over their shoulders in any fanciful way – It covers them but does not conceal any part of their dress. Their choulies or little bodies are also of the most shewy colours & patterns.[65]

Symonds described Muslim women's dress to Thomas Clarke, the father of their friend and lodger Richard Clarke, in a letter dated 14 October 1804.[66] Her description was very similar to Elizabeth's. The trousers that both of them wrote about are actually pyjamas or izars. The fabric was most likely mashru, a kind of woven striped silk satin, or something similar.

Cholis (short blouses) were referred to as "choulies" by Gwillim and as a short waistcoat by Symonds; Symonds writes of "a little sort of waistcoat, made of silk and richly embroidered, but it is so small & short that the whole of the ribs are quite bare," a design that made sense, given the climate. Both Hindu and Muslim women wore cholis, but Hindus wore them with draped fabric called the sari. A sari is usually a 5.5-metre long woven cloth. It can be made out of cotton or silk, with coloured borders. If worn like a trouser, a sari is even longer – a little more than eight metres. Gwillim and Symonds do not describe the styles of draping of the sari, but we can see from their paintings the transparency of the fabric and that some women wore it with a choli and others without: Symonds painted a Brahmin woman wearing a white sari without a choli, but in a different painting, she also depicted women wearing coloured sarees with cholis.

Muslim women wore their cholis as a part of a four-piece ensemble, which included a peshwaz, a pyjama (trouser), and a dupatta or odhani (veil), in addition to the choli. The peshwaz is the upper coat-like garment, worn by Muslim women and sometimes by Hindu women. Gwillim described it as a "muslin or gauze robe," while Symonds called it a "full gown." This garment would generally be made of very fine muslin. The final piece was an unstitched fabric draped like a shawl, known as the odhani or dupatta. This is a piece

of unstitched fabric, forming a thin scarf- or shawl-like garment measuring 2.5 metres in length; it is meant to conceal the body and cover the head in front of visitors. It was made of a fine transparent fabric like muslin or silk tissue (plate 58).

In addition to describing the richly coloured "Trowsers" worn by both Muslim men and women, Gwillim noted that "over these the men wear shawl or sattin short pelices – or worked muslin jams like childrens jams shawls round the waist over their shoulders & on their heads."[67] What Gwillim called a "pelice" (or pelisse – a European outer garment like a coat) is called a *farzi* in India. It is an open-front coat-like garment, with elbow-length or long sleeves. The *farzi* worn could be made of silk velvet, wool, or even muslin, depending on the weather. While it was usually Muslims who wore this jacket in public, some elite Hindus did as well. On the upper body, under the coat, was worn the jama, a long coat made of muslin. On the lower part of the body a pyjama was worn. Like the women's pyjamas, the men's were made of mashru. As Gwillim observed, men's trousers (like women's) were as full as petticoats. One of the reasons for these loose garments was that Indians were accustomed to sitting on the floor. Finally, Indian men used cashmere shawls as their waistbands or cummerbunds.

A February 1802 letter from Symonds to Hester James includes a description of the dress of the nawab who attended a ball held by officers of the Scotch Brigade to celebrate St Andrew's Day:

> The Nabob and all his attendants were there they were all dressed very fine some in shawl dresses with embroidered silver sashes and turbans. The Nabob wore a muslin dress richly ornamented with silver, a sash all of silver and a turban the same, besides a great quantity of jewels and the plume which was presented to him by the governor at his coronation.[68]

Indian men had worn muslin robes, jamas, *farzi*, and Kashmir shawls since the sixteenth century. Many of these styles became popular with European women in the late eighteenth and early nineteenth centuries. It was only much later, by the end of the nineteenth century, under the influence of the Raj, that Indian men began to wear fitted, tailored garments.

The clothing and appearance of the sepoys, native soldiers (both Hindu and Muslim) in the East India Company and British armies, became political when a new commander-in-chief and his general staff proposed changes to their uniforms. Among other changes, new headgear was proposed that was made partially of leather, which the Hindus found objectionable, and it was ornamented with a cross, to which both Hindus and Muslims took exception. New regulations such as this would culminate in a mutiny or uprising at the fort of Vellore in 1806.[69]

Other Europeans wrote about or made images of the Indian people they saw. However, from the body of their surviving correspondence and paintings, it is evident that Elizabeth Gwillim and Mary Symonds were particularly acute observers. Symonds's paintings together with the written descriptions of both sisters provide an evocative picture of the many Indian inhabitants they saw during their time in Madras.

Notes

1 Elizabeth Gwillim to Hester James, 24 August 1805, British Library, India Office Records (BL IOR) Mss.Eur.C.240/4, ff. 279r–296r, on f. 290r.

2 Vikram Bhatt and Vinita Damodaran discuss shipping and the monsoon in more detail in chapter 3.

3 Clemons, *Manners and Customs*, 50.

4 Elizabeth Gwillim to Hester James, 7 February 1803, BL IOR Mss.Eur.C.240/2, ff. 107r–110v, on ff. 107r–107v.

5 Nathalie Cooke discusses foodstuffs in chapter 8, while Victoria Dickenson addresses china in case study 4.

6 Elizabeth Gwillim to Hester James, 18 March 1802, BL IOR Mss.Eur.C.240/1, ff. 49r–53r, on f. 51r.

7 Elizabeth Gwillim to Hester James, 7 February 1802, BL IOR Mss.Eur.C.240/1, ff. 33r–38v, on f. 35 v.

8 Mary Symonds to Hester James, 18 March 1802, BL IOR Mss.Eur.C.240/1, ff. 55r–75v, on ff. 55r–56v.

9 Elizabeth Gwillim to Esther Symonds, 23 January 1802, BL IOR Mss.Eur.C.240/1, ff.21r–32r, on f. 22v.

10 Mary Symonds to Hester James, 22 February 1806, BL IOR Mss.Eur.C.240/4, ff. 319r–321v, on f. 319r.

11 Elizabeth Gwillim to Hester James, 11 February 1806, BL IOR Mss.Eur.C.240/4, ff. 310r–313v, on ff. 310r–310v.

12 Mary Symonds to Hester James, 4 March 1807, BL IOR Mss.Eur.C.240/4, ff. 365r–368v, on f. 365r.

13 Mary Symonds to Hester James, n.d. [1803], BL IOR Mss.Eur.C.240/2, ff. 122r–127v, on f. 123v.

14 Elizabeth Gwillim to Hester James, n.d. [spring 1803], BL IOR Mss.Eur.C.240/2, ff. 167r–177r, on f. 167r.

15 Elizabeth Gwillim to Hester James, 14 August 1803, BL IOR Mss.Eur.C.240/2, ff. 134r–139v, on f 134v.

16 Ibid., ff. 134v–135r.

17 Elizabeth Gwillim to Hester James, 3/4/10 September 1803, BL IOR Mss.Eur.C.240/2, ff. 142r–149v, on f. 143v.

18 Ibid.

19 [Mary Symonds] to Hester James, n.d. [1802], BL IOR Mss.Eur.C.240/1, ff. 58r–61v, on ff. 59r–59v.

20 Elizabeth Gwillim to Hester James, 3/4/10 September 1803, BL IOR Mss.Eur.C.240/2, ff. 142r–149v, on f. 143v.

21 Mary Symonds to Hester James, 10 September 1803, BL IOR Mss.Eur.C.240/12, ff. 150r–153v, on f. 151r.

22 Elizabeth Gwillim to Hester James, 13 August 1804, BL IOR Mss.Eur.C.240/2, ff. 208r–211v, on f. 208r.

23 Mary Symonds to Hester James, 12 August 1804, BL IOR Mss.Eur.C.240/3, ff. 202r–207v, on ff. 206r–206v.

24 Mary Symonds to Hester James, 4 March 1805, BL IOR Mss.Eur.C.240/4, ff. 253r–257v, on 253r–253v.

25 Elizabeth Gwillim to Hester James, 6 March 1805, BL IOR Mss.Eur.C.240/4, ff. 258r–266r, on f. 265r. For more on gloves, see "'Best for This Country': Limerick Gloves," The Gwillim Project, https://thegwillimproject.com/case-studies/best-for-this-country-limerick-gloves/. "Polly" was Elizabeth Gwillim's nickname for Mary Symonds.

26 Elizabeth Gwillim to Hester James, 24 August 1805, BL IOR Mss.Eur.C.240/4, ff. 279r–296r, on f. 292v.

27 Elizabeth Gwillim to Hester James, 7 February 1803, BL IOR Mss.Eur.C.240/2, ff. 107r–110v, on f. 108v.

28 Elizabeth Gwillim to Hester James, August 24, 1805, BL IOR Mss.Eur.C.240/4, ff. 279r–296v.

29 Elizabeth Gwillim to Hester James, n.d. November 1806, BL IOR Mss.Eur.C.240/4, ff. 344r–345v, on f. 344v.

30 Mary Symonds to Hester James, n.d. [November 1806], BL IOR Mss.Eur.C.240/4, ff. 346r–352v, on f. 351r.

31 Mary Symonds to Hester James, 4 March 1807, BL IOR Mss.Eur.C.240/4, ff. 365r–368v, on f. 366r.

32 Elizabeth Gwillim to Hester James, 7 February 802, BL IOR Mss.Eur.C.240/1, ff. 33r–38v, on f. 34r.

33 In February 1802, they sent items with Mr Livingstone, a surgeon on the *Lord Thurlow*; in March, with Mr Longdill, a surgeon of the *Monarch*; and in September by a Mr Long. Elizabeth Gwillim to Hester James, 7 February 1802, BL IOR Mss.Eur.C.240/1, ff. 33r–38v, on f. 34r; Elizabeth Gwillim to Hester James, 18 March 1802, BL IOR Mss.Eur.C.240/1, ff. 49r–54v, on f. 49r; Elizabeth Gwillim to Hester James, 14 September 1802, BL IOR Mss.Eur.C.240/1, ff. 77r–81v, on f. 81r.

34 Elizabeth Gwillim to Hester James, 14 September 1802, BL IOR Mss.Eur.C.240/1, ff. 77r–81v, on f. 80v.

35 Davidson, *Dress in the Age of Jane Austen*, 262.

36 Elizabeth Gwillim to Esther Symonds, 7 March 1804, BL IOR Mss.Eur.C.240/1, ff. 184r–192v, on f. 185v.

37 Elizabeth Gwillim to Hester James, 7 February 1802, BL IOR Mss.Eur.C.240/1, ff. 33r–38v, on f. 34r.

38 Elizabeth Gwillim to Esther Symonds, 16 August 1803, BL IOR Mss.Eur.C.240/1, ff. 140r–141v, on f. 141r.

39 Ashmore, *Muslin*, 9.

40 For example, Elizabeth Gwillim to Hester James, 18 March 1802, BL IOR Mss.Eur.C.240/1, ff. 49r–54v, on f. 50r.

41 Ashmore, *Muslin*, 28.

42 Ibid., 31.

43 Elizabeth Gwillim to Hester James, 7 February 1802, BL IOR Mss.Eur.C.240/1, ff. 33r–38v, on f. 34r.

44 Graham, *Journal of a Residence in India*, 32–3.

45 Elizabeth Gwillim to Hester James, 18 October 1802, BL IOR Mss.Eur.C.240/1, ff. 92r–94v, on f. 93v.

46 See, for example, Elizabeth Gwillim to Hester James, 18 March 1802, BL IOR Mss.Eur.C.240/1, ff. 49r–54v, on f. 50v.

47 "A gentleman's waistcoat of ivory shawl cloth, woven with a blue leaf sprig, late 18th century shawl fabric, the waistcoat circa 1800," Lot 158 in a Fine Costume and Textiles sale, Christie's South Kensington, London, 11 June 1996, and twill woven wool/silk waistcoat, ca. 1790–1810, Chertsey Museum, Surrey, M.1991.63 k.

48 Elizabeth Gwillim to Hester James, n.d. [spring 1803], BL IOR Mss.Eur.C.240/1, ff. 122r–127v, on f. 123r.

49 Elizabeth Gwillim to Hester James, 7 February 1802, BL IOR Mss.Eur.C.240/1, ff. 33r–38v, on f. 34r.

50 Elizabeth Gwillim to Hester James, 17 October 1801, BL IOR Mss.Eur.C.240/1, ff. 19r–19v, on f. 19r.

51 For square Indian shawls in the British press, see, for example, the advertisement for Foster and Brown in the *Morning Post*, 24 December 1801, and Beamon and Abbott in the *Morning Post*, 26 December 1801.

52 Elizabeth Gwillim to Hester James, n.d. [spring 1803], BL IOR Mss.Eur.C.240/1, ff. 122r–127v, on f. 123r.

53 Ibid.

54 Elizabeth Gwillim to Esther Symonds, 16 August 1803, BL IOR Mss.Eur.C.240/1, ff. 140r–141v, on f. 140v.

55 Elizabeth Gwillim to Hester James, 15 February 1803, BL IOR Mss.Eur.C.240/1, ff. 111r–114v, on f. 112v.

56 Woollen shawl, ca. 1800–30, McCord Museum M967.12.2. For jamdani, see the fine example, ca. 1800–30 sold by Cora Ginsburg in 2015: Cora Ginsburg Catalogue (2015), 26–7.

57 Elizabeth Gwillim to Hester James, 15 February 1803, BL IOR Mss.Eur.C.240/1, ff. 111r–114v, on f. 112v.

58 Elizabeth Gwillim to Hester James, 7 February 1802, BL IOR Mss.Eur.C.240/1, ff. 33r–38v, on f. 34r.

59 Elizabeth Gwillim to Esther Symonds, 7 March 1804, BL IOR Mss.Eur.C.240/1, ff. 184r–192v, on f. 185v.

60 Mary Symonds to Esther Symonds, 14 October 1801, BL IOR Mss. Eur.c.240/1, ff. 4r–11v.

61 Ibid.

62 Mary Symonds to Hester James, 14 October 1801, BL IOR Mss. Eur. C 240/1, ff. 12r–13v.

63 Elizabeth Gwillim to Esther Symonds, 23 January 1802, BL IOR Mss. Eur. C240/1, ff. 4r–11v. Victoria Dickenson quotes Elizabeth's complete description of the dinner in case study 4.

64 Elizabeth Gwillim to Hester James, 18 March 1802, BL IOR Mss.Eur.c.240/1, ff. 49r–54v.

65 Elizabeth Gwillim to Hester James, 7 February 1802, BL IOR Mss.Eur.c.240/1, ff. 33r–38v.

66 Mary Symonds to Sir, 14 October 1804, BL IOR Mss.Eur.c.240/3, ff. 242r–247v.

67 Elizabeth Gwillim to Hester James, 7 February 1802, BL IOR Mss.Eur.c.240/1, ff. 33r–38v.

68 Mary Symonds to Hester James, 11 February 1802, BL IOR Mss.Eur.c.240/1, ff. 39r-49v.

69 Jeffrey Spear addresses the uprising at Vellore in detail in chapter 9.

Lady Gwillim's China

A Case Study in Global Exchange

VICTORIA DICKENSON

Although Elizabeth Gwillim preferred to fill her days in Madras with botany, birding, and painting, she could not avoid the responsibility of managing a large and socially prominent household. Her sister Mary Symonds did the housekeeping, but it was Lady Gwillim who ensured that they had a home and furnishings appropriate to their status. The sisters' correspondence not only provides an intimate look at domestic material culture, in particular the dishes and pots fundamental to any household, European or Indian, but also reveals the webs of trade and taste that link an English household in Madras at the beginning of the nineteenth century with a global network of production and exchange.

Moving to India in 1801 was not for the faint of heart. The passage on an East India Company (EIC) ship could take anywhere from four to six months – or longer, if bad weather, repairs, pirates, and, later, attacks by the French navy delayed the arrival. Elizabeth Gwillim, travelling with her husband, Henry, her younger sister Mary Symonds, Henry's clerk, and two Indian servants, likely had some apprehensions before they sailed, though she did not share this in her letters, but she did complain about how poorly they and their belongings were treated by the captain of their ship on the voyage out.[1] She wrote to her sister Hester James that, "though the company gave separate leave for that an unlimitted quantity [of their luggage] in the gunroom a dry place," the captain "put our things in the Hold where they were very damp & injured to get that room for himself."[2] Despite this rough passage, most of what the Gwillim family packed, including their china, arrived intact in Madras.

"China" was the name Elizabeth Gwillim and most people gave to ceramics, no matter where they were made. The EIC had imported literally tons of

Chinese porcelain into England in the seventeenth and eighteenth centuries.[3] Most of these imports were destined for the tables and halls of the elite, but the rising fashion for tea drinking in England created a broader demand for fine china cups and teapots. Where the English had previously eaten and drunk from wood, pewter, or common earthenware, tea drinking demanded more durable and heat-resistant wares. Mrs Papendiek, assistant keeper of the wardrobe to Queen Charlotte, described the furnishings of her own home in 1783: "Our tea and coffee set were of Common India china, our dinner service of earthenware, to which, for our rank, there was nothing superior, Chelsea porcelain and fine India china being only for the wealthy. Pewter and Delft ware could also be had, but were inferior."[4] The "India china" to which Papendiek refers is the porcelain imported by the East India Company, but her earthenware dinner service is the product of the newly vigorous domestic pottery industry. New habits of consumption and the increasing prosperity and refinement of a large middle-class market stimulated English potters, primarily in Staffordshire, to develop new products to compete with Chinese imports. These included the delicate soft paste porcelains of Bow and Chelsea, which were "only for the wealthy," as well stonewares, bone china, and fine glazed earthenwares. By the end of the eighteenth century, English "chinaware" had become not only the choice of the English but, according to the French traveller Faujas de Saint Fond, the choice of the world: "in travelling from Paris to St Petersburg, from Amsterdam to the farthest point of Sweden, from Dunkirk to the southern extremity of France, one is served at every inn from English earthenware. The same fine article adorns the tables of Spain, Portugal, & Italy, and it provides the cargoes of ships to the East Indies, the West Indies and America."[5]

"MY WEDGWOOD HAVE BEEN ADMIRED BEYOND EVERYTHING"

In 1802, in a letter to her sister Hester James in London, Elizabeth Gwillim sketched herself sitting before her writing table, the wall facing her hung with portraits, and on her table three large vases.[6] Josiah Wedgwood (1730–1795) and his partner Thomas Bentley (1731–1780) had been producing decorative vases, sometimes with gilded ormolu metal mounts, since the 1760s. The garniture of vases on Gwillim's dressing table may have been produced at Wedgwood's Etruria factory – similar pieces can be seen in the engraving of the Wedgwood & Byerley showrooms in London that appeared in Ackermann's *Repository of Arts* in 1809. Vases like these were at first created for an elite clientele, but, as Wedgwood wrote to Bentley in 1772,

the Great People have had these Vases in their Palaces long enough for
them to be seen and admired by the Middling Class of People, which
Class we know are vastly, I had almost said, infinitely superior, in num-
ber to the great, and though a great price was, I believe, at first necessary
to make the vases esteemed Ornament for Palaces, that reason no longer
exists. Their character is established, and the middling People would
probably buy quantitys of them at a reduced price.[7]

"Middling people" like the Gwillims not only acquired decorative vases at
reduced price, they also purchased vast quantities of the more utilitarian table-
ware produced by Wedgwood and other English potteries.

Josiah Wedgwood, in particular, was conscious that women, who were the
primary tea drinkers, were an important clientele for his wares. He provided
pattern books in all his warehouses and showrooms, to "be looked over by our
customers here, & they will often get us orders, & be pretty amusem[t]. for the
Ladies when they are waiting, w[ch]. is often the case as there are som[e] times
four or five diff[t]. companys, & I need not tell you, that *it will be our interest* to
amuse, & divert, & please, and astonish, any, & even to ravish the Ladies."[8]
Like many of her compatriots, Elizabeth Gwillim was indeed "ravished" by

Wedgwood. On 26 November 1800, only a few months before they were to sail for India, she visited Wedgwood and Byerley's London showroom on York Street in St James Square to order additional pieces for her sets. A day later, however, she changed her mind and wrote from her sister's home in Brompton to cancel the order: "Mrs Gwillim when she was at Mr Wedgwoods yesterday ordered 12 Egg cups to her dinner set & 12 to her breakfast set. She has since ordered some silver ones & therefore begs that neither of those that she ordered yesterday may be done as she will not want them."[9] "Mrs Gwillim" (she was not yet Lady Gwillim, as her husband's appointment was not announced officially until June 1801) had likely ordered creamware egg cups.[10] When first developed in the early 1760s, Wedgwood had described creamware as "a species of earthenware for the table quite new in its appearance, covered with a rich and brilliant glaze bearing sudden alterations of heat and cold, manufactured with ease and expedition, and consequently cheap having every requisite for the purpose intended."[11] By 1800, creamware was the standard in tableware, and, though made by other potteries, creamware (also called Queensware and later Pearl or Ivory) had become Wedgwood's brand.

Once the family was in Madras, it was evident that, despite her planning and purchases, Lady Gwillim had underestimated her need for fine tableware. The Gwillim household consisted not just of the family, Sir Henry's clerk Richard Clarke, and their servants, but also a revolving cohort of young men, many the sons of various acquaintances from Herefordshire, sent to India to work for the EIC or to join the army. Breakfast for the household was most often a casual meal, but still required a large number of cups and plates, as is evident from Elizabeth Gwillim's 1802 letter to her sister in London:

> I want also from Wedgwoods' – 2 doz[e]n plates to match my breakfast set – one doz[e]n small dishes of different shapes for fruit which is always set here at breakfast – 12 breakfast cups & sawcers & 12 coffee cups with Muffin plates or any little things but no Chocolate cups – several slop basins, & bread & butter plates I will draw a bit of the pattern but I fancy they know it for I told them to write it down.[12]

Unfortunately, the drawing in Elizabeth Gwillim's letter has not survived, but thanks to Mary Symonds's determination to get the right replacement pieces, we do know what the Gwillims used at breakfast. In 1805, when they once again replenished the breakfast set, Symonds took pains to draw the pattern: "I have just recollected one thing we are in great want of, which is some more of the Wedgwood breakfast Cups, both Tea & Coffee cups; pray have the goodness to send them by the first opportunity 2 dozen Teacups & one dozen Coffee cups with Saucers & two Teapots to match I will sketch the pattern."[13] The sketch

(figure 18) can be identified as Wedgwood creamware pattern 219 and is described in the pattern books as "Red berries, brown leaves, fine line and edge."[14]

Dinnerware was another matter. British society at Madras dined in some style. Elizabeth Gwillim wrote to her mother in October 1802 that "Lord Clive opens a Magnificent Banqueting House on the 7th with a Ball &c to the whole settlement – His house & this ... Banqueting house altogether is extremely beautiful & looks like a Palace for Priam & his fifty sons."[15] Most dinners were, however, held at home, and, given the climate, people often ate outdoors. Gwillim described a dinner in 1802:

> There are Verandoes at the back & front of the house & in these the dinner &c is generally laid the Other rooms are called ... halls & are used as drawing rooms or sitting rooms – The dinners look very pretty laid out in these Verandoes open to the Garden & well lighted up ... The first dinner I saw I thought it wonderfully striking particularly from the immense number of servants waiting with such extreme stillness & so delicately dressed all in white muslins & white or figured turbans & large gold earings. Besides ones own servants every body who dines brings one or two with him so that if we sit down twenty or three or four & twenty to dinner there are at least thirty servants waiting at

table … I think nothing of the kind can exceed the beauty of an evening ride to see all the houses lighted up & people dining or dancing in the Verandoes with the attendants lying about the garden, particularly at a Ball when if there are 150 people or 200. which is generally the number, there will be 400. 500 or more of these people in their muslin dresses scattered under the trees before the house.[16]

Mary recounted such a ball for the Queen's Birthday in 1802: "Lord Clive gave a Ball on the Queens Birthday in the same style as the others, the supper was in the garden, under tents."[17] The dinners were lavish, and the quantity of plates, bowls, and glasses required was formidable: "We were last night at a grand ball given by a Mrs. Chinery at which there were about a hundred and fifty persons they danced in the house which was finely lighted and dressed with flowers, the supper was in the garden where a table was laid near 3 hundred feet long upon carpets."[18]

Elizabeth Gwillim refers to her own "great dinners" when she entertained the governor and others of high rank in Madras society, and was particularly glad that she had shipped her Wedgwood dinner set: "My Wedgwood have been admired beyond everything, For except Lord Clives I do not see any Wedgwood but what looks as if it had been bought in Covent Garden. As well for pattern as shape."[19] Wedgwood was marketed as premium china in the latest styles and commanded higher prices than the products of many other potteries.[20] There is no record of the Gwillims' dinner service pattern, but Lady Gwillim was not unaware of the most fashionable shapes, as she wrote to her sister in March 1802: "Polly [Mary] wrote to you to send me some more dishes &c the same as our dinner set, we do not want plates but a great many dishes all sizes. one soup Tureen & it must be the best shape – the tall sort – sallad bowls & vegetable dishes – no sauce boats."[21] She was also pleased she had invested in a Derby bone china dessert service: "I am glad I brought out China desert set for here is so much glass that tho' it costs so much they do not value it & here is no china except mine & a few things Sr. Thomas Strange has."[22] She added to her order: "I want from the Derby China Warehouse 12 plates to match my desert set & 12 dishes. The dishes must be 4 of each shape for corners."[23] (Regency dessert tables were dressed not only with round and oval plates but also with unusual shapes to fill up the corners.) It is remarkable that, despite the dangers of the voyage and the complications of landing cargo through the heavy surf in Madras, the additional china was delivered safely in the summer of 1803: "Amongst the innumerable things sent me I hardly know which to thank you for first – but first to put out of the way the things of little interest & yet of Value my cases of China & of Wedgwood came without any fractures & now my sets are very full & compleat."[24]

Why did the Gwillims and others of their station require quite so much chinaware? Ceramics, more than most material goods, are associated with the preparation and consumption of food, and what is used is determined by what is eaten and how it is served.[25] Fashion and practical considerations dictated that a family like the Gwillims required a great deal of tableware, as they used different sets for breakfast, tea, and dinner, and for formal and informal occasions. A formal English dinner, for example, might consist of three courses, and each course might have twenty or more dishes. Elizabeth Raffald, author of *The Experienced English Housekeeper*, first published in 1787, described a simple two-course dinner (without a third course of "things extravagant"): "have all your Sweetmeats and Fruits dished up in China Dishes, or Fruit Baskets; and as many Dishes as you have in one Course, so many Baskets or Plates your Desert must have; and as my Bill of Fare is twenty-five in each Course, so must your Desert be of the same Number, and set out in the same Manner."[26] Despite the warm weather in Madras, for "great dinners" the Gwillims kept to English fashion and served a side of gammon, ham, or turkey as well as soup, curries, fish, and vegetables. Food was served hot, which also required considerable work as well as more chinaware: "one plate each person goes through the dinner here it is laid at first but they all use China water plates which are set on the plate & water plates are changed – They keep kettles of water boilling outside the house to fill the plates constantly."[27] The fashionable style of dining *à la française* also required a panoply of different serving dishes. Diners would arrive to find the table already groaning under the first course, which included two or more varieties of soup in tureens, entrées, and small dishes of hors d'oeuvres. Once the soup had been served, the soup bowls were removed, to be replaced by plates. Diners were crowded along the sides of the table and were expected to select from the platters nearest to them. They were often assisted by the servants who had accompanied them; in the dining rooms of Madras, Mary Symonds observed that "most Ladies have … servants who fan them during dinner and stand behind their chairs for that purpose."[28] After this first course, a second course might consist of a large roast accompanied by dishes of salads and vegetables. Once this was removed, the table was cleared and the dessert service was laid, with china baskets, fluted bowls, lidded sauce compote dishes on stands, and fancifully shaped serving plates.[29] Even less formal occasions, such as a joint birthday dinner for Mary Symonds and one of the many young men who frequented their home, required quantities of tableware: "On the 18th which was Biss's & Mary's birthday we had a grand Gala – 27 sat down to dinner."[30] For such a dinner, a hostess might easily

use sixty individual bowls and plates, plus fifty or sixty serving platters of various kinds, not to mention the dessert service.[31]

The Gwillim correspondence reveals one family's participation in the English china trade at the beginning of the nineteenth century; it also allows us to examine the larger context of a global trade. Up until the end of the eighteenth century, the "china trade" meant the circulation of Chinese porcelain to markets in South, Central, and West Asia, Europe, and North America. India had been importing Chinese porcelain for hundreds of years, primarily to serve elite markets.[32] Imported celadon was particularly prized by Mughal rulers for its reported ability to detect poisons.[33] Blue-and-white porcelain was also appreciated in Mughal courts,[34] and Chinese kilns developed products specifically for the Indian market, with vivid glazes and inscriptions in Urdu for Mughal royalty and nobility.[35] By the seventeenth century, the Dutch and English had effectively taken over the trade in Chinese porcelain from Portuguese and Southeast Asian traders, and India became a stop on the export route to Europe. With the development of the domestic ceramics industry in England, and changes in taste of the domestic market, the English East India Company ended bulk imports of Chinese porcelain to Britain in 1791, but not after bringing, according to one study, fifty million pieces to Europe between 1699 and 1805.[36] Even if the EIC vessels no longer carried the prodigious quantities of porcelain, private trade to India continued. Merchants commissioned Chinese export porcelain for the British colonial market in India, with tureens, bowls, and plates in European shapes, decorated with elephants and Indian scenes.[37] More utilitarian wares were also imported from the EIC's entrepôts in Southeast Asia. Elizabeth remarked that they put "China pots with flowers" on the terrace of their house in Madras.[38] She also wrote that her friend Mrs Young, Dr Anderson's daughter, gave her two ginger jars shipped through Malacca: "I have two jars of ginger from China which I want to send to you because the jars look to be pretty & as the pair shou'd be kept together I will send them to you."[39]

The English potteries saw the potential of the expanding expatriate market in India. As early as 1769, Josiah Wedgwood wrote to Thomas Bentley that

> The demand for this said Creamcolour, Alias Queens Ware, Alias Ivory still increases. It is really amazing how rapidly the use of it has spread allmost over the whole Globe, and how universally it is liked ... An East Indian Captain and another Gentleman and Lady from those parts ... ordered a Good deal of my Ware, some of it printed and gilt to take with them for presents to their friends, and for their own use. They told me it was allready in Use there, and in much higher estimation than the finest Porcellain.[40]

By the beginning of the nineteenth century, Wedgwood and other British manufacturers dominated imports to India, for sale not to the indigenous population but to the British residents in the East India Company's settlements.

"EARTHEN POTS"

British earthenwares supplied much of the global market for ceramics during the nineteenth century, with special patterns and dishes created for local tastes, from North America to Southeast Asia. For example, English and Scottish potteries supplied large "rice" dishes for communal dining to what is now Indonesia and created Islamic designs for export to Iran and to Muslim communities in India. While upper- and middle-class households did buy the durable and inexpensive British manufactures, India does not seem to have been an important market for specialized imported wares.[41] India had a very long tradition of ceramics production, beginning in the Mesolithic period, the bulk of its production absorbed by the domestic market. What was eaten and how it was made and served drove local demand. Indian potters produced utilitarian earthenware pots and dishes, used for food preparation, storage, and serving, from local clay deposits. Elizabeth wrote to her mother in 1804 that "we have a Pariah man a Cook & he has a Maty ... they cook immense dinners all in earthen Saucepans & earthen frying pans."[42] Mary Symonds also described the earthenware used for cooking:

> These people are very excellent cooks but they have a very odd way of cooking all their utensils are very simple but elegant in their forms ... The boiling is generally done over Charcoal fires which are lighted in earthen pots and stand out in the garden on any convenient place. They boil and stew every thing in earthen vessels which they have of all sizes and various pretty shapes.[43]

Elizabeth was particularly impressed by the large pots used for boiling rice at Pongal:

> The Pots they use are of red earthen ware & on this occasion the red ware is spread on the ground in profusion. It consists chiefly of large pots or Vases from 5 to 10 gallons measure ... The parents or elder relatives give to the younger ones on this occasion one of these pots filled with rice, green ginger, turmeric & a large quantity of sugar-cane fresh cut – the green leaves hang out at the top of the Jar & round the neck of it is tyed long wreaths of flowers of a golden yellow strung together in their way.

These yellow flowers are the ornament for three months of the year. It was curious to observe for some weeks, whichever way one went people carrying these large pots so elegantly adorned with wreaths of flowers.[44]

In addition to cooking, earthenware vessels were used for storage and transport. Mary drew street scenes with processions of women and men carrying large pots on their heads or shoulders, and men balancing trays full of empty pots on their heads (plate 59).

Unlike the Mughal elites who sustained the trade in Chinese porcelain, affluent Hindus often preferred the inexpensive and disposable country-made earthenware. Rules around food preparation and consumption to prevent defilement meant that they disliked reusing plates and cups, and, for this reason, many showed a "great dislike" for imported porcelain and earthenwares, which were more durable and too expensive to be thrown away after each use.[45] Metal utensils were widely used for cooking and eating, the Hindus generally preferring alloys like brass and the Muslims tinned copper.[46] Mary Symonds drew women "with chattys and brass pots" drawing water, and noted that "the high cast women never carry the pots on their head, but on the shoulder & the Braminy women never touch any earthen pot They only use the Brass ones."[47] Indian potters also produced highly prized decorative wares. Elizabeth sent home to her sister "a pot value about a groat but from the interiour of India, of a curious light black ware" given to her by a "sweet neighbour," Mrs Stone, General Smith's daughter.[48] Perhaps this pot was an example of the highly polished black pottery from Nizamabad in Uttar Pradesh, where it continues to be made today, an example of "china" from India.[49]

In their choice of dinnerware or tea services, English women such as Elizabeth Gwillim played a part in driving the economy of empire. Their predilection for tea drinking – itself stimulating the tea trade – made women avid consumers of chinaware.[50] As the taste for tea spread through the middle classes, the market for less expensive but durable earthenwares to replace not only costlier Chinese porcelains but older, coarser domestic products expanded rapidly. The invention of decorated creamwares by Wedgwood and others filled these new markets with quantities of English "china," promoted to and chosen primarily by women. Over the course of the eighteenth and nineteenth centuries, the ships that had carried tons of Chinese porcelain now carried barrels of English creamware to the outposts of empire.[51] With the cups and saucers came notions of civility, fashion, and taste, often learned at the dinner table, where the products of British industry were on display, the empire made material.

Notes

1 George Millett was the captain of the *Hindostan* on its third voyage, when it took the Gwillim/Symonds family to Madras.

2 Elizabeth Gwillim to Hester James, 14/15 August 1803, British Library, India Office Records (BL IOR) Mss.Eur.C.240/2 ff. 134r–139v, on f. 138v. The Gwillim family allowance may not have been unlimited. A regulation dating from 1818 laid out in detail the allowance for baggage per passenger by rank and sex – three tons plus two wine chests for gentlemen and one ton for an accompanying wife or a single lady – as well as cabin furnishings of a table, sofa or two chairs, and a washstand. See Hardy and Hardy, *A Register of Ships*. East India Company captains were also allowed considerable room for articles of private trade and often appropriated more. See Bowen, "Privilege and Profit."

3 Maxine Berg notes that in 1721, "The highpoint of imports during the first half of the eighteenth century, ... amounted to 2 million pieces of porcelain." Berg, *Luxury and Pleasure*, 130.

4 Ibid., 151. "India china" refers to the Chinese export wares imported by the East India Company; the bowls, plates, teacups, and teapots were available in varying grades.

5 Cited in Mckendrick, "III Josiah Wedgwood," 63.

6 Elizabeth Gwillim to Hester James, 7 February 1802, BL IOR Mss.Eur.C.240/1, ff. 33r–38v, on f. 36v.

7 Josiah Wedgwood to Thomas Bentley, 23 August 1772, Wedgwood Archives, Keele University, W.E25-18392, cited in Jenny Uglow, "Vase Mania," in Berg and Eger, *Luxury in the Eighteenth Century*, 159.

8 Wedgwood to Thomas Bentley, February 1769, quoted in Mckendrick, "III Josiah Wedgwood," 50

9 Elizabeth Gwillim to Wedgwood and Byerly, 27/28 November 1800, V&A Wedgwood Collection Archive, L130-25839. The letter shows that, while some pieces could be bought in a show room, specific orders were fulfilled directly from the factory. Thanks to Lucy Lead, archivist, the Wedgwood Museum for locating this letter.

10 "News," *E. Johnson's British Gazette and Sunday Monitor*, 5 July 1801.

11 Josiah Wedgwood, quoted in Berg, *Luxury and Pleasure*, 133.

12 Elizabeth Gwillim to Hester James, 18 March 18 1802, BL IOR Mss.Eur.C.240/1, ff. 49r–54v, on f. 51v.

13 Mary Symonds to Hester James, 9 September 1805, BL IOR Mss.Eur.C.240/4, ff. 297r–298v, on ff. 297v–8r.

14 Identification courtesy of Lucy Lead, archivist, the Wedgwood Museum.

15 Elizabeth Gwillim to Esther Symonds, 2 October 1802, BL IOR Mss.Eur.C.240/1, ff. 82r–83v, on f. 82v

16 Elizabeth Gwillim to Esther Symonds, 23 January 1802, BL IOR Mss.Eur.C.240/1, ff. 21r–32r, on f. 29v.

17 Mary Symonds to Hester James, 11 February 1802, BL IOR Mss.Eur.C.240/1, ff. 39r–46v, on f. 43v.

18 Mary Symonds to Esther Symonds 14 October 1801, BL IOR Mss.Eur.C.240/1, ff. 4r–11v, on f. 8r.

19 The market at Covent Garden had numerous shops, stalls, and street vendors selling Staffordshire ware. Elizabeth Gwillim to Hester James, 7 February 1802, Mss.Eur.C.240/1, ff. 33r–38v, on f. 38v.

20 See the discussion in Mckendrick, "III Josiah Wedgwood," 38–41.

21 Elizabeth Gwillim to Hester James, 18 March 1802, BL IOR Mss.Eur.C.240/1, ff. 49r–54v, on f. 51v.

22 Elizabeth Gwillim is referring to English cut glass, which by 1800 was widely used not only in England but in France. Elizabeth Gwillim to Hester James, 7 February 1802, BL IOR Mss.Eur.C.240/1, ff. 33r–38v, on f. 38v.

23 There is no record of Lady Gwillim's dessert service pattern, but it might be possible, given her interests, to imagine that she ordered a fashionable botanical service. Derby had begun to decorate their porcelain with botanical images from April 1791, when the factory owner, William Duesbury II, bought the first fifty-one numbers of William Curtis's monthly periodical the *Botanical Magazine*, to which Elizabeth herself would later contribute. See Henry Noltie's chapter in this book.

24 China was packed in straw or wood shavings and shipped in barrels. Elizabeth Gwillim to Hester James, 14/15 August 1803, BL IOR Mss.Eur.C.240/2, ff. 140r–141v, on 141v.

25 Sinopoli, *Pots and Palaces*, 5.

26 Raffald, *The Experienced English Housekeeper*, 384.

27 Elizabeth Gwillim to Hester James, 18 March 1802, BL IOR Mss.Eur.C.240/1, ff. 49r–54v, on f. 51v.

28 Mary Symonds to Esther Symonds 14 October 1801, BL IOR Mss.Eur.C.240/1, ff. 4r–11v, on f. 6r.

29 For a fuller description of dining *à la française*, see Visser, *The Rituals of Dinner*, 198–202.

30 Elizabeth Gwillim to Hester James, September/ October 1806, BL IOR Mss.Eur.C.240/4, ff. 329r–343v, on f. 342v.

31 Both Elizabeth and Mary praise their cooks for their desserts. Elizabeth wrote that "whatever can be made of milk & eggs Custards, Trifles &c and all sorts of Pastry is in perfection." Probably from Elizabeth Gwillim, to an unknown recipient, n.d., BL IOR Mss.Eur.C.240/4, ff. 374r–375v, on f. 375. Mary Symonds opined that "all sorts of mixtures of eggs milk and sugar as good as possible custards trifles &c." Mary Symonds to Esther Symonds, 14 October 1801, BL IOR Mss. Eur.C.240/1, ff. 4r–11v, on f. 6v.

32 Ahmad, "Porcelain in Medieval India."

33 Ghori dishes or "poison plates" were said to change colour or crack if poisons were present. See the Ghori poison plates in the collection of the Archaeological Museum Red Fort Delhi, on the National Mission on Monuments and Antiquities website, http://nmma.nic.in/nmma/ antiqDetail.do?refId=763924&mat=78. These may be Persian copies of Chinese originals. See Victoria and Albert Museum, *Review of the Principal Acquisitions*, 25.

34 Sharma, "Chinese Porcelain in India."

35 See "Indian and other Islamic Markets," Daniel & Serga Nadler Collection of Chinese Export Porcelain, Winterthur Museum, http:// nadlerchineseporcelain.winterthur.org/indian- other-islamic-markets/.

36 Giehler, *The Ceramics of Eurasia*.

37 See the tureen with cover at the Metropolitan Museum of Art, accession no. 51.86.29a, b, dated 1785–1800, https://www.metmuseum.org/art/ collection/search/201018.

38 Elizabeth Gwillim to Esther Symonds, 17 October 1801, BL IOR Mss.Eur.C.240/1, ff. 14r–18v, on f. 17v.

39 Elizabeth Gwillim to Hester James, 24 August 1805, BL IOR Mss.Eur.C.240/4, ff. 279r–296v, on f. 293r.

40 Josiah Wedgwood to Thomas Bentley, 1769, quoted in Berg, *Luxury and Pleasure*, 81.

41 Otte, "Pountneys, Bristol."

42 Elizabeth Gwillim to Esther Symonds, 12 October 1804, BL IOR Mss.Eur.C.240/3, ff. 217r–228v, on f. 222v.

43 Mary Symonds to Esther Symonds, 14 October 1801, BL IOR Mss.Eur.C.240/1, ff. 4r–11v, on f. 6v.

44 Elizabeth Gwillim to Esther Symonds, 20–21 October 1803, BL IOR Mss.Eur.C.240/2, ff. 154r–159v, on f. 157r. As Jeffrey Spear observes in chapter 9 in the present volume, Elizabeth also noted that it was the potter who was called up to set a broken limb. (Elizabeth Gwillim to Hester James, 6 March 1805, BL IOR Mss.Eur.C.240/4, ff. 258r–266r, on f. 263v.)

45 Roy, "Home Market and the Artisans in Colonial India," 365.

46 Ibid, 359.

47 Mary Symonds to Hester James, n.d. [1807], BL IOR Mss.Eur.C.240/4, ff. 376r–377v, on f. 376v.

48 Elizabeth Gwillim to Hester James, 6 March 1805, BL IOR Mss.Eur.C.240/4, ff. 258r–266r, on f. 262r.

49 Balasubramaniam, "Etched Black Pottery."

50 Berg, *Luxury and Pleasure*, 245.

51 Maxine Berg cites Collingham, who writes, in *Imperial Bodies*, that the choice of Wedgwood creamware over Chinese porcelain was a part of a wider process of "Anglicization" of lifestyles of the British merchants and administrators in India. Berg, *Luxury and Pleasure*, 144n62.

8

"There Are as Many Sorts of Mango as of Apples"

The Gwillim Archive and the Emergence of Anglo-Indian Cuisine

NATHALIE COOKE

The correspondence of sisters Elizabeth Gwillim and Mary Symonds offers a glimpse of the foods they and Judge Henry Gwillim tried, enjoyed, and cultivated while in Madras between 1801 and 1807, as well as those they missed from their home in England. Their stay in India predated those documented in the better-known, published autobiographical accounts of female Britons in India: for example, Fanny Parks's *Wanderings of a Pilgrim in Search of the Picturesque* (1850) about her time and travels there in 1822–46, and Emily Eden's *Up the Country* (1866) detailing her six-year tour of duty accompanying her brother as of 1836.[1] The Gwillim archive is valuable not only because it sheds light on a period undocumented by later published accounts, but also because the observations of Symonds and Gwillim were keen and precise.

Their letters precede by thirty years the earliest books detailing Indian foodways published in Britain: *Indian Cookery, as Practised and Described by the Natives of the East*, translated by Sandford Arnot in 1831, and Hadjee Allee's *Recipes for Cooking the Most Favourite Dishes in General Use in India* (1835). In her *Bibliography of Cookery Books Published in Britain*, Elizabeth Driver writes, "The nineteenth century saw the expansion and consolidation of the colonial administration in India. The earliest books to be published in Britain about Indian cookery date from the 1830s and were collections of genuine recipes. By the last quarter of the century, however, most writers on the topic presented an anglicized version of the cuisine."[2] That is, by 1900, the English had adopted and modified Indian dishes to such an extent that Anglo-Indian cookery could properly be considered a cuisine, with curries, kedgeree, and chutney

playing central roles. Nearly one hundred years earlier, when the Gwillims and Mary Symonds set foot in the Madras Presidency, their letters vividly detailed first encounters with new plant varietals and species of fish, as well as food production and gardening techniques unfamiliar to them.

Elizabeth Gwillim and Mary Symonds's letters offer a detailed account of descriptive practice revealing the everyday dietary experience of Britons in India that led to the emergence of Anglo-Indian cuisine, and eventually to the welcome that Indian cuisine received across the British Empire. This chapter focuses on three specific stages of culinary adaptation evident in the Gwillim and Symonds correspondence and explores the transformation and migration of Indian foods through contact with colonial British visitors.

BRINGING BRITAIN TO INDIA

Before adopting and modifying Indian dishes, which I identify here as the third stage of culinary adaptation corresponding to the emergence of Anglo-Indian cuisine, the British first worked hard to bring Britain to India. The local cuisines of India did not immediately appeal to the British, who both assiduously avoided what they perceived to be unsavoury foods and ensured that familiar foods were shipped over from their home country. For example, in Elizabeth Gwillim's letter to her mother on 23 January 1802, she remarked on the local penchant for eating white ants, a delicacy that she presumably had not sampled herself:

> They are the white ant which in their first state burough in the ground to the quantity of bushels, in this state when found and they are watched for, they are dug up & sold in the Bazer (market) as we sell elvers or shrimps – They are esteemed a great delicacy, & all the people of the country are very fond of them for stews. A nest of them as you may suppose frequently gets to a state of perfection & come out unobserved & they then fly about as other insects do.[3]

The Gwillim and Symonds correspondence shows few examples of requests for prepared foods to be brought with their visitors: some exceptions are Elizabeth Gwillim's request for confectionary as well as Mary's requests for vinegar, catchup, and jam.[4] Rosemary Raza traces the arrival of British plants and vegetables to India in the late eighteenth century and identifies the 1820s – after the Gwillims and Symonds's departure – as a moment when provisioning expanded dramatically:

The desire for European food was underpinned by the growing provision of the ingredients necessary for it ... The development of a sophisticated social as well as family life created a demand for an astonishing range of foodstuffs. Apart from the wines, spirits, cheese, and ham which were early available, women from the 1820s enumerate hermetically-sealed salmon, herrings, sardines, smoked sprats, lobsters, oysters, reindeer-tongues, pati de foie gras, becasses truffes, potted meat, pickles, cakes, sweets, preserves, sauces, raspberry and strawberry jam, and dried fruit.[5]

One result of this provisioning of European food items was that they established themselves as staples on Anglo-Indian tables in a way that continued into the twentieth century when hosts sought to make a special statement to honour a particular guest. The widely respected culinary authority Wyvern, otherwise known as Colonel Arthurs Kenney-Herbert, despaired in 1878: "Take now, for instance, a tin of the ordinary preserved mushrooms, – those made you know of white leather, – what is the use of them, what do they taste of? Yet people giving a dinner party frequently garnish one *entrée* at least with them, and the Madras butler would be horrified if his mistress were to refuse him that pleasure."[6] Inevitably, some staples of English cookery could not be easily obtained in India: notably, walnuts, mushrooms, and, during the stay of Elizabeth and Mary, raspberries, strawberries, and damsons. Particularly precious was good vinegar and such vinegar-based foods as pickles, because Indian vinegar was largely cut with toddy, a fermented form of coconut water. Pickles were also precious because cauliflower for pickling was not readily available.[7]

Of all the food-related items carried with care over the seas, perhaps the most prized were seeds and seedlings. Avid botanists, the sisters paid particularly close attention to the quality of seeds they exchanged between England and India.[8] Elizabeth Gwillim bemoaned the lack of success she had with sending plants to their sister Hester ("Hetty") James and noted that "it is of particular consequence to entrust seeds to some persons care."[9] Her exchange with a Mr Whitley continued throughout the years. In 1804, she told Hester James that his package of seeds had arrived safely and that, in return, she had sent him a bag of seeds.[10] However, in an 1806 letter she wrote, "I am tired of sending plants because they are so unlucky & give more trouble to Mr. Whitley in fetching them than they are worth."[11]

The sisters frequently requested seeds from England, in part to replenish garden stock. "Parsley grows very well," Elizabeth Gwillim wrote, "but the seed ought to be fresh from England at every opportunity, for the seed will not do a second time ... The second it becomes like Chervil & after two or three times

as rank as Fennel."[12] Certain plants were unavailable in India and had to be sourced from England – thyme and marjoram, for example – while other herbs and vegetables were readily available. Gwillim came across "radishes & mint in great abundance" and opined that the "onions, cucumbers, spinach & sage also are good."[13] Some vegetables, like lettuces and beetroot, were accessible but disappointingly small. Asparagus, per Gwillim, appeared as "miserable small straws," but she identified the reason: "They are very sweet & would no doubt, as a few do, occasionally grow to a good size, but they have been lately introduced."[14] Presumably, recent British visitors had brought asparagus to India, but the plants need a minimum of three years, undisturbed, to establish themselves. That staple of English foodways, the potato, was available for only half the year.

It seems to have been the difficulty of accessing strawberries, however, that most disappointed English newcomers. In her *Letters from Madras,* Julia Maitland wrote to a friend in 1837 that "all the fruit in India is not worth one visit to your strawberry-beds."[15] In a letter dated from mid-August 1803, Elizabeth Gwillim sent thanks to her sister Hester James for strawberry preserves. Gwillim described being able to purchase strawberries at Madras markets, but only in impractically large cases and quantities.[16] A woman writing in 1853 of her trip to Calcutta decried the lack of strawberries, raspberries, currants, peaches, cherries, gooseberries, pears, apricots, and grapes (she did, however, identify and praise two local fruits: the mangosteen and custard apple).[17] However, a century later, when Emily Eden wrote to her sister in 1930, strawberry cultivation had fully taken hold. "The strawberries here," she wrote, "are quite as fine as in England, but they last a very short time."[18]

During the time Elizabeth Gwillim and Mary Symonds spent in Madras, the strawberries they were familiar with from England were not readily available for consumption. Within India, however, three species of wild strawberry were known. Most available was *Fragaria nilgerrensis*, a variety of wild strawberry found in the southern regions of India.[19] In an 1837 publication by the Madras Agricultural and Horticultural Society, strawberries were described as having a thriving potential in the Mysore region, especially "under a moderate shade of almost any kind of tree."[20]

As the earliest British visitors were quick to note, part of the difficulty of cultivating British fruit and vegetables in India was the very different climate. Elizabeth Gwillim wrote to her mother that "agriculture is carried on here in a manner just the reverse of yours & so is gardening, for as you raise beds for the vegetables & leave a sunk path to walk around them, here they sink the bed about a hand breadth, and the path around is raised, this is in order to retain the water, which is of course much exhausted in the day."[21] As David Burton notes in his 1993 *The Raj at Table: A Culinary History of the British in India,* some

Europeans adopted these methods: Dutch settlements near Madras employed Hindu gardeners "whose skill in irrigation was considerable. The beds were enclosed by raised walks so that they could be flooded at various times with water, which was soon absorbed into the sun-baked soil. The flow was controlled by tiny sluice-gates made of clay, from a reservoir fed laboriously by buffaloes carrying leather bags of water."[22]

Certainly, British determination to introduce favourite and familiar fruit and vegetables changed Indian agricultural landscapes. In the 1990s, Burton writes,

> while the British may have had only a minimal influence on Indian cookery directly, the impact of the vegetables they introduced to India has been enormous. Nowadays, potatoes, cabbages, tomatoes, lettuces, runner beans, avocados and corn are well integrated into the Indian diet and countless "traditional" recipes exist for them, yet the cultivation of them all dates only from the arrival of the British and the Portuguese.[23]

In addition to asking for familiar fruits and vegetables, the sisters also made requests of their family to send them fine china and dishes for meals and entertainment, especially in the early years when they were caught up in social activities.[24] Taken together, the letters from the early years of the Gwillims and Mary Symonds's residency in Madras – requesting food items, cookware, and china – provide evidence of what I suggest is the first stage of culinary adaptation: a desire to bring as much of the beloved foodways of Britain as possible to India.

APPROXIMATING BRITISH FOODWAYS

Since it was not possible to import British cuisine wholesale to India, given the obstacles of both shipping and climate, British visitors also sought to adapt local foods to approximate what was familiar to them. This strategy, the second stage of culinary adaptation, shares with the first adaptive stage a clinging to familiar tastes and dishes. In a letter to Hester James, for example, Elizabeth Gwillim described shrimps of all sizes and shellfish she had never seen before; attesting to her interest in these novelties, she included a delightful illustration of a sort of shellfish.[25] However, bemoaning the lack of lobsters, Gwillim wrote, "we have no lobsters here, but we have prawns as large as the tail of a midling lobster & exactly the same, but there is no inside to them, but we mix some crab with it, & it makes a very fine lobster like sauce."[26] Thus, in the early years of her time in India, instead of eating the local crab and prawns as they were, Gwillim blended them to approximate a familiar food from her home country.

In this way, she provides us with a classic example of the culinary adaptation that occurs in migrant foodways.

Key to providing familiar foods were hired cooks. Very little has been written about the rationale of sourcing, preparing, and serving foods to the British in India, precisely because records of British settlement in India were penned by the British themselves. One can occasionally read between the lines of the Gwillim and Symonds correspondence, however, to glimpse the ways in which the servants anticipated the family's food tastes, sometimes in advance of giving them the opportunity to sample new foods, so attuned were they to the stark lines drawn by race and caste. Elizabeth Gwillim wrote to Hester James that "Mr. Gwillim asks them why they did not bring us any fish that we had got by accident. They always say, 'Gentleman cannot eat that fish,' then he asks them if they can eat it, they say 'Yes, black people very much like that, but Gentleman can't eat, no custom to bring Gentlemen.'"[27] However, the British eventually developed a taste for certain varieties of fish, once they had been exposed to and come to terms with the astonishing variety of fish in India (there were more than 2,000 varieties, some of which, as discussed in case study 2, were painted by Mary Symonds – see, for example, plate 60).[28] The most popular, according to David Burton, was the seer, "similar in size to salmon, and although the flesh is white, it also resembles the salmon in flavour."[29] Next in popularity came pomfret and sole.[30]

Cecilia Leong-Salobir argues that the colonial cuisine of British India was essentially shaped by decisions made by Indian staff cooks, who catered to the tastes of their English employers in the first half of the nineteenth century: "The cooks wielded far more influence on the diet of the British than what has been acknowledged. Many of the hybrid colonial dishes had origins from local dishes and were adapted for what servants thought were more to European tastes."[31]

In keeping with Leong-Salobir's assertion about the significant role played by Indian staff, Elizabeth Gwillim's correspondence records specific instances of her cook and butler determining what ended up on the dinner table. An 1802 letter discussing the bounty of hares in contrast to the paucity and expense of rabbits reveals an exchange Gwillim had with her employees that impacted what food was prepared and served in her household. "Hares are very plentiful here, but rabbits are dear. A rabbit [costs] eight shillings for there are none but [those] some gentlemen keep & so far as I find must be stolen before you can buy them."[32] She went on to write:

We by means of some directions got the hares dressd so much in our own way that I wished to have one for company & desired among the rest it might appear cooked in that stile, however it was not brought, & as I had

observed the butler was disturbed when I told him to [word crossed out] get it – I enquired why it had not been done – Upon which he said he was very sorry but the Cook & he had both agreed that all the company wou'd laugh if a Country hare was brought to so handsome a dinner, but he promised me the next time he wou'd not fail to get a rabbit. They always call them by way of contempt Country hares & I believe are perfectly convinced that it is from stinginess that I order them & I have never so far prevailled as to have one for company.[33]

Eventually, a hybrid Anglo-Indian cuisine emerged from the interplay of local dishes and European food tastes, negotiated by Indian cooks, which became entrenched in the decades following the Gwillim/Symonds family's stay in Madras. Leong-Salobir musters significant evidence to argue that "in spite of the availability of European food in these colonies by the middle of the nineteenth century, most of the British continued to eat the hybrid dishes that their antecedents did before them."[34] The longstanding culinary discourse between India and England has played out to be largely one-sided, with much more of an Indian influence on British foodways than a British influence on Indian foodways. While acknowledging this, Uma Narayan, writing in 1995, hastened to point out that "this is not, however, to say that there has been no 'western' influence on what contemporary Indians consume. 'Luxury' commodities such as chocolate, cookies, and ice-cream are routinely consumed by middle-class Indians."[35]

EXPLORING THE VARIETY OF NEW FOODS

Despite their interest in continuing to partake of familiar English cuisine while abroad, the British in India were nevertheless intrigued with the variety of foods, fruit, and vegetables available. They were often adventurous eaters, even though their curiosity was sometimes curbed by their servants. Henry Gwillim, in particular, seems to have been very willing to try new flavours and foodstuffs.

Mangoes were particularly fascinating. Elizabeth Gwillim was quick to learn about and appreciate the dominant fruit in the country. She observed:

the favorite fruit of the country is the Mango & the Mango trees are now in full flower & smelling very fresh & nice. The orchards look like Walnuts or Pear trees, but the flower is a large spike of small blossoms like Meadow-sweet. There are as many sorts of Mango as of apples & as much difference in them. I like them unripe in tarts, they are like a fine green apple, but I fear I shall not like them ripe again as I was ill after eating them.[36]

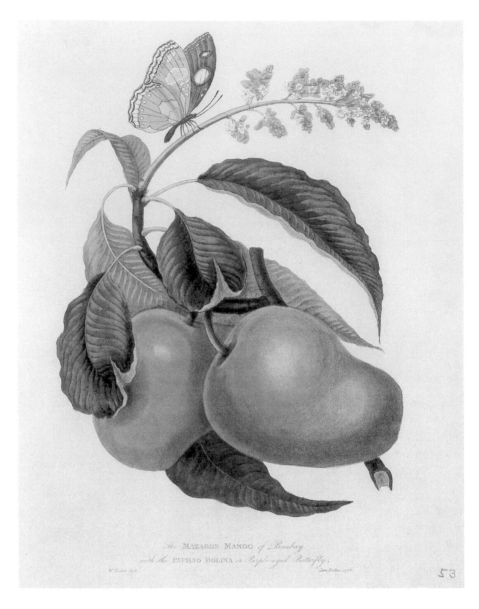

FIGURE 19
W. Hooker, coloured aquatint after J. Forbes, Mango (*Mangifera indica L.*) flower
and fruit with a purple-eyed butterfly (Papilio sp.) 1768. Wellcome Collection.

Inadvertently, Elizabeth Gwillim here describes another form of adaptation: adapting one's gastro-intestinal system to the indigenous fruit varietals.

In terms of vegetables, Elizabeth Gwillim noted the "infinite" variety – including "yams … greens or sorrels of several sorts" – but observed that the local custom was to use the "seed vessels of plants. Almost all the plants of this country are of the pea or bean shaped flower & produce pods of various forms,

& these they use in their stews either shelled or young."[37] She also reported that "several things of the cucumber and gourd kind ... are excellent stewed."[38]

Elizabeth Gwillim seemed disappointed that some of the most familiar English vegetables could not be obtained easily. But she was delighted that "mustard, cresses, radishes [and] mint" were grown in "great abundance," that "onions, cucumbers, spinach & sage also are good," and that French beans were "here all the year."[39] As Gwillim's very positive comments about local varieties of fruit – like mangoes – and vegetables anticipate, the Gwillim and Symonds household gradually substituted local food varietals for some of their English food staples. "I find now that the Mango fruit used green makes the finest jelly I ever eat in my life," Mary Symonds wrote to a friend. "It will not keep above a month, but the trees bear more or less all the year." In the same letter she wrote, "we have Colaccas for tarts much superior to Goosberries & several other fruits of the same nature particularly one called Billimby, & another called Aranelly; besides which the green Mangoes make us *apple* puddings & pies every day."[40] Robert Wright in 1851 confirmed that calaccas do, indeed, "serve well for tarts."[41] Generally, finding alternative fruit or alternative food preparation techniques was a form of culinary adaptation that enabled the British to enjoy the tarts and jams that were central to English foodways.

THE EMERGENCE OF AN ANGLO-INDIAN CUISINE

Mary Symonds and Elizabeth Gwillim's accounts of daily fare negotiated by their Indian kitchen staff begin to sketch the emergence of distinct foodways for Britons in India. The information about food their letters provide is complemented by detailed diary entries of Eliza Fay, writing in 1780 of Bengal:

> In order to give you an idea of my household expenses and the price of living here, I must inform you that, our house costs only 200 rupees per month, because it is not in a part of the town much esteemed; otherwise we must pay 3 or 400 rupees; we are now seeking for a better situation. We were very frequently told in England you know, that the heat in Bengal destroyed the appetite, I must own that I never yet saw any proof of that; on the contrary I cannot help thinking that I never saw an equal quantity of victuals consumed. We dine too at two o'clock, in the very heat of the day. At this moment Mr F— is looking out with an hawk's eye, for his dinner; and though still much of an invalid, I have no doubt of being able to pick a bit myself. I will give you our bill of fare, and the general prices of things. A soup, a roast fowl, curry and rice, a mutton pie, a fore quarter of lamb, a rice pudding, tarts, very good cheese, fresh

churned butter, fine bread, excellent Madeira (that is expensive but eatables are very cheap,) – a whole sheep costs but two rupees: a lamb one.

...

At one o'clock, or somewhat later, the tiffin was served – a hot dinner, in fact, consisting always of curry and a variety of vegetables. We often dined at this hour, after which we all lay down, the adults on sofas, and the children on the floor, under the punkah, in the hall.[42]

Here Fay offers bills of fare that reveal a hybrid cuisine – curry and rice appearing on the table alongside mutton pie, rice pudding, "good cheese," and Madeira. As Leong-Salobir explains, "the colonial cuisine retained elements of British food practices and at the same time incorporated ingredients and practices from the colonies. This cuisine was not wholly British nor was it totally Asian. At any given meal European dishes sat side by side with colonial dishes, that is dishes that has been adopted and adapted for British taste."[43] Staples of this hybrid cuisine – soon to be dubbed Anglo-Indian – included "countless types of curries, mulligatawny, kedgeree, chicken chop, pish pash and the inimitable meal of tiffin [lunch]."[44]

Fay's use of words like "tiffin" and "curry" signal another product of colonial India: a distinctive Anglo-Indian idiom. In its 1,021 print pages, *Hobson-Jobson* offers a glossary of colloquial Anglo-Indian words, thereby attempting to fix the inevitably dynamic process of language creation. In their introductory remarks, Yule notes that, "of words that seem to have been admitted to full franchise, we may give examples in *curry, toddy, veranda, cheroot, loot, nabob, teapoy, sepoy, cowry*." He defines "curry" as follows: "the staple food consists of some cereal, either (as in N. India) in the form of flour baked into unleavened cakes, or boiled in the grain, as rice is. Such food having little taste, some small quantity of a much more savoury preparation is added as a relish, or 'kitchen,' to use the phrase of our forefathers. And this is in fact the proper office of *curry* in native diet."[45]

By writing about their foodways – describing distinctive dishes and documenting practices – women such as Fay and the Gwillim and Symonds sisters advanced the emergence of a fully fledged cuisine. Patricia Parkhurst Ferguson provides a considered definition of "cuisine" as opposed to "cookery": "Where cooking humanizes food by making it fit for human consumption," she writes, "cuisine socializes cooking."[46] For cooking to be transformed into a cuisine, in other words, there has to be an accompanying literature to document its components and evolution and the relationship of individual dishes to the whole repertoire of flavours and production techniques. Writes Ferguson, "culinary preparations become a cuisine when, and only when, the preparations are articulated and formalized, and enter the public domain."[47]

In the case of Anglo-Indian cuisine as served to Britons in India, the process of documentation was perhaps formally cemented by Colonel Arthur Robert Kenney-Herbert's extraordinarily detailed account of the production of food in his Indian kitchen, *Culinary Jottings for Madras, or a Treatise in Thirty Chapters on Reformed Cookery for Anglo-Indian Exiles*. Even before his retirement from the army in 1892, Wyvern, to use his pen name, wrote newspaper articles about Indian cookery, which were then collected in *Culinary Jottings* in 1878. After retiring to England, Kenney-Herbert opened a cookery school, and, in 1904, published another cookery book, *Vegetarian and Simple Diet*.[48] Wyvern was not a vegetarian but generally promoted the service of fresh produce and bemoaned the Anglo-Indian tendency to favour tinned provisions over fresh.[49] Based on the Gwillim/Symonds sisters' careful observations of local produce and available raw ingredients, as well as their striving to see it represented in ample variety on their table, one might conclude they would be of like mind.

THE MIGRATION OF ANGLO-INDIAN CUISINE

Wyvern also demonstrates the way Indian foodways travel across imperial contexts. Upon his retirement to Britain, he, like so many other Britons returning after their tour of duty in India, brought with him a taste for the spices and flavours of the Indian continent and an interest in sharing his culinary knowledge. In the case of the Gwillim/Symonds family, in part because of Elizabeth Gwillim's untimely death, we unfortunately have no details as to whether their food preferences were influenced by their Indian sojourn.

Perhaps the best-known account of the impact of Indian cuisine on visiting Britons – albeit a fictional one – appears in William Thackeray's *Vanity Fair*, where Mr Sedley, returned from his tour with the East India Company, enjoys an extraordinarily hot goat curry prepared for his English table, and goads the visiting Becky Sharp, who is already struggling to cope with the dish's cayenne, to eat an additional chilli.[50] One implication of Becky's unfortunate experience is that readers understand that she has had limited world experience, in that she has not been exposed to curry, something that was familiar in 1848 England. Thanks to travel between the colonies, Indian spices and sauce-based dishes became popular outside India very early on. The shorthand for this style of cuisine was, and still is, the term "curry." We know from Colleen Taylor Sen's history of curry in England, as well as from Rosemary Raza, that curry was consumed in Britain at places such as the Norris Street Coffee House in Haymarket as early as the late eighteenth century.[51] David Burton writes that "by 1773 curry had become the speciality of at least one coffee house, and from about 1780 the first commercial curry powders were on sale."[52] The first

FIGURE 20
Advertisement for the Bombay Emporium, May 1937.
© The British Library, Board File 45/34.

purely Indian restaurant was the Hindoostanee Coffee House, which opened in 1809 at 34 George Street near Portman Square, Mayfair.[53] And as a 1931 advertisement for the Tottenham Court Road Bombay Emporium in London attests, Indian goods and flavours had an enduring appeal in England.

By the time of the reign of Queen Victoria, who became the empress of India as of 1877, the palace required the presence at mealtimes of two "Indian footmen wearing turbans," who were responsible for serving the daily "curry." In turn, this curry was prepared downstairs in the palace by two Indian cooks, who refused to use curry powder and instead ground their own spices.[54] During the reign of Victoria's son, Edward VII, the two Indian footmen were no longer required, but his successor, George V, insisted that curry be served "when the family dined alone."[55]

Many scholars who have studied the entry of curry to British foodways argue that the first published cookery book recipe for curry was the one in Hannah Glasse's 1747 *The Art of Cookery Made Plain and Easy*.[56] Glasse's recipe involves boiling "Fowls or Rabbits" with onions, pepper corns, browned and

ground coriander seeds, a large spoonful of rice and a bit of salt. To this is added a "Piece of fresh Butter, about as big as a large Walnut," and the mixture is stirred with a watchful eye until the right consistency is reached.[57]

However, there is evidence that Indian foodways had already gained popularity prior to this, and at least two earlier recipes for dishes prepared in the "Indian way" can be found. The Wellcome Collection includes a manuscript cookbook dating to around 1675, written over seventy years prior to Glasse's *The Art of Cookery*, that offers a recipe that seems to be similar to Glasse's. The author does not refer to the food as a "curry." Instead, the recipe is titled "To Dress a Hen, Mutton or Lamb in an Indian Way," which anticipates Glasse's own phrasing: "To make a Currey the India way." The seventeenth century recipe offers a technique that includes the addition of sour (lemon and vinegar) and sweet (herbs) notes and does not mention the ingredients in what Britain would eventually package as curry powder:

> Take a hen and cut her down the back and wash her from the blood and dry her, then take salt, pepper, cloves and mace and beat the spices very well, then take also sweet herbs and some shallots and mince them very small with lemon and mingle all these well together; then rub up the hen all over with these things and lay it flat in an earthen pan and cover it with some vinegar and let it steep two hours; then roast it and baste with this liquor – when it is enough, set the liquor a cooking, take off the grease, and pour off the hen; dissolve anchovies in it and heat it with beaten butter. So, serve it up.[58]

Only about five years after the composition of this seventeenth-century recipe, another recipe for curry was published in a Portuguese cookbook, *Arte de Cozhina*. This recipe uses fish as its primary protein and suggests serving the prepared sauce over rice. Key ingredients include shrimp, clams, almonds, and curry (it is unclear whether this referred to the leaf itself or to curry powder).[59]

A Canadian cookbook from 1829 contains recipes for curries and predates the first published British cookery book dedicated entirely to reproducing Indian cookery techniques, demonstrating the reach of popularity of Indian dishes beyond Britain and Europe. Written by Mrs Dalgairns, it contains a full chapter on curries (spelled "currie") with fourteen different recipes: Currie; Currie of Veal; A Dry Currie; Currie Pimento; Kebobbed Currie; A Fish Currie; Cold Fish Currie; Indian Currie; Currie of Veal, Rabbit, or Fowl; To Boil Rice; Currie Powder; and Another way to make Currie Powder.[60] Food historian Mary F. Williamson notes that "there are other Anglo-Indian recipes in other chapters too" and suspects that "Mrs. Dalgairns' three brothers-in-law, or their

wives [who had Indian connections], were the sources of the recipes."[61] This early movement of recipes across colonial spaces is attributable partly to the way that colonial officials themselves moved between postings.[62] For example, Henry Gwillim's fellow judge Sir Thomas Strange served both in India and in Canada.[63]

THE GLOBALIZATION OF INDIAN
AND ANGLO-INDIAN CUISINE

While Elizabeth Gwillim and Mary Symonds mentioned curry only a few times in their correspondence, the fact that they spoke of it at all is helpful to understand the migration of the word "curry" into common English parlance. That Gwillim was able to mention curry in her letters to her family back home without providing context indicates a level of familiarity with the term in England of the early 1800s.

Specifically the term *kari* (akin to the Portuguese word *karil*) refers to a sauce or gravy produced from the leaf of the curry tree; Lizzie Collingham notes that the word joined the lexicon with the arrival of the Portuguese in India in the 1500s.[64] An interesting passage in one of Elizabeth's letters demonstrates how the word was used locally: "Curry is the name of cooking with them & pilly signifies leaves – so they cry *Curry pillly vankilliko* – will you buy my Curry leaves."[65]

Together, the cluster of curry recipes that predate Glasse's book and the earlier etymological origins of the term *kari* suggest that the spread of curry and the influence of Indian food preparation techniques throughout Europe occurred years before the publication of Glasse's famous recipe.[66] Therefore, Glasse's cookbook likely represents not the start of the journey of curry in the English public consciousness, but rather a formalized admission of the place it had already earned in the English kitchen.

The term "curry" not only appears to describe foods prepared "in the Indian way" for British tables, but is also used by Britons visiting India, as we saw with Eliza Fay in 1780s Bengal. However, Indian cooks themselves would be unable to identify a particular dish called curry. Instead, the term could apply to a wide variety of dishes involving sauces of subtly nuanced flavours. As Sarah Maroney convincingly argues while focusing on three different sites of its consumption – by the British in India, the East India Company community in England, and English domestic cooks – "movement, or mobility, is a ... productive way to conceptualize curry's history" such that curry becomes "a case study that provides evidence for how complicated the processes are in the mobility of foodways."[67]

FIGURE 21
Recipe for "English Curry." Mrs June Cooke, ca. 1963.

It is important not to romanticize the way in which Indian food preparation techniques made their way to Europe, as they arrived through the workings of empire and the subjugation of India's people – first by the Portuguese and then by the English. Uma Narayan approaches the fabrication of curry powder itself as a metaphor for colonial praxis. She points out that "British curry powder is a fabricated entity, the logic of colonial commerce imposing a term that signified a particular type of dish onto a specific mixture of spices."[68]

Certainly, of all Anglo-Indian dishes, none has been more discussed and debated than curry itself, in part because it was, and is still, so ill defined. Curry – as it has come to be known in the West as a dish prepared with a purchased mixture of spices – is a dish that is representative of Anglo-Indian cuisine, one adapted to suit British palates.

My own mother's recipe for "*English* Curry" (emphasis mine), dating from the mid-twentieth century, includes beef dripping and flour, two ingredients that were brought to India by the British and certainly were never part of Indian food traditions.[69] Quite the contrary: British expats were often hard pressed to find cooks willing to work in kitchens that prepared beef, so abhorrent was the concept of cooking and eating the sacred animal. The sultanas and apple in my mother's recipe are also additions found in many Anglo-Indian recipes, intended to add a touch of sweetness; the hard-boiled egg would be served as a garnish, adding a touch of protein if the curry base was vegetable. The "curry powder" is pre-blended, and the final, key ingredient is a bit of golden syrup (presumably Lyle's brand). I remember it being served in my childhood homes in South India, England, and then Canada with fragments of edible silver as garnish, along with side dishes of sliced banana, peanuts, and roasted dried coconut. How very far had this Anglo-Indian recipe travelled from its original inspiration!

Of course, Indians themselves also moved and adapted their cuisine to new environments, especially with significant waves of migration from the subcontinent during postcolonial times.[70] And this process occurred alongside the spread of Anglo-Indian cuisine as British people migrated across colonial settings.[71] Most famously, in 2001, Robin Cook, the British foreign secretary, declared chicken tikka masala to be England's national dish.[72] As Elizabeth Buettner points out, Cook claimed that chicken tikka was an Indian dish, and that the masala sauce was added to appeal to British palates.[73] Although it is foundational to what is colloquially described in England as "going for an Indian," the dish is likely not originally an Indian dish, but rather something devised by Indian cooks to appeal to British diners.[74] Thus, chicken tikka masala, as well as other variations of Indian cuisine prepared for diners in new contexts, makes up part of the continually evolving repertoire of hybrid Indian cuisines, in a process observed closely by the Gwillim/Symonds sisters in the Madras Presidency between 1801 and 1807.

Notes

1 Parks, *Wanderings of a Pilgrim*; Eden, *Up the Country*. For more details, see Lusin, "Curry, Tins and Grotesque Bodies."

2 Driver, *A Bibliography of Cookery Books*, 31.

3 Elizabeth Gwillim to Esther Symonds, 23 January 1802, British Library, India Office Records (BL IOR) Mss.Eur.C.240/1, ff. 21r–32r, on 23v. See also Deb Roy, "White Ants."

4 Elizabeth Gwillim to Hester James, 14 September 1802, BL IOR Mss.Eur.C.240/1, ff. 77r–81v; [Mary Symonds] to unknown recipient, 10 February 1804, BL IOR Mss.Eur.C.240/3, ff. 212r–216v.

5 Raza, *In Their Own Words*, 94.

6 Kenney-Herbert, *Culinary Jottings for Madras*, 20.

7 Mary Symonds to Esther Symonds, 14 October 1801, BL IOR Mss.Eur.C.240/1, ff.12r–13v.

8 For additional details in the sisters' interest in botany, see Henry Noltie's chapter in this volume.

9 Elizabeth Gwillim to Hetty James, 7 February 1802, BL IOR Mss.Eur.C.240/1, ff. 33r–38v, on 34r.

10 Elizabeth Gwillim to Hetty James, 13 August 1804, BL IOR Mss.Eur.C.240/3, ff. 208r–211v.

11 Elizabeth Gwillim to Hetty James, 11 February 1806, BL IOR Mss.Eur.C.240/4, ff. 310r–313v, on 313v.

12 Elizabeth Gwillim to Esther Symonds, 23 January 1802, BL IOR Mss.Eur.C.240/1, ff. 21r–32r, on 26r.

13 Ibid.

14 Ibid.

15 Maitland, *Letters from Madras*, 24.

16 Elizabeth Gwillim to Hester James 14/15 August 1803, BL IOR Mss.Eur.C.240/2, ff. 134r–139v.

17 A.U., *Overland, Inland and Upland*, 101.

18 Eden, *Up the Country*, 130.

19 Achaya, *Indian Food Tradition*, 205–6.

20 Ingledew, *Treatise*, 6.

21 Elizabeth Gwillim to Esther Symonds, 23 January 1802, BL IOR Mss.Eur.C.240/1, ff. 21r–32r, on f. 28r.

22 Burton, *The Raj at Table*, 16.

23 Ibid., 160.

24 See case study 4 by Victoria Dickenson in this volume.

25 Drawing presumably by Elizabeth Gwillim in Elizabeth Gwillim to Hester James, 7 February 1802, BL IOR, Mss.Eur.C.240/1, ff. 33r–38v, on 37v. The drawing is likely of a sand crab or mole crab (*Emerita* sp.). These can still be found on the Chennai beach, and are eaten as well as used as bait for fishing.

26 Ibid.

27 Ibid., f. 38r.

28 Burton, *The Raj at Table*, 101.

29 Ibid., 102.

30 Ibid., 105.

31 Leong-Salobir, *Food Culture in Colonial Asia*, 9.

32 Elizabeth Gwillim to Hester James, 7 February 1802, BL IOR, Mss.Eur.C.240/1, ff. 33r–38v, on f. 38r.

33 Ibid.

34 Leong-Salobir, *Food Culture in Colonial Asia*, 21.

35 Narayan, "Eating Cultures," 69.

36 Elizabeth Gwillim to Hester James, 18 March 1802, BL IOR Mss.Eur.C.240/1, ff. 49r–54v, on f. 52r.

37 Elizabeth Gwillim to Esther Symonds, 23 January 1802, BL IOR Mss.Eur.C.240/1, ff. 21r–32r, on f. 26r.

38 Ibid., f. 26v.

39 Ibid., f. 25v.

40 [Mary Symonds] to unknown recipient, 10 October 1804, BL IOR Mss.Eur.C.240/3, ff. 212r–216v, on f. 212r–212v.

41 Wight, *Spicilegium Neilgherrense*, 29.

42 Fay, *The Original Letters*, 141 and 65.

43 Leong-Salobir, *Food Culture in Colonial Asia*, 53.

44 Ibid., 60.

45 Yule, *Hobson-Jobson*, xvi and 281.

46 P. Ferguson, *Accounting for Taste*, 17.

47 Ibid., 19.

48 Kenney-Herbert, *Vegetarian and Simple Diet*. The first edition was published in 1904; a more widely available edition was published in 1907.

49 Kenney-Herbert, *Culinary Jottings for Madras*, 25.

50 Thackeray, *Vanity Fair*.

51 Raza, *In Their Own Words*, 94; Sen, *Curry*.

52 Burton, *The Raj at Table*, 75.

53 Sen, *Curry*, 37.

54 J. Smith, *Eating with Emperors*, 7–8.

55 Ibid., 169 and 202.

56 Collingham, *Curry*, 141; Maroney, "'To Make a Curry the India Way,'" 127; Bickham, "Eating the Empire," 103.

57 Glasse, *The Art of Cookery*, 52.

58 Wellcome MS. 4050, ca. 1675.

59 Rodrigues, *Arte de Cozinha*, 127.

60 Dalgairns, *The Practice of Cookery*.

61 Mary Williamson, personal communication, 12 February 2020.

62 See Lambert and Lester, *Colonial Lives*.

63 Wilson, "Strange, Sir Thomas Andrew Lumisden."

64 An interview with Lizzie Collingham, Cynthia Graber, and Nicola Twilley, *The Curry Chronicles* (podcast), Gastropod, 9 April 2019, https://gastropod.com/the-curry-chronicles/.

65 Elizabeth Gwillim to Hester James, n.d. [spring 1803], BL IOR Mss.Eur.C.240/2, ff. 167r–177v, on f. 176v.

66 It may be interesting to note that *Forme of Cury*, a recipe book compiled in 1390 by the master-cooks of King Richard II, features not only the term "cury" but also several recipes utilizing broth and gravy infused with spices such as clove, mace, peppercorns, and ginger – for example, "Connyng in Grauey," recipe number xxvi in Pegge, *The Forme of Cury*.

67 Maroney, "'To Make a Curry the India Way,'" 123.

68 Narayan, "Eating Cultures," 65.

69 Laudan, *Cuisine and Empire*, writes that arrivals in India "in the late eighteenth and nineteenth centuries were the 'Anglos,' British and Americans, who brought with them beef cattle and wheat flour" (2).

70 In the 1960s and 1970s, Indian restaurants expanded their customer base beyond Asian diners, and increasingly appealed to white Britons. Buettner, "'Going for an Indian,'" 879.

71 My thanks to Anna Winterbottom for this insight.

72 Robin Cook, "Robin Cook's Chicken Tikka Masala Speech," *Guardian*, 19 April 2001.

73 Buettner, "'Going for an Indian.'"

74 See Collingham, *Curry*, 2.

9

Elizabeth Gwillim

The Lady as Proto-ethnographer

JEFFREY SPEAR

TRANSITIONS I: CONTEXT

Elizabeth (Betsy), Lady Gwillim, was born in 1763, and her sisters Hester (Hetty, Mrs Richard James) in 1768, and Mary (Polly) Symonds in 1772, making the sisters slightly older than Jane Austen (b. 1775) and younger than Mary Wollstonecraft (b. 1759), author of *A Vindication of the Rights of Woman* (1779). Although the late eighteenth-century publications that directly addressed women primarily featured fashion, piety, propriety, teaching (including natural history), and other domestic responsibilities – with an occasional spicing of sometimes ribald humour – literacy itself had no such restrictions. Literate women who had the luxury of time as well as the inclination could master most of what their culture had to offer, since field specialization was in its infancy and higher education devoted largely to divinity and classics. As the Austen narrator in *Mansfield Park* says of young Fanny Price, "a fondness for reading ... properly directed, must be an education in itself."[1]

Elizabeth Gwillim, while exceptional, was far from the only well-read woman of her time to move from the realm of conventional female accomplishments to genuine mastery in the arts as well as the sciences of observation and classification – moving, in her case, from gardening to botany, from Bewick's *British Birds* to Indian ornithology, from European languages to Telugu and, like Mary Symonds, from the rudiments of drawing and painting to works of art. Given the opportunity, some women were already making scientific contributions on a par with the men of the period.[2]

Just as late eighteenth-century clothing for women was less confining than Victorian fashion, so the realms of discourse open to women of the late

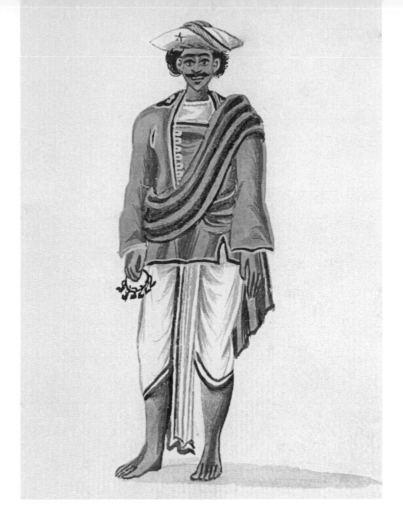

FIGURE 22

Butler. Nineteenth-century Company painting, ca. 1840 from a costume and occupation series collected by Mary and Thomas Young, Bengal Civil Service. Most of these formulaic paintings were gouache on mica and were common souvenirs before the advent of the picture postcard in the 1890s. Collection of Jeffrey Spear.

eighteenth century were considerably wider than what would be considered proper in generations that followed. It would be a long time before another female novelist would feel free to indicate the dubious moral nature of a character by having her joke about sodomy, as Austen does with Mary Crawford in *Mansfield Park*, nor would it become any Victorian lady to amuse her mother as Elizabeth did by writing about the fun they had enticing their Indian butler to say the word "chit" because he pronounced the *ch* as *sh*.

The increasingly conservative government in Britain and the transition from the "loose" morals of the Regency to the moralizing, socially conservative, imperialistic, and positivistic Victorian period had its echo in British India. The respect, however qualified, that the original Orientalists had for

Indian culture gave way to Anglicists convinced that the British were materially and morally superior to their Indian subjects. That shift was stirring while the Gwillims and Mary Symonds were in Madras, if far from the consensus young Rudyard Kipling encountered late in the century. As in Jane Austen's world, the sisters placed people by country or county of origin, family, income, class, and connections. They generally judged people by their probity, sensibility, taste, and manners, though, excepting their friends, they were not pleased by the ascendancy of so many Scots.[3]

It took from four to six months for ships carrying the sisters' correspondence to reach England – sailing times were irregular and contingent upon seasons, weather, and the war with France. As a result of the irregular opportunities to send correspondence, their letters were not written at one sitting. They read like a cross between the usual stuff of family correspondence, journal entries, and essays, breaking off when a when suitable ship was about to depart. The letters give the impression that Elizabeth was the more objective of the sisters; Mary, who admitted to writing "quizzy" (bantering) letters, the more emotive and livelier – something like Elinor and Marianne in Austen's *Sense and Sensibility*. But there are reasons beyond personality that bear on the ways the sisters reacted to the people of India and their British compatriots.

The Gwillims were a distinguished family whose line ran back to the days of the Marcher Lords of Wales, and marriage to a well-connected judge of the Supreme Court placed Lady Gwillim at the apex of Madras society. Just prior to departure for India, she was presented at court. One of her sponsors was Agnetta Yorke, widow of the late Lord Chancellor Charles Yorke, and she was presented in the company of the bishop of Ely and his brother, John Yorke, MP for Reigate, Surrey. It was her acquired rank, not just concerns for her health, that left Elizabeth Gwillim free to pursue her passion for science and satisfy her curiosity about the ways of the Hindus. Mary Symonds, on the other hand, was single and, as was common practice, obliged to assist a married sister in need. While the letters make clear that Gwillim was style-conscious and proud of setting a fine table, it was Symonds who managed the household and took on most routine social obligations in deference to her sister's delicate health. As she put it, "Betsy has not the strength to bear much racketing I am obliged to visit for all the family for Sir H."[4] A wide acquaintance was also in Symonds's interest as a single woman hoping to be married.

Mary Symonds was already twenty-nine when she travelled to India and, like Austen's Anne Elliot in *Persuasion*, well aware that her "bloom" had passed. She noted with asperity that men of property, middle aged and older, were marrying teenage girls; and while she appreciated the attention of men younger than herself, they could not meet the family means test. It might seem surprising that she was also critical about the lack of British class deference and

decorum she found in Madras, given that her sister had married up, but access to elite Madras society was an asset that the relaxing of class distinctions devalued. Like the heroine of *Persuasion*, when Mary Symonds did marry it was to a sea captain of good family.

Putting aside the mutual concern for family, friends, and goods passing to and from Madras, it was logical that Mary Symonds would report home on English society and Elizabeth Gwillim on the Indian, but there was a notable exception. In 1804, Symonds was invited to visit the women's quarters, the zenana, of "moorish Princes," as she referred to the nawabs of Arcot.[5] Their extended families lived together. The women's buildings housed the wives, concubines, and female slaves of all the adult men in apartments around a central courtyard under the aegis of the begum, the first wife of the eldest brother.

Mary Symonds experienced the zenana as alien and disorderly. With her painter's eye she recorded the dress of the wives, their jewellery, fine features and figures, graceful posturing on cushions, and "childish sports," such as dressing in animal costumes or dressing up pets, but she reported that their hearts were "as ferocious as tigers, & capable of shocking, deliberate cruelty."[6] She was taken aback by the casual mixing of ladies and servants, coupled with the "unmerciful" exercise of raw power. She personally witnessed a lady nonchalantly resume her conversation after seizing the ear of a slave and banging her head against a wall for being slow on an errand.[7] One slave showed Symonds scars on her bosom where her mistress had burned her with a firebrand. "I thank God," Symonds wrote, "there are no slaves amongst the English, our servants are as independent as they are in England."[8] In reality, Bristol, just fifty miles from their Hereford home, was a major slave port, and the movement to end the slave trade was in full swing back home, but Symonds's focus was strictly local and underscored difference.

Above all, Mary Symonds considered the zenana to be filthy. She wrote that the women's elegant gold and silver vessels were "beat & bruised with such savage carelessness" and that they were dirty, as were the servants: "so filthy! That no descriptions can give a just idea of them; they smell of the various oils with which they anoint their hair & bodies, in a most odious manner."[9] Our double use of "dirty" to refer to a material mess and sexual aberrance is gender neutral. But in the nineteenth century, a dirty domestic space still implied a moral failing of the household women, as reflected in the sexualization of such terms as "slut" and "slattern," an attitude that would still be evident in Victorian sanitation reports. Symonds's emphasis on dirt is a moral judgment on a "part of the creation which seems to us very useless to say the best of them" (the "Moor" women), but "He [God] knows best."[10] This emphatic demarcation between us and them was commonplace. The admiration often expressed for the material products of Indian civilization, from ancient monuments to

contemporary shawls, was rarely extended to the people. Elizabeth Gwillim was one of the exceptions to the rule, but even she saw the squalor in which the poorest of the "outcastes" lived as a moral failing.

Elizabeth Gwillim never questioned the superiority of her own culture in general, nor Protestant religion in particular. But she carried over from her work with birds and plants what John Ruskin called the science of aspects into her observations of Hindu life. When it came to particulars, she was more interested in description and understanding than in passing judgment. She was unusually reflexive when comparing Hindu and British ways, willing to examine practices on their merits and not assume that British was best. A prime example was the traditional Indian method of treating a fractured limb by setting it, then encasing it in potter's clay: "they lay it over a slow heat, as great as the patient can bear," creating a pottery cast, Gwillim wrote fifty years before Europeans devised the similar plaster of Paris cast.[11]

When observing or relating what she learned from her Indian interlocutors, Elizabeth Gwillim tried to understand and communicate their point of view, anticipating what became ethnography. She praised the cleanliness, sobriety, and colourful dress of the people "of caste," while noting how Britishers would disparage the bilingual personal and commercial translators (dubashes) (plate 61), who were better educated than they were, as ignorant, and call people dirty whose ritual hygiene, unlike their own, included regular bathing, tooth brushing, and "*wash[ing] head* once a week ... with a paste of eggs & lime juice & pounded Vetches." Like the plaster cast, shampoo was adopted in Britain over the course of the nineteenth century, imported from India by returning East India Company (EIC) servants and Indian migrants to Britain. As for servants, she wrote, "even those who beat them & abuse them acknowledge that their care in illness is beyond all things. It is a religious principle with them never to be made angry by any thing that an old person or a sick person says."[12] The cultural horizon that enabled Elizabeth's reasoned and largely objective account of Indian people and practices would not survive the reactionary period following the Napoleonic Wars.

DANCING GIRLS AND THE HINDU SUBLIME

In a long letter dated 16 July 1802, Elizabeth wrote to her mother about that "most extraordinary people," the "Hindoos," who, she says, in accordance with the Orientalist ideas of the day, adhere "to customs so Ancient & so unlike those of any other people."[13] She mentioned several Hindu festivals, noting the emphasis upon cleanliness and decoration that extended even to the horns of the bullocks that pull the bandy carts, which were adorned with gold or brass

ornaments, and on special occasions dyed bright coral and draped with flow-
ers, reminding her of "a carriage in some Romance." She went into particular
detail about Pongal, the January rice harvest festival: she described people
visiting carrying pots "adorned with wreaths of flowers … The wife takes the
flowers to dress her head with them. The children take the sugar-cane and
the rest for boiling, or Pongoll, which is rice, milk & sugar in this new pot …
Cleanliness seeming to produce the best sign of good *luck*. If the pot mantles
well & rises high and *white*, the year it is supposed will be favorable."[14] These
customs are still part of the Pongal celebration.

Elizabeth Gwillim was particularly impressed with what she calls "the
Braminy part of Santhome and its great square" – that is, Mylapore and the
Kapaleeswarar Temple complex. In the same letter in which she wrote of the
harvest festival, she described cocoa palms festooned during holidays with
shimmering silk, the tops of the pagodas visible behind the walls, and "the
houses all illumined with innumerable lamps till it is a blaize of light."[15] As
much as any visitor today, she was impressed by the Mylapore tank and the
practice of placing lamps in a zig-zag pattern on the steps that reflect in the
water at night. Had Gwillim visited fifty years earlier, the site would have been
overrun and rundown, but, under the aegis of the wealthy dubash Kumarappa
Mudali, who became the temple *dharnakarra* (administrator) in the 1740s, the
temple and tank were restored, and encroaching squatters cleared away, mak-
ing avenues wide enough for the great temple car. Palm trees were planted,
and new housing built for the temple women and servants.[16] The avenues
remained clear into the twentieth century.

Our focus, however, is on those occasions when "the gods are Carried
out of the Swamy houses," to see and be seen by the faithful, attended "by
bands of musick Bramins & dancing girls a certain number of whom belong
to each Pagoda & attend to the Swamies or that is the gods of the different
swamy houses."[17] The musicians were not Brahmans but men from the danc-
ers' matrilineal families, the *isai velalar* community; the Swami houses were
wayside shrines outside the main temple. Elizabeth's detailed account of a ten-
day festival celebrating the marriage of Shiva, the Panguni Uttiram festival of
Kapaleeshwarar Temple, is the high point of the letter. "The god is carried out
each night in a different way one night he rides on a Bullock & on each side of
him one of his wives [actually Shaivite saints] also on a Bullock the next day
they ride out on Horsback - an third night on Elephants."[18] On the climactic
night, 19 March 1802, Elizabeth Gwillim, draped with flowers, had a seat of
honour on a pandal – that is, temporary seating next to a choultry, a wayside
place for rest and refreshment associated with a temple (plate 62).

Elizabeth Gwillim's choultry and pandal were near the temple entrance.
Some of the best dancing girls did the guests the honour of appearing before

them. That she was accorded such an honour perhaps derives from a dispute between right-hand (*Valangai*) and left-hand (*Idangai*) devotees – broadly speaking, the traditional agricultural groups versus the urban merchants and artisans. That long-vanished distinction was, at the time, a recurrent source of conflict in South India. In the temple context, it was a question of which group had the right to carry the more prestigious symbols. Unable to settle the rights to ritual displays internally, the temple authorities referred the dispute to the ruling East India Company for adjudication. While it may have no bearing on the deference Elizabeth Gwillim was shown, the dispute, at that time in the Mayor's Court, would soon be appealed to the Supreme Court on which her husband, Henry Gwillim, sat.[19]

The "dancing girls" were devadasis, temple women ritually married to the deity. Devadasis were not a caste; they had a way of life that was an unstable matrilineal subculture within a patriarchal society, part of an alternative family structure in which the women were the educated breadwinners. Their divine marriage made them auspicious as they could not be widowed; they made manifest the *shakti*, the vital energy of the god. Devadasis were the only systematically educated women in pre-British India and were performance artists in many modes, even creative writers, not simply dancers. But unlike the priests, who had a subject position, the essence of the temple women lay in what they embodied in performance, whether ritual attendance upon a deity, tales of the gods, or stories from the Indian epics.

The West had no category for women who are simultaneously unchaste and holy. The Gwillims' contemporary Abbé Jean-Antoine Dubois, who did the most to universalize the Sanskrit term, defined "devadasis" as essentially prostitutes and only accidentally artists and holy women. "Devadasi" became a de facto English language borrowing from Sanskrit with a Western definition, temple prostitute, an instance of "Sanskritization," the process in which the British invoked the prestigious ancient language to establish a universal terminology for local Indian practices. As Joep Bor notes, Westerners did not have "access to the dancers who performed *inside* the temples. Their descriptions were either based on reports of local informants or on the public displays of dancers *outside* the temples. It is likely therefore that travellers confused the *devadasis*, who performed in the inner part of the shrines, with 'dancing prostitutes' (*dasis*), who had no association with the temples whatsoever."[20]

During the Company Raj, having no access to devadasi temple rites and rarely to their services in private estates, the British saw devadasis as public entertainers and did not generally distinguish temple women from other nautch, or dancing, girls, or from the parallel but secular hierarchy of Islamic dancers. Formulaic Company paintings rarely showed devadasis dancing as part of car festivals, such as Elizabeth witnessed, their one public religious function.[21]

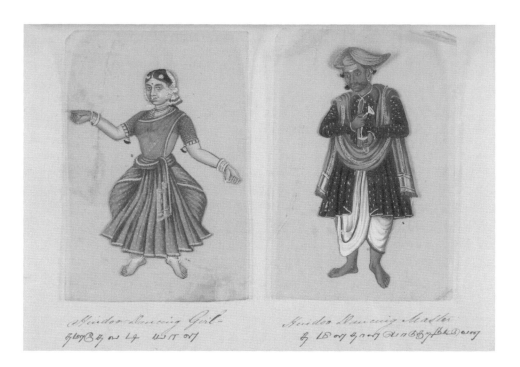

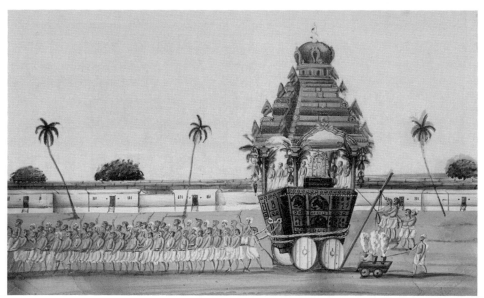

FIGURE 23 (top)
Devadasi. From *Seventy-two specimens of castes in India*: "All people, nations and languages shall serve Him ... presented to the Revd. William Twining as a token of obligation by his ... friend Daniel Poor," Madura, Southern India, 2 February 1837. Painting on mica. Beinecke Rare Book and Manuscript Library, NKP24 837p, p. 21.

FIGURE 24 (bottom)
Car Festival, gouache on mica. Collection of Jeffrey Spear .

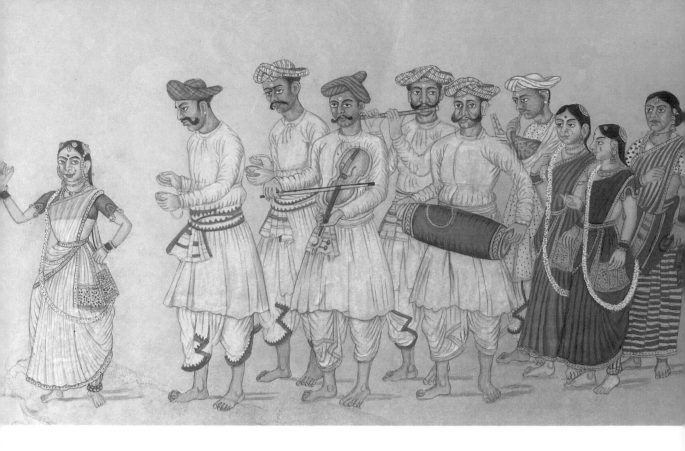

FIGURE 25

Melam, gouache on mica. Collection of Jeffrey Spear.

Most paintings were commissioned to record the costumes associated with different occupations and consequently depicted dancing girls individually or in small groups, devadasis distinguished only by the married woman's bindi dot. Under the Raj, the equation of the devadasi way of life with prostitution was reified in law, which, together with late nineteenth-century "Anti-Nautch" social purity movement, deprived the devadasis of their patronage and unique status, condemning most of them to poverty.

While it functioned, the patronage system allowed the elite devadasis who performed in temples, courts, and great houses, as well as those who fronted the respectable troupes known as *melams*, to earn enough to support their family of musicians and *nattuvanars*, the dance masters, who kept the beat with hand cymbals and taught the formal aspect of the dance to the women, who were the repository of expression. Famous performers earned large fortunes, much of which they donated to the temples.[22] Today anyone can learn India's classical dances, but, in the traditional Hindu world, dance was inseparable from the body of the dedicated woman. You could no more distinguish the dancer from the dance than a sculpture from its stone.

Elizabeth Gwillim's account of the car festival and the women who dance before the temple chariot of their god husband is of particular historical interest because she witnessed an unaltered, traditional ceremony by dancers whose primary service was inside the temple, and she recounted it to inform and entertain her family in England, not to pass moral judgment on the devadasi way of life. And her description of the dancers' costume provides details that supplement the stylized paintings of devadasis. The dancers were

> richly dressed, their hair is combed smooth parted in the front ... with a fringe of fine work in gold & small jewels ... with a conspicuous piece of jewelry in the middle of the forehead ... One piece of gold like a small saucer finishes the back of the head. Wreaths of colored natural flowers were twisted several times round. The back hair is plaitted & hangs down to a great length intermixed with gold and pearl tassels and flowers. Their ears are covered with ornaments ... hung in the ear & others suspended from bands in the hair. The necklace and chains they wear are very fine & cover their necks – their arms have bands round the middle of the upper part of the arm & bracelets on the wrists innumerable.[23]

The jewels included diamonds, but Elizabeth Gwillim called them table diamonds, too thin to cut. The dancers wore no shoes or stockings but an immense weight of gold around their ankles in strings of small bells, which sounded as they danced.

Having no key to the gestural language of the dance, Elizabeth Gwillim saw it as an aesthetic performance through the lens of ballet, noting that the women never stepped on the toes, but kept the knees bent, moving in a very small space and sometimes singing as they danced, sometimes for an hour, within the space of a sheet of paper with the feet in constant motion. The chief display of skill, she wrote, "is in the motion of the hands & arms the air of the head & expression of the features – in these they excel. The action of the upper part of the figure is extremely graceful it is sometimes voluptuous but never affected." She noted the presence of a man –the *nattuvanar* – immediately behind the dancer, who kept time by clashing two pieces of metal and seemed to direct her every motion. This initial dance before the deity would have been votive in nature. It was followed by a long solo performance that, she was told, relates the story of how Shiva as "a pilgrim of great beauty, set all the women in love with him." This narrative dance would have told the story of Shiva as Bhikshatana in Sadir or Dasi Attam, the dance of the dasis, which would soon be arranged and codified by the Pillai brothers in the court of King Serfoji II of Tanjore into the ancestral from of Bharatanatyam.[24]

From her pandal vantage point, Elizabeth Gwillim anticipated the role of participant observer, recording the lived experience of the Hindu ceremony through the rhetoric of obscurity, awe, vastness, and wonder that Edmund Burke called the sublime.[25] At midnight, fireworks signalled the emergence of the gods on three carriages drawn by large numbers of people, Shiva in the middle car and a figure Elizabeth mistook for a wife in each of the smaller carriages. (These would have been Nayanars, South Indian saints and poets.) In a unique extended passage, she created an absorptive text as an historical novelist might, allowing us to experience a vanished past:[26]

The Carriages were like large thrones with many carved figures of the Horses supposed to be drawing it & coachmen in carved wood & most gaudily painted, larger than life; besides many angels & lions – the whole dressed up with hundreds of little flags & wreaths of flowers in short the ornaments are so profuse that one can hardly be sure, even after much prying, that one has seen the face of either god or goddess – after these shows the ornaments of a Theatre woud look very miserable The clear moon above, looking pale with the glare of fire works & lights, the profusion of which you cannot guess at it. It is a constant explosion during the whole tour made by the procession – if it were not almost profane to say so, these things really come on like a god – *thick darkness* goes before them – The great clouds of smoke roll on before the carriages & conceal every thing, but what peers above them the great waving leaves of the Cocoa trees which receive the light of the fires & of the Moon & the Mango & other trees coverd with white clusters of flowers – The glare of fresh fires upon the volumes of smoak & the showers of fire from different fire works whilst Rockets thrown up unceasingly, twenty, forty, a hundred at a time seeming to pierce the skies have altogether such an effect as cou'd hardly be conceived – The noise of their instruments is most tremendously piercing but I think a little use wou'd make it not disagreeable. The dancing girls preceeded the Cars – & when they stopped, danced perhaps twenty standing as ours do but dancing in their own way only advancing now & then to meet what we shou'd call the partner & retiring – They are all women vast numbers of Pandamanums men & women follow the cars dancing in their way – There are no other carriges allowed The crowd all walk. Thousands attend & they are the great beauty of the picture for the dress is so graceful & so clean – the white muslin turban & drapery & the order & tranquility of their behaviour gives great solemnity to the scene – *one can hardly be surprized that they are unwilling to give up these shows for a better Religion the fruits of which do not appear very good in the examples our people who come out here give them.*[27]

As it happens, Elizabeth Gwillim witnessed a parallel Christian ceremony during "Passion week," San Thomé being the location of the church attributed to Thomas the Apostle. The sisters grew up before the fear of revolutionary Jacobins displaced the fear of Catholic Jacobites, and they shared a Protestant distaste for Catholic graven images. As usual, Mary was the more vociferous: "I perceive no difference between their Idolatry & that of the Heathen ... yet their discipline makes [the heathen Hindus] clean, sober, & orderly," whereas the Catholics "are the vilest miserable wretches drunken & abandoned."[28] Elizabeth Gwillim gave a more elaborate account of a Passion Week procession and showed, again, her willingness to find elements of Indian practice superior to what prevailed at home:

> I was amused with a little english boy crying out "run that Swaamy – (that is that Idol) is coming." It was a representation of our Saviour as taken from the cross & so shockingly represented in wax as large as life as to be very distressing ... Behind the bier the women were caried Mary & Mary Magdalen each as large as life in wax & dressed in black silk flounced peticoats & gowns with head dresses like Portegueze nuns ... The figures had their feet upon the top of a pole, which raised the feet as high as the heads of the people. The Chaunt of the Priest I thought extremely fine & solemn & ridiculous as the procession was the effect of the voices was beyond anything of the kind I ever heard. These people are dark; as black as the other natives; very few of them being really Portegueze ... The smaller angels had a quarrel & were kicking one another as they went along to the amusement of the spectators – In short it was a most unnatural mixture of solemnity & absurdity. We followed the Procession into the chappel ... The Chancel is very large ... The [altar] design is an immense sarcophagus, gilded with many images & gold candlesticks & lights innumerab[le] in all the nitches & little hollows which in our Church[es] are, in such parts, filled with dust & cobwebs ... The newness & brilliancy of the Gilding, the rich effect of so many small parts & the lights dispersed in every part, give a delicacy that of effect that I cou'd not have guessed at by seeing a dirty monument in Westminster Abbey, which is the same kind of thing.[29]

Gwillim's willingness to set aside her own beliefs, to recount religious ceremonies as cultural phenomena, and to note aspects of Indian practices that contrast favourably with things British, even as she entertained her readers, is remarkable in itself, and a significant supplement to the more abstract accounts of the Orientalists.

HINDUISM: CASTES, OUTCASTES, AND THE TRAFFIC IN WOMEN

For the Protestant British, a proper religion had an historical founder and a foundational text: Hinduism had neither, nor was there a pan-Indian term for the culture, beliefs, texts, observances, rituals, and practices of Indians who were not Muslims, Sikhs, Buddhists, Jains, Jews, Christians, or tribal.[30] "Hindu," originally a limited territorial reference, became the term that subsumed local traditions.

Elizabeth Gwillim gives a standard Orientalist account of the three major deities, "Bramha the Creator," Vishnu "the Preserver," and "Sheeva the Destroyer," worshiped in "the Temples or as we call them Pagodas" dedicated to either Vishnu or Shiva, regardless of caste.[31] The four "tribes" – castes or varnas – now standardized as Brahmins (priests and scholars), Kshatriyas (warriors, rulers, administrators), Vaishyas (farmers, merchants), Shudras (labourers, servants), she calls Bramins, Kittri, Bise, and Sudra – the nomenclature of the Orientalist Andrew Dow's *History of Hindustan* (1770). These four varnas are the basis of the Brahman version of caste derived from ancient Sanskrit texts that the British accepted as universal and directly applicable. The recovery of Sanskrit and the discovery that Indo-European languages had a common ancestor led Sir William Jones and his fellow Orientalists to the idea that philology could provide a key to all mythologies. Elizabeth Gwillim references such notions as a universal, proto-Christian belief in trinities (Brahma, Shiva, and Vishnu), but treats them as speculation. As for distinctions between Indian people, "they are easily distinguished when one sees them not indeed the minute divisions of Casts for they do not know them all themselves but the different Nations."[32]

The idea that Indian people themselves might not know all caste distinctions is not as strange as it might seem. Like Hindu ritual observances and festivals, the rules that determined who could associate with whom and practise what trade (*jati*), which Elizabeth observed among the people who served and provided for the family, were regional. There was no Indian nation as such, and it is not clear how rigid these customs were, particularly in South India, where, as Arjun Appadurai writes, "there are no clear-cut occupants for the second two categories of the varna scheme, the Ksatriya and the Vaisya, although there are perfectly distinct Brahman and Sudra *jatis*."[33] We do know that, after 1857, the British Raj bureaucratized caste by making it a key census category, even allowing groups to petition the government to change or acquire caste status, in effect creating a national caste system. (In a last-ditch effort to regain respectability, the Madras Presidency Devadasi Association petitioned the Indian Statutory Commission in January 1929 to reclassify their way of

life as an official caste, but was denied.)[34] There is, however, one major distinction that has persisted before, during, and after British rule, that between the people Elizabeth called "of caste" and the outcasts, or Pariahs, the present-day Dalits, whose bodies were exploited by both the British and other Indians, the strong men for labour, the comelier girls for sex, and all for service.

Elizabeth Gwillim compared the "Pariah people" to the outcasts described in the thirtieth chapter of Job. Their labour supported the servants of caste as well as the British. They were the water carriers, the house water woman who swept the floors with a whisk broom, the cook-room water woman who prepared spices a hundred yards away from the house. The Gwillim butler employed two "Pariahs" who did dish washing and like tasks, and two torch bearers to clean the house during the day and run before the carriage at night to light the way. In her descriptions of them as unclean and unchaste, Elizabeth mirrored some of the attitudes that were communicated to her by her servants "of caste":

> Chastity is a virtue they know nothing about. – If they have any well looking girls they dispose of them to European gentlemen – that is the mother does, for they are like the beggars' children in London according to Hetty's remark all fatherless … The money for which the girl is sold is sometimes considerable & it is soon spent in meat & drink – The young women from ten years old to twenty are generally thus in the service of some man or another at somewhat better wages than could be obtained by better means & sometimes as you may suppose they get a great deal; however they save none.[35]

From our perspective, this is a blame-the-victim attitude, but it is notable that an English lady would equate the outcastes of India with the immiserated inhabitants of London's rookeries.

Surprisingly enough, there was a potential route leading out of this traffic: "If a girl has had the good fortune to have been kept by an Englishman, a Sarjeant, Soldier, or young officer she learns a little English & is by these means qualified to attend a lady."[36] Poppa, Elizabeth Gwillim's lady's maid, the twenty-one-year-old daughter of a water woman, was a case in point. Gwillim interviewed her, and her brief narrative is a rare, if not unique, account of life by a Dalit woman in the early years of the nineteenth century.

Poppa told Elizabeth that she started to learn English while accompanying her mother at domestic work. She said that she had been married twice – first to "a Dutch Captain of a ship who had bought her for two hundred pagodas when she was 10 years old,"[37] and, after he returned to Europe, to "a gentleman in Madras by whom she had a son whom she had put into a charity school, but

that the man had now taken another woman, the Ladies maid of that family & gave her nothing nor took any notice of the child, wherefore she came to seek my service."[38] Elizabeth Gwillim allowed her to leave to see her child once a week.

> "I suppose," says I, "you were very sorry when this man took another," "no" – said she, "what shou'd I care for him?, I care only for my child & do not wish to go again to any gentleman – some servants have been to me & wanted me to come & live with their masters; but I like Ma'am's money better. It is true they will give me five pagodas a month but if I go to one of them, in a few months he will leave the place & I cannot leave my child for I shall dye if I do not see my Slid as they say for child."[39]

Poppa had been with Elizabeth almost three years "in perfect innocence. The only trouble she gives me is asking frequently to see Slid; but a refusal occasions no resentment. She is honest in the strictest sense of the word, sober, & not guilty of falsehood."[40]

Excepting the retired sepoys who stood guard, servants went home at night, but Poppa slept on the stucco floor in the room next to Elizabeth. She slept

> in the same apparel she wears all day, her muslin dress & her gold necklaces &c. Mr. Gwillim calls three or four times every night to bring toast & water &c, & she always jumps up in good humor & appears in full dress ... She never lays even a mat under her the only indulgence I have seen her use (tho' there are carpets at her command) is to bring a couple of bricks which she uses as a pillow for her head ... At five in the morning she smokes her Saroot of strong tobaco & when her work is done reheats it & basks under a tree asleep on the ground in the best cloaths I can give her.[41]

The customs and conventions governing the treatment of servants are a matter of research today, not second nature, as they were to the Gwillims. We are not apt to see giving permission for a mother to see her child, or giving "best cloaths" without waiting for Boxing Day, as particularly favourable treatment, nor appreciate fully what it meant for a female servant to find employment free from sexual harassment – in Britain as much as in India. (The entire plot of Samuel Richardson's *Pamela, Or Virtue Rewarded* [1740] chronicled an orphaned, fifteen-year-old servant's narrow escapes from Mr B's assaults on her virtue until, in a fairy tale ending, she was rewarded with marriage.) It was customary to refer to servants, as Poppa was, by one name, often assigned by

the family, particularly if the servant's given name was the same as that of a family member. The clerical Austen family and the Gwillims were of similar social rank, and Jane Austen's correspondence reflects a level of concern for her servants comparable to that displayed by Elizabeth Gwillim for Poppa. For example, in a letter of 1807, Austen referred to a servant, Jenny, whose expected return was, she conjectures, likely delayed by illness in her family, but her primary concern was not Jenny, but the effect her absence would have on the family's dinners.[42] Austen's relative indifference to Jenny's well-being, as compared to the absence of her cooking, contrasts mightily with the overriding concern for the health and safety of friends and family that runs through the letters. Indeed, any other attitude would have been considered improper. For example, in *Pride and Prejudice*, one indicator of Lydia's imprudence before her elopement was her overfamiliarity with the servants.

Before the Company Raj was fully established, East India Company traders had to follow Indian customs and were often aided in that regard by Indian women with whom they cohabited, "bibis" who knew local languages and customs. When the Gwillims arrived in Madras, domestic relationships between Indian women and British men were still routine. The first edition of the Company's guide to civil and military service, *The East India Vade-Mecum* (1810), included a section on relationships with Indian women and provision for biracial children. It was removed in the second edition (1825). The progressive stigmatization of interracial cohabitation has obscured the degree to which some relationships among the more affluent were affectionate, even (if rarely), formal marriages, with the Indian wife accompanying her husband back to Britain. As William Dalrymple put it, "Company servants rich enough to send their Anglo-Indian children home tended to do so, and many mixed-blood children were successfully absorbed into the British upper classes."[43] Lord Liverpool, a cabinet official during the Gwillims' India years and later prime minister (1812–27), was from an Anglo-Indian family. Mrs Young, the Anglo-Indian "natural daughter" of Elizabeth's friend Dr Anderson, was raised and schooled in England. Elizabeth described her as "very dark, but extremely pretty," clever, and sweet: "her voice and manner are just like Nancy Green," a dear friend of the Gwillims.[44] Ayahs and servants were less fortunate, often cut adrift after accompanying the family home and left to search for a family going east to serve, although some did remain with their employers' families in England.[45]

Elizabeth treated relations between British men and Indian women as a matter of fact, but Mary expressed the disapproval that was growing more common among British elites, in a way that makes uncomfortable reading in our post-colonial period, but at the same time provides significant details:

We have great numbers of people offsprings of the English by the lowest creatures, some of these are bred up for fine Ladies & Gentlemen & are called English – great numbers of the children of poor Officers [and] soldiers & are by these wretched drabs are here to be seen & the Company & Government here have established two large Schools for their reception, one for the boys the other for the girls there are at least 400 of each, and they are well taught & the boys bred to be writers [entry-level EIC employees] &c the girls are Married to Soldiers & their offspring will in time be called English a shocking thing enough, for they are a wretched race of evil disposition & full of disease.[46]

The sense of the superiority of their Christian culture to that of India was an almost universal assumption of the British that Mary and Elizabeth shared despite their differences regarding the details of Indian life.

TRANSITIONS II: FAREWELL

After the defeat and death of Tipu Sultan of Mysore at Seringapatam in 1799 secured British domination of South India, his remaining family was confined in the fort of Vellore. On 10 July 1806, the sepoy troops of Vellore staged a mutiny or uprising. They seized the fort, killed fourteen of their own officers and 115 men of the 69th Regiment, and proclaimed Tipu Sultan's son, Fateh Hyder, king, before being violently suppressed by EIC and British troops from the nearby town of Arcot. The rebels who fled were pursued; there were summary executions, and likely supporters were rounded up. Elizabeth knew from the retired sepoys who were part of the Gwillims' retinue that the old company officers "became well acquainted with the habits & customs of the Natives," keeping strict discipline, but "they never ventured to thwart their prejudices of any kind, above all they regarded those of a Religious nature," regarding dress, cutting of hair and whiskers, and other particulars that distinguished castes from each other.[47] The Hindu troops were willing to forego their forehead marks on duty, "but these late unnecessary orders led them to fear they were to be wholly prevented from putting on their marks, & thus be mingled together with sects, bearing like other religious sects mutual hatred." Elizabeth had no doubt as to where the blame for the uprising belonged: "Sir John Craddock who last came out Commander in Chief & who is the weakest Man, I think, that I ever spoke to, & as arrogant as weak took it into his head to dress all the Regiments himself & to dress them all alike." Next below him, she noted sarcastically, "a Captain Pearce ... a young man whose friends have mistaken

his talents & made him an officer instead of a Taylor." He made "inumerable changes in their dresses & caps" that the Sepoys had to pay for with up to half of their allowance. The last straw after outlawing beards, which violated Muslim belief, and forbidding Hindu devotional marks and ornaments, was the new Agnew turban. It was partially leather, and therefore considered polluting by caste Hindus; it was shaped like the headgear of the drummers, who were Pariahs, and it displayed a cross, anathema to Muslim and Hindu alike. Elizabeth wrote that "Tippoos sons & doubtless many others ... took advantage of this alarm & persuaded the Sepoys that we were going to make them lose their casts & having thus made them Pariahs to force them all to become Christians."[48] Those who refused to wear the new uniform were subject to flogging. There had been mass conversions to Christianity in the Tinnevelly area, which had been witnessed by Vellore sepoys who had been stationed there, and there was a proposal to remove boys from battalions to teach them English, so, as Penelope Carson notes, "it was relatively easy for disaffected Indians to put about the rumour that there was a concerted plan on the part of the Company to convert the Sepoys to Christianity."[49]

At this time, Sir Henry was, de facto, the Supreme Court of Madras. Justice Sullivan was elderly, infirm, and at home, while Chief Justice Strange was away yet again attending to personal business. Sir Henry was at one with Elizabeth regarding the uprising and made known in no uncertain terms his opposition to the extra-legal actions of the authorities in its aftermath. The EIC administration rousted Justice Sullivan from his sick bed and recalled the chief justice to duty post haste to make sure that the "irascible" Sir Henry would be outvoted, and it dispatched a demand to London that he be recalled, though sailing times meant no action could be taken for a year. The Company replaced the officials who created the new dress code, which was then rescinded.[50]

In the midst of this turmoil, Elizabeth Gwillim contracted the illness that led to her death on 21 December 1807. Sir Henry was recalled, and in 1808 he and Mary Symonds set sail for England – he to remarry and resume his distinguished legal career; she to begin married life with the captain of their ship, John Ramsden, a man of means and good family. It was a mark of the British community's respect for Elizabeth Gwillim, not to mention the Indians whose rights Henry Gwillim had tried to uphold, that, despite the controversy that engulfed her husband, her grave marker lies not on the grounds, but within the church, of St Mary in Chennai. Although Elizabeth Gwillim never had the public reputation of Jane Austen or Mary Wollstonecraft, she was, like them, an exemplary woman of the Age of Reason: artist, scientist, and proto-ethnographer, who respected both the culture of South India and the people who created and embodied it.

Notes

1 Austen, *Mansfield Park*, 18.

2 For more on women and science, see Rosemary Raza's chapter in the present volume.

3 McLaren, *British India and British Scotland*, notes that "the relative poverty of Scotland's more privileged classes ... sent a high proportion of men from well-educated gentry and professional families to India ... [Their] technical skills, and above-basic knowledge of mathematics [shows the] significant benefits of a Scottish education [leading to] the number of Scotsmen ... who rose to prominence in the East India Company's military and civil services" (249).

4 Mary Symonds to Esther Symonds, 3 October 1802, British Library, India Office Records (BL IOR) Mss. Eur. C 240/1, ff. 8r–87v, on f. 87r. See Victoria Dickenson's case study, "Lady Gwillim's China," in this volume for details.

5 Mary Symonds to Thomas Clarke, 14 October 1804, BL IOR Mss. Eur. C 240/3, ff. 242r–247v, on f. 243v.

6 Ibid., f. 245r.

7 Ibid., f. 245v.

8 Ibid., f. 245v.

9 Ibid., f. 245v

10 Ibid, on ff. 244v–246r.

11 Elizabeth Gwillim to Esther Symonds, 20–21 October 1803, BL IOR Mss. Eur. C.240/2, ff. 154r–159v, on f. 158r.

12 Elizabeth Gwillim to Hester James, 23 August 1802, BL IOR Mss. Eur. C.240/2, ff. 72r–76v, 75v, on f. 75r.

13 Elizabeth Gwillim to Esther Symonds, 16 July 1802, BL IOR Mss.Eur.C.240/1, ff. 62r–71v.

14 Ibid., emphasis in original.

15 Ibid., f. 66v.

16 Bukund, *The View from Below*, 99–106. Because they mediated between people who did not understand each other's language, dubashes could manipulate bargaining to their advantage. Some became extremely wealthy, particularly if they worked for high officials.

17 Elizabeth Gwillim to Esther Symonds, 16 July 1802 BL IOR Mss.Eur.C.240/1, ff. 62r–71v, on f. 63v–64r.

18 Ibid., f. 66r.

19 For the history and complexity of left-right caste distinctions, see Appadurai, "Right- and Left-Hand Castes"; for temple-specific history, Bukund, *The View from Below*, chap. 6.

20 Bor, "Mamia, Ammani and other *Bayadères*," 69.

21 A "car festival" refers to a religious event in which the deity travels in a chariot functioning as a mobile temple to be witnessed by devotees.

22 The standard work on the ritual function of the devadasis is Kersenboom-Story, "Nityasumangali." I detail how "devadasi" came to refer to a Dalit population in "Was She This Name?"

23 Elizabeth Gwillim to Esther Symonds, 16 July 1802, BL IOR Mss.Eur.C.240/1, ff. 62r–71v, on ff. 62r–63v.

24 "Lord as Mendicant," *The Hindu*, 25 March 2010, updated on 18 November 2016, https://www.thehindu.com/features/friday-review/history-and-culture/Lord-as-mendicant/article16614589.ece.

25 Burke, *A Philosophical Enquiry*.

26 For absorption in a text, see Nell, *Lost in a Book*, 71–84.

27 Elizabeth Gwillim to Esther Symonds, 16 July 1802, BL IOR Mss.Eur.C.240/1, ff. 62r–71v, on ff. 67r–70r, my emphasis.

28 Mary Symonds to unknown, 10 February 1804, BL IOR Mss.Eur.240/3, ff. 212r–216v, on f. 214v.

29 Elizabeth Gwillim to Hester James, 14 September 1802, BL IOR Mss.Eur.C.240/1 ff. 77r–81v, on ff. 77v–78r.

30 The tribal, or aboriginal, designation was invoked by the British to categorize "primitive" groups outside the religious mainstream. They are "scheduled tribes" in the Indian Constitution and are also known as "Adivasis," a name that denotes their status as the original people of India.

31 Elizabeth Gwillim to Esther Symonds, 16 July 1802, BL IOR Mss.Eur.C.240/1, ff. 62r–71v, on f. 62v.

32 Elizabeth Gwillim to Esther Symonds, 17 October 1801, BL IOR Eur.Mss.C.240/1, 12r–13v, on f. 13v.

33 Appadurai, "Right- and Left-Hand Castes," 220.

34 E-Mad-1032: The Madras Presidency Devadasi Association, Madras, BL IOR/Q/13/1/11, item 47.

35 Elizabeth Gwillim to Esther Symonds October 12, 1804, BL IOR Mss.Eur.C.240/3, ff. 217r–228v, on f. 218v.

36 Ibid., f. 218v.

37 Ibid., f. 220r.

38 Ibid., f. 220r.

39 Ibid., f. 220v.

40 Ibid., f. 220v.

41 Ibid., ff. 217v–221v.

42 Le Faye, *Jane Austen's Letters*, 116.

43 Dalrymple, *White Mughals*, 40. Dalrymple traces the lives and relationships of British men who "went native" in eighteenth-century India.

44 Elizabeth Gwillim to Hester James, August 24, 1805, BL IOR Mss.Eur.C.240/4, ff. 279r–296v, on 292v.

45 For examples, see the chapter "Chattels of the Empire: Servants and Ayahs" in Visram, *Ayahs, Lascars and Princes*.

46 Mary Gwillim to unknown, 10 February 1804, Mss.Eur.C.240/3, ff. 212r–216v, on f. 216v.

47 Elizabeth Gwillim to Hester James, September/October 1806, BL IOR Mss.Eur.240/4 ff.329r–343v, on ff. 333v–334r.

48 Ibid., ff. 333r–336v.

49 Carson, *The East India Company and Religion*, 72.

50 For details on Sir Henry's career and recall, see Arthur MacGregor's chapter in this volume.

Of Mimesis and Mockery

The Letters of Elizabeth Gwillim and Mary Symonds

MINAKSHI MENON

Elizabeth Gwillim was a percipient correspondent. Her letters, rich in details about household management, the latest fashion in caps and gowns, and observations of the natural world, also reveal what the anthropologist and historian Ann Laura Stoler has called a "discursive density around issues of sentiment."[1] Lady Gwillim reflected upon and moralized about private feelings and their public consequences, about racially inflected sensibilities, about the psychic effects of colonization on both colonizer and colonized. It shouldn't surprise us, then, to find her acutely observing emerging new subjectivities among the colonized in Madras.

This is what she wrote in a letter to her mother, Esther Symonds, soon after her arrival in Madras:

> Is not it a strange thing to see ourselves thus masters of a place? – you never meet an English person but in a carriage or in a Palankeen – The Sepoys that is the black soldiers have all the manners of ours even now when I see them so often regiments of them whether horse or foot I cannot help being surprized when I pass them & look back at the black faces drilled by our people they have so much the same air & they think so much of themselves that there is no danger of their befriending their country men – I used in my morning rides to pass the Camp we had here for some time & I was much diverted to see the Corporals drilling the awkward squads – & young beginners. so completely Corporals exactly the airs and affectation of those in the Park.[2]

A reader, even one ever-so-slightly acquainted with postcolonial cultural critique, will recognize the phenomenon described. It has been theorized, famously, by Homi K. Bhabha as "mimicry," "the desire for a reformed, recognizable Other, *as a subject of a difference that is almost the same, but not quite*."[3] Bhabha's sentence neatly captures both the colonial anxieties and the subversive effects produced by the civilizing mission. The colonizers' will to reform, to confer the benefits of European reason on their subjects, produces a condition of ambivalence. "Mimic men," schooled to be "almost the same but not quite," must remain subjects of the empire. But would they? Were the British to gift the Indians the British Constitution, could they continue to rule? Bhabha helps us recognize the fear in Gwillim's confident assertion that British-trained sepoys would never return to the dark side. The force of his analysis lies in the insistence that mimicry is always partial – the anglicized can never *be* the English. Such partial presence necessitating continuing colonial control carried the ever-present threat of disavowal, as became dramatically evident in a violent insurrection by East India Company sepoys at Vellore, near Madras, in 1806, of which Elizabeth and Mary were frightened observers. The "Vellore Mutiny" breached the peace of colonial mimesis.

Black soldiers at Madras, as Elizabeth observed in a letter to her sister Hester ("Hetty"), were distinguished by the daily observance of "trifling forms of dress" marking their religious identities. Company uniforms were quickly shed at home, returning their wearers to their caste selves through a change of clothing and signifying marks on the forehead. "The Muslemans have not these marks on the foreheads; but their whiskers are equally sacred & to say to any one I will cut your whiskers – or to offer to touch them is an affront of the most unpardonable kind."[4] Upper-caste Hindus abhorred leather in any form, which seasoned East India Company officers knew well. As Elizabeth reported to Hetty in September 1806,

The Sepoys have from time to time been brought, without orders strictly for the purpose to wear leather belts & various straps & c necessary to their uniform. This has been brought about by the native officers who have great power with the Sepoys & act under English officers They love finery & are certainly more fond of imitating us than is generally believed they now copy us in all they can consistently as they heretofore copied the muslemans their former masters – but all this has been done without threat or force – They have even gone so far in their civilities & their desire to look regular, & like the British troops as to come to the parades without the marks on their foreheads – but then as soon as they go home they make their supplication that is repeat certain collects which they are taught; & in order to which, they must first wash & put on

their marks – thus at home for the sake of religion they appear in their proper dress, & were well satisfied to forebear their customs when on duty – But these late unnecessary orders led them to fear that they were to be wholly prevented from putting on their marks, & thus be mingled together with sects, bearing like other religious sects, mutual hatred to Each other.[5]

As Jeffrey Spear notes in chapter 9, the "late unnecessary orders" were the work of two men, the recently arrived Sir John Craddock, commander in chief, "who took it into his head to dress all the Regiments himself & to dress them all alike"; and a deputy adjutant, a Captain Pearce, an officer much given to inventing new accoutrements for the native troops. "The last and unfortunate invention was a new cap of leather raised very high," against which the troops rebelled. Punishments designed to mortify the native soldiers were devised by the European officers in charge, and the inevitable followed, inspired, it was thought at the time, by the presence of the young sons of Tipu Sultan, prisoners at Vellore.[6] English officers lost their lives, and, Elizabeth wrote, "600 Sepoys were instantly killed – some officers are said to have cut down twenty or thirty with their own hands – It was a dreadful slaughter and none were spared – In such a desperate case perhaps nothing else cou'd be done the British flag was replaced & a stop put to the proceedings but the plan was formed with a design to murder the Europeans here & in every station hereabout."[7]

Colonial mimesis, as we see, was never really stable. One could never predict when it would break down. It is this uncertainty, I suggest, lurking at the margins of consciousness, that produced the astonishing language of Mary Symonds's letter to her botanical correspondent, Reginald Whitley, three years before the affair at Vellore, and transcribed below.[8]

A purported note of gratitude for a bag of seeds ("eshids"), the letter mockingly reproduces English as spoken by servants as slavish mimesis. The waggish Whitley, who lettered the bags of seeds in imitation Chinese characters, is punished with a sample of "Black English," a fitting retort to a metropolitan unaware of the parlousness of colonial mimicry.[9] Symonds writes as the black servant who, having taken charge of the proceedings, places the seeds in the ground to help them germinate ("I tinking one too parsley tree some esallady tree too much esleep, that sake, after I thinking never come to life"), afterwards quickly dispatching the resident dubash to find the "China man" to decode the "Chinese" name of the plant. The black servant's anxiety to please, to respond immediately to the language of command ("I directly make sigiram send Bullock bandy get Blacktown dirt"), guarantees the security of Britain's empire. Or does it?

Symonds, again the black servant, explains that ingratiating yourself with Master and Mistress is easier done if you can wholeheartedly enter into their

interests. You may have the expertise needed to expel serpents from the mistress's garden – build a nullah – but all *she* wants is a scientific identification of the cat that ravishes her fowls and sheep. This nondescript, once killed, is propped up to be figured, and identified as a "lynx," but then, much more usefully, transformed into a fine curry for the palki-bearers. Mary's observations on the animal recorded in a letter of 1803 to her sister Hetty, however, allow us to conclude that the beast in question was probably a palm civet, known today as *Paradoxurus hermaphroditus,* a viverrid widely present in south India:

> Betsy sits opposite me drawing ... an extraordinary kind of animal which was killed in Dr. Andersons Garden our noses are teribly regaled by the scent of it, but it is very curious so we must have its picture 'tis something like a dog and somthing like a Cat, and somthing like a mouse, it has a beautiful black fur, & a long tail, half a dozen doctors have been consulted & five hundred books hunted over but no one can discover the name of this wonderful brute!! But everyone rejoices in his downfall as he is known by the natives to be a sad devourer of cocoa nuts & other fruit.[10]

The last paragraph of the letter, voicing both Mary Symonds, and Mary Symonds as black servant, adjures Whitley to make sense of the language of the letter. The British, it cajoles, must learn the native idiom or risk losing control: "I think after too much trouble I take, Master Regi never make fuzzle, thats sake I telling Mrs must make little Gentoo [Telugu] writing; I send one Cajan [a strip of palm leaf], if Master never find that Cajan writing, then must keep on more." And if not? A prescient warning for Company rule, "bad fun," a thorough trimming, will inevitably follow: "But if Master make hungry upon me directly cut off ears, cut him neck estrong wound."

LETTER, MARY SYMONDS TO REGINALD WHITLEY, MADRAS, 6 FEBRUARY 1803

1803

My Dear Regi

I sending your Honour too many salams so fine eshids you send,[11] I thinking master taking too much trouble to keep so fine name, I directly make sigiram send Bullock bandy[12] get Blacktown dirt, some river esand, Bullock make trouble that sake never come soon, I telling, what for so long time coming, you very well understand af fast pive[13] oclock evening time that's [freser[14]] time, this countries custom, never keep in grownn eshid hot time that sake tomorrow morning too esoon get up before hot time coming.

This time all eshid I keep in ground, some eshmall eshmall[15] thus come very fine, I go see evening time; by & by tomorrow morning, maistrie coming tell, some one, one. Esort eshmall tree little esleeping, I directly go see woun[16] eyes I tinking one too parsley tree some esallady tree too much esleep, that sake, after I thinking never come life, Maistrie, telling, let's take it out she says, put more eshid, indeed much pleasure this kind business, Auyah I call come keep in hand eshmal bag Auyah all day sit down sit down to esmoke Charoot,[17] then I send Dobashe[18] directly bring fine new Chattee,[19] this so fine eshid, must keep some fine tree. good eshmell, in Chattee, near to Mrs rooms, that beranda[20] can looking too much pretty, this chit,[21] I send tappall,[22] because I thinking this good pleasure, Master can understand all this thing, plenty good water Mrs's Garden got very fine tank, besides three wells, I give order, some pandall[23] keep over Europe tree hot time, because too much sun comeing so eshmall tree never keep life, So soon I see eshmall bags one minute I call Gardener Maistrie,[24] he espeake this some China name can very well understand, that sake I tell Misalgee[25] go bring China man, make eexplain misalgee come back, China man can't find; in this place not one person can understand name that eshmall bags;[26] hear to

Mrs's Garden one fine Tope,[27] all Cocaa-nut tree, very handsome, only that place too many Esnig[28] near to that Tope one nulla[29] that sake Esnig never come Mrs's Garden very seldom Esnig come in water, Bad Esnig never come, Only Jackall come night time near to godown making to much noise, Mrs sometimy get up call Seapoy,[30] send away, One time is coming one, one esort large cat, kill away fowl some sheep, Mrs can very well understand that Cat because Mrs got book Dr. Anderson giving Buffon book[31] that sake Mrs telling Palanqueen Boys kill away that Cat, then after Mrs draw picture Mrs espeak name Lynx.[32] After Mrs draw picture too much bad eshmell[33] coming Palanqueen boys keep ready [messal[34]] when Mrs. throw away cat, directly make Currie after that Palanqueen Boys' telling that Cat currie too much nice. all they eat for supper. Suppose Master Regi taking little trouble. I thinking can find this good sence letter, suppose Master never find then I thinking Lizzy, Mary, Mama will find Grandmama I thinking never get sence in head this countries espeaking, Master Regi garden i never see all different sort chillies only one two esort no any more, when I come Europe I think I take little walk in Garden dayly every day once a day. I never find how Master Regi get muster so fine China name to keep that eshmall bag, This paper I writing; some one Black man espeak Lawyer Gentleman alway custom telling that Lawyer; Master must draw paper fuzzle[35] nother Turney,[36] now, I think after too much troubl I take, Master Regi never make fuzzle, thats sake I telling Mrs must make little Gentoo writing; I send one Cajun,[37] if Master never fid that Cajan writing, then must keep on nose looking Glass; now I finding this fun very bad fun, so I take leave & run away going, but if Master make hungry[38] upon me directly cut off ears, cut him neck estrong wound

> I am Honourable Sir
> Your Honours most obedt
> daughter & very faithfull
> servant Mongataiya
> Feranostate

Madras February 6th, 1803

I wish to express my deepest gratitude to Anna Winterbottom for her patient and good humoured assistance as I wrote this essay.

1 Stoler, *Along the Archival Grain*, 58.
2 Elizabeth Gwillim to Esther Symonds, 17 October 1801, British Library, India Office Records (BL IOR) Mss.Eur.C.240/1, ff. 14r–18v, on f. 17r.
3 Bhabha, *The Location of Culture*, 86 (emphasis in original).
4 Elizabeth Gwillim to Hester James, September/October 1806, BL/IOR Mss.Eur.C.240/4, ff. 329r–343v, on f. 333v.
5 Ibid., f. 335r.
6 Winterbottom, "Behind the Scenes."
7 Elizabeth Gwillim to Hester James, September/October 1806, BL IOR Mss.Eur.C.240/4, ff. 329r–343v.
8 Mary Symonds to Reginald Whitley, 6 February 1803, BL IOR Mss.Eur.C.240/2, ff. 97r–99v.
9 Pranking language mimicking Black English was not uncommon at the time. See Green, *The Love of Strangers*, 10–11. Green's example, an instance of benign metropolitan humour regarding the English of the Iranian ambassador to England, Abu'l Hasan Khan, was quite different in tone from the edgy language of Mary Symonds's letter to Whitley. Context made all the difference to the meaning of mimicry.
10 Mary Symonds to Hester James, 7 February 1803, BL IOR Mss.Eur.C.240/2, ff. 100r–103v, at f. 103v.
11 In reference to seeds (eshids) sent by Whitley.
12 "BANDY, s. A carriage, bullock-carriage, buggy, or cart. This word is usual in both the S. and W. Presidencies, but is unknown in Bengal, and in the N.W.P. It is the Tamil *vaṇḍi*, Telug. *baṇḍi*, 'a cart or vehicle.'" Yule, *Hobson-Jobson*, 59.
13 I.e., half past five.
14 Perhaps "fresher," a cooler time of day.
15 "Small, small."
16 "Own"
17 "H पी आया *aya* (from the Portuguese), s.f. Female attendant on children or on a lady, nurse, lady's maid, ayah." Platts, *Dictionary of Urdu*, 111.
18 Dobashe: "DUBASH, DOBASH, DEBASH, s. H. *dubhāshiyā, dobāshī* (lit. 'man of two languages'), Tam. *tupāshi*. An interpreter; obsolete except at Madras, and perhaps there also now, at least in its original sense … The *Dubash* was at Madras formerly a usual servant in every household; and there is still one attached to each mercantile house, as the broker transacting business with natives, and corresponding to the Calcutta banyan." Yule, *Hobson-Jobson*, 328.
19 "Chattee: சட்டி¹ *caṭṭi*, n. [T. K. M. Tu. caṭṭi.] Earthen vessel, pan; மட்பாண்டம். (பெரும்பாண். 377, உரை.)" University of Madras, *Tamil Lexicon*, 1237.
20 Beranda: "P ﺑﺭﺍﻣﺩﻩ *bar-āmada, bar-āmda* (perf. part. of *bar-āmadan*), part. s.m. Verandah, balcony, porch, gallery, piazza, eaves (syn. *baraṇḍā; bārjā*)." Platts, *Dictionary of Urdu*, 144.
21 Chit: "CHIT, CHITTY, s. A letter or note; also a certificate given to a servant, or the like; a pass. H. *chiṭṭhī;* Mahr. *chiṭṭī*. [Skt. *chitra*, 'marked.']." Yule, *Hobson-Jobson*, 203.
22 Tappall: "TAPPAUL, s. The word used in S. India for 'post,' in all the senses in which dawk (q.v.) is used in Northern India. Its origin is obscure … It is sometimes found in the end of the 18th century written *tappa* or *tappy*. But this seems to have been derived from Telugu clerks, who sometimes write *tappā* as a singular of *tappālu*, taking the latter for a plural (*C.P.B.*). Wilson appears to give the word a southern origin. But though its use is confined to the South and West, Mr. Beames assigns to it an Aryan origin: *tappā* 'post-office,' *i.e.* place where letters are stamped, *tappāl* 'letter-post' (*tappā* + *alya* = 'stamping-house'), connecting it radically with *ṭāpā* 'a coop,' *ṭāpnā* 'to tap,' 'flatten,' 'beat down,' *tapak* 'a sledge hammer,' *ṭīpnā* 'to press,' &c. [with which Platts agrees.]" Yule, *Hobson-Jobson*, 901.
23 Pandall: "பந்தல், s. a booth, a shed." Fabricius, *J.P. Fabricius's Tamil and English Dictionary*, 661. Used here to mean a temporary shelter.
24 Maistrie: "MAISTRY, MISTRY … s. Hind. *mistrī*. This word, a corruption of the Portuguese *mestre*, has spread into the vernaculars all over India, and is in constant Anglo-Indian use. Properly 'a foreman,' 'a master-workman'; but used also, at least in Upper India, for any artisan." Yule, *Hobson-Jobson*, 539.
25 Misalgee: "MUSSAULCHEE, s. Hind. *mash'-alchī* from *mash'al* (see MUSSAUL), with the Turkish termination *chī*, generally implying an agent. [In the *Arabian Nights* (Burton, i. 239) *almasha'ilī* is the executioner.] The word properly means a link-boy, and was formerly familiar in that sense as the epithet of the person who ran alongside of

a palankin on a night journey, bearing a mussaul." Yule, *Hobson-Jobson*, 602.

26 Whitley had marked the bags containing the seeds with made-up Chinese characters.

27 Tope: "தோப்பு tōppu- , *n*. perh. தொகுப்பு. [T. K. Tu. *tōpu*, M. *tōppu*.] Tope; சோலை. (பிங்.)" University of Madras, *Tamil Lexicon*, 2110. Also, Yule, *Hobson-Jobson*, 935: "A grove or orchard, and in Upper India especially a mango-orchard. The word is in universal use by the English, but is quite unknown to the natives of Upper India. It is in fact Tam. *tōppu*, Tel. *tōpu*, [which the *Madras Gloss*. derives from Tam. *togu*, 'to collect']."

28 Snakes.

29 Nalla: "NULLAH, s. Hind. *nālā*. A watercourse; not necessarily a dry watercourse, though this is perhaps more frequently indicated in the Anglo-Indian use." Yule, *Hobson-Jobson*, 632. In this instance used to prevent snakes from entering the garden.

30 Seapoy: "P سپاهی *sipāhī* [*sipāh*, q.v.+*i* = S. इन]], s.m. Soldier (in India, a native soldier, in contradistinction to *gorā*, 'an English soldier')." Platts, *Dictionary of Urdu*, 634.

31 I.e., Dr James Anderson, from 1786 physician-general of Madras, from whom Elizabeth borrowed a copy of Georges-Louis Leclerc, Comte de Buffon's *Histoire naturelle, générale et particulière* (published in French in 1749–67 and in English translation by 1775–76). See the discussion by Henry Noltie in chapter 4 of the present volume.

32 Elizabeth identified the animal with the European lynx described by Buffon, whose habitat does not include peninsular India. It was more likely to have been the Asian palm civet,

Paradoxurus hermaphroditus, widely known in south India.

33 Smell – i.e., the dead animal was beginning to decompose.

34 Possibly "vessel" – i.e., to keep the meat in.

35 Fuzzle: This word as used in the letter approximates the Anglo-Indian "Foozilow," to flatter, to cajole. "FOOZILOW, TO, v. The imperative *p'huslāo* of the H. verb *p'huslānā*, 'to flatter or cajole,' used, in a common Anglo-Indian fashion … as a verbal infinitive." Its cognates in Anglo-Indian include "Lugow" – H. inf. *lagā-nā*, imperative *lagā-o*. The meanings of *lagānā*, as given by Shakespeare, are "to apply, close, attach, join, fix, affix, ascribe, impose, lay, add, place, put, plant, set, shut, spread, fasten, connect, plaster, put to work, employ, engage, use, impute, report anything in the way of scandal or malice." Yule, *Hobson-Jobson*, 524. Symonds is urging Whitley to apply himself and make sense of her letter. She implies that not doing so could produce unpleasant consequences, the least of which would be being forced to decipher a palm-leaf letter written in Gentoo (Telugu) by Elizabeth.

36 Possibly "attorney."

37 Cajun: "Cadjan A strip of fan — palm leaf, *i.e.* either of the Talipot (q.v.) or of the Palmyra, prepared for writing on; and so a document written on such a strip. (See OLLAH.)" Yule, *Hobson-Jobson*, 140; "OLLAH, s. Tam. *ōlai*, Mal. *ōla*. A palm-leaf; but especially the leaf of the Palmyra (*Borassus flabelliformis*) as prepared for writing on, often, but incorrectly, termed cadjan (q.v.)." Ibid., 636.

38 "Angry."

10

Elizabeth Gwillim and Mary Symonds and the World of Women in Late Eighteenth- and Early Nineteenth-Century India

ROSEMARY RAZA

When Elizabeth Gwillim and her sister Mary Symonds arrived in Madras in 1801, they joined a British female presence in India that had begun in a small way in the early seventeenth century and was to grow considerably in the nineteenth. The sisters' letters and interests give us a clear idea of their life in India. But to what extent did their gender shape the social, cultural, and intellectual world in which they moved, and how did it compare with the experience of other women at about the same time?

Elizabeth Gwillim and Mary Symonds came from the middle class, which grew considerably from the eighteenth century; their father was an architect and stone mason with a substantial business. Gwillim was a friend and correspondent of Mary Yorke, wife of the bishop of Ely, whose sister-in-law, Agneta Yorke, presented her at court before her departure for India. From the mid-eighteenth century, many women from a similar – and indeed more aristocratic – background began to arrive in India. The women who had first sailed out to India, following the establishment of the East India Company (EIC) as a trading entity in 1603, were mainly from a working or lower-class background, wives and often workers and traders in their own rights. However, by the eighteenth century, the changing role of the EIC in administration and military engagement brought an increasing number of officers from the middle and upper classes to India, accompanied by their better-educated womenfolk.

Not that female society in British India became genteel overnight – far from it. As Mary Symonds commented, leading hostesses included the daugh-

ters of an innkeeper, a tailor, and the like.[1] Other evidence also pointed in the same direction. Jemima Kindersley (1741–1809), whose *Letters from the East Indies* was published in 1777, came from a very modest background before marrying an army officer and sailing for India in 1764. Her undoubted talent won her an acclaim unmatched by those

> Who barter English charms for Eastern gold;
> Freighted with beauty, crossing dang'rous seas
> To trade in love, and marry for rupees.[2]

Such ladies, alluded to in this prologue to Mariana Starke's play *The Sword of Peace* (first performed in 1788), were typical of the raffish society in Madras in which Starke had spent her youth as the daughter of a deputy governor. The important point, however, was that there were enough women in the upper reaches of society to establish a British pattern of life in India. This we see in the Gwillim and Symonds sisters' descriptions of the endless social calls, dinners, balls, and races, with, on occasion, a play and a concert. These gaieties were of less interest to Elizabeth Gwillim than to Mary Symonds, who commented, "I do all the gossiping, visiting and most of the housekeeping."[3]

Women were able to impose a British tone in society, which was evident in other ways. The sisters took under their wing several young men, notably William Biss and Richard Clarke, Sir Henry Gwillim's court clerk, who lived or stayed with them; others were welcomed and cared for, particularly in times of stress. Young men often went to India as teenagers and faced considerable challenges, not least in the shape of dissipation. The sisters showed little of the moralistic attitude of later generations toward the charm and availability of Indian women and commented in a matter-of-fact way on men having Indian mistresses and children. On the other hand, they regarded uncontrolled sexual activity, and the financial burden of informal relationships, as dangerous, and sought to protect young men (they showed no such concern for the women involved). As Symonds noted, "We are never without one, two or three young men in the house, nor indeed are any of the families in Madras, for it is thought both dangerous and disreputable for any young man to live in a hostel."[4] Other women were similarly protective. Maria Nugent (1771–1834), the wife of the commander-in-chief in India, recorded in her journal for the years 1812 and 1813 her concerns about several young men and attempts to help them, though sometimes with little prospect of success: "Much talk with young Nepean – I fear he is likely to give his friends a great deal of trouble."[5] Eliza Clemons (d. 1845), the wife of a military officer in South India in the 1820s, published a guide for cadets on their conduct in India, including advice on personal and domestic concerns not covered in male-authored works.[6]

Another way in which the increasing presence of British women shaped the experience of living in India was food, for, as housekeepers, women largely determined what was to be cooked by their numerous staff. While some Indian dishes graced the tables of the British, their cuisine was essentially derived from home, with local adaptations. (See chapter 8 by Nathalie Cooke for a discussion of British and Indian foodways.) By the late eighteenth century, many English vegetables were grown in India, and the sisters also enjoyed local vegetables and fruit, some of which provided an excellent replacement for the typical gooseberry and apple tarts of home. Nevertheless, many of the ingredients necessary for British recipes were not available, and the sisters' letters are filled with requests for various foodstuffs, accompanied by comments on the state in which those previously sent survived the months-long sea journey. Pickles, mushroom ketchup, and capers were all popular; for the sweet tooth, those in England shipped preserved fruit not available in India, particularly raspberries, strawberries, and damsons, plus a wide range of sweets. Cheshire cheese made its way over, and ham and gammon from Britain were much appreciated. Many of these products, particularly the preserves and pickle, were made at home in Britain, and their despatch depended on a chain of willing female relatives. This pattern of consumption was common and lasted a long time. Amelia Heber (1787–1870), wife of Bishop Heber, recorded receiving ham, cheese, and bottled fruit in the 1820s. Emma Roberts (1791–1840), who, like Mary Symonds, accompanied a married sister to India, published extensive advice in the 1830s for those setting out, which included the foodstuffs to take with them.[7]

British women also maintained the distinctiveness of their culture through their appearance, as the sisters' record bears witness. It seems astonishing that, given the heat and humidity of the climate in Madras at most times, stockings, gloves, caps, bonnets, and hats – as well as stays – should have been such important items of apparel and constantly requested from home. Attempts by some British women in Calcutta around 1810 to adopt more climatically suitable Indian clothes were scorned and short lived. A considerable portion of the sisters' letters home concerns very specific requests for clothes, commissions that were, of course, dependent on the co-operation of their mother, sister, or other female friends (see chapter 7, by Toolika Gupta, Alexandra Kim, and Ann Wass, for discussion of such requests). Looking as up-to-date as possible was important, and the sisters' latest acquisitions were often lent out as patterns to be copied by their friends. As Mary Symonds wryly commented, "the plain muslin frock with lace down the front has been lent out to half the settlement for a pattern."[8] Nor were men's aspirations any lower, particularly when they were in positions of authority. The sisters relayed to family back home the precise requests of the tetchy Henry Gwillim for his coats and stockings.

Appearance was seen as a general indicator of social status and propriety: as Eliza Clemons later warned in her advice to cadets, "we judge of your general character through your dress."[9] Women's accounts over the ensuing decades frequently emphasized the importance of correct and fashionable dressing, and, as the journey time to India decreased, it became easier to be up-to-date. In the 1830s, Julia Maitland, the wife of a judge in a remote part of the Madras Presidency, recorded how a lady came to call on her "with all her best clothes on, worked muslin and yellow gloves."[10] As the decades passed, the use of Indian fabrics, decorative items, and jewellery as adjuncts to British fashion grew less acceptable, and the presence of women helped increasingly to underline the distinctive and alien appearance of the British.

Women, including Elizabeth Gwillim, Mary Symonds, and their family in England, were an important channel for the fashionable goods that flowed to India. But there was also the reverse stream, by which women facilitated the movement of Indian goods to Britain, often helping shape fashion and interiors at home (see the discussion in chapter 7). The "Empire" style of high-waisted dress fashionable around the beginning of the nineteenth century required light and easily draped fabric for which Indian muslin was ideal, and the sisters' letters frequently record the gifts they sent home, either locally made muslin, or the more expensive Bengal muslin, sometimes in ready-made gowns. Indian shawls were also highly prized in Europe, and Gwillim in particular sent detailed accounts of her presents, to be worn as shawls or made up into items such as gloves and stockings, as well as waistcoats for men (see chapter 7). Other prized local products included hand-painted palampores – Gwillim sent one for her friend Nancy Green's bed – as well as painted chintz, used for both clothes and furnishing. Exotic feathers were popular for decoration and headwear, and Symonds mentions sending supplies home.[11] Men naturally also sent such gifts, but it was women's knowledge of the uses to which they could be put and greater awareness of the dictates of fashion in design and colour – Gwillim was fond of orange shawls – that were important in mediating the incorporation of Indian goods in the domestic world of Britain.

British women had, from the earliest days of the EIC, worked and traded in India, and, as the British presence expanded, there were even greater opportunities to do so. Eliza Fay (1756–1816), whose *Original Letters from India* was published posthumously in 1817, left an account of her career in dressmaking, as well as her trading ventures, to which she turned in Calcutta after the failure of her marriage to a philandering barrister. But in the upper reaches of society, the role of women was domestic, as wife and mother, and women's main point of contact with India was through their servants. Often a woman's most significant relationship was with the ayah who looked after her children. Infant deaths were generally higher in India than at home, and

an ayah frequently occupied a position of confidence and trust. This was not the case in the childless Gwillim household, and the sisters did not have such a close relationship with their female servants. Elizabeth Gwillim complained that their "Portuguese" maids, women of mixed Indian and European descent living outside the system of Hindu and Muslim society, were unable to sew and sometimes drank or stole.[12] It was with their male servants that the sisters achieved the closest rapport, helped by the social status and customs enjoyed by British women. Not only could they mix freely with men, but their education and interests created points of contact. The sisters' passionate interest in the world about them might have seemed strange to their servants. Nevertheless, as Gwillim noted in 1802, "there is certainly one thing very pleasing in the servants: they all enter into your pursuits," bringing her new vegetables, flowers, and insects and pointing out things of interest.[13] Other Indians captured birds for Gwillim (plate 48), taught her local languages, and initiated her into Hindu culture and learning, including botany.

However, it was particularly in the upper reaches of Indian society that the sisters stood to gain as British women. Indians accepted the social freedom of British women, although it was not permitted in their own world, and interaction was possible between upper-class Indian men and the British ladies of Madras. In 1802, Mary Symonds described the presence of the local "Nabob" (Azim ud Doula, nawab of the Carnatic) and his attendants at a St Andrew's Day ball and supper and his subsequent visit to the Gwillim home for breakfast. He talked a great deal, and, when Elizabeth Gwillim expressed an interest in his elephants, he sent nine richly decorated animals round the next morning. This type of social engagement was frequently echoed by other women, such as Lady Nugent, who was often present at her husband's meetings with Indian rulers during his "up country" tour of 1812 and 1813. Women from less exalted positions who were interested in exploring India also record their acquaintance with a wide range of Indian men, among them Marianne Postans (1811–1897), who travelled extensively in western India, Sindh, and Balochistan in the 1830s and 1840s, and counted aristocrats, traders, and scholars – and even a Baluch prisoner – among her friends.[14]

While social relations with Indian men gave British women a new perspective on Indian life, and Indian men an awareness of a different gender model, it was the ability of British women to move in the closed society of upper-class Indian women that gave them a particular advantage. British men mixed freely and often lived with (or married) Indian women from a lower social class, but the upper reaches of both Muslim and Hindu female society were barred to male outsiders. The asymmetric access allowed to British women gave them a substantial advantage in reporting on Indian society, of which they made the most. In a letter of 1804, Mary Symonds described visiting the zenana of the

sister of the "Nabob Wallajah" (Muhammad Ali Khan Wallajah [1717–1795], the former nawab of the Carnatic).[15]

Mary was here playing into the long-established Western fascination with the social and sexual mores of the East, particularly in the Muslim world. Montesquieu's *Lettres persanes* (1721) had explored the theme of despotism and the sexual control of women, while Lady Mary Wortley Montagu's *Turkish Embassy Letters* of 1763 had piqued a Western readership with her own perceptions. Fascination with the theme of the zenana had encouraged the first published work on India by a woman, Jane Smart (ca. 1705–1753), who in 1743 recounted a visit she had made in Madras in the company of the governor's wife and her two daughters to the wife of the nawab.[16] Further revelations on Indian women were provided by Jemima Kindersley, who lived in the later 1760s in Calcutta and Allahabad. In an essay published in 1781, she reflected that Indian men's control of women was a response to female sexual power and the challenge it posed.[17] In an early letter of 1801, Elizabeth Gwillim repeated this trope – "the moor men, a ferocious people enervated by luxury, by turns voluptuaries & slaves."[18]

Mary Symonds's account of her visit to the zenana provided a surface impression of its social composition, the appearance and clothes of the women, and some of their amusements, all of which merely confirmed another long-held prejudice about the "mixture of misery and splendour" in assumed "Eastern magnificence."[19] Elizabeth Gwillim, on the other hand, who had a more inquiring and academic mind, reflected further on the respective freedom of Indian and European women, reporting to her sister Hester James that the writer and traveller Mirza Abu Taleb Khan considered that Asian women enjoyed more liberty than their English sisters in some respects.[20]

The truth was hard for the British to gauge, for it was difficult for them to get to know Indian women in anything but a superficial way in Madras and Calcutta – though the more responsive Parsi community made it easier in Bombay. It was not until they began to live and move about more readily in the "up country" areas that British women were able to establish relationships that revealed the reality beneath the surface. Eliza Clemons, who visited the Madras Presidency with her army husband a couple of decades after the death of Elizabeth Gwillim and departure of Mary Symonds, described her interactions with both Muslim and Hindu women.[21] Marianne Postans, another army wife, noted that, in western India, "it has been my good fortune to have seen much of native society amongst the gentler sex."[22] Fanny Parks (1794–1875), who made close friends among aristocratic Indian women, capitalized on what she could offer in the book recounting her life in India with the final part of its title: *Revelations of Life in the Zenana*.[23] Writers such as these began to give a truer picture of the occupations and interests of upper-class

Indian women. However, it was an "outsider become insider" who gave the most accurate account. The prosaically named Biddy Timms (born ca. 1782) made a bold change of life when, in 1817, she married Meer Hassan Ali, who had been a language instructor at the East India Company's military college at Addiscombe. She returned with him to Lucknow, where she lived in an exclusively Muslim society, reporting on its nature, including the life of women, in her account published in 1832.[24] She depicted these women as well-employed, happy on their own terms, and puzzled by what to them seemed the strange ways of British women. Most British women, however, were far from accepting such an alternative perspective.

Elizabeth Gwillim and Mary Symonds were among the many women who helped shape Britons' social interchange with India, in ways that reflected their gender. As women, they were also part of an intellectual engagement for which the changing world of the eighteenth century prepared them. The concept of "polite society" had developed to embrace both men and women who were expected to be acquainted with literature, art, and the natural sciences. Knowledge had not been "professionalized," as it was to become in the later nineteenth century, and much investigation and progress was made by amateurs in the leisured moneyed classes. Although girls did not usually receive the same education as boys, science began to creep into their syllabus. Numerous magazines written for women contained mathematical and scientific information, like the *Ladies Diary*, which ran for over a century from 1704. Meanwhile, "bluestockings" claimed intellectual recognition for women, a goal to which their distant sisters in India might aspire.

Interest in the life and culture of lands overseas had been stimulated by worldwide exploration, particularly the three voyages of Captain Cook to the Pacific from 1768. An extensive range of ethnographic and other material had been documented, which provided a template for inquiry in other parts of the globe. Elizabeth Gwillim and Mary Symonds fitted into a society that sought to explore this new world. We know little of their education, but many women from their middle-class background were competent achievers: their mother, for example, took over her husband's business on his death. Their upbringing, whatever its details, encouraged them to take a keen interest in the life and culture of India.

They were far from being alone in this. In India in the second half of the eighteenth century, mathematics and astronomy were explored by women such as Margaret Clive, wife of Robert Clive, victor at Plassey; Margaret Fowke, the daughter of a diamond merchant in Calcutta; and the aristocratic Hester Johnson. Margaret Fowke also collected Indian songs and music, as did Sophia Plowden in Lucknow. Women's published writing bore witness to wide-ranging interests. Jemima Kindersley's *Letters* described Indian life,

culture, and religion. Maria Graham (1785–1842), who visited India in the first decade of the nineteenth century at roughly the same time as Elizabeth Gwillim and Mary Symonds, was an intellectual who acquired the nickname "metaphysics in muslin" in the society of the Scottish Enlightenment in Edinburgh. With a well-trained mind, she wrote extensive accounts of India and its culture.[25] In the 1820s, Anne Elwood (1796–1873), the daughter of a member of Parliament, showed similar interests,[26] while, in the following decades, Marianne Postans in western India and Sindh and Fanny Parks in northern India reported on many different facets of the subcontinent.

Such pursuits required learning local languages, and Elizabeth Gwillim was diligent in studying Telugu. In this she was again part of a well-established practice. Henrietta, Lady Clive (1758–1830), an aristocratic Welsh woman married to the governor of Madras, and who was in Madras immediately prior to the Gwillims' arrival, learned both Hindustani and the court language, Persian. Maria Graham also learned Persian on her visit to India. Marianne Postans's ability to meet and report on a huge range of people was facilitated by her command of Cutchi, Hindustani, Sindhi, and Persian. Fanny Parks spoke Hindustani and Persian, as did the army wife Ann Deane.[27] This fluency gained them ready acceptance at the highest level in Muslim courtly settings. Their readiness to learn Indian languages was a reflection of how seriously some women took their engagement with the country.

While the interests of many women could be generally described as ethnographic, there was one science that women very much made their own from the eighteenth century: botany. Botany was given a boost by Britain's extensive exploration overseas and the desire of the East India Company to increase its profits through the exploitation of newly found products in the plant world. Botany had been enhanced as a science by the creation of a universal system of classification by the Swedish botanist Carl Linnaeus, first published in 1735 as *Systema naturae*. Women had long-established associations with the plant world: they had traditionally grown and gathered plants for medicinal purposes, and, from the seventeenth century, many richer women were involved in the growing craze for gardens. The Duchess of Beaufort (1630–1715) amassed a vast collection of plants, many of them specimens from overseas regions, including India, while Lady Amelia Hume (1751–1809), wife of a director of the East India Company, imported plants from India and China for their famous garden in Hertfordshire.

As we can see from Elizabeth Gwillim's and Mary Symonds's letters, they were involved at the other end of the plant trail, supplying seeds and plants to be sent home to nurserymen and friends, some of them women. Gwillim was a serious student of botany, which she saw as essential to an understanding of Hindu religion and culture. Besides learning from Indian teachers,

she was also instructed in the science by the German missionary and botanist Dr Johann Rottler (1749–1836), as described in Henry Noltie's chapter in this volume.

Gwillim was not unusual in being interested in Indian plants. One of the earliest female botanists to arrive in India was Anne, Lady Monson (1726–1776), who joined her military husband there in 1774. A friend and correspondent of Linnaeus, she was credited with helping in the translation of his 1760 edition of *Philosophia botanica*. While in Calcutta, she made several expeditions into the surrounding countryside to collect plants. Henrietta, Lady Clive collected specimens on her astonishing 1,000-mile exploratory tour around southern India with her two young daughters in 1800, sending some to a friend at home and others to her husband for their garden in Madras. She also established there a complete collection of the plants of Mysore and the Carnatic. Other aristocratic women displaying a serious interest in botany included Sarah, Lady Amherst (1762–1838), whose husband was governor-general from 1823 to 1828, and her daughter, also named Sarah Amherst (1801–1876). In 1827, while they were staying in Simla, they explored the surrounding hills looking for new plants. As the British presence became established more widely in India, many more educated women from further down the social scale became involved in the compelling search for new specimens. In Ceylon in the 1830s, Anna Maria Walker (ca. 1778–1852) shared with her husband, a military officer, a passion for botanical exploration and collection, a pursuit that became increasingly popular with women over the coming decades.

Not all women lived in areas with scope for botanical exploration, or indeed were able to mount expeditions and arrange collections, which required money and institutional support. However, surrounding most British women in India were the extensive gardens that were a feature of British domestic life on the subcontinent. Unlike Henrietta Clive, whom the sisters regretted not meeting, Elizabeth Gwillim and Mary Symonds made no extensive journeys in search of plants. They were, however, keenly interested in what could be grown close at hand. While many British vegetables were available in India from the late eighteenth century, and women like Gwillim enjoyed experimenting with local vegetables and fruit, some products required for British cuisine – herbs such as parsley, for example – were not grown locally. Gwillim recorded bags of different seeds being sent to them from England, though the success rate was often not great.

The westernization of the vegetable garden was matched in the flower beds, although this was not an area in which the sisters appeared to have shown any great interest. However, as the ranks of the military and civil administration grew, an increasing number of women came to India, bringing with them the interest in gardening, which spread widely through the middle classes in

the course of the nineteenth century, nurtured by a wealth of books and manuals. British women in India often delighted in introducing the comforting familiarity of home in their flower gardens, the management of which was later judged by the *Calcutta Review* as "particularly suited to many tender natures."[28] The exchange of plants and seeds initiated in the eighteenth century was continued in the nineteenth century by women such as Fanny Pratt (b. 1808), the wife of a military officer in the Madras Presidency in the 1840s, who recorded sending deodar seeds home to her sons in return for daisy seeds and roots.[29]

While botany was the female science par excellence, the wider natural world was also of interest. A later observer, Emma Roberts, who wrote extensively on the British in India, noted the lack of occupation for what she termed the "softer sex," suggesting that "a love of natural history opens up endless fields of pleasurable research," and urged the establishment of menageries and museums.[30] As we know, Elizabeth Gwillim was fascinated by birds, and Mary Symonds by fish, which she illustrated. Again, such interests were not unique to them. Anne Monson made a collection of insects in Bengal, which she sent to Ann Lee, daughter of the famous nurseryman James Lee.[31] Lady Impey, wife of the chief justice in Calcutta, kept birds and wild animals in their garden in the late 1770s and 1780s, while, in 1794, the wife of General Ellerker in Bengal was reported to have an amazing aviary of Indian birds, containing rare species. Henrietta Clive established a menagerie in Madras, adding to its inmates over the course of her tour, and sent home a collection of butterflies, stuffed birds, and bottled insects. Her interest extended to a wider range of natural objects, including shells, rocks, and minerals, and her mineral collection is now in the National Museum of Wales.[32]

Recording new discoveries was an essential part of exploration. Visual images were a basic requirement, and many women employed trained artists. Anne Monson, whose wealth supported her interests, brought a draftsman with her to India. Others employed Indian artists. In the 1770s and 1780s, both Mrs Wheler and Mary, Lady Impey in Calcutta commissioned Indian artists to paint plants, birds, and animals, and for decades women record buying such paintings from local artists.

In an age when drawing and painting were regarded as a polite accomplishment for both men and women, a considerable number of women made visual records of every aspect of Indian life. Many girls had lessons at home, and we learn from their letters that Elizabeth Gwillim and Mary Symonds studied with, or were mentored by, the painter George Samuel. Botanical illustration was thought to be a particularly suitable field for women, and one that they virtually took over, encouraged by a substantial number of manuals from the mid-eighteenth century, like Bowles's *Drawing Book for Ladies; or Complete Florist* of 1753. Gwillim had probably painted flowers and plants from her youth. In

India, however, her botanical studies gained fresh impetus, and though only one completed watercolour of her botanical work survives (plate 47), it shows great skill and sophistication.

Elizabeth Gwillim was not alone in this pursuit. Henry Noltie, who explores Gwillim's botanical interests in chapter 4, has recently discovered and generously shared with me information about some botanical paintings done by Janet Dick (1774–1857) in Madras in 1802. Gwillim makes no mention of her or their common interest. Mary Symonds merely comments rather sniffily on her social prominence in Madras – despite her father being a London tailor – due to her husband's position as the leading member of the EIC Council in Madras.[33] No such social opprobrium could be said to adhere to Anna Maria, Lady Jones (1748–1839), the daughter of a bishop who educated his daughters in modern and classical languages. She married Sir William Jones (1746–1794), a lawyer in Calcutta and a scholar of Hindu culture, shared many of his interests, including botany, and collaborated with him in illustrating a number of specimens. Other botanical work survives, sometimes chance discoveries at auction, such as the album compiled by Rachel Welland, the wife of a judge in North India, between 1798 and 1804.[34] Such finds add to the collections of women's work in museums and libraries, and doubtless in private homes where they often still remain unacknowledged. Further afield, on the island of Mauritius, which the British had seized from the French in 1810, two women shared an interest in botanical illustration. Frances, Lady Cole (d. 1847), wife of the governor, and her friend Annabella Telfair (1787–1832), wife of the supervisor of the island's botanical garden, painted local plants and flowers. The botanical gardens that had been established in India from the late eighteenth century provided inspiration for many women. This was particularly true of the Calcutta Botanic Garden, where two women created a rich record. Between 1818 and 1820, Clementina Abbott (d. 1826) painted illustrations of the flowers and fruit of a variety of plants. In 1817, Janet Hutton, the wife of an East India Company merchant, arrived in Calcutta, where she continued the painting career she had already begun in Penang, producing a particularly striking series of plants and flowers (plate 63).

Women's skill in botanical painting fed into a wider world of general and scientific interest, and, as European expansion overseas increased, there was a growing demand for visual records. Dr Rottler, who had named the magnolia *Gwillimia indica* after Elizabeth Gwillim, sent her painting of that flower to England to the distinguished botanist Dr J.E. Smith (1759–1828), who had founded the Linnaean Society in 1788, noting in his letter Gwillim's "love and application to botany."[35] The general public also provided a ready market for information, and *Curtis's Botanical Magazine,* founded in 1787, was one of many publications that provided textual descriptions and illustrations of the

astonishing variety of plant life being discovered. Botanical illustration for publication was a field in which many women in Britain made a professional career, and botanical painters overseas fed into this trend. *Curtis's Botanical Magazine* featured an illustration of the *Tanghin* tree in Mauritius drawn by Lady Cole, while Annabella Telfair depicted its fruit.[36] More of Telfair's drawings of plants appeared in *Curtis's Botanical Magazine* between 1826 and 1830.[37] So attractive were the botanical portfolios of some women artists that they demanded publication in their own right. Marianne Cookson, the wife of an army officer who served in India, reproduced her botanical paintings as hand-coloured lithographs in a limited number of leather-bound editions, the paper watermarked mainly 1834.[38] Her publication provided an early example of a tradition that was to expand in the nineteenth century.

By collecting and illustrating plants and flowers, women fed informally into a network of professionals. In her pursuit of botany, Gwillim worked closely with Dr Rottler and corresponded directly with Dr Smith in Norwich. Lady Amherst and her daughter sent plants from their exploratory tours back to Dr Wallich, the director of the Calcutta Botanic Garden, for identification; in tribute to their commitment and skill, he named the scarlet-flowered *Amherstia nobilis* after them. From Mauritius, Annabella Telfair corresponded with William Hooker, who in 1820 became professor of botany at Glasgow University, sending him drawings as well as a collection of algae, while Anna Maria Walker in Ceylon was among his other correspondents.

While many women shared Elizabeth Gwillim's enthusiasm for botany and botanical illustration, she was much more unusual in her interest in birds and their depiction. This may in part have been caused by the difficulty of capturing and retaining specimens for study and painting. Her husband's position of authority and their substantial staff enabled her to recruit bird catchers and others who showed an enthusiastic interest in her pursuit. Other women had to be content with paintings by Indian artists, or stuffing and preserving birds – often following instructions by the always undaunted Fanny Parks.[39] It was only much later in the nineteenth century that the ornithologist Margaret Cockburn, who was born in India in 1829, painted beautiful and accurate depictions of birds (plate 64). However, no one matched Elizabeth Gwillim in the scale of her depictions – some of the paintings were life size – or in the perfect observation and intricate rendering of the arrangement of feathers. (See chapter 2, by Suryanarayana Subramanya, for a detailed analysis of Gwillim's bird paintings.)

The *Madras Album*, now housed in the South Asia Collection Museum in Norwich, contains paintings that also distinguish the sisters from other women artists. (A perceptive analysis of the album is given by Ben Cartwright in chapter 1.) Besides botanical studies, landscapes and buildings were common

features of the sketchbook that every self-respecting lady carried on her travels, including the artist Anna Tonelli, who accompanied Henrietta Clive and her daughters to India,[40] and Lady Hood, wife of Admiral Sir Samuel Hood and one of the most renowned travellers of the early nineteenth century.[41] Like the sisters, women artists of all periods often painted the houses in which they lived, seeking in the days before photography to give a visual impression of how and where they lived to families and friends at home. What makes the paintings in the *Madras Album* stand out – particularly those by Mary Symonds – are the studies of Indian figures and groups, sometimes related to religious and social events.

The British often collected illustrations by Indian artists known as "Trades and Castes," representations of local people that served as souvenirs or presents for those at home. Painting the human form was generally more difficult than illustrating landscape, architecture, or botany, and fewer amateurs attempted the subject. Mary Symonds was unusual in doing so.[42] What distinguishes her work from the "Trades and Castes" model is the plasticity of her figures, their soft colouring, and their incorporation in a background scene. She was very imaginative in her attempt to give family and friends at home the impression of a crowded Indian street scene: as Hana Nikčević details in case study 1, she painted figures that were intended to be cut out and arranged in a viewing box to give a sense of life and depth. Some of her other paintings of Indian figures engaged with Indian culture: one of her scenes illustrated a fifth-century Sanskrit drama, which had been translated by Sir William Jones and published in 1799 as *Sakuntala; or, The Fatal Ring* (plate 6). In other scenes, she portrayed pandarams or Hindu priests (plates 9 and 56). However, this was religion at one remove: it was very difficult to depict the reality of Muslim or Hindu religious observance, apart from the processions visible in the street. One of the few artists able to do so was Sophia Belnos, born in India in the late eighteenth century and married to a French artist. She persuaded a Brahmin priest to perform the Hindu rites in front of her and published a folio album illustrating them, with a translation of the prayers.[43]

Much of the purpose of women's art was to inform those at home about the far-away land in which they lived. But besides providing an illustrative bridge to the world of India, Mary Symonds also used her art as a social bond in local British society. She began painting miniatures of women of her acquaintance and was much in demand; she also painted a portrait of young Richard Clarke, who lived in the Gwillim household, intended for his father but to be shown to his friends at home as well. These likenesses played a particularly important role before the advent of photography in strengthening the bonds of memory and affection. Female professional portrait painters in India included Catherine Read, who was in Madras in 1777, and, from the later eighteenth

and early nineteenth century, Martha Isaacs, Diana Hill, and Martha Bellett Browne, as well as Sophia Belnos, among others in Calcutta.[44] But the role of an amateur was different. Emily Eden, a talented artist, who accompanied her brother when he served as governor general from 1836 to 1842, narrated how she was asked to copy portraits of relatives: "and though I cannot make much of all these likenesses, yet it feels like a duty to help anybody to a likeness of a friend at home, and it is one of the very few good-natured things it is possible to do here."[45]

The sisters' letters are as much a part of their legacy as their paintings. The past couple of decades have seen several academic works focused on women's role as letter writers from locations overseas that had a British presence.[46] Here, too, gendered practices helped create a specific role for British women in India. Women became prominent in many fields of writing in Britain in the eighteenth century, among them letters, at which they were thought to excel, given their supposed light and entertaining touch and ability to convey information in an engaging way. Men in India were busy in their work and professions, but women had many empty hours to fill, often employed in conveying information to those at home. Networks of communication were created, very often in the first place among female relatives and friends, though many letters were written for a wider readership, as the sisters often noted. Letters were left open so that they could easily be passed on. A letter written by Elizabeth Gwillim to her sister Hester James in August 1805 also enclosed one from a woman friend who had moved to Vizagapatam, giving an account of the interesting country and its people.

Through letters, readers could gain informal access to information otherwise confined to professional or academic works or learned societies. Women were usually barred from the latter, including the Asiatic Society, which had been established in Calcutta in 1784. Its founder, Sir William Jones, played a very important role in exploring Hindu culture, and women, though not members of the Asiatic Society itself, helped disseminate this information. Elizabeth Gwillim and Mary Symonds were not alone in acquiring academic information about India and filtering it toward more popular channels. Maria Graham notes that she consulted leading scholars and was greatly indebted to the renowned orientalist Colonel Colin Mackenzie. She also illustrated the value of female networks in transmitting information about Indian culture when she noted that she had heard about a newly translated Sanskrit poem from a woman friend in Calcutta.

For many women, letters were a first step into the world of publication. Elizabeth Gwillim and Mary Symonds might well have intended their letters and paintings to form the basis of a book on their return to England. Gwillim's death in Madras in 1807 and Symonds's marriage to the captain of

the ship in which she sailed home possibly derailed such a potentially success-ful project. In publishing, they would have been following what would become a well-trodden path. As has been noted, the first publication by a woman on India, in 1743, reproduced a letter written about a visit to a zenana. Eliza Fay's *Original Letters from India* (1817) was based on letters to her family and a friend in Blackheath. Maria Graham tells us that the pages of her *Journal of a Residence in India* (1812) "were really and truly written, nearly as they now appear, for the amusement of an intimate friend."[47] Fanny Parks, one of the greatest chron-iclers of Indian life and culture in her *Wanderings of a Pilgrim in search of the Picturesque* (1850), based her account on letters to her mother.

These publications, and others by women, often reflect the interests that the sisters showed in their letters. Fay gave a lively insight into the life of the British community in Calcutta. Anne Elwood described the British in Bombay in her *Narrative of a Journey Overland ... to India* (1830). At the same time, she mirrored the sisters' interest in Indian culture and attempted to describe it in popular terms. Graham equally sought to interpret India for an audience at home and – as the sisters might have done – illustrated her book with her own drawings, covering a wide range of cultural subjects. Many writers travelled much more widely than the sisters, whose experience of India was limited to Madras. Notable among them were Marianne Postans and Fanny Parks, both of whom illustrated their works with numerous drawings and paintings, including their own.

One of the chief claims of women's writing from India was its authenticity. Women were there, on the spot, writing about what they saw and experienced. Their accounts, unmediated by the often tedious and long-winded modes of official or academic records, provided a fresh and spontaneous record of what they had witnessed. Elizabeth Gwillim's letter to her mother in July 1802 pro-vides an example, describing at length the Hindu festivals and ceremonies they witnessed in the streets, the appearance and clothes of the participants and their attendant animals, the colour, light, music and dancing, in an as-tonishingly vivid kaleidoscopic panorama (see chapter 9, by Jeffrey Spear, for a discussion of Gwillim's descriptions of these festivals).[48] In September of the same year, she reported on the Easter celebrations of the local Christians, which were quite unlike anything at home. While distancing herself from the event, she was nevertheless caught up in it: "I thought the chant of the priest extremely fine and solemn and, ridiculous as the procession was, the effect of the voices was beyond anything of the kind I ever heard."[49]

This was the journalism of its day, its validity claimed by participation in the events described. Women continued to stress this value. Ann Deane, an army wife, spoke for many when she noted in the "advertisement" to her *Tour through the Upper Provinces of Hindostan*, published in 1823, that "the following

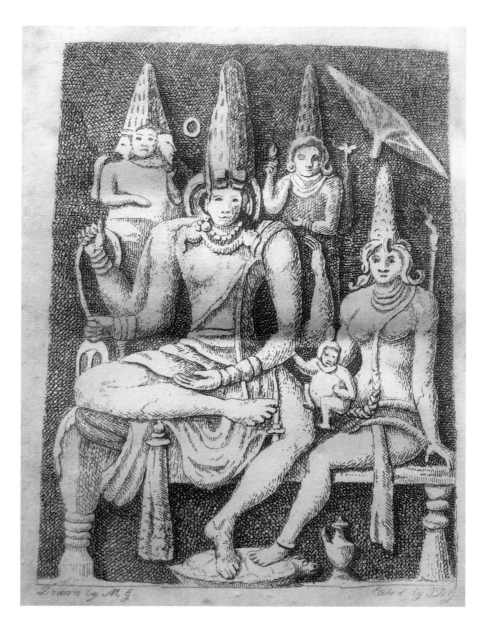

FIGURE 28
Maria Graham's drawing of Siva and Parvati, from her illustrations
to her *Letters on India* (1814). Collection of Rosemary Raza.

pages ... are neither the production of a philosopher, nor of a man of genius; but
of a lady, who has witnessed all that she has described, and whose chief claim
on the indulgence of the reader is *authenticity*."[50]

Not only did such authenticity add value to descriptions of Indian life
and culture, it also, on occasion, gave women an important role in reporting

and commenting on public events involving the British administration. This was the case with the mutiny or uprising in 1806 of Indian troops of the East India Company at Vellore, west of Madras. In a letter to her sister Hester James in November of that year, Mary Symonds enclosed an account of the actual events by an officer's wife, Amelia Fancourt, as well as another participant. Having first-hand accounts of what had happened, Symonds was in a strong position to pass judgment. The rebellion had been provoked by the British ordering the Muslim troops to shave, and Hindus to remove caste marks from their foreheads. In a move that foreshadowed the causes of the 1857 First War of Independence, sectarian sensitivities were further inflamed by an order "to make a new turban in which a piece of pig's skin was introduced, and a stock of cow's leather ... The Mussulmans objected to the pig's skin, and the Hindus to the form of the turban, which they said resembled that of a pariah, or outcast."[51] Mary Symonds was in no doubt about the folly of the military authorities and the "ridiculous orders of the government which principally occasioned the mutiny." She also expressed misgivings about the future: "Certain it is that the mischief done cannot be undone in many years perhaps, now our mutual confidence has been so completely shaken."[52] As a woman, she stood outside the structure of authority in India and, in full position of the facts, was able to make an independent judgment.

She was not the only woman to use her perspective as a witness to give warnings about Britain's position and future role in India. A decade later, Maria Graham underlined the fragility of a British supremacy that was based on Indian acquiescence and easily undermined.[53] Eliza Clemons, who had spent time in the field with her officer husband, echoed Mary Symonds's criticism of a failure to respect religious and cultural sensitivities, predicting that Indians "will take deadly vengeance on you at last, as surely as you have committed an offence against them."[54] At the very apex of British society, the witty aristocrat Emily Eden looked on with detached amusement at the celebration of Queen Victoria's birthday in 1839 near Simla, where the British with their "polite amusements" were vastly outnumbered by the surrounding hillmen: "I sometimes wonder they do not cut all our heads off, and say nothing more about it."[55] Women were sometimes in a position to issue warnings to a popular audience with whom the military and civilian authorities might have been more reticent in communicating.[56]

Elizabeth Gwillim and Mary Symonds reflect in their writing and interests the gendered role that was evolving for women in British India. As women, they helped impose "Britishness" on society, in the way it looked, what it ate, the entertainments it enjoyed, and the social cohesion it embraced. Their status as women also gave them access to Indian society that was denied their menfolk. The norms of social engagement that existed between men and women in British culture were accepted by Indian men, with whom British women were

able to mix freely. On the other hand, women had an asymmetrical advantage over British men in being permitted access to the segregated society of upper-class Indian women. This was an asset used long into the nineteenth and early twentieth century, until Indian women were largely emancipated from old restraints. The interests of British women in India, particularly botany and painting, were pursuits particularly popular with upper- and middle-class women more generally. The means by which they conveyed information in other fields was also common to women in general, recycling in a popular mode the information gained from academic and professional sources. We can thus see Elizabeth Gwillim and Mary Symonds pursuing practices and interests that were shared by other women and, indeed, became even more popular in the decades to come. Yet suggesting that their experience fit into a commonly established pattern that strengthened over time is not to deny that the sisters were in many ways outstanding. Their writing has considerable vivacity and spontaneity in its description of British life and, particularly, Indian culture and events. More than anything else, however, it is Gwillim's bird paintings that sets their oeuvre apart. Preceding the renowned bird painter James Audubon by several decades, her series of often life-sized birds in their natural settings remains unequalled and a testimony to a remarkable engagement with India.

Notes

1 Mary Symonds to Hester James, 11 February 1802, British Library, India Office Records (BL IOR) Mss.Eur.C.240/1, ff. 39r–46v.

2 Starke, *The Sword of Peace*, prologue, ix. The prologue was written by the theatre manager, George Colman.

3 Mary Symonds to Hester James, n.d. [1802], BL IOR Mss.Eur.C.240/1, ff. 58r–61v.

4 Mary Symonds to Hester James, n.d. [November 1806], BL IOR Mss.Eur.C.240/4, ff. 346r–352v, on f. 351v.

5 Lady Maria Nugent, *A Journal*, 2: 268

6 Clemons, *The Manners and Customs of Society in India.*

7 Roberts, *Scenes and Characteristics of Hindostan*; *The East-India Voyager.*

8 Mary Symonds to Hester James, 19 August 1803, BL IOR Mss.Eur.C.240/2, ff. 128r–133v.

9 Clemons, *Instructions for the Guidance of Cadets*, 325.

10 Maitland, *Letters from Madras*, 96.

11 Mary Symonds to Hester Symonds James, 12 August 1804, BL IOR Mss.Eur.C.240/3, ff. 208r–211v.

12 Elizabeth Gwillim to Esther Symonds, 12 October 1804, BL IOR Mss.Eur.C.240/3, ff. 217r–228v.

13 Elizabeth Gwillim to Hester James, 7–11 February 1802, BL IOR Mss.Eur.C.240/1, ff. 33r–38v, on f. 38r.

14 See Postans, *Cutch.*

15 Mary Symonds to Thomas Clarke, 14 October 1804, BL IOR Mss.Eur.C.240/3, ff. 242r–247v.

16 Smart, *A Letter from a Lady in Madrass.*

17 Kindersley, *Essay.*

18 Elizabeth Gwillim to Esther Symonds, 7 October 1801, BL IOR Mss.Eur.C.240/1, ff. 14r–18v, on f. 16r.

19 Mary Symonds to [Mr Clarke], 14 October 1804, BL IOR Mss.Eur.C.240/3, ff. 242r–247v, on f. 246r.

20 Elizabeth Gwillim to Hester James, n.d. [spring 1803], BL IOR Mss Eur C 240/2, ff, 167r–177v.

21 Clemons, *The Manners and Customs of Society in India*.

22 Postans, *Western India*, 2: 129.

23 Parks, *Wanderings of a Pilgrim*.

24 Mrs Meer Hassan Ali, *Observations on the Mussulmauns of India*.

25 Graham, *Journal of a Residence in India*.

26 Elwood, *Narrative of a Journey*.

27 Deane, *A Tour through the Upper Provinces of Hindostan*.

28 "Married Life in India," 413.

29 Macmillan and Miller, *Exiles of Empire*.

30 Cited in Desmond, *The India Museum*, 48.

31 Britten, "Notes on Mesembryanthemum," 66.

32 See Raza, *In Their Own Words*, 121, and, on Lady Clive's interest in botany, Shields, *Birds of Passage*, 38–9.

33 Mary Symonds to Hester James, 11 February 1802, BL IOR Mss Eur.C.240/1, ff. 39r–46v.

34 Rachel Welland's work appeared in auctions in London in 2018 and 2019.

35 Linnean Society, the Smith Herbarium, Specimen: LINN-HS 981.11; drawing and letter: LINN-HS 981.10.

36 Cole, "*Cerbera Tanguin*."

37 For further information about Annabella Telfair's work in Mauritius and collaboration with her husband, Charles, see Riviere, "From Belfast to Mauritius," 139, 141. See also Charles Telfair's correspondence with Professor William Hooker in the Directors' Correspondence, Royal Botanical Gardens Kew, in which he refers to his wife's botanical illustrations, and to the work of another woman artist, Miss Baigrie. The collection also contains a letter from Annabella Telfair to Hooker.

38 A copy of Marianne Cookson's publication is held in the Wellcome Library, London,Closed stores EPB G o/s Shelfmark F.822.

39 Parks, "Easy Method of Preserving Small Birds," in *Wanderings of a Pilgrim*, appendix XXV, 509.

40 Some of Anna Tonelli's watercolours were copied into a version of the journal kept by Lady Clive's younger daughter, Charlotte, during their tour of South India. This journal was professionally transcribed ca. 1857 and is available at the British Library, WD4235. Two albums containing some of Anna Tonelli's original watercolours are in the possession of Clive family members.

41 Mary, Lady Hood accompanied her husband to Madras in 1812–14 and, from there, travelled extensively. Heather-Ann Campbell, who is researching her letters from India, notes her interest in sketching on her travels (personal communication).

42 Mary was unusual but not unique. Besides botanical studies, Rachel Welland's album also contains figures of Indians, some of which appear to have been painted by her, while others are by Indian artists.

43 Belnos, *The Sundhaya*.

44 See Archer, *India and British Portraiture*: on Catherine Read, 118–21; Martha Bellett Browne, 383–5, 397 (illustration); Martha Isaacs, 398; Diana Hill, 398–9, with illustrations.

45 Emily Eden, letter to a friend, Government House, 23 July 1836, in Eden, *Letters from India*.

46 See, for example, Stierstorfer, *Women Writing Home*, especially volume 4, *India*.

47 Graham, *Journal of a Residence in India*, vi.

48 Elizabeth Gwillim to Esther Symonds, 16 July 1802, BL IOR Mss. Eur. C.240/1, ff. 62r–71v.

49 Elizabeth Gwillim to Hester James, 14 September 1802, BL IOR Mss.Eur.C.240/1, ff. 77r–81v.

50 Deane, *Tour through the Upper Provinces of Hindostan*, iii. Emphasis added.

51 Mary Symonds to Hester James, November 1806, BL IOR Mss.Eur.C.240/4, ff. 346r–352v, on ff. 348r–348v.

52 Ibid., 348v.

53 Raza, *In Their Own Words*, 217–23.

54 Clemons, *The Manners and Customs of Society in India*, 334.

55 Eden, *Up the Country*, 294.

56 For a general overview of British women's lives and experience in India in the eighteenth and nineteenth centuries, see Raza, *In Their Own Words*.

Conclusion

VICTORIA DICKENSON AND ANNA WINTERBOTTOM

We began this collection of essays by describing how two English sisters, Elizabeth Gwillim and Mary Symonds, came to find themselves in Madras in 1801 and the interests and skills they brought with them. We conclude by asking what we learned from their archives about women, environment, and networks of empire. We describe how the strength of a diverse and multidisciplinary collaboration enriched our collective discourse and shaped the questions we posed to the materials. We also reflect on how our practices and our ideas shifted in response to major events that took place between 2019 and 2022, particularly the disruption caused by Covid-19 and the calls for cultural decolonization that gathered pace during the pandemic. We end by looking to the new directions that grew out of the shared insights of the collaborators into the entangled worlds described in the Gwillim Project.

WOMEN AND ENVIRONMENT

We originally approached the Gwillim collections with the intention of uncovering women's voices, so often lost or ignored, and adding a gendered inflection to the history of natural history in India. In making available to scholars the sisters' detailed observations of people, events, weather, and local flora and fauna, we also saw the archive as a resource for the social and environmental history of Madras in the early nineteenth century. We focused on the experience of two English sisters in India and asked a range of questions. What accommodations and adaptations they make in matters of dress, housing, and food? How were these influenced by the local environment? What could we learn from images and letters about the weather and its effects on their health and well-being? We asked how European perceptions of gender affected the sisters' participation in colonial society and their activities in natural history. How did what they observed and what they privileged in their correspondence and depictions differ from the writings and images made by their male counterparts? We also wanted to understand more about Elizabeth Gwillim's participation

in colonial natural history. She learned Telugu, allowing her to interact with her servants, gardeners, and bird catchers and keepers. How did this affect her depiction of birds and her view of European systems of classification?

Despite interest from scholars in both European women's participation in metropolitan natural philosophy and science and in women's writings on empire,[1] there are few studies of women's scientific practice in colonial settings.[2] Because the sisters never published their work, they were not exposed to either the recognition accorded to many male naturalists or the mixture of admiration and ridicule that greeted female contemporaries, such as Maria Graham (1785–1842), who made their scientific work public. Nonetheless, as several chapters in this book emphasize, their natural history work was truly exceptional for its period. As Suryanarayana Subramanya shows, Elizabeth Gwillim's ornithological work rivals, as well as precedes, the better-known work of John James Audubon. Moreover, her accurate depictions or descriptions of 136 species constituted the first thorough documentation of the bird life of Madras from a Western perspective. Subramanya also notes that her practice of painting birds from life, observing them in her gardens and in the surrounding countryside, enabled her to give the birds a life-like appearance unrivalled by many of her contemporaries. The depictions of fish, many of them by Mary Symonds, were simpler in execution than the bird paintings, but, as Shyamal Lakshminarayanan and Hana Nikčević show, they are relatively accurate in their depictions of characteristic anatomical features. These paintings, made before any comparable work was published by East India Company (EIC) naturalists, were pioneering in the field of Indian zoology.

The sisters' embeddedness in "Banksian" networks of scientific naturalists was useful in validating and disseminating their work. Writing of the sisters' botanical work, Henry Noltie demonstrates how their connections with the circles of EIC botanists as well as with Reginald Whitley's nursery garden in Brompton provided them not only with collaborators in Madras but also with connections to naturalists in England such as J.E. Smith, the founder of the Linnean Society, and John Sims, the editor of *Curtis's Botanical Magazine*. The less formal networks the sisters maintained with other women were also important to their natural history work. From Elizabeth Gwillim's correspondence, it becomes clear that Whitley's stepdaughters, Elizabeth and Mary Thoburn, were active partners in running the Brompton gardens. Their shared botanical expertise comes through clearly in Gwillim's comment that "I have had a good deal to write to Lizzy Thoburn which no one else cou'd do, about seeds & plants."[3] Although Elizabeth Gwillim and Mary Symonds rarely left Madras, the scope of their collecting was enlarged by friends who sent them specimens from different parts of India and further afield. Some of these correspondents were also female, such as Ann Young, who shared with Gwillim

natural and cultural artifacts from Southeast Asia,[4] and Mrs A.W. Stone, who sent caged birds from Vizigapatam (north of Madras, in modern Andhra Pradesh).[5] Probably most important to their work, though only partially revealed in the letters, was the sisters' dependence on a network of knowledgeable Indians, beginning with their servants and expanding to include physicians, plant collectors, fishermen, artists, bird catchers, and hunters.

Clearly, further study of European women's networks will reveal still more women involved in the information-gathering projects of the Enlightenment and Romantic eras, especially in colonial settings. Rosemary Raza's chapter in this volume highlights several other instances of women whose studies of the natural world merit more attention. But was there anything distinctive in women's approaches to the natural world, compared with their male counterparts? In many ways, Elizabeth Gwillim and Mary Symonds wanted the same things as male naturalists: recognition for their efforts, the respect of their European peers, and to contribute to the grand projects of classification and "improvement" of the natural world.[6] Like their male counterparts, they relied on information provided by local experts, while only partially acknowledging this fact. One difference was that, as observers working outside established societies and institutions, they used a range of approaches to document their environment. The watercolour paintings of their surroundings, which included genre scenes and portraits as well as landscapes, and their intimate correspondence with family, allow us to learn more about their networks and their approach to acquiring knowledge as well as about their own reactions to their new environment than is usually possible for male naturalists in colonial settings, whose work often focused on a particular field and passed through official channels.

The character of the sisters' painting was also influenced by their gender. As Ben Cartwright notes in his chapter, the themes of the watercolours in the *Madras Album* echo those of other contemporary paintings of Madras. But while images of "garden-houses" by soldier-artists are "flat" or "formal," the paintings Mary Symonds creates document the houses from within, lively with their inhabitants, including the servants. Similarly, when compared with the stock images showing different professions produced by Indian artists on mica later in the nineteenth century,[7] the images of the household servants are portraits of individuals. The intimate style of these images was partly a function of their expected audience: they were made to be displayed to friends and acquaintances in the drawing room of Symonds's sister Hester James, rather than commercially published or placed on public exhibition. In her close study of Symonds's miniature street scenes, Hana Nikčević similarly points out that Mary was using a specifically feminine form of craft to communicate her experience of Madras. Women's activities centred on the home could also have

far-reaching impacts. As Nathalie Cooke emphasizes, European women were crucial in creating the hybrid Anglo-Indian cuisine that eventually spread to other parts of the world. And as Toolika Gupta, Alexandra Kim, and Ann Wass show, women shaped both male and female fashion, creating demand for Indian fabrics and their British imitations. Victoria Dickenson's case study demonstrates how the colonial presence in India and the requirements of hospitality within this community generated a new and continuing market for English ceramics in a market previously dominated by Chinese export ware and local production.

As well as illuminating the sisters' own lives and work, Elizabeth Gwillim and Mary Symonds's letters and paintings can shed light on aspects of the environmental and social history of early nineteenth-century Madras. Vikram Bhatt and Vinita Damodaran demonstrate that the sisters' letters can provide information about the historical environment of Madras as well as about the climate and weather. With their family background in architecture, the sisters also paid unusual attention to local styles of construction and design, commenting on their suitability to the local climate. In terms of social history, Ben Cartwright, Jeffrey Spear, and Rosemary Rasa all note that the sisters had access to the world of Indian women, largely closed to European men. Although some of their descriptions are formulaic or stereotypical, others provide valuable information about, for example, the ornaments and dance steps of the devadasi and the lives of their own female servants.

EMPIRE AND THE GWILLIM ARCHIVE

The sisters' first-hand accounts provide access to a certain view of Madras and its social, cultural, and natural histories. Their voices are clear, but there are a multitude of other voices that can be heard only faintly in the correspondence. Throughout the project, conversations between members of the network raised questions about the work of Elizabeth Gwillim and Mary Symonds within the context of colonialism, of which they were agents and by which they were shaped. The sisters' perspectives were part of a broader colonial narrative, and we wanted to consider how the sisters participated in colonial structures, and how their observations were shaped by prevalent European tropes about India.

As earlier generations of scholars have noted, relying on the colonial archive is problematic, because colonial records are themselves part of the infrastructure of colonial power.[8] Studies of records in non-European languages, as well as material culture studies, have enriched and changed our perception of the colonial period, and the practice of scholarship.[9] Nonetheless, the colonial state generated a wealth of close documentation of Indian societies, often, as

Minakshi Menon notes in her case study, in response to colonial anxiety about the possibility of insurrection. These records sometimes provide the only means of recovering the voices of the least wealthy and powerful in colonial societies, even when they are "muffled" in reported speech or translation.[10] As a result, some historians have returned to the colonial archive, with the aim of reading it "against the grain," to extract information and perspectives that the original collectors of such information never intended to reveal.[11]

Reading against the grain also means to read without a sense of what is to come.[12] As historians began to read early colonial records without considering the transition to the Raj to be inevitable, they re-envisioned colonial regimes as more fragile and permeable, as shaped as much by local circumstances, interactions, and precedents as by European ideologies. This idea is central to the "new" imperial histories, which focus attention on the anxieties and uncertainties of colonial rule and argue that Europe itself was shaped by the colonial experience as much as the countries it colonized were.[13] Problems remain with these reformulations; as David Washbrook notes for South India, if we place too great an emphasis on the permeability of the colonial regime and its continuity with earlier forms of governance, it becomes hard to explain how "empire" came about at all.[14] From reading against the grain, therefore, some historians have turned to what Laura Ann Stoler has called reading "along the archival grain," teasing out from colonial archives the anxieties, fears, and divided affections and loyalties that lay behind colonial policy and social mores.[15]

The Gwillim and Symonds archives can be read both against and with the grain. Reading against the grain can mean retraining our focus on the local people who appear as tiny figures in the backgrounds of Gwillim's bird paintings or as subjects of Symonds's portraits. Several chapters and case studies in this volume focus on the clues that the correspondence and paintings provide about those who are present in them, but who were not fully recognized by their authors. The case study by Saraphina Masters shows that the bird catchers who held the birds in place, enabling Gwillim to produce her detailed rendering of feathers, were vital yet largely unrecognized actors in the natural history work the sisters produced. Similarly, Shyamal Lakshminarayanan and Hana Nikčević highlight the importance of the fishermen, artists, and translators who, along with Mary Symonds, produced knowledge about the fish, and the plant collectors, local physicians, and scholars who informed them about plants. Marika Sardar and A.J. Urfi's chapter puts these observations in a larger frame, by showing that natural history in colonial India was a culmination of traditions of observation and depiction that arose as much from India as from Europe.

Reading against the grain can also mean reading with our backs to the Raj that was to come. In Elizabeth Gwillim's and Mary Symonds's descriptions

and paintings, we can catch glimpses of the devadasi, yet resplendent, and the landscape, yet verdant, and the communities of weavers and artisans, still producing textiles of unrivalled quality, and we can imagine how things might have turned out differently. Reimagining in a practical sense – using aspects of the past to build new futures – is important, not only for historians but for people like food designer and network member Akash Muralidharan, who uses historical records in a quest to explore the diversity of local vegetables, described in the sisters' letters,[16] or for textile researchers who seek to recreate the fine and almost transparent Dacca muslin, shown in several of the *Madras Album* paintings.[17]

And what if we read along the grain? What can the Gwillim archive tell us about the uncertainties, fears, and contradictions of everyday life in a colonial settlement for the colonizers? As argued in the introduction, the period that the Gwillim/Symonds family spent in Madras was transformative, because during this time the British assumed political supremacy in the subcontinent. The Gwillim letters give us a close-up portrait of a society in which people were adjusting to this new reality of British power in India, in which new ideas of race and racial difference were being formed, but where Indian and European society was not separate, but still intermeshed; where families were mostly mixed; where Europeans were frequently financially indebted to Indians; and where naturalists and scholars sought patronage from Indian rulers as well as the EIC hierarchy.

In one of the passages in which she disparages local European society, Elizabeth Gwillim writes:

> Our scandal is not a whit more entertaining than that of an old Ladies tea table & ones only hopes is that it not more true Instead of hearing that an old lady stints her maid in bread & butter or gives the cold meat to the lap dog instead of a *Christian* we hear of one who has hanged up innocent Polygars & another who is haunted by the ghost of a Rajah & such like morning chat.[18]

Here, as in most of the correspondence, the violent struggles for supremacy between the Company and Indian rulers taking place around Madras appear only in passing; however, the passage reveals the guilt that was clearly felt by those involved in campaigns like that against "Poligars" and those who were "haunted" by the thoughts of the local rulers they had deposed.[19] And no wonder, for these local rulers were often former intimate acquaintances of the EIC's agents. Mary Symonds's description of hosting the nawab of Arcot for breakfast was typical of the everyday social interactions of Indian and European elites in this period. Perhaps these very feelings of guilt made it more likely that the Europeans

involved would gradually (and often partially) come to accept theories of racial difference and of the inferiority of Indian culture, even when these ideas were contradicted by their daily experiences and their knowledge of Indian history and culture, often gained through the study of Indian languages and texts.

In their letters, Elizabeth Gwillim and Mary Symonds displayed contradictory views about colonialism and about race. Like some of their contemporaries, they expressed ambivalent sentiments about the British presence in India. In 1804, one of the sisters wrote that, on first arriving in Madras,

> I thought it most awfull, wonderful it is certainly to see that we rule these people absolutely, & not a boat of ours can touch their shores without being dashed to atoms by the high surf, the planks of the boats with which they land us are sewed, together with threads of the Coacoa nut & are saved by yielding to the pressure but cou'd not be used by us, – yet here we are masters of the Soil – supported by their disunion & distractions.[20]

The passage highlights an awareness that British rule survived, not through any superiority, technological or societal, but only through taking sides in local conflicts. Nonetheless, by 1805, Elizabeth Gwillim apparently regarded British colonialism as inevitable and expressed her regret that the British did not seize Mauritius while they had the chance.[21]

As the chapters by Jeffrey Spear and Rosemary Raza both show, the sisters' experience in Madras made them dismissive of the idea that conversion to Christianity would be possible or desirable in India, and they both blamed the Vellore uprising largely on European meddling with Indian social customs. They were similarly unconvinced by the idea that Asian women were oppressed by their menfolk (a popular justification for European interventions in India social customs), Elizabeth quoting from an article by the traveller and author Mirza Abu Taleb Khan, who argued that elite Asian women enjoyed more liberties than their European counterparts.[22] On the other hand, as Spear and Raza also show, the sisters repeated tropes that were becoming central to Orientalist scholarship about both Hindu and Muslim society. Their ideas about Indian society were influenced not only by what they read by Orientalist scholars, but also by those around them in Madras, and their perspectives shifted according to these interactions. For example, Elizabeth Gwillim expressed negative opinions about "pariahs" (Paraiyars, part of the Dalit community),[23] which apparently reflected those of her high-caste interlocutors, including her dubash. She declared herself "half inclined to think with the Hindus of cast, that they cannot be good" and described them as "dirty, lazy, saucy, vicious & extravagant."[24] In the same letter, however, she expressed approval of her "pariah" maid, whom she referred to as

"Poppa" and described as honest, sober, and diligent.[25] Both sisters also made derisive comments about mixed-race women, despite the fact that Elizabeth Gwillim was close friends with Ann Young, James Anderson's daughter by his Indian partner.[26]

The contradictory impulses expressed in the letters illustrate how individuals in colonial societies were pulled in different directions by the genuine affections they developed for the people they interacted with daily and the discourses that became accepted as "common sense" in a colonial society that was struggling to rationalize the violence routinely visited on Indian people and societies. As Arthur MacGregor demonstrates, Elizabeth and Henry Gwillim were highly critical of the abuses of power by the EIC and its members that they perceived around them in Madras, and they sought refuge in the social circles of naturalists and scholars. Nevertheless, the Gwillims supported a liberal protectionist form of British rule in India. The irony is that Henry's alienation and final expulsion from the settlement for his attempts to uphold British justice in the face of Company despotism illustrate just how impossible that vision was.

The observations of plants and animals described in the sisters' letters and depicted in their watercolours reflected a view of nature that was also pulled in different and sometimes opposing directions. Elizabeth Gwillim was preoccupied with naming and grouping the plants and animals her servants and others collected for her, in line with the practices of classification that dominated European natural history in the eighteenth century. She had access to a botanical library and Miller's *Gardener's Dictionary* as well as Buffon's *Natural History* and she assigned generic or binomial Latin names to birds, mammals and plants. At the same time, she consulted local Brahmins for Sanskrit names and her servants for the Telugu or Tamil names, as did many naturalists of the period. As is clear from Henry Noltie's chapter, it was Gwillim's desire to learn Telugu that led her to study botany.[27]

European botany was not, however, the only way to know plants. Through her study, Gwillim glimpsed a very different view of nature, which she attempted to reconcile with European norms. Like other Orientalist scholars, she did so by comparing it with an earlier stage of European science, writing that "their mode of studying Botany differs from our's at least our modern mode" and concluding that "their books & descriptions are exactly in the stile of Culpepper. & a plant is seldom selected as a remedy for any natural quality but for the influence which some Planet is supposed to have over it." Nicholas Culpeper first published his herbal, *The English Physician*, in 1652,[28] intending to offer ordinary people access to herbal remedies based on common plants in the English countryside.[29] Gwillim herself evidently knew the herbal, but, as she sought to understand the plants of the Madras countryside, she rejected

both Indian and older European ways of knowing in favour of the "modern mode" – the system of classification of plants developed by Carl Linnaeus, based largely on morphology.[30]

Influenced by the Orientalists and contemporary European physicians, Elizabeth Gwillim also relegated Indian medical knowledge to a static and superstitious culture. While local people "have many excellent medicine amongst their Vegetables & which they apply frequently with great success," she thought that "they have formed no notion how the qualities of vegetables act on the human body." Lourdusamy suggests that Europeans like Gwillim, despite her acute observations, assumed that Indian naturalists and healers could not possibly have underlying theories, only rough trial-and-error methods. She wrote that the Indian physicians "divide all diseases into hot & cold & certain plants are supposed to be suited to cool & others to warm," and remarked wryly that, though " an English Physician wou'd neither agree with them as to the nature of the disorder or the power of the herb," they were successful in their practice, since "their experience is better than their reasoning."[31] While Gwillim acknowledged that "indeed there is a knowledge of Plants even amongst the lowest of the people that shews a great attention to the productions of nature," she could not see this knowledge as equivalent to the European "modern mode" of knowing.

NETWORKS OF EXCHANGE, PAST AND PRESENT

This book is the culmination of the collaborative work of a remarkable network of researchers in Canada, India, Britain, and the United States, who formed around the Gwillim Project at McGill University in Montreal. Inspired by the sisters' own webs of connection with ship's surgeons, gardeners, botanists, East India Company employees, friends, and relations, we proposed that the best way to approach this study was through an international multidisciplinary network of researchers. The project had already begun informally with just such a collaboration between a historian in Montreal, a literary scholar in New York, and an ornithologist in Bengaluru. All had examined the Gwillim watercolours at McGill and saw the potential for further study.[32] Their conversations led us to study not only Elizabeth Gwillim's natural history watercolours in Montreal, but also the sisters' correspondence at the British Library, and the paintings by Mary Symonds in the *Madras Album* held by the South Asia Collection Museum in Norwich.[33] In 2019, thanks to this collaboration, the Gwillim Project received funding from the Social Sciences and Humanities Research Council of Canada, and later from the Shastri Indo-Canadian Institute and the Paul Mellon Centre for Studies in British Art. The funding

enabled us not only to create a virtual Gwillim archive, but also to connect the network to the online archive. Over the course of the project, the network grew to include historians, botanists, ornithologists and ichthyologists, art and dress historians, researchers in architectural and environmental history, culinary historians and food designers, geographers, librarians, curators, and archivists. The research funding also enabled us to engage a team of enthusiastic students in information studies, history, and art history.

Elizabeth Gwillim and Mary Symonds managed their networks in India and England through the exchange of letters; the project used a virtual platform to make text and images accessible to all participants. We acquired scans of over 700 pages of the sisters' correspondence held by the British Library (MSS Eur C240).[34] These letters were transcribed by McGill students, with assistance from experts in the network who explained archaic dress terms, translated the sisters' phonetic rendition of Tamil or Telugu words, identified sketches of animals, and created finding aids. Network members also examined the over 200 watercolours, identifying birds, fish, and flowers, providing contemporary scientific names, and pinpointing the locations of temples and landmarks.[35] Plans for a symposium in Montreal to share preliminary findings were disrupted by the advent of the global pandemic in spring 2020; so, the project turned to an online format, which provided the opportunity not only for the members of the network to present their findings, but also attracted new and wider interest in the project.[36] The Gwillim Project Online, a series of nine webinars held over the course of 2020, has formed the basis for many of the chapters and case studies collected in this book. Collaborations flourished, as network members found others who shared their interests but approached the material from a different disciplinary background. As our comfort with working online grew, co-authors who never met in person chatted regularly over video-conferencing platforms, worked on widely dispersed physical materials hosted in the digital archive, and wrote together using file-sharing technologies.

A planned series of international study visits and in-person events in Montreal and Toronto were cancelled as a result of the pandemic; we channelled our travel funding, particularly that received from the Shastri Indo-Canadian Institute, toward local events in Chennai, coordinated by network members at the Dakshina Chitra Museum and the Indian Institute of Technology (IIT) Madras. These events expanded the reach of the project beyond an academic audience, connecting with schoolchildren, university students, local historians, and birding enthusiasts, and generating local media coverage. Although we missed the informal aspects of conferences and regular in-person meetings with colleagues, our digital and local networks were, in many ways, closer and more inclusive, as well as more environmentally friendly, than more traditional forms of collaboration. They constituted a lesson for the future.

FUTURE DIRECTIONS

Elizabeth Gwillim and Mary Symonds left an engaging and often surprising record of their experiences during the short time they lived in Madras. Their responses to India were conditioned by the cultural influences they experienced in Britain before their arrival and by both the settler and Indian societies with which they engaged in Madras. Their close observation of the natural world and social life in India was enabled by a freedom of movement and social intercourse that would be increasingly limited to European women in India over the course of the nineteenth century.[37] That their letters and paintings were not broadly disseminated in their own time was the result of both accident and cultural indifference. Elizabeth Gwillim's untimely death and her family's seeming lack of interest in her scientific legacy are not surprising; what is remarkable is that any of the sisters' works survived at all. Thanks to the multidisciplinary and multi-perspectival readings of these materials by the members of the network, we have come to an appreciation of what records like these can and cannot do. Taken at face value, they can tell us a good deal about English women's experience in a particular time and place, but not much about that time and that place as experienced by the local people among whom they lived.

Yet, reading the records both against and with the grain, as the members of the network did, opens new paths of inquiry, which have taken us to unexpected places. Prompted partly by the work of our research assistants, we focused closely on the images of the bird catchers and fishermen and the descriptions accompanying them and considered their importance to the sisters' study of natural history. This inspired our new project, "Hidden Hands in Colonial Natural History Collections,"[38] which looks at three collections ascribed to European men or women in French or British colonial settings between the late eighteenth and early nineteenth centuries. In each survive traces of other hands and minds – those of the people who selected local plants, supplied local names and knowledge, caught and observed birds and fish and animals and prepared them for drawing, or produced the drawings themselves. The final collection, of Sri Lanka healing artifacts and texts, provides a slightly different challenge: how can we reread ethnographic collections, often placed within natural history museums, as different perspectives on the natural world of the period? This project is also a partnership and a collaboration, with an extensive research network that brings together participants from Canada, Haiti, India, and Sri Lanka. We hope that, as with the Gwillim Project, the connections and conversations between members of the network will yield new perspectives on the materials, foster new insights, and lead to new ways of working together over distance and discipline.

Notes

1 On science, see Fara, *Pandora's Breeches* and Shteir, *Cultivating Women*; on empire, see Raza, *In Their Own Words*.

2 Some exceptions include Guelke and Morin, "Gender, Nature, Empire," and Thompson, "Women Travellers."

3 Elizabeth Gwillim to Esther Symonds, 17 October 1801, British Library, India Office Records (BL IOR) Mss.Eur.C.240/1, on ff. 19r–19v.

4 Elizabeth Gwillim to Hester James, 24 August 1805, BL IOR Mss.Eur.C.240/4, ff. 297r–298v.

5 A. Stone to Elizabeth Gwillim, 9 July 1805, BL IOR Mss.Eur.C.240/4, ff. 267r–270v.

6 On the idea of "improvement" in colonial botany, see Drayton, *Nature's Government*.

7 On the mica paintings, see Archer, *Company Paintings*.

8 A recent study that looks at archives as a source of EIC power is Raman, *Document Raj*.

9 Pollock, *Forms of Knowledge in Early Modern Asia*.

10 Ballantyne, "Archives, Empires, and Histories of Colonialism."

11 For reading "against the grain" in postcolonial thought, see Spivak, "Introduction," in Guha and Spivak, *Selected Subaltern Studies*. And for a recent summary of approaches to reading colonial archives to uncover subaltern lives, see Sowry, "Silence, Accessibility, and Reading against the Grain."

12 Walter Benjamin (who was perhaps the first to use the phrase) employs the idea of "brushing against the grain of history" in this way in his essay "On the Concept of History," in Benjamin, *Walter Benjamin: Selected Writings*, 4: 389–400.

13 Wilson, *A New Imperial History*.

14 Washbrook, "South India, 1770–1840."

15 Stoler, *Along the Archival Grain*.

16 Muralidharan, "A Kitchen in Nineteenth-Century Madras."

17 See, for example, the work of the Textiles & Clothing Research Centre (https://www.tcrc.in/).

18 Elizabeth Gwillim to Esther Symonds, 7 March 1804, BL IOR Mss.Eur.C.240/3, ff. 184r–192v, on f. 191r.

19 "Poligar" is from *palaiyakkarar*, a chieftain or "little king." For a recent account of the hanging of several Poligar leaders, see Yang, "Bandits and Kings." For a similar point about colonial guilt, see Doniger, "'I Have Scinde.'"

20 [Mary Symonds or Elizabeth Gwillim] to unknown recipient, 10 February 1804, BL IOR Mss.Eur.C.240/3, ff. 212r–216v, on f. 214v.

21 Elizabeth Gwillim to Hester James, 24 August 1805, Mss.Eur.C.240/4, ff. 279r–296v, on f. 281r.

22 Khan, "Vindication of the Liberties of the Asiatic Women." For a recent discussion of Abu Talib and this text, see Sivasundaram, *Waves across the South*, 27–33.

23 The word "pariah" is now widely considered to be a derogatory term.

24 Elizabeth Gwillim to Esther Symonds, 12 October 1804, BL IOR Mss.Eur.C.240/3, ff. 217r–228v, on ff. 225v and 218r. See also Cartwright, *Different Idea of India*, 43.

25 Ibid., f. 220v.

26 Elizabeth Gwillim to Hester James, 24 August 1805, BL IOR Mss.Eur.C.240/4, ff. 279r–296v, on f. 292v.

27 Elizabeth Gwillim to Hester James, 6 March 1805, BL IOR, Mss.Eur.C.240/4, ff. 258r–266r on f. 264r.

28 Culpeper, *The English Physician Enlarged*, 4.

29 The book was still in print in the late eighteenth century and was used, as the botanist Richard Pulteney noted in 1790, by "the good ladies in the country." Pulteney, *Historical and Biographical Sketches*, I: 80–1.

30 Linnaeus's system of nature helped naturalists group plants, but he acknowledged that his system was artificial, since a natural system was lacking.

31 Elizabeth Gwillim to Esther Symonds, 20–21 October 1803, BL IOR, Mss.Eur.C.240/2, ff. 154r–159v, on f. 157r.

32 Professor Suryanarayana Subramanya had written on Gwillim as a bird artist ("Paintings of Indian Birds by Lady Elizabeth Gwillim"); Professor Jeffrey Spear of NYU used Gwillim's description of the devadasi in his article "Gods and Dancing Girls"; Professor Victoria Dickenson works in the Blacker Wood Collection and instigated the Gwillim Project.

33 The Gwillim natural history illustrations had originally been catalogued by McGill librarian Eleanor MacLean and digitized by McGill with funding from Professor Jeffrey Spear. Spear located the correspondence in the British Library with the help of a Canadian researcher, the late Dr Rosemary Ruddell. Her daughter, Jane

Ruddell, now archivist at the Mercers Union in London, kindly provided her mother's notes and transcriptions of the letters to the project. The *Madras Album* was acquired by the South Asia Collection Museum in Norwich in 2007 from an auction at Christies. The then curator, Dr Ben Cartwright, became an early member of the network.

34 The team applied for and received an Orphan Works License OWLS000203, which permitted the distribution of the Gwillim correspondence held by the British Library.

35 Suryanarayana Subramanya co-ordinated the identification of the birds painted by Gwillim; Shyamal Lakshminarayanan, working with scientists from the ICAR-Central Marine Fisheries Research Institute, identified the fish; and Dr Henry Noltie of the Edinburgh Botanical Garden examined the flower paintings. Professors Vikram Bhatt and Vinita Damodaran located buildings and rivers, with the collaboration of Rekha Vijayashankar and Dr Deborah Thiagarajan of the Dakshina Chitra Museum in Chennai.

36 The presentations in the Gwillim Project online (https://www.youtube.com/channel/UCpOChk_PyUWcmdYGgXkpVmA) have been viewed thousands of times.

37 Raza, *In Their Own Words*.

38 Funded by SSHRC, 2022–25.

Bibliography

Achaya, K.T. *Indian Food Tradition: A Historical Companion*. Delhi: Oxford University Press, 1994.

Agoramoorthy, G. "Disallow Caste Discrimination in Biological and Social Context." *Current Science* 89 (2005): 727.

Ahmad, Saleem. "Porcelain in Medieval India: Finds from Some Important Excavations." *Proceedings of the Indian History Congress* 66 (2005): 1445–9.

Ainslie, Whitelaw. *The Materia Medica of Hindoostan*. Madras: Government Press, 1813.

Albin, Eleazar. *A Natural History of Birds: Illustrated with a Hundred and One Copper Plates, Curiously Engraven from Life*. 3 vols. London: William Innys, John Clarke and John Brindley, 1713–1738.

Ali, Mrs Meer Hassan. *Observations on the Mussulmauns of India: Descriptive of Their Manners, Customs, Habits and Religious Opinions. Made during a Twelve Years' Residence in Their Immediate Society*. London: Parbury, Allen, 1832.

Ali, Salim. *The Illustrated Salim Ali: The Fall of a Sparrow*. Oxford: Oxford University Press, 2008.

– "The Mughal Emperors of India as Naturalists and Sportsmen." *Journal of the Bombay Natural History Society* 31, no. 4 (1927): 833–61; 32, no. 1 (1928): 34–64; 32, no. 2 (1928): 264–73.

– *Ornithology in India: Its Past, Present and Future*. Sunder Lal Hora Memorial Lecture, INSA, New Delhi, 1971.

Ali, Salim, and S.D. Ripley. *Handbook of the Birds of India and Pakistan: Together with Those of Bangladesh, Nepal, Bhutan and Sri Lanka*. New Delhi: Oxford University Press, 2001.

Ali, Salim, and Carl D. Silva. *The Book of Indian Birds*. Bombay: Natural History Society, 2002.

Allan, R.J., C.J.C. Reason, P. Carroll, and P.D. Jones. "A Reconstruction of Madras (Chennai) Mean Sea Level Pressure Using Instrumental Records from the Late 18th and Early 19th Centuries." *International Journal of Climatology* 22 (2002): 1119–42.

'Allami, Abu'l Fazl. *The Ain-i Akbari*. Vol. 1. Translated by H. Blochmann. Calcutta: Asiatic Society of Bengal, 1878.

Almeida, Hermione de, and George H. Gilpin. *Indian Renaissance: British Romantic Art and the Prospect of India*. Burlington: Ashgate, 2005.

Altick, Richard. *The Shows of London*. Cambridge, MA: Belknap Press of Harvard University Press, 1978.

Alvi, M.A. "Jahangir's Passion for Exotic Animals," in Verma, *Flora and Fauna in Mughal Art*, 83–93.

Alvi, M.A., and A. Rahman. *Jahangir the Naturalist*. New Delhi: National Institute of Sciences of India, 1968.

Andrews, Henry. "Magnolia Pumila." *Botanist's Repository* 4 (1802): plate 226.

Appadurai, Arjun. "Right- and Left-Hand Castes in South India." *Indian Economic and Social History Review* 11 (1974): 216–59.

Archer, Mildred. *Company Paintings: Indian Paintings of the British Period*. London: Victoria and Albert Museum, 1992.

– *Early Views of India: The Picturesque Journeys of Thomas and William Daniell, 1786–1794: The Complete Aquatints*. London: Thames and Hudson, 1980.

– *India and British Portraiture*. London: Sotheby Parke Bernet, 1979.

– *Natural History Drawings in the India Office Library*. Her Majesty's Stationery Office, 1962.

Arnold, David. "The Travelling Eye: British Women in Early Nineteenth-Century India." In *British Women and Cultural Practices of Empire, 1770–1940*, edited by Rosie Dias and Kate Smith, 35–6. London: Bloomsbury Visual Arts, 2018.

– *The Tropics and the Travelling Gaze: India, Landscape and Science*. Seattle: University of Washington Press, 2005.

Aronson, J., and E. Wiesman, eds. *Perfect Likeness: European and American Portrait Miniatures from the Cincinnati Art Museum*. New Haven, CT: Yale University Press, 2006.

Ashmore, Sonia. *Muslin*. London: V&A Publications, 2012.

A.U. *Overland, Inland and Upland: A Lady's Notes of Personal Observation and Adventure*. London: Seeley, 1873.

Audubon, J. James. *The Birds of America*. London: Printed for the author, 1827–39.

Austen, Jane. *Mansfield Park*. 1814. Edited by Claudia L. Johnson. New York: Norton, 1998.

Axelby, Richard. "Calcutta Botanic Garden and the Colonial Re-Ordering of the Indian Environment." *Archives of Natural History* 35, no. 1 (2008): 150–63.

Babur. *Baburnama*. Translated and edited by Wheeler M. Thackston. Oxford: Oxford University Press, 1996.

Bachelard, Gaston. *The Poetics of Space*. Boston: Beacon Press, 1969.

Bagchi, Anita, and Prithwiraj Jha. "Fish and Fisheries in Indian Heritage and Development of Pisciculture in India." *Reviews in Fisheries Science* 19, no. 2 (2011): 85–118.

Balasubramaniam, C. "Etched Black Pottery from Azamgarh, Nizamabad, India." *Ceramics Technical* 20, no. 38 (2014): 56–9.

Balfour, E., ed. *Cyclopedia of India and of Eastern and Southern Asia, Commercial, Industrial and Scientific: Products of the Mineral, Vegetable and Animal Kingdoms, Useful Arts and Manufactures*. Madras: Scottish and Adelphi Presses, 1871.

Ballantyne, Tony. "Archives, Empires, and Histories of Colonialism." *Archifacts* (2004): 21–36.

Basu, Raj Sekhar. *Nandanar's Children: The Paraiyans' Tryst with Destiny, Tamil Nadu, 1850–1956*. New Delhi: Sage, 2011.

Basu, Susan Neild. "The Dubashes of Madras." *Modern Asian Studies* 18, no. 1 (1984): 1–31.

– "Madras in 1800: Perceiving the City." *Studies in the History of Art* 31 (1993): 221–40.

Batsaki, Yota, Sarah Burke Cahalan, and Anatole Tchikine, eds. *The Botany of Empire in the Long Eighteenth Century*. Washington, DC: Dumbarton Oak Research Library and Collection, 2016.

Bayly, C.A. *The Birth of the Modern World, 1780–1914: Global Connections and Comparisons*. Oxford: Blackwell, 2004.

– *Empire and Information: Intelligence Gathering and Social Communication in India, 1780–1870*. Cambridge: Cambridge University Press, 1999.

Bayly, Susan. *Saints, Goddesses and Kings: Muslims and Christians in South Indian Society, 1700–1900*. Cambridge: Cambridge University Press, 2004.

Belnos, Sophia. *The Sundhaya, or the Daily Prayers of the Brahmins*. London: Day & Son, 1851.

Benjamin, Walter. *Walter Benjamin: Selected Writings*. Vol. 4, *1938–1940*. Cambridge, MA: Belknap Press of Harvard University Press, 2006.

Berg, Maxine. *Luxury and Pleasure in Eighteenth-Century Britain*. Oxford: Oxford University Press, 2007.

Berg, Maxine, and Elizabeth Eger, eds. *Luxury in the Eighteenth Century*. Basingstoke, UK: Palgrave, 2001.

Bermingham, Ann. "Girtin's Sketching Club." *Oxford Dictionary of National Biography*, 2007. doi.org/10.1093/ref:odnb/96319.

– "Technologies of Illusion: De Loutherbourg's Eidophusikon in Eighteenth Century London." *Art History* 39, no. 2 (2016): 376–99.

Bewick, Thomas. *A History of British Birds*, 2nd ed. Printed by Sol. Hodgson, for Beilby & Bewick, 1798.

Bhabha, Homi K. *The Location of Culture*. New York: Routledge, 1994.

Bhaduri, J.L., K.K. Tiwari, and B. Biswas. "Zoology." In *A Concise History of Science in India*, edited by D.M. Bose, S.N. Sen, and B.V. Subbarayappa, 403–44. New Delhi: Indian National Science Academy, 1971.

Bickham, Troy. "Eating the Empire: Intersections of Food, Cookery and Imperialism in Eighteenth-Century Britain." *Past and Present* 198, no. 1 (2008): 71–109.

Blakey, Dorothy. *The Minerva Press, 1790–1820*. London: Printed for the Bibliographical Society at the University Press, 1986.

Boddaert, Pieter. *Table des planches enluminéez d'histoire naturelle de M. D'Aubenton ...* Utrecht, 1783.

Bor, Joep. "Mamia, Ammani and other *Bayadères*: Europe's Portrayal of India's Temple Dancers." In *Music and Orientalism in the British Empire, 1780s–1940s: Portrayal of the East*, edited by Martin Clayton and Bennett Zon, 39–70. Aldershot, UK: Ashgate, 2007.

Bowen, H.V. *The Business of Empire: The East India Company and Imperial Britain, 1756–1833*. Cambridge: Cambridge University Press, 2006.

– "Privilege and Profit: Commanders of East Indiamen as Private Traders, Entrepreneurs and Smugglers, 1760–1813." *International Journal of Maritime History* 19, no. 2 (2007): 43–88.

Britten, James. "Notes on Mesembryanthemum." *Journal of Botany* 55 (1917): 65–74.

Brompton Botanic Gardens. *A Catalogue of the Brompton Botanic Garden: Containing Hardy Plants*. London: W. Bulmer & Co., 1803.

Brown, Patricia. *Anglo-Indian Food and Customs*. Bloomington, IN: iUniverse, 2008.

Browne, M. *Practical Taxidermy: A Manual of Instruction to the Amateur in Collecting, Preserving, and Setting up Natural History Specimens*. London: L. Upcott Gill, 2015.

Buchanan-Hamilton, Francis. *An Account of the Fishes Found in the River Ganges and Its Branches*. Edinburgh: Printed for Archibald Constable and Company, 1822.

– *A Journey from Madras through the Countries of Mysore, Canara and Malabar*. London: T. Cadell & W. Davies / Black, Parry & Kingsbury, 1807.

Buettner, Elizabeth, "'Going for an Indian': South Asian Restaurants and the Limits of Multiculturalism in Britain." *Journal of Modern History* 80, no. 4 (2008): 865–901.

Buffon, Georges-Louis Leclerc. *Histoire naturelle des oiseaux*, Vol. 14. Paris: De l'Imprimerie royale, 1780.

Buffon, Georges-Louis Leclerc, François-Nicolas Martinet, Edme-Louis Daubenton, and Louis-Jean-Marie Daubenton. "Heron, de la côte de Coromandel." *Planches enluminées d'histoire naturelle*. Vol. 10. Paris: De l'Imprimerie Royale,1765.

Bukund, Kanakalatha. *The View from Below: Indigenous Temples and the Early Colonial State in Tamil Nadu, 1700–1835*. New Delhi: Orient Longman, 2005.

Burke, Edmund. *A Philosophical Enquiry into the Origin of Our Ideas of the Sublime and the Beautiful*. London: Dodsley, 1757.

Burton, David. *The Raj at Table: A Culinary History of the British in India*. New Delhi: Rupa & Co., 1993.

Butterworth, William John. *The Madras Road-Book*. Madras: Edmund Marsden at the Asylum Press, 1839.

Byrne, Angela. *Geographies of the Romantic North: Science, Antiquarianism, and Travel, 1790–1830*. New York: Palgrave Macmillan, 2013.

Calcott, Wellins. *A Collection of Thoughts, Moral and Divine: Upon Various Subjects, in Prose*, 6th ed. London: Printed for the Author, 1766.

Campbell, George, and W.W. Hunter. *Extracts from the Records in the India Office Relating to Famines in India, 1769–1788*. Calcutta: Office of Superintendent of Government Printing, 1868.

Candolle, A.P. de. *Regni Vegetabilis Systema Naturale*. 2 vols. Paris: Treuttel & Würtz, 1817–21.

Cannon, Garland, and Siddheshwar Pandey. "Sir William Jones Revisited: On His Translation of the Śakuntalā." *Journal of the American Oriental Society* 96, no. 4 (1976): 528–35.

Carson, Penelope. *The East India Company and Religion*. Woodbridge, UK: Boydell & Brewer, 2012.

Cartwright, Ben. *A Different Idea of India: Two Sisters Painting Southern India, 1801–1808*. Norwich, UK: South Asia Collection Museum, 2022.

Catesby, Mark. *The Natural History of Carolina, Florida and the Bahama Islands*. London: Printed for the author, 1729, 1777.

Chandra Babu, B.S. "A Study of the Factors that Led to the Outbreak of Famines in Chingleput District of Tamilnadu during the Nineteenth Century." *Social Scientist* 16 (1998): 3–25.

Chatterjee, Amal. *Representations of India, 1740–1840: The Creation of India in the Colonial Imagination*. Basingstoke, UK: Macmillan, 1998.

Clarke, Michael. *The Arrogant Connoisseur: Richard Payne Knight, 1751–1824*. Manchester: Manchester University Press, 1982.

Clements, James. *The Clements Checklist of the Birds of the World*. 6th ed. Ithaca, NY: Cornell University Press, 2007.

Clemons, Eliza. *The Manners and Customs of Society in India ... To Which Are Added, Instructions for the Guidance of Cadets and Other Young Gentlemen*. London, Smith: Elder & Co, 1841.

Clerk, George R., and D.A. Bannerman. "Obituary: William Lutley Sclater." *Geographical Journal* 104, nos 1/2 (1944): 68–9.

Clive, Henrietta. *Birds of Passage: Henrietta Clive's Travels in South India 1798–1801*. Edited by Nancy K. Shields. London: Eland, 2009.

Cocks, Raymond. "Social Rules and Legal Rights: Three Women in Early Nineteenth-Century India." *Journal of Legal History* 23, no. 77 (2002): 77–106.

Cohen, Michèle. "'A Little Learning'? The Curriculum and the Construction of Gender Difference in the Long Eighteenth Century." *Journal for Eighteenth-Century Studies* 29, no. 3 (2006): 321–35.

Cohen-Vrignaud, Gerard. *Radical Orientalism: Rights, Reform, and Romanticism*. Cambridge: Cambridge University Press, 2015.

Cole, Frances. "*Cerbera Tanguin*: Poison Tanghin." *Curtis's Botanical Magazine* 57 (1830): tab. 2967.

Cole, Juan. *Napoleon's Egypt: Invading the Middle East*. New York: Palgrave Macmillan, 2008.

Collar, Nigel J., ed. *Threatened Birds of Asia: The BirdLife International Red Data Book*. Cambridge: BirdLife International, 2002.

Collingham, Elizabeth M. *Curry: A Tale of Cooks and Conquerors*. New York: Oxford University Press, 2006.

– *Imperial Bodies: The Physical Experience of the Raj, 1800–1947*. Oxford: Polity Press, 2001.

Conner, P. "The Poet's Eye: The Intimate Landscape of George Chinnery." In *Under the Indian Sun: British Landscape Artists*, edited by P. Rohatgi and P. Godrej, 67–80. New Delhi: Marg Publications, 1995.

Contadini, Anna. "A Bestiary Tale: Text and Image of the Unicorn in the Kitāb Naʿt al-Hayawān (British Library, or. 2784)." *Muqarnas* 20 (2003): 17–33.

– "The Kitab Manafiʿ al-Hayawan in the Escorial Library." *Islamic Art* 3 (1989): 33–58.

Cooper, Randolf G.S. *The Anglo-Maratha Campaigns and the Contest for India*. Cambridge: Cambridge University Press, 2003.

Culpeper, Nicholas. *Culpeper's Complete Herbal*. London: Milner & Co., n.d.

– *The English Physician Enlarged* [1653]. London: Folio Society, 2008.

Dalgairns, Catherine. *The Practice of Cookery, Adapted to the Business of Everyday Life*. Edinburgh: Cadell & Co., 1829.

Dalrymple, William. *The Anarchy: The Relentless Rise of the East India Company*. New York: Bloomsbury Publishing, 2019.

– ed. *Forgotten Masters: Indian Painting for the East India Company*. London: Philip Wilson, 2019.

– "Paintings for the East India Company." In Dalrymple, *Forgotten Masters*, 9–23.

– *White Mughals*. New York: Viking Penguin, 2002.

Damodaran, Vinita. "The 1780s: Global Climate Anomalies, Floods, Droughts and Famines." In *Palgrave Handbook of Climate History*, edited by Sam White, 517–50. London: Palgrave, 2018.

Damodaran, Vinita, Anna Winterbottom, and Alan Lester, eds. *The East India Company and the Natural World*. Basingstoke, UK: Palgrave Macmillan, 2015.

Damrosch, D., ed. *World Literature in Theory*. Hoboken, NJ: John Wiley & Sons, 2014.

Daniell, Thomas, and William Daniell. *Oriental Scenery*. London: Robert Bowyer, 1795–1808.

– *A Picturesque Voyage to India: By the Way of China*. London: Longman, Hurst, Rees, and Orme, 1810.

Daniélou, Alain. *The Myths and Gods of India: The Classic Work on Hindu Polytheism*. Rochester, VT: Inner Traditions / Bear & Co., 1991.

Das, Asok Kumar. *Wonders of Nature: Ustad Mansur at the Mughal Court*. Mumbai: Marg Publications, 2012.

Dave, K.N. *Birds in Sanskrit Literature*. New Delhi: Motilal Banarsidass, 1985.

Davidson, Hilary. *Dress in the Age of Jane Austen: Regency Fashion*. New Haven, CT: Yale University Press, 2019.

Day, Francis. *Fishes: The Fauna of British India, Including Ceylon and Burma*, edited by W.T. Blanford. 2 vols. London: Taylor and Francis, 1889.

– *The Fishes of India; Being a Natural History of the Fishes Known to Inhabit the Seas and Fresh Waters of India, Burma, and Ceylon*. London: B. Quaritch, 1875–78.

– *The Fishes of Malabar*. London: Bernard Quaritch, 1865.

Deane, Ann. *A Tour through the Upper Provinces of Hindostan; Comprising a Period between 1804 and 1814*. London: Rivington, 1823.

Deb Roy, Rohan. "White Ants, Empire, and Entomo-Politics in South Asia." *Historical Journal* 63, no. 2 (2020): 411–36.

Delbourgo, James. *Collecting the World: Hans Sloane and the Origins of the British Museum*. Cambridge, MA: Harvard University Press, 2018.

De Ritter, Richard. "'Wonderful Objects' and 'Disagreeable Operations': Encountering the Leverian Museum in Writing for Children, 1800–05." *Journal for Eighteenth-Century Studies* 41, no. 33 (2018): 427–45.

Desmond, Ray. *The India Museum, 1801–1879*. London: Her Majesty's Stationery Office, 1982.

Dias, Rosie. "Memory and the Aesthetics of Military Experience: Viewing the Landscape of the Anglo-Mysore Wars." *Tate Papers* 19 (2013).

– "Recording and Representing India: The East India Company's Landscape Practices." British Library, Picturing Places, n.d. https://www.bl.uk/picturing-places/articles/recording-and-representing-india.

Dickenson, Victoria. "Lady Gwillim and the Birds of Madras." *Notes and Records: The Royal Society Journal of the History of Science*. Published online, 28 September 2022, https://doi.org/10.1098/rsnr.2022.0029.

Dirks, Nicholas B. *Castes of Mind: Colonialism and the Making of Modern India*. Princeton, NJ: Princeton University Press, 2001.

Dodson, Michael S. *Orientalism, Empire, and National Culture: India, 1770–1880*. Basingstoke, UK: Palgrave Macmillan, 2007.

Doniger, Wendy. "'I Have Scinde': Flogging a Dead (White Male Orientalist) Horse." *Journal of Asian Studies* 58 (1999): 940–60.

Drayton, Richard. *Nature's Government: Science, Imperial Britain, and the "Improvement" of the World*. New Haven, CT: Yale University Press, 2000.

Driver, Elizabeth. *A Bibliography of Cookery Books Published in Britain, 1875–1914*. London: Prospect Books, 1989.

Driver, F., and L. Martins. "John Septimus Roe and the Art of Navigation, c.1815–1830." *History Workshop Journal* 54, no. 1 (2002): 144–61.

Dutta, Sutapa. "The Memsahibs' Gaze: Representation of the Zenana in India." In *British Women Travellers: Empire and Beyond, 1770–1870*, edited by Sutapa Dutta, 120–36. London: Routledge, 2019.

Easterby-Smith, Sarah. *Cultivating Commerce: Cultures of Botany in Britain and France, 1760–1815*. Cambridge: Cambridge University Press, 2017.

– "On Diplomacy and Botanical Gifts: France, Mysore and Mauritius in 1788." In *The Botany of Empire in the Long Eighteenth Century*, edited by Yota Batsaki, Sarah Burke Cahalan, and Anotole Tchikine, 193–212. Washington, DC: Dumbarton Oak Research Library and Collection, 2016.

Eden, Emily. *Letters from India*. London: R. Bentley, 1872.

– *Up the Country: Letters Written to Her Sister from the Upper Provinces of India*. London: Virago, 1983.

Edwards, George. *Gleanings of Natural History*. Parts 1–3. London: Printed for author at the Royal College of Physicians, 1758.

– *A Natural History of Uncommon Birds*. Parts 1–4, published in 2 vols. London: Royal College of Physicians, 1743–51.

Ehrlich, Joshua. "Plunder and Prestige: Tipu Sultan's Library and the Making of British India." *South Asia: Journal of South Asian Studies* 43, no. 3 (2020): 478–92.

Ekarius, C. *Storey's Illustrated Guide to Poultry Breeds*. North Adams, MA: Storey Publishing, 2007.

Elvin, Mark. *The Retreat of the Elephants: An Environmental History of China*. New Haven, CT: Yale University Press, 2004.

Elwood, Anne. *Narrative of a Journey Overland from England ... to India; Including a Residence There*. London: H. Colburn & Richard Bentley, 1830.

Evenson, Norma. *The Indian Metropolis: A View toward the West*. New Haven: Yale University Press, 1989.

Fabricius, Johann Philipp. *J.P. Fabricius's Tamil and English Dictionary*. 4th ed., rev. and enl. Tranquebar: Evangelical Lutheran Mission Pub. House, 1972.

Fara, Patricia. *Pandora's Breeches: Women, Science and Power in the Enlightenment*. London: Pimlico, 2004.

Farber, P.L. "The Development of Taxidermy and the History of Ornithology." *Isis* 68, no. 4 (1977): 550–66.

Fay, Eliza. *The Original Letters from India of Mrs. Eliza Fay*. Calcutta: Thacker, Spink & Co., 1908.

Ferguson, Donald William. "Joan Gideon Loten F.R.S.: The Naturalist Governor of Ceylon (1752–57), and the Ceylonese Artist de Bevere." *Journal of the Ceylon Branch of the Royal Asiatic Society* 19 (1907): 217–71.

Ferguson, Priscilla Parkhurst. *Accounting for Taste: A Triumph of French Cuisine*. Chicago: University of Chicago Press, 2004.

Finn, Frank. *Garden and Aviary Birds of India*. Calcutta: Thacker and Spink, 1907.

Foltz, Richard C. *Animals in Islamic Tradition and Muslim Cultures*. Oxford: OneWorld Publications, 2006.

Forbes, James. *Oriental Memoirs: Selected and Abridged from a Series of Familiar Letters Written during Seventeen Years Residence in India*. London: White, 1813.

Foster, Joseph, ed. *Alumni Oxonienses: The Members of the University of Oxford, 1715–1886*. Oxford: Parker & Co., 1887.

Foster, William. *Early Travels in India, 1583–1619*. London: H. Milford, Oxford University Press, 1921.

Foulkes, Thomas. "Biographical Memoir of Dr. Rottler." *Madras Journal of Literature and Science* 6 (1861): 1–17.

Fricke, Ronald. "Authorship, Availability and Validity of Fish Names Described by Peter (Pehr) Simon Forsskål and Johann Christian Fabricius in the 'Descriptiones animalium' by Carsten Niebuhr in 1775 (Pisces)." *Stuttgarter Beiträge zur Naturkunde A*, Neue Serie 1 (2008): 1–76.

Giehler, Thorsten. *The Ceramics of Eurasia: How Export Porcelain Has Shaped a Globalized World*. IMI Research Report, no. 102 (2019).

Glasse, Hannah. *The Art of Cookery, Made Plain and Easy*. London: Printed for A. Millar, R. Tonson, W. Strahan, T. Caslon, T. Durham, and W. Nicoll, 1767.

Gold, Charles. *Oriental Drawings*. London: G & W Nicoll, 1806.

Graham, Maria. *Journal of a Residence in India*. Edinburgh: Archibald Constable and Company, 1812.

Gray, John Edward, and Thomas Hardwicke. *Illustrations of Indian Zoology: Chiefly Selected from the Collection of Major-General Hardwicke*. London: Treuttel and others, 1833–34.

Green, Nile. *The Love of Strangers: What Six Muslim Students Learned in Jane Austen's London*. Princeton, NJ: Princeton University Press, 2016.

Grouw, Hein, and Wim Dekkers. "Temminck's *Gallus Giganteus*: A Gigantic Obstacle to Darwin's Theory of Domesticated Fowl Origin?" *Bulletin of the British Ornithologists' Club* 140, no. 3 (2020): 321–34.

Grootenboer, Hanneke. "Thinking with Shells in Petronella Oortman's Dollhouse." In *Conchophilia: Shells, Art, and Curiosity in Early Modern Europe*, edited by Marisa Anne Bass, Anne Goldgar, Hanneke Grootenboer, and Claudia Swan, 103–23. Princeton, NJ: Princeton University Press, 2021.

Grove, Richard. "Climate and Empire." In *Palgrave Handbook of Climate History*, edited by Sam White, 517–50. Cambridge: White Horse Press, 1997.

– *Ecology, Climate and Empire : The Indian Legacy in Global Environmental History, 1400–1940.* Oxford: Oxford University Press, 1998.

– *Green Imperialism: Colonial Expansion, Tropical Island Edens and the Origins of Environmentalism, 1600–1860.* New York: Cambridge University Press, 1995.

Guelke, Jeanne Kay, and Karen Morin. "Gender, Nature, Empire: Women Naturalists in Nineteenth-Century British Travel Literature." *Transactions of the Institute of British Geographers* 26, no. 3 (2001): 306–26.

Guha, Ranajit, and Gayatri Chakravorty Spivak. *Selected Subaltern Studies.* New York: Oxford University Press, 1988.

Gwillim, Henry. *Charge Delivered to the Grand Jury, at the Assizes Holden at Ely, on Wednesday the 27th Day of March 1799.* London, 1799.

– *A Collection of Acts and Records of Parliament, with Reports of Cases Argued and Determined in the Courts of Law and Equity.* London: Printed by A. Strahan, for J. Butterworth, 1801.

– *A New Abridgement of the Law, by Matthew Bacon.* 5th ed., 7 vols. London, 1798.

Habib, Irfan. *Atlas of the Mughal Empire.* Delhi: Oxford University Press, 1982.

Hadjiafxendi, Kyriaki, and Patricia Zakreski, eds. *Crafting the Woman Professional in the Long Nineteenth Century: Artist and Industry in Britain.* Farnham, UK: Ashgate, 2013.

Hamilton, Francis. *An Account of the Fishes Found in the River Ganges and Its Branches.* Edinburgh: Printed for Archibald Constable and Company, 1822.

Hamsadeva, *Mriga Pakshi Sastra, or Science of Animals and Birds.* Translated and edited by M. Sundaracharya. Kalahasti: V. Krishnaswamy, 1927.

Hardgrave, Robert L. *The Nadars of Tamilnad.* Berkeley and Los Angeles: University of California Press, 1969.

Hardy, Charles, and Horatio Charles Hardy. *A Register of Ships, Employed in the Service of the Honorable the United East India Company, from the Year 1760 to 1819.* 3rd ed. London: Black, 1820.

Harrison, Mark. *Climates and Constitutions: Health, Race, Environment, and British Imperialism in India, 1600–1850.* New Delhi: Oxford University Press, 2002.

Harvey, John H. "The Nurseries on Milne's Land-Use Map." *Transactions of the London and Middlesex Archaeological Society* 24 (1973): 177–98.

Helms, Mary W. *Craft and the Kingly Ideal: Art, Trade, and Power.* Austin: University of Texas Press, 1993.

Henrey, Blanche. *British Botanical and Horticultural Literature before 1800.* London: Oxford University Press, 1975.

Herbert, Eugenia. *Flora's Empire: British Gardens in India.* Philadelphia: University of Pennsylvania Press, 2012.

Heyne, Benjamin. *Tracts Historical and Statistical, on India.* London: Robert Baldwin, and Black, Parry & Co, 1814.

Hill, Christopher. *South Asia: An Environmental History.* Santa Barbara, CA: ABC-CLIO, 2008.

Hobsbawm, Eric. *The Age of Revolution: Europe, 1789–1848.* London: Weidenfeld and Nicolson, 1962.

Hodges, William. *Selected Views in India, Drawn on the Spot.* London: Printed by Joseph Cooper for the author, 1785–88.

Hoover, James W. *Men without Hats: Dialogue, Discipline, and Discontent in the Madras Army, 1806–1807.* New Delhi: Manohar Publishers, 2007.

Hora, Sunder Lal. "An Aid to the Study of Hamilton Buchanan's 'Gangetic Fishes.'" *Memoirs of the Indian Museum* 9 (1929): 169–92.

Howes, Jennifer. *Illustrating India: The Early Colonial Investigations of Colin Mackenzie (1784–1821).* Oxford: Oxford University Press, 2010.

Hussain, S.A. "Zakhira-e-Nizam Shahi: A Medical Manuscript of the Nizam Shahi Period." *Bulletin of the Indian Institute of History of Medicine* 23, no. 1 (1993): 58–65.

Hyde, Ralph. *Paper Peepshows: The Jacqueline and Jonathan Gestetner Collection.* Woodbridge, UK: Antique Collectors' Club, 2015.

Inagaki, Haruki. *The Rule of Law and Emergency in Colonial India: Judicial Politics in the Early Nineteenth Century.* Cham, CH: Palgrave Macmillan, 2021.

Ingledew, W. *Treatise on the Culture of the Red Rose, Strawberry, Brazil Gooseberry, Peach, Mango, and Grape Wine.* Madras: Printed for the Society at the Asylum Press, Mount Road by George Calder, 1837.

Jacobs, N.J. "The Intimate Politics of Ornithology in Colonial Africa." *Comparative Studies in Society and History* 48, no. 2 (2006): 564–603.

Jahangir. *Jahangirnama: Memoirs of Jahangir, Emperor of India.* Translated and edited by Wheeler M. Thackston. Washington, DC: Freer Gallery of Art, 1999.

Jain, M.P. *Outlines of Indian Legal History.* Delhi: Dhanwantra Medical and Law Book House, 1952.

James, C.L.R. *The Black Jacobins: Toussaint L'Ouverture and the San Domingo Revolution.* London: Penguin, 2001.

Jarvis, Charles E. "A Seventeenth-Century Collection of Indian Medicinal Plants in the Natural History Museum, London." *Journal of the Department of Museology (University of Calcutta)* 11/12 (2016): 87–98.

Jasanoff, Maya. *Edge of Empire: Lives, Culture, and Conquest in the East, 1750–1850*. New York: Vintage Books, 2006.

Jayaram, Suresh. "Lalbagh Botanical Drawings." *Marg: A Magazine of the Arts* 70, no. 2 (2018): 70–2.

Jerdon, Thomas Caverhill. *The Birds of India: Being a Natural History of All the Birds Known to Inhabit Continental India*. Calcutta: Military Orphan Press, 1862–64.

– "Catalogue of the Birds of the Peninsula of India, Arranged According to the Modern System of Classification; with Brief Notes on Their Habits and Geographical Distribution, and Description of New, Doubtful and Imperfectly Described Species." *Madras Journal of Literature and Science* 10, no. 24 (1839): 60–91.

– "A Catalogue of the Species of Ants Found in Southern India." *Annals and Magazine of Natural History* 2, no. 13 (1854): 45–56.

– "Ichthyological Gleanings in Madras." *Madras Journal of Literature and Science* 17 (1851): 128–51.

Jones, William. "Botanical Observations on Select Indian Plants." *Asiatick Researches* 4 (1795): 238–312.

– "On the Gods of Greece, Italy, and India." *Asiatick Researches* 1 (1785): 221–75.

– "The Tenth Anniversary Discourse, delivered 28 February 1793." *Asiatick Researches* 4 (1795): xii–xxxi.

Jussieu, A.H. Laurent de. "Mémoire sur le groupe des Méliacées." *Bulletin des sciences naturelles et de geologie* 23 (1830): 140.

Kālidāsa. *Śakuntalā: A Sanskrit Drama in Seven Acts*. Translated by Monier Williams. Oxford: Clarendon Press, 1876.

Kattenhorn, Patricia. "Sketching from Nature: Soldier Artists in India." In *Under the Indian Sun: British Landscape Artists*, edited by Pauline Rohatgi and Pheroza Godrej, 17–30. New Delhi: Marg, 1995.

Kenney-Herbert, A.R. *Culinary Jottings for Madras, or a Treatise in Thirty Chapters on Reformed Cookery for Anglo-Indian Exiles*. Madras: Higginbotham, 1878.

– *Vegetarian and Simple Diet*. London: S. Sonnenschein, 1907.

Kerner, Jaclynne J. "Art in the Name of Science: The Kitab al-Diryaq in Text and Image." In *Arab Painting*, edited by Anna Contadini, 25–39. Leiden: Brill, 2007.

Kersenboom-Story, Saskia. *Nityasumangalī: Devadasi Tradition in South India*. Delhi: Motilal Banarsidass, 1989.

Keulemans, Tony, and Jan Coldewey. *Feathers to Brush: The Victorian Bird Artist, John Gerrard Keulemans, 1842–1912*. Epse, NL: Printed for the authors, 1982.

Khan, Mirza Abu Taleb. "Vindication of the Liberties of the Asiatic Women." *Asiatic Annual Register*, no. 3 (1801): 100–7.

Kindersley, Jemima. *Essay on the Character, the Manners and Understanding of Women*, London: J. Dodsley, 1781.

King, J.C.H. "New Evidence for the Contents of the Leverian Museum." *Journal of the History of Collections* 8, no. 2 (1996): 167–86.

Kipling, Rudyard. *The Seven Seas*. London: Methuen, 1896.

Koch, Ebba. "Jahangir as Francis Bacon's Ideal of the King as an Observer and Investigator of Nature." *Journal of the Royal Asiatic Society Series* 19, no. 3 (2009): 293–338.

Kochar, Rajesh. "Madras and Kodaikanal Observatories: A Brief History." *Resonance* 7 (2002): 16–28.

Kothari, Ashok S., and Chhapgar, B.F. *Salim Ali's India*. Bombay: Bombay Natural History Society, 1996.

Lambert, David, and Alan Lester. *Colonial Lives across the British Empire: Imperial Careering in the Long Nineteenth Century*. Cambridge: Cambridge University Press, 2006.

Lank, David M. "Forgotten Women of Wildlife Art." *International Wildlife* (July–August 1980), 25–32.

Latham, John. *A General Synopsis of Birds*. London: Printed for Benjamin White, 1801.

Laudan, Rachel. *Cuisine and Empire*. Berkeley and Los Angeles: University of California Press, 2015.

Lawson, Philip, and Jim Phillips. "'Our Execrable Banditti': Perceptions of Nabobs in Mid-Eighteenth Century Britain." *Albion: A Quarterly Journal Concerned with British Studies* 16, no. 3 (1984): 225–41.

Lear, Edward. *Edward Lear's Indian Journal: Watercolours and Extracts from the Diary of Edward Lear (1873–1875)*. Edited by Ray Murphy. London: Jarrolds, 1953.

Le Faye, Deirdre, ed. *Jane Austen's Letters*. Oxford: Oxford University Press, 1995.

Leong-Salobir, Cecilia. *Food Culture in Colonial Asia: A Taste of Empire*. Hoboken: Taylor & Francis, 2011.

Linley, William. *Forbidden Apartments: A Tale*. London: Printed at the Minerva-Press, for William Lane, 1800.

Linnaeus, Carl. *Species plantarum: Exhibentes plantas rite cognitas ad genera relatas, cum diferentiis specificis, nominibus trivialibus, synonymis selectis, locis natalibus, secundum systema sexuale digestas*. Stockholm: Laurentii Salvii, 1753.

– *Species plantarum: Exhibentes plantas rite cognitas, ad genera relatas, cum differentiis specificis, nominibus trivialibus, synonymis selectis, locis natalibus, secundum*

systema sexuale digestas. Stockholm: Laurentii Salvii, 1762.

– *Systema naturæ per regna tria naturæ, secundum classes, ordines, genera, species, cum characteribus, differentiis, synonymis, locis. Tomus I*. Editio decima, reformata. Stockholm: Laurentii Salvii, 1758.

– *Systema naturæ per regna tria naturæ, secundum classes, ordines, genera, species, cum characteribus, differentiis, synonymis, locis. Tomus I*. Editio duodecima, reformata. Stockholm: Laurentii Salvii, 1766.

– *Systema naturæ per regna tria naturæ secundum classes, ordines, genera, species, cum characteribus, differentiis, synonymis, locis. Editio decima tertia, aucta, reformata*. Edited by Johann Friedrich Gmelin. Lugduni: Apud J.B. Delamolliere, 1788–89.

– *Systema vegetabilium secundum classes, ordines, genera, specie, cum characteribus differentiis et synonymis*. Edited by J. J. Römer, Joseph August Schultes, and Julius Hermann Schultes. Editio novaed. Stuttgart: Sumtibus J.G. Cottae, 1817–30.

Lodge, George Edward. "Obituary: Henrik Grønvold." *Ibis* 82 (1940): 545–6.

Losty, J. *India Life and People in the 19th Century: Company Paintings in the Tapi Collection*. New Delhi: Roli Books, 2019.

Love, Henry Davidson. *Vestiges of Old Madras, 1640–1800*. Madras: Government Press, 1914.

Lusin, Caroline. "Curry, Tins and Grotesque Bodies: Food, Cultural Boundaries and Identity in Anglo-Indian Life-Writing." *English Studies* 94, no. 4 (2013): 468–88.

MacGregor, Arthur. *Company Curiosities: Nature, Culture and the East India Company, 1600–1874*. London: Reaktion Books, 2018.

– "European Enlightenment in India: An Episode of Anglo-German Collaboration in the Natural Sciences on the Coromandel Coast, Late 1700s–Early 1800s." In *Naturalists in the Field: Collecting, Recording and Preserving the Natural World from the Fifteenth to the Twenty-First Century*, edited by Arthur MacGregor, 365–92. Leiden: Brill, 2018.

Macmillan, Mona, and Catriona Miller, eds. *Exiles of Empire: Family Letters from India and Australia by Fanny and Annie Pratt, 1843–1863*. Edinburgh: Pentland, 1997.

"Madras Law Reports." *Annual Asiatic Register* 9 (1807): 6–7.

"Madras Occurrences for June 1803." *Asiatic Annual Register* (1804): 11–12

"Madras Occurrences for October." *Asiatic Annual Register* 10 (1808): 153–7.

Maitland, Julia Charlotte. *Letters from Madras during the Years 1836–1839*. London: John Murray, 1861.

Manning, Patrick, and Daniel Rood, eds. *Linnaeus's Apostles and the Globalization of Knowledge, 1729–1756*. Pittsburgh: University of Pittsburgh Press, 2016.

Margerison, Kenneth. "French Visions of Empire: Contesting British Power in India after the Seven Years War." *English Historical Review* 130, no. 544 (2015): 583–612.

Maroney, Stephanie R. "'To Make a Curry the India Way': Tracking the Meaning of Curry across Eighteenth-Century Communities." *Food and Foodways* 19, no. 1 (2011): 122–34.

"Married Life in India." *Calcutta Review* 4 (1845): 394–417.

Marshall, George W. *The Registers of Sarnesfield, Co. Hereford, 1660–1897*. London: Privately Printed for the Parish Register Society, 1898.

Martyn, Thomas. *The Gardener's and Botanist's Dictionary … the Whole Corrected and Newly Arranged*. London: F.C. and J. Rivington, 1807.

Matthew, K.M. "Notes on an Important Botanical Trip (1799–1800) of J.P. Rottler on the Coromandel Coast (India)." *Botanical Journal of the Linnean Society* 113 (1993): 351–88.

Mckendrick, Neil. "III Josiah Wedgwood: An Eighteenth-Century Entrepreneur in Salesmanship and Marketing Techniques." *South African Journal of Economic History* 8, no. 1 (1993): 36–66.

McLaren, Martha. *British India and British Scotland, 1780–1830*. Akron, OH: University of Akron Press, 2001.

McNeill, John. "Observations on the Nature and Culture of Environmental History, History and Theory." *History and Theory* 42, no. 4 (2003): 5–43.

Menon, Minakshi. "Making Useful Knowledge: British Naturalists in Colonial India, 1784–1820." PhD diss., University of California, San Diego, 2013.

Mertinelle, A., and G. Michell. *Oriental Scenery: Two Hundred Years of India's Artistic and Architectural Heritage*. New Delhi: Timeless Books, 1998.

Mills, Sarah. *Discourses of Difference, Women's Travel Writing*. London: Routledge, 1991.

Minto, Gilbert Elliot, Earl of. *Lord Minto in India; Life and Letters of Gilbert Elliot, First Earl of Minto from 1807 to 1814, While Governor-General of India, Being a Sequel to His "Life and Letters" Published in 1874*. Edited by Emma Eleanor Elizabeth Hislop Elliot-Murray-Kynynmound, Countess of Minto. London: Longmans, 1880.

Moienuddin, Mohammad. *Sunset at Srirangapatam: After the Death of Tipu Sultan*. Chennai: Orient Longman, 2000.

Morgan, Caesar. "A Sermon Preached at the Assizes Held at Wisbech on 7 August 1800." *Anti Jacobin Review and Magazine* 7 (1800): 303.

Morley, W.H. *The Administration of Justice in British India: Its Past History and Present State*. London and Calcutta: Williams & Norgate, 1952.

Mulhallen, Jacqueline. *The Theatre of Shelley*. Cambridge: Open Book Publishers, 2010.

Müller, J., and F.G.J. Henle. *Systematische Beschreibung der Plagiostomen*. Berlin: Veit, 1841.

Muralidharan, Akash. "A Kitchen in Nineteenth Century Madras." The Gwillim Project, n.d. https://thegwillimproject.com/case-studies/a-kitchen-in-nineteenth-century-madras/.

Nair, Savithri Preetha. "Illustrating Plants at the Tanjore Court." *Marg* 70 (2019): 45–51.

– "Native Collecting and Natural Knowledge (1798–1832): Raja Serfoji II of Tanjore as a 'Centre of Calculation.'" *Journal of the Royal Asiatic Society* 15, no. 3 (2005): 279–302.

– *Raja Serfoji II: Science, Medicine and Enlightenment in Tanjore*. London: Routledge, 2012.

Naoroji, Rishad. *Birds of Prey of the Indian Subcontinent*. New Delhi: Om Books International, 2006.

Narayan, Uma. "Eating Cultures: Incorporation, Identity and Indian Food." *Social Identities* 1, no. 1 (1995): 63–86.

Nell, Victor. *Lost in a Book*. New Haven, CT: Yale University Press, 1988.

Nellen, Walter, and Jakov Dulčić. "Evolutionary Steps in Ichthyology and New Challenges." *Acta Adriatica* 49, no. 3 (2008): 201–32.

Nightingale, Carl H. "Before Race Mattered: Geographies of the Color Line in Early Colonial Madras and New York." *American Historical Review* 113, no. 1 (2008): 48–71.

Nikčević, Hana. "'I Shall Want Colours and Paper for Drawing': Artists' Materials." The Gwillim Project. n.d. https://thegwillimproject.com/artwork/i-shall-want-colours-and-paper-for-drawing-what-did-the-gwillims-use-to-paint/.

– "A Scene from a Sanskrit Drama: Mary Symonds's Painting of the Śakuntalā." The Gwillim Project. n.d. https://thegwillimproject.com/artwork-2/a-scene-from-a-sanskrit-drama-mary-symondss-painting-of-the-sakuntala/.

Noltie, Henry J. "Lady Gwillim's 'Madras' Magnolia." *Botanic Stories*, posted 15 September 2020. https://stories.rbge.org.uk/archives/34065.

– "Moochies, Gudigars and Other Chitrakars: Their Contribution to 19th-Century Botanical Art and Science." *Marg* 70 (2019): 35–43.

– *Robert Wight and the Botanical Drawings of Rungiah and Govindoo*. Edinburgh: Royal Botanic Garden Edinburgh, 2006.

Nugent, David, and Joan Vincent, eds. *A Companion to the Anthropology of Politics*. Malden, MA: Blackwell, 2004.

Nugent, Lady Maria. *A Journal from the Year 1811 till the Year 1815, Including a Voyage and Residence in India*, 2 vols. London: T. & W. Boone, 1839.

Nyberg, Kenneth. "Linnaeus's Apostles and the Globalization of Knowledge, 1729–1756." In *Global Scientific Practice in an Age of Revolutions, 1750–1850*, edited by Patrick Manning and Daniel Rood, 73–89. Pittsburgh: University of Pittsburgh Press, 2016.

Oates, Eugene William. *Birds of British India*. 4 vols. London: Taylor and Francis, 1889.

– *The Fauna of British India, Including Ceylon and Burma. Birds*. Edited by W.T. Blanford. Vols 1–4. London: Taylor & Francis, 1889–1898.

"Obituary: Mr. H. Kirke Swann." *Nature* 117 (1926): 831–2.

Otte, Jaap. "Pountneys, Bristol: A Case Study of Transfer Printed Earthenware in India." *TCC Bulletin* 23, no. 2 (2022): 18–20.

Parks, Fanny. *Wanderings of a Pilgrim in Search of the Picturesque, during Four-and-Twenty Years in the East: With Revelations of Life in the Zenana*. Illustrated with Sketches from Nature. 2 vols. London: Pelham Richardson, 1850.

Pegge, Samuel. *The Forme of Cury, a Roll of Ancient English Cookery*. London: Printed by J. Nichols, 1780.

Pennant, Thomas. *Indian Zoology*. London: Henry Hughs for Robert Faulder, 1769–90.

Pequignot, Amandine. "The History of Taxidermy: Clues for Preservation." *Collections: A Journal for Museum and Archives Professionals* 2 (2006): 245–55.

Phillimore, Reginald Henry. *Historical Records of the Survey of India*. Vol. 1. *Eighteenth Century*. Dehra Dun: Survey of India, 1945.

Pittie, Aasheesh. "A Bibliographic Assessment of T.C. Jerdon's Illustrations of Indian Ornithology (1843–1847)." *Indian Birds* 12, nos 2/3 (2016): 29–49.

– *Birds in Books: Three Hundred Years of South Asian Ornithology, a Bibliography*. New Delhi: Permanent Black, 2010.

Platts, John T. *A Dictionary of Urdu, Classical Hindi, and English*. London: W.H. Allen & Co., 1884.

Plliay, K.K. "The Causes of the Vellore Mutiny." *Proceedings of the Indian History Congress* 20 (1957): 306–11.

Plunkett, John. "Light Work: Feminine Leisure and the Making of Transparencies." In Hadjiafxendi and Zakreski, *Crafting the Woman Professional in the Long Nineteenth Century*, 43–68.

Pole, Sebastian. *Ayurvedic Medicine: The Principles of Traditional Practice*. London: Singing Dragon, 2006.

Pollock, Sheldon I. *Forms of Knowledge in Early Modern Asia: Explorations in the Intellectual History of India and Tibet, 1500–1800*. Durham, NC: Duke University Press, 2011.

Postans, Marianne. *Cutch, or random sketches … of Western India*. London: Smith, 1839.

– *Western India in 1838*. 2 vols. London: Saunders and Otley, 1839.

Price, John. *An Historical Account of the City of Hereford*. Hereford, UK: D. Walker, 1796.

Prideaux, John Selby. *A Catalogue of the Generic and Sub-Generic Types of the Class Aves, Birds, Arranged According to the Natural System*. Newcastle: T. and J. Hodgson, 1840.

Prinsep, Charles Campbell. *Record of Services of the Honourable East India Company's Civil Servants in the Madras Presidency, from 1741 to 1858*. London: Trübner, 1885.

Pulteney, Richard. *Historical and Biographical Sketches of the Progress of Botany*. 2 vols. London: T. Cadell, 1790.

Pyne, William Henry. *Wine and Walnuts, Or, After Dinner Chit-Chat*. London: Longman, 1823.

Quilley, Geoff. ed. *William Hodges, 1744–1797: The Art of Exploration*. London: National Maritime Museum, 2004.

Ramachandran, Ramesh, Ajith Kumar, Kolla S. Gopi Sundar, and Ravinder Singh Bhalla. "Hunting or Habitat? Drivers of Waterbird Abundance and Community Structure in Agricultural Wetlands of Southern India." *Ambio* 46, no. 5 (2017): 613–20.

Raffald, Elizabeth. *The Experienced English Housekeeper, for the Use and Ease of Ladies, Housekeepers, Cooks, &c.* 10th ed. London: R. Baldwin, 1787.

Raj, Kapil. "Beyond Postcolonialism … and Postpositivism: Circulation and the Global History of Science." *Isis* 104, no. 2 (2013): 337–47.

– *Relocating Modern Science: Circulation and the Construction of Knowledge in South Asia and Europe, 1650–1900*. Houndmills, UK: Palgrave Macmillan, 2007.

Rajayyan, K. "British Annexation of the Carnatic, 1801." *Proceedings of the Indian History Congress* 32 (1970): 54–62.

Raman, Anantanarayanan. "Plant Lists from 'Olde' Madras (1698–1703)." *Current Science* 115 (2018): 2236–41.

Raman, Bhavani. *Document Raj: Writing and Scribes in Early Colonial South India*. Chicago: University of Chicago Press, 2012.

Ramaswami, N.S. *Political History of Carnatic under the Nawabs*. New Delhi: Abhinav Publications, 1984.

Rangarajan, Mahesh. "The Raj and the Natural World: The War against 'Dangerous Beasts' in Colonial India." *Studies in History* 14, no. 2 (1998): 265–99.

Rangarajan, Mahesh, and K. Sivaramakrishnan. *Shifting Ground: Peoples, Animals and Mobility in India's Environmental History*. Delhi: Oxford University Press, 2014.

Rasmussen, P. Cecile, and John C. Anderton. *Birds of South Asia: The Ripley Guide*. Vol. 2. Washington, DC: Smithsonian Institution, 2012.

Ratcliff, Jessica. "The East India Company, the Company's Museum, and the Political Economy of Natural History in the Early Nineteenth Century." *Isis* 107, no. 3 (2016): 495–517.

– "Hand-In-Hand with the Survey: Surveying and the Accumulation of Knowledge Capital at India House during the Napoleonic Wars." *Notes and Records* 73, no. 2 (2019): 149–66.

Ray, John. *Synopsis Methodica Avium & Piscium: Opus Posthumum*. London: G. Innys, 1713.

Raza, Rosemary. *In Their Own Words: British Women Writers and India, 1740–1857*. Oxford: Oxford University Press, 2006.

Rees, William Jenkins. *The Hereford Guide*. Hereford, UK: Allen, 1806.

Reports from Committees of the House of Commons. Vol. V: *Reports on the Administration of Justice , &c. in the East Indies*. London, 1781–2.

Richards, Thomas. *The Imperial Archive: Knowledge and the Fantasy of Empire*. London: Verso, 1993.

Riviere, Marc Serge. "From Belfast to Mauritius: Charles Telfair (1778–1833), Naturalist and Product of the Irish Enlightenment." *Eighteenth-Century Ireland* 21, no. 1 (2006): 125–44.

Roberts, Emma. *The East-India voyager, or ten minutes advice to the outward bound*. London: J. Madden & Co., 1839.

– *Scenes and Characteristics of Hindostan, with Sketches of Anglo-Indian Society*. London: Wm. H. Allen and Co., 1835.

Robinson, Tim. *William Roxburgh: The Founding Father of Indian Botany*. Chichester, UK: Phillimore in association with the Royal Botanic Garden Edinburgh, 2008.

Rodrigues, Domingos. *Arte de Cozhina*. Lisbon, 1680.

Rogers, J.M. "Dioscorides and the Illustrated Herbal in the Arab Tradition." In *Arab Painting: Text and Image in Illustrated Arabic Manuscripts*, edited by Anna Contadini, 41–8. Leiden: Brill, 2007.

Roscoe, Ingrid. *A Biographical Dictionary of Sculptors in Britain, 1660–1851*. New Haven, CT: Yale University Press, 2009.

Roth, Albrecht Wilhelm. *Novae Plantarum Species Praesertim Indiae Orientalis ex Collectione Doct Benj. Heynii*. Halberstadt: H. Vogler, 1821.

Rottler, Johann Peter. *A Dictionary of the Tamil and English Languages*. Vol. 1, Part 1. Madras: Vepery Mission Press, 1834.

Roxburgh, William. *Flora Indica: Or, Descriptions of Indian Plants*. Serampore: Mission Press, 1820–24.

Roy, Malini. "The Bengali Artist Haludar." In *Forgotten Masters: Indian Painting for the East India Company*, edited by William Dalrymple, 104–16. London: Wallace Collection, 2019.

Roy, Tirthankar. "Home Market and the Artisans in Colonial India: A Study of Brass-Ware." *Modern Asian Studies* 30, no. 2 (1996): 357–85.

Rudd, Andrew. *Sympathy and India in British Literature, 1770–1830*. London: Palgrave Macmillan, 2011.

Russell, Patrick. *An Account of Indian Serpents, Collected on the Coast of Coromandel*. London: Printed by W. Bulmer and Co. for George Nicol, 1796–1809.

– *Descriptions and Figures of Two Hundred Fishes: Collected at Vizagapatam on the Coast of Coromandel*. Vol. 2. London: W. Bulmer and Co., 1803.

Salhi, Muhannad. "Prodigies of Cosmology: A Muslim Perspective." 31 October 2019. Library of Congress, https://blogs.loc.gov/international-collections/2019/10/prodigies-of-cosmology-a-muslim-perspective/.

Santharam, V. "The Desert Wheatear Oenanthe Deserti in Madras." *Journal of Bombay Natural History Society* 86 (1989): 452.

Schaffer, Talia. "Women's Work: The History of the Victorian Domestic Handicraft." In Hadjiafxendi and Zakreski, *Crafting the Woman Professional in the Long Nineteenth Century*, 25–42.

Schiebinger, Londa L., and Claudia Swan, eds. *Colonial Botany: Science Commerce and Politics in the Early Modern World*. Philadelphia: University of Pennsylvania Press, 2007.

Schwartz, K.L. "The Curious Case of Carnatic: The Last Nawab of Arcot (d. 1855) and Persian Literary Culture." *Indian Economic and Social History Review* 53, no. 4 (2016): 533–60.

Sealy, J.R. "The Roxburgh *Flora Indica* Drawings at Kew." *Kew Bulletin* 11, no. 2 (1956): 297–348.

Selby, John. *A Catalogue of the Generic and Sub-Generic Types of the Class Aves, Birds*. Newcastle: T. and J. Hodgson, 1840.

Sen, Colleen Taylor. *Curry: A Global History*. London: Reaktion Books, 2009.

Seth, Suman. *Difference and Disease: Medicine, Race and the Eighteenth-Century British Empire*. Cambridge: Cambridge University Press, 2018.

Sharma, Aprajita. "Chinese Porcelain in India: Archaeology Maritime Trade and Historical Significance." PhD diss., Assam University, 2013.

Shaw, John. *The Charters of the High Court of Judicature at Madras and of the Courts Which Preceded It, from 1687 to 1865*. Madras: Government Press, 1888.

Sheridan, Frances. *The History of Nourjahad*. London: Printed for J. Dodsley, 1767.

Shields, Nancy K. *Birds of Passage: Henrietta Clive's Travels in South India 1798–1801*. London: Eland Publishing, 2009.

Shortt, T. Michael. "Gwillim as Artist and Ornithologist." In *Elizabeth Gwillim: Artist and Naturalist, 1763–1807*, edited by Allan Walkinshaw, 35–4. Oshawa, ON: Robert McLaughlin Gallery, 1980.

Shteir, Ann B. *Cultivating Women, Cultivating Science: Flora's Daughters and Botany in England, 1760–1860*. Baltimore, MD: Johns Hopkins University Press, 1996.

Sims, John. "Althaea Flexuosa." *Curtis's Botanical Magazine* 23 (1806): 892.

– "Magnolia Pumila." *Curtis's Botanical Magazine* 25 (1806): 977.

– "Trichosanthes Anguina." *Curtis's Botanical Magazine* 19 (1804): 722.

Sinha, Nitin. "Who Is (Not) A Servant, Anyway? Domestic Servants and Service in Early Colonial India." *Modern Asian Studies* 55 (2021): 152–206.

Sinha, Nitin, Pankaj Jha, and Nitin Varma. *Servants' Pasts*. Telangana, India: Orient BlackSwan, 2019.

Sinopoli, C.M. *Pots and Palaces: The Earthenware Ceramics of the Noblemen's Quarter of Vijayanagara*. New Delhi: Manohar, 1993.

Sivasundaram, Sujit. *Waves across the South: A New History of Revolution and Empire*. Chicago: University of Chicago Press, 2021.

Skelton, Robert. "A Decorative Motif in Mughal Art." In *Aspects of Indian Art: Papers Presented in a Symposium of the Los Angeles County Museum of Art*, edited by P. Pal, 147–52. Leiden: Brill, 1970.

Smart, Jane. *A Letter from a lady in Madrass to her Friends in London*. London: H. Piers, 1743.

Smith, Bernard. *Imagining the Pacific: In the Wake of the Cook Voyages*. New Haven, CT: Yale University Press, 1992.

Smith, Jake. *Eating with Emperors: 150 Years of Dining with Emperors, Kings, Queens ... and the Occasional Maharajah*. Carlton, AU: Miegunyah Press, 2009.

Smith, W.J., and J.C.H. King. "Sir Ashton Lever of Alkrington, and His Museum 1729–1788." *Transactions of the Lancashire and Cheshire Antiquarian Society* 72 (1962): 61–92.

Snyder, R.F. "Complexity in Creation: A Detailed Look at the Watercolors for *The Birds of America*." In *Book and Paper Group Annual*. Vol. 12. American Institute for Conservation, 1993.

Sobrevilla, Iris Montero. "Indigenous Naturalists." In *Worlds of Natural History*, edited by Helen Anne Curry, Nicholas Jardine, James Andrew Secord, and Emma C. Spary, 112–30. Cambridge: Cambridge University Press, 2018.

"Society in India." *New Monthly Magazine* 22 (1828): 224–35.

Southern, Richard. *The Georgian Playhouse*. London: Pleiades Books, 1948.

Sowry, Nathan, "Silence, Accessibility, and Reading against the Grain: Examining Voices of the Marginalized in the India Office Records." *Interactions: UCLA Journal of Education and Information Studies* 8, no. 2 (2012).

Speaight, George. *Juvenile Drama: The History of the English Toy Theatre*. London: Macdonald, 1946.

Spear, Jeffrey. "Gods and Dancing Girls: A Letter from 1802 Madras." *Wordsworth Circle* 31, no. 3 (2000).

– "Was She This Name? Law, Literature and the 'Devadasi.'" In *The Letter of the Law: Literature, Justice and the Other*, edited by Stamatina Dimakopoulou, Christina Dokou, and Efterpi Mitsi, 115–33. Frankfurt: Peter Lang, 2013.

Srinivasachari, C.S. "Notes on the Maps of Old Madras Preserved in the Madras Record Office." *Journal of the Madras Geographical Association* 3, no. 2 (1928): 83–106.

Stafford, Barbara Maria, and Frances Terpak. *Devices of Wonder: From the World in a Box to Images on a Screen*. Los Angeles: Getty Research Institute, 2001.

Starke, Mariana, *The Sword of Peace; or a Voyage of Love*. London: Printed for J. Debrett, 1789.

Stevenson, William, and James Bentham. *A Supplement to the Second Edition of Mr. Bentham's History & Antiquities of the Cathedral & Conventual Church of Ely ...* Norwich: Printed by and for Stevenson, Matchett, and Stevenson, 1817.

Stewart, Susan. *On Longing: Narratives of the Miniature, the Gigantic, the Souvenir, the Collection*. Durham, NC: Duke University Press, 1993.

Stierstorfer, Klaus ed. *Women Writing Home, 1700–1920: Female Correspondence across the British Empire*. Vol. 4. *India*. London: Pickering & Chatto, 2006.

Stoler, Ann Laura. *Along the Archival Grain: Epistemic Anxieties and Colonial Common Sense*. Princeton, NJ: Princeton University Press, 2010.

Sturgess, H.A.C., ed. *Register of Admissions to the Honourable Society of the Middle Temple, From the Fifteenth Century to the Year 1944*. London: Butterworth, 1949.

Subramanya, S., "Paintings of Indian Birds by Lady Elizabeth Gwillim at McGill University, Canada." *Newsletter for Birdwatchers* 34, no. 4 (July–August 1994): 74–6.

Sykes, W.H. "Catalogue of Birds Observed in the Dukhun." *Proceedings of the Committee of Science and Correspondence of the Zoological Society of London* 2 (1832): 149–72.

– "On the Fishes of the Dukhun." *Transactions of the Zoological Society of London* 2 (1839): 349–78.

Taylor, S. *Storm and Conquest: The Battle for the Indian Ocean, 1808–10*. London: Faber & Faber, 2007.

Tegetmeire, W.B. *The Poultry Book: Breeding and Management*. London: George Routledge and Sons, 1867.

Teltscher, Kate. *India Inscribed: European and British Writing on India, 1600–1800*. Delhi: Oxford University Press, 1995.

Temminck, C.J. *Histoire naturelle générale des pigeons et des gallinacés*. Edited by J.C. Sepp and Fils. Amsterdam, 1813–15.

Thackeray, William. *Vanity Fair*. 1848. New York: W.W. Norton, 1994.

Thapar, Romila. *The Past and Prejudice*. Delhi: National Book Trust, 1975.

Thompson, Carl. "Women Travellers, Romantic Era Science and the Banksian Empire." *Notes and Records* 73 (2019): 431–55.

Tillotson, Giles. *Birds of India: Company Paintings, c. 1800 to 1835*. Delhi: DAG, 2021.

Topsfield, A. "The Natural History Paintings of Shaikh Zain Ud-Din, Bhawani Das and Ram Das." In *Forgotten Masters: Indian Bird Paintings for the East India Company*, edited by W. Dalrymple, 40–75. London: Bloomsbury Publishing, 2019.

Trautmann, Thomas. *Elephants and Kings: An Environmental History.* Chicago: University of Chicago Press, 2015.

– *Languages and Nations: The Dravidian Proof in Colonial Madras.* Berkeley and Los Angeles: University of California Press, 2006.

Uglow, Jenny "Vase Mania." In Berg and Eger, *Luxury in the Eighteenth Century*, 151–62.

University of Madras. *Tamil Lexicon.* Madras: University of Madras, 1924–36.

Urfi, A.J. "What Colonial Writing about Indian Birds Reveals about the British Raj." Scroll.in, 16 December 2018. https://scroll.in/article/904783/what-colonial-writing-about-indian-birds-reveals-about-the-british-raj.

Verma, Som Prakash, ed. *Flora and Fauna in Mughal Art.* Mumbai: Marg Publications, 1999.

– "Portraits of Birds and Animals under Jahangir." In Verma, *Flora and Fauna in Mughal Art*, 12–24.

Victoria & Albert Museum. *Review of the Principal Acquisitions of the Victoria & Albert Museum.* London: His Majesty's Stationery Office, 1912.

Vikery, Amanda. "Hidden from History: The Royal Academy's Female Founders." *Royal Academy Magazine* (3 June 2016). https://www.royalacademy.org.uk/article/ra-magazine-summer-2016-hidden-from-history.

Visram, Rozina. *Ayahs, Lascars and Princes.* London: Pluto Press, 1986.

Visser, Margaret. *The Rituals of Dinner: The Origins, Evolution, Eccentricities and Meaning of Table Manners.* New York: Grove Weidenfeld, 1991.

Wallis, Patrick. "Consumption, Retailing, and Medicine in Early-Modern London." *Economic History Review* 61, no. 1 (2008): 26–53.

Warr, Frances E. *Manuscripts and Drawings in the Ornithology and Rothschild Libraries of the Natural History Museum at Tring.* Tring, UK: British Ornithologists' Club, 1996.

Washbrook, David. "South India, 1770–1840: The Colonial Transition." *Modern Asian Studies* 38, no. 3 (2004): 479–516.

Watson, Alex, and Laurence Williams, eds. *British Romanticism in Asia: The Reception, Translation, and Transformation of Romantic Literature in India and East Asia.* New York: Palgrave Macmillan, 2019.

Watson, Mark F., and Henry J. Noltie. "Career, Collections, Reports and Publications of Dr Francis Buchanan (Later Hamilton), 1762–1829: Natural History Studies in Nepal, Burma (Myanmar), Bangladesh and India. Part 1." *Annals of Science* 73 (2016): 392–424.

Webster, Anthony. *The Twilight of the East India Company: The Evolution of Anglo-Asian Commerce and Politics, 1790–1860.* Boydell Press, 2009.

Welch, Stuart Cary, Annemarie Schimmel, Marie Lukens Swietochowski, and Wheeler M. Thackston. *The Emperors' Album: Images of Mughal India.* New York: Metropolitan Museum of Art, 1987.

White, Gilbert. *The Natural History and Antiquities of Selborne.* London: Printed by T. Bensley: Benjamin White and Son, 1789.

Wight, Robert. *Spicilegium Neilgherrense; or a Selection of Neilgherry Plants: Drawn and Coloured from Nature …* Madras: Messrs. Franck and Co., 1851.

Wilson, Kathleen. *A New Imperial History: Culture, Identity, and Modernity in Britain and the Empire, 1660–1840.* Cambridge: Cambridge University Press, 2004.

Wilson, Jon E. "Strange, Sir Thomas Andrew Lumisden (1756–1841)." *Oxford Dictionary of National Biography.* 23 September 2004. https://doi.org/10.1093/ref:odnb/26640.

Winius, George D. "A Tale of Two Coromandel Towns: Madraspatam (Fort St. George) and São Thomé De Meliapur." *Itinerario* 18, no. 1 (1994): 51–64.

Winterbottom, Anna. "Behind the Scenes: Colonial Violence and Resistance in the Gwillim Archive." n.d. The Gwillim Project. https://thegwillimproject.com/behind-the-scenes-colonial-violence-and-resistance-in-the-gwillim-archive/.

– "Elizabeth Gwillim's Botanical Networks." Library Matters, McGill University Library News. 15 May 2020. https://news.library.mcgill.ca/elizabeth-gwillims-botanical-networks/.

– "An Experimental Community: The East India Company in London, 1600–1800." *British Journal for the History of Science* 52, no. 2 (2019): 323–43.

– *Hybrid Knowledge in the Early East India Company World.* London: Palgrave, 2016.

– "Medicine and Botany in the Making of Madras, 1680–1720." In *The East India Company and the Natural World*, edited by Vinita Damodaran, Anna Winterbottom, and Alan Lester, 35–57. Basingstoke, UK: Palgrave Macmillan, 2015.

Wood, Casey A. "Lady [Elizabeth] Gwillim: Artist and Ornithologist.'" *Ibis* 67, no. 3 (1925): 594–9.

Wujastyk, Dominik. "A Body of Knowledge: The Wellcome Ayurvedic Anatomical Man and His Sanskrit Context." *Asian Medicine* 4 (2008): 205–6.

Yang, Anand A. "Bandits and Kings: Moral Authority and Resistance in Early Colonial India." *Journal of Asian Studies* 66, no. 4 (2007): 881–96.

Yule, Henry. *Hobson-Jobson: A Glossary of Colloquial Anglo-Indian Words and Phrases, and of Kindred Terms, Etymological, Historical, Geographical and Discursive.* New ed., edited by William Crooke. London: J. Murray, 1903.

Zadeh, Travis. "The Wiles of Creation: Philosophy, Fiction, and the 'Aja'Ib Tradition." *Middle Eastern Literatures* 13, no. 1 (2010): 21–2.

Zebrowski, Mark. *Deccani Painting.* London: Sotheby Publication, 1983.

Zon, Bennett, and Bennett Clayton, eds. *Music and Orientalism in the British Empire, 1780s–1940s: Portrayal of the East.* Aldershot, UK: Ashgate, 2007.

Contributors

VIKRAM BHATT, FRAIC, FRSC, is a professor emeritus of architecture at McGill University, Montreal. He is author of *Resorts of the Raj: Hill Stations of India* and co-author of *After the Masters: Contemporary Indian Architecture* and *Blueprint for a Hack*. He is an expert on housing and urban design and is keenly interested in colonial urban developments.

BEN CARTWRIGHT is a writer and curator who has worked on numerous projects in India. During the completion of this project, he was collection curator at the South Asia Collection Museum, Norwich, in the United Kingdom. He is the author of *A Different Idea of India: Two Sisters Painting Southern India, 1801–1808*.

NATHALIE COOKE is professor of English at McGill University. Her publications focus on the shaping of culinary and literary taste. From 2016 to 2022 she was associate dean of the McGill University Library, with oversight of ROAAr (Rare and Special Collections, Osler, Art, and Archives), a configuration of rare and special collections units.

VINITA DAMODARAN is a professor of South Asian history at the University of Sussex. Her work ranges from the social and political history of Bihar to the environmental history of South Asia, including the use of historical records to understand climate change in the Indian Ocean world.

VICTORIA DICKENSON is a former curator and museum director who writes in the areas of museums and material culture. She has a PhD in the history of science and has also published extensively in the history of natural history, as well as environmental and culinary history. She is currently professor of practice, Rare Books and Special Collections, McGill Library, with a number of ongoing research projects in the Blacker Wood Collection, including *The Gwillim Project* (2019–23) and *Hidden Hands in Colonial Natural History Collections* (2022–25).

TOOLIKA GUPTA is director of the Indian Institute of Crafts and Design (IICD), Jaipur, India. Professor Gupta's research interests include history of fashion and material culture, especially clothing and textiles. More can be found at https://glasgow.academia.edu/ToolikaGupta.

ALEXANDRA KIM is is a museum professional and dress historian who has worked in a range of museums in the UK and Canada over the last twenty years. She is currently administrator for Spadina Museum and Mackenzie House for Toronto History Museums.

SHYAMAL LAKSHMINARAYANAN is an independent researcher with an interest in the history of natural history in India. He contributes to the digital commons primarily through researching and enhancing Wikipedia entries. He also blogs at https://muscicapa.blogspot.com.

ARTHUR MACGREGOR is currently a visiting professor at the V&A Research Institute, studying the East India Company's collections. Formerly, he was a curator at the Ashmolean Museum, Oxford. He has published over a dozen edited volumes and is the author of a further four books, as well as numerous papers.

SARAPHINA MASTERS earned her master of arts at McGill University, studying the history paintings of Angelica Kauffman. She currently works as the assistant curator of engagement at the Sheldon Museum of Art at the University of Nebraska-Lincoln.

MINAKSHI MENON leads a working group at the Max Planck Institute for the History of Science, Berlin. She recently edited a special issue of the journal *South Asian History and Culture*, entitled "Indigenous Knowledges and Colonial Sciences in South Asia." She is working on a monograph with the working title *Empiricism's Empire: Natural Knowledge Making, State Making and Governance in East India Company India, 1784–1840*.

HANA NIKČEVIĆ is a doctoral student in history, theory, and criticism of art at MIT, researching the historical deployment of plastics as an artistic medium. She formerly managed collections and outreach at the Art Museum at the University of Toronto and has an MA in art history from McGill University.

HENRY NOLTIE is an honorary research associate of the Royal Botanic Gardens of Kew and Edinburgh. His research concerns the botanical drawings made by Indian artists for East India Company surgeons. He has recently catalogued the large collection of pre-1850 drawings at Kew, and has started to work on the collection of the Natural History Museum, London.

ROSEMARY RAZA graduated from Oxford, joined the British Foreign Service, and subsequently lived in Pakistan. She has published *In Their Own Words: British Women's Writing and India, 1740–185* and *Representing Sindh: Images of the British Encounter*, and has written entries on British women writers on India for the *New Dictionary of National Biography*. She is currently researching British women artists in British India.

MARIKA SARDAR is an independent scholar, who has held curatorial positions at the Aga Khan Museum in Toronto; the Museum of Islamic Art in Doha; San Diego Museum of Art; and the Metropolitan Museum of Art in New York. Her most recent publication, with John Seyller, examines a Persian-language copy of the *Ramayana* made for the mother of the Mughal emperor Akbar.

JEFFREY SPEAR taught Victorian studies at New York University, 1983–2018. He writes and lectures on the Victorians, British India, visual culture, Leonard Cohen, and current issues, most recently "Does Nature Have Rights?" (Institute for New Economic Thinking, 2022). He is the author of *Dreams of an English Eden* (1984).

SURYANARAYANA SUBRAMANYA, a former faculty member of the University of Agricultural Science in Bengaluru, is an Indian ornithologist based in Bengaluru. He has been studying birds in India for over four decades and specializes in studying heronries, wetlands, waterbirds, and threatened birds. He has played a key role in the establishment of bird sanctuaries and reserves in India.

ABDUL JAMIL URFI is a professor and currently head of the Department of Environmental Studies, University of Delhi. He was a European Commission Marie Curie Fellow in the United Kingdom and a Fulbright Fellow in the United States. His books on birds include *Birds of India: A Literary Anthology.*

ANN WASS is an independent costume history scholar after a career with the Riversdale House Museum in Maryland, in the United States. Her research interests include Federal/Regency-era costume and social history as well as the clothing of enslaved African Americans. She writes for and presents to both academic and popular audiences.

LAUREN WILLIAMS is the curator of the Blacker Wood Collection in the Rare Books & Special Collections department of McGill University Library. She was co–principal investigator, with Victoria Dickenson, on *The Gwillim Project: Women and Networks of Knowledge and Exchange in the Company Raj* (2019–22).

ANNA WINTERBOTTOM is a research associate at McGill University. She is a historian of science, medicine, and environment in the Indian Ocean region. She is the author of *Hybrid Knowledge in the Early East India Company World* and co-editor of *The East India Company and the Natural World* and *Histories of Medicine and Healing in the Indian Ocean World.*

Index